Art Treasures in the North

NORTHERN FAMILIES ON THE GRAND TOUR

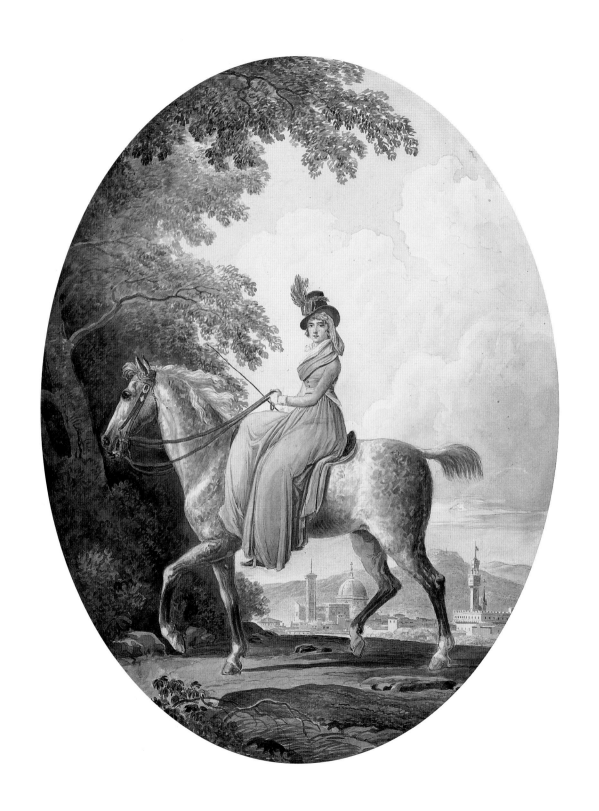

Art Treasures in the North

NORTHERN FAMILIES ON THE GRAND TOUR

ANNE FRENCH

UNICORN PRESS

Unicorn Press
47 Earlham Road
Norwich NR2 3AD
email: unicornpress@btinternet.com
www.unicornpress.org

The author and publisher acknowledge with thanks the support of The Paul Mellon
Centre for Studies in British Art, and *Connecting through Culture*, Tyne and Wear
Museums.

ISBN 978 0 906290 36 1

Designed by Mick Keates and printed in Spain

Front cover:
Nathaniel Dance
Olive Craster (detail)
oil on canvas, 1762

Back cover:
Wiliam Ord
View of St. Peter's, Rome, from Monte Mario
pencil and watercolour, 1814–5

Frontispiece:
Jean-Baptiste Thian
Harriet Carr on horseback in the Boboli Gardens, Florence
pencil and watercolour, 1794

Contents

Foreword

Art Treasures in the North has its origins in a major loan exhibition, of the same name, held at the Laing Art Gallery, Newcastle upon Tyne, on the occasion of the Millennium from 13th November 1999 to 15th February 2000. The exhibition celebrated the very significant contribution to the North's rich cultural heritage made by the men and women from this region who were privileged to undertake that extraordinary cultural pilgrimage, the Grand Tour of Europe, during the period from around 1700 to 1870.

The often exceptional works of art that these pioneers of modern tourism brought back with them provided a unique opportunity to exhibit art treasures from some of the North's greatest houses such as Alnwick Castle, Wallington and Raby Castle, as well as a selection of works from the national collections that are associated with Northern collectors.

The exhibition was hailed at the time in the *Burlington Magazine* as 'a remarkable achievement' for a regional gallery, and as one which 'admirably took up the task and theme of exploring local patronage and collecting' initiated in previous Laing exhibitions such as *Pre-Raphaelites: Painters and Patrons in the North East* (1989).

As the wealth of material available became apparent, both visual, and especially in the form of the diaries and letters written by tourists, the decision was taken to produce a much more comprehensive publication than had originally been planned, in order to do justice to this hitherto unexplored aspect of Northern culture.

Art Treasures in the North is the first book ever to focus on the 'Northern Grand Tour', offering a definitive study of the impact that the experience of continental Europe, above all Italy, had on the cultural heritage of the North of England.

It not only differs from most Grand Tour books in focusing on a single region, but is also unusual in being written from the perspective of individual tourists: at its core are the individual men and women and occasionally families who travelled from the North, the letters they wrote home, the private journals in which they recorded their experiences, and the works of art (including their own) which they brought back with them from the continent.

Tyne & Wear Museums is grateful above all to the lenders, both public and private, whose generosity at the time of the exhibition, and support for this project subsequently, have made this ambitious undertaking possible. The publication of this book would not have been possible without the help of *Connecting through Culture*, Tyne & Wear Museums' Business Partners scheme, while the Paul Mellon Centre for Studies in British Art has also generously supported the book with a grant – a most appropriate partnership, given the Centre's long-standing expertise in this area. We are indeed grateful to them both.

Anne French's *Acknowledgements*, which follow, pay tribute to the very many other institutions and individuals who have supported and assisted this project from its inception, and enabled us to see it through to a successful conclusion. We hope that this celebration of the North's past cultural achievements will find a resonance with readers not only in this region, but beyond.

Cllr. Ged Bell
Chair, Tyne & Wear Museums Joint Committee

Acknowledgements

My first and greatest debt is to the many lenders, private and public, who not only so generously parted with their possessions for the *Art Treasures in the North* exhibition on which this book is based at the time of the Millennium, but have also been endlessly generous in giving up so much of their time to discuss their family history with me, and, in several cases, allowing me to consult their archives as well.

This book would not have been possible without the lifetime's research on the British in Italy undertaken by the late Sir Brinsley Ford, doyen of Grand Tour studies. This was published in 1997 in John Ingamells' *A Dictionary of British and Irish Travellers in Italy 1701–1800*, and I should like to record my gratitude both to John Ingamells and to the compiler of the entries on Northern tourists, Carol Blackett-Ord, for lightening what would otherwise have been an impossibly daunting task.

I should also particularly like to thank Alec Coles, Director of Tyne & Wear Museums, whose energetic direction and support enabled this book to be published at a time when that seemed unlikely of achievement. My unfailingly courteous publisher, Hugh Tempest-Radford of Unicorn Press, and the book's designer, Mick Keates, have both met the delayed instalments of this publication with unwearying patience and professionalism.

Special thanks are also due to a number of people who helped the project in specific ways. My fellow Northumbrian, Matthew Festing, then at Sotheby's, has been unswervingly supportive and helpful from the project's inception over matters such as Northern Catholicism, Northumbrian families, and much else besides, while Katie Barron very kindly provided the text on Lord Lumley. Abbot Geoffrey Scott generously shared with me much information on the Swinburne family and Professor Jeremy Black read the 18th century part of the manuscript and commented most helpfully on my text. Clare Baxter, Chris Hunwick, Lisa Little and Michael Johnson at Alnwick have been endlessly helpful and patient in allowing me access to the archive and collections at Alnwick Castle, while, at the National Trust, Alastair Laing, as ever, shared with me his wealth of knowledge, and Hugh Dixon and Lloyd Langley have patiently answered my often lengthy enquiries. Bill Purdue introduced me to key Northern Grand Tour collections and archives, while his books and articles on the Carrs, the Ellison and the Blacketts have been thumbed over nearly as much as John Ingamells' *Dictionary* itself. John Ruffle generously shared his research and then unpublished material on Lord Prudhoe's Egyptian travels, while I am indebted to Tom Faulker and to Phoebe Lowery's unpublished notes on Northern houses for much information on tourists' architectural activities on their return home. Kim Sloan and Ian Jenkins provided so much help and support at the British Museum, as did the staff at the Paul Mellon Centre, home of Brinsley Ford's Grand Tour archive. I should also particularly like to thank the staff of the British Museum Prints and Drawings Department and of the Northumberland and Durham Record Offices and Local Studies libraries.

In addition, many directors, curators, librarians, and other professional colleagues in British museums, libraries, country houses, universities and other institutions have been unstinting with their help and support in a variety of ways, as have a number of individuals, and I am most grateful to the following: Brian Allen, Jon Astbury, Hugh Belsey, Melanie Blake, Nicholas Booth, Catherine Clement, Elizabeth Conran, Father Adrian Convery, Thomas F.R. Coulson, Jane Cunningham, Kay Easson, Peter Ellis, Karen Exell, Jane Farington, Iain Gordon-Brown, Richard Green, Andrew Heard, Peter Higgs, Alan Hobart, James Holloway, Jane Holmes, June Holmes, Dennis Inch, Sarah Jury, Robert Kirton-Darling, Martin Ladds, Emma Lauze, Lisa Little, Michael Liversidge, Krystyna Matyjaszkiewicz, Jennifer Melville, Theresa-Mary Morton, Sheila O'Connell, Anna O'Sullivan, Clare Owens, Pippa Pease, Marcia Pointon, C.L. Ridgway, Matt Ridley, Neil Robinson, Anne Rose, Judy Rudoe, Colin Shrimpton, Elizabeth Smallwood, Kathleen Soriano,

Karen Stewart, Malcolm Stewart, Stuart Tulloch, Pamela Wallhead, Adam White, Jonathan Wilson, Evelyn Wood and Sue Wood.

It is particular sadness that Pat Brown, without whose patient filleting and transcription of family papers in the Northumberland Record Office and elsewhere this book would not have been possible, did not live to see its completion. Nor did Helen Watson, who also helped in researching local records. A number of other dedicated volunteers provided key support, among them Joyce Arkless, Charlotte Boyce, Rachel Boyd, Sam Fenwick, Dominique Hostettler, John Hudson, Caroline Jordan, Catriona Miller, Sasha Newall, Gillian Robertson and Catherine Scurfield.

My former colleagues at Tyne and Wear Museums have lent support in a wide variety of ways, notably at the time of the exhibition, and I should particularly like to thank the former Curator of the Laing, Andrew Greg; my then job-share Sarah Richardson; Ruth Trotter, Alex Thirlaway and Christine Dawson; John Teesdale and Dave Shoulder, the exhibition designers; Les Golding, who took so many of the photographs;

and especially Sharon Henry, who not only handled the typing of the exhibition correspondence, but also typed much of the first draft of this publication, in the days when my computer literacy was in its infancy.

Finally, I should like to thank my husband William Monroe. Not only has he diligently and painstakingly undertaken so much research and checking in archives and libraries, to the extent that he is now as familiar with the Northern tourists in this book as I am, but he has given me invaluable assistance over editing as well. My thanks go to him and my four children for their patience, on which I have trespassed greatly, as on many others', over several years. If this project has indeed seemed endless to them and all others involved in it, I hope it does represent, to misquote Wordsworth, something of the nature of 'research recollected in tranquillity', and that it is hence a more considered analysis of Northern tourism than the one that was originally planned to appear, in much shorter form, in 2000.

Anne French

Author's Preface

The impetus for this book, and the exhibition at the Laing Art Gallery from 1999-2000 which preceded it, came originally from the Tate's *Grand Tour* exhibition in 1996. Intriguingly, no English Grand Tour material from further north than Yorkshire had been included, with the exception of one travel book, and two major paintings by Vernet which had arrived in the region only relatively recently. Had the traffic between the English regions and continental Europe then stopped abruptly in its geographical tracks in North Yorkshire, which was covered in detail, including well-known tourists such as William Weddell of Newby Hall? (Or perhaps even closer to the Durham border, at another famous Grand Tour house, Rokeby Park, which, sadly, owing to its position, falls outside the remit of this study as well?). The research for this book indicates that, on the contrary, the far North of England made a remarkable, and distinctive, if not invariably aesthetically distinguished, contribution to the history of the Grand Tour, both in terms of artefacts and, even more so, of written records.

In a book which aims to explore the character of the Grand Tours made from the 'North', as opposed to other regions of Britain, it is important to define the geographical area intended by this term, and to consider whether the area chosen for study represented a region as such in 18th century terms. It will be evident from the exclusion of Yorkshire that I am not referring here to the 'North' as it descended historically from the old Kingdom of Northumbria, although others have recently, and with considerable justification, used this area to discuss images of Northern-ness in the 18th century.[1] Nor am I using county boundaries, which have the disadvantage of changing over the years,[2] although this book does in practice focus on tourists mainly from the

counties of Northumberland, Durham, and westwards towards Carlisle.

Instead, in my references to the 'North' in what follows – the term 'North-East' I avoided, as being too specifically focused on Tyneside and Tees-side, despite its resonance for the identity of the region today – I have decided to follow a definition which has the merit of having been in currency with 18th century commentators, who were 'broadly in accord with the idea of a "North Sea" cultural province: the geographical territory between the Tees and the Tweed, with the Pennines forming a western boundary'.[3] *Art Treasures in the North* therefore excludes the western and southern parts of what is today Cumbria; as an almost entirely agricultural area, which was comparatively unknown elsewhere until the last quarter of the 18th century, when it was transformed by the 'discovery' of the Lakes, this area had a noticeably different profile in terms both of its social and industrial development, religious affiliations, and, as a consequence of this, its inclination towards Grand Tour travel. Very few social or marital contacts seem to have existed among the gentry (who for much of the 18th century formed the majority of Grand Tour travellers) across the Pennine east-west divide. Conversely, my singling out of 'Northern' tourists seemed to have coherence for the area selected; those Northumberland and Durham tourists who largely make up the present study formed social, political and cultural networks, meeting and corresponding among themselves, becoming involved in projects for their mutual benefit, forming political alliances, employing many of the same architects and artists both here and abroad, and frequently intermarrying.

Remaining confusions over the Anglo-Scottish border,

which had persisted as late as the Civil War, suggest that the North can hardly have been an identifiable English region until shortly before 1700, the effective date of the commencement of the Northern Grand Tour. However, the Northern region seems to have existed from the early years of the 18th century as a relatively clear concept in the minds of southern writers such as Defoe, whose perception in 1724–6 in his *Tour thro' the Whole Island of Great Britain* was of an 'alien' or backward area, comprising vast tracts of wild, open land (the 'satanic mills' represent a later, 19th century, construct), and the tours made by southerners to Northumberland and Durham as the 18th century progressed, seeking the romantic scenery soon to be painted by Turner on his highly important tour of the North in 1797, clearly offer an important context for those made from the North during this same period to continental Europe. Those who actually lived in the North of England during the 'long' 18th century would probably have stressed instead the region's increasing prosperity through agriculture, lead-mining and the coal trade.[4] Meanwhile, numerous factors, ranging from coal itself, though images of Northern-ness in poetry and popular ballads, to actual differences in lifestyle and cultural ownership, as well as the socialising of the gentry around regional centres, perhaps gave Northerners of all social classes a distinctive sense of identity.[5]

A second question concerning regional identity, highly germane to this book, relates not to the identity of the region itself, but to when those living in it first began to see themselves as a part of English, or indeed British, national culture.[6] Although 1660 finds general acceptance among recent historians as a *terminus post quem* nationally for the primary loyalty of the elite towards their county being replaced by integration into a national frame of reference, Helen Berry and Jeremy Gregory have recently shown in their seminal *Creating and Consuming Culture in North-East England, 1660–1830* (2004) that 'integration into the wider national picture' in the North was slower than elsewhere, notably in terms of the delayed development of polite leisure activities, and of country house architecture.[7] In a book which tests

theories as to regional against national identity specifically in terms of the consumption of culture – something which clearly has many resonances for a study of the Grand Tours made from this same area – they suggest that it would therefore be 'premature to discount the importance of regional identity' in the North, certainly in the earlier part of the 'long' 18th century. Despite this, both Berry and Gregory and their contributors (together with Phoebe Lowery, whose essay in 1996 on 'Patronage and the Country House in Northumberland' complements their discussion in its focus on architectural patronage),[8] conclude that the North did share 'much consumer behaviour and material culture with the rest of the country'.[9] As I will argue in my Introduction (pp. 30–1), the same conclusions can be drawn for the Grand Tour: while some sense of national identity and integration seems a prerequisite for those electing to form part of a fashionable, nation-wide exodus to 'foreign' parts, there are clear reasons for suggesting that the Grand Tours made from the North by the families of county leaders have a distinctive regional flavour, and that there was a time-lag between the North and other regions in the gradually increasing 'take-up' of Grand Tour travel.

The presence of regional cultural variances within a broadly national framework finds support in a chapter by Lorna Scammell in *Creating and Consuming Culture* which analyses household inventories in the diocese of Durham (then including Northumberland) from 1675 to 1715/25.[10] While values for moveable goods such as clocks, books, earthenware and china were in the middle of the national range, a similar pattern of late development in the North in terms of key consumer spending on cultural artefacts and other 'luxury' spending emerges: in particular, the very low level of book ownership found on Northern inventories (26%, as opposed to 54% for households in London and the south), has crucial implications for the development of those wider cultural interests which were surely essential for Grand Tour travel.[11] While comparable tables for household expenditure in the latter half of 18th century are lacking, they would almost certainly be entirely different, painting a picture identifiable

from Helen Berry's fascinating study of the aspirations of 'polite society' as expressed in the construction of the ambitious new Assembly Rooms in Newcastle, which opened in 1776. Grand Tour travel can thus take its place as part of the new consumption of culture by the still-powerful gentry, together with the civic elite and families newly enriched by trade, following on from the more settled state of the region after the 1715 and especially the 1745 Jacobite rebellions.

By the second half of the 'long' 18th century, the aspirations of the region's now expanded elite to be seen as players on the national stage can be seen both in Grand Tour travel itself, and in the closely related establishment of the new Assembly Rooms in 1776 (see pp. 30–1), which were not simply, as Berry points out, a demonstration of the North's internal cultural needs and preoccupations, but an assertion of Newcastle's equality with national centres such as nearby York, or Bath – or indeed with smaller cities such as Sheffield which had stolen a march on them in this respect. And if this was one manifestation of a desire for a national frame of reference, another was the tendency of the 'wealthy *nouveau riche* business men, colliery owners… and the "millocracy"' 'to send their sons southwards to acquire education and fashionable tastes'.[12] Similarly, these families began from around 1780 to send their sons (and occasionally daughters) abroad.

Once on the continent, Northern tourists became fully absorbed into this national pilgrimage, mixing with British tourists from other regions, and sharing their goals and itineraries, if not always acquiring similar artefacts (p. 34). However, tourists from the sons of the 1st Duke of Northumberland down to those on modest incomes also seem to have seen themselves distinctively as Northerners, or at least as belonging to a Northern elite, often commenting in their diaries on their increasingly frequent meetings on the continent as the 18th century progressed, so much so indeed that, had all of these interactions been cross-referenced, the text of this book would be literally peppered with comparative page numbers. Remarkably few leading Northern 18th century families (the Delavals and the Londonderrys are notable exceptions) appear to have eschewed Grand Tour travel – a

fact which itself perhaps offers further testimony of those regional networks under discussion here. Northern tourists also shared tutorial know-how, notably in the person and writings of Louis Dutens, in contacts with bankers and *cicerone*, and, to a lesser, but still significant, extent, in the patronage of artists abroad. Such patterns, emerging from the many surviving Northern tour diaries and letters, seem to offer a justification for exploring the distinctive qualities of Northern tourism, albeit within a wider, national framework.

September 2008

END NOTES

1 Katie Wales, 'North of the Trent: Images of Northern-ness and Northern English in the Eighteenth Century', in Berry and Gregory, pp. 24–36.
2 Berry & Gregory, p. 6.
3 Op. cit., p. 5.
4 Katie Wales, in Berry & Gregory, p. 28.
5 Berry & Gregory, *passim*.
6 See especially Linda Colley, *Britons. Forging the Nation, 1710–1837* (1992).
7 Berry & Gregory, pp. 3-4; their article contains a discussion of this debate and its relevance to the North.
8 *Northumbrian Panorama*, ed. T.E. Faulkner, 1996, pp. 49-73.
9 Lorna Scammell, 'Was the North-East Different from Other Areas? The Property of Everyday Consumption in the Late Seventeenth and Early Eighteenth Centuries', in Berry & Gregory, p. 22.
10 Op. cit., pp. 12-23.
11 The household goods of Betty Bowes, whose Durham landowning family was in fact much more prominent in the early history of the Grand Tour than most from the region (although, as a woman and a spinster, she is something of a special case), shows that she owned only two books relating to the classics (in translation), including a Homer.
12 Katie Wales, in Berry & Gregory, p. 33.

Introduction

By the early years of the 18th century, the sons of the British nobility and gentry were being packed off in droves by their families to finish their education, after university, by making a continental Grand Tour; as Lady Polworth put it in 1778, 'travelling… is… eligible from the difficulty of finding employment for a young man not yet of age', and the experience of Italy came to be seen by the social elite of the day not just as 'eligible', but as an essential part of a young man's education, so much so that James Boswell would later refer disparagingly to 'the common course of what is called the tour of Europe'.[1]

Although travel was expensive, and tourism therefore tended to be restricted to a wealthy social elite, and to those ranging from professionals such as tutors, artists, musicians and diplomats to servants who catered for their needs, the traditional perception of the Grand Tourist as a young country gentleman or aristocrat (fig. 92) can be rounded out by those who travelled abroad on their honeymoon (figs. 80–1, 163); for their health, in an age which was ravaged by consumption, for which there was no cure, but for which a Mediterranean climate often provided a respite (figs. 82, 114); in the wake of bereavement, separation or divorce; to give birth discreetly to illegitimate children; or simply for pleasure. The tour made from 1774–9 in early middle-age by the Catholic travel writer, Henry Swinburne, a man of moderate, although independent, means, with his wife and young family, does much to counteract the generally received view of those who ventured abroad. Although young unmarried women did not generally make the Grand Tour, the profile of Northern tourists on pp. 29–35 shows that there was at least one notable exception, and sometimes, as with the Lambtons or, once again, the

Swinburnes, whole families remained abroad for lengthy periods. This would be even more the case in the early 19th century, when the Northumbrian Matthew White Ridley bemoaned the 'wanderings of the Ridley family in Switzerland'.[2]

This extended journey – which is, of course, the ancestor of the mass tourism of today, of our own summer holidays abroad – took travellers through France or The Netherlands and often Switzerland, Austria (with its Imperial capital in Vienna), and the German princely states as well. The foundation stone of British 18th-century culture, however, was a familiarity with the civilisations of ancient Greece and Rome, so, to successive generations of British tourists, the goal of most Grand Tours, after crossing the Alps, was Italy, and above all Rome. Only a few adventurous spirits visited Spain, eastern Europe or Russia, or sailed across the Mediterranean to Greece or Constantinople, and it was not until the early 19th century, after the suspension of the Grand Tour following Napoleon's invasion of Rome in 1798, that tourism changed radically in character, embracing Greece, Egypt and the Near and Far East.

Grand Tour routes were not, however, as stratified as is sometimes suggested. Not all travellers visited Italy, and the remarkable tour of Henry and Martha Swinburne (pp. 40–52), which included the Loire, South West France, Spain and Sicily, as well as more usual destinations, was by no means the only one made from the North to deviate markedly from the norm. In the late 1760s Elizabeth, 1st Duchess of Northumberland made a series of tours to The Netherlands, specifically to visit the province's art collections, and Henry Swinburne's guidebook did much to popularise Spain as a destination for tourists in the last few decades of the century. One of the most remarkable tours of the whole 18th century, however, was that of Scandinavia made by the Durham tourist Sir Henry George Liddell in 1786, which is said (erroneously) to have been undertaken as a result of a bet that he could bring back with him two reindeer and their female Lapp attendants.

As well as enabling tourists to see the great monuments of classical Rome, and the picture galleries of Italy, Paris, and the rest of Europe, the Grand Tour also offered travellers a chance to become themselves collectors and patrons of the arts. They could buy classical sculptures, antique gems, and Renaissance or 17th-century pictures – or alternatively 18th-century copies of these – together with contemporary paintings, sculpture, porcelain, and furniture, and send them home, often by the ship-load, to grace the walls of their British country houses, and impress their neighbours with their classical culture and learning. One tourist, William Weddell, sent home no less than nineteen cases of classical statuary to Newby Hall in Yorkshire, but the 1st Duke and Duchess of Northumberland were not far behind him when they employed the young James Adam to select a large number of antique statues and columns for their Middlesex home, Syon House (p. 61–75). Many tourists also sat for their portrait while in Rome to the greatest Italian portraitist of the 18th century, Pompeo Batoni (p. 19), or to one of his rivals, and patronised other British or Italian artists resident here, in Florence, or in Venice (pp. 17–20).

The surviving evidence suggests that a surprising number of young tourists managed to live up, at least to some degree, to the lofty aims expressed by the Northumbrian John Carr, who wrote that 'the only end and intention of our expedition is improvement',[3] or by the Durham traveller Robert Wharton, who wished to mingle in Italy, not with the 'Jolly boys who see St Peters by torchlight, ride a-panting the morning, and drink d-n to Gusto all the rest of the day, who I look upon to be more contemptible than the animals they hunt', but with 'men of letters and science'.[4] There was, however, a more convivial aspect to the Grand Tour, and it was no doubt partly for this reason, to protect young men seeking to throw off the shackles of parental control from what parents saw as the heady dangers of continental wine, women and gambling to which they would be exposed – as well as to assist in their assimilation of a classical education – that most families prudently sent along a tutor or travelling companion with the young Grand Tourist (figs. 73, 77).

Despite such precautions, by no means all tourists returned unscathed from the Grand Tour. For some, like Lord Morpeth, who died of venereal disease in 1741, their death

was the direct result of a dissolute lifestyle. Others died from very different causes. Although the warmer climates of Italy and southern France were considered, rightly, to benefit those suffering from consumption, two Northerners, Olive Craster and William Henry Lambton, died abroad of the disease. Others, like John Carr in Vienna in 1789, were taken seriously ill with fevers or other complaints, and the presence of bubonic plague in Turkey and further east deterred some, though not all, tourists from venturing that far. A small number of tourists, like Lord Warkworth's servant, Gisman, who was stabbed in Italy in 1763 in a quarrel with a postillion,[5] were the victims of actual violence, and stories of robbery and brigands abound in Grand Tour diaries; many others considered that they had been cheated, inn-keepers and postillions usually being the chief culprits, but the resilience of tourists like Sir Charles Monck or Major George Anderson under such adversity suggests that many tourists were well equipped to cope with what Monck on one occasion saw as 'bringing the Inn and the whole country into disgrace to abuse strangers so'.[6] The 'filth & misery' which tourists like William Ord saw everywhere around them was another common complaint, bugs and flies causing particular annoyance: mosquitos so tormented the artist William Bewick that he was 'covered with red spots like the chicken-pox',[7] while Newbey Lowson's stay at the Hotel du Nord in Paris in 1816 was marred by the 'little apartment', which he considered the 'temple of abomination and filth', and where he was constantly interrupted by the shrill squall of a female voice exclaiming 'il y a du monde'!'[8]

Even the sunshine, which draws so many to the Mediterranean today, was considered to present its dangers, and John Carr's criticism of Florence, which he declared was 'hot enough to hatch chickens in' is a witty expression of what most tourists felt about the sun; perhaps sensibly, in view of what we know today of its dangers, the Carrs became 'close prisoners of the sun' in their early days in Italy, staying firmly indoors.[9]

For the majority of tourists who did return home safely, the Grand Tour could act as a catalyst for change; if a number became prominent as art patrons and connoisseurs, many more altered or rebuilt their family mansions in the years following their tour. For others, the effect was social rather than cultural, and at least two Northerners gained promotion to a higher social group on their return from Italy. Others adapted contentedly and apparently more seamlessly to the life they had left behind them. A concrete reminder of Italy for some male tourists was membership of the Society of Dilettanti, founded in 1732 by a group of former tourists; according to Horace Walpole, the 'nominal qualification' for this society was 'having been in Italy, and the real one, being drunk'.[10] The society's presentation in 1794 to Henry Swinburne (pp. 40–52) of a weighty study by Sir William Hamilton concerning the survival of a cult of Priapus in southern Italy, in which the phallus had been reincarnated as 'St. Cosmo's big toe', certainly suggests that its intellectual activity had a lighter side.[11] However, the Society of Dilettanti undoubtedly promoted the study of Italian art and classical architecture, sponsoring archaeological excavations and paying for young artists to travel abroad. Other, perhaps more intellectual tourists, became members of the great historian Edward Gibbon's Roman Club.

Several recent books and exhibitions have explored this fascinating pilgrimage, which, together with those medieval pilgrimages from which it is descended, is surely one of the most extraordinary cultural phenomena of the last millennium, involving, as it did, not only British tourists (who represented, however, the vast majority of travellers) but those of other European countries as well. This is, however, the first publication to focus on the men and women who made the Grand Tour from the North of England, and to explore, near the beginning of the new millennium, their contribution to the rich cultural heritage of the region over the last three hundred years. The following pages provide a brief introduction to the Grand Tour in a national context; although the illustrations in this section relate mostly to the Grand Tour in general, rather than specifically to the tours made from the North, quotations are, wherever possible, drawn from the accounts of Northerners.

PREPARATIONS FOR THE GRAND TOUR

'ITALIAN LIGHT ON ENGLISH WALLS'

Long before they visited Italy, many tourists were familiar with its most famous sights and scenery. Landscape paintings of the Roman *campagna* or countryside by the great triumvirate of 17th-century French artists living in Rome, Claude Lorrain, Nicolas Poussin and Gaspard Dughet (fig. 1), and by their Italian contemporary, Salvator Rosa, were highly popular with British 18th-century collectors, for whom the landscapes of Claude and Rosa perfectly embodied the two polarities in landscape expressed in contemporary aesthetics, the 'beautiful' and the 'sublime'. While Claude and Dughet offered an arcadian world based on the Roman *campagna*, littered with ruins of the classical past, and peopled with pastoral figures or characters from Ovid's *Metamorphoses*, Nicolas Poussin offered a more learned interpretation of the world of Greece and Rome. All four artists, however, provided a touch of 'Italian light on English walls',[12] and did much to create among their British owners a desire to see Italy for themselves. So steeped were most tourists in the classical landscape tradition that an early 19th-century traveller, William Ord, even saw the Italians themselves through these

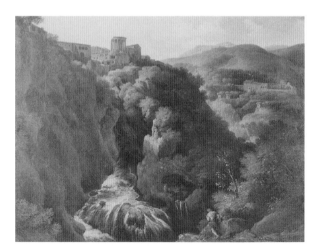

Fig. 1 *View of the Temple of the Sibyl at Tivoli*
by Gaspard Dughet, oil on canvas, 1640s

painters' eyes, noting the contrast between the Tuscans, and the 'swarthy wild looking inhabitants of the south' who resembled 'the figures of Salvator [Rosa] or Murillo'.[13] Italy was also familiar to British tourists through their study of the classics, and on a visit to Naples in 1792 Harriet Carr saw the landscape in terms of the classical authors with whom it was associated: 'Here it is that Horace laugh'd, that Pliny died, that Cicero fell'.[14]

TOUR JOURNALS

Our extensive knowledge of the travels and activities of Northern tourists is based on the very large number of surviving tour journals and letters. The reason for such persevering industry and productivity becomes apparent in the letters between Ralph Carr of Dunston Hill near Newcastle and his son John before the latter's departure on a tour of 1788, in which Ralph enjures him to 'commit Every Observation & Information most minutely and sacredly Into your Book of Travels with a regular Diary hour Every day'.[15] Evidently, Ralph regarded such record keeping as *de rigueur*, and indeed parents clearly expected some accountability from their offspring in return for the funding they provided. One later, admittedly highly eccentric, tourist, Sir Charles Monck, although long freed from such constraints, was so conscientious that he even made his travel notes 'in pencil on the spot and at the moment as I rode in my carriage or on my horse or mule and inked afterwards'.[16] While not everyone was so industrious, the young Lord Barnard dutifully wrote much of his journal (containing coded references to his love affairs abroad) in French, so as to practise his linguistic skills, reserving the left hand pages of his diary for descriptions of the sights he had seen.

PREPARATIONS FOR DEPARTURE

The letters between Ralph and John Carr in 1788 are a treasure trove of information on the very considerable planning necessary to those contemplating a lengthy tour.[17] Essential purchases included travelling equipment such as dressing cases and maps, while, for those who could afford it,

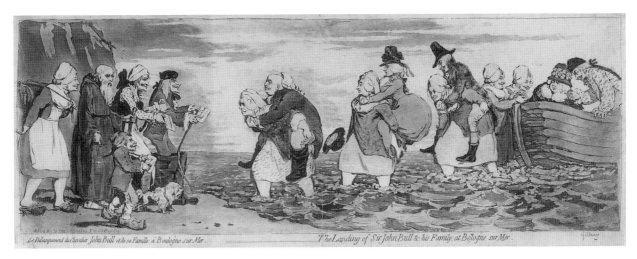

Fig. 2 *The Landing of Sir John Bull and his Family at Boulogne sur Mer* by Gillray after W. H. Bunbury, aquatint, 1792

a travelling carriage was a *sine qua non*. Arrangements had to be made with bankers for letters of credit, so that tourists could draw money at major centres of the Grand Tour. Although they often hired supplementary staff abroad, most travellers took a small number of servants with them, usually including in the party at least one who could speak the language: in 1788 John Carr was 'under the necessity of hiring a servant accustomed to travelling upon the continent, as Stephen [his manservant] would have been a very great incumbrance instead of being any use'.[18] Whereas a relatively modest traveller such as Carr, this time travelling with his sister Harriet, took two servants, including Stephen, on his tour of 1791–4, the 1st Duchess of Northumberland travelled with a whole retinue, as well as her dog, Tizzy, such an indispensable companion that one servant was dismissed for throwing her roughly out of the ducal carriage.[19]

John Carr's letters of 1788 also shed considerable light on the not-always-compatible expectations of parents and their tourist sons; John, while forever stressing his desire for economy, nevertheless found it necessary to buy a complete stock of linen, boots, shoes and other leather articles before setting out, on the grounds that they were cheaper and more durable in England, and it is not difficult to agree with the

Carr family historian, Bill Purdue, that the chaise formerly belonging to the Duke of Bedford, which he purchased second hand for £80, may not have been entirely the bargain he represented it as being.[20]

THE JOURNEY

CROSSING THE CHANNEL

Grand Tourists began by crossing the channel, usually from Dover to Calais or Boulogne, although from 1763 onwards an increasing number of tourists chose to sail instead from Brighton or Southampton to Normandy, given the shorter distance from here to Paris. A caricature by William Henry Bunbury (fig. 2) shows *The Landing of Sir John Bull and his Family at Boulogne sur Mer* in 1792, where their arrival is awaited by a group of lean and avaricious Frenchmen. Crossings were made by public packet boat or in privately hired vessels; in September 1791 John Carr chartered a boat for himself and his sister as the 'common Paquet had neither room for us nor our chaise'.[21] Contrary winds meant that tourists often had to wait hours or sometimes even days for a sailing, and sea sickness was a common problem; in 1775

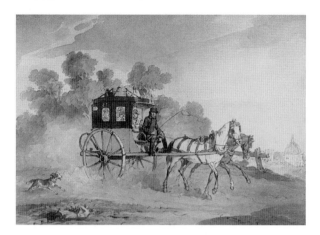

Fig. 3 *The Post Cart* by John Augustus Atkinson,
watercolour, 1818

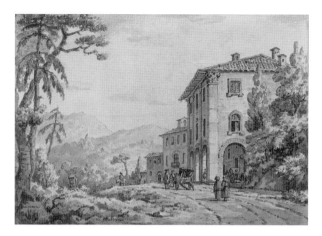

Fig. 4 *A Post House near Florence* by William Marlow,
watercolour over pencil, about 1770

Robert Wharton was sick most of the way from Dover to Calais; 'it is the most disagreeable sickness imaginable'.[22]

Once on the continent, all tourists, whether they could afford their own carriages, or had to travel in hired vehicles or by the public coach or *diligence* (cf. fig. 3), were obliged to rely on the system of 'posting', which meant that they had to stop at inns or 'post houses' along the route to obtain fresh horses (figs. 4, 5). Journeys were consequently measured in terms of the number of posts (the average distance between them was about five miles) that could be completed in one day, and travelling was often gruelling: in 1772 Elizabeth, 1st Duchess of Northumberland, an inveterate traveller, recorded that she had 'got up every morning by 4, get no breakfast, am in chaise by 5... Travel on till between 8 & 9 at night & then have the great satisfaction of knowing that I have performed a Journey of about 25 English measured miles'.[23] One of the constants in almost every tourist's diary is dissatisfaction with all aspects of the posting system. The Papal States were agreed to be particularly at fault, John Carr finding in 1793 that the postillions were careless and insolent, and William Ord noting that they had to cross a mountain on a road 'that does not seem to have had any repairs done to it since the days of Hanibel'.[24] Faced with such difficulties, two Northern travellers, Sir Charles Monck and Major George Anderson,

adopted a choleric, even confrontational attitude to postillions, Anderson even going so far as to have a group of Italians arrested for over-charging him in 1803.[25]

While waiting for horses to be changed, travellers could take refreshments at the Post House: another caricature by William Henry Bunbury (fig. 5) gives an impression of the

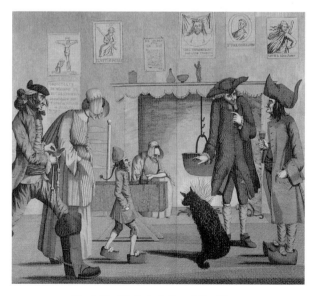

Fig. 5 *The Kitchen of a French Post House*
by William Henry Bunbury, engraving, 1771

interior of one such establishment in France. With formidable efficiency, the 1st Duchess of Northumberland not only kept a note of every post along her route; she often added somewhat abrasive comments as to the cleanliness and the quality of the food and wine at the inns: 'Post but indifft bad Beds Good Wine monstrous dear'[26] reads one typically pithy entry. If travel was frequently uncomfortable – in Spain, for example, the principal method of travel was by mule, and travellers often had to sleep on straw – it could also be actively dangerous: in 1774 the Duchess of Northumberland crossed the River Drôme over a makeshift bridge of loose stones from which another carriage had been dashed to pieces only two hours before.[27]

FROM CALAIS TO PARIS

From Calais and Boulogne, the ports preferred by the aristocracy and gentry – 'Calais will always be the port for our gentry, who had rather go thirty leagues more post by land than across twelve leagues of water instead of seven' – there was a well-established post route leading to Paris, the first, and, apart from Italy, the principal, destination of Grand Tourists.[28] The parents of young travellers were, however, wary about a stay in the French capital, fearing that their sons would fall prey to unsuitable company. In 1788 John Carr managed to slip into his itinerary, clearly against his father's wishes, a stay there, which, despite his declaration that he 'would not willingly stay at Paris above one day', lengthened to eight; he assured his father, however, that his time had been spent profitably in seeing the 'most striking public buildings' on the 'usual round recommended to strangers'.[29] Both parents, and tutors such as Louis Dutens, expressed concern that young tourists should 'mix with the company of Nobility in Paris rather than frequent *solely* their countrymen'.[30]

Although visitors flocked to Paris to see the Royal court at Versailles, and sights such as the Louvre and Tuileries, the Luxembourg, the Duc d'Orléans' famous picture collection at the Palais Royal, Nôtre Dame and Les Invalides, not everyone's impressions were favourable: in 1814 William Ord characterised the older part of the city as having 'crooked

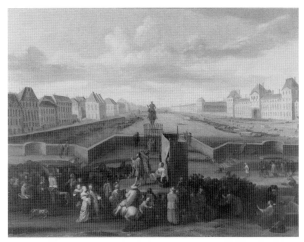

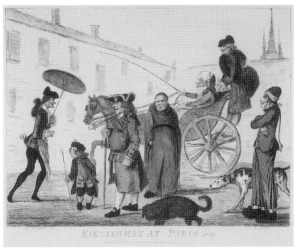

Fig. 6 *The Pont Neuf, Paris* by Hendrik Mommers, oil on canvas, mid-17th century

Fig. 7 *Englishman at Paris,* 1767 by J. Bretherton after W. H. Bunbury, etching, 1782

crowded narrow streets with a river of mud flowing down the middle of them'.[31] Paris not only boasted major sights and public buildings. Luxury shopping and factories such as the Sèvres porcelain factory and the Gobelins tapestry works were a major draw, but undoubtedly even more appealing for many was Parisian social life with its opera, theatres and private balls. The vibrancy of everyday life in the French capital can be

sensed in a mid-17th-century view of the Pont Neuf, which was famed for its street life, by Hendrik Mommers (fig. 6); the bridge would have looked very similar at the height of the Grand Tour era. A caricature, again by Bunbury (fig. 7), offers a satirical contrast between the sturdy British visitor out walking in the streets of Paris, and the thin Frenchmen (with the exception of the friar) who surround him.

FROM PARIS TO ITALY

From Paris, many travellers made their way through Savoy and over the Mt. Cenis pass into Italy. The crossing of the Alps represented a major barrier in the 18th century, as the mountain passes were only open in the summer months, and those who had not crossed by October were obliged to spend another year abroad. Roads were, moreover, hazardous, and accidents frequently happened: Henry Swinburne's account in 1779 of travelling along a road 'hewn out along the side of a large rocky mountain' where 'Parapets keep the traveller from tumbling over, which might otherwise happen, as the passage is narrow and slippery'[32] is graphically illustrated in a fine

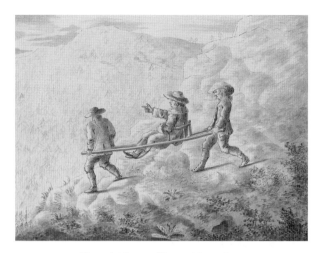

Fig. 9 *A Manner of Passing Mount Cenis* by George Keate, wash drawing, 1755

watercolour, *Going up Mount Splügen* (fig. 8). Coaches had to be dismantled on the higher reaches, and tourists were carried in chairs like the one shown in a drawing by George Keate (fig. 9); Henry Swinburne described in 1779 how he was 'seated on a little stool with a back to it, fixed on poles, which two men bore like chairmen.[33] By the early 19th century, however, travellers were able to benefit from Napoleon's construction of a new road over the Simplon: although their ascent required seven horses, the Ord family was able to cross the pass in their coach in 1816, but 'the people of the neighbourhood' had to 'attend with ropes etc. to assist the Carriages in going up & down'.[34]

Perhaps understandably, given the dangers and discomforts of crossing the Alpine massif, a significant percentage of tourists chose an alternative route. This was to travel by road through Lyons to the south of France, and then to sail to Italy from Marseilles or Nice in small boats called *feluccas*, usually landing at Genoa. However, travel by sea was perhaps equally dangerous; apart from the obvious vulnerability of these craft to storms and shipwreck, Barbary pirates lurked in some parts of the Mediterranean. The lack of regular passenger services meant that only very wealthy tourists like the Northumbrian, Lord Warkworth, could contemplate

Fig. 8 *Going up Mt. Splügen* by Francis Towne, watercolour and pen and ink, 1781

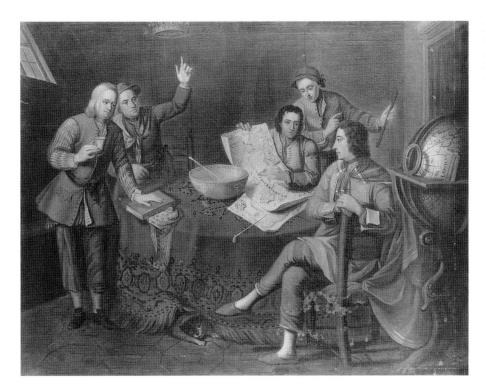

Fig. 10 *Gustavus Hamilton (1639–1723), Viscount Boyne, in the Cabin of his Yacht* by Bartolomeo Nazari, oil on canvas, about 1730–1

chartering a private yacht and sailing on from Italy across the Mediterranean; a view by Bartolomeo Nazari shows one such tourist, *Viscount Boyne in the Cabin of his Yacht* (fig. 10).

THE GRAND TOUR CENTRES: ROME, FLORENCE, NAPLES AND VENICE

Once in Italy, travellers tended to head for Rome via Milan, Bologna, and Florence. Naples, which for many travellers was the southern-most point of the Tour, tended to be visited as an excursion from Rome; on their way back through Northern Italy tourists usually made a detour to Venice, then regarded as the city of festivities rather than of art.

ROME

Either individually or, like today's coach parties (but on a far smaller scale), Grand Tourists in Rome were taken on accompanied tours of the sites by a *cicerone* or guide (p.16). Among the principal monuments of ancient Rome on their itinerary was the Forum or ancient Market Place, with its ruined temples, triumphal arches and basilicas, now invested with a picturesque quality from its later incarnation as the *Campo Vaccino* or livestock market (fig. 11). The Colosseum (fig. 12), or ancient amphitheatre, which had been one of the great sights of the city since its erection in the 1st century A.D., was equally important, while the Pantheon (fig. 13), built in the reign of the Emperor Hadrian, was admired more than any other single antique building, having survived intact owing to its conversion into a Christian church.

The Roman *campagna* or countryside was also exceptionally popular with British tourists, who made short excursions from Rome to see its classical ruins, Renaissance villas and gardens, volcanic lakes and picturesque hill towns (fig. 14). Among the most visited sights were Ariccia and nearby Lake Albano; Lake Nemi, whose magical beauty and associations with classical

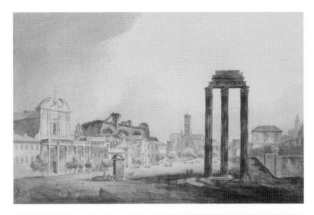

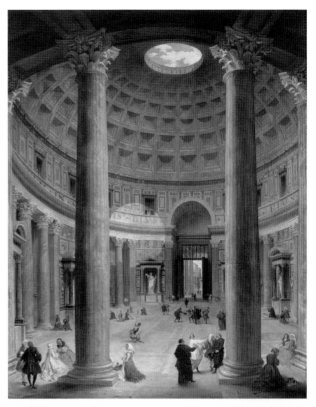

Fig. 11 *The Campo Vaccino, Rome* by John 'Warwick' Smith,
pen and watercolour, 1776–81

Fig. 12 *The Colosseum, Rome*
by William Pars, watercolour, 1775–82

myth and legend drew many artists, including J.R. Cozens
(fig. 15); and above all Tivoli, where the so-called Temple of
the Sibyl perched above the famous cascade was already
familiar to many tourists from the paintings of Claude Lorrain
and especially Gaspard Dughet (fig. 1).

For Protestant and Catholic tourists alike, St. Peter's, seat
of the Papacy, which Henry Carr aptly said 'rather resembles a
palace than a church',[35] was usually the first sight they saw on
their arrival, and William Ord probably spoke for generations
of tourists when he found that the church 'quite overpowered
one'.[36] The Capitoline and Vatican museums, with their great

Fig. 13 *The Interior of the Pantheon, Rome,*
by Giovanni Paolo Panini, oil on canvas, 1735

Fig. 14 *The Alban Hills*
by Richard Wilson, oil on canvas, 1752–7

collections of classical sculpture, which opened in 1734 and 1771 respectively, were essential viewing. So too were the city's principal picture galleries, most of them still in private hands, with their Renaissance and 17th-century masterpieces by artists like Leonardo da Vinci, Raphael, Michaelangelo and the great Bolognese *seicento* painters, Annibale Carracci and Guido Reni – all of whom, in their different ways, had interpreted classical culture to a more recent audience.

Few works of art can give such a vivid impression of the expectations both felt and aroused by a British Grand Tourist as David Allan's *The Arrival of a Young Traveller in the Piazza di Spagna*, Rome (fig. 16). Here, a wealthy young man is almost mobbed outside his hotel by a crowd of people, all of whom hope to sell him their Grand Tour wares; one man holds up a copy of a Madonna *tondo* perhaps by Raphael. The presence of a group of Italian musicians and dancers on the right indicates that, like many of his compatriots, the tourist has arrived in Carnival week. On the left is the Caffè degli Inglesi, the coffee house which was one of the principal meeting points for the British in Rome.

FLORENCE

Florence, usually visited on the return journey, was ruled over by the Grand Dukes of Medici until 1737 and then by the Hapsburgs. Here tourists visited the great art treasures of the *Galleria*, now the Uffizi, which included the famous octagonal gallery known as the *Tribuna* (fig. 17), home to the renowned *Venus de' Medici* and other prized classical statues, as well as to the Renaissance and later paintings most tourists would associate with the gallery today. The Pitti Palace, the Medici Chapel with its tombs by Michelangelo, and the cathedral or *Duomo*, whose chequered marble exterior aroused conflicting opinions, were among the other principal sights, while the view along the Arno (fig. 18) was famous. Florence, however, was not appreciated only for its art treasures. The relaxed social life here, presided over from 1738–86 by the British diplomat, Sir Horace Mann, was also a major draw for 18th-century tourists.

Fig. 15 *Lake Nemi* by John Robert Cozens, watercolour, about 1783–8

Fig. 16 *The Arrival of a Young Traveller and his Suite during the Carnival in the Piazza di Spagna, Rome* by David Allan, wash drawing, about 1775

NAPLES

Naples and its coastline held many attractions: the city was at this time the third largest in Europe, with its own Royal court, and from 1764–1800 the British ambassador was the highly cultivated Sir William Hamilton, husband of the notorious Emma, whose 'attitudes' (poses bringing classical sculpture dramatically to life) themselves constituted a considerable draw for tourists towards the end of the century. Hamilton's

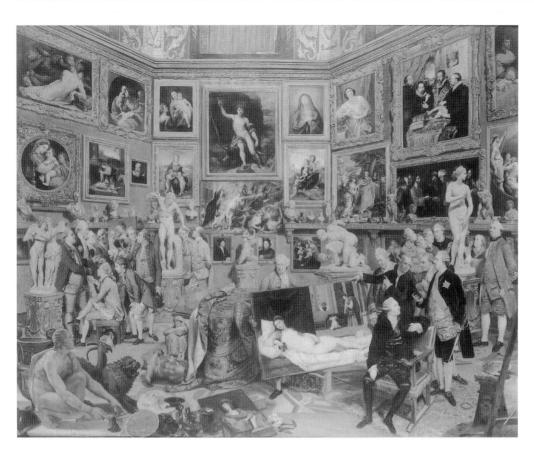

Fig. 17 *The Tribuna degli Uffizi* by Johan Zoffany, oil on canvas, 1772–8/9

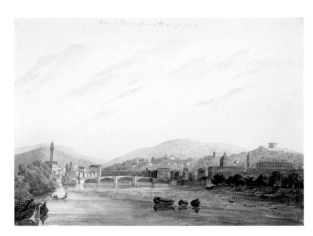

Fig. 18 *View of Florence along the Arno* by William Ord, watercolour, 1814–17

antiquarian interests, outstanding collection of Greek vases, and sympathetic and extensive patronage of living artists, made the court a highly important centre for the arts. Not all tourists, however, were impressed: William Artaud's account of Emma Hamilton bawling out nine toasts of 'Hip Hip &c' to the King on his birthday confirms that there was a less refined side to court activities,[37] while in 1792 the amateur artist Harriet Carr considered, rather oddly, that 'the Arts except music flourish very little at Naples'.[38] To William Blackett the 'high class of people' were 'the most uninteresting, uninformed, ignorant set of people in the world', and the streets were filled with 'rascals' who regularly stabbed visitors.[39]

The south of Italy also contained three of the greatest classical sites at Paestum, Herculaneum and Pompeii, while

the view over the Bay of Naples (figs. 19,20), with Mount Vesuvius in the distance, was spectacular. The volcano's constant activity and frequent eruptions at this period proved a major draw for tourists; despite being 'almost choked with smoak' and burnt by debris, as was a member of the Riddell family in December 1770,[40] they often climbed up to the crater to witness these events, and intellectuals like Sir William Hamilton, believing that volcanoes were creative forces, made a serious study of vulcanology.[41] Painters such as Pietro Antoniani, Pier Jacques Volaire and Joseph Wright of Derby produced large, spectacular images showing the 'liquid fire' and lava that flowed from Mount Vesuvius; a view of *Naples at Night with Vesuvius Erupting* by Antoniani (fig. 20) is typical instead of the small-scale *veduta* or view paintings that Grand Tourists often took home with them as a souvenir of their travels. Only in the later years of the century did some brave spirits, motivated by Henry Swinburne's guidebook (pp. 45–6), sail on from Naples to Sicily to tour the Greek temples there.

VENICE

For most tourists, Venice was the final destination on the Italian Grand Tour (fig. 21). Visitors usually made only a short stay, arriving in time for the Carnival, and largely ignoring the city's artistic treasures. Given their classical upbringing, many of them found St. Mark's cathedral difficult to appreciate; Sir Charles Monck, for example, noted that 'the church… Is ornamented with columns brought from Egypt and Greece, placed promiscuously, different orders of architecture and different sorts of marbles mixt…'.[42] However, it is to the credit of a minority of travellers that they responded to the building's extraordinary magnetism, and comments such as this one, by William Ord, typify their somewhat reluctant admiration: the 'outside with all its pillars & arches & spires & domes is a most barbarous mixture but it is picturesque'.[43]

Discriminating tourists also visited the Old Master paintings by Titian, Tintoretto and Veronese in the city's churches and guilds, and ordered the *veduta* paintings of Canaletto to send home to England; among Northern tourists, it was left to an early 19th-century visitor, Major Anderson, to

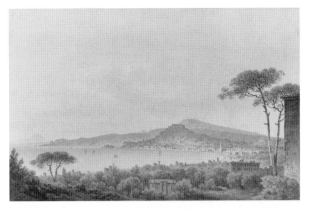

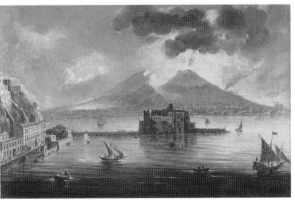

Fig.19 *Naples from Sir William Hamilton's villa at Portici* by John 'Warwick' Smith, watercolour over pencil, about 1778–98

Fig. 20 *Naples at Night with Vesuvius Erupting* by Pietro Antoniani, oil on canvas, about 1781

appreciate earlier Venetian painting to the full. By 1815, when the Ords visited Venice, they found tourism in the city in a state of decline: the number of coffee houses, for example, had dwindled from an astonishing 562 to around 100,[44] and by 1830 another Northern tourist, Matthew White Ridley, was beginning to write prophetically of the 'desolation everywhere apparent', and of the city's 'gradual decay', a feature ignored by earlier tourists in the age before Romanticism.[45]

Fig. 21 *The Bucintoro anchored at the Molo* by Francesco Guardi, oil on canvas, about 1750–60

OTHER CENTRES OF THE ITALIAN GRAND TOUR

In addition to Milan, where tourists inspected the city's 'White Marble' cathedral and Leonardo's *Last Supper*, and Bologna, home of the great Bolognese school of painters, which most tourists visited on their way south, travellers often toured the other principal Northern Italian cities: Verona, with its Roman amphitheatre; Vicenza, home of the great 16th-century architect, Palladio; and Padua, from where many tourists travelled by water down the Brenta to Venice, taking in Palladio's villas on the way. Although Padua is today world-famous for the frescoes by Giotto in the Arena Chapel, most 18th-century tourists had little appreciation of medieval art. A number of them did, however, respond to the 14th-century Last Judgement frescoes in the *Campo Santo* in Pisa, another centre of the Grand Tour, where tourists debated endlessly as

to whether the famous tower had been constructed to lean on purpose.

Those tourists who arrived by sea usually sailed from Genoa down the coast to Leghorn (modern Livorno), gateway to Tuscany, where two long-serving consuls, Christopher Crowe (fig. 123) and Sir John Dick, both came originally from the North of England. When William Ord visited the city in 1815 he was struck by the crowds of tourists to be found there, and lamented the production of associated souvenirs, considering the alabaster and marble vases to be in 'very bad taste'.[46]

Very few tourists travelled on from Italy to Greece or the near East, although the Northern artist, Richard Dalton (fig. 118), accompanied the great Irish art patron, Lord Charlemont, to Greece, Egypt and Asia Minor in 1749–50,

while the Society of Dilettanti financed an expedition to Greece and Turkey in 1764–66, during which the classical sites were recorded in watercolour by William Pars.[47]

TUTORS, GUIDES, ARTISTS AND ART AGENTS

TUTORS

As the Grand Tour expanded, the role of tutors, or 'bear-leaders',[48] developed to take charge of the educational and other needs of young tourists, and most young men up to 1780 made accompanied tours abroad. Tutors ranged from the Jesuit or Benedictine priests who accompanied boys from Catholic families, to the clergymen and other professional tutors employed by Protestants. The best tutors (pp. 71–80) were men of considerable learning; however, 'bear-leaders' like Dr James Hay, who accompanied at least eight young men to Italy,[49] were often ridiculed, as in this witty drawing by Pier Leone Ghezzi (fig. 22), which shows Hay leading one of his reluctant protégés by the nose.

Relationships between tutors and their charges varied; in 1771, meeting her son Lord Algernon Percy and his tutor Louis Dutens (pp. 75–80) in Germany after a four-year absence, Elizabeth, 1st Duchess of Northumberland found the 'greatest harmony and Friendship subsisting between them',[50] perhaps owing to Dutens' vaunted method of dealing with his pupil by offering fatherly advice rather than styling himself his 'gouvernour'. Other tutors were more prescriptive: the Catholic tutor and chaplain to Sir Carnaby Haggerston, who had a tendency to gamble, kept a close eye on his charge, and his reports home to a fellow Jesuit show that he was under no illusions about Haggerston's weaknesses.[51] The tutor to the next generation of this Catholic family, another Jesuit, Walter Fleetwood, even went so far as to argue with his employer over the extent and financing of the tour (p. 90).[52] Some of the surviving images, including a caricature showing the arrival of a young Grand Tourist – clutching his *de rigueur* copy of Lord Chesterfield's *Letters* – and his tutor at a French Post House (fig. 23), appear to confirm that tutors sometimes occupied a

position of considerable dominance over their charges. At the end of the day, however, they were in a subservient position, as the correspondence between Louis Dutens (figs. 76, 77, 78) and the Duchess of Northumberland makes abundantly plain: Dutens was obliged to clear departures and future plans with his patrons, a problem not eased by the notorious unreliability of the postal system abroad.

Tutors often combined their role as educator with that of art agent to their charges' parents, as happened with the two tutors employed by the 1st Duke and Duchess of Northumberland. By the end of the 18th century, however,

Fig. 22 *Dr James Hay as Bear Leader* by Pier Leone Ghezzi, pen and brown ink drawing, about 1725

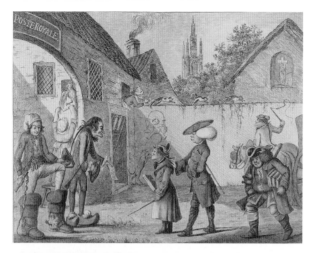

Fig. 23 *A Tour to Foreign Parts* by J. Bretherton
after William Henry Bunbury, etching, 1778

Fig. 24 *Evening Amusement at Rome* by David Allan,
watercolour, 1769

the tutorial system was on the wane: many of the young tourists from the final decades of the century travelled alone, or in a group of young compatriots, sometimes including women.

GUIDES AND ART AGENTS

In Rome and other centres of the Grand Tour, the tutor's knowledge of the art and antiquities on view was supplemented by the *cicerone*, who guided tourists young and old around the sights; Robert Wharton noted that 'it was impossible to conceive a just idea of antient Rome without Byers' remarks on the spot'.[53] In David Allan's *Evening Amusement at Rome* (fig. 24), which perhaps commemorates Sir William Hamilton's first visit to Rome in 1768, the young woman on the right being squired by a *cicerone* is probably Hamilton's first wife, Catherine.[54] Almost all tourists began their stay in Rome by taking a course in the city's antiquities and art collections, which could last for some time: William Blackett's was intended to take six weeks, but, after seeing about half the city, he owned to becoming 'a little tired of it', admitting that he was 'not yet sufficient Antiquarian to prefer the society of the Antients to that of the Moderns'.[55] Many tourists probably experienced similar culture fatigue, particularly as the daily routine could be fairly intensive: Blackett, for example, rose at 6.30 a.m, and spent from 10 a.m. until 3 p.m. every day with his *cicerone*.[56]

Tourists set great store on obtaining the best guides; in practice, this meant that in the second half of the century they were usually conducted around Rome by two highly enterprising Englishmen, Thomas Jenkins or James Byres; the latter's Catholicism – and in some cases also his Jacobitism – recommended him to tourists like the Swinburnes. Byres lived in Rome from 1758–90 in considerable style, as a portrait of around 1775–8 by the Polish artist, Franciszek Smuglevicz (1745–1807), which shows him with his family and his business partner (and nephew), Christopher Norton, confirms (fig. 25). Not all tourists chose an expensive *cicerone*, however. William Blackett congratulated himself on having found a guide who, unlike Byres, cost only one sequin a week – and who allowed his party, consisting of Blackett and a friend, to walk around the sights rather than travel in his carriage in the heat.[57]

Both James Byres and Thomas Jenkins were also active as art agents, guiding 'the Taste and Expenditures of our English Cavaliers',[58] and making a fortune out of 'selling them Cameos and Antiquities';[59] according to William Blackett, Jenkins 'sends [home] every year … enough [works of art] to freight a

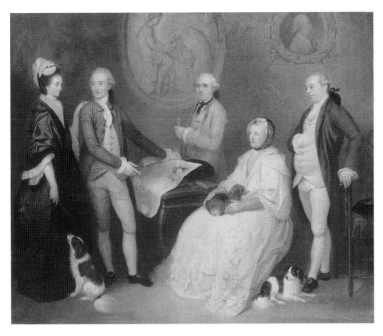

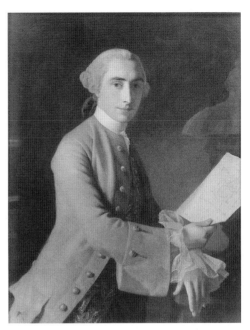

Fig. 25 *James Byres of Tonley and Members of his Family* by Franciszek Smuglevicz, oil on canvas, about 1775–8

Fig. 26 *James Adam* by Allan Ramsay, oil on canvas, about 1754

ship'. Both men also introduced tourists to Pompeo Batoni, and to the large colony of British and other artists working in Rome; many aspiring artists complained about the stranglehold both men exercised over tourists' tastes. In Naples, art dealing revolved around the person of Sir William Hamilton, who 'trafficked in the arts, and his hotel was [a] broker's shop'.[60]

Although none of the principal British art agents in Rome came from the North of England, Christopher Crowe and Sir John Dick, both long-serving diplomats in Leghorn (Livorno), combined their consular activities with art dealing. Others became part-time agents as a way of financing their own Grand Tours, as did the young Scottish architect James Adam – brother of Robert – seen in a portrait by Allan Ramsay painted some years before his departure (fig. 26). Among his purchases from 1760–3 for his august client, Hugh, future 1st Duke of Northumberland, was a series of *verde antique*

columns for the Ante-Room at Syon House, and a number of Roman portrait busts.

ARTISTS

By the 1750s, British artists such as Sir Joshua Reynolds had come to regard it as an essential part of their education to study in Italy, and, in the second half of the century, a large community of British artists was resident in Rome, from whom tourists could order paintings; sculpture; watercolours and drawings; gems; and copies of Old Master paintings and antiquities in a variety of media. Although several artists, notably Gavin Hamilton, profitably combined these activities with art dealing, 18th-century tourists were often content to purchase contemporary works rather than genuine Old Master paintings and antiquities. By the 1760s, Rome had also become the centre of the emergent neo-classical movement, and history painters and sculptors such as Gavin Hamilton,

Thomas Banks, Christopher Hewetson (figs. 57–8) or the Northerner, Guy Head, were inspired to settle here, often permanently. Other specialists at various times in the century were the landscapist Richard Wilson; the painter of Roman conversation pieces, Nathaniel Dance; the coterie of British watercolourists formed in the 1770s and 1780s by J.R.Cozens, Francis Towne, John 'Warwick' Smith, William Pars and Thomas Jones; and the great gem engraver Nathaniel Marchant.

Among the Italian artists who appealed most strongly to tourists were painters of Roman ruins: as the century progressed the more straightforward *vedute* of G.P. Panini (fig. 13) were replaced by those of Piranesi (fig. 27), whose emotionally-charged view of antiquity was exported all over Europe. The portraits and history paintings of Pompeo Batoni were also exceptionally popular with British patrons, as, later in the century (although to a lesser extent) were those of the great Swiss artist, Angelica Kauffman, who settled in Rome in 1782. The British were not alone in having a large community of artists living in Rome: many French and German artists also catered for the needs of British tourists, and there was also a veritable industry of copyists after the antique.

Other cities apart from Rome also had contingents of British artists, notably Florence, where Thomas Patch, who had been banned from Rome for homosexual activities, was welcomed by the British diplomat Sir Horace Mann. Patch's caricatures of British tourists are among the wittiest and most memorable images of the Grand Tour, and he also specialised in painting views of Florence from the banks of the Arno such as the one in the background of *The Music Party* (fig. 28). Artists in Naples included the Scotsman David Allan and the Italian Pietro Fabris, both painters of the contemporary Neapolitan scene, and the great German landscape painter and friend of Goethe, J.P. Hackert. Most British watercolourists, including the Northerner John 'Warwick' Smith, made extended stays in the city, taking excursions to paint the rocky southern coastline and its classical sites.

Although Venice produced the pastel portraitist Rosalba Carriera, and the two greatest Italian view painters of the

Fig. 27 *View of the Temple of Minerva Medica, Rome* from the collection at Wallington Hall, by Giovanni Battista Piranesi, etching

century in Canaletto and Guardi – whose reputations with tourists could not have been more polarized – most tourists came to Venice for relaxation, rather than regarding it as a centre for contemporary art. The exceptional popularity of Canaletto with British patrons meant that it was almost a commonplace for 18th-century tourists to feel that they saw Venice through his eyes; Nicholas Ridley, visiting the city in 1802, found virtually no Canalettos there, as ' they tell me that they are all in England'.[61] However, visitors did not buy works direct from Canaletto's studio; instead, his paintings were usually ordered through two British agents and long-term Venetian residents, Owen McSwinney and, later, Joseph Smith, who also became Canaletto's greatest patron, and was British Consul here from 1744–60. The vogue for Guardi's work began only after his death, in the early 19th century; although few tourists bought his work, one Northerner, John Ingram, was among his earliest patrons in the 1790s (fig. 153).

In Rome and Florence, making the rounds of artists' studios was a highly popular pastime, although more wary tourists, like William Blackett, were sensible of the pressures to buy created by the particular circumstances existing in Rome: 'by seeing so many good things we become kind of enthusiasts and wish to be possessed of something of the kind

even at a high price…'.[62] Blackett could also sense the traps being laid out for tourists' enticement – 'the artists here pant for our arrival just as we do in England for a flight of woodcocks'.[63]

For many Grand Tourists, however, their single most important act of patronage while in Rome was much more personal: they could commission a portrait of themselves surrounded by the classical remains they had come so far to study; they could sit for their portrait to the man who by 1760 was the most famous painter in all Italy, Pompeo Batoni. From 1740 Batoni had begun to specialise in painting portraits of visitors to Rome, notably the British, and these records of tourists' sojourns in the 'Eternal City' soon became an accepted feature of the Grand Tour, and one which was eagerly awaited by relatives at home (p. 98). It is, in fact, a perfect example of supply and demand: as an increasing number of Grand Tourists beat a path to his studio door, Batoni developed a specific type of portrait to cater to their needs.

Although Batoni was not the inventor of the Grand Tour portrait (fig. 92), in which painters made flattering allusion to their sitters' culture and learning by placing them against a backdrop of ancient Rome, the views of Italy and its classical remains that seem almost accidental in the work of earlier

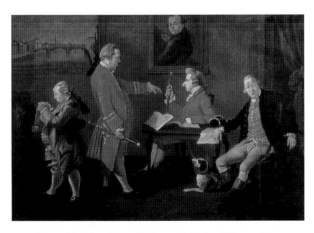

Fig.28 *The Music Party* (William, 5th Duke of Devonshire, William Fitzherbert and Mr. Short) by Thomas Patch, oil on canvas, about 1768

artists (fig. 123), now became all-important. It was also Batoni who popularised and standardised the type: of the nearly 200 men and women who sat to him, an astonishing 154, or 79%, were British. Among them were a considerable number of Northern tourists, most of whom sat to Batoni in the decade following the ending of the Seven Years War. The portrait of George Craster in 1762 was swiftly followed by those of Hugh, Lord Warkworth and Henry Ellison in 1763–4 (figs. 73, 88); three further sitters during the 1770s were R.W. Grey, Rowland Burdon, and Thomas Orde (figs. 83, 87, 86). Given the telescoped timescale of these commissions, it seems likely that we are looking here at a network of Northern patronage; as Peter Bowron has pointed out, Batoni frequently painted groups of friends and neighbours.[64]

However, it was the two well-known *cicerone* James Byres and Thomas Jenkins who provided the main point of contact between Pompeo Batoni and his British clients. Jenkins, who combined his activities as art dealer, excavator and guide with the even more lucrative position of banker and unofficial ambassador to British visitors to Rome, was responsible for obtaining many commissions for the artist. Whether Byres and Batoni were friends or just close business associates is not known, but certainly Batoni's portrait of Byres's sister, Isabella Sandilands, hung in the latter's dining room in Strada Paolina, where it may have served as an advertisement to potential clients, and a tour of the Roman sights with Byres tended to lead, as it did with the Swinburnes and Sir Thomas Gascoigne, to a portrait (or portraits) by Batoni (figs. 53–55).

Batoni, who sometimes took four months or longer to complete a portrait, was by no means the only option available to British tourists seeking a portrait painter in Rome in the second half of the century. His British partner, Nathaniel Dance, painted portraits very much in the same manner during his years in Rome from 1754–66 (fig. 82), and also specialised in the 'conversation piece' portraits that were highly popular with tourists (fig. 73). Batoni's principal rival, however – until the arrival in 1782 of Angelica Kauffman (figs. 114,115), who became, in effect, his successor – was the German artist, Anton Raphael Mengs, whose more academic

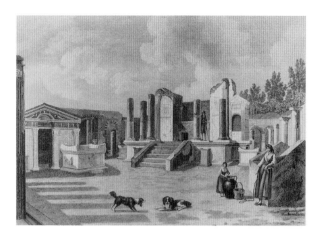

Fig. 29 *View of the Interior of the Temple of Isis, Pompeii*
by G.A. Hackert after Jacob Philipp Hackert, etching, 1793

most famous of the German porcelain factories was at Meissen, near Dresden, founded in 1710, which was visited by most of those who travelled in Germany; the mid-18th-century rococo style in decoration, with its use of natural forms including vegetables and fruit, finds perfect expression in early Meissen. Tourists also visited the Gobelins tapestry factory near Paris, and purchased silks and velvets from Lyons, where William Blackett 'was almost ruining myself in cloaths' in 1785.[66] When in Italy, many tourists bought in Florence the *pietre dure* mosaics featuring shells, butterflies and landscapes for which the city was renowned.

approach to antiquity appealed strongly to learned clients. Like his pupil and brother-in-law, Anton von Maron (figs. 46, Appendix 1, fig. 7), Mengs painted in the somewhat drier vein of German neo-classicism.

LUXURY GOODS

In addition to paintings and antiquities, consumption and expenditure on the Grand Tour embraced luxury goods and clothing. Shops in Paris were as exclusive then as now, Elizabeth, 1st Duchess of Northumberland citing in 1766 a lengthy list of tradespeople including milliners, jewellers, mantua makers, clock makers, snuff box makers, *ébenistes*, gilders and varnishers, embroiderers and booksellers.[65] The famous Sèvres porcelain factory near Paris was a particular draw for Grand Tourists. Although many tourists purchased pieces direct from the factory, much more porcelain was ordered from England; several tour diaries, however, such as those of Major George Anderson, compare Sèvres and other European porcelain factories unfavourably with those at home. The most important period of production at Sèvres coincided with the spread of the neo-classical style, and the influence of the antique is not only found on pieces like urns (fig. 134) or ewers that imitated classical shapes, but in the simple, restrained lines of cups and saucers. The earliest and

THE LURE OF THE ANTIQUE

As we have seen, Roman antiquities were the principal draw for Grand Tourists throughout the 18th century, exceeding even Old Master paintings in importance among tourists brought up on classical history and literature, and it was not until the early 19th century that this obsession began to wane.

Although many tourists paused in southern France on their way to Italy to take in the antiquities at Nîmes, Orange, and Arles, the 'course' of antiquities in Rome formed the cultural climax of the Grand Tour, while one of the principal reasons for visiting Naples was to see the Roman towns of Herculaneum and Pompeii, which had been buried by an eruption of Mount Vesuvius in 79 A.D. Modern excavations at Pompeii began in 1748, when many of the streets were found to be almost intact, and the stay in Naples in 1766 of Lord Warkworth's former tutor, Jonathan Lippyeatt, coincided with the rediscovery of the Temple of Isis (fig. 29), which was particularly prized on account of its supposed Egyptian origins. Many tourists commented on the astonishing sense of the past evoked by actually walking 'on streets and into houses inhabited 17 hundred years ago',[67] and the many wall paintings that were discovered here had a major impact on the neo-classical movement; fig. 106 shows a copy by a Northerner, Harriet Carr. Discriminating tourists, like William Blackett, drew parallels between these Roman frescoes and the interiors Robert

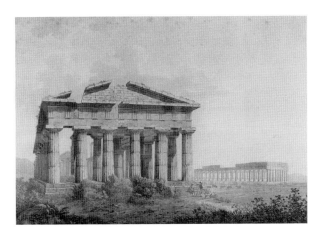

Fig. 30 *The Temples of Paestum, Naples* by Franz Kaisermann
pen, pencil and watercolour, early 19th century

Adam was then recreating back in England.[68]

The Greek temples at nearby Paestum (fig. 30), rediscovered in 1746, became a favourite subject with British and other artists, and their Doric columns and capitals stimulated a new interest in this, the simplest and most austere of the Greek orders. Before the publication of Henry

Swinburne's ground-breaking *Travels in the Two Sicilies* in 1783, only a few tourists moved on from Naples to Sicily to see the great classical temples there; the normally cultivated William Blackett, for example, was persuaded by a friend that 'it is really hardly worth while, what is to be seen does not repay you for the trouble which consists only in some temples of Grecian architecture' of which 'you have a better Specimen…at Paestum'.[69]

From the 1750s a new scientific interest in antiquity was stimulated by the discoveries at Herculaneum, Pompeii and elsewhere. Scholars, notably the great German antiquary, Johann Joachim Winckelmann, who was murdered in Trieste in 1768, began to make a systematic study of classical art, and from the 1750s onwards a string of seminal publications, notably Robert Wood's *The Ruins of Palmyra* (1753), James Stuart and Nicholas Revett's *The Antiquities of Athens* (1762–1816), and Robert Adam's *Ruins of the Palace of the Emperor Diocletian, at Spalatro, in Dalmatia* (1764) promoted a more rigorous study of ancient architecture, also beginning to shift the locus of classical studies away from Italy alone.

The second half of the century saw a flurry of excavations,

Fig. 31 *Gavin Hamilton leading a party of Grand Tourists to the Archaeological Site at Gabii* by Giuseppe Cades, pen and ink and wash over pencil, 1793

Fig. 32 *An Excavation of an Antique Building in a Cava in the Villa Negroni at Rome* by Thomas Jones, oil and chalk on paper, about 1777 (later dated 1779)

witnessed, for example, by Henry Swinburne in Rome in 1779; a drawing by Giuseppe Cades showing an expedition led by the British artist, archaeologist and art dealer, Gavin Hamilton, to the archaeological site at Gabii in 1793 gives a vivid glimpse of the excitement generated by these discoveries (fig. 31). Perhaps even more fascinating is an oil sketch by Thomas Jones (fig. 32) which shows an excavation of a house of the Hadrianic era actually in progress in Rome; Jones records in his *Memoirs* that he visited the site in July 1777, when he saw the 'Antique rooms just discovered'.[70]

In Naples Sir William Hamilton's two outstanding collections of Greek vases were assembled as a result of the excavation of tombs in the vicinity; a rare cork model of a tomb at Paestum illustrates the contemporary fascination with these classical tombs and their contents (fig. 33). In 1763, Hamilton employed the gifted but unreliable Frenchman, the self-styled 'Baron' d'Hancarville, to publish his first collection of vases. Although d'Hancarville's attempted chronology of Greek art has now been entirely discredited, the resulting publication, *Antiquités Etrusques, Grecques et Romaines* (1767–76) is one of the foremost books of the neo-classical movement. The frontispiece to the first volume (fig. 34), dedicated to George III, reproduces a Greek vase in a setting

intended to represent the Apennines – a reference to d'Hancarville's (erroneous) theory that these vases were made by Greeks living in Italy.[71]

The impact of such texts and archaeological discoveries on succeeding generations of British and other artists and architects in Italy from the 1750s onwards can hardly be over-estimated, and the neo-classical style, forged in Rome, spread throughout Europe, informing every aspect of the arts from history painting to portraiture, architecture and the decorative arts. The Grand Tour made by Robert Adam from 1755–7 led to the development in Britain of the neo-classical style in architecture, and a whole generation of British architects,

Fig. 33 *Cork Model of a Tomb at Paestum* by Domenico Padiglione, about 1805

Fig. 34 *Dedication plate of the first volume of Antiquités Etrusques, Grecques et Romaines,* anonymous engraving after P.F. Hugues, called Baron d'Hancarville, about 1766

market, and dealers such as Gavin Hamilton or Thomas Jenkins had great success in selling them to wealthy British clients such as Charles Townley or William Weddell. For those who could not afford, or did not choose, to buy originals, there was a thriving market in life-size or smaller-scale copies (figs. 75–6) both in plaster or bronze; many visitors frequented the 'famous shop of sculptures' run by Bartolomeo Cavaceppi, which combined 'fine real antiques [restored by Cavaceppi] & copies of all the principal ones in Rome'.[72] Also available from draughtsmen such as Pompeo Batoni, early in his career, or the Cumbrian artist Richard Dalton, were chalk drawings after the antique (fig. 117) Smaller scale wares were also exceptionally popular, and Lord Chesterfield referred disparagingly to tourists running through Italy 'knick-knackically'.[73] These had, of course, the advantage of being readily portable; classical gems were either bought in the original, or in reproductions in glass paste or sulphur (figs. 94–96).

The central position occupied in the life of a cultivated Grand Tourist by the cult of the antique is nowhere better illustrated than in a pair of paintings by Pietro Fabris, which show *Lord Fortrose at Home in Naples*, both fencing, and at a concert party (figs. 35,36). Among the purchases which the young Scottish aristocrat displays in his Naples apartment are copies of wall paintings from Pompeii or Herculaneum; a collection of Greek vases; and objects from everyday life in antiquity, including lamps, candlesticks and stirrups. These two images – the *Concert Party* celebrates the visit to Naples in 1770 of the young Mozart – also stand out among Grand Tour paintings as those which perhaps best express the lifestyle enjoyed by wealthy British tourists abroad.

including John Soane (pp. 102–3), and the Northerner Christopher Ebdon, followed him to Italy.

Classical sculptures such as the *Apollo Belvedere*, the *Hercules Farnese* or the *Venus de' Medici* (see fig. 76) had been famous throughout the century and often long before, and were on every tourist's itinerary. Thomas Orde's reaction to the *Venus de' Medici* in 1773 (pp. 99–100) is typical of the highly charged, emotional response these images evoked. Newly excavated sculptures were constantly coming onto the

SOCIAL LIFE ABROAD

Most British tourists enjoyed an active social life abroad. On their arrival in major continental cities, British diplomats such as Sir Horace Mann in Florence, or Sir William Hamilton in Naples, introduced the newcomers to other tourists. Largely thanks to their influence, but also to the letters of

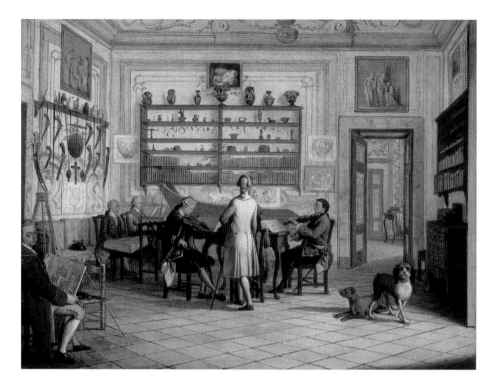

Fig. 35 *Lord Fortrose at Home in Naples: Concert Party* by Pietro Fabris, oil on canvas, 1771

recommendation that most tourists carried with them, many travellers were also welcomed at foreign courts, from the Vienna of the Emperor Joseph II, or the Versailles of Louis XVI and Marie Antoinette, down to smaller courts such as the Kingdom of the Two Sicilies in Naples, or the German princely courts at Hanover, for example, or Dresden. Some Grand Tourists, such as Henry and Martha Swinburne, were adroit courtiers: their son was appointed a royal page to Queen Marie Antoinette – an exceptional honour for an English child – and her sister, Queen Maria Carolina of Naples, stood godmother to their daughter Caroline (fig. 51).

Even in smaller continental towns travellers were continually meeting their compatriots, and this trend became more noticeable as the century progressed; when Elizabeth, 1st Duchess of Northumberland met the Duke and Duchess of Cumberland in southern France in 1774, they descended from their chaises and embraced.[74] For later tourists, however, such meetings had become almost the norm; Lord Barnard,

for example, met a trio of Northerners in Dresden in 1786.[75] Inevitably, tourists tended to follow in one another's footsteps from one Grand Tour centre to the next, often finding travelling companions for the next stage of their journey among the compatriots who thronged a particular town. The diaries of Lord Barnard (pp. 122–4) are particularly revelatory of this social mix, where, as in a kaleidoscope, a small, and continually shifting, population of British visitors met, socialised together, moved on, and then reformed. The profile of tourists changed, however, as the century progressed. Whereas earlier in the century the Grand Tour was dominated by young men travelling with their tutors, with an admixture of couples on wedding tours, invalids, and a small number of family groups, by the time of William Blackett's tour in 1784–7 mixed parties of ladies and gentlemen were travelling together for recreation, inhabiting a world that is recognisably closer to our own experience of continental travel.

Evenings abroad were usually spent at the theatre, the

Fig. 36 *Lord Fortrose at Home in Naples: Fencing Scene* by Pietro Fabris, oil on canvas, 1771

opera, or at private parties, dinners and balls. Even smaller towns, such as the spa of Montpellier in southern France, could boast a comedy theatre, which the Crasters visited regularly in 1762–3. Visits to the opera were made by the Swinburnes in Paris and Rome, by W. H. Vane in Bordeaux, by John Carr (who admitted to being no musician) in Italy and by Robert Wharton (who certainly was) in Paris, Lyons, Florence and Rome. In 1770 the 1st Duchess of Northumberland attended at Versailles, during the celebrations for the Dauphin's wedding, a production of *Castor and Pollux* with a cast of six hundred, in which several performers changed their costumes five times, while the principal soprano's hair was 'entirely and differently dress'd three Times.[76] Despite such lavish display, William Ord was not alone in thinking that the singing in operas abroad was uniformly bad. Daytime entertainment, apart from the inevitable sightseeing, included shopping, social calls on other tourists, walks, real tennis, and visits to shops and factories producing luxury goods.

As well as the more strenuous sightseeing in the principal centres of the Grand Tour, tourists also made excursions, such as the one from Rome to Tivoli to see the famous Temple of the Sibyl and the dramatic cascades. Two of the tourists in a drawing of the 1780s by George Dance, *Morning amusements previous to a jaunt to Tivoli*, seem, however, considerably more interested in their bowl of punch than in sightseeing. Artists, too, made excursions, usually travelling either with patrons, or in groups of fellow-artists.

One of the principal goals of the Grand Tour was the acquisition of social polish. To judge by Ralph Carr's somewhat scathing indictment of his son's linguistic abilities, by no means all tourists spoke fluent French, and young travellers often spent a quiet few months at the beginning of their tour taking language lessons in a part of France, for example the Loire, where it was considered that good French was spoken: in 1788 John Carr settled down in Tours to a course of study with an emeritus professor, Monsieur le Fay,

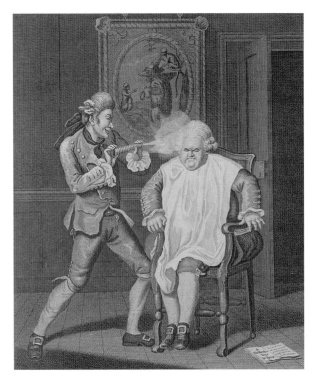

Fig. 39 *Lord – tolàn prenant sa leçon de danse*
(*Lord – tolàn's dancing lesson*), anonymous engraving,
French, about 1800-20

Fig. 37 *The Englishman in Paris* by J. Caldwall
after John Collet, line engraving, 1770

Fig. 38 *Morning Amusements previous to a jaunt to Tivoli* attributed
to George Dance, pen and ink drawing with grey wash, 1780s

a handsome man of forty-four who, although 'brought up to ye church', had just married his niece![77] Other specialists who catered for the needs of Grand Tourists were Italian masters, fencing (fig. 36) and riding instructors, and especially music and dancing masters. A French caricature, *Lord – tolàn prenant sa leçon de danse* (fig.39) shows a grotesquely fat British tourist taking a dancing lesson from a tall, thin Frenchman playing the violin; a dog pirouettes on its hind legs in a mocking echo of the Englishman's activities. Even the diligent and sensible Robert Wharton did not think a 'lesson in the art of walking, Bowing, giving, receiving, standing &c avec bonne grace too

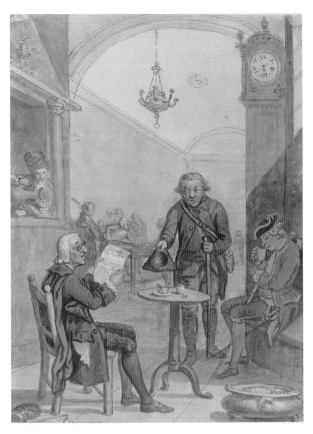

Fig. 40 *A Roman Coffee House*
by David Allan, pen, ink and watercolour
over black chalk, about 1775

Fig. 41 *L'Anglais en Bonne Fortune*
(*The Fortunate Englishman*), published by Basset,
French engraving, about 1800–20

ridiculous to receive'.[78]

Amateur music-making, sketching from nature, copying Old Master paintings, and paying visits to artists' studios, were also popular pastimes, while in Italy, coffee houses (fig. 40) like the famous Caffè degli Inglesi in Rome were popular meeting places where male – but not female – tourists could read and play billiards. Unmarried women were usually obliged to lead a quieter social life abroad than their male counterparts, although Harriet Carr eventually effected an entrée into the Italian aristocracy during her four-year stay abroad. Not all tourists employed their time profitably. A large number of prints satirised the vanity (fig. 37), gambling, drinking and sexual activities (fig. 41) of the British abroad, and the youthful adventures of Lord Barnard, whose courtship of a young English girl was followed by liaisons with a French actress and with the singer Anna Storace (Mozart's first Susanna in the *Marriage of Figaro*) in Vienna, are atypical only in being recorded in such detail.

A visit to Italy was not complete without attendance at some of its more spectacular public entertainments: the carnivals in Venice and Rome (fig. 43), or the great Venetian ceremony of Ascension Day (fig. 21, col. pl. 14), during which

Fig. 42 *Design for a Bissona or
Ceremonial Gondola*
by Francesco Guardi,
pen and ink and watercolour
over black chalk

Fig. 43 *The Opening of
the Carnival near the Porta del
Popolo, Rome* by David Allan,
wash drawing, 1775

Fig. 44 *A Performance of the Commedia dell' Arte in Piazza San Marco* by Canaletto, pen and brown ink with grey wash

the Doge threw his ring into the lagoon to celebrate the city's marriage with – and long dominion over – the Adriatic Sea. A drawing by Francesco Guardi (fig. 42) shows a design for the highly elaborate *bissone* or ceremonial gondolas used by leading Venetian families at the famous regattas (fig.138) on the Grand Canal; in 1763 Lord Warkworth travelled in one such gondola decorated in sky blue silk with silver tassels and yellow cushions.[79]

Carnivals were so popular that visitors often timed their arrival in Rome or Venice to coincide with these festivities. In 1775 David Allan made a series of ten highly important wash drawings of the Carnival in Rome, including *The Opening of the Carnival near the Porta del Popolo* (fig. 43); among the revellers are figures in masks, a man on horseback dressed as a bear, and figures from the Italian *Commedia dell'Arte*, notably the Harlequin dancing in the centre. Artists like Luca Carlevaris and Pietro Longhi have left vivid impressions of the masked balls that were such a staple element of Venetian life; here, the

element of disguise allowed greater sexual liberty, as well as providing an opportunity for members of different classes in society to mix more freely. One of the pleasures for tourists in Italy, then as now, was the prevalence of outdoor entertainment: in Canaletto's *A Performance of the Commedia dell' Arte in Piazza San Marco* (fig. 44), a crowd has gathered to see a performance on an open air stage at the foot of the famous *campanile* or bell-tower. The Pope's celebration of Mass at St. Peter's on Easter Day was another kind of spectacle, albeit a sacred one, which drew not only Catholic tourists, but all Protestant visitors in the city as well.

GRAND TOURS FROM THE NORTH

The rest of this book focuses on the tours made by men and women from Northumberland, Durham, and Cumbria (as far west as Carlisle), from the early pioneers to those who

travelled in the aftermath of the Grand Tour in the 19th century. The changes which took place in the Grand Tour during this period are addressed in detail in the chapters which follow, and no attempt is therefore made here to offer an historical survey of the period covered in this book. Before moving on to examine the individual tours made by travellers from the North of England, however, two principal questions arise: as to whether it is possible to build up a profile of these Northern tourists, and, as a result of this, to establish if the Grand Tours from this region differed from those made from the rest of Britain.

Perhaps the most significant feature of a Grand Tour made from the North lay in historical factors. If the North, as defined in the Preface, was indeed a region by 1700, the opening date for this book, it had become so only very recently. The borders had been fought over by the Scots and English throughout the late Middle Ages, and the Scots had occupied Durham and Northumberland for a year as recently as 1640. Writing in the early 19th century, Macaulay sought for the epitome of wildness and lawlessness in 17th-century England, and found it in Northumberland.[80] Similarly, in *North Country Life in the Eighteenth Century*, Edward Hughes in 1952 pointed to the 'greatly retarded' social and political development of the northern counties, and to the fact that the rise of the landed gentry in the North took place a century and a half later than elsewhere in England.[81] Country house architecture also lagged behind national developments, and it was not until the 'second half of the eighteenth century that steady progress' began to be made.[82] However, the first half of the century saw the beginnings of 'polite' society in Newcastle and other centres. The first Newcastle assemblies were held in 1716, Charles Avison's subscription concerts opened their doors in 1736, and Newcastle could boast as many as thirty-five clubs and societies by 1750. Thereafter, the next fifty years saw the establishment of some of the North's cultural icons, the Theatre Royal (1788), the Literary and Philosophical Society (1793) and especially the new Assembly Rooms (1776). As the Assembly Rooms and the Grand Tour both represented a form of social investment designed to increase

further the standing of the elite, it comes as no surprise to find that a list of shareholders in this venture, from Newcastle and its hinterland, corresponds almost exactly to the names of Northumbrian and Durham tourists or their families at this same period.[83]

Although, in the absence of detailed comparative data, any conclusions must remain tentative, it seems probable that the region's troubled early history, and its isolated geographical position – any Northerner intending to make the Grand Tour had first to reach London, which took about three days – led to the Grand Tours made from the North both beginning, and ending, later than elsewhere in Britain. Very few recorded tours took place before 1740, and there seems little doubt that Grand Tour travel from the North in the first half of the 18th century was dominated by the great landed families of the day: many of the earliest tourists, such as Sir Carnaby Haggerston or Sir John Swinburne were Catholic in religion and conservative, often Jacobite, in politics. It was not until after the ending of the Seven Years War in 1763 that a significant number of Northerners ventured abroad. It is perhaps not surprising that this now burgeoning fashion in the region for continental travel was spearheaded by Elizabeth, 1st Duchess of Northumberland and her two sons, great territorial magnates, with estates in the south and elsewhere. Two other tourists of the 1760s, George and Olive Craster, also had an added social dimension to their lives, having a house in London, and enjoying friendships with leaders of fashionable and intellectual society such as the Hollands, or the Lyttletons of Hagley.

Following in the wake of these cosmopolitan spirits came tourists from a wide variety of backgrounds. In a recent study, the historians Lawrence and Jeanne C. Fautier Stone noted the very high percentage of estates in Northumberland at this period that were transferred by inheritance rather than by sale, as compared with a county much nearer to London such as Hertfordshire.[84] Although this survey, strongly suggestive of continuity in terms of membership of the landed elite, can be called into question, Hughes's earlier contention that the 18th century saw the gradual elimination of the old (largely

Catholic) Northern gentry, and their replacement by around 1745 by a new generation of Protestant landowners, is also open to debate.[85] More recent research by Phoebe Lowery[86] suggests that the actual composition of the county elite in the second half of the 18th century, and hence of the region's tourists, lies somewhere in between: a judicious mix of older (often Catholic) families, many of whom had maintained links with trade or industry over several generations, those who had arrived at the status of major landowners via smaller estates, and newcomers enriched by the creation on Tyneside of the country's first fully industrialised society. The names of the subscribers to the new Assembly Rooms in 1776 offer a snapshot of the varied social composition of the region's elite, and of its tourists, around 1776. Headed by Hugh, 1st Duke of Northumberland and his tourist son Lord Algernon Percy, stakeholders range from numerous gentry families, still clearly powerful in civic affairs at this period, to the civic merchant or banking elite (pp. 132–41), down to those involved in trade (pp. 186–94).

What seems certain is that the heyday of the Grand Tour from the North was the period from 1780. By this time merchant entrants to the landowning class, having purchased estates, now began to send their sons and daughters abroad. In many cases, a Grand Tour set the seal on a family's assimilation into the social elite, as was the case with the brother and sister John and Harriet Carr in 1791–4. They were joined by tourists from families such as the Lambtons or the Blacketts, who combined interests in trade or coal with their status as major landowners, but who also seem to have waited until the final decades of the century to travel abroad. The continuing survival of Catholic landowners among the county elite, at least until the 1770s, is confirmed by the fact that this decade seems to have represented something of a peak for Catholic tourism. Most of these later tourists would by now have seen the Grand Tour in the context not just of developing 'polite' leisure activities in the North, or of tourism within Britain itself, but of an aspiration to acquire a fashionable education that accorded with national as well as regional expectations.

Not surprisingly, many of the later tourists hailing from entrepreneurial backgrounds were affiliated to the Whig party, not least because, 'thanks to coal' there was always a greater 'fusion of landed and merchant interests' in the North than elsewhere',[87] with both new and established landowners combining farming with coal mining or shipping. When, at a dinner held in Newcastle in the early 19th century on the anniversary of Charles James Fox's first election for Westminster, the former Grand Tourist and graecophil Sir Charles Monck proposed a toast to his fellow Whigs, his list read like a roll-call of former tourists from the region – all of them connected as friends, neighbours, and often by inter-marriage as well.[88] Ironically, the great age of the gentry in the North, as Hughes points out, was made possible only by trade:[89] in seeking for differences between the Grand Tour here and in other parts of Britain, one need seek no further than industrialised Tyneside, its entrepreneurs, and their pursuit of leisure in a period from 1780–1820 that provided them with such enormous prosperity.

Confirmation that the Grand Tours made from the North did not come to an abrupt conclusion in 1798 with the French occupation of Rome is found in the two highly important tours from the region made by Major George Anderson and William Ord during the Napoleonic era, surely offering confirmation that, just as the Grand Tour appears to have developed later in the North, so it almost certainly finished later here as well. In any case, there was no sudden transformation in the pattern of tourism with the arrival of the new century. Among the last Northern tours in the 18th-century mould were those made from around 1830–40 by Sir Matthew White Ridley and his son, and Walter Calverley and Pauline Trevelyan; both families commissioned works from a new generation of artists and sculptors in Rome which could stand comparison with many of the more munificent acts of patronage of the last century, [90] and the Trevelyans also formed in Florence a choice collection of Old Masters. It is probably not accidental that these tours were made in the last decade to maintain the link between landed interests and trade; this would be severed around 1840, and thereafter only the 4th Duke and Duchess of Northumberland made a Grand Tour with major

repercussions for the cultural life of the region.

However, an even more fundamental difference between the Grand Tours made from this and other regions is the very high percentage of Northern tourists to come from Catholic families. Despite years of suppression, Catholicism held considerable sway in the North of England – with the exception of Cumbria – in the early 18th century. Many of the great landed families were recusants, with a strong allegiance to the Jacobite cause, and they were among the region's earliest and most determined tourists. The fact that succeeding generations of families such as the Swinburnes of Capheaton, the Riddells of Swinburne Castle and the Haggerstons of Haggerston Castle made the Grand Tour testifies to the survival of many major Northern Catholic landowning families in the years following the 1745 rebellion. Even though many Catholics followed the same itinerary and apparently had the same goals as their Protestant counterparts, religion undoubtedly added a different dimension to recusants' tours, while in the case of Henry and Martha Swinburne their religious upbringing was responsible for some of the most remarkable travels of the 18th century.

If Protestant tourists regarded the Catholicism of France and Italy with unease and distrust, British Catholics were entirely at home on the continent, not simply because of shared religious tenets, but because many of them had spent the formative years of their life there. Barred until 1778 from securing for their sons a Catholic education in England, almost all the landed Catholic families of the North sent their sons away from an early age to be educated in France or Belgium. Popular choices were the Jesuit seminaries at, successively, St. Omer, Bruges and Liège, or that run by the Benedictines at St. Gregory's, Douai, which had the advantage of being very near to Calais; one Northumbrian, the Rev. Roger Midford (d.1697) even left in his will a fund to educate Catholic boys, preferably one of his own relatives, there.[91] Other parents sent their children even further afield to Lambspring in Germany or to the English College in Rome, where Joseph Lambton from Durham and the Northumbrian Thomas Riddell were educated as early as 1592 and 1651

respectively. University education, too, was undertaken abroad. By the time young men like Henry Swinburne came to make the Grand Tour they were already familiar with most, if not all, aspects of continental life – perhaps more so, indeed, than with the life in the North of England they had left behind them. Young girls, too, were despatched to French convents; some did not return, taking the veil when their education was completed. A useful Protestant counterbalance to this prevalent practice is provided by a later Whig tourist, William Ord, who inveighed against the sight of nuns 'imprisoned for life', adding that 'I never go to a convent without shuddering'.[92]

Catholic tourists also arrived on the continent supplied with a ready network of contacts. Seminaries such as St Gregory's, Douai, or St. Edmund's in Paris, acted as hosts to British travellers, and in Rome the Procurator of the Benedictine order was responsible for introducing Catholic travellers to intellectual and artistic circles in the city; these contacts would dictate the nature of Henry and Martha Swinburne's stay in Rome. Catholics also tended to deviate from standard Grand Tour routes both to visit places of pilgrimage, such as the shrine of the Virgin at Loreto, and to see relatives abroad. When Sir John Swinburne (fig. 45) toured France in 1749–51 he called on his brother Edward in Bordeaux. Some years later, the youngest of this triumvirate of Swinburne brothers, Henry, also visited Bordeaux with his wife and family; by this time Edward himself had inherited the baronetcy and returned to Northumberland, but Henry and Martha met his relatives by marriage, the Dillons.

The key role of tutor to the young Grand Tourist was also arranged very differently in Catholic families. While Protestants often had to cast around for suitable employees, Catholics could either send their own household chaplain abroad as tutor, or apply to the head of the Benedictine or Jesuit order regionally for a monk-tutor; the considerable numbers of young Northern Grand Tourists who came from families which supported a chaplaincy or mission on their estates[93] only serves to confirm the power of these two orders in this region in the earlier part of the 18th century. More than

one Grand Tour tutor, including Cuthbert Farnworth, who travelled with Sir John Swinburne, 3rd Bart., shortly after the 1715 rebellion, returned to the North of England with their charges to become the family's household chaplain.

If it is possible to build up a distinct profile of Northern tourists in terms of their politics and religion, and the class to which they belonged, in more personal terms, including gender, the national profile corresponds perhaps more closely to the regional one under discussion here. As we have seen, the Grand Tour is usually perceived as the prerogative of young men, still unmarried. Certainly in the first half of the 18th century, young unmarried women did not usually make the Tour, staying at home instead to learn music, dancing and needlework, and to be launched on the London 'season' in the hope of finding a suitable husband. Although Harriet Carr (fig. 110) was an exception to this rule, touring Italy for her health from 1791–4 with her brother John, her somewhat bluestocking elder sister, Annabella, who was not consumptive, was offered no such opportunity, and stayed at home in Northumberland. Married women, however, were more fortunate: Olive Craster (fig. 81), wife of a wealthy Northern landowner with fashionable London connections, made a delayed wedding tour in 1762–3, while, much later, both the intrepid Mrs. Anderson, the first woman, according to her husband, to climb Mount Etna, and Pauline Trevelyan, were childless, and perhaps therefore able to spare the time to accompany their husbands on second, lengthy tours abroad in addition to their extended honeymoons of 1801–3 and 1835–8. Women's motives for travel were often more complex than men's,[94] the continent offering them freedom from the inadequacies of home with its straight-laced laws and customs; men's reactions to such free spirits is perhaps summed up by Sir Matthew White Ridley in 1801 as: 'few women who retain any respectability at home venture to leave it for foreign parts'. That Europe could provide a useful retreat for those who had contravened contemporary *mores* is illustrated in the life of Anne Liddell (pp. 114–15), heiress of Henry, Lord Ravensworth, who not only travelled in considerable state through Italy with her husband, Augustus, 3rd Duke of

Grafton and their daughter,[95] but returned there after leaving him for the Earl of Upper Ossory. Among the Northern families who braved the continent as a unit were William Henry and Lady Anne Lambton and their children, who travelled in a vain attempt to restore W. H. Lambton's health, and Henry and Martha Swinburne, who seem to have been motivated by a wish to expand their intellectual horizons beyond the confines of County Durham. There were, however, real risks attendant on taking young children abroad, and the Swinburnes' daughter Martha died in Rome in 1779.

Many young Grand Tourists were elder sons, who could expect to inherit titles and large estates; more effort was put by parents into the education of boys who would, one day, control considerable wealth – often sooner rather than later, as mortality in the 18th century meant that some inherited their father's titles as children, or not long after coming of age at twenty-one. A number of Northern tourists, notably Sir Carnaby Haggerston, Henry Ellison, and John Carr, correspond to this national profile. Often, however, parents' calculations could misfire, and tourists such as Sir Edward Swinburne made the Grand Tour after inheriting his elder brother's title and estates. The number of Pompeo Batoni's sitters who went on to have careers in the church, law, navy, and above all the army, all traditionally the preserve of younger sons, confirms, however, that younger siblings did travel abroad. Henry Swinburne (fig. 53), Thomas Orde (fig. 86), and Nicholas Ridley, three Northern tourists who can be numbered among the intellectual elite of travellers, were all younger sons, although Swinburne's first continental tour did not take place until after his elder brother's death provided him with a small estate in County Durham. Thomas Orde was not the only younger son whose Grand Tour provided the entrée to a higher social group, and a successful political career.

If Northern tourists conform in respect of gender, or their position in the family, to national trends, they can also be distinguished from their contemporaries in other areas of Britain by the artefacts they brought back from the continent, which reflect discernible regional trends. Although, in general, earlier British tourists seem to have bought more in Italy than

their successors, who could benefit from a more developed art market back at home, very few Northerners from before 1800, with the exception of the 1st Duchess of Northumberland, purchased Old Master paintings abroad.[96] This was left to early-19th-century travellers from the region, notably Major George Anderson, whose Grand Tour purchases also included two of the greatest paintings by Canaletto to reach an English collection (col. pl.14, figs. 137, 138). However, in terms of the developing attitudes towards connoisseurship reflected in tourists' diaries, Northerners approach much closer to the national paradigm: the letters of Matthew and Nicholas Ridley from 1800–2 show a connoisseurship of Old Master paintings that is conspicuously absent from the majority of Northern diaries or letters of the 18th century – Thomas Orde, Sir John Edward Swinburne and Elizabeth, 1st Duchess of Northumberland providing notable exceptions to this rule. Even the amateur artist Harriet Carr in 1791–4 still wrote of Old Masters as works to be idolised, and copied, rather than as artefacts to be appreciated for their painterly qualities and technique. However, educated tourists like Harriet were well versed in classical literature and its associations with the sites they now saw, and surely no tourist has reproduced more dramatically that touch of cultural pretentiousness that led would-be connoisseurs to fall into ecstasies at the sight of Renaissance paintings or classical sculpture than Thomas Orde, when he came face to face with the *Venus de' Medici* in 1772 (pp. 99–100).

What is perhaps more remarkable than the absence of Old Master paintings in Northern collections is the fact that, with the exception of the Dukes of Northumberland, almost no antiquities of note were purchased by a Northerner abroad, and the only major collection of antique sculpture in the region, that of the Earl of Lonsdale, formerly at Lowther Castle near Penrith, belonged to the very last phase of this vogue in the mid 19th century. The reasons for this were probably largely financial; with only a few exceptions, Northern tourists – many of them Catholics penalized for their beliefs – belonged to the landed gentry rather than the aristocracy. Many Northerners, however, sat for their portrait

to Pompeo Batoni; a network of Northern patronage, coupled with a dearth of portraitists in the North-East itself, was probably responsible. One Northerner, William Henry Lambton, was prevented only by his early death from becoming one of the greatest British 18th-century patrons of contemporary artists abroad, while, much later, Matthew White Ridley, 3rd Bart., also became a discerning patron of contemporary art. And although only one Northern mansion – Belsay Hall (fig. 14) – was directly inspired by the Grand Tour, it is surely not accidental that so many of the North's returning tourists went on to have their houses rebuilt or remodelled in the classical style in the years immediately following their continental travels. This was the case with Lancelot Allgood at Nunwick, Henry Ellison at Hebburn, R.W. Grey at Backworth, George Craster at Craster Tower and Sir John Edward Swinburne at Capheaton. The three latter are by or attributed to the local artist William Newton,[97] whose clients included a network of closely related tourist families. the Ords, the Brandlings, the Burdons, and the Greys of Backworth. Although, again with the notable exception of Belsay, there is no evidence to suggest that any Northern tourist went so far as to provide his own architectural designs, the more educated tourists were certainly 'knowledgeable enough to play a role in the construction or alteration' of [their] stately houses'.[98]

However, the area in which almost all Northern tourists seem to have excelled is in the writing of Grand Tour journals and letters. Whether or not we should regard these and the similar outpourings of tourists from other regions as a self-conscious 'literary legacy',[99] or simply as dutiful educational exercises written for parents holding the purse-strings, or attempts to record, for those at home, an experience that most tourists could not expect to repeat in their lifetimes, and that their readers might never have, is debatable. However, it seems clear that the keeping of diaries, or alternatively the penning of lengthy letters (few achieved both), was regarded, at least for young men, as an essential Grand Tour activity, and much thought often went into their method of presentation. From the fragmentary evidence provided by the four Northern

18th-century women who left behind records of their tours, women's letters from abroad, not linked so strictly to self-improvement, appear to have been very different and perhaps more individual in character – although all but one of these tourists were highly intelligent women whose travels, if not undertaken for 'improvement', nevertheless reaped considerable intellectual rewards. Given that Harriet Carr's letters home were much less frequent than her brother's, perhaps because she was recording her tour visually instead, it may not be only an accident of survival that Martha Swinburne's correspondence from abroad is so slight in volume in comparison to that of her writer husband, whose letters to her were certainly written with more than one eye on posterity, or the publisher. The fragmentary papers of Olive Craster relate rather to shopping than to culture, and, of Northern women, only Elizabeth, 1st Duchess of Northumberland systematically kept both letters and diaries; her richly humourous account of 18th-century life on the continent is interspersed, in the latter, with highly detailed and valuable accounts of art dealing and the Old Master picture collections she had visited. Much later, the formidably intelligent Pauline Trevelyan kept voluminous diaries of her tours which far surpass in wit and brilliance those of her intellectual but more prosaic husband.

It is these remarkable documents penned by Northern men and women that form the basis of this book, which focuses on tourists' attitudes to the great cultural sights of the Grand Tour, as well as, more specifically, on their acquisition of works of art. It focuses too on the many Northerners who were themselves amateur artists of some talent, since, if Northerners excelled as journalists and correspondents, a relatively high proportion of them also illustrated their travels, either in their tour journals themselves (fig. 140) or in separate portfolios (for example, figs. 48–9, 143–4). Harriet Carr's records in watercolour of the Old Master paintings and landscapes she saw in Italy, and of her circle of friends in Florence (figs. 104–8), represents one of the most complete surviving examples of the activities of an 18th-century British amateur abroad, while Northerners also recorded French

Gothic architecture (fig. 139) and Greek and Egyptian antiquities, as well as more usual Grand Tour sites. The Swinburnes of Capheaton form one of that group of elite 18th-century families such as the Aylesfords and the Howards who excelled as amateurs, and in Henry Swinburne produced a traveller whose drawings, as well as his publications, place him among the most important of all contributors to Grand Tour literature.

END NOTES

1 Black, p. 302; *Grand Tour*, Tate, 1996, p. 96.
2 Ridley MSS., ZRI 32/5/1–2, Diary of Sir Matthew White Ridley, 4th Bart., 30th May 1830.
3 Carr-Ellison MSS., letter from John Carr, 22nd April 1788.
4 Wharton MSS., letter 131, 13th June 1775.
5 Percy Letters and Papers, 117, no.18, 22nd April 1763.
6 Monck MSS., ZMI B 52/3/1, Journal, p.35, 3rd November 1804.
7 Thomas Landseer, ed., *Life and Letters of William Bewick*, London, 1871, p.298.
8 Diary of Newbey Lowson, p. 21, 4th July 1816.
9 Carr-Ellison MSS., letters from John Carr, 21st July, 22nd June 1792.
10 Quoted in Black, p. 208.
11 For this publication, *An Account of the Remains of the Worship of Priapus*, ed. Richard Payne Knight, London, 1786, see *Vases & Volcanoes*, pp. 238–9; a presentation copy in a British private collection is inscribed as having been presented by the Society to Henry Swinburne on the motion of his friend Charles Townley, 1st June 1794.
12 William Cowper, *The Task*, Book II, 425.
13 Ord MSS., Diary, vol.2, 12th July 1815.
14 Carr-Ellison MSS., letter from Harriet Carr, 24th February 1792.
15 'Letters From and To the Carrs of Dunston Hill', vol. I, 20th August 1788, private collection.
16 Monck MSS. ZMI B 52/3/1, title page.
17 Letters from John Carr, April–June 1788, Carr-Ellison MSS., Nothumberland Record Office, and see note 15.
18 Ibid., 7th June 1788. Carr noted however that Stephen had 'been so good a servant that I could not willingly part with him', continued his wages, and 'turned him over' to his brother Ralph.
19 Duchess of Northumberland Diary, 121/56, 17th May 1774.
20 Purdue, 1994, p. 125.
21 Carr-Ellison MSS., letter from John Carr, 2nd September 1791.
22 Black, p. 16.
23 Duchess of Northumberland Diary, 121/40, 1772.
24 Ord MSS., Diary, vol. 1, 25th November 1814.
25 Anderson MSS., Box 1, 660, uncatalogued, 10th March 1803.
26 Duchess of Northumberland Diary, 121/13, 1764.
27 Ibid., 121/57, 17th April 1774.

28 *St James's Chronicle*, 20th May 1769.

29 Carr-Ellison MSS., letter from John Carr, 15th June 1788.

30 Percy Letters & Papers, 179, Dutens to Duchess of Northumberland, 24th June 1769.

31 Ord MSS., Diary, vol. 1, 2nd September 1814.

32 *Courts*, I, p. 278.

33 Op.cit., pp. 273, 278.

34 Ord MSS., Diary, vol. 3, 8th June 1816.

35 Ellison MSS., 3419/A/28.

36 Ord MSS., Diary, vol. 1, 1st December 1814.

37 Sewter, William Artaud draft letter, no. 31, 18th July 1797.

38 Carr-Ellison MSS., letter from Harriet Carr, 24th February 1792.

39 Blackett MSS., 8th January 1785.

40 Riddell MSS., 29th December 1770.

41 He commissioned from Pietro Fabris a series of drawings to accompany his magnificent publication on the volcanic area around Pozzuoli to the west of Naples, *Campi Phlegraei*, Naples, 1776.

42 Monck MSS., ZMI B 52/3/1, Journal, 1804, p. 64.

43 Ord MSS., Diary, vol. 2, 24th August 1815.

44 Ibid, 23rd August 1815.

45 Ridley MSS., Sir Matthew White Ridley, 4th Bart., Diary, 1829–30, 19th May 1830.

46 Ord MSS., Diary, vol. 2, 26th July 1815.

47 A series of watercolours made by Dalton on this tour are in the Royal Library at Windsor Castle. Many of Pars's drawings are in the British Museum.

48 Bear-leaders were named after the street entertainers who travelled around Europe with their bears.

49 According to John Carr, the tutor of his travelling companion, Mr. Dillon, had taken charge of no less than thirteen young Grand Tourists, all of whom were said to be doing well in the world.

50 Percy Letters & Papers, vol. 44, 116, 25th April 1771.

51 Haggerston MSS., 1711–20; see *Biographical Note*.

52 M.B. Joyce, 'The Haggerstons: The Education of a Northumbrian Family', *Recusant History*, vol. 14, 1977–8, p.187.

53 Wharton MSS., Letterbook II, 24th January 1776.

54 For the identification of the woman as Catherine Hamilton, see *Vases & Volcanoes*, pp. 242–3.

55 Blackett MSS., March 6th 1785 and undated letter, March 1785.

56 Ibid.

57 Op. cit., 6th March 1785.

58 Ingamells, p. 169.

59 Blackett MSS., undated letter, March 1785.

60 Op.cit., 6th March 1786; *Apollo*, December 1982, p. 419.

61 Ridley MSS., letter from Nicholas Ridley, 20th April 1802.

62 Blackett MSS., 29th March 1785.

63 Op.cit., undated letter, March 1785.

64 Edgar Peters Bowron, *Pompeo Batoni and his British Patrons*, The Iveagh Bequest, Kenwood, 1982, p. 9.

65 Duchess of Northumberland Diary, 121/15, 1766, p. 29.

66 Blackett MSS., 16th September 1785.

67 Ibid, 8th January 1785.

68 Ibid.

69 Ibid.

70 *Courts*, I, p. 231; 'Memoirs of Thomas Jones', *Walpole Society*, 1946–8, p. 62, 5th July 1777.

71 *Vases & Volcanoes*, p. 147.

72 Riddell MSS., ZRW 64, 7th March 1771.

73 *Grand Tour*, Tate Gallery, 1996, p. 271.

74 Duchess of Northumberland Diary, 121/55, 22nd May 1774.

75 The diplomat, Morton Frederick Eden, his own relative, Mr. Vane, and 'Trevelyan', surely the Northumbrian John Trevelyan (pp. 130–5).

76 Greig, p. 135.

77 Carr-Ellison MSS., letter from John Carr, 8th July 1788.

78 Robert Wharton MSS., letter 126, 19th May 1775.

79 Percy Letters & Papers, Jan.–June 1763, no. 19, Jonathan Lippyeatt to Countess of Northumberland, 18th May 1763.

80 Purdue, 1999, p. xv.

81 Hughes, p. xviii.

82 Lowery, p. 55.

83 The subscribers are listed in Berry, pp. 125–8.

84 Stone, p. 143, passim.

85 Hughes, p. xviii.

86 Lowery, pp. 58–61.

87 Hughes, p. xix. Hughes's emphasis on coal is reinforced in Berry and Gregory, in which they, and the majority of their contributors, notably Lorna Scammell, conclude that coal was responsible for many of the differences between this and other regions – chiming with the conclusion reached by this book as regards the Grand Tour.

88 Apart from Monck himself, these included Sir John Edward Swinburne, Matthew White Ridley, 'Radical' Jack Lambton, who had made the Tour as a child with his father, William Charlton of Hesleyside and Earl Grey. The North-East was perceived as a Whig stronghold at this period.

89 Hughes, p. xix. See also Rebecca King in Berry and Gregory, pp. 57–71, who points to the high proportion of gentlemen's sons joining prestigious Northern guilds, notably the Newcastle Adventurers – another confirmation of the strong regional links between the gentry and trade from the late 17th century onwards.

90 Sadly, very few of the works Ridley commissioned can be identified today.

91 Ann C. Forster, *Ushaw Magazine*, LXXII, July 1962, no. 215, p. 85.

92 Ord MSS., Diary, vol. 2, 29th September 1815.

93 For example, the Swinburnes, the Haggerstons, the Riddells, or the Charltons. See note 91 above for the excellent summary by Ann C. Forster of Catholic missions in the North-East at this period.

94 Dolan, p. 10, *passim*.

95 Ingamells, p. 415, and Walpole, Letters to Sir Horace Mann; see *Bibliographical Note*.

96 See, however, Huon Mallalieu, 'Lost and Found, A Cargo of Grand Tour Souvenirs', *Country Life*, 8th May 2003, pp. 126–9, for Grand Tour artefacts sent home on the ship *Westmorland*, which was captured in 1779 by French frigates. These souvenirs remained in store for 225 years before being exhibited in 2003. Almost all the works of art on board were contemporary, not Old Master paintings or antiquities, a reminder that Northern tourists were perhaps not so different from their counterparts elsewhere in Britain in their Grand Tour acquisitions.

97 For a recent discussion of these and other houses owned by Grand Tourists, see Lowery, pp. 60–72.

98 Black, p. 275.

99 Dolan, p. 30.

The Swinburnes
A Catholic Family Abroad

Perhaps the most distinctive feature of the Grand Tours made from the North is the extent to which tourism from the region was dominated until relatively late in the century by the great Catholic landed families. Their religion had a major impact both on the nature and extent of their travels, and the works of art they bought abroad. Nowhere is this demonstrated more forcibly than in the case of the Swinburnes of Capheaton Hall. Several generations of this leading Catholic family cemented the links with the continent, which had already been built up during their education abroad at Catholic seminaries, by making a Grand Tour.

A colourful tradition has grown up around the education abroad of Sir John Swinburne, 1st Bart., and builder of Capheaton (d. 1706), to the effect that his identity was lost, and that he was educated as an *enfant trouvé* at a college in France for some years before his identity as a Swinburne was rediscovered by chance by a Northumbrian visitor to the seminary.[1] The earliest member of the family known to have made a tour abroad is, however, Sir John Swinburne, 3rd Bart., who records in his diary that he had been to Douai – evidently to receive a Catholic education – in 1712. He then spent three years travelling in France from 1716–1719; his tutor, Cuthbert Farnworth, subsequently became Benedictine chaplain at Capheaton, later reverting to his role as Grand Tour tutor for Sir John's second son Edward.[2]

SIR JOHN SWINBURNE, 4TH BART. (1724–63)

Little more is known of this very early tour from the North, but we are on more secure ground with the travels of his son, another Sir John, who set off from Capheaton for Calais in November 1749, equipped with his writing box, on a tour of

Fig. 45 *Sir John Swinburne* by Giles Hussey, 1740s

also visited Toulouse and Bordeaux, a detour from the usual Grand Tour route clearly dictated by his wish to see his second brother, Edward, who was working as a merchant there. He also seems to have visited his eleven-year-old sister Eleanor (Nelly), who was presumably being educated abroad.

Sir John's tour finished at Dover on October 1st 1751; he records having spent 201,653 livres 5 sous while abroad, which he notes was the equivalent of £1,274 sterling. None of the expenses he itemises relate to major works of art, although he did purchase a snuff box, an *étui* and a number of French books. Instead, his chief luxury seems to have been clothes, on which he spent considerable sums, buying, amongst other items, 'A waistcoat of rich Lyon's stuff' (216 livres) and paying the princely sum of 840 livres for the 'embroidery of a suit of cloaths in Gold'. Besides travelling and living expenses he also records payments to his servant, John; to a Paris apothecary; for the purchase of a bear skin (then a great novelty); for presents to take home to England; and for what was presumably an act of charity: 401 livres to 'Mr Mangle, a poor Irishman'.

A portrait by Giles Hussey showing Sir John in 'Hussar' dress (fig. 45) – often worn by Jacobite sitters – was presumably painted in England; there is no record of a payment for it in the careful record Sir John made of his continental expenses, and Hussey does not appear to have left England again after his seven year stay in Italy from 1730–7. This is, however, a portrait closely associated with the Grand Tour by an artist who, like his sitter, had been educated on the continent because of his Catholicism, and had moved in Jacobite circles abroad. Swinburne's introduction to Hussey may have come, however, through a network of Northern patrons; Hugh, 1st Duke of Northumberland, probably paid for Hussey's return from Italy, and commissioned three major works from the artist, while a very similar portrait to this one survives at Raby Castle in Durham, the seat of the Vane family.

Sir John must have visited France at least once more, for he is known to have died in Paris on 1st February 1763. He was unmarried, and with the legacies they received on his death

France which lasted until October, 1751.[3] The eldest of three brothers, two of whom would prove to be even more addicted to Grand Tour travel, Sir John made an extended stay in Paris from November 1749 until late May 1750. As a staunch supporter of Jacobitism, who had contributed to the upkeep of prisoners in Carlisle Castle after the 1745 rebellion only a few years previously, he would have been warmly welcomed in Jacobite circles in the French capital.

On leaving Paris in 1750, Sir John headed for the South of France, staying in the spa town of Montpellier, and in Aix-en-Provence, both popular destinations with British 18th-century tourists, as they were not far off the main route to Italy. He

his two younger brothers now took on the family mantle of tourism.

SIR EDWARD SWINBURNE (1733–86)

Sir Edward Swinburne (see fig. 46), who inherited the family estates in 1763, had been sent to France as a child in 1743 with his father's former tutor, now Benedictine chaplain at Capheaton, Cuthbert Farnworth, to be educated at Douai. Edward later worked in Bordeaux, probably in the wine trade, marrying a Frenchwoman and settling in South West France until his elder brother's death brought him home to Capheaton in 1763. He was not the only member of a leading British Catholic family to take up commercial employment abroad.

Although his younger brother Henry (pp. 40–52) was the family's most indefatigable tourist, Sir Edward's adventurous tours included Spain in 1763 – immediately after his elder brother's death had freed him from the constraints of paid employment – and Hungary and Moravia in 1770. They may well have provided the inspiration for Henry's own highly unusual Grand Tour travels. Certainly, there was a family culture in which tourism could flourish. The two brothers corresponded frequently about their travels, and, unlike Henry's, Edward's extensive Grand Tour journals survive.[4]

Sir Edward also made a more conventional tour of Italy on his return from Eastern Europe in 1771, visiting all the principal cities of the Grand Tour. Although strongly imbued with the tastes of his generation, admiring 'divine grecian statues', the paintings of Raphael and the Carracci (of one of whose works, a *Birth of Alexander*, he acquired a copy in Bologna) and the Palladian architecture in Vicenza, he was discriminating enough to form his own opinions. Praising, for example, the Gothic architecture he saw in Venice, although not St Mark's cathedral itself, which he found 'singular but not at all handsome & has not the old grecian simplicity nor the gothic lightness to recommend it', he noted that the paintings by Tintoretto, Veronese and Bassano in the Doge's Palace, although 'noble pictures in the boldest stile' were 'much darkened & ill preserved'. In Rome, as elsewhere, his reactions

were mixed: of St. Peter's, he wrote, 'the inside only strikes', while the Pantheon he found 'delightful', but 'the streets of Rome indifferent'; he was particularly struck by the great equestrian statue of Marcus Aurelius, then on the Campidoglio – 'the horse is short necked & rather heavy in his hind quarters but full of life' – and by Raphael's Vatican frescoes, which exhibited 'Genius', but 'there are parts that are not agreeable'. Unusually for a Catholic, Sir Edward's audience with Pope Clement XIV betrays a sardonic attitude later echoed in his brother Henry's writings: noting disapprovingly the Pope's unpowdered and greasy hair, he

Fig. 46 *Sir Edward Swinburne* or *Henry Swinburne*, attributed to Anton von Maron, oil on canvas, 1771(?)

considered him 'very chearfull & chatty and his conversation making allowance for the Papal language & the cant of the divine holy man of the cloister was lively & clever'. On his departure, the Catholic *cicerone*, James Byres, entrusted Sir Edward with a cameo portrait by the great Italian gem engraver J.A.Pichler of the Yorkshire Catholic and art collector William Constable, 'to be delivered to Mr. Dunn in London'.[5]

Almost certainly, Sir Edward made extensive purchases of works of art in Italy; his bank account shows that two cases were shipped home from Leghorn in March and April 1773. It is just possible that these included the original drawings for 'Baron' d' Hancarville's publication of Sir William Hamilton's collection of Greek vases (see fig. 34), one of the seminal works of neo-classicism; although the drawings are today lost they are known to have belonged to the Swinburne family, and Sir Edward, whose tour was made only a few years after the book's publication, or his brother Henry, who was a friend of d'Hancarville's, seem to be their most likely purchasers.[6] A similar uncertainly surrounds the portrait traditionally said to be of Sir Edward and to have been painted in Rome by Anton von Maron (fig. 46) – an obvious choice for a Catholic patron, given this painter's close association with the *cicerone* James Byres – which may instead be of his brother Henry, whom it much more closely resembles.[7] It may have been on Sir Edward's later tours of France and Austria in 1774–6 that he bought a major Old Master painting by Rubens, *Faith, Hope and Charity*, which survives in engraved form. On his return to England, he seems likely to have maintained his Italophile interests, as in 1779 he was elected a member of the Society of Dilettanti.

HENRY SWINBURNE (1743–1803) AND MARTHA SWINBURNE (1747–1809)

Perhaps the most discriminating, certainly the most dedicated, of all travellers from the North of England were Henry Swinburne and his wife Martha, who, singly, or together with their growing family, toured the Courts of Europe and post-revolutionary France on travels lasting half a lifetime.

The third and youngest of the triumvirate of Swinburne

brothers, Henry was born in 1743, and educated at the monastic seminary of La Celle near Paris, where he is said to have made rapid progress in ancient and modern languages, history, philosophy and *belles lettres*, and to have greatly improved his natural taste for painting and the fine arts. Unable, like other British Catholics, to attend a university in his own country, he went on to study in Paris, Bordeaux and in Turin.[8]

In 1763, however, Henry's fortunes changed. His eldest brother, Sir John, died, leaving him the estate of Hamsterley in County Durham and the prospect of financial independence. Henry reacted to this change in his circumstances, not by returning to England to visit his new estate, but by planning a tour abroad. By October 26th 1763 he wrote to his brother, now Sir Edward, from Turin, describing his recent crossing of the Alps in words which wittily mock the taste for the 'sublime': 'We had the satisfaction of enjoying the Mountain in all its horrors. Hail, snow, wind and rain were the constant companions of our Journey upwards'.[9] In May 1764 he arrived in Genoa, where his libertarian, indeed republican, sentiments reveal him – at least in his youth – as a political radical: 'It was with great pleasure I enter'd this Land of Liberty and…my Ideas wander'd back to Ancient Rome & the contemplation of its Patriots'.[10] The reference to Rome comes as no surprise: like most of his contemporaries, Henry Swinburne almost always saw the present reflected in the glass of the classical past. It seems likely that he also visited Florence on this early tour, where the great historian Edward Gibbon met one of the Swinburnes in 1764; Gibbon's writings refer to Henry on several occasions. Henry is said to have carefully examined the pictures, statues and classical architecture, and to have perfected his knowledge of drawing and of Italian;[11] we know that he also cast an eye over the ladies and their *cicisbeos*, commenting on the 'astonishing' freedom available to Italian women, who could appear in public with their lovers.

On his way back to England in 1764, Henry stopped off in Paris. Here, although he appears to have stayed only a short time, he is traditionally said to have met his future wife,

Fig. 47 *Martha Swinburne*,
by Hugh Douglas Hamilton, pastel, around 1771

qualities of a bluestocking as well: she is said to have read Greek and Latin authors in the original and to have been a talented musician. Possibly the only thing her admiring biographer admits she did not do was to draw or paint – although she had an 'intuitive purity of taste' for the fine arts. Whether or not these encomia were strictly true – and her father's diary certainly confirms the care lavished on her education, while her daughter would later confirm her lack of forwardness, claiming it was for her that the 'device of a violet with 'Il faut me chercher' was invented'[13] – Martha was, to judge by her later letters, a woman of considerable spirit, talents, and abilities, and she was clearly a highly suitable wife for the young Catholic intellectual from the North of England.

Although this was evidently a marriage of inclination, Henry's bride also brought him the practical benefit of a good fortune, and the newly married couple now returned to his Northern estate at Hamsterley, where Henry proceeded to lay out the grounds in a way which is said to have combined the more natural English style of landscape gardening with 'the classic precision of the Italian style.[14]

In the early years of their marriage, the Swinburnes were painted in pastel by a future Grand Tourist whose clients included many Catholic patrons, Hugh Douglas Hamilton (fig. 47). Life in Durham proved, however, inimical to these cosmopolitan spirits. For while Henry and Martha 'almost exclusively devoted themselves to the cultivation of literature and the arts, [their neighbours] thought of little else than...of corn or turnips, unless indeed it were the pursuit of foxes'.[15] Martha appears to have borne the brunt of the problem, her country neighbours being 'as little able to comprehend or estimate her talents, as she was able to appreciate the skill with which they executed those pickle and preserve accomplishments'. Although such comments by the editor of *The Courts of Europe* must be treated with some reservations – particularly as Martha's daughter revealed her mother's abilities at those very same pickles and preserves! – disappointment in provincial society seems a not unlikely reason for the Swinburnes to have gone abroad again.[16]

Martha Baker (figs.47, 54);[12] certainly they were married in Aix-la-Chapelle on 24th March 1767. A miniature of Martha, painted the previous year in Lille, was formerly at Fonmon Castle in Wales, and may have been painted to commemorate their betrothal.

The daughter of a Protestant barrister from Chichester, who was Solicitor General of the Leeward Islands, Martha Baker had been brought up in her mother's faith as a Catholic with her father's consent, and educated at the Ursuline convents in Lille and Paris. The editor of Swinburne's letters, published in 1841 under the title of *The Courts of Europe*, invests Martha not only with considerable personal beauty, graceful manners and an entire lack of vanity, but with the

Figs. 48 and 49
Castle of Blois and
View of Nîmes, from
'*A Tour of France in
the Years 1773, 1774*'
by Henry Swinburne,
pencil, pen and grey
wash drawings

After a short visit to Paris in 1770, Henry and Martha Swinburne set off four years later with their young family on a full-scale Grand Tour. Leaving London on 26th February 1774, they arrived in Calais, deviating almost immediately from the usual tourist route by heading for Rouen, the capital of Normandy.

Arriving in Paris on April 30th 1774, the Swinburnes were presented to Louis XV at Versailles, where Henry and his party 'surprised his most Christian Majesty in his waistcoat'. They also met the King's daughters, whom he dubbed 'the three *not Graces*' and the 'Dauphiness', the future Queen Marie Antoinette, 'who quite won my heart'. In all, he found France a 'land of foppery' and when Louis XV died of small pox during the Swinburnes' stay in Paris, this future adroit courtier castigated him: 'never did a King deserve more than he did to lose the affections of his people'.[17]

Leaving their daughter Martha and her sixteen-year-old servant behind in Paris at the convent of the Blue Nuns, the Swinburnes now headed South, through Orléans. Here Henry accounts in a letter to Sir Edward Swinburne for the beginning of his career as a travel writer, which seems to have originated with his brother's request for a description of his tour. 'I will keep a sort of journal of all I see, and forward it to you *de tems en tems*. I intend giving way to my propensity to taking views'.[18] Happily, the visual record of this tour survives in a series of eighty-three sketches, which were later pasted into an album entitled *A Tour of France in the Years 1773, 1774*, dedicated to Martha Swinburne (figs.48, 49).[19] Although there

is no evidence to suggest that Swinburne intended to submit these for publication, the combination of sketches and letters is one he would shortly use in his first book, *Travels through Spain*. The drawings range from topographical records of châteaux, cathedrals, Roman antiquities and towns, to picturesque studies of estate views and French village life. In style they are typical of the productions of amateurs at this period: careful delineations of buildings in pen and wash, often enlivened by small figures or boats, and composed according to those picturesque principles which still prevailed a few decades later when Jane Austen parodied them in *Northanger Abbey*, where the heroine was invited to reject the whole city of Bath as being unworthy to form part of a landscape.

The Swinburnes now took a detour through the Loire Valley, which was not much visited by British tourists at this period, perhaps because a generation reared on the 'sublime' found its gentle landscape rather tame.[20] Like the tourists of today, the Swinburnes admired the beauties of the Loire châteaux at Blois, Chaumont, Amboise and Chambord, and Henry made a large number of drawings (fig. 48), also proving his powers of verbal description when he called Chambord 'a stupendous pile of building of stone, in a strange whimsical style of architecture'.[21] After this the Swinburnes headed for Bordeaux, where they took a house in March 1775, and stayed for some time. In visiting the South West, they were deviating again from the main tourist itinerary, in this case to visit Sir Edward's Catholic parents in-law, the Dillons.

It was in Bordeaux in the summer of 1775 that Henry and Martha were joined by the wealthy Yorkshire baronet Sir Thomas Gascoigne (fig. 55), who would be their travelling companion for the next four years. The reason for their friendship with Sir Thomas is not hard to find. Like the Swinburnes, he hailed from Catholic emigré circles abroad; born in Cambrai and educated in Paris, he had only come to know his ancestral home, Parlington, in Yorkshire, when he inherited it from an elder brother in 1762. It was presumably in Paris, or at the Academy in Turin, (which he, like Henry, attended in 1764) that he had first met Henry Swinburne.

Gascoigne now proposed that Henry should come with him to Spain, offering to pay some – or all – of his expenses. Clearly this was an opportunity not to be missed, and, leaving Martha and their children in Tarbes, Henry set off with 'my Pylades' – an apt analogy between Orestes' upbringing at a foreign court with his inseparable companion, Pylades, and Swinburne's own early years on the continent, which Gascoigne had shared. Spain in 1775 was still – as Lord Tyrawley, envoy in Lisbon, wrote earlier in the century – a surprising choice for an 18th-century tourist: 'the least known, and quite out of the Old John Trott beaten, pack horse road of all travellers'. Although rather more British visitors made their way there as the century progressed, Henry and Gascoigne were very much in the vanguard, and the celebrated elderly statesman General Wall, whom they visited near Grenada, told them 'Such birds of passage seldom alight in these parts'. However, in Henry's case, he was following in the footsteps of his elder brother Edward's visit in 1763.[22] Conditions in Spain were poor. For much of the time Swinburne and Gascoigne journeyed by mule, carrying their beds and provisions, and on at least one occasion they slept on straw.

Although Henry set out saying that he had 'some thoughts of making up a pamphlet' on his travels, certainly by January 1776 he had taken a definite decision to write a tour guide: 'I have been more minute and inquisitive about every particular on the route, than a fellow of the Antiquarian Society in a heap of rubbish, and intend most bravely to get

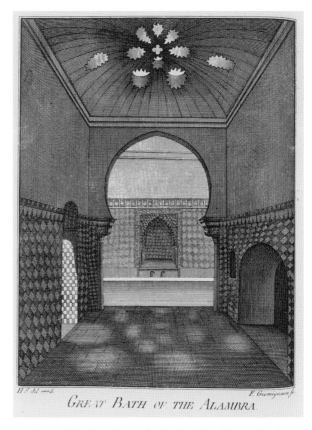

GREAT BATH OF THE ALAMBRA.

Fig. 50 The 'Great Bath of the Alambra', from Travels through Spain in the Years 1775 and 1776, engraving after Henry Swinburne, 1787

into print hereafter'. He set much store on writing a 'plain, unaffected tour' and on drawing antiquities, cities and 'remarkable views' with 'great attention and accuracy'; 'I never took the liberty of adding or retrenching a single object for the sake of improving the beauty and harmony of the landscape'.[23] The Travels take the form of a series of letters, almost certainly addressed to Martha Swinburne in Bayonne, supplemented by research on the country's history, literature and commerce.

Swinburne's Travels through Spain in the Years 1775 and 1776 represents an important contribution to Grand Tour literature. This was the first major travel book on the country

to be written by a British author, and one that – unusually for its period – could be relied on for accuracy and precision both in the drawings and the accompanying text. However, it is Henry Swinburne's powers of description, and his sensitive understanding of art and architecture, that make him such an impressive armchair companion. Although most contemporary travellers took little interest in Moorish remains, he set out intentionally to describe them. Visiting the Alhambra in Grenada he responded to those same qualities that attract visitors today: 'The richness of the stucco work, the profusion of water, marbles, paintings and gildings, are…unlike anything I ever met with before. There is a light fairy kind of appearance in the pillars and ornaments not to be expressed'.[24]

Although Henry's original drawings for the publication have not survived, the engravings show the same enthusiasm for Moorish and other medieval architecture as for the Roman antiquities he had been brought up to admire; one of the finest in the book is of the *Great Bath of the Alambra Palace in Grenada* (fig. 50).

After crossing the Pyrenees, Swinburne and his companion travelled to Barcelona, then proceeded down the Mediterranean coast to Gibraltar and Cadiz. They then returned north through Seville and Cordoba to Madrid, where the travellers were received by King Charles III at his court at Aranjuez, and the King's librarian flatteringly lent Swinburne a translation of the Arabic manuscripts in the Escorial to study for his book. Like other British 18th-century travellers, Henry found Madrid disappointing: 'Nor do I believe there is in Europe a capital that has so little to show'. However, he could not fail to be impressed by the city's paintings – seeing the Rokeby Venus by Velázquez in the Duke of Alba's private collection, before its translation to North Yorkshire – and the Royal palace, where, of a daunting number of treasures, he singled out works by Raphael, Titian, Rubens, Murillo, Van Dyck, Correggio and Velázquez. He also visited Philip II's great palace of the Escorial, where he composed an elegy on the royal tombs and pronounced the picture collection 'equal, if not superior to any gallery in Europe'.[25]

Back on French soil in Bayonne in June 1776, Henry, who

had earlier sent the 'first sheets' of his travels to his father-in-law, John Baker, to 'peruse, alter and correct', began 'labouring very hard in polishing and arranging my tour', intending to have 'the literary part ready this winter' and to send it back to England. The book was published in 1779; its popularity is attested not only by contemporaries, notably Horace Walpole, who was 'much amused' with Swinburne's *Travels*, but by its re-issue in a more portable, octavo, format in 1787 (with a supplementary volume on Swinburne's journey from Bayonne to Marseilles in 1776), and by its translation into French the same year by J.B. de la Borde.[26] There were later abridged editions, with some additional drawings, in 1806 and 1810.

The Swinburnes had by now spent a considerable time abroad on a tour which corresponded hardly at any point to a 'typical' Grand Tour. As Henry wrote to his brother on September 3rd 1776, 'I have been so great a rambler of late, that I can scarcely recollect having lived in a house of my own'.[27] Still accompanied by Sir Thomas Gascoigne, the party now set out from Toulouse for Marseilles, taking in, as they passed, the Roman antiquities in the South of France. In Marseilles, they rejoined one of the main tourist thoroughfares, and

Fig. 51 Green leather case containing pencil and dance card, given by Queen Maria Carolina to Caroline Swinburne

Fig. 52 *View of the Country near Segesta* from: *Travels in the Two Sicilies*, engraving, after Henry Swinburne, 1783–85

they now took the sea route to Naples, arriving there on 28th December 1776 to find snow on Mt. Vesuvius, and a large contingent of British tourists.

As we have seen, the Kingdom of the Two Sicilies held many attractions for tourists. These included a lively royal court, a temperate climate, the spectacular view over the Bay of Naples to Mount Vesuvius (fig. 20) and the great classical sites at Paestum, Herculaneum and Pompeii. Henry and Martha Swinburne soon found themselves at home in expatriate and court circles in the city. They were introduced to the pleasure-seeking Ferdinand IV and his formidable queen, Maria Carolina, the effective ruler of Naples; although Henry's initial opinion of them was far from flattering, he was soon playing cards with the King, while Martha became a particular favourite of the Queen's. When the young Swinburnes played with the royal children, the Queen 'loaded them with the most expensive toys, silver cages, gilt coaches, &c';[28] three years afterwards, Caroline Swinburne, born in Naples in 1779, became the Queen's god-daughter, and Maria Carolina gave her namesake a green leather case containing a pencil and dance card, decorated on the lid with a portrait miniature of herself and a lock of her hair circled with diamonds. This still survives in the collection of a descendant at Fonmon Castle in Wales (fig. 51).

If the Swinburnes' evident wit, charm and sophistication,

easy familiarity with continental society, and Catholicism, accounts for their undoubted popularity with these and other European monarchs, given their shared intellectual interests, it is perhaps not surprising that they also became friendly with the British Resident, Sir William Hamilton, and his first wife, Catherine, with whom, Henry reported, 'we live on the most intimate terms'. In their circle they would surely have encountered the great connoisseur Charles Townley, who was a close friend of Hamilton's, and paid a brief visit to Naples during the Swinburnes' stay. Almost certainly, however, this would not have been Swinburne and Townley's first meeting: Townley was a fellow Northern Catholic from Lancashire, and had been educated, like Swinburne, in France. Other acquaintances included Lord Algernon Percy's former tutor, Louis Dutens, who was travelling in Italy from 1777–8 with his former patron, James Stuart Mackenzie and his wife Lady Betty. On his return to England, Dutens took home with him a miniature of young Harry Swinburne, which he delivered to the boy's maternal grandfather, John Baker, in August 1778, regaling him with accounts of how fond Queen Maria Carolina was of Martha Swinburne. Henry and Martha's friendships with both Townley and Dutens survived into later life.[29]

If much time was taken up with theatre and opera, soirées, cards, carnivals and masked balls, such as the one where Sir Thomas Gascoigne dressed up as a chamber-maid to the great amusement of the King, there was a more serious, though still highly enjoyable, side to the Swinburnes' activities. Husband and wife made excursions together to the local classical sites including Herculaneum and Pompeii. Clearly, Henry Swinburne enjoyed having his wife as a travelling companion, reporting that 'except in taking views [sketching], my wife has the same propensities as myself for antiquities, and our mode of life is so pleasant in this delicious climate, where no impediment of weather prevents our daily journeys of discovery'.[30]

Henry Swinburne was not simply sightseeing, however. He was working on a new book, *Travels in the Two Sicilies ... in the Years 1777, 1778, 1779 and 1780*, published in 1783–5.

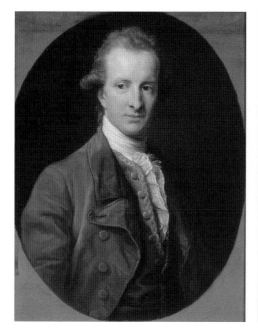

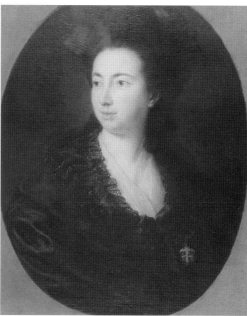

Fig. 53
Henry Swinburne
by Pompeo Batoni,
oil on canvas, 1779

Fig. 54
Martha Swinburne
by Pompeo Batoni,
oil on canvas, 1779

This highly erudite, if somewhat prolix, publication, which Henry intended as 'the accounts of a real tour and not an imitation of Sterne's *Sentimental Journey*', would prove to be the most important guide to Southern Italy and Sicily of the century. Like Swinburne's earlier guide to Spain, it did much to satisfy the rising demand, as Boswell put it, for 'more than just the common course of what is called the tour of Europe', and, like its predecessor, it was well received in the contemporary press, notably in the *Critical Review*.[31] Although the book contains lengthy descriptions of those antiquities and sites around Naples which were already well-known to British tourists, Swinburne also toured the more far-flung parts of the Kingdom of the Two Sicilies, notably Taranto and Reggio in the South and the Abruzzi to the North. The most interesting part of the book, however, is his two-month tour of Sicily from Christmas Day 1777 to February 1778.

Travelling once again with Sir Thomas Gascoigne, Swinburne had not only visited the temples of Agrigentum and Selinunte but hired a muleteer to take them to the more remote temple of Segesta, which the two previous British travel writers on Sicily, John Breval in 1738, and Patrick Byrdone in 1773, had not reached, and which Henry considered to be one of the finest and most entire Doric temples in existence (fig. 52). Its isolated situation 'on a bold eminence in the midst of the desert' had 'something singularly awful and sublime' in its effect.[32] Although Swinburne's visit provides a precedent for Goethe's historic visit to the temple a few years later, he arrived in Sicily just after another British party: that of the future antiquary, connoisseur and collector Richard Payne Knight, who had travelled round the island the previous March, together with the artist Jakob Philipp Hackert and his pupil Charles Gore.

Henry Swinburne was not only preoccupied with sightseeing during his stay in Southern Italy and Sicily. He was also trying to acquire a collection of medals, referring to his 'chasse aux médailles'. It seems likely that it was in Naples that either he or Gascoigne acquired the Petroni collection, for he later recorded in Rome: 'Sir Thomas has brought us the Petroni collection of medals from Naples'. The collection was probably destined for Sir Thomas rather than for Swinburne

himself, and part of it may be shown in Batoni's portrait of Gascoigne (fig. 55): sadly, its fate is unknown. Henry, however, certainly acquired some medals in Italy, as he was given 'a box full of silver and brass ones' by the Archbishop of Palermo, and he later wrote from Vienna that 'The medals we brought from Italy are much admired here';[33] his later correspondence with Charles Townley in Paris makes it apparent that he was dealing in medals, probably as a way of supplementing his income. Not all of Swinburne's interests were related to the arts. Like many 18th-century tourists, he was not above being fascinated by lurid and grotesque spectacles, and at the house of Dottore Cyrillo near Capo di Monte, where he had gone to

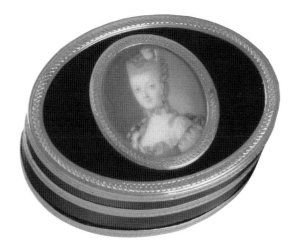

Fig. 56 Tortoise-shell and gold snuff box with a miniature portrait of Queen Marie Antoinette on the lid, Paris, 1773–4

Fig. 55 *Sir Thomas Gascoigne* by Pompeo Batoni, oil on canvas, 1779

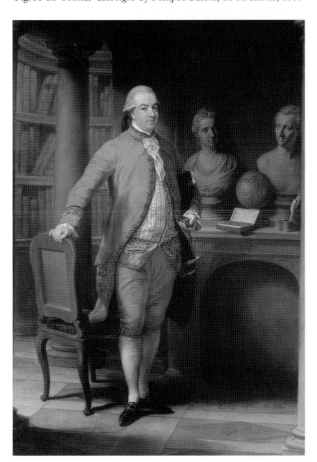

inspect his host's drawings of Calabria, he also saw the skeleton of a celebrated courtesan whose body was exhumed after she had died at the exact day and hour predicted by a Jesuit priest – who had tried in vain to persuade her to repent![34]

After well over a year in Southern Italy, and still accompanied by Sir Thomas Gascoigne, the Swinburnes finally arrived in Rome in March 1778. Henry Swinburne's reaction to the city was what one would expect of a man reared on the classics; he couched it in words from Corneille's *Les Horaces* that Louis Dutens had used to announce his own arrival in the city ten years earlier: 'I am happy if ever man was, *car me voici à Rome, l' unique object de mon desir*' [because here I am in Rome, the sole object of my desire].[35] As practising Catholics, the party had evidently timed its arrival to coincide with the Easter Papal celebrations in Rome. The two men were soon granted an audience with Pope Pius VI, as was Martha Swinburne a few days later, when she 'made the children kiss his foot'.[36] These introductions set the keynote for a visit which, right from the start, was shaped by the Swinburnes' Catholic connections.

Henry Swinburne already had important contacts in Rome among men who formed the last phase of the 'cultural Jacobite disapora'. His former tutor, George Augustine Walker, who

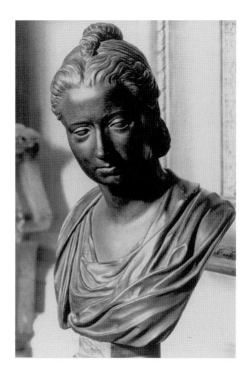
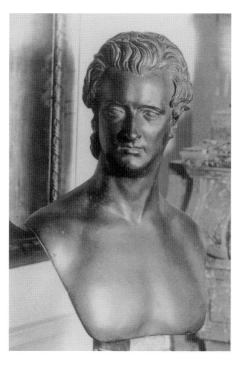

Figs. 57, 58
Martha and Henry Swinburne
by Luigi Valadier,
after Christopher Hewetson,
bronze busts, 1779

had been chaplain to another Durham family before becoming the Benedictine Procurator (or agent) in Rome from 1757–77, had lived at the centre of 'a circle of men of culture and learning attracted to Rome by a line of scholarly Popes and by a renewed interest in Roman and Italian art'.[37] Among Walker's friends were the Irish sculptor, Christopher Hewetson (figs.57–8), the artist and *cicerone* Colin Morison, and the 'Pope's antiquity in Rome', James Byres (fig. 25). Although, to Henry's regret, Walker had left Rome two years earlier, his successor as Procurator, Placid Waters, a member of the household of the Young Pretender, Prince Charles Edward Stuart, also kept in close touch with the Catholic artistic community, including Byres, who owned his portrait, and it was from this circle that the Swinburnes' and Sir Thomas Gascoigne's remarkable art patronage in Rome emanated. It comes as no surprise, therefore, that the *cicerone* whom Henry employed immediately after the Easter festivities to give him a tour of ancient Rome was Byres himself. As Henry records:

'Upon Easter Monday we began our tour of all the antiquities, churches, &c, under the direction of Mr. Byres the antiquary, and commenced by the Campo Vaccino' (fig. 11).[38]

As we have seen, Byres took an active role in introducing his clients to artists in the city, and particularly to the doyen of Grand Tour portraitists, Pompeo Batoni. Like so many of their compatriots, therefore, the Swinburnes and Sir Thomas Gascoigne now sat to Batoni. As one might expect from such unusual tourists, however, the portraits are by no means typical of Batoni's Grand Tour productions.

The portraits of Henry and Martha (figs. 53–4, col. pl. 1) were obviously intended to hang together as pendants. As such they are a comparative rarity in Batoni's work, since most Grand Tourists came to Rome still as bachelors. While their friend, Sir Thomas Gascoigne, could afford Batoni's most expensive, full-length format, for which he would have paid about £50 (even in 18th-century terms this was relatively cheap), the Swinburnes could manage only bust-length

canvases, which would have cost around £15 each. The format is 'modest, and conservative for its date'[39] – a simple dark green oval, with buff spandrels. However, very few of Batoni's portraits show such a sensitive understanding of character as the Laing Art Gallery's portrait of Henry Swinburne. Batoni has managed to capture the forceful intelligence of a sitter whom Hannah More found, despite being 'the author of two or three great big burly quartos', to be 'a little genteel young man…modest and agreeable, not wise and heavy like his books'. The arresting pose, the implied sense of movement of the head, and the compelling gaze all have an immediacy not found in Batoni's more elaborate compositions, and the picture's spontaneity leads one to speculate as to whether Batoni and the Swinburnes may have known each other socially: we do know that Henry and Martha had heard Batoni's daughter Ruffina sing.[40]

The portrait of Martha Swinburne is perhaps less successful. She was certainly a woman of considerable resource and intelligence – saving her life when mistaken by a French revolutionary mob for the mistress of the Duc d'Orléans by leaning out of her carriage window and pointing out that she was neither young nor beautiful enough to satisfy the Duke's taste – but Batoni's portrait is pleasant rather than profound, and gives no hint of Martha's fascinating and somewhat unconventional life. Batoni has given her face the same sense of arrested movement as her husband's, catching her as if she is just about to speak, but the features and expression are rather standardised, and one cannot help suspecting that he found her husband the more interesting sitter.

Batoni's portrait of the Swinburnes' friend Sir Thomas Gascoigne (col. pl. 2, fig. 55) represents a radical departure from his other Grand Tour full-lengths. Instead of standing against a backdrop of classical Rome, Sir Thomas is shown indoors in a library, surrounded by the spoils of his Grand Tour, including a set of medals (perhaps the Petroni collection) on the chimneypiece, and holding a snuff box decorated on the lid with a miniature of Queen Marie Antoinette (fig. 56). This is likely to have been a gift from Henry and Martha, since

they, unlike Sir Thomas, knew her well. Also among the contents are two classical busts which, instead of representing Roman gods and goddesses, are of Sir Thomas's two travelling companions, Henry and Martha Swinburne! Batoni's portrait clearly stands as a tribute to a memorable friendship, in which the Swinburnes 'provided companionship and art expertise while Thomas, seven years Henry's senior, supplied financial aid'.[41]

These busts are not Batoni's invention. They were almost certainly copied in his studio from terracotta or plaster busts of Henry and Martha Swinburne, modelled in Rome by the Irish sculptor Christopher Hewetson, whom the Swinburnes and Gascoigne would have met in Benedictine circles in the city. Hewetson had already produced a marble wall tablet for the Swinburnes in memory of their daughter Martha, who died in Rome on 8th September 1778; erected in the English College there, it contains a moving account of her short life by Henry himself. As a specialist in portraits in the neo-classical mode, Hewetson must now have seemed an obvious choice for these sculptures; British sculptors in Rome were quicker than their Italian contemporaries to develop a profoundly neo-classical style.

Hewetson's plaster models of Henry and Martha Swinburne are now lost, but the bronze busts cast from them by the well-known founder, Luigi Valadier, still survive in the Gascoigne collection at Lotherton Hall, Yorkshire (figs.57–8). Presumably the busts were modelled in 1778–9, just in time to be included in Batoni's portrait of Gascoigne, and were destroyed when the casting of the bronzes was completed. Hewetson also produced a bust of Sir Thomas himself, dated 1778, which again survives in a bronze cast at Lotherton. Given that all three busts remained with the Gascoigne family, it seems almost certain that Sir Thomas was the purchaser. However, the impetus to commission them may well have come from Henry, who, unlike Sir Thomas, took a strong interest in both classical and contemporary sculpture, referring to it often in his diary, and owning at least one antiquity, a Roman altar.[42]

The Swinburnes' involvement with British neo-classical

sculptors in Rome does not end with these commissions. In a letter of 8th February 1779, Henry reports that 'Lady C. Beauclerk has had a raffle of a bas-relief of Casper and Alcyone by Mr. Bankes, which I won and gave to Sir Thomas'.[43] The British sculptor Thomas Banks executed four highly important reliefs while in Rome. This one, *Ceyx and Alcyone* (fig. 59), was on the popular neo-classical theme of a wife mourning over the dead body of her husband. In this story, taken from Ovid's *Metamorphoses*, the husband, Ceyx, has been shipwrecked, and Alcyone comes upon his lifeless body on the shore.

Henry Swinburne's acquisition of this important relief, by a man whom he knew as a friend, was not simply a piece of luck, as the mention of a raffle would seem to imply. In the 18th century a raffle was not a way of raising money for charity, but a form of sale, in which all the participants staked equal amounts.[44] This particular raffle seems likely to have been held to enable Banks, who was ill and suffering from depression, to return to England with his family. Swinburne's gift of the relief to Gascoigne may have been prompted by the financial support his friend had given him while they were abroad.

Sometime between 1776 and 1780, either in Rome or Naples, Martha Swinburne also sat to the gem-engraver Nathaniel Marchant for a portrait which is now lost, although a paste copy survives in a private collection.[45] The portrait appears to have belonged to the Pittite statesman and collector Lord Mulgrave; more interesting is the fact that a version was owned by the German artist and friend of Goethe, J.P. Hackert (see fig. 135), whom the Swinburnes must have met in Naples.

The Swinburnes' visit to Rome did not differ entirely from those enjoyed by their Protestant contemporaries. Henry

Fig. 59 *Alcyone discovering the dead body of her husband Ceyx* by Thomas Banks, marble relief, before 1775

made similar excursions to the principal sites of the Roman *campagna*, visiting Tivoli, Frascati and the cascades at Terni; saw the Colosseum, which he called a 'stupendous edifice'; and attended the opera – hearing what was probably Pergolesi's 'Adriano in Siria' he commented, in his epigrammatic style, that 'the music [was] bad and the theatre dirty, old, and dark, with a great show of diamonds in the boxes'.[46] Having a conventional taste in pictures, he praised the *Transfiguration* of Raphael and the expression of devotion in a Guido Reni Madonna. Only his mornings in the Vatican library, collating Horace, and a visit to the Vatican with a party of Russians to see the effects of torchlight on the classical statues, mark him out from the average Grand Tourist in his day-to-day activities.

On leaving Rome, the Swinburnes returned to Naples, where the pregnant Martha and the children stayed when her father's death caused Henry to return to England, apparently with Sir Thomas Gascoigne; Caroline Swinburne (p. 45) was born in Naples in September 1779. On the route north, in Assisi, Henry failed even to note the frescoes formerly attributed to Giotto in the Church of San Francesco, which are the chief attraction today. A visit to Pisa, however, brought a more sympathetic response to medieval art when he admired the Last Judgement frescoes in the Campo Santo: quite an achievement for a devotee of Raphael.[47]

Swinburne now set off for home via Genoa and Turin, crossing the Alps, but missing the convent of the Grand Chartreuse, 'much cried up by travellers', because of bad weather. At Calais, Georgina, Duchess of Devonshire gave him the 'first sight of my Spanish travels in print'. However, having left his family abroad, Henry's return to England was no more than an interlude in this Grand Tour. Having arrived back in London in July 1779, Swinburne was enjoying a shooting party on his brother's land up the North Tyne valley in Northumberland in September, and socialising with members of three Northern tourist families, the Ridleys, the Riddells and the Erringtons. Later he visited the great painting collection at Burleigh with Sir Joshua Reynolds. By February 1780, however, he was in France once again, *en route* for Italy,

where, on his way south to rejoin his newly expanded family in Naples, he saw the paintings of the 'divine Correggio' in Parma, the Bridge of Augustus at Rimini, and the shrine at Loreto, crowded with what he considered to be 'the most filthy nauseous beings in human form', but redeemed by a Raphael. On the Swinburnes' final departure from Naples in May 1780, shortly after his return there, Queen Maria Carolina gave Martha 'a pair of diamond bracelets, with her picture and ciphers, and two fine medals'.[48]

Returning northwards once again, this time with his family, Swinburne travelled via Rome, where he had an audience with the Pope in Italian, and Florence, where in June 1780 he and Martha saw the Young Pretender carried away, drunk, from the opera: from his caustic comment, 'I drew my wife's attention to this undeserving object of all her Jacobitical adoration', we learn that whereas Mrs. Swinburne was a Jacobite, her husband was not. They now hired a *vetturino* to take them, their children and five servants to Vienna, via Bologna, Modena and Verona. Arriving in Vienna in October 1780, towards the close of this extraordinary, six-year tour – which finally ended only in July 1781 – the Swinburnes benefited from letters of introduction to the Emperor Joseph II and his mother, the Empress Maria Theresa, from her daughter, Queen Maria Carolina. Once again, Henry and Martha proved themselves adept courtiers. The Emperor stood godfather to the Swinburnes' son, and the Empress presented Martha with the Croix Etoilée, which was painted into Batoni's portrait of her (fig. 54) by a later hand. On their return to London, Henry delivered to Horace Walpole, as a gift from Sir Horace Mann, what Mann described as 'a [vase] of rock crystal…stripped… of a gold foot that the Medici had adorned it with', and carved with scenes of battles, from the Grand Duke of Tuscany's collection.[49]

What had begun as a Grand Tour, albeit a highly unusual one, had by now metamorphosed for the Swinburnes into a life spent largely as expatriates, and they can have seen very little of their estate in Durham during the second half of their lives. By 1783 Henry and Martha were in Paris, where they spent much time in the 1780s, armed once again with letters

of introduction, this time from the Emperor to his sister, Marie Antoinette, and they now became favourites with the French Queen, who made their son Harry (Henry Joseph) a royal page. When Martha Swinburne's property in the West Indies was ravaged by the French, the Swinburnes persuaded Marie Antoinette to intervene on their behalf, and in 1788, on the eve of the Revolution, Martha was in Paris, trying to interest the Queen in her affairs. Her position was ambivalent; as her letters to Henry make clear, she was deeply critical of the Queen, and both husband and wife clearly looked forward to her removal from power.[50] Caught up, however, in the Revolution itself in 1789, Martha preferred her help, suggesting that, in the event of danger, the Queen should disguise herself as her maid and escape with her to England. Martha was also close to the Young Pretender's wife, the Countess of Albany, Walpole reporting sarcastically that when the Countess visited England in 1791 she was going to stay with Mrs. Swinburne, 'who it seems is the friend of all sorts of queens'. If the Swinburnes relished their contacts with royalty, they also fraternised with intellectuals such as Madame de Staël and Madame de Genlis, while Henry's correspondence with Charles Townley (which includes discussions as to the latest escapade in the career of the antiquary and adventurer 'Baron' d'Hancarville, for whom Henry could not 'help having a tendre...especially as Poverty puts me above all apprehensions of tricks'), confirms his continuing interest in art and connoisseurship in the years following his Grand Tour.[51]

The Swinburnes' last years were tragic ones. Attempts to obtain compensation for the eventual complete loss of Martha's West Indian inheritance ended in failure, as did Henry's brief diplomatic mission to revolutionary France, which was undermined through no fault of his own, while their much-loved son Harry, who had made his own Italian tours in the 1790s, was drowned on the way to Jamaica in 1800. When Henry was offered the lucrative post of Vendue-Master in Trinidad in 1801 he could not afford to refuse, and, with 'nothing but thoughts of distant home [occupying] my mind' he died, away from his family, of sunstroke, in 1803; three years later, Martha and her daughters had to leave Hamsterley

for good when an unsatisfactory second son also died at sea, bequeathing the estate to a – grasping – widow.

Although Henry Swinburne does not appear to have pursued his travel writing in the later years of his life, he certainly continued sketching, working industriously on botanical studies of Trinidad in the last months of his life.[52] To his earlier Italianate drawings, several of which survive in a private collection, while others appeared at Sotheby's in 1979, can be added a group related to tours made in Switzerland, Germany and Hungary in the 1780s.[53] Henry also refers amusingly in 1788 in letters to Charles Townley to his concerns over paying customs duty on 'my own drawings which are all pasted in order into two books, & which I don't choose to trust from my propria persona...I should be sorry to pay sixpence per sketch, that would be paying too dear for my peeping [?]'; later he resolved to face 'the formidable phalanx of Custom house officers with due intrepidity'.[54] Swinburne's library, including his Grand Tour books, was sold in 1802, with his nephew Sir John Edward acquiring much of the contents.[55] However, many of Henry's letters from the latter half of his life remain, and show that, even when playing the role of courtier, he – like Martha, in her letters from Paris – retained the spirit, independent thinking and intellectual grasp that make Henry's travel books some of the most important of all contributions to Grand Tour literature.

SIR JOHN EDWARD SWINBURNE (1762–1860)

Like so many of his family, Sir John Edward's experience of life on the continent began at an early age. The eldest son of Sir Edward Swinburne, he was sent abroad to be educated with his younger brother Robert in 1776, first in Lille and afterwards in Paris, with their tutor, the Abbé Daraud. In 1781 their father collected his two sons in Paris to take them on a tour through Flanders and Switzerland to Vienna which was no doubt intended to 'finish' their education. Adhering to family tradition, Sir John Edward kept a detailed journal of this tour, also making a 'Memorandum' of the paintings he had seen in the Low Countries. Even at this young age he clearly had a strong interest in the visual arts, and his journal

contains fascinating accounts of the individual paintings he had seen, as when he describes a crucifixion of St. Peter by Rubens as 'a capital picture remarkable for the strength expressed in the muscles & the foreshortening' – a quality many would single out when describing Rubens's art today.[56] Sir John Edward made at least one further continental tour in 1786, which was cut short by his father's death.

In later life Sir John Edward was almost certainly influenced by the knowledge of art he had gained on the Grand Tour. Although apparently not a collector of Old Master paintings, he was a distinguished patron of contemporary art, owning an oil painting by Turner of *Mercury and Hersé*, and works by Girtin, Calcott, Varley, Stothart, Flaxman, Wilkie and William Mulready, who was drawing master to his children (p. 57). He was also President of the Newcastle Literary and Philosophical Society, and of the local Society of Antiquaries.

A few months prior to inheriting his father's title in October 1786, Sir John Edward converted to Protestantism. With his apostasy came the severing of the link between the Swinburnes, their Catholic chaplains and the continent that had existed for generations. The new baronet married a niece of the 2nd Duchess of Northumberland, who shared his radical politics (he called himself Citizen Swinburne), and, as a friend of Charles, 2nd Earl Grey and Charles James Fox, and supporter of the Reform Bill, took an active role in Whig politics. His brother, Robert, may have been influenced even more profoundly by his European education and tour. He became a general in the Austrian army and married a German baroness.

EDWARD SWINBURNE (1765–1847)

Italy and the Grand Tour had an equally marked, though different, effect on Sir John Edward's third brother, Edward, who was an amateur artist of some talent. Edward was in Italy in 1792-3, when he visited Rome on his way south, moved on to Naples for the winter, and then returned to Rome by 1st April 1793.

While he was in Italy on this and a subsequent tour in 1797, Edward produced a series of drawings, largely in brown wash (figs.60–1).[57] These show that at the age of twenty-seven he was already an accomplished draughtsman, although somewhat conservative in his choice of medium and selection of subject matter. The places he sketched, for example Tivoli and Ariccia in the Roman *campagna*, were those frequented by the great 17th-century landscapist Claude Lorrain and his contemporaries, and later favoured by British artists working in Italy in the mid-to-late 18th century. In style as well as content, the drawings look back to Claude and his evocation of a serene, arcadian world, and Swinburne's use of brown

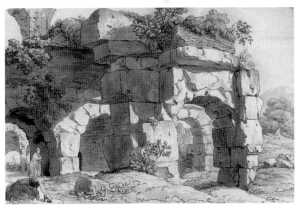

Fig. 60 *On the Florence Road* by Edward Swinburne, pencil and brown wash drawing, 1790s

Fig. 61 *Part of the Amphitheatre, Capua* by Edward Swinburne, pen, pencil and brown wash drawing, 1790s

wash may even reflect Claude's own preference for this medium.

A finished watercolour in the British Museum of *Tasso's House, Sorrento* (fig. 62), traditionally attributed to Edward's uncle, Henry Swinburne, has been recently re-identified as Edward's work by Kim Sloan.[58] Painted on his second tour of Italy in 1797, Edward's view of the birthplace of the great Renaissance poet shows that he was capable of producing work of considerable quality. Although he deploys only a limited range of coloured washes, the freedom of their application, lack of framing devices and the dramatic perching of the villa on its cliff-top all make this a particularly fine drawing by an amateur.

On this second Italian visit, Edward Swinburne spent the months of February to June 1797 in Naples, where he became friendly with the British artist William Artaud (pp. 142–47), whose letters cast considerable light on this part of Swinburne's tour, Artaud citing him as a 'glorious and luminous' exception to his judgement that most gentlemen tourists had received a defective classical education. Describing Swinburne as a 'Great lover of Art & a most able designer of Landskape himself', Artaud reports that 'There is not an interesting spot in Italy w[h]ether for its picturesque Beauty or its being the scene of some great historical Event or the residence of some celebrated Personage of Antiquity which he has not delineated', while there was no 'Precious remain of Graecian or Roman archi[te]cture in the same country that he has not accurately examined & represented' – an analysis of Swinburne's subject matter that accords well with his surviving work,[59] although he might have added that Swinburne also produced those studies of picturesque continental costume which were then in vogue.

In common with 'several brother Artists', Artaud enjoyed a 'considerable degree of Intimacy' with Swinburne in Naples, and in May 1797 the two men, together with three other artists, Henry Thomson (1773–1843), Richard Duppa

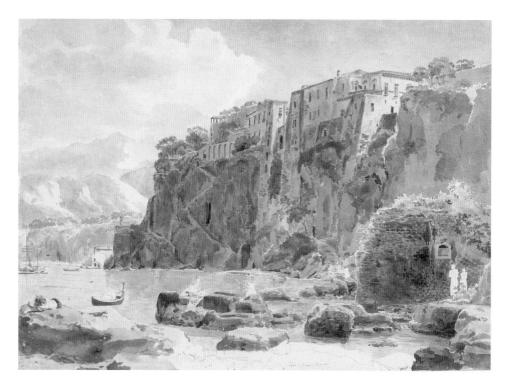

Fig. 62
Tasso's House, Sorrento
by Edward Swinburne,
watercolour and pencil,
about 1797

Fig. 63
Castle of Chillon
by J.M.W. Turner,
watercolour,
about 1809

(1770–1831) and Richard Ramsay Reinagle (1775–1862) set out on what Artaud called 'one of the most romantic and interesting tours I have ever made' around Capri and the Gulfs of Naples and Salerno, which included the temples at Paestum.[60]

At Priano, however, the excursion nearly came to grief in an episode which offers a graphic illustration of the very real personal dangers to which Grand Tourists could sometimes be subjected. Going some way into the mountains to admire their romantic appearance, Swinburne and Artaud were accosted by a man looking like a bandit, who had been drinking, became abusive, and forced them into an inn. In the ensuing scuffle, Artaud lost his pistols and Swinburne his money. Even the Lieutenant Governor was not entirely on their side, and the travellers were forced to stay overnight in a remote house, with people whom they suspected of complicity in the crime, before

the culprit was finally arrested on the intervention of the Governor the next morning. Not surprisingly, the episode strongly reminded Artaud of the banditti scenes of Salvator Rosa which were so popular with British connoisseurs (p. 4).[61]

William Artaud was soon to become the protégé of another Northern tourist whom Swinburne must have known in the North of England, and whose stay in Naples coincided briefly with his own: William Henry Lambton of Lambton Hall in County Durham (figs.112, 114). A possible bond between all three men may have been an interest in radical politics. This is known to have been the case with Lambton and Artaud, and Edward's brother, Sir John Edward Swinburne, certainly espoused radical causes. Even if Artaud and Edward Swinburne did not have such common ground, Artaud undoubtedly had considerable sympathy for Swinburne's position as an indigent younger son, which perhaps brought

him closer than most tourists to the economic level of professionals such as artists: according to Artaud, 'provision for the younger branches of this family are but slender' – a comment borne out by the lives of Henry and Martha Swinburne, as well as Edward's own – and Swinburne's adoption of a 'system of rational Enjoyment proportioned to the extent of his Mind & his fortune' earned his fellow artist's approbation.[62]

Edward Swinburne also made a tour of France and journeyed down the Rhine. However, it was his early experience of Italy that was to prove decisive. In 1804 the diarist Joseph Farington recorded meeting 'a Mr. Swinburne, brother of Sir John Swinburne of Northumberland, who drew landscape well and had been in Italy, where he found that "reckoning from the Alps, – it included every character of Landscape in the highest perfection"';[63] his comment perhaps suggests that Edward still thought of landscapes as being divided into the two 18th-century categories, formulated by Edmund Burke, of the 'Beautiful' and the 'Sublime'.

It is often said, erroneously, that Edward Swinburne was a pupil of J.M.W. Turner. Certainly he was a personal friend and patron of the artist, paying Turner fifty guineas for a view of *Grenoble* in 1809, and dining with him at the London home of Turner's great patron, Walter Fawkes, which was almost next door to Sir John Edward Swinburne's house in Grosvenor Place, on several occasions in the 1820s.[64] At least some of the several other Turner views of the continent known to have been commissioned by the Swinburne family between 1809–20 (fig. 63) were also painted for Edward, as he lent two Turner watercolours to the Northern Academy in 1828; however, his brother, Sir John Edward, was also a patron of the artist.[65]

Several Turner scholars have commented on the close correspondence between these Turner watercolours, now dispersed, and the famous set of views commissioned by Walter Fawkes himself. It is surely no coincidence that the works Edward Swinburne seems to have commissioned from Turner were based on his tours abroad. Memories of the continent – perhaps shared between artist, patron and Walter

Fig. 64 *Majuri from a Cavern in Salerno* by Edward Swinburne, watercolour, early 19th century

Fawkes – seem likely to have been much in Edward's mind in making these outstanding purchases from his friend and contemporary. Like his brother Sir John Edward, Edward also collected works by other leading watercolourists including Cotman, Varley and Girtin.

On his return to the North of England, Edward soon established himself as the leading amateur artist of the region, and, at least in the opinion of – somewhat fawning – local journalists, as well as his friends, his work stood comparison with that of his professional contemporaries: in 1805 Teresa Cholmeley, on a visit to Capheaton, wrote: 'Oh how I wish Cotty [John Sell Cotman] could see all Edw. S[winburne's] drawings…[his] taste and knowledge and experience are certainly all of the highest class'.[66] Swinburne became friendly with the most influential Newcastle painter of this generation, T.M. Richardson Senior, and used his social standing to promote the visual arts in the region and beyond, becoming a Founder and President of the Northumberland Institution for the Promotion of the Fine Arts (1822), and later President of the Northern Water Colour Society (1831). To these early Newcastle exhibitions Edward sent watercolours based on his experience of Italy many years before. His fine view of *Majuri* (fig. 64) – which was turned into a diorama by Richardson and

another leading Newcastle painter, Henry Perlee Parker – is typical of the finished Italian watercolours he produced, based on sketches made on his earlier tours. Edward Swinburne also contributed etchings to two of the most important topo-graphical publications on the Northern counties, Robert Surtees's *The History and Antiquities of the County Palatine of Durham* (1816–23) and John Hodgson's *A History of Northumberland* (1820–58). The next generation of Swinburnes, who were tutored by William Mulready, also produced talented artists, notably Edward's niece Julia (1796–1893), whose watercolours continue well into the 19th century the tradition whereby amateurs recorded the sites they had seen on their travels both in England and abroad.

Apart from a short continental tour in 1814, when he observed the tense political situation in Paris, Edward Swinburne does not appear to have visited the continent again. On his death in 1847 he was praised by the *Newcastle Weekly Chronicle* as 'one of the first amateur artists of the age, Mr. Swinburne's taste and judgement on all subjects connected with the arts, were of the highest order, and his opinion was constantly appealed to.[67] His life and career represent a very clear illustration of the way in which an early visit to Italy could shape the entire later career of a successful, though amateur, artist, in an era when 'Mr. Swinburne and Sir George Beaumont were the only gentlemen who condescended to take a brush in hand'.[68]

END NOTES

1 The historian John Hodgson and the Swinburne family pedigree (in Hodgson, part 2, vol. 1, pp. 231–4) both state that it was Sir John Swinburne, 1st Bart., who was the *enfant trouvé*. Other commentators have much less convincingly identified the *enfant trouvé* as the 3rd Bart., suggesting that he was sent abroad after the1715 Jacobite rebellion; this is negated by his own statement that he left England in 1712.

2 The 3rd Bart's Diary is in a British private collection. The Ushaw MSS., 99/ix, 1716 show that Sir John dined at Douai with Cuthbert Farnworth, on their way to Paris, in 1716. Family links with the continent were clearly maintained: according to Thomas Gray in 1753, Sir John's widow had also 'been much abroad, seen a good deal'; see A.F.Allison and D.M. Rogers, 'Materials towards a biographical dictionary of Catholic history in the British Isles, *Biographical Studies 1534–1829*, vol. 2, no. 1, 1953, p. 87.

3 Swinburne MSS., ZSW 456. All the following references to his tour are from this source.

4 In a British private collection.

5 Journal no. 9, Vienna to Rome, 1771, 5th May (Venice), and Journal no. 10, 1771, undated entry, and 21st June (Rome); private collection. For the cameo of Constable, see Ingamells, p. 916.

6 They were included in the Sir John Swinburne sale, Christie's, London, 8th June 1915 (86). For Henry's friendship with d'Hancarville, see Townley MSS. 7/1485.

7 Although it would seem surprising that the less affluent Henry Swinburne should commission two Grand Tour portraits, while his wealthier brother returned home with no record of his stay in Rome, the physiognomy (cf. fig. 53), and the inclusion of books (perhaps in reference to Henry Swinburne's guide) both point strongly to the younger brother as being the sitter. Against this, the portrait, unlike the Batonis, did not descend to Henry Swinburne's heirs, and the traditional attribution to Sir Edward should also carry weight. I am grateful to Alastair Laing for his comments as to why the sitter should perhaps be identified as Edward, not Henry.

8 *Courts*, vol. 1, p. iv.

9 Henry Swinburne letters, British private collection.

10 Ibid.

11 *Courts*, vol. 1, p. v.

12 Ibid.

13 Op. cit., pp. vi, xii; Baker Diary, p. 25, passim.

14 *Courts*, vol.1, p. vii.

15 Op. cit., p. viii.

16 Op. cit., p ix; Baker Diary, pp. 24–5.

17 *Courts*, vol. 1, pp. 10, 12, 11–12, 21, 23.

18 For Martha's education in Paris, see A.F.Allison and D.M. Rogers, 'Materials towards a biographical dictionary of Catholic history in the British Isles', *Biographical Studies 1534–1829*, vol. 2, no. 1, 1953, p. 88; she rejoined the family in Bordeaux the following year; *Courts*, p. 24.

19 The drawings clearly correspond to the tour taken by the Swinburnes in 1774. The mention of the date 1773 as well as 1774 on the title page is therefore puzzling, but is presumably accounted for by Henry Swinburne's imperfect recollection of dates when he later came to

paste the drawings into the album. Kim Sloan points out the similarity in handling between Swinburne's drawings and those of two other Grand Tour amateur artists of this period, George Keate (fig. 9) and Sir Roger Newdigate.

20 Black, p. 25.

21 *Courts*, vol.1, p. 40.

22 Black, p. 76; Baker Diary, p. 28.

23 *Courts*, vol.1, pp. 64, 70; Baker Diary, p. 30.

24 *Courts*, vol.1, p. 76.

25 Swinburne, 1779, pp. 350, 353, 357-9, 393; *Courts*, vol.1, pp. 109–12.

26 Baker Diary, p. 29; *Courts*, vol. 1, p. 114; Walpole, vol. 2, p. 149.

27 *Courts*, vol. 1, p. 116.

28 Op. cit., p. 207.

29 Op. cit., p. 205; for Townley and Swinburne, see Townley MSS., 7/1483/4/5/6; Baker Diary, p. 460; for Dutens see, for example, *Courts*, vol. 2, pp. 69, 267.

30 *Courts*, vol. 1, pp. 144–5.

31 Baker Diary, p. 31; quoted in *Grand Tour*, Tate, 1996, p. 96; Swinburne's guide included two prints by another talented amateur Heneage Finch, Earl of Aylesford; for reviews of the book, see Baker Diary, p. 32.

32 Swinburne, 1783–5, vol. 2, p. 235.

33 *Courts*, vol.1, pp. 185, 236–7, 185, 360; Townley MSS. 7/1484/5.

34 *Courts*, vol.1, p. 148.

35 Op. cit., p. 208.

36 Op. cit., p. 209.

37 Scott, pp. 163, 162.

38 *Courts*, vol.1, p. 211.

39 Friedman, p. 19.

40 *The Life of Hannah More*, London, 1856, p. 94; *Courts*, vol.1, p. 215.

41 Friedman, p. 21. The snuff box also forms part of the Gascoigne collection at Lotherton Hall. A very similar snuff box, also with a portrait of Marie Antoinette, survives in the Cleveland Museum of Art.

42 Baker Diary, p. 32, quoting the *Gentleman's Magazine*, 1784, p. 974, for which Swinburne wrote as 'Porcustus'.

43 *Courts*, vol. 1, p. 238.

44 Stainton, 1974, p. 330.

45 Seidman, cat. 152.

46 *Courts*, vol.1, pp. 215, 230.

47 Op. cit., p. 258. Swinburne's route through northern Italy in 1779 is difficult to disentangle from his similar journey, this time with Martha and their family, in 1780. One crucial letter dated 'Florence, June 10' (*Courts* p. 254–6), although grouped with the 1779 journey north, must refer instead to the Swinburnes' 1780 visit to the city, when Martha Swinburne, referred to in the letter as in Florence, was present; she had remained behind in Naples in 1779. Other letters, too, could be out of sequence.

48 *Courts*, pp. 276, 287, 306, 310, 314.

49 Op. cit., pp. 254–5; Walpole, vol. 25, p. 65.

50 British Library, Add.MSS. 33121, ff. 5–17.

51 *Courts*, vol. 2, p. 92; Walpole, Vol. 11, p. 258; for Townley and Swinburne, see Townley MSS., 7/1483/4/5/6; MSS. 7/1485 refers to d'Hancarville, as do Mrs. Swinburne's letters from Paris, see note 50.

52 These have recently surfaced at Fonmon Castle, Wales, in an album, 'Flora Trinidadiensis', dated 1802; Swinburne had completed around eighty by the time of his death.

53 A group of drawings by Henry and Edward Swinburne was sold at Sotheby's, London, on 22.11.1979, lots 65–73; several of those attributed to Henry are certainly by Edward, including two drawings now in the British Museum and the Stanford University Museum of Art, California. The (twenty-three) drawings of Germany, Switzerland and Austro-Hungary were lot 71 in the sale; seventeen of these were subsequently offered for sale in 1980 by Alister Matthews, 58, West Overcliff Drive, Bournemouth, BH4 8AB.

54 Townley, MSS. 7/1483/4.

55 Henry Swinburne's library sale in 1802 was at Leigh and Sotheby.

56 For Sir John Edward's education abroad, see Lille, Archives du Nord, 18H, letters of 20th May and 20th November 1779. His Journal and the Memorandum are both in a British private collection.

57 For Swinburne's itinerary, see Ingamells, p. 916. Dates on a number of these drawings (British private collection) place Swinburne in Italy between July 1792 and June 1793.

58 In conversation with the author; subsequently published in Sloan, 2000, pp. 188–9. See note 53 above for the group of drawings by Edward (and Henry) Swinburne sold at Sotheby's in 1779, which included the British Museum drawing. Watercolours by Edward from a private collection were exhibited at the Laing Art Gallery in 1982 and 1984. There is also a signed work in the Victoria and Albert Museum.

59 Sewter, vol. 2, no. 21, draft letter, 2nd June 1797.

60 Ibid.

61 Op. cit., vol. 2, no.31, draft letter, 18th July 1797.

62 Op. cit., vol. 2, no.21, draft letter, 2nd June 1797.

63 Farington Diary, 12th, 13th June 1804; quoted in Ingamells, p. 916.

64 See Sloan, p. 189, and David Hill, *Turner Society News*, 23, 1981.

65 For the Swinburnes' complex patronage of Turner, see especially Hill (note 64 above). Unlike Hill, Andrew Wilton considers that the 1809–20 watercolours painted by Turner for a member of the Swinburne family were commissioned by Sir John Edward, although he suggests that *Tancarville sur Seine*, dating to around 1840 was painted for Edward Swinburne. Edward's loan to the *Northern Academy* exhibition of 1828 of Turner's 1820 watercolours of *Marksburg* and *Biebrich Palace* however, surely now confirms his ownership of these watercolours.Sir John Edward's purchase of *Mercury and Hersé* from Turner in 1813 is his only recorded acquisition from the artist, but by 1852, when Ruskin visited Capheaton with the Trevelyans, there was a group of Turner's continental views there, including *Bonneville* and *Bacharach*; see Batchelor, p. 84 and Trevelyan, p. 83. These could, however, have passed to Sir John Edward following Edward's death in 1847.

66 Quoted in Hill, p. 2; see note 64 above. Given the reference to his 'experience', the artist referred to is surely Edward senior, and not his nephew, Edward junior, who was only seventeen at the time, but who was, however, also present during Teresa Chomeley's visit to Capheaton in 1805.

67 *Newcastle Weekly Chronicle*, 10th September 1847.

68 *A Memoir of Thomas Uwins R.A. by Mrs. Uwins*, vol. 2, 1858, p. 252 (letter to Joseph Severn).

The 1st Duke and Duchess of
Northumberland
and their two sons

HUGH, 1ST DUKE OF NORTHUMBERLAND (1715–86)

Hugh, 1st Duke of Northumberland and his wife Elizabeth (figs. 65, 66) made Alnwick Castle in Northumberland their home for only part of each year, spending the rest of their time in London; at their Middlesex home, Syon House; in Ireland, when the Duke was Vice-Regent there from 1763–5; or, in the case of the 1st Duchess, abroad on one of her many continental tours. No history of the Grand Tour as it relates to the North of England could, however, be complete without the inclusion of these great territorial magnates, whose contribution to the Grand Tour extends beyond mere geographical place, and is part of the history of British neo-classicism. The Northumberlands' close contact with other Northern tourists, both through their art patronage (pp. 19, 38, 73), their involvement with them socially both at home (p. 30) and abroad (p. 96), and the key role played by their tutor, Louis Dutens (pp. 164–5, 75–80) in encouraging and advising other tourists from the region, make it clear that, although their journeys may have started from Northumberland House in London rather than from the North of England, they were inextricably linked to the Northern Grand Tour. If the tour made by Lord Warkworth, later 2nd Duke of Northumberland, from 1762–3, did much to promote the fashion for continental travel among the Northumbrian gentry, the influence was by no means entirely one-sided, and the patronage of Pompeo Batoni by George and Olive Craster in 1762 may well have been the catalyst

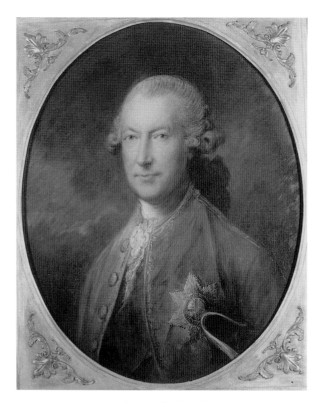

Fig. 65 *Hugh, 1st Duke of Northumberland*
by Thomas Gainsborough, oil on canvas, around 1783

The new Earl, shortly to be created Duke by King George III in 1766 in recognition of his political services to the Crown, as well as of his vast territorial influence, was a man of exceptional talents, with, as Thomas Chippendale wrote when he dedicated to him his *Director*, an 'intimate acquaintance with all the arts and sciences that tend to perfect and adorn life'– or at least, in Louis Dutens's more matter-of-fact assessment, 'more knowledgeable than is generally found among the nobility'.[1] As well as being a Fellow of the Royal Society and of the Society of Antiquaries, Smithson became, on his return from Italy, a founding member of the Society of Dilettanti. He was equally well informed about Egyptian or Italian Renaissance art, and his knowledge of classical

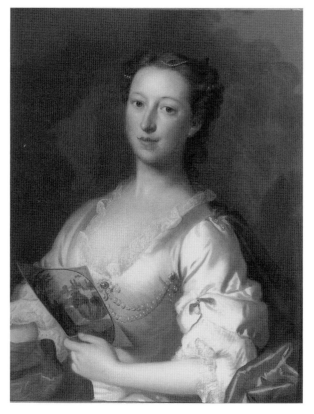

Fig. 66 *Elizabeth, 1st Duchess of Northumberland*
by Allan Ramsay, oil on canvas, c.1740

which persuaded Lord Warkworth to sit to Batoni in the following year.

The 1st Duke was born a commoner, before inheriting a Yorkshire baronetcy from his grandfather in 1729. As Sir Hugh Smithson, he made the Grand Tour with his tutor, Benjamin Crowe, in 1733–4, visiting Rome, Venice, Vicenza, and Milan. Although he made a highly advantageous marriage to the grand-daughter of the 6th Duke of Somerset, it was only with the death of her brother on the Grand Tour in 1744 that his wife, Elizabeth Percy, became heiress to the vast Percy estates in Northumberland and elsewhere; on her father's death in 1750 this great inheritance propelled the future Duchess and her gifted husband right into the centre of national political and cultural life.

architecture would make him an exacting patron: on one occasion, in November 1764, he caused Robert Adam to send back to the craftsman concerned some classical orders that were not executed to his liking. A politician of some note, the Earl was also a highly capable business-man and administrator, who devoted much of his time to modernising his estates and farming methods. He is, however, best remembered today as the moving force behind the restoration of his wife's three great mansions at Alnwick Castle, Syon and Northumberland House; as we shall see, it was at Syon that he showed his most thorough-going absorption of the lessons he had learnt on the Grand Tour.

The Earl's highly discriminating patronage of the arts had not, however, begun only with his wife's inheritance. Although his predilection for the paintings of Canaletto may well have been strengthened by family connections,[2] it was surely inspired primarily by his Grand Tour; this included a visit to Venice in 1733, when he would almost certainly have seen the collection of Canalettos then being formed by the merchant banker and collector, Joseph Smith, who was also the most important agent for the sale of the artist's work to British clients.

Canaletto's *London seen through an arch of Westminster Bridge* was almost certainly painted for Smithson in 1746, the year of Canaletto's arrival in London,[3] and this makes the future Earl one of the artist's earliest English patrons. Canaletto went on to paint for the Earl during his second visit to England in 1751–3 a group of highly important English scenes, including views of his three great properties at Alnwick, Syon and Northumberland House. Smithson also owned two fine early Venetian views by Canaletto which hung at his Yorkshire house, Stanwick, until early this century.

The Earl also took the lead in patronising a much less talented, but highly unusual, Grand Tour artist. This was the British painter Giles Hussey (1710–88), who lived in Italy from 1730–7, where he was regarded, at least by one critic, as the greatest master of drawing since Raphael, and was expected by others to 'prove ye greatest painter of ye age'.[4] Hussey, however, was dogged by ill-luck. Having been tricked

out of all his money on his arrival in Italy by the painter under whom he had been studying, Damini, he was left without even the money for his fare home when his father died in 1736, bequeathing him nothing in his will. According to W.T. Whitley, the money for his return passage was raised by Sir Hugh Smithson, who had given him commissions while in Italy, and 'other English at Rome'; presumably Smithson had met Hussey abroad and agreed with some of the more inflated contemporary estimates of his talent. Three paintings by Hussey remain at Alnwick today, including a pair of subject paintings of *Bacchus and Ariadne* of *c*.1744. Smithson considered the latter 'finer than any Picture he ever saw of Guido's'.[5]

THE REMODELLING OF SYON HOUSE

The accession in 1760 of a new monarch, George III, known to have a strong interest in the fine arts and architecture, together with the nation's recent victories over France, and the expansion of the Empire, had created in Britain a sense of anticipation, the dawning of a new cultural age. As Lord Deskford predicted: 'I expect we are just going to begin a reign in Britain of Taste and Architecture'.[6] The young neo-classical architect Robert Adam had returned from his Grand Tour in 1758 as if in answer to just such expectations, having risked 'all his patrimony on the great adventire in Rome in the hope that he might, one day, have a chance of "reviving something of the Old Style in England"'.[7]

The Earl of Northumberland's invitation to Robert Adam (fig. 67) in 1761 to remodel the earlier house at Syon in Middlesex came at a moment when Adam's career was just beginning to gain momentum, and offered him a supreme opportunity to realise his ambitions in this commission for a prestigious, cultivated, and exacting patron. Syon is an outstanding example of the enthusiasm for the classical world shared by two exceptional men, both of whom had gained first-hand experience of it on their respective Grand Tours, and the interiors there (fig. 68) are among the greatest of the neo-classical movement.

As Adam later made clear in his *Works in Architecture*

Fig. 67 *Robert Adam* by James Tassie, 1792

(1773), the choice of the antique style for Syon House was the Earl's own: 'He communicated his intentions to me, and having expressed his desire that the whole might be executed entirely in the antique style, he was pleased in terms very flattering, to signify his confidence in my abilities to follow out his idea'. He went on to praise the Earl as a person of 'extensive knowledge and correct taste in architecture', someone who possessed 'not only wealth to execute a great design, but skill to judge of its merit'.[8]

Adam's earliest interior at Syon was the monumental *Great Hall* of 1762–9, with its heavily coffered ceiling and apse, chequered marble floor, and large-scale copies – in plaster and bronze respectively – of the *Apollo Belvedere* and the *Dying Gladiator*. There are few more thorough-going tributes to the Roman past than this magnificent, spartan, Doric interior, which was intended to form a prelude to an (unexecuted) Roman Rotunda.

A more personal interpretation of antiquity is to be found in the *Ante Room* of *c*.1761–5 (fig. 68), where the richly coloured green and gilt interior is evocative of the most lavish period of the Roman Empire. The twelve giant columns, thought at the time to be of *verde antique* marble, were purchased direct from Rome in 1765, and brought to Syon by boat; the long and frustrating search to find a suitable set had involved not only James Adam (fig. 26), acting as art agent to the Earl of Northumberland, but also the Earl's son, Lord Warkworth, and his tutor Jonathan Lippyeatt, while they were in Naples on the Grand Tour. In November 1761 Lord Warkworth wrote home to report of an early alternative: 'I do not find that my Pappa is likely to get his columns of Sicilian Jasper at all'. Although both Sir James Gray, the minister plenipotentiary in Naples, and a man with a strong interest in the antique in general, and Herculaneum in particular, and James Adam, are reported to have written several times to Sicily, their letters were not answered, and 'As Mr Adams does not propose going over till next Spring, my Pappa will have no certain answer till the beginning of next summer'.[9]

Lord Warkworth's active part in this search seems to have ended in Naples. However, before he and his tutor left Rome, Jonathan Lippyeatt wrote on 25th March 1763 to assure the Countess that the columns – a set of *verde antique* marble had purportedly been found lying on the bed of the Tiber – were in 'great forwardness'; today, these are known to be only veneered in *scagliola*.[10] Two years later, in April 1765, James Adam wrote to the Earl to say that he had received from Rome the bills of lading for columns and pilasters, and that the ship had sailed from Civita Vecchia.[11]

Lippyeatt's letter also reveals the second direct link between the Earl's classical interiors at Syon and the Grand Tour. He reports to the Countess that he has 'sounded Mr. Adam about his statues and find that some are bought by

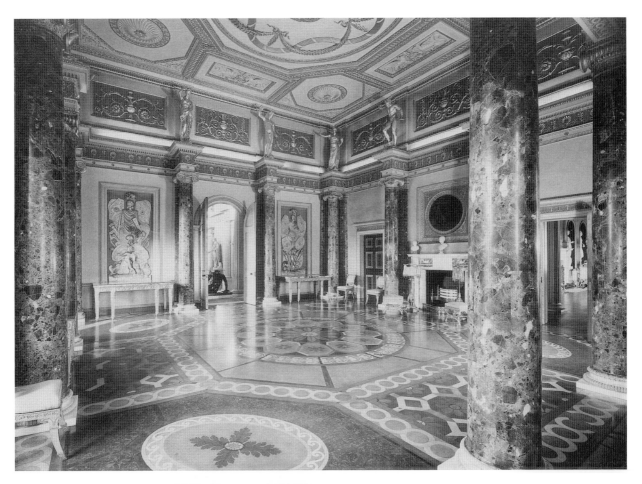

Fig. 68 The Ante-Room at Syon House by Robert Adam, 1760s

Fig. 69 *Bust of a Julio-Claudian child, called Germanicus*, marble, Roman, 1st Century A.D. and later

commission and some on his own account'.[12] James Adam was indeed active as an art agent and dealer during his Grand Tour of 1760–3, which exactly coincided with his brother's alterations for the Earl of Northumberland, and the Earl was one of his principal clients. Syon House remains a textbook example of the way in which Roman sculptures, collected abroad, could be used to complement a British neo-classical interior; the bust of '*Germanicus*' illustrated here (fig. 69) was, however, acquired in England. These classical marbles were displayed by Adam with copies after the antique, such as the full-scale replicas of the *Apollo Belvedere* by John Cheere and of the *Dying Gladiator* (cast in Rome in bronze by Luigi Valadier in 1773), or the copies by Joseph Wilton, Cavaceppi

and others which filled the niches in the Dining Room (*c*.1761–7). In the *Red Drawing Room* the Adam pier tables have tops of mosaics found in the Baths of Titus in Rome.

Confirmation of the Earl's extensive dealings with James Adam is provided in a letter written by Robert Adam in July 1765, when he was trying to obtain customs clearance for 'a shipload of works of art commissioned by Lords Northumberland and Shelburne and collected for them "by my brother James" during his "several years in Rome" ' – a clear indication that most if not all of the marbles James Adam had ordered for the 1st Earl had arrived in England in that year.[13]

James Adam was not the Earl's only contact in his search for antiquities. In early 1763 he was in correspondence with

Fig. 70 *Design for the Ceiling for the Circular Room in the Ravine Tower at Alnwick* by Robert Adam, pen and ink, wash and gouache, 1755–66

the banker and antiquarian, Lyde Brown, whose outstanding collection of antique sculpture was acquired mainly through agents in Rome, notably Thomas Jenkins. In a letter of 7th February 1763 from Foster Lane in London, Lyde Brown mentions to the Earl a number of antiquities which he hopes he will acquire for Syon: 'these singular antiques will be looked upon as more noble ornaments & become more celebrated in Sion … [than] when in the Villa of a private person'. He also refers to the Earl's intention of 'buying many modern copies from the Antique', appending a list of those he could obtain for him.[14] Lyde Brown was apparently disappointed in his hopes, but his intervention shows how widely the Earl had cast his net in his search for suitable antique sculptures.

If the redecoration of Syon House began as a thorough-going exercise in the classical style, by the time Robert Adam came to re-model the Jacobean *Long Gallery*, he had set his own personal stamp on the neo-classical movement: the somewhat ponderous classicism of the Roman *Great Hall* is replaced by a room encrusted with light, decorative ornament, while the sixty-two painted pilasters illustrate Adam's well-known desire for 'movement' in architecture. There are echoes here of the Renaissance as well as of antiquity, and the *Long Gallery* is a supreme example of Adam's attempt to unleash the 'spirit' of antiquity rather than to echo its every detail.

THE REDECORATION OF ALNWICK CASTLE AND NORTHUMBERLAND HOUSE

Alnwick Castle had fallen into disrepair by the mid-18th century, and about 1752 the Earl and Countess embarked on a major campaign of restoration; from now on, the family spent at least part of the year at Alnwick. Their architect for the structural repairs was probably James Paine, but it was Robert Adam who created the outstanding interiors in the newly fashionable Gothic style admired by the Countess; his drawings for Alnwick date from 1769–83. In the *Circular Room* in the Ravine Tower, however, Adam reverted to the classical mode (fig. 70). At Northumberland House (demolished in 1874 to make way for Northumberland

Avenue) Adam's *Glass Drawing Room* (*c*.1773–4) achieved new heights of richness with its creation of glass walls painted red to simulate porphyry. The earlier *Ballroom* (*c*.1750–7), perhaps by Roger Morris and Matthew Brettingham the Younger, contained copies after Renaissance and later Italian paintings ordered from Pompeo Batoni, A.R. Mengs and their contemporaries in Rome. Although it, too, was sumptuous in the extreme, Horace Walpole considered that the room 'might have been in better taste'.[15]

THE TRAVELS AND ART PATRONAGE OF ELIZABETH, 1ST DUCHESS OF NORTHUMBERLAND (1716–76)

Lady Elizabeth Smithson, later 1st Duchess of Northumberland (fig. 66), was one of the most colourful characters of the whole 18th century. Horace Walpole memorably described her for posterity when he wrote: 'The blood of all the Percies and Seymours swelled in her veins and in her fancy, her person was more vulgar than anything but her conversation, which was larded indescriminately with stories of her ancestors and her footmen... she was familiar with the mob, while stifled with diamonds'. Although not a woman of profound learning, the Duchess nevertheless shared her husband's taste for art and literature, and, herself a gifted diarist, was on 'terms of intimacy with the eminent writers of her era'.[16]

This 'jovial heap of contradictions', as Walpole also called her, was a committed, intrepid and highly discerning traveller. Her energetic travel journals[17] show that her tours abroad – which reveal an engagement with continental society at its most elevated social levels – followed a very different pattern from that of the classic Grand Tour. The 'junkettaceous' Duchess seems to have had very little desire to visit Italy – her only recorded soujourn there is with the Duke in November 1773, when they were in Milan. Instead, she preferred France, Germany, Switzerland and especially the Austrian Netherlands and the United Provinces, homeland of her ancestor, Josceline of Brabant. Although the Low Countries, 'lacked the thrill of Italy or Paris, the grandeur of the classics...[or] the lure of the

sun', they remained, as Black points out, the third most popular destination for British tourists, on account of their artistic treasures, churches and impressive civic buildings. The Duchess's preference for the 'wide regular streets &...elegant Churches & convents',[18] the neatness and cleanliness of the towns, and the presence of so many great collections of Dutch and Flemish painting, was not therefore in itself unusual, and there was, for her, an additional draw in the Protestant Royal court at The Hague, at which she was warmly received.

As we have seen, the Duke and Duchess were great and catholic patrons of the arts. Despite the draw she felt towards the new Gothic style, the Duchess's involvement in the redecoration of Syon House confirms that, like her contemporaries, amongst whom she played a leading role in terms of interior design, her artistic interests were shaped to a large degree by an absorption of Italian culture, and her eclectic collection included at least one archetypal Grand Tour commission (pp. 70–71), in addition to voluminous quantities of other items frequently acquired by tourists such as prints, coins and medals (see Appendix 2).[19] She was, moreover, hardly singular in her liking for cabinet-sized Dutch and Flemish paintings, which became increasingly popular with British collectors throughout the 18th century. Nevertheless, her single-minded dedication on her tours abroad to the assimilation of visual culture, and the way in which her travels in the 1760s were inextricably linked to her formation of an important collection of Dutch and Flemish genre paintings, does seem to represent a different pattern of tourism and art collecting from that of her male contemporaries, and indeed from that of her own husband, whose discerning patronage of Canaletto, interest in classical art, and support of Giles Hussey in Italy, all indicate tastes that were very much shaped by his Italian Grand Tour of 1733–4.

On her first visit to The Netherlands in 1766, the Duchess began, with characteristic thoroughness, to tour the provinces' many important art collections, keeping an eye out for works for sale, whether by Old Master or contemporary artists; given the lack of real estate and land to purchase, many wealthy 18th-century Dutchmen, unlike their British counterparts, had opted to invest in art instead. Perhaps the most famous of the many private collections she visited on this tour was that of Jan Bisschopp in Rotterdam, which consisted of medals, coins, 'curiosities', China, Japan and filigree work, ivories, books, glassware, miniatures and shells, as well as pictures, drawings and prints 'most of which are stuffed into a house not larger than a Middle sized Closet'. Among the 'Chef D'Oeuvres' of painting that attracted her attention were a 'John Stein' [Jan Steen], a genre scene by 'Terburgh' [Ter Borch], a seascape by 'Old Vandevelde' [Willem van de Velde I], and several pictures by Dou and Van Mieris. Mr Bisschopp himself the Duchess found 'almost as great a Curiosity as any in his collection'; aged eighty-seven, and having acquired his vast wealth in the haberdashery business, he still often served customers in his shop with '2 penniworth of Thread whilst some of his Emissaries are at an auction bidding a thousand pounds for a picture not 20 Inches square for him'.[20]

This formidable woman was not afraid to make her own judgements; indeed she considered herself, perhaps with justification, to be something of a connoisseur. When, in Amsterdam, she visited another renowned collector and elderly eccentric, Gerrit Braamcamp, who received her wearing a 'yellow flowered Calmanco Night Gown with a pipe in his mouth', she was unimpressed, pronouncing that, despite having a collection of six hundred paintings, Braamcamp had 'not the least taste for pictures'; as evidence for this, she cited his preference for an artist he retained in his house, Jacob Xavery IV, to all his Old Masters.[21] On this same tour, the Duchess made an almost royal progress to Moerdijk, on a yacht lent to her by the States of Holland. Her arrival was proclaimed by trumpet, but her visit was short-lived; after viewing the paintings of a widow who wanted 1,000 guineas for her collection, which she condemned as 'trash', and a 'Vanderwerff' [Adriaen van der Werff] which 'is looked on as inestimable but I did not covet it', she returned to her yacht, which, she noted with satisfaction, was equipped with a 'neat privy'.[22]

The Duchess returned to the Low Countries in 1767 and in 1769. On her latter visit she saw in Brussels at 'Mr. du Noorts a banker' a collection which she admired for its quality rather than quantity: the 'flower' of the collection was what she considered

(erroneously) to be none other than Leonardo da Vinci's *Mona Lisa*, 'bought out of the Collection of François the first of Frances as appears by his mark burnt in the back of it'.[23] On this tour the Duchess seems to have focused her considerable energies for sightseeing on viewing collections which were for sale. At an auction on 16th November 1769 at The Hague she left bids for eight pictures, purchasing three of them, including 'A conversation with a red Bed in one Corner by Palamedes'; this very similar interior scene (fig. 71) is one of three paintings by the artist to remain in the Northumberland collection today. The Duchess also bought two paintings by Van Goyen from a picture dealer in Rotterdam.[24]

On her fourth visit to the Low Countries in 1771 the Duchess succumbed even further to her enthusiasm for Dutch pictures and on 11th June was 'Fool enough to buy 4 Pictures' from Mr. De Dehnsters in Antwerp, although she also 'saw another wch I longed for but could not afford'.[25] Clearly the Duchess's resources, at least in her own opinion, were not without limit, and complaints as to the high cost of Dutch and Flemish cabinet paintings are a constantly recurring theme in the diaries: 'they don't scruple giving from three hundred to a thousand Guineas for a picture not two Feet square', she wrote on one occasion. Evidently shrewd at driving a hard bargain, she often sacrificed quality to considerations of cost. The very next day after her purchases on 11th June 1771, this indefatigable tourist visited 'Beschey the painter's'; Balthasar Beschey (1708–76) and his four brothers worked as both artists and picture dealers. Amusingly, the Duchess made the rounds of the brothers' studios, seeking a bargain; having rejected a Rubens of *Hercules Spinning* for 1,400 guineas, she finally clinched a deal, almost certainly with Karel Beschey, for one of his own works, a Franciscan hermit in his cell (Appendix 1, fig. 3), for which he

Fig 71
An interior with a lady at her toilet
by Anthonie Palamedesz, oil on canvas

was asking seven guineas! Although Beschey 'declared he never abated a farthing of what he ask'd at first.... upon my calling up my Chariot he let me have it for 4'.[26]

Such concentrated activity reaped considerable rewards. When, probably around 1771–2, the Duchess made a list of the paintings and other works of art in her collection (Appendix 2), perhaps to take stock of her recent purchases,[27] she had evidently acquired both abroad, and presumably at auction in London as well, a considerable number of Dutch and Flemish genre scenes, winter and other landscapes and townscapes, church interiors, still lives and marines. The 'List' confirms her penchant for 'low life' genre scenes showing card players, for example, or soldiers relaxing in guardroom, and in particular for those with unusual, even prurient, subjects, such as the painting by David Ryckaert the Younger then titled *Physician examining a Urinal*. Successful purchases, in addition to paintings certainly acquired abroad, such as *Orpheus attacked by Thracian Women* by Francken the Younger, Keirincx and Savery, and the works by Anthonie Palamedesz and Jan Van Goyen mentioned above, include landscapes by Philips Wouwermans, and Joos and Franz de Momper. More typical, however, are the large number of works resulting from the Duchess's bargain-hunting proclivities which are now attributed to followers or imitators of, amongst others, David Teniers the Younger, Gerrit Dou, Jan van der Heyden and Paul Brill, rather than to the masters themselves. Other 'hopeful' attributions such as *A Kermesse*, acquired as a 'Breughel', but today attributed to David Vinckeboons, or the 'Teniers' *Fishmonger's Stall* (Appendix, fig. 4) have now been re-ascribed to lesser masters.

As we have seen, the Duchess's collection grew dramatically in the the years from1769–71, when another of the three paintings by Palamedesz was acquired; his name is frequently singled out by the Duchess for comment in her panegyrics on the collections she visited.[28] Many of these purchases still hang in the *Duchess's Sitting Room* at Syon House today. From 1772 until her death, however, the Duchess's continental tours changed in nature and direction, and it seems probable that she considered her collection of Dutch and Flemish paintings to be now more or less fully formed.

The Duchess's strong penchant for Dutch and Flemish art is also reflected in the very large number of ivories decorated with scenes of revelry after Teniers and Ostade, and hunting scenes after Wouwermans, which she purchased abroad. By 1772 she was able to report of the ivories she saw in Mannheim that 'I really think my own collection of Ivorys at least equal to any which I saw there'.[29] Many of her purchases were later incorporated into a cabinet at Alnwick, commissioned by the 3rd Duke from Morel and Hughes in 1823–4 (Appendix 1, fig.5).

The Duchess's diaries not only allow us to eavesdrop on the formation of a major collection containing paintings, prints, ivories, coins and medals, china and other works of art (Appendix 2). They are also a veritable treasure trove for historians of 18th-century travel. Clearly someone with a strong interest in minutiae, and an equally strong passion for order and efficiency, the Duchess records at the front of each diary her exact route, listing each change of post horses, the mileage travelled, her expenditure at each stage of her journey, and the state of the inns, which, like most travellers of the period, she found far from satisfactory; one characteristically terse entry for 1772 reads 'I found a good Veal Cutlet but a dirty House & a horrid Bed'.[30] The Duchess reveals herself as a redoubtable character, undeterred by high seas, thieves and voyeurs, ill-health (on her later tours she suffered from both gallstones and gout), extreme weather conditions, or long hours on the road, which frequently lasted from 5 am until 8 or 9 pm.

Perhaps hardly surprisingly for one who claimed her descent from Charlemagne, the Duchess travelled in considerable state, with her dog Tizzy, who on one occasion narrowly escaped execution by the police in Payerne, a whole retinue of servants, and a wagon loaded with her art acquisitions. Her peregrinations around Europe are punctuated with accounts of her flattering receptions by Emperors, German Princes and Electors (Appendix 1, fig. 6), and by the Prince of Orange, whom she knew well on account of her many visits to The Hague. On one occasion she recounts amusingly how, at Koblenz, a 'great fat headed young Chambellan...lugg'd me after him with a force & velocity wch by no means suited either my legs or my breath' to meet the Elector, who was 'lodged au cinqieme', while in 1770

she attended the Dauphin's wedding in Paris, reporting delightedly that not only was she sleeping in sheets from the Royal wardrobe, given her stay in the house of Louis XV's mistress, the Comtesse du Barry, but that Louis XV had ordered coffee 'on purpose' for her, of his own roasting and grinding. [31]

If the Duchess's diaries were merely an account of the social round they would hold little interest for us today. She was, however, as Boswell said, 'a lady not only of high dignity of spirit such as became her noble blood but of excellent understanding and lively talents', an entertaining companion, both because of her very considerable powers of narrative and description, her determination to view everything, whatever the inconvenience, and her insight into human nature and fallibilities, including her own. Despite her evident penchant for royalty, she was, as Greig notes, naturally frank and devoid of humbug, and social equality did not automatically protect those she encountered from her sometimes caustic tongue: 'The principal occupation…of a French lady is her Toilet', she declared scathingly, while in Bonn, 'a virtuous Woman is here almost as rare a Bird as a Black Swan'. On a lighter note, the Duchess had a habit of comparing those she met on her travels, often in far from flattering terms, with members of her own social circle at home; the Prince of Hesse Darmstadt, however, was 'exactly like a great Mastiff puppy'. In all, her account of her somewhat picaresque wanderings often has a flavour of Fielding or Defoe, and offers us a broad canvas of 18th-century life, rich in humour and anecdote. [32]

Like all good travel writers, the Duchess was acutely aware of life at all social levels. In describing the Paris Boulevards as a 'whimsical mixture ... of Riches & Poverty Hotels & Hovels, All sorts & conditions of men... In short the whole is such a jumble that it always puts me in mind of Vanity Fair in the pilgrims progress', [33] she gives us a flavour of the diaries themselves, and the rich cross-section of life they present. At one moment she is playing at cards with the German Emperor. At the next she is feeding her landlady's tame rabbit, resplendent in a 'Collar of Silver Bells', on parsley and peach parings; occupying lodgings in Lyons that 'stunk so of the Stables it was enough to suffocate one'; or having a picnic at the abbey of La Repaille (Appendix 1, fig. 2) near Geneva, where she was surrounded by beggars 'all covr'd with Rags & Lice': when a servant advanced to give the beggars the left-overs, 'they all flew upon him… & began to fight & scramble for it'. Others fled, but the Duchess was fastened to her chair by the gout, and 'in the fray a tall old Woman with a Cold Shoulder of Mutton in her hand tumbled directly across my Lap & I thought she really would have brought me down to the Ground'. [34]

One of the most remarkable things about the diaries is the sheer length of time the Duchess seems to have spent abroad, and away from her 'Soul's best Joy' – as she called her husband – and her family. Although her duties as Lady of the Bedchamber to Queen Charlotte tied her to England for much of the time until 1770, she nevertheless managed to make four visits to The Low Countries and Germany from 1766–70, and her tours continued unabated, despite considerable ill-health, until 1774, only two years before her death. From 1772, instead of visiting principally the Austrian Netherlands and the United Provinces, the Duchess began to tour southern and south-west France. However, her comment on Nîmes, 'there are many things worth seeing at this place', confirms that her passion for antiquities was no more than lukewarm: there is none of the enthusiasm found in her earlier exhaustive descriptions of the art collections she had visited in Holland and Flanders. The Duchess also made a tour of Switzerland in 1772, when, like many British tourists, she made a pilgrimage to visit Voltaire at Ferney, applying her exceptional powers of observation almost indiscriminately to his Old Master paintings (which included works by Carlo Maratta and Veronese); the 'fire in his Eyes'; his possibly incestuous relationship with his niece; and the refreshments provided by his servants. She was gratified that Voltaire, 'received me with great politeness & made me a present of a Melon & a Pine Apple', the latter a rarity in Switzerland, and that he escorted her 'quite to the post Chaise' on her departure. [35]

The Duchess not only recorded her foreign and domestic tours in her diary. She also appears to have taken with her a drawing master, Jean Vilet, who also acted as her *valet de chambre*. [36] In the archive at Alnwick are preserved four fascinating albums illustrating her continental and British tours,

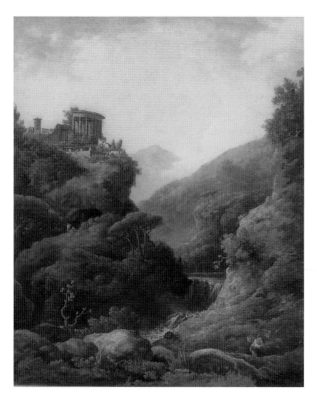

Fig. 72 *The Gorge at Tivoli* by William Marlow,
oil on canvas, after 1765–6

A Series of Sketches, Views of Great Britain the Continent and America, 1772–8, which contain watercolours arranged four to a page, very much as in a modern photographic album. Presumably, the other artists whose drawings are included in the albums, notably J. Bell, were also in the Duchess's retinue, although in what capacity remains uncertain. Nor is it possible to reconstruct her journeys from the pages of the album, as the sketches (Appendix 1, figs. 1, 2) have been pasted in afterwards, rather than following the order of the tours themselves. They do, however, stand as a delightful visual record of the Duchess's later tours in Switzerland, Germany, Savoy, France and Holland, ranging in subject matter from picturesque villages to castles, classical remains and scenic views, and including the *Huis ten Bosch* [The House in the Wood] at The Hague (Appendix 1, fig. 1) near where the Duchess exercised her dog Tizzy.[37]

WILLIAM MARLOW (1740–1813)

The Duchess's patronage of the British view painter, William Marlow, whose tour of France and Italy in 1765–6 is said, in an obituary of 14 January 1813, to have been taken 'by the advice of the late Duchess of Northumberland', finds a clear precedent in her husband's earlier patronage of Canaletto, and confirms that, despite her penchant for Dutch Old Masters, the Duchess shared his liking for Italianate views, as indeed the landscape included in her portrait by Ramsay (fig. 66) implies.[38] The group of eight *veduta* paintings by Marlow at Alnwick of Tivoli (fig. 72), Ariccia and the Bay of Naples confirm the Duke and Duchess as having been major patrons; the differences in the sizes and media of the canvases suggest that at least two different sets of paintings are involved.

William Marlow was a pupil in London from 1754–59 of the view and marine painter, Samuel Scott, who in turn had learned much from the work of Canaletto. He was, however, later influenced by the work of Claude-Joseph Vernet, and by Richard Wilson (fig. 14), whose own earlier visit to Italy in 1750–7, and subsequent painting of Italianate views for English clients seeking a record of their Grand Tour experiences, might well have encouraged Marlow to embark on a similar career. Marlow was in Rome in February 1766. The rest of his Grand Tour can be recreated only from his surviving sketches, none of which are dated. He seems, however, to have travelled to Italy via Paris and the south of France, visiting, as well as Rome and the *campagna*, Naples, Florence and Venice.

At his best, as in the exceptional painting of *The Gorge at Tivoli* in the collection at Alnwick Castle (fig. 72), Marlow's painting is comparable to that of Richard Wilson, although he eschews intellectual content, preferring simply to record a Grand Tour site for his clients in classical compositions which have an eye to its picturesque possibilities and often a rather rococo disregard for its structure. Marlow was probably back in England by late 1766, where he soon acquired a network of Northern clients.[39] His first Italianate views were shown at the Society of Artists in 1767, and set the pattern for his later

works. Perhaps identifying a niche in the market, Marlow supplemented the more standard Grand Tour views such as the *The Gorge at Tivoli* (fig. 72), or Rome from the Tiber with the Castel Sant' Angelo, with views of Florence, the coast near Naples, and the south of France. Marlow's evident success as a painter of Grand Tour views suggests that, unlike Richard Wilson, he had judged the market for Italian souvenirs correctly. His popularity continued until the 1790s, when tastes changed; Marlow spent his later years in semi-retirement in Twickenham, where he formed part of a *ménage à trois*.

LORD WARKWORTH, LORD ALGERNON PERCY AND THEIR TUTORS

The Grand Tours made by the two sons of the 1st Duke and Duchess of Northumberland are in many ways typical of the tours made by young aristocrats to finish their education abroad, in that they both left for the continent following either school or university under the care of carefully chosen tutors. In each case, however, there are fascinating deviations in their itinerary from the usual routes, which call into question the whole concept of an 'archetypal' Grand Tour, suggesting that even the escorted tours made by young men such as these were often more adventurous and less stratified than is generally recognised.

HUGH, LORD WARKWORTH (1742–1817), LATER 2ND DUKE OF NORTHUMBERLAND, AND THE REV. JONATHAN LIPPYEATT (*c.*1723–1812)

Having finished his studies at Cambridge, Lord Warkworth set sail from Portsmouth on 25th August 1761 with the experienced bear-leader and clergyman, Jonathan Lippyeatt, on a Grand Tour that would last almost exactly two years. Nominally the rector of a parish in Hertfordshire, Lippyeatt had returned only in June from a three-year Grand Tour with another pupil. Nor was this Lord Warkworth's first experience of the continent; he was a career soldier, who had already seen

active service in the Seven Years War, and his absence abroad in the midst of this same conflict clearly caused him considerable consternation. As he wrote to his father in March 1762, 'I am quite ashamed to show my face when I consider that I am a young man whose profession is arms & that I am now travelling about for my pleasure'. According to Horace Walpole, however, Lord Warkworth suffered from a 'miserable constitution…[and] has been very near taking a longer journey', and concerns about his health may well have been a contributory factor in deciding his parents to send him on the Grand Tour: both he and Lippyeatt frequently refer in their letters home to his state of health, but almost always in positive terms.[40] This seems to have been one of the occasions when a Grand Tour really did stop consumption in its tracks.

Presumably because of the war, the two travellers bypassed France and sailed via Gibraltar to Naples. They had arrived in stirring times. As Lord Warkworth reported to his mother in his early letters home, a number of important discoveries had recently been made at Herculaneum: 'There are several very fine statues found lately in a theatre they have discovered', and people in Naples were in 'vast expectation of an eruption from Mount Vesuvius'. Lord Warkworth's correspondence shows that he was also involving himself in James Adam's (fig. 26) commission from the future Duke to find a set of antique marble columns for Syon House (p. 62).[41] Social relations between the young nobleman and the aspiring architect were not necessarily what one might have expected: James Adam, who claimed to be the only British artist in Italy who 'kept his own coach and assumes the title of *Cavaliere*', had already enjoyed considerable social success on his tour, and he refers patronisingly to Lord Warkworth as 'a fine obliging boy: we play frequently at chess'.[42]

In January 1762, Lord Warkworth and his tutor – apparently a reluctant escort on this expedition – took the unusual step of sailing across the Mediterranean to Constantinople with Henry Grenville, who had recently been appointed British ambassador there. Jonathan Lippyeatt's attitude is hardly surprising, for, as well as the danger from pirates, the plague in Turkey was, as Lord Warkworth reports,

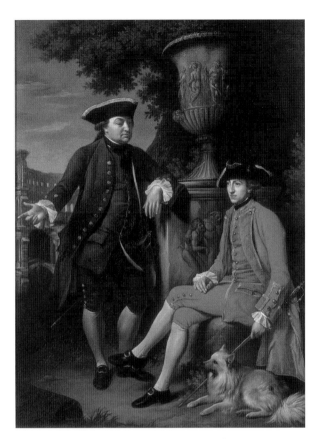

Fig. 73 *Hugh, Lord Warkworth, later 2nd Duke of Northumberland*
and the Rev. Jonathan Lippyeatt, with a View of the Colosseum,
by Nathaniel Dance, oil on canvas, 1763

1762, however, he was sailing back to Italy, having visited the putative site of ancient Troy in Asia Minor: 'The Troy that we went to see is not that, the siege of which is so famous, the place w[h]ere that stood not even being known at this time'.[44] From Florence, where the travellers were installed by September 1762, they moved on to Pisa, and then to Rome, where they had arrived by 11th March 1763.

Jonathan Lippyeatt was by now acting as much as art agent for the future 1st Duke and Duchess as tutor to their son, and his letters to the Countess, which survive at Alnwick, offer a fascinating insight into the relations between agent and patron. They show that Lippyeatt by no means confined himself to commissions on which he had received definite instructions. Instead, although considerably hampered in his purpose by the poor state of the mail, he sought to persuade the Earl and Countess into making further purchases, no doubt because he hoped to be paid for each transaction.

Lippyeatt's most important commission from the Countess was to buy a set either of pastes or 'sulphurs' – two different methods of reproducing antique gemstones. Such sets were highly popular with Grand Tourists, and a veritable industry existed in Rome to feed this appetite for the antique. The task clearly cost Lippyeatt much time and trouble, as he set out for the Countess's information the various larger or smaller sets that were currently available, ranging in number from the 3,444 sulphurs reproduced from the famous collection formed by the late German gem and coin collector, and diplomat, Baron Philipp von Stosch (1691–1757), which had been catalogued by Winckelmann, down to the 800 pastes belonging to Lippyeatt's friend Crespin. While negotiating on the Countess's behalf with often dilatory makers and dealers, the tutor also pondered whether the largest set was suitable for a lady, given that some of the subjects were 'more remarkable for their elegance of workmanship than for their decency', and made arrangements for the shipment of another set back to England 'on approval', through the agency of the Durham-born art agent Richard Dalton and the consul at Leghorn, Sir John Dick, who hailed originally from Newcastle.[45] The letters are, unfortunately, silent on the fate of this archetypal

a 'bugbear to travellers',[43] and both men found that tourism in Constantinople itself was fraught with problems. It was against the law for Christians to visit Hagia Sophia, then and now a mosque, but once the greatest church of Byzantium, and the man who showed them round was so frightened that they had no time to admire it properly. Moreover, they were more or less stranded in Constantinople as their ship, the *Dunkirk*, had returned hurriedly on account of the war.

Lord Warkworth had intended to journey back to Europe overland through Poland, relishing the prospect of seeing 'a Part of Europe that is very little known at present'. By June

Grand Tour commission, but it seems unlikely that a set was, in fact, bought, as no record of it survives today.

In Rome, Lippyeatt reported to the Countess in February 1763 that he and Lord Warkworth had not yet 'begun our course of antiquities' as 'the two best & only antiquaries are both ill' (tantalisingly he does not say who these are), adding that 'we must be diligent for I find Lord Warkworth designs to go immediately after the Holy Week to Venice'.[46] Like so many Grand Tourists, Lord Warkworth now set about commissioning a Grand Tour portrait (or in his case portraits) to commemorate his stay. Although he sat to Pompeo Batoni (fig. 74), it is the conversation piece by the young English portrait painter Nathaniel Dance, showing the young aristocrat and his tutor against a backdrop of classical Rome (fig. 73), that is so redolent of the Grand Tour.

Fig. 74 *Hugh, Lord Warkworth, later 2nd Duke of Northumberland* by Pompeo Batoni, oil on canvas, 1763

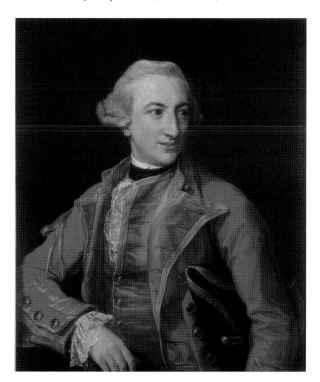

Dance had trained in England under Francis Hayman, whose conversation pieces of the 1740s and 1750s, showing sitters informally posed, small-scale and outdoors, had profoundly influenced not only his pupil, but also the young Gainsborough. Once in Rome, Dance began to tailor this type of conversation piece portrait to his new position as a junior partner of Pompeo Batoni, and an emergent painter of British Grand Tourists. His portrait of *Lord Warkworth and his tutor, Jonathan Lippyeatt* is a classic example of the way in which he uses classical antiquity to enhance an essentially British type of outdoor portrait: his sitters are shown beside the famous Borghese Vase, then in the Villa Borghese in Rome and now in the Louvre.[47] Interestingly, it is Lippyeatt who dominates the composition, pointing out to his pupil the ruins of the Colosseum in the distance, while Lord Warkworth relaxes with his Spitzbergen dog at his feet. The composition is closely related to an earlier conversation piece by Dance of *Pietro Nardini and an unknown man* (1759), but to compare the two portraits is to measure the distance Dance has travelled from this earlier exercise in Hayman's style to a painting which shows the influence of Batoni not only in its allusions to classical antiquity, but in the more elegant, less robust figures of the two sitters, and in the more highly pitched colour key.[48]

By 1763 Nathaniel Dance had already painted a number of British Grand Tourists, including Olive Craster (fig. 82), whose husband, George Craster, owned extensive lands in Northumberland, and who was certainly an acquaintance, if not a friend, of the Duchess of Northumberland.[49] It seems likely, however, that it was Dance's partnership with Batoni that obtained him this important commission, although Lord Warkworth's choice of Pompeo Batoni for the portrait of himself in army uniform (fig. 74) may itself have been prompted by a network of Northern patrons; Peter Bowron has pointed out how often groups of neighbours sat to Batoni,[50] and there are strong similarities between Batoni's portrait of *Lord Warkworth* and that of *George Craster*, painted a year earlier in 1762 (fig. 81). Batoni, however, had already worked for the 1st Earl and Countess of Northumberland, copying Raphael's *Council of the Gods* and *The Wedding*

Fig. 75 The *Venus de' Medici* by Giacomo Zoffoli, bronze statuette after the antique, before 1769

of Cupid and Psyche for their central London home, Northumberland House, in 1752–5, and this could have been the most important factor weighing with Lord Warkworth in his choice of artist.

Batoni's portrait can be dated to between February and April 1763. Unlike Dance's conversation piece, however, this is not an overtly Grand Tour portrait. Instead, Lord Warkworth is shown against a plain background, leaning on a marble pedestal and wearing officer's uniform, in a surprisingly modest 'half-length' format. The almost lyrical feeling of the portrait and the exceptional refinement with which both costume and head are painted set this canvas apart from Batoni's more routine exercises. Perhaps, as so often, the artist responded more warmly to a sitter who (later a successful career soldier) had more to offer than the average young aristocrat on the Grand Tour. This was also, however, a period in Batoni's art which saw him working at the height of his powers, when the more Baroque works of the 1750s had been replaced by supremely confident compositions, often based on antique poses, with brilliant colouring and a greater psychological intensity.

Lord Warkworth's Grand Tour commissions did not end with these portraits. He also purchased a pair of landscapes from the Irish painter, Solomon Delane, who spent twenty

Fig. 76 The *Dying Gladiator* by Giacomo Zoffoli, bronze statuette after the antique, before 1769

years in Italy but who, curiously, was absent on a brief visit to London in 1763 when Lord Warkworth was in Rome. The paintings were seen in Rome on 18th September 1764 by James Martin;[51] sadly, their subsequent fate is unknown.

What does survive in the collection at Alnwick and Syon is a highly important set of miniature bronzes after the antique which Lord Warkworth commissioned from the leading maker in late 18th-century Rome, Giacomo Zoffoli (figs. 75–6). The vogue for bronze statuettes stretches back to classical times, and was revived in early Renaissance Italy. However, accurate replicas of famous antique statues were produced only from the late 17th-century, and it was only with the Grand Tour that they became so fashionable. Part of the attraction of these miniature replicas was that they could be displayed on chimneypieces as a *garniture de cheminée*, and a number of sets in British country houses testify to their popularity. The set acquired by Lord Warkworth is among the largest known: of the fifty-nine statuettes offered for sale by Zoffoli's foundry, he purchased ten, including the *Farnese Hercules*, the *Apollo Belvedere*, the *Venus de' Medici* (fig. 75), the *Dying Gladiator* (fig. 76), and the *Belvedere Antinous*.[52]

Lord Warkworth and Jonathan Lippyeatt now left Rome for Venice, where they arrived on 18th April 1763 in time to assist at the election of a new Doge, and to see the famous Ascension Day ceremony. On their way north they made one last major stop, in Bologna, where they had come – together, according to Lippyeatt, with 1,600 other foreigners – to see the opening of the new theatre, built by Antonio Galli-Bibiena (1700–74); predictably, Lippyeatt praised the great 17th-century Bolognese masters who were then revered as greatly as Raphael.[53] Their route home took them through Parma, Milan, Turin, Geneva, Lyons and Paris. From Lyons, on 14th July, Lippyeatt reported that Lord Warkworth would have little time to enjoy Paris, as he was intending to be in England by the end of the month. A few days later, in Paris itself, Lord Warkworth sold his travelling chaise to James Martin, thus effectively bringing his Grand Tour travels to an end. His safe return to London is reported in a letter of 6th August 1763.[54] In the following year he set the seal on his Grand Tour

activities by becoming, like so many of his contemporaries, a member of the Society of Dilettanti; his artistic and intellectual interests are also attested by his membership of the Royal Society and the Society of Arts. Although a 'very mediocre' politician, Warkworth went on, before inheriting the Dukedom in 1786, to have a relatively distinguished military career, serving in the American War of Independence, where, at Lexington, he commanded the rear-guard and covered the British retreat; soon afterwards he was promoted Lieutenant-General. A coda to his Grand Tour is provided by his decision, as 2nd Duke, to send his favourite artist, Thomas Phillips, to Paris at the time of the Peace of Amiens in 1802, to paint Napoleon.

Jonathan Lippyeatt made one further tour of Italy in 1767–68 as tutor to the Hon. John Hussey Montagu, when he continued to solicit commissions from the 1st Duke and Duchess of Northumberland. He also reported to the Duchess from Naples on the discovery of the Temple of Isis at Pompeii (fig. 29), together with a cache of soldiers' helmets and skeletons with irons on, presumed to be prisoners, and on the humiliating position occupied in Rome by Prince Charles Edward Stuart, whose claims to the English crown were ignored to the point where he was obliged to stand at a papal audience while his younger brother, the Cardinal Duke of York, and the Pope, remained seated.

LORD ALGERNON PERCY, LATER 1ST EARL OF BEVERLEY (1750–1830) AND LOUIS DUTENS (1730–1812)

Five years after Lord Warkworth's return from Italy in 1763, the 1st Duke and Duchess of Northumberland sent their second son, Lord Algernon Percy, on the Grand Tour. The fascination of this lengthy, four-year, and atypical tour lies in the personality of the tutor they selected to accompany him, the Frenchman, later turned Northumbrian, Louis Dutens (figs. 77–8), who was a diplomat of considerable experience as well as a bear-leader, the author of several Grand Tour books, and a man whose *Memoirs* reveal, often unwittingly, the constant struggle of the Grand Tour tutor to achieve social parity with his charges.

Louis Dutens's account of his upbringing and early life in his *Memoires d'un Voyageur qui se repose* (*Memoirs of a Traveller now in Retirement*, London, 1806), offers a fascinating picture of the type of young man who turned to tutoring to earn a living. Dutens's family came from Blois, and were of Protestant extraction, a fact which, although he does not explicitly say so, clearly profoundly influenced his career. The young Louis, at least in his own estimation, was something of a child prodigy, and in 1748 he left for Paris, where he wrote a tragedy, and moved in literary circles. After an early visit to England as a protégé of the Pitt family, Dutens was engaged as tutor to the young Mr. Wyche, whose father introduced him to the Greek and Latin authors; Dutens also claims to have learned Oriental languages, Hebrew and Italian. After his pupil's death, a career as a diplomat opened up to him with his appointment in 1758 as chaplain and secretary to the English minister in Turin, James Stuart Mackenzie, brother of the 3rd Earl of Bute; it was a condition of his new employment that he should become a clergyman.

Although he was recalled to England in 1762, where he remained until the following year, Dutens spent most of the years between 1758 and 1765 in Turin, where he edited an edition of the work of the German philosopher, Baron von Leibnitz, and even, as a Frenchman, found himself in 1761 in the 'singular' position of acting as chargé d'affaires to 'the King of England at a foreign court during a war with France'.[55] Clearly, he preferred a prestigious life abroad, where, according to one commentator, 'he did usually take more state upon him than the Ambassador himself',[56] to his more humdrum existence in England, although one tourist at least found him 'a very well bred, agreeable Man'.[57]

In 1766, however, Dutens was presented by the future 1st Duke of Northumberland, a relative through marriage of his patron and former employer, James Stuart Mackenzie, with the living of Elsdon, in Northumberland. On going to thank his new patron, he was swept into the orbit of the then Earl and Countess, dazzled by the Earl's culture and learning and by the contrast between the Countess's high birth and her flattering attentions to himself. Soon he had agreed to act as

tutor to Lord Algernon Percy, who was going abroad straight from Eton, given the poor state of his health.

As a prelude to a full Grand Tour, the Earl suggested that Dutens should first take Lord Algernon with him on a visit he was paying to his father in France, saying that it would be beneficial not to expose his son to the fashionable world too soon. Once abroad, where he stayed from 1766–7, Lord Algernon settled down with Dutens to life in provincial France, lodging with a rich 'bourgeois', having a passion for dogs and horses, dining occasionally with French aristocrats, and falling in love with a French *pensionnaire*.

Back in London, Dutens now accepted a proposal from the Duke, as he had recently become, to make a full European tour with Lord Algernon: 'partisan des anciens comme je l'etois, ce voyage avait de grands attractions pour moi'.[58] In his *Memoirs*, Dutens was later at pains to point out that he was not Lord Algernon's 'gouverneur'. Instead, the young man was to be guided by his advice and to treat him similarly to the way in which he would treat his own father. Although Dutens insists that the Duke had given him *carte blanche* to organise the tour, this is hardly the impression that emerges from the contemporary letters, when Dutens was on one occasion obliged to await the Duke's instructions as to their next destination.[59] Dutens also stresses that he was not paid for his role as tutor, although he seems to have had strong hopes that the Duke would recompense him suitably on his return. The ex-diplomat also parades the strengths he brought to the partnership: when the travellers arrived somewhere new, Lord Algernon was received as a 'grand seigneur', and Dutens as the former Minister of the King of England in Turin.

Despite Dutens's evident high opinion of himself, the success of this Grand Tour tutor-pupil relationship seems to have been considerable. John, 3rd Earl of Bute, who met Dutens and Lord Algernon abroad, wrote to the Duke: 'You have in Dutens a jewel who is himself as happy with the charge as a man can be', and from Vienna Dutens himself reported that 'we are the happiest couple here, and I cannot sufficiently express the sense I have of the marks of friendship and confidence I receive daily from his Lordship'.[60]

Setting out in 1768 on this full Grand Tour, Dutens and Lord Algernon made a brief stop in Paris before moving on to La Rochelle and then to Southern France, where Dutens found the Maison Carrée in Nîmes to be one of the most impressive, and also best preserved, temples in Europe – a verdict most travellers would endorse today. Crossing the Alps at Col du Tende, the travellers moved on to Genoa and in October to Florence, where Dutens was delighted to make the acquaintance of Sir Horace Mann, with whom he had corresponded for many years. On 11th November 1768, having attended a dinner to celebrate Mann's investiture with the Order of the Bath,[61] they left for Rome.

In his *Memoirs*, Louis Dutens, using the same words as Henry Swinburne, calls Rome 'le but de mes désirs' [the goal of my desires],[62] a quotation from Corneille's *Les Horaces* which aptly summarises the rapture most tourists felt the 'Eternal City' should evoke. During Lord Algernon and Dutens's stay in Rome the Pope, Clement XIII, died, on 3rd February 1769, and Dutens paints a vivid picture of a papal conclave: the cardinals were locked up in fifty-three cells until they chose a new Pope, and their food was delivered through a turnstile, as in a convent.

On 18th–19th February Lord Algernon and Louis Dutens left for Naples, where they were presented by Sir William Hamilton to the King and Queen, and visited the sites of Herculaneum, Pompeii and Mount Vesuvius, while Dutens also met the Neapolitan prime minister, the Marchese Bernardo Tanucci, who told him of a 'system of electricity' he had invented. What was probably always intended as a short visit was perhaps curtailed even further by the news that the Emperor Joseph II, travelling incognito as Count Falkenstein, was in Rome with his brother, and the travellers hastened back to Rome in the expectation of some 'fêtes brillantes'. They were not disappointed; the Cupola, facade and colonnade of St Peter's were illuminated in the Emperor's honour, the dome itself 'appearing like a globe of fire', while at a ball given by the Duke of Bracciano the largest room was lit with twenty-four 'lustres' [chandeliers] containing 370 'torches', while the musicians were dressed in white, laced with gold.[63]

The letters which Lord Algernon and Louis Dutens wrote home to the Duchess, unlike those of Lord Warkworth and Jonathan Lippyeatt, are almost entirely silent on the subject of art commissions, although in February 1769 Dutens mentions some 'Medails I have bought for your Grace',[64] and he was clearly a learned companion, as he later published an *Explication de Quelques Médailles* (1773), followed in 1776 by *Des Pierres Précieuses* and helped the Duchess form her collection of medals (Appendix 2). While he was in Rome, however, Lord Algernon followed his brother's example in commissioning a half-length portrait from Pompeo Batoni, which is now at Alnwick, and which was probably, given its similar format, intended as a companion to that of Lord Warkworth (fig. 74). Batoni's portrait must have been executed to a tight timetable. Lord Algernon had arrived in Rome by 3rd February, was in Naples from 18th–19th February until 15th March, and had arrived in Venice by 3rd May. It seems likely that, as usual, Batoni would have had to finish the portrait after his sitter's departure.

The same short timescale must also have applied to Lord Algernon's much more ambitious commission in Rome of a large-scale conversation piece (fig. 77) showing himself and Louis Dutens. The portrait of his elder brother Lord Warkworth and his tutor by Nathaniel Dance (fig. 73) must surely have been in Lord Algernon's mind; both pictures share the same Grand Tour background, and it is surely not coincidental that, while his elder brother is portrayed seated beside the *Borghese Vase*, the backdrop to Lord Algernon's portrait is the other classical vase most admired by Grand Tourists, the *Medici Vase*.[65] It is, however, the differences between the two paintings that are more striking than their similarities. In this portrait, conceived on a much more ambitious scale than its predecessor, Dutens is shown, not as the sober tutor, but as a gentleman, whose fashionable attire rivals in elegance that of Lord Algernon himself. In compositional terms, he is given as much prominence as his charge, and a dialogue between two – apparent – social equals replaces the homely yet didactic presence of Jonathan Lippyeatt in the earlier portrait. Lord Algernon also differed from his brother in his choice of artist, moving out of the orbit

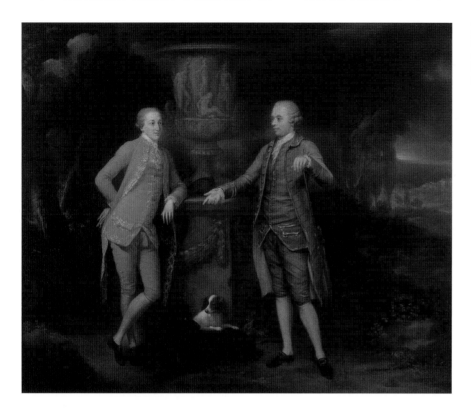

Fig. 77
Lord Algernon Percy, later 1st Earl
of Beverley, with Louis Dutens
by Anton von Maron,
oil on canvas, 1769

of Batoni's studio to commission this portrait from Anton von Maron, who, with his brother-in-law, Anton Raphael Mengs, formed one of the coterie of German artists who had clustered around the great German scholar and antiquary in Rome, J.J. Wincklemann.

Like so many tourists, Lord Algernon and Louis Dutens left Rome in time to see the Ascension Day festivities in Venice. They then moved on to Turin, where Dutens claimed that he was welcomed by the Royal family as 'an old acquaintance'. Perhaps the most interesting aspect of this Grand Tour from an historical perspective, however, is the length of time the travellers spent North of the Alps on their return home. From October 1769 to March 1771 they were in Vienna – an increasingly popular destination with British tourists from the 1780s onwards – having arrived to join in the celebrations surrounding the ill-fated marriage of the Emperor's sister, Marie Antoinette, with the future King Louis

XVI of France. Like another young Northern aristocrat, Viscount Barnard, Lord Algernon clearly found court life in Vienna much to his liking.

Around April 1770, however, he accompanied Louis Dutens on a visit which the latter had been invited to make to see Voltaire at Ferney. Unfortunately, the meeting was jeopardised by Dutens's near-exposure as the author of an anonymous pamphlet, *Le Tocsin* (The Alarm-Bell), which painted the philosophy of Voltaire and Rousseau 'avec des couleurs un peu fortes', and Dutens was obliged to exert all his ingenuity to leave open the question of his involvement.[66]

On 7th March 1771, Dutens and Lord Algernon finally left Vienna, managing – after various abortive attempts which amusingly illustrate the frustrating lack of communications available to 18th-century travellers – to rendezvous in Germany with the Duchess, who had set out from England to meet them. Having satisfied herself as to the improvement in

Algernon's 'figure' and manners (although not in his face!), the Duchess received from Dutens a judicious report on his pupil's progress: whatever gaieties Algernon might give way to in private, Dutens considered that he always behaved with 'decency' in public, and, although he was extravagant, he was also very generous.[67] A rather different view is provided by the expatriate Lady Mary Coke, who accused Lord Algernon of vanity and mischief making.[68] The social polish which, for many parents, was sufficient enough reason for sending their offspring abroad, having now been successfully accomplished, the travellers began their slow progress home, lingering for some months, however, at the Duchess's favourite European court at The Hague.

This marathon Grand Tour was finally over by July 1771; a pastel portrait of Louis Dutens by the Irish artist Hugh Douglas Hamilton (fig. 78), painted two years later, survives at Alnwick,[69] and commemorates Dutens's continuing friendship with Lord Algernon and his family; he seems to have been particularly close to the Duchess, even visiting her on her deathbed. Only two years after his return home Lord Algernon was once again ordered abroad by his doctors. He had soon recovered enough to make from 1773–4 an unusual and highly ambitious tour across the Mediterranean, visiting Tunis, Smyrna, Cairo and Alexandria, where Mahomet Beg lent him a house and entertained him at his expense, and is known to have brought back from Cairo a 'compleat mummy of an Infant' which was in the Library at Alnwick in 1785.[70] It seems almost certain that this second tour, which probably ended in France in 1775, included Rome, as in November 1776 the Jesuit and antiquarian, Father Thorpe, recorded the completion of a second and much more ambitious full-length portrait of Lord Algernon by Pompeo Batoni, which does not survive: 'Pompeo has finished a noble whole-length of Lord Percy: it is really well done'.[71]

Lord Algernon made one further visit to Italy in 1782, with his wife, Isabella Burrell. In Florence, the Percys were able to rendezvous with Louis Dutens, who had returned to Italy three years earlier in the retinue of Lord Mountstuart, on his appointment as envoy extraordinary in Turin. Dutens's

Fig. 78 *Louis Dutens* by Hugh Douglas Hamilton, pastel, 1773

relations with Mountstuart were, however, considerably less successful than those with his previous employers, and, although he had acted briefly as *chargé d'affaires* during Mountstuart's absence in 1781, he was now travelling somewhat aimlessly on his own, completing his *Memoirs*: 'having no particular avocation anywhere, I stay where I find myself well, and except an engagement with Lord & Lady Algernon Percy... to meet them somewhere in Italy in the autumn, I don't know what I shall do, and where I may go'.[72] In the intervening years Dutens had published a major Grand Tour guide, *Itinéraire des Routes les plus fréquentées* (1777), based on his travels with Lord Algernon (see *Bibliographical Note*), and made yet another tour of Italy from 1777–78 in the

company of his earlier patron, James Stuart Mackenzie and his wife, Lady Betty; in Naples, and later in Rome, the party spent some time with Henry and Martha Swinburne.[73] For Dutens, as for Lord Algernon, this present tour of Italy was to be his last, and the author of *Recherches sur l'Origine des Découvertes attribuées aux Modernes*, and Honorary Member of the French Academy of Belles Lettres, retired in 1784 to the Northumbrian living of Elsdon, near Rothbury, which he held (often *in absentia*) from 1765 until his death in 1812.

The last word should, perhaps, go to the strange dialogue between this remote Northumbrian parish near the Scottish border and its French rector which was, indirectly, created by the Grand Tour. According to the distinguished local historian, W.W. Tomlinson, Dutens was able to reconcile his parishioners to sermons of which they 'professed not to understand a single word' by a good-humoured joke. Inviting them by word of mouth to dine with him, he claimed to be highly surprised when they all arrived at the right time: 'When I preach you from my pulpit, you no understand my speak, but when I invite you to my goot dine, you very well understand'!'[74] As Dutens himself wrote: 'Life is like a game at backgammon; the most skilful make the best of it' and, in Ingamells's words, 'he had played well'. Although the notice in the *Edinburgh Review* on his *Memoirs* was to condemn him as a 'dangler in large houses' and a 'worn-out odometer', whose *Itinéraire* was useful only as a 'measure of the post-roads on the continent',[75] Dutens had also proved that, for an indigent young intellectual, life as a Grand Tour tutor could prove a sure road to self-advancement and a comfortable old age in a Northumbrian rectory.

THE BEVERLEY GEMS.

Lord Algernon later played a considerable part in national political life. A Tory, and supporter of William Pitt the Younger, he was in 1790 created Earl of Beverley for his political services. He also maintained his contacts with the North of England; with his father, he was the principal subscriber to the new Assembly Rooms in Newcastle in 1776. His Grand Tour had one important aftermath. Sometime before 1790 he formed a major collection of antique and later gemstones, known today as the Beverley Gems.[76] This outstanding cabinet of cameos and intaglios (where the design is incised into the stone) contains examples of gem making from the classical Greek period through to the 18th century, and is one of the finest ever to be formed by a British Grand Tourist. It seems likely to have been acquired soon after Lord Algernon's third visit to Italy in 1782–3.

Although many of the gems were purchased from the collection of the Duc de Rohan Cabot, two of them can be linked directly with Lord Algernon's Italian travels. He is said to have bought a Roman amethyst intaglio with the head of Omphale[77] by Dioskourides from a Neapolitan courier for 30 guineas – a classic example of the rather *ad hoc* way in which gems were often purchased on the Grand Tour.[78] The other gem in the collection with a Grand Tour legend attached to it is a Roman intaglio with a winged figure of Victory, said to be the 'famous Scipio ring, discovered within a sarcophagus of a member of the Scipio family in 1780 & presented by the Pope (then Pius VI) to M. Dutens... during his second visit to Rome' in 1790. Dutens is then said to have given the ring to Lord Algernon.[79] Unfortunately this colourful story, redolent as it is of the discoveries of antiquities being made in Rome almost daily in the late 18th century, cannot be true, as neither Dutens nor Lord Algernon were in Italy in that year. Lord Algernon also owned three 18th century gems, presumably bought on his second or third visit to Rome, by the great British neo-classical gem engraver, Nathaniel Marchant.[80]

END NOTES

1 Beard, p. 11; Dutens, vol. 1, p. 226.

2 Dr. Shrimpton, former archivist at Alnwick, suggests that Lord Brooke, later Earl of Warwick and Algernon, 7th Duke of Somerset, were key factors in the Earl's patronage of the artist.

3 The painting shows the timber centreing of the bridge, which was under construction in that year.

4 Ingamells, p. 540.

5 According to Lady Hertford, quoted in Collins Baker, p. 220; her letter confirms that these subject pictures were painted at the Duke's order. For Hussey and Smithson, see W.T. Whitley, *Artists and their Friends in England, 1700–1799*, I, pp. 126–7.

6 Fleming, p. 279.

7 Op. cit., p. 312.

8 Robert Adam, *The Works in Architecture*, 1773, quoted in *Noble Patrons*, p. 94.

9 Percy Letters and Papers, vol. 33, 1761–2, 3rd November 1761.

10 Op. cit., 25th March 1763. King points out that although all twelve columns were apparently brought back from Rome by James Adam, who thought they were all made of *verde antico*, and recently dredged up from the Tiber, one column, damaged in an air raid in World War II, was found to be only veneered, thus raising doubts as to whether others in the set were also veneered by an 18th century faker. See also Geoffrey Beard, *Georgian Craftsmen*, 1966, pp. 81–2, for a discussion of the payments in the 1st Duke's bank account for the movement of the columns from Rome to Syon.

11 James Adam letter to the Earl of Northumberland, 22nd April 1765, quoted in *Syon House Furniture Catalogue*.

12 Percy Letters and Papers, 25th March 1763

13 Fleming, p. 377. In all, twelve antique marbles, not all ordered by James, are at Syon today; Paulson, nos. 461–72.

14 Percy Letters and Papers, 7th February 1763.

15 Quoted in *Noble Patrons*, cat. 109.

16 Percy & Jackson-Stops, I, p. 192; Greig, p. xiii.

17 Alnwick Castle archives; references here are to the typed transcript also at Alnwick.

18 Walpole, vol. 38, p. 59; Black, pp. 59, 56; Duchess of Northumberland Diary, 1766, 121/17–19, p. 19.

19 Louis Dutens records the Duchess as amusing herself 'by collecting prints and medals and making other collections of different sorts'; quoted in *Apollo*, December 1982, p. 418.

20 Duchess of Northumberland Diary, 1766, 121/17–19, 13th October. Jan Bischopp (1680–1771), and his brother Pieter (d. 1758), invested their fortune in a collection of art and natural objects that gained an international reputation. A description of 110 of the pictures was published by Gerard Hoet in 1752. See E. Wiersum, 'Het – schilderijen kabinet van Jan Bischopp te Rotterdam' [Jan Bischopp of Rotterdam's Collection of Paintings], *Oud Holland*, xxviii, 1910, pp. 161–86.

21 Duchess of Northumberland Diary, 1766, 121/17–19, 24th October. The collection of Gerrit Braamcamp (1699–1771), formed from around 1743, comprised paintings, prints, drawings, sculpture, gold

and silver, glass, porcelain and lacquerwork. Although Braamcamp's main interest was in Dutch 17th-century paintings, he also collected Flemish and Italian art, and, as the Duchess noted disparagingly, patronised contemporary artists, notably Xavery and Jacob de Wit. See C. Bille, *De tempel der kunst of het kabinet van den Heer Braamcamp*, 2 vols., Amsterdam, 1961.

22 Duchess of Northumberland Diary, 1766, 121/17–19, 7th November.

23 Op cit., 1769, 121/25, 29th November. The Duchess identifies the picture as: 'a half length of the Wife of Jodenz Monalisa'. The reference to the stamp of François I is puzzling, given that the original Leonardo was certainly in François I's collection, having been acquired by him shortly after it was painted. However, Leonardo's painting undoubtedly remained in the French Royal Collection, finally passing to the Louvre in 1804, so the Duchess must have seen another version of this painting.

24 Op cit., 1769, 121/25, 16th November. For works by Palamedesz and Van Goyen in the Northumberland collection today, see Courtauld Institute of Art, Photographic Survey, List of Dutch Pictures in the Northumberland collection, nos. 279–81 and 253–5. Three further works in the Northumberland collection are from the circle of, or by a follower of, Anthonie Palamedesz (nos. 282–4). The other two works purchased at auction were *The Shepherds' Adoration* by Jacopo or Leandro Bassano, and a picture of a church with friars giving alms, by an unknown artist.

25 Op cit., 1771, 121/33–35, 11th and 13th June.

26 Percy Letters & Papers, vol.43, 1766–9, letter 74, and Duchess of Northumberland Diary, 1771, 121/33–35, 12th and 13th June. Probably, Karel Beschey capitulated still further, as three other hermit pictures, all attributed to him, survive in the Northumberland collection, together with another painting definitely by the artist; see Photographic Survey (note 24), List of Flemish Pictures in the Northumberland collection, nos. 316–320. The other three Beschey brothers were Jacob-Andries, Jan-Frans and Joseph Hendrik.

27 Alnwick Castle archives DNP, MS. 122A (paintings).

28 Duchess of Northumberland Diary, 121/15, 1766, p. 18; 121/17–19, 1766, pp. 25–26; 121/23, 1767, pp. 1–2. The list and photographs of the Dutch and Flemish paintings in the Northumberland collection at the Courtauld Institute of Art (see notes 24, 26), taken together with the Duchess's own 'List', offer a complete analysis of her taste; many of the paintings not recorded on her 'List' were probably also acquired by Duchess Elizabeth, given that they are often so similar in subject matter, and by (or attributed to) the same artists as those on the 'List'.

29 Op cit., 121/42, 6th June 1772. A good recent overview of the Duchess's ivories collection is provided by the lists and photographs in the Courtauld's Photographic Survey (see notes 24,26,28).

30 Op cit., 1772, 121/39, 1st April.

31 Op cit., 1769, 121/26, 2nd May; Greig, p. 128.

32 Boswell's *Life of Johnson*, quoted in Greig, p. xiii, Greig, pp. 135, 148, 150.

33 Percy Letters & Papers, 44, 1770–73, Letter 20.

34 Duchess of Northumberland Diary, 1772, 121/34, 14th April (Lyons) & 8th May (La Repaille).

35 Op cit., 1773–75, 121/50, 1st May 1773 (Nimes); 1772, 121/40, 13th May (Ferney). Voltaire's painting by Maratta was of the Holy

Family; the subject of the Veronese was 'a Woman with 3 boys'. Voltaire also owned two copies after Albano by his pupils: 'Venus dressing by the Graces, and... sleeping Cupids rob'd of their Bows by the Nymphs'. It seems likely that the Duchess's pilgrimage to see Voltaire was inspired by the visit to Ferney two years previously of her second son, Lord Algernon Percy, with Louis Dutens (p. 85). See also Sir Gavin de Beer, 'Voltaire's British Visitors' in *Studies on Voltaire and the eighteenth Century*, vol. IV, 1957, pp. 102–4.

36 Percy and Jackson Stops, III, p. 309. For Vilet's role as *valet de chambre* as well as draughtsman, see, for example, Greig, p. 183, when the Duchess sent him to announce her arrival at Baden to the Duke and Duchess of Cumberland.

37 The Courtauld Institute Photographic Survey includes a handwritten list of all the works in this album, identifying most of the sites the Duchess visited, and had recorded. A 'Bell' is listed as accompanying the Duchess's entourage to Ireland in 1763. Views of Italy and especially Spain are, however, unlikely to be connected to actual tours by the Duchess.

38 Whitley MSS., quoted in Ingamells, p. 643. The original obituary is now lost. The Duchess also owned two pairs of Roman views by Willem van Nieulandt and from the circle of Hendrick van Lint, together with other Italianate landscapes by Swanevelt, Rosa and Zuccarelli. It is not known whether the paintings by Dughet, Orizzonte and Locatelli in the collection were acquired by the 1st Duke and Duchess or by one of their successors.

39 There are paintings by Marlow at Castle Howard and at Scampston Hall. Information kindly provided by Michael Liversidge; see also Liversidge, 2000, pp. 83–99.

40 Percy Letters and Papers, vol. 33, 5th March 1762; Walpole, vol. 21, p. 514.

41 Percy Letters and Papers, vol. 33, 3rd November and 1st December 1761.

42 Ingamells, pp. 4, 978.

43 Percy Letters and Papers, vol. 33, 5th March 1762.

44 Op. cit., 5th March, 15th June 1762.

45 Op. cit., 17th December 1762 and vol. 34, 11th February 1763. Two boxes of sulphurs were shipped from Leghorn on 25th March 1763.

46 Percy Letters and Papers, vol. 34, 26th February 1763.

47 A sketch by Dance for this bacchic *krater* survives in the British Museum.

48 Goodeau, 1977, Introduction (n.p.) The painting was exhibited in London at the Free Society of Artists in 1764 as 'A Nobleman and his tutor'.

49 The Duchess's diary records meeting the Crasters in Lille on 27th October 1769, when they 'civilly offer'd' to give up their lodgings to her, 'which I cou'd by no means think of accepting', while George Craster also lent the Duchess his coach in Paris in 1770 (see p. 96).

50 Bowron, 1982, p. 9.

51 Ingamells, pp. 978–9.

52 For Zoffoli's miniature bronzes, see *Grand Tour*, Tate Gallery, 1996, pp. 280–1. Sets were purchased by Sir Lawrence Dundas for 19, Arlington Street, London; by Lord Boringdon for Saltram House, Devon; and in 1790 for the Prince Regent himself.

53 Percy Letters and Papers, vol. 34, 9th June 1763.

54 Op. cit., vol. 35, 14th July and 6th August 1763.

55 Ingamells, p. 325.

56 Ibid.

57 Sir William Farington, Journal, 25th February 1765, Preston Record Office, Farington MSS., DDF/14.

58 Dutens, 1806, vol. 1, p. 238.

59 Percy Letters and Papers, vol. 43, 24th June 1769.

60 Op. cit., 19th August 1769 and vol. 44, 15th September 1770.

61 On 22nd October 1768, as reported in the *Gazetta Toscana*, III, 43, p.181.

62 Dutens, 1806, vol. 1, p. 249.

63 Ingamells, p. 326; Greig, p. 74.

64 Percy Letters and Papers, vol. 43, 15th February 1769. These included 'medals...of the present Pope [Clement XIII] and one or two of the Pretender's family', see *European Historical Medals from the Collection of His Grace the Duke of Northumberland*, Sotheby's, 17th June 1981, Introduction.

65 Then in the Villa Medici, but removed to Florence in 1780.

66 Dutens, 1806, vol. 1, p. 287.

67 Percy Letters and Papers, vol. 44, 25th/26th April 1771.

68 Bowron, 1985, p. 317.

69 Hamilton also painted a portrait of Lord Warkworth, again dated 1773. He later lived and worked in Rome from 1782–91.

70 This tour is documented in his 'Journal of a Voyage to Tunis, Smyrna [etc]', 1773, Alnwick Castle archives, DNP. MS. 140. For the mummy, see *Noble Patrons*, opposite cat. nos. 113–4.

71 Ingamells, p. 759.

72 BM, Egerton MSS. 1970, f.92, Dutens to Strange, 20th July 1782.

73 *Courts*, pp. 182, 213.

74 W.W. Tomlinson, *Comprehensive Guide to the County of Northumberland*, 1885, vol. 5, pp. 305–6.

75 Grinke & Rogers, Antiquarian Booksellers, Catalogue No. 4, *Pamphlets from the Library of Louis Dutens*, 34 Bruton Place, London W.1, p. 3, no. 3 (Dutens's copy of the *Edinburgh Review* for April to July, 1806, containing a long and savage review of his *Memoirs*).

76 Alnwick Castle archives.

77 Omphale, daughter of Iardanus, and Queen of Lydia. She bought Heracles when he was a slave. He performed many deeds for her and she bore him a son.

78 Knight, cat. 190.

79 Op. cit., cat. 209; the 1921 catalogue by Alfred E. Knight is based on manuscript notes in the family's collection.

80 The *Alexander* (before 1789) was a copy of an antique fragment that already belonged to Lord Algernon, and was probably made to 'supply the deficiency [of] the original'. Lord Algernon also owned an *Antinous* (1772–4 or earlier), taken from the head of a bas-relief in the Villa Albani in Rome, and *Cupid in a Car drawn by Two Boars* (1772–88), also taken from a classical bas-relief, this time in the Museo Pio-Clementino.

Northerners Abroad
1700–1780

Only a very small number of tourists from the North appear to have made the Grand Tour in the first half of the 18th century, and, although precise figures are lacking,[1] it seems likely that the region's troubled recent history, with the consequent delay in the development of 'polite society' here, and the comparative isolation of the North at this period, all contributed to tourism being well below the national average. As one might expect, early continental travel, certainly until around 1730, was largely confined to the great landed families; as the century progressed, the landed gentry, many of them Catholics affected to a lesser or greater extent by the 1715 rebellion, were on the whole superceded as Grand Tourists by new entrants to the landed elite, who, since the late 17th century, had made their fortunes as merchants – families like the Ellisons or the Liddells. A number of professionals also made interesting tours abroad at this period.

EARLY TOURISTS 1700–1730

Perhaps the earliest 18th-century tourist from the region[2] was Christopher Vane Barnard (1653–1723), of Raby Castle, County Durham, who visited Rome and Florence in 1701 in late middle age,[3] shortly after his support for the accession of William and Mary led to his creation as 1st Baron Barnard. At a meeting in Florence, Barnard lent the cultivated 1st Duke of Shrewsbury a Latin manuscript by Algernon Percy concerning Oliver Cromwell and his father, the Puritan and republican Sir Henry Vane the Younger, whose refusal to accept Oliver Cromwell as Head of State had not saved him from execution at the Restoration. Little else, however, is known, of this tour.

Although the century opened with the War of the Spanish Succession (1702–13), British tourists were not greatly

deterred, and one young Northumbrian, Sir Carnaby Haggerston (1698–1756), of Haggerston Castle near Berwick-on-Tweed,[4] certainly set out for Europe in 1711 before the conflict ended, on what would be the earliest tour from the North to be recorded in any detail. Given the family's recusancy, Sir Carnaby, who hailed from a prominent landed family which could trace its origins back to the 13th century, and had achieved a baronetcy under Charles I, was sent abroad from 1711–19 with a priest-tutor, the Jesuit John Thornton, the year after succeeding to the baronetcy on his grandfather's death. Despite the heavy fines imposed on the North's Catholic families, he was by no means the first – or indeed the last – member of this family to be educated abroad. His travels around Europe, during which the thirteen-year-old boy was taught by various masters, observing term-time and vacations much as he would have done at home, are typical of the well-developed system which existed at this time for educating wealthy young Catholics on the continent (pp. 32–3). Sir Carnaby's visit to Italy took place only after several years abroad, when he was nearly adult, and represented the culmination of these years of continental study.

Haggerston's gentry-born tutor, John Thornton, reported on the progress of the tour, not only to his pupil's mother, but to another Jesuit priest, Father Francis Anderton, who took over the chaplaincy at Haggerston during Thornton's absence abroad, and who seems to have taken an overview of the tour's efficacy in educating this wealthy young member of the Catholic community, whose support could later be crucial in maintaining the Catholic presence in North East Northumberland. As Haggerston soon developed a disturbing passion for gambling, as well as some initial reluctance towards learning, and a tendency to be 'close as to his own designs', his progress clearly required some monitoring.[5]

From 1711–17 the travellers were in Germany, and they later spent extended periods in Bourges and Montpellier, where, although the young Baronet had made 'the resolution of seriously improving himself', recognising 'the necessity and advantages of learning', his tutor reported bluntly that, while his charge was 'without exception the fairest person for stature and features thats here seen', he had still 'much of his nature to overcome to render him entirely agreeable'![6]

By 1717, however, the travellers had begun to plan their Grand Tour to Italy, part of which was undertaken with a certain John Jackson, and by early 1718 they were in Genoa, Livorno (Leghorn) and Florence, arriving in Rome for Holy Week. After a short visit to Naples, where he was received by the Viceroy, Sir Carnaby returned to Rome, feeling that the city 'requests six months at least'.[7] Here he employed language and architectural masters as well as an antiquary (or *cicerone*), bought Italian books and clothes, and shipped crates of wine and lemons, and Neapolitan soap, back to England from Leghorn.

Now an adult, Sir Carnaby was by this time very much in charge of his tour, deciding to see the Carnival in Venice before returning home via Switzerland and the Rhine, to the regret of his tutor, who hoped to persuade him to take the alternative route home through France and Brussels. From Rome, in November 1718, Sir Carnaby reported to his mother that he was 'quite tired of rambling'; by the time he had arrived in Antwerp on his return journey in May 1719, he was looking forward to settling down, hoping to find 'a lady I could like and a great deal of money'.[8] When the travellers finally arrived back at Haggerston, Thornton, like many priest-tutors, took over the chaplaincy there, remaining for the next thirty-four years. Strangely, it was he who became the boon companion of the hunting and racing fraternity among the Northumbrian gentry, while his patron was perhaps more influenced by his Grand Tour, Thornton writing that: 'Our diversion consists now in walks, allies, parterres, vestoes, Belvideres, grottos, and such like, so that the very name of hunting sounds barbarous'.[9] Haggerston duly married in 1721. Although the Haggerstons were among the leading Jacobites in the North of England, Sir Carnaby's youth meant that the family was not actively involved in the 1715 rebellion, but, much later, after the 1745, Sir Carnaby obtained a modicum of revenge; when he sent his coach to convey the notorious victor of Culloden, the Duke of Cumberland, from Belford to Berwick, he is said to have 'instructed his coachman to overturn the vehicle on the way'.[10]

Although Sir Carnaby bought a diamond ring in 1712 for £300, there is no reference in his correspondence to his having purchased works of art abroad, with the exception of the 'pictures, treacle & other things you desire' that he bought for his mother in Rome before his departure. The young baronet did, however, ask Francis Anderton to send him a plan of Haggerston House and grounds 'for amusement to talk with architects who I have in every town to see some of their designs', in case 'I or any that should have Haggerston should have a mind to build'.[11] Sir Carnaby's interest in Italian architecture seems to have lived on at Haggerston: his grandson later commissioned designs from G.A.D. Quarenghi (fig. 91).

If the youth and absence abroad on the Grand Tour of Sir Carnaby himself, and of his contemporary John Swinburne, shortly to become 3rd Bart, protected their estates from sequestration after the 1715 rebellion, the pre-eminent Jacobites in Northumberland, the Radclyffes, Earls of Derwentwater since 1688, were less fortunate. The family, whose principal seat was at Dilston Castle in the Tyne valley, but who owned estates throughout Northumberland and in Cumbria, commanded great wealth and influence, including, until the 1688 revolution, in royal circles. However, James, 3rd Earl of Derwentwater, came into his inheritance in 1705, just in time to lose both this and his head in the 1715 rebellion, and his family's travels are connected, not to tourism, but to Catholic education abroad, and to the Jacobite diaspora in the wake of the 1715 rebellion. As a child, Derwentwater had been sent abroad with his brother to be the playmate of the young Prince James Stuart (The Old Pretender) – whose cousin by marriage he was – at the court in exile at St. Germain. His loyalty to the Stuarts was therefore never in doubt, and his education in France, where he attended a Jesuit College in Paris with a member of the North's other leading Jacobite family, Lord William Widdrington, must stand as being representative of many such Northern Catholic educations abroad in the years following the 'Glorious Revolution'.[12]

Unlike Derwentwater himself, his brother Charles Radclyffe (1693–1746) managed to escape to France after the 1715. Having married the Countess of Newburgh in Brussels in 1724, he lived in Rome from 1726–36 with his young family. Radclyffe's years here seem to have been devoid of a cultural dimension; instead he gained a reputation in Rome as 'ye fiercest Jacobite alive', who on one occasion with a 'cabal of monks' chased out of the city an unfortunate Hanoverian spy. Meanwhile, his drinking and the assemblies at his house, at which his two step-daughters acted as a magnets to young men, became so disorderly that they were stopped by the Pope.[13] Radclyffe was eventually executed after the 1745. His uncle, William (1662–1732), son of the 1st Earl of Derwentwater, also spent many years in exile in Rome, from 1720; an even less appealing character than his nephew, he seems to have been a 'merchant usurier', and was on one occasion arrested for ill-treating a Mrs. Morison who had been both his mistress and his servant. He must have lived in Rome in some style, as when he died in 1732 he left £50,000, and bequeathed to his nephew Charles his house and family heirlooms including pictures, tapestries, and armour.[14]

By no means all early travellers from the North were Jacobites, whose complex links with early tourism are illustrated by an anecdote concerning the 3rd Baron Widdrington, who retired to the continent in the wake of the 1688 revolution, and moved around in a coach 'pretending to be a tourist to avoid detection as a Jacobite activist'.[15] Instead, many came from landed estates in County Durham, which, as a county, was distinctly less enthusiastic about the Stuart cause. The Bowes family, who had lived at Streatlam Castle since medieval times were, like the Radclyffes, among the most powerful in the North, with similar links to court circles, and, perhaps, a culture of tourism already in the family, as Sir William Bowes, knighted by Charles II, had travelled in France and elsewhere on the continent after the Peace of Nimeguen in 1678. In addition to Streatlam, William Bowes also acquired the estate of Gibside on his marriage in 1692, but he died in 1706 when his eldest son was still a child, and considerable care was evidently taken over the education of William Blakiston Bowes (1697–1721) 'a considerable

traveller and extensive collector of books',[16] who was educated at Durham Grammar School and then at Cambridge, but who seems to have suffered from chronic ill-health.

Bowes is first recorded in Italy in 1714, when the Prebend of Durham wrote to Bowes's mother of 'your son's recovery on his travels to Rome'. He also visited France in April 1715, and then journeyed through Switzerland, Venice, Padua, Rome and Naples in 1716–17, when he was apparently travelling for part of the time with the Scottish portrait painter, Andrew Hay, one of the most important early dealers to sell works of art to Grand Tourists.[17] Whether or not Bowes became one of Hay's many clients is not recorded. On his return, Bowes focused on his interests in the coal trade (comparing his newly constructed 'Waggon Way' to the Via Appia in Rome) and his potential marriage to an heiress; it has been suggested that his rebuilding of his 15th century castle at Streatlam from around 1717–21, to make it the 'the best in our northern parts' was connected to the latter project.[18] In the event he died young, and it was his entrepreneurial brother George who created at Gibside one of the great (Whig) landscape gardens of England. Ralph Carr of Cocken (b.1694), who came from another prominent Durham landowning family, but one which had made its fortune much more recently, was probably the tourist of this name who studied at the University of Padua in 1714–5, and visited Venice 'to enjoy the Carneval'. He was again in Padua in 1723, and possibly also travelled abroad with his brother Henry in 1739–40 (pp. 89–90).[19]

TOURISM 1730–1760

Tourism in the 1730s was still dominated by the landed elite – including new entrants to this class – in a decade which marked one of the early high points of Grand Tour travel both nationally and from the North, during a period of prolonged European peace. It is surely not accidental that four early Northern tours, those of Sir Henry Liddell, Henry Carr, Lancelot Allgood and James Dagnia, took place during this decade. However, in 1739 the relative peace of these years was interrupted by the War of the Austrian Succession (1739–48).

Although Anglo-French hostilities broke out only in 1744, and tourism certainly continued during these years, the Seven Years War (1756–63) undoubtedly restricted, although it did not entirely stop, tourism in France, and very few tours appear to have been made from the North in the unsettled period from 1740–60. Those who did venture abroad appear to have gone for the purpose of study or education rather than to make a full Grand Tour. Among them were the three sons of Sir Carnaby Haggerston; the lack of adult Catholic tourists during these years – in contrast to the diaspora in the immediate aftermath of the 1715 – is perhaps explained in part by financial penalties, and the restrictions placed on their movements by the authorities, although Sir John Swinburne (pp. 37–9) did manage two years in France from 1749–51.

SIR HENRY LIDDELL (1708–84)

Sir Henry Liddell of Ravensworth Castle, Durham was one of the new generation of powerful Protestant landowners whose family had exchanged their role as Newcastle merchants and aldermen for an estate and a baronetcy; his accession to the upper ranks of the North's great landed families would shortly be confirmed when he was created Baron Ravensworth in 1747, and his daughter Anne Liddell would later marry – only temporarily, as it turned out – the statesman and aristocrat Augustus, 3rd Duke of Grafton. Liddell, who had already visited Paris in 1729,[20] made a tour in 1733–4 which included most of the Northern Italian cities of note; his travelling companion for much of the time was the Yorkshire baronet Sir Hugh Smithson, future 1st Duke of North-umberland (pp. 59–65). Together they obtained passes to inspect the French army near Mantua during the War of the Polish Succession, and heard the great *castrato* Farinelli sing in Vicenza. Liddell's tour had at least one practical result: in 1735 he employed a French chef.[21]

LANCELOT ALLGOOD (1711–82)

Fortunately, we know rather more of the tour made by the Northumbrian landowner Lancelot Allgood of Brandon White House near Wooler, who travelled in France and Italy from

1737–8 in his late twenties to acquire 'post-graduate polish', and went on to become one of the leading figures in mid-18th-century Northumberland, building at Nunwick one of the finest Palladian houses in the county.[22]

From May to July 1737, Allgood was in Montpellier, perhaps detained by the lameness he mentions in his letters home to his aunt, Mrs. Widdrington, of Hexham. Unlike many British tourists, he appears to have enjoyed socialising with the French rather than with his own compatriots: 'Since the English that past the winter here, went away, I have dropt all acquaintance with my countrymen & live entirely amongst the French who are so gay that they make the most grave spaniard smile'. Allgood's tour to Italy was, however, on his mind right from the beginning: in May 1737 he wrote to reassure his aunt that 'You need to be under no concern of my travelling into Italy because there are so many people upon that road & if I shou'd chance to go alone the custom of having ordinaries at all the Inns abroad renders it less unpleasant than in England for those that travel without company'.[23]

Allgood appears to have arrived in Italy in early 1738 with Thomas Forster, a Jacobite friend of his father, whom he had met in France. During his stay there he evidently joined up with a group of young British tourists, one of whom, a young Welsh squire, George Lewis Langton, died in Rome in September 1738; Allgood's name, together with those of Charles Churchill and Edwin Lascelles, of Harewood House in Yorkshire, appears on a memorial to Langton in the Protestant cemetery there.[24] Allgood was later in Padua, and on 13th October in Turin, which marked the end of his Italian journey: 'I shall set out the day after tomorrow & hope to be in London within the month allowing for the tedious journey over the Alps & resting in Paris four or five days'.[25]

Unfortunately, no correspondence survives which might cast any light on Allgood's reactions to the principal sights of the Grand Tour. Nor is he recorded as having bought any works of art abroad. However, it seems likely that a copy after Raphael's *Madonna della Sedia* in the Pitti Palace in Florence (fig. 79), which is known to have been in his collection, was acquired in Italy: the original was one of the paintings most admired by British tourists and large numbers of copies for the Grand Tour market were made. The framing of this particular copy in a fine gilt Italian frame indicates the importance Allgood attached to his purchase: the distinction between copies and originals was not as clear-cut in the 18th century as it is today, and, if a collector could not obtain the original, he would often settle happily for a replica instead.[26] Two fine *capriccio* views of Rome, now attributed to Viviano Codazzi, were also in Allgood's collection, and are likely to have been bought either on the Grand Tour itself, or in its aftermath. In the *Landscape with the Arch of Constantine* (fig. 80) the famous Roman triumphal arch is combined with an imaginary Italian seaport. The rather haunting, dream-like quality of the painting, and its strong sense of an empire in decay, would

Fig. 79 *Madonna della Sedia*, 18th century copy after Raphael, oil on canvas

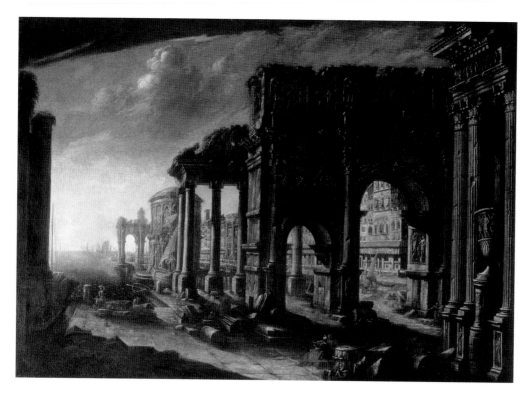

Fig. 80
*Capriccio View of
Rome with the Arch
of Constantine*,
attributed to
Viviano Codazzi,
(1606/11–1672)
oil on canvas

have appealed greatly to 18th-century collectors like Allgood, reared on the often elegiac landscapes of Claude Lorrain and his contemporaries.

On his return to England, Lancelot Allgood consolidated the family estates by marrying his cousin Jane, whose father, Robert Allgood, had recently purchased the properties of Nunwick and Chipchase up the North Tyne valley. It was left to Lancelot and Jane, however, to build the fine Palladian house at Nunwick from 1748–52, almost certainly to the designs of Daniel Garrett. Although Allgood would have gained considerable experience of classical architecture during his two-year Grand Tour, his decision to build a house in the Palladian style was almost certainly the result of the gradual spread northwards in the 1730s and 1740s of British Palladianism, rather than of any direct contact he may have had with Palladian buildings abroad.[27] Allgood also seems to have added wings to his original home at Brandon sometime

after 1739. Despite his Catholic connections – evident in his relationship to the Widdrington family, and his travels in Italy with a known Jacobite – Allgood was a supporter, unlike many of his Northern tourist neighbours, of the Hanoverian monarchy, and had a relatively prominent, albeit somewhat brief, career on the national and local stage: he was a Member of Parliament from 1748–53; High Sheriff of the county in 1746; and was rewarded with a knighthood in 1760. Although he lived on until 1782, it was the years following his Grand Tour that saw him at his most active.

JAMES DAGNIA (C.1709–55)

A very different tour from Allgood's, highly colourful, but for which the evidence is fragmented, was that made by James Dagnia, the 'famous gentleman glass blower' and 'gentleman painter', who 'figured in Rome as Count Dagnia'.[28] The self-styled Count, who made the Grand Tour around 1738, was

actually the son of John Dagnia, whose family, almost certainly of Italian extraction, had been members of the Tyneside glass trade since the late 17th century. Their prosperity, by the time of James's tour, is confirmed by John Dagnia's building of a modest mansion at Cleadon Hall, Northumberland, around this same time.[29]

In Rome, James Dagnia became an important patron of Vernet, commissioning three works from the artist in 1738,[30] and it may have been this interest in *veduta* painting that commended him to William Windham, whose stay in Rome coincided with his own, and who acquired there a series of outstanding *veduta* paintings for his Norfolk home, Felbrigg Hall; the two men later owned each other's portrait, and Dagnia's by John Shackleton survives at Felbrigg. Dagnia's niece, who published his travels as *The Adventures of Jemmy Gosemore Dagnia*, apparently owned a bronze bust of her uncle executed in Rome, while other Grand Tour memorabilia may have survived for some time in the collection of his nephew, the Rev. Griffith of Newcastle.[31] It seems possible that Dagnia also brought back a horticultural record of his tour, as the owner of Cleadon Hall in 1865 claimed that some larch trees in the grounds had been brought by Dagnia from Italy.[32] A 'celebrated amateur in painting',[33] Dagnia is said to have been patronised by Charles, Earl of Malton (later 2nd Marquis of Rockingham and owner of Wentworth Woodhouse), the Earl of Denbigh and the Duke of Cleveland,[34] and it seems likely that he devoted himself after his Grand Tour to artistic pursuits rather than to the management of his estates or of his father's business; certainly, by the time of his relatively early death, he had sold both Cleadon Hall itself and the estate he had bought at Woolsington near Newcastle.

HENRY THOMAS CARR (b. after 1694)

A penetrating, though insular, account of Rome just before mid-century is provided in the letters of Henry Thomas Carr, the son of a Durham landowner, Ralph Carr of Cocken Senr., and a relative by marriage of the Ellisons. Carr was in Rome, perhaps with his brother Ralph Jnr., in 1739–40, finding 'a great deal more company than usual of our Nation and more expected every day', and taking a ten-day course on the antiquities and palaces. While he felt that 'for people who have any taste for Antiquities, Statuary, Painting or Musick here is sufficient Entertainment for almost every hour', he was disappointed to note that 'fine palaces' were 'frequently let off and divided into little Shops, ye Greatness & Meanness are so jumbled together...that the Appearance they make upon the whole is but very indifferent'. Despite his admiration for the city's churches, he did not think that Rome could offer anything as fine as Grosvenor or St. James's Square, while St. Peter's itself he thought more like a palace than a church and 'does not equal St. Paul's'.[35]

Carr had an eye for piquant contrasts, and few Grand Tour diarists or letter writers can equal his entertaining description of the behaviour of a crowd in the Piazza Navona during Lent: despite being entertained simultaneously by 'A mountebank...holding forth to his auditory in one place, a Man with a monkey shewing tricks in another' and an 'old Greyheaded Conjuror sitting exalted on a High Stool telling of fortunes thro' a long tube', this was harangued so successfully by a Jesuit priest, armed with a crucifix, that it solemnly processed off to perform acts of penitence in his church with chains and lashes.[36] This is the Protestant view of Rome and its religious life, from a sceptical but not unsympathetic observer.

If Carr's account of Rome is witty and pungent, his career was a chequered one. In 1730 he had made a highly successful marriage to Elizabeth Cotesworth, joint heiress, with Hannah Ellison, to estates in Durham which had been founded on their father's partnership in the coal industry with the powerful Liddell family. For many years afterwards, Carr ran his Cotesworth heritage prosperously, together with his talented brother-in-law and close friend, Henry Ellison, father of the tourist, and became an important figure in Durham industrial, agricultural and legal circles. His Grand Tour, made, unusually, in mid-life, can probably be seen in the context both of a marriage which provided him with the resources to travel, and of his evidently restless disposition, which led him to move from one estate to another in Durham, and even as far afield as Northamptonshire and Cheshire.

He also, again unusually, sent his son Robert to be educated at the Royal Military Academy at Caen in 1750. In the mid-1750s, after a serious illness, Carr was declared a lunatic, and his sons' interest in the now encumbered Cotesworth estates was bought out by the more successful Ellisons, who had come to regard the Carrs as 'capricious and unpleasant gentry'.[37] This Grand Tour, then, represents a rare occasion when a tour was made by a member of a family which was soon to decline, rather than rise, in terms of its social standing.

OTHER TOURISTS 1730–60

Of all the recusant families of Northumberland, the Haggerstons benefited from what was perhaps the most complete and rigorously planned, certainly the most fully documented, programme of continental schooling. From 1740 the education abroad of Sir Carnaby Haggerston's sons and daughters was supervised by his uncle Sir Marmaduke Constable (1682–1747), a wealthy Yorkshire landowner and former tourist, whose Jacobite sympathies now caused him to live abroad. Constable's 'extraordinary interest in the education and welfare of his great-nephews and nieces' meant that the family was 'able to experience a Continental education far over and above that which was usual'.[38]

In 1740 Sir Carnaby's eldest son and heir, Thomas Haggerston, was being educated on the continent with two of his sisters; accompanied by the Jesuit William Pemberton, he was to remain abroad until 1745. It seems probable that he subsequently made a Grand Tour, as he is recorded in Rome at Easter 1750, travelling with the great art collector William Constable and a Jesuit tutor, Walter Fleetwood. Unusually, however, it is Thomas's younger brothers William and Edward (destined, despite doubts as to his suitability, for a business career in Leghorn under a relative, Mr. Scroope), who are known to have made a full Grand Tour, from 1748–51. Again supervised by Walter Fleetwood, they visited southern France, Genoa, Milan and Rome. By this time, William had become Sir Marmaduke's heir, and it was presumably to educate him to fulfil this role that his tutor planned an extended Grand Tour. Financial worries, however, beset the tour from the start,

and the boys' father accused Fleetwood of exceeding the 'limits of his commission by undertaking the journey to Italy'.[39]

Another young Catholic tourist, Sir Edward Smythe (1719–84) of Eshe in County Durham, who later married into the powerful Clifford family, had already succeeded his father when he travelled in Italy in 1740–1 with a Scottish tourist with whom he shared a French governor; all that is recorded of his travels are visits to Rome and Venice, but Smythe must have felt the benefits of his tour, as he later sent his eldest son Edward abroad from around 1779–80.[40]

Another tourist whose career abroad, like James Dagnia's some years before (pp. 88–9), spanned the usually disparate worlds of landed interest and professional (or at least semi-professional) endeavour, was Robert Surtees (1737–1801), son of a Newcastle merchant, Hauxley Surtees.[41] Fortunately for Robert, his bachelor uncle, George Surtees of Mainsforth Hall, Durham, seems to have played a major role in promoting his nephews' careers – not, as it happened, always to their benefit[42] – and, given Robert's talent for drawing, George Surtees paid for his soujourn in Rome and Florence from 1755–9. Although the young Surtees appears to have preferred pleasure to hard work,[43] he did produce a Roman sketchbook, which was still with his descendants in 1955, and, after his return, he painted a portrait of his uncle, together with likenesses of other members of the family, which, 'the old Uncle not being a judge of Art', had the 'good luck to please him'.[44]

Surtees, however, would not be obliged to earn his living as an artist. On making a financially advantageous marriage to his cousin, he was assimilated into the landed gentry when his uncle gifted him Mainsforth Hall itself, and his artistic interests could now be pursued comfortably as an amateur. In later life, he showed 'not merely a refined taste, but very considerable talent in arts of design and engraving', which he put to some use in producing vignettes for the publications of his eponymous son, the great historian of County Durham.[45] Many a 'spirited sketch and oil painting, of original character' by Robert senior was apparently still at Mainsforth Hall in 1925 and some of his paintings were sold at Christie's in

1983.[46] An album of Surtees's drawings and prints, dated 1768, which included copies after Old Master paintings, and drawings of antique sculpture, appeared at Christie's in 1980 and is typical of the type of production one might expect of an amateur whose artistic interests were shaped by the Grand Tour.[47]

Another tourist with hedonistic tendencies, but this time with literary rather than artistic aspirations, was the poet and satirist John Hall Stevenson (1718–85), the son of Joseph Hall of Durham, who went on to own Skelton Castle in Yorkshire, where he is said to have called himself 'Crazy Hall' after the title of his own *Crazy Tales* (1762). Stevenson is said to have made the Grand Tour after Oxford in 1738, and was certainly in Capua in 1753. Like another slightly later Northern tourist, Henry Errington, he was a friend, and in this case also a literary 'cousin', of Lawrence Sterne.[48]

NORTHERN TOURISTS 1760–80

Grand Tourists from the North in the first half of the 18th century were very much blazing a trail. It was not until after 1760 that the trickle of tourists from the region became a steady stream. Even before the ending of the Seven Years War in 1763 opened the continent up again fully to British travellers, two highly important tours were made by members of major landowning families with estates in the North: George and Olive Craster and Hugh, future 2nd Duke of Northumberland, and it may well be that these tours acted as a catalyst, establishing the fashion for continental travel among their neighbouring landowners. Certainly, after 1763 Northerners were visiting the continent in sufficient numbers to make encounters with fellow tourists from the region while abroad a relatively common occurrence; in 1767 R.W. Grey wrote to his son informing him that he was likely to meet a fellow Northumbrian, Thomas Charles Bigge, in Paris, adding 'you see that a jaunt to France is toute à la mode'.[49]

A more fundamental reason for the new appetite for foreign travel can, however, be found in recent social changes in the North East (p. 30), which had produced, belatedly, a 'polite' society given to the cultivation of leisure, and in the development of a transport infrastructure which meant that by 1760 Europe no longer seemed so far removed from the lives of well-to-do families of the day. It was no longer only great social magnates such as the future 1st Duke and Duchess of Northumberland who moved readily between the North East and London; families with trading as well as gentry connections, such as the Ellisons and the Carrs, also had a London dimension to their lives, and this greater mobility surely had a strong impact on the number of Northerners who now made the Grand Tour. By 1760 it was no longer necessary to be a member of the landed elite to travel abroad, although less wealthy tourists often made a somewhat curtailed version of the Grand Tour. Unlike the period from 1730–60, a significant minority of tourists, particularly in the 1770s, the decade when Henry and Martha Swinburne travelled abroad, were Catholics; it seems likely that, as the Jacobite rebellion of 1745 increasingly faded from memory, Catholic tourists could enjoy their leisured pursuits alongside their Protestant contemporaries.

The level of British tourism abroad remained high throughout most of the 1770s, and although renewed hostilities with France following the American rebellion in 1778 caused some interruption in the flow of visitors, this did not deter Rowland Burdon or Henry Swinburne, who travelled through France in both 1779 and 1780 during a brief interlude in his Grand Tour. The fact that several of the North's most intelligent tourists, including the Swinburnes themselves, Henry Howard, Thomas Orde, and Robert Wharton made the Grand Tour in this decade can probably be accounted for by the gradual expansion of the tour to include younger sons and those on more moderate incomes.

GEORGE (1735–72) AND OLIVE (d.1769) CRASTER

That George Craster was by no means a typical Northumbrian landowner is perhaps indicated by the somewhat supercilious air adopted in his portrait by Pompeo Batoni, painted in Rome in 1762 (fig. 81).

The Crasters belonged to an old Northumbrian family which had fallen into debt in the late 17th century, with the result that, by the time of George Craster's birth in 1735, the

family mansion at Craster in North East Northumberland had not been occupied by the head of the family for nearly fifty years. George's father, John, who presided over a revival in the family fortunes, was a clever, cultivated London lawyer with literary connections, who had also found time to buy back his ancestors' Northern estates as they became available. His marriage in 1727 to Catherine Villiers, descendant of the notorious 1st Duke of Buckingham, gave him the entrée to aristocratic London society, and the Crasters' only surviving son, George, was brought up in London at his parents' house in Lincoln's Inn Fields, and at their villa on Taplow Common. George Craster was educated at Eton, and his father's actions suggest that his expectations for this only son were high: he was entered at Grey's Inn, presumably 'in order to acquire such knowledge of the law as befitted a future landowner' rather than with any intention of practising at the Bar. John Craster also purchased for his son a commission in the Royal Troop of Horse Guards. Just as relevant for George's future, he gave him £100 to go to France – thus initiating a lifetime's enthusiasm for travel abroad.[50]

It was in London that George Craster met his future wife and companion on his tours abroad, Olive Sharpe (fig. 82), who lived with her widowed mother only a few doors away from the Crasters in Lincoln's Inn Fields. There seems little doubt that this was a marriage of affection, but Olive was the daughter of the Solicitor of the Treasury, John Sharpe, and heiress to a £30,000 fortune, and the marriage, in February 1757, was one of two almost simultaneous events that completed the revival in the Crasters' fortunes, giving the couple an income that would soon be funding a Grand Tour on which no expense was spared. The other was John Craster's successful claim to the estates of a remote Northumbrian cousin, who owned extensive lands in Capheaton, Long Benton, Willington and Jesmond.

If John Craster had spent his life in shrewdly amassing the family's material assets, George and Olive would spend much of their – short – lives in lavish expenditure. In the autumn of 1760 they set off on what was presumably a delayed wedding tour of the continent, undeterred by the continuance of the

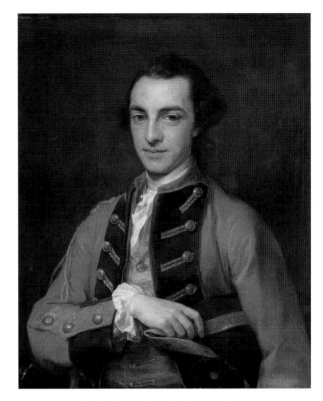

Fig. 81 *George Craster* by Pompeo Batoni,
oil on canvas, 1762

Seven Years War (1756–63). Although in Italy, the Crasters' eventual destination, there were few signs of hostilities, the earlier part of their tour was spent in France – a much more risky undertaking.

Passing through Paris in November 1760, George and Olive Craster spent the winter of 1760–61 in the popular spa town of Montpellier in Southern France. As neither of them enjoyed good health, they probably came here more to benefit from taking the waters, than because of their enthusiasm for the town or its inhabitants; although Olive found 'Montpellier in situation is beyond discription beautyfull', the town itself was 'not agreeable the Streets very narrow…the Houses are mostly surrounded with high walls on purpose to keep of[f] the sun, which is insupportabley hot in summer', while local

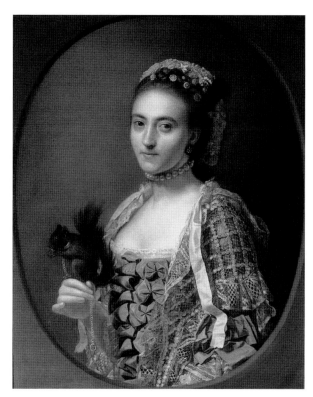

Fig. 82 *Olive Craster* by Nathaniel Dance,
oil on canvas, 1762

society came in for even harsher criticism: 'a very poor society, the people proud & envious the Gentlemen all Intrigue with the Grisets...the ladies are mostly ugly & formal [and] have none of the gaiety & life usually given by Travellers to the langudociery'.[51]

It was in Montpellier that Olive Craster began the lavish shopping for clothes which from now on would characterise this Grand Tour. Her *Memorandum Book* meticulously records a string of purchases, ranging from yards of dress fabric, negligées and petticoats down to gloves, shoes and slippers, fans, flower egrets, gauze and feathers, silk stockings, mittens, lace, corsets, handkerchiefs and boxes for combs and brushes. She also spent considerable sums at the milliner's, having her dress fabrics made up into gowns.

The Crasters remained in the South of France for most of 1761. By October, however, they were in Marseilles, ready to take the sea route to Naples, where they had arrived by January 13th 1762. Here Olive spent over 159 ducats on a 'blue & silver Negligee', which is possibly the gown shown in her portrait by Nathaniel Dance, shortly to be painted in Rome (fig. 82). She also hired an Italian tutor for 8 ducats, spent over 12 ducats on the barber, and bought bric à brac such as snuff and bon-bon boxes, needles, pins and combs in the Neapolitan shops. Her *Account of Antiques & Curiosities* also records the purchase of some gems: 'an intallio of Tullys Head' and 'two small heads' of members of the Roman Imperial family, Germanicus and Agrippina.[52]

By June 1762, the Crasters were staying at the Ville de Londres in Rome, being conducted around the city by the well-known painter and *cicerone* James Russel, whom Olive described as a 'modest agreable man'. Olive was quick to appreciate that, as regards the purchase of works of art and antiquities, there were no bargains to be had: 'all antiques to be met with here, tho' at present very difficult, anything rare that is found being bought up imediatly & at high prices what is good & really valuable cannot be bought so cheap as strangers imagine, the Romans well know [their] value. I mean Pictures, Statues, Cameos, Intalios etc that are Antique'. However, Olive's *Account of Antiques & Curiosities* confirms that the Crasters did purchase five antique (or later) gemstones, including 'an agatte of Hercules Mistress' (3 scudi) and a 'blue onix of Cupid who has rob'd Mercury of his purse & Caduceus, set in a gold ring' (3 scudi, 8 paoli).[53]

These gemstones were not, however, to be the Crasters' most important art acquisitions in Rome. Sometime between June and August 1762 George Craster sat to Pompeo Batoni (fig. 81, col. pl. 00), wearing his surely little-worn regimentals. In July, Olive sat to Batoni's young British partner, Nathaniel Dance, for a delightful companion portrait, which portrays her holding a pet squirrel (fig. 82, col. pl. 8). Fortunately, Olive's *Account of Antiques & Curiosities* for 1762 records the transaction: 'Two portraits of C & Self by Sigre Batoni & Mr Dance', (61 scudi 5 paoli), while an undated memorandum on

the various people they had met indicates the reason for their choice of artists, speaking of 'Sigre Pompeo Battoni & Mr Dance for Portraits & History painting Mr Hamilton for the lat[t]er only & Mr Delane for landskip'.[54]

George Craster's confidence in Pompeo Batoni as the best artist to paint his portrait is hardly surprising. By 1762 Batoni was the most famous painter, not only in Rome, but in all of Italy, and his reputation as the portrait painter *par excellence* of British visitors to Rome had been well established for a decade. Craster was, however, Batoni's earliest Northern client, and it is probably no coincidence that over the next few years several other Northern neighbours also sat to Batoni (figs. 74, 84, 87).

At twenty-eight, George Craster was slightly older than the majority of the artist's sitters. In other ways, however, he was typical of Batoni's clients, over half of whom were landowners, and Batoni also painted a considerable number of army officers – although George Craster's uniform, certainly by this stage in his life, was clearly decorative rather than functional. And it is very much as a landowner and a member of the officer class that he has chosen to be represented. Unlike many of Batoni's clients, Craster evidently had no desire to be portrayed as a learned *virtuoso*. Instead, he opted for a simple 'half-length' portrait, in which he is shown against a plain background, wearing his brilliant scarlet regimentals. The rather modest format of the portrait is perhaps surprising, given that the Crasters did not stint on other aspects of their Grand Tour: the price, 61 scudi, 5 paoli for this, and the companion portrait of Olive, was the equivalent of about £30, at a time when, in England, Sir Joshua Reynolds was charging twenty-four guineas for a single portrait of similar size.

This is, however, as Nathaniel Dance himself recognised, one of Batoni's most successful smaller-scale portraits. For an artist who revelled in depicting luxurious fabrics and dazzling colours, the opportunity to paint army officers in their scarlet coats, laced with gold froggings[55] was galvanic, and the contrast here between the plain background and the strongly lit face is impressive. It is, however, the brilliant device of the over life-sized hand, together with the powerful intensity of the sitter's gaze, at once arrogant and sensitive, that lends the portrait its individuality. George Craster's tensely held arm has the effect of forming a horizontal barrier across the lower half of the painting, thus detaching the sitter from the viewer's space and creating a sense of aristocratic aloofness comparable to that found in portraits by Van Dyck, by whom Batoni was deeply influenced.

If Batoni was the obvious choice for a Grand Tour portrait, the Crasters' selection of Nathaniel Dance as the artist to paint Olive is rather more unusual. Presumably, it was Batoni himself who passed on this commission to his young English partner, although the Crasters' *cicerone*, James Russel, had recommended Dance's architect brother George to other British clients in 1761. Whatever the reason for their choice, it is unlikely to have been dictated by Batoni's often cited dislike of painting women,[56] for which there is no real evidence.

Nathaniel Dance had arrived in Rome in 1754, ambitious to make his name as a history painter, but also, as we have seen, painting portraits and conversation pieces in the style of Francis Hayman. By 1758, he was apparently gaining an entrée to British expatriate society, as he was able to help the watercolourist Jonathan Skelton, when he was accused of being a Jacobite, through his knowledge of 'all the English Cavaliers in Rome'. But it was not until 1762, when he became, in effect, a junior partner of Batoni's, that Dance could write to his father: 'I am now in such a situation in Rome that I cannot fail of making acquaintance with some of the greatest people in England'.[57] Over the next two years Dance's predictions were amply fulfilled. His portrait of Mrs. Craster was the earliest of a series of important commissions which presumably came to him through his new partnership. In the following year, 1763, Dance painted another Northumbrian, Lord Warkworth (fig 73., col. pl. 4), while by 1764 the fashionable world was beating a path to his door; sitters in this year included Viscount Spencer, the actor David Garrick and the King's brother, the Duke of York, both of whom also sat to Batoni. The Crasters, in fact, had chosen a young artist whose career as a fashionable portrait painter was just beginning to ignite.

Since *Olive Craster* was the first life-size portrait undertaken by Dance after he began working with Batoni, the artist had been, understandably, rather nervous about its reception: 'Mr Crastow and his lady have had their portraits painted, the Gentleman by Pompeo Batoni, who is esteemed the best Italian painter living, and the lady by me. When it was proposed to me, I was not very desirous of undertaking a thing in competition with a Man of his Merit'. Fortunately, however, Dance 'had the courage to undertake it, and ...had the good fortune to succeed better than my best friends expected – and not withstanding Pompeo has made one of the best heads he ever painted'.[58] It is not difficult to agree with Dance's own verdict on his portrait, although it remains, essentially, an English portrait painted abroad.

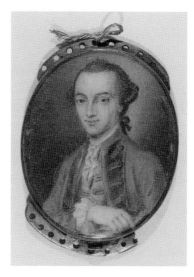

Fig. 83 *George Craster*
by Maria Felice Tibaldi-Subleyras (?),
miniature, 1762

Although it is tempting to relate the meticulous attention Dance pays to the frills and furbelows of Olive's rococo costume to her extravagant interest in clothes, the format of a female sitter placed within a feigned oval, with the focus directed towards her costume, finds numerous parallels in British portraits of around this time. Many of the more prominent features of the portrait, however, probably owe more to the sitter than to the artist himself: although the artificial flowers Olive Craster wears in her hair are a recurrent motif in Dance's female Italian portraits, his sitter is known to have bought large quantities of flowers as hair ornaments from Italian convents. Similarly, the squirrel she holds on a silver chain is almost certainly a pet – Olive acquired two lap-dogs on her travels – rather than an artistic device inspired by portraits such as Holbein's famous *Unknown Lady with a Squirrel and a Starling*.[59]

George and Olive Craster also succumbed to the Grand Tour vogue for bringing home replicas of a sitter's portrait in miniature (often, although apparently not in this case, intended as gifts for friends or relatives), commissioning copies of their Batoni and Dance portraits either from Maria Felice Tibaldi, one of the most famous miniaturists of her day, or from one of her two sisters who also specialised in this genre; at 32 scudi 8 paoli these were nearly half the cost of the portraits themselves. The Crasters would not have had to step far outside Batoni's circle for this commission, since Maria Felice was the widow of the painter Pierre Subleyras, whose work Batoni is known to have copied. Although the miniature of Olive Craster is now lost, that of George survives (fig. 83); a number of miniatures painted by Batoni himself after his own Grand Tour portraits are also known.[60]

Shortly after Olive Craster sat to Dance, the Crasters left Rome, arriving in Florence by 19th August 1762, where they found the British resident, Sir Horace Mann 'a most polite obliging & very friendly Man'. Their route home took them through Venice, Milan, Bologna and Turin; they also stopped in Leghorn (Livorno), where a memorandum by Olive refers to the British consul, Sir John Dick (pp. 167–9) and his wife as 'very friendly agreeable people'.[61] The Crasters now crossed the Mount Cenis pass to Lyons, where they arrived on 1st November 1762. After spending a second winter in the South of France, enlivened by boxes at the Comédie Theatre, lessons from guitar and dancing masters, and another extensive round of shopping, the couple returned home via Paris, where, like many tourists, they visited the Sèvres factory and bought a tea-service (now lost) decorated by Aloncle[62] with partridges and kingfishers. They had evidently made their tour supplied with French and Italian guidebooks, as the Library at Craster seems to have contained examples of these.[63]

George and Olive's arrival back in England in the summer of 1763 was swiftly followed by the death of George's father, John Craster. George was now a major Northern landowner,

but the North was only intermittently his and Olive's home. For the Crasters had the entrée to London society at its most fashionable, enjoying a friendship with Stephen Fox, son of the 1st Lord Holland, and brother of Charles James, and with Sir Richard Lyttelton, with whom they may have coincided in Rome, as Lyttelton stayed there with his wife, the Duchess of Bridgewater, from March to May 1762 and also sat to Batoni. Through Lyttelton, the Crasters had the entrée to the great Whig houses of Stowe and Hagley.[64] The house in Lincoln's Inn Fields was replaced by one in more fashionable Pall Mall, and London, and the friendships it produced, remained the axis of their lives.

George Craster did not, however, neglect his Northumbrian home, where he and Olive spent the late summer months each year. From 1767 they added a new five-bay classical front to the medieval tower at Craster. Although this was perhaps to the designs of the local architect William Newton, whose clients included other Northern tourists, this major addition to the medieval house may have been inspired by the villas the Crasters had seen on the Brenta.[65]

Ironically, such matters must soon have been far from their minds. By 1769 Olive Craster was seriously ill, and, having consulted a London doctor, she and George set off once more for the continent, this time for more sombre reasons. They arrived in Paris in October. Only six weeks later (on 7th December 1769) Olive was dead, not so much a victim of Grand Tour travel, as yet another tragic illustration of one of the principal reasons for making a continental tour at this period – the attempted restoration of health in warmer climates.

Even today, with the benefit of modern communications, death abroad presents grave difficulties. In the 18th century it was even more traumatic, and only the very wealthy could afford to return the corpse to England for burial. George Craster's decision to bury his wife in the new family vault at Embleton Church near Craster is therefore yet another, though tragic, illustration of the conspicuous expenditure which he and his wife had practised. It took the procession twenty-four days to reach Craster; the journey alone cost £288-18s.[66]

Only a few months later, George Craster was in Paris again, this time to participate in the festivities attendant on the marriage of the Dauphin, the future King Louis XVI, and Marie Antoinette on May 17th 1770. He was not the only Northumbrian tourist in Paris. Elizabeth, 1st Duchess of Northumberland (pp. 65–71) persuaded him to lend her his 'vis à vis'[67] while hers was being repaired, and noted 'we were not got 20 yards, before it turn'd over with us. But, tho all Glass, providentially we were not cut, nor the Glasses broke'. As Sir Edmund Craster rather wryly remarks, 'It cost George 600 livres to repair'.[68]

It seems possible that George Craster was intending to settle in Paris, as he rented a house there in April 1771. However, he, too, was now gravely ill, and he soon left Paris, first for a country house near Boulogne, and then for the North of England, dying at Craster on May 9th, 1772. It is of a piece with what we know of their joint lives that the local press commented that he was buried beside Olive in the family vault at nearby Embleton 'in a grand manner'.[69]

RALPH WILLIAM GREY (1746–1812)

The two tours made by Ralph William Grey are of particular fascination on account of the surviving correspondence between him and his eponymous father. Unusually, these letters reveal attitudes to the Grand Tour by a parent rather than by his tourist son, and they also contain the only detailed account by a Northerner of a portrait commission from Pompeo Batoni (fig. 84).

Ralph William Grey Jnr. was the eldest son of the owner of Backworth Hall near Whitley Bay on the Northumbrian coast. Prominent in Newcastle public life since the early 17th century, the family had purchased land at Backworth in 1628, and, although they retained their business interests in Newcastle, and were prominent coal owners – a fact which, unusually in this case, would eventually prove to be their undoing – they had effectively integrated into the gentry by the time of the death of the tourist's grandfather in 1699. Having graduated from Cambridge in 1765, R.W. Grey Jnr. spent a year at the Inner Temple in London before leaving for

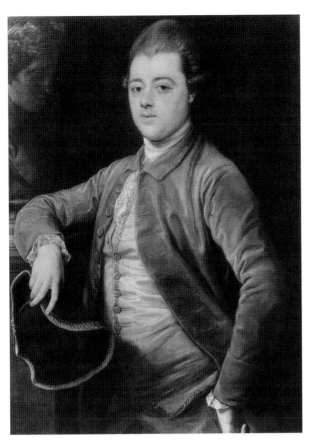

Fig. 84 *Ralph William Grey*, by Pompeo Batoni,
oil on canvas, 1768

the continent in 1767, pursued by advice from his father as to the desirability of obtaining in Paris 'the best minuet dancing master you can get', and of keeping 'as little English company as possible';[70] the concern that young British tourists should make good use of their time in the French capital, rather than socialising only with each other, was, as we have seen (p. 7), a common one with parents. Two exceptions to his father's rule, however, were Grey's fellow Northerner, Thomas Charles Bigge, who had made an Italian tour in 1764–5, and who, Grey Snr. informed his son, was likely to be in Paris in September 1767, and 'Mr Cuthbert', who was perhaps the Durham tourist John Cuthbert.[71]

Seven years later, R.W. Grey left on a second and much more extended tour, this time including Italy. On 21st June 1774 R.W. Grey Snr. wrote to his son in London before his departure to discuss his future plans, hoping that he would find companions for his travels. Four days later his son replied that he was 'in great hopes of having a very agreeable companion [for] a great part of the tour viz. Mr. Dutens'. It is clear from R.W. Grey Senior's reply that Louis Dutens's fame as a Grand Tour tutor, or in this case companion, had spread throughout Northumberland following his tour of 1768–71 with Lord Algernon Percy: 'I am exceedingly glad that you have hopes of Mr Duten's company: no one can be of more Service and advantage to you in every respect than him he being so well known everywhere abroad'.[72] This plan proved, in the end, to be abortive, but the Northern network did not extend only to companions. R.W. Grey Snr. also sent his son letters of recommendation from a member of the Fenwick family to a cousin in Genoa, while Mr. Ridley (probably the father of the tourist Matthew Ridley), provided a letter for Sir John Dick, the Newcastle-born consul in Leghorn.[73]

Ralph William Grey Senior's letters to his son in Italy offer a fascinating perspective on the Grand Tour from a man reared on the classics, who had never seen the sights of Italy for himself. 'Of all your Italian travels yet (excepting Rome)' he wrote in December 1774, 'I could have wished the most to have been with you on top of Mount Cenis and in the Grand Duke's gallery at Florence, to have seen the busts of Tully, Julius Caesar, Virgil etc. and ...the capital pictures by Raphael, Titian, Correggio etc'. If such reactions were commonplace, rather more interesting is Grey's suggestion that his son's appreciation of classical literature will be deepened by his visit to the places with which the authors were associated: 'The coast of Baia, I imagine must be very pleasant, Cicero and Horace I think had villas at that place. some of the letters of the former and some of the odes of the latter you will read with more pleasure from having seen the place'.[74] Although this approach to 'classic ground' had been pioneered by Joseph Addison when travelling in Italy in 1701, and would later be more eloquently expressed by another Northerner,

Harriet Carr, by no means all tourists – or their correspondents – made comparisons of this nature.

By 15th December 1774, R.W. Grey Jnr. had arrived in Rome, where he took the usual course of antiquities and (in his father's words) found Hadrian's Villa at Tivoli 'somewhat bigger and finer than the old château at Backworth'. Probably, he sat to Pompeo Batoni (fig. 85) soon after his arrival, as by February 10th 1775 his father was writing to say that he 'did not know that the Italians were reckoned good portrait painters for likeness'. Grey Snr. strongly recommended his son to choose a format that would focus on the sitter's countenance, and that would fit readily into the rooms back at home: 'I think the best size for portraits is the common size, being most easily disposed of in rooms (three quarters I believe they call it) such as my fathers, uncles etc. in the red room, for it is the likeness of the countenance in one's relations and friends one values most in a picture, and if yours is so like as you mention that is the main thing that can be desired'.[75] As it happened, the son exactly followed his father's prescription, and Batoni's painting shows a rather fleshy young man with a tricorne hat leaning on a stone pedestal; for the antique bust in the background, Batoni deviated from his usual Grand Tour 'props', showing instead one of the muses which had recently been discovered by Domenico De Angelis in a villa near Tivoli.

The portrait was shipped back to England in 'the *Betsy*, Timothy Wallace, Master' and had arrived with R.W. Grey Jnr. in London by 19th April 1776, when Grey's father was thinking how he could 'contrive a place for it' at Backworth. A few days later, Grey wrote to his father to caution him that 'You must tell whoever opens it to take particular care not to thrust in any chisel or instrument of that kind, as the case fits the picture so exactly that if not very carefully opened, the frame will run great danger of being cut'. The portrait had arrived safely at Backworth by 10th June 1776; fortunately, Grey's father thought it 'a very good portrait and vastly like you'.[76]

Only a year after his return, in 1777, R.W. Grey Jnr. married Elizabeth Brandling, member of another prominent Northumbrian tourist family, and in the following year went on to replace the 'château' at Backworth with a new house in the classical style, designed, like so many Northumbrian houses of this period, by the local architect William Newton. The commission offers one of the clearest examples of the way in which the Grand Tour acted as a catalyst for house building in the North of England. According to Welford, R.W. Grey Jnr. later 'exercised a lordly hospitality' here, and he became High Sheriff of Northumberland in 1792. However, the family's enjoyment of their new house was short-lived. Shortly after the tourist's death, his son sold Backworth to the Duke of Northumberland, following a dispute over the Duke's title to the coal Grey was mining on the estate, and it was left to R.W. Grey's grandson to re-establish the family presence in Northumberland, at Chipchase Castle in the North Tyne valley.

THOMAS ORDE (1746–1807)

Undoubtedly one of the most fascinating of all tourists from the North was Thomas Orde, second son of John Orde of West Morpeth, who made the Grand Tour in 1772–4. Orde's tour followed a recent increase in this Northumbrian family's status, after his father had both inherited the estate of East Orde from a cousin, and married the heiress to the Nunnykirk estate. As a younger son, however, Thomas Orde, 'a tall – Rawboned young Man [with a] taste for Drawing',[77] was obliged to make his own way in the world, and, after taking a degree at King's College, Cambridge he became a Fellow there in 1768. Here his talent as a caricaturist somewhat in the manner of William Henry Bunbury became evident in a series of drawings and engravings of street vendors and college servants.[78] Orde seems to have intended to pursue a career as a lawyer, and was called to the Bar in 1775. However, despite his position as a younger son, he was able to make an extended Grand Tour, which began in France and Switzerland in 1772, continued with a journey to Italy from around November 1772 until April 1773, and ended with travels in Flanders, Holland and Switzerland in 1774.[79]

On his way through Switzerland in 1772, Orde joined the long line of British and Northern tourists who visited Ferney

Fig. 85 *The Hero of Ferney at the Théâtre de la Chatelaine*
by Thomas Orde, etching, 1772

near Geneva to see the exiled Voltaire[80]. Here he made a satirical print, *Le Héros de Ferney au Théâtre de la Châtelaine* (fig. 85), which shows the great French *philosophe*, armed with a plumed helmet and sword, acting the part of Lusignan in one of his own plays; Orde's etching offers 'the only evidence that Voltaire himself performed on the stage at his theatre near Geneva'.[81] Five years later Orde's print gained some currency in Grand Tour literature when it was reproduced in William Jones's popular travel guide, *Observations in a Journey to Paris by way of Flanders in the month of August 1776*, Jones explaining that Voltaire, wishing to 'have one of his own pieces represented…got some strollers to fill the under-parts, but at the rehearsal, being out of all patience at the performance of

one of them…started up and threw himself into the above attitude, to shew the Fellow what acting was'.[82] A witty couplet beneath the image implies that the great author's acting may not have been all that he himself imagined:

'*Ne prétens pas à trop, tu ne scaurais qu'écrire*
Tes vers forcent mes pleurs, mais tes gestes me font rire. Anon.'
('Do not claim too much, you only know how to write,
Your verses force my tears, but your gestures make
me laugh'.[83]

A fragmentary journal for November 1772[84] allows us to trace the first part of Orde's Italian tour through Bologna, Florence and Siena. It is, however, the pages on Florence, and particularly on his reactions to classical antiquity, which make this perhaps the most remarkable document penned in Italy by a traveller from the North of England. Orde arrived in Florence on 6th November 1772, after a moonlit journey which had included a visit with Lady Carlisle to the volcano at Pietra Mala, where he had found 'offerings of the Pagan inhabitants who have worshipped the fire as a deity'. Finding the Uffizi closed until Monday, Orde overcame his vexation with visits to the Pitti Palace, where he felt that Andrea del Sarto 'is beyond himself in this place, or rather only to be known here', and to the Biblioteca Laurenziana, where he noted that the oldest extant Virgil was of the 3rd century.[85]

From the moment he saw the Uffizi itself, however, Orde appears to have thought of little else; although visiting the *Galleria* 'on every day this week from ½ after eight till two o' Clock', comparing the various classical statues of Venus on display there, and debating the subject of the *Arrotino or Knife Grinder*, he reserved his raptures for the *Venus de' Medici*. In a passage which deliberately, and only partially in jest, makes use of the language of sexual ardour, he evokes the heightened feelings aroused in him by what was, at that time, perhaps the most famous of all classical sculptures: 'My heart beats now at the recollection of the moment, when I first saw the doors of the Tribune open, and in three steps I had the very Venus de' Medicis in my arms, If she be sensible to touch, which she seems gently retiring from, why would she not answer. The

kisses I could not help printing all over her delicate form – It is really astonishing, that no model, no cast, no painting, no description can do justice to this incomparable piece'; Zoffany's famous *Tribuna* (fig. 17) includes a group of young British tourists whose ogling of the *Venus de' Medici* offers an intriguing, albeit more earthy, parallel to this description. As if to atone for his heady flight of fancy, Orde then proceeded to enumerate those faults which he and others had noted in the statue: 'I will not be so partial to the dear Goddess, as to say she is all in all perfection, for I must dislike the fingers which are too thin and small. I will not pretend to say, that the arms are modern, tho: many are of that opinion…' However, he admired the statue's recent cleaning, considering that the 'operation has succeeded well – as it has only taken off the dirt, and still left the softening coat of antiquity'. If Orde was a determined connoisseur, he was also imaginative enough to

be stirred by the classical past: of the Roman portraits in the *Galleria* he wrote: 'What a field is there open in which to exercise the memory and imagination…In short half the Roman story is here in detached pieces…'.[86]

By the winter of 1772–3 Orde was probably in Naples, and by the following February he had arrived in Rome. Here he remained at least until April 1773, clubbing together with a group of friends, most of whom had already spent some part of their Grand Tour together, to employ James Byres as their *cicerone*. The party's stay in Rome, and its association with Byres, is recorded in two conversation pieces which capitalise on a vogue, currant since around 1760, for showing learned parties of tourists discoursing on Roman antiquities; in the picture featuring Orde, Byres can be seen discussing the famous statue, *Lion attacking a Horse*, in the Palazzo dei Conservatori, with his clients (fig. 86).[87] These paintings are

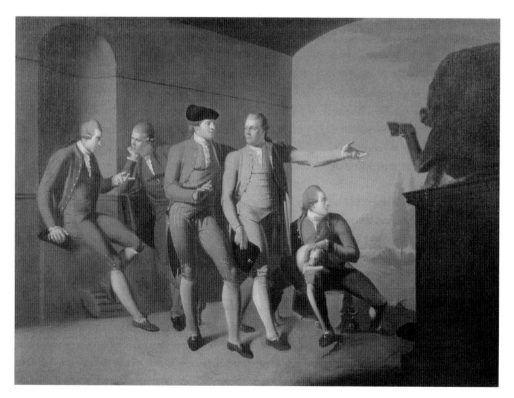

Fig. 86 *Conversation Piece with a group of Englishmen discussing the bronze group of 'The Lion and the Horse' in the Palazzo dei Conservatori, Rome,* attributed to Philip Wickstead, oil on canvas, c.1773.

currently attributed to Philip Wickstead, a little known British artist whose career in Rome was at its height in 1773 – largely thanks to James Byres, if we are to believe the sculptor Thomas Banks, who wrote a trifle sourly in July of that year that 'little Wickstead has had most of the portraits to paint last season, owing to the endeavours of Messrs. Norton and Byres to carry every gentleman they could get hold of to see him'.[88] As Orde's friend John Staples is the only sitter to appear in both portraits, it was perhaps he who commissioned this record of his own and his companions' stay in Rome.[89]

A more important introduction for Thomas Orde and his friends, which again must have come through James Byres, was to Pompeo Batoni; four of the group, including Orde himself, Richard Neville, and John Staples, sat to the artist in 1773. Although Orde's three-quarter length portrait (fig. 87) has few accessories, depicting him leaning nonchalantly on a stone pedestal, book in hand, this is one of Batoni's finest and most sympathetic likenesses of an Englishman. With the better-known portrait of *Valentine Quin, Earl of Dunraven* (painted in this same year), *Thomas Orde* marks one of the high points in Batoni's portraiture, in which the more robust likenesses of the 1760s have been replaced by these supremely elegant, lyrical creations; among portraitists, perhaps only Van Dyck has managed to capture more surely the essence of aristocracy and 'gentility'.

Orde was, indeed, soon to join the ranks of the aristocracy himself. In 1778, only four years after his return home, he married the illegitimate daughter and heiress of the 5th Duke of Bolton, eventually acquiring, through her, the seat of Bolton Castle in Yorkshire; it is perhaps not fanciful to suggest that the widening experience and personal contacts he had made on the Grand Tour may have contributed to this social elevation of a gifted younger son. Orde's advantageous marriage now propelled him into politics, where his administrative abilities led to his appointment as secretary to the Duke of Rutland during his tenure as Lord Lieutenant of Ireland. However, his health was severely damaged by the three years he spent from 1784–7 as the government's principal spokesman in the Dublin parliament. Perhaps in

Fig. 87 *Thomas Orde, later 1st Baron Bolton* by Pompeo Batoni, oil on canvas, 1773

recognition of this, he was created Baron Bolton in 1797.

Although there must have been little time for cultural pursuits during his years in politics, Orde had become a fellow of the Society of Antiquaries on his return from the Grand Tour, and four volumes of his drawings, which he himself assembled in the 1790s, testify to continuing artistic endeavour.[90] He also knew George Stubbs, of whom he made a drawing, but a more important and productive friendship was with George Romney. As well as sitting to the artist for several portraits, Orde owned two of Romney's most important subject paintings, *Mirth* and *Melancholy*, based on Milton's *L'Allegro* and *Il Penseroso*, and inspired,

respectively, by Renaissance bacchanals and classical sculpture; astonishingly, he had purchased these at the Society of Artists' exhibition in 1770, just before his Grand Tour, at the age of only twenty-three.[91] Shortly after Romney's own Grand Tour, Orde commissioned from him, for the chapel of his Cambridge college, King's – perhaps in emulation of recent commissions for other Oxford and Cambridge colleges from artists including Benjamin West, A.R. Mengs and Sir Joshua Reynolds – an altarpiece of the *Mater Dolorosa* weeping at the crucifixion of Christ; as 'an elegant scholar and a man of taste', Orde 'used frequently to read to Mr. Romney such passages in the poets as he thought would afford good subjects for pictures', and the cowled figure of a grieving woman comes so close to *Melancholy* that the choice of subject was surely Orde's.[92] Unfortunately for Romney, his controversial painting, with its overtones of mariolatry, eventually had to be abandoned, and Romney's unfinished composition survives only in sketches.

ROWLAND BURDON (*C.*1757–1838)

Another highly important tourist in this decade was Rowland Burdon (fig. 88), whose family had long been prominent in Stockton-on-Tees as burgesses and mayors. They had risen to landed status, however, only in 1758, when Rowland's father, Rowland Burdon Snr., a wealthy Newcastle merchant and banker, bought the derelict estate of Castle Eden near Hartlepool. Almost exactly twenty years later the younger Rowland, whose education at Newcastle Grammar School and subsequent joining of his father's Newcastle bank represented an education notably different from that of most tourists (although it did include Oxford), left home on an extensive Grand Tour. This took him from London to Spa with the future expurgator of Shakespeare, Dr Thomas Bowdler, and subsequently through Switzerland and France to Italy, where he visited almost every major centre of the Grand Tour. Passing through Rome, in April 1779, on his way to southern Italy, Burdon commissioned from the landscapist Thomas Jones one of three views of the *Bay of Baia* (fig. 89) that he was then working on,[93] and by the time of his return visit in July he

Fig. 88 *Rowland Burdon* by Pompeo Batoni, oil on canvas, after 1779

seems to have been on familiar terms with Jones and his coterie of artists, which included William Pars, John 'Warwick' Smith and Nathaniel Marchant, sightseeing and dining with them, and buying from Marchant a gemstone of *Jupiter Serapis*. At the same time, Burdon sat to Pompeo Batoni for one of his most sensitive, bust-length studies (fig. 88), and he also acquired copies from the highly original British artist, John Brown, who made drawings after the antique, but also more dramatic studies in the manner of Fuseli and Alexander Runciman, and numbered among his clients the great collector, Charles Townley.[94]

The most significant aspect of Burdon's tour, however, was the visit he and Bowdler arranged to Sicily from April to June 1779 in the same year as Henry Swinburne, who must have

inspired their visits to the less-known sites of Selinunte and Segesta. The party, which otherwise followed (in reverse) the route given in Patrick Byrdone's guidebook of 1773, included the young John Soane, who in 1777 had won the Royal Travelling Scholarship to Rome, and whose two years in Italy set him on course to become one of the greatest of all British architects; one of the group, John Patteson, commented that Burdon was 'quite an Enthusiast after Antiquities, if he sees 4 Rows of Stones the Ruins of a Roman building it gives him infinite pleasure [and] Soane the architect cannot help siding with him'. Presumably having discovered themselves to be kindred spirits, Burdon and Soane repaired to Rome together in July, and then made a tour of 'the classic cities of Lombardy', inspecting the Palladian buildings in Vicenza, visiting Verona (where Burdon paid for Soane to measure the works of Michele San Michele), and becoming life-long friends. When Soane visited his friend at Castle Eden on his return from Italy, he produced designs for a porch, and for tripods for the staircase there, as well as a seminal – but unexpected – design for a small house at Castle Eden inspired by the villas he and Burdon had seen on the Brenta. Fifty-seven years later Burdon reminded Soane of the time they had spent together abroad, 'when the foundation of your science was laid', adding in the following year that 'Few expeditions have begun, continued and ended, with more uniform and satisfactory results'.[95]

Fig. 89 *Bay of Baia* by Thomas Jones, oil on canvas, 1780

Although Burdon was later referred to scathingly by one commentator as a 'macaroni manqué grafted on the son of Newcastle banker by two years running about in Italy',[96] he went on to become a key figure in the Industrial Revolution of the North-East, a 'public benefactor, a statesman, an engineer and a philanthropist', and a man who considered the 'good of the community more than [his] own private advantage'.[97] One of Burdon's earliest projects was to promote the construction of the turnpike road from Stockton to Sunderland; later, through his influence, this ran from Newcastle to Thirsk, providing a crucial arterial link that facilitated the growth of Tyne and Wear. In 1790 Burdon was elected to Parliament as Tory MP for Durham – an early instance of 'a mercantile man being chosen knight of the shire'[98] – when he was able to facilitate and largely pay for the building of the single span Iron Bridge across the River Weir; replacing the original ferry, this was acclaimed in 1796 as one of the wonders of the new industrial age. Among the design consultants was Soane himself. When, three years earlier, Burdon laid the cornerstone in a Masonic ceremony, the inscription offered an intentionally pointed contrast between English and French activities: 'At that time when the mad fury of French citizens, dictating acts of supreme depravity, disturbed the peace of Europe with iron war, Rowland Burdon, Esqre., M.P, aiming at worthier purposes, hath resolved to join the steep and craggy shores of the river Wear with an iron bridge'.[99] Such sentiments may not have been altogether shared by Burdon's fellow MP, who attended the ceremony with him, the political radical, prominent freemason and future tourist William Henry Lambton.

Burdon's philanthropy in this and other directions would later pay unexpected personal dividends. When, in 1806, his Newcastle bank, Surtees and Co., failed, the local gentry clubbed together to save his life interest in Castle Eden – where Burdon had completed his father's mansion, and opened up to the public the dene from the castle to the sea, in a pioneering approach to land access – in recognition of his 'disinterested exertions… from which the commercial and landed interest of the county of Durham have derived

advantages of the most extensive importance'.[100] Through his first wife, Margaret Brandling, he was connected to several leading Northern tourist families, and his son, Rowland Burdon V, also made the Grand Tour.

ROBERT WHARTON (1751–1808)

Perhaps the most informative, certainly the most engaging, of the region's many tourists, although one who apparently brought back no artefacts to the North beyond a few of his own drawings,[101] was Robert Wharton, a highly cultivated young man with a strong appreciation of music, who went to Italy 'not to stare but to study', translated 'backwards & forwards' Montesquieu's 'Letters familieres & Persanes.', and read his *L'Esprit des Lois* [102] while in France because 'I am going into different nations, differently governed' and 'That is the only book to enable me to judge of, and profit by seeing their governments'.[103] This was a preparation for the Grand Tour beyond that of most tourists, and Wharton undoubtedly shared with a later Northern tourist, John Carr, a belief that continental travel concerned not just 'my present pleasure, but my improvement and future advantage', noting that in Italy:

> 'I would not wish to go like some Jennyns's
> "My Lord" who Runs over Italy & France
> Measures St. Peters Dome, & learns to Dance.'[104]

Indeed, he told his uncle that if he returned 'full of the follies of ye country thro' which I have passed; all you will have to do will be to Laugh at the Macaroni & Petit Maitre & send him back as untrustworthy'. Wharton, however, also had a lively, and unusually appreciative, eye for continental customs, and the remarkable series of letters he wrote home to his mother and to his extended Durham family throughout his Grand Tour of 1775–6 are as illuminating on the subject of the acquisition of French polish, or the nonchalant Gallic attitude to urinating in public, as they are on more serious aspects of the Grand Tour.[105]

The feeling that here was something of a free spirit, who, always enthusiastic, and occasionally naïve, was not afraid to judge differently from the majority of tourists, and who,

indeed, could often be highly critical of them, can probably be accounted for to a large extent by Wharton's social origins.[106] Although he had been sent to Eton and Cambridge, he was the son of a Durham woollen draper, and his Grand Tour was undertaken in the interval before taking his M.A. degree, initially to perfect his French – he had won the Chancellor's medal at Cambridge for languages. This was to be a tour played out at a very different social level from most of those made from the North; although Wharton was independent of the financial constraints which governed professional tourists, he was typical of those travellers on moderate incomes who made up an increasing percentage of Grand Tourists after 1763.[107] Perhaps because of the delayed development of a 'polite' society in the North of England, however, tours such as this one were still the exception rather than the norm.

Wharton was destined to become a clergyman – indeed, his mother expressed her concern that the extension of his tour into Italy might hold up his ordination and preferment in the church – and, unlike wealthier tourists, he took the public *diligence* for much of the way from Calais to Paris, defending this means of transport as a way of seeing the French people as much as possible.[108] He could, however, afford to hire a servant recommended by his uncle, and on his way through Cambrai he called on a Miss Swinburne and her aunt and uncle,[109] a fact which suggests that his apparently modest social origins should perhaps not be overestimated. Arriving in Paris in late February 1775, where, like other intelligent tourists, Wharton seems to have avoided spending too much time with his compatriots, seeing 'hardly…any but Frenchmen' and reading and speaking 'little else but French', he was struck by the civility to strangers, good manners, and relative honesty of the French; by the fact that not all their dishes were stuffed with onions; and by such Parisian habits as kissing each other on both cheeks, 'a ceremony that we should think rather ridiculous in England', bathing in the river (a pastime undertaken by both sexes), and carrying umbrellas (fig. 7). Although he was, on the whole, receptive to continental customs, the latter, he considered, would 'set an English mob in a roar'.[110]

Like other tourists from the North, Wharton found the streets of Paris, 'dark, narrow & dirty', but the public buildings and palaces were glorious: 'we have nothing like them'. Although he enjoyed the theatre, seeing what was presumably Moliere's *La Malade Imaginaire*, and the dancing at the *Comédie Italienne*, he found the Opera 'truly execrable both as to the singing and the composition'. The French sang 'thro' their teeth in a thin voice', and he was not alone among British tourists in feeling that 'the eye is the only organ to be pleased at the French opera'; Gluck's recent *Iphigénie en Aulide* alone met his exigent standards. Perhaps because of his musical inclinations, Wharton also went to hear 'Grand Mass' at St. Roch on the feast of the Assumption, rather predictably finding the ritual 'nothing grand or majestic…but…more like a shew'.[111]

The time Wharton had available for sightseeing in Paris must have been somewhat curtailed by his having his hair done once, sometimes twice a day – an occupation he almost certainly shared with most British visitors to the city (fig. 37). However, he still saw more than most tourists, visiting Notre Dame, which was 'by no means equal to York Minster'; the Luxembourg; and the great picture collection of the Duc d'Orléans, which he considered superior to those at Blenheim, Keddleston or Burleigh. However, it was Le Brun's portrait at the Carmelite convent in the Rue Saint Jacques of Louise de la Vallière, mistress of Loius XIV, as a Magdalen 'tearing off her strings of Pearls' in an act of penitence, which riveted the future clergyman.[112] Wharton also visited the Bastille, which he pronounced 'horrible indeed'; the Sainte Chapelle ('a most Elegant Gothic structure. I think we had hardly anything of the kind in England'); and a Carthusian convent where the inmates dug their own graves. At Versailles he was shocked by the run-down appearance of part of the gardens, with 'the fountains broke, or not playing; several statues pulled down. in short it had more the appearance of a large wood merchants shop than the Park of a great Prince'.[113]

By May 1st 1775 Wharton had moved on to Dijon, where, in pursuance of his plan to improve his French, he lodged with a French family; at his first meal with them he ate a fricassee,

which he subsequently discovered was composed of frogs. Here, however, Wharton's tour changed radically both in its focus and its extent,[114] when he met George, 2nd Earl of Powis, whom he found 'much more…[amiable] than most young Noblemen are in general', and his experienced bear-leader, William Patoun, a 'universal scholar', who remembered Wharton from his days in Cambridge, and advised him that he could see Italy in four months for only 150 guineas. Although Wharton then had precisely 190 guineas left to his name, he needed little persuasion. Patoun, who was 'au fait de tout', having guaranteed him the entrée to consuls, *literati* and antiquarians in Turin, Florence, Rome and Naples, Wharton now sought permission from his guardian uncles to extend his tour, asking them to intercede on his behalf with his mother – clearly a necessary precaution. He spent the time until their answer arrived playing sonatas with a young French officer; dallying with a young lady who, were she 'prettier, genteeler, Richer, & a Protestant', might, he joked with his mother, have become her daughter-in law; and taking lessons in riding and in the 'art of walking, Bowing, giving, receiving standing &c *avec bonne grace*' from a 'Professor of Bows', which he did not consider it 'too ridiculous to receive'. He also made an excursion to the great monastery of Citeaux, where he was received by the double-chinned Abbé, the 'true picture of ease & good living', who shocked Wharton's Protestant sensibilities by consuming almost a whole bottle of wine at lunch before excusing himself for an afternoon nap.[115]

Permission to travel to Italy having duly arrived, Wharton moved on, via Geneva, to Lyons, where his French improved rapidly under the tutelage of two 'very formidable…sensible, Lively, handsome & musical' young ladies. Although he reported thankfully to his cousin Miss Raine that he had escaped a 'couple of syrens' without mischief, the delay in his departure, owing to his tailor not having finished his winter wardrobe, cannot have perturbed him greatly.[116] A more serious delay was caused by the illness of William Patoun, who, with Lord Powis, had left Dijon before him, but whom he now met again, Wharton helping Lord Powis to nurse him. On Patoun's recovery, Wharton parted from his two friends,

hoping to see them in Rome. Unlike most Northern tourists, he chose to make much of the next part of his journey by boat instead of over the Alps, travelling down the Rhône to Avignon, where he arrived on 2nd October to find narrow, vilely paved and dirty streets, and a language (Provençal), which he could not understand. After a visit to Aix, he moved on to Marseilles: here, on the Quais, he saw a group of galley slaves working at their trades, among them perhaps the party of three hundred slaves he had heard of earlier in transit in Lyons, chained two by two by the neck. Although Wharton mentions the sympathy for them evinced by the French, his own attitude is not apparent from his careful record of their plight.

On 23rd October Wharton arrived in what he had recently dubbed 'the land of ancient virtue and modern virtu (otherwise called taste)'.[117] Having landed at Leghorn, almost his first act in Italy was to dine with the consul there, the Northerner Sir John Dick, who 'received me with more than politeness'; four days later he was writing that he was now 'in the High Road to Taste in all Arts & Sciences'. On his way to Rome, where he spent the winter of 1775–6, Wharton passed through Pisa and then Florence, where, to his surprise, he found an 'old acquaintance', Giuseppe Millico, singing the castrato role in Giuseppe Gazzaniga's opera *Perseo*. Wharton, however, found the orchestra inferior to that of the Haymarket at home. Like most tourists, including his Northern contemporary, Thomas Orde, he discovered that the *Venus de' Medici* was 'beyond all imagination', while scenes on the journey from Florence to Rome would have made his correspondent, Thomas Brand, 'tressaillir de plaisir [throb with pleasure]. Such a country'.[118]

By November 15th 1775 Wharton was in Rome, finding 'hardly above 30' Englishmen there. Among these were his friends Lord Powis and William Patoun, and the three men clubbed together to take a course of antiquities from James Byres, which had begun (with the Forum) by 8th November, and ended by 20th December. Wharton thought highly of his *cicerone*, reporting that he was 'perhaps the best Antiquarian living' and that it was impossible to 'conceive a just idea of ancient Rome without Byers's remarks on the spot'.[119] From a tourist whose diligence in reading guidebooks is indisputable, such a compliment was worth receiving, and Wharton goes on to explain what was perhaps the key to Byres's success with countless British tourists: his ability to conjure up for his auditors that part of a ruined building 'wch is lost'.[120] Ever an industrious pupil, Wharton took short notes on the sights he saw, and his letters consequently provide a more complete list of the Grand Tour itinerary in Rome than that offered by most tourists. By the time his course had ended, he was confident enough to instruct his mother as to the identification of the antiquities to be seen in a picture of the Roman Forum over her Chimney Piece, concluding: 'now you may study Antiquities whenever you like'.[121]

As for other British tourists, Rome, for Wharton, represented the pinnacle of the Grand Tour: 'the Magnificence of the Palaces, vast collections of Pictures, Statues, antiques of all kinds, and above all the noble Remains of its antient Grandeur are beyond any thing one sees elsewhere' he wrote, and he admired the *Apollo Belvedere*, which aroused feelings of a 'more awful kind', even over the *Venus de' Medici*. Rather surprisingly, however, he was not altogether impressed with the Forum, which he found 'Magnificent but heavy – neither the architecture or the sculpture is good', and although, in common with almost all British tourists of his generation, he was at first 'more struck' with Rome's most complete antique temple, the Pantheon (fig. 13), it was St Peter's that, as his stay progressed, he came to consider 'the most Glorious Building in the World', the dome, completed by Michelangelo, astonishing him by the architect's having made good his vow to 'Build it in the Air'.[122]

As an industrious young man, it is not surprising to find Wharton taking lessons in drawing, Italian, and on the 'cello (he had brought his own instrument with him on his travels), and we know that he made some costume drawings which he told his cousin he would ship back to England.[123] His morning was divided into reading, writing and then visiting the antiquities (from 12 until 3 pm); after dinner he studied with his tutors, while evenings were passed with Lord Powis and William Patoun, 'with whom almost all my leisure hours are

spent'. Clearly, Rome, for Wharton, was 'no place to be idle in', and his letters offer an insight – unique among Northern travellers – into the young tourist's organisation of his room, his studies and his books: 'Take a Sketch of My Room – There lies Vignola – There Bentivoglio – There some Heads to copy – There La Crusca – There the papers of Notes on the Antiquityes – There others of a different Kind for the Violoncello – There Du Fresnoy with Italian Notes & on him Cochin's School of Painting – & by Way of filling up Time a Classic or two'; in writing to his Cambridge friend, Thomas Brand, he compared the present 'agreable' contents of his table with the books they had studied at Cambridge, which had included Euclid.[124]

It was, however, Wharton's musical experiences in Rome which set this tour apart from the norm. His music master, Pietragna, who taught him the 'cello, was a friend of Boccherini, and Wharton was also introduced to the Pope's 'Chapel Master', Santarelli. His penetration right to the heart of Rome's musical life is confirmed by his attendance at the twice-weekly concerts in Pompeo Batoni's house, where he hoped in time to make himself useful by playing the bass part. Here he heard performances of Boccherini quintets, and Batoni's daughters, Ruffina and Beneditta – whom Wharton considered to be 'the best singers (virtuose) in Rome, & the eldest perhaps in Europe', far exceeding even Mrs Sheridan – singing the *Stabat Mater* of Pergolesi, which he found the 'highest perfection of Music on Earth. There may be better elsewhere but it must not be for Human Ears…all other music sinks before it'.[125] Wharton also attended a concert given by the Duke of Gloucester, at which Handel's *Alexander's Feast*, translated into Italian, was performed, and heard the English harpsichordist, John Burton, a short-lived protégé of William Beckford, perform at the home of the Marchesa Lepzis.

Wharton, however, was not interested only in serious music. He attended every musical diversion the city could provide, from the outdoor symphonies played to celebrate the creation of four new cardinals, down to the comic operas at the Alberti theatre and the 'Farcical Comedies with Musical intermezzi' by Giovanni Paesiello (whose *Barber of Seville*

achieved fame many years before Rossini's) at the Teatro della Valle which were performed during the Carnival. This famous spectacle was, however, the occasion for 'continued scenes of noise & riot', and Wharton was also critical of the 'desire to show & parade' which, together with their ignorance, was, for him, the distinguishing characteristic of the Roman nobility; the people themselves still harboured, in his view, 'that brutal spirit that it had when Gladiators were its delight'.[126] Wharton's hopes of meeting a very different group of people, the Roman *literati*, were gratified when he was introduced to the Arcadians, 'the first Literary Society in Rome', which, however, he later judged to be 'sunk into a Gloom & Obscurity from which there are small hopes of it ever Emerging'. Like most Protestant tourists, Wharton was also critical of Catholic customs and ritual, noting with consternation that at least a quarter of the people in Rome seemed to be priests, and later, like William Ord, expressing his distaste at witnessing (in Naples) two nuns taking the veil. However, he attended the installation of the new Pope, Pius VI, in December 1775, and the Easter ceremonies the following year, during which, on Maundy Thursday, the Pope washed the feet of poor priests from several countries, while the cardinals ate 'like any Alderman at a Turtle Feast'. With Lord Powis, he also had a 'short & civil' audience with the Pope soon after his inauguration.[127]

Like most British tourists, Wharton made an excursion from Rome to Naples, which lasted almost a month from mid-January 1776, in the course of which he climbed Mount Vesuvius, eating a 'beef stake broiled on the Lava', and saw the usual sites, noting, like Harriet Carr nearly twenty years later, that the whole area around Naples 'is infinitely indebted to Virgil', and that the Museum at Portici had 'the furniture of every part of a Roman house from the ladies dressing room to the kitchen'. His visit here, however, was, distinguished by his regular attendance at the concerts given by Sir William Hamilton and his musical first wife, Catherine, 'at whose house I was almost Every Evening that they were in town'; Lady Hamilton, Wharton judged, was 'the Greatest performer on the harpsichord I have yet met with for Taste of

Expression'.[128] In the year before Henry Swinburne's arrival in Naples to research his guide, it proved too expensive and inconvenient for Wharton to think of extending his tour to include Sicily.

It seems almost certain that, like so many tourists, Wharton left Rome, on 19th April 1776, with regret: shortly beforehand he wrote that 'when I have left Rome I shall look on the other objects but with an Eye of Indifference, as one who has just lost his Mistress passes every other beauty and scarce looks at them'. Travelling with a French physician, he headed north for Venice, taking, instead of the usual itinerary through Florence, a route up the Adriatic coast through Ancona and Rimini, before turning inland to visit Bologna, an essential port of call for a tourist who rated the Carracci even above Raphael.[129] Spending two weeks in Venice in May, Wharton noted the singularity both of this 'Vast City rising from the Sea' and of the gondoliers singing verses by Tasso and Ariosto, but failed to see Ascension Day, which was delayed by bad weather. He then made a lightning tour of Padua, Verona (which he considered 'next to Rome… for its situation, air, Neatness and beauty, & above all for its Literary Society'), and Vicenza,[130] before heading over the Alps to Innsbruck and returning home through Augsburg and Strasbourg.[131]

Although, as a future clergyman, Wharton felt obliged to deplore 'the Works of Tyranny & Superstition', he concluded that Italy was 'the finest Country in the World & the most worthy of the Examination & Curiosity of Every one who loves Instruction',[132] and his interest in the Grand Tour, from which he returned in July 1776, just in time to take his M.A. degree, clearly remained: as the friend and contemporary at Cambridge of another clerical tourist, the Rev. Thomas Brand (c.1751–1814), Wharton later became the recipient of a number of Brand's own continental letters, which provide an even more valuable account of the Grand Tour than his own.[133] Although Wharton's mother feared that his career in the church might suffer from his being in Italy, and therefore 'neither in Orders nor likely to be within reach of accepting' the living of the ailing Rector of Escrick, Mr Harrison, who was expected to 'go off soon',[134] Wharton went on to have a

relatively distinguished career in the church, becoming rector of Sigglesthorne in Yorkshire, and later Archdeacon of Stowe and Chancellor at Lincoln, a post in which Brand succeeded him on his comparatively early death in 1808.

THE ELLISON FAMILY ABROAD: 1743–83

Few families from the North were such persistent tourists as the Ellisons,[135] who had made their mark on Newcastle life and trade in the mid-17th century, when Robert Ellison had become Sheriff and purchased the estate and hall at nearby Hebburn. By the time of the Restoration, he owned much of the land from Gateshead to Jarrow, but, despite the family's new landowning status, it retained its interests in trade, managing coal-mines, salt pans, mills and the ballast shores on its property at Hebburn. Robert's grandson, another Robert, connected the Ellisons with one of the most powerful families in the North when he married the daughter of Sir Henry Liddell of Ravensworth Castle, but it was left to his second son, Henry Ellison Snr., to turn the family into the greatest landowners of the district south of Newcastle by his shrewd management of the family's property, and his marriage to a wealthy heiress, Hannah Cotesworth, through whom he acquired the estate of Gateshead Park.[136]

Both Henry Ellison Snr. and his elder brother, General Cuthbert Ellison, who inherited the family estate at Hebburn, made tours abroad for their health. Henry Ellison visited Spa in the Austrian Netherlands in 1743, but later found it cheaper and more convenient simply to order 'consignments of Spa water at £20 a time from the English Physician' there.[137] Cuthbert Ellison, despite being a successful career soldier who eventually rose to the rank of Lieutenant-General, nevertheless managed to spend much of his life after 1745 in semi-retirement at spas both in England and abroad, being, in his own opinion, 'better fitted for an Hospital than the Field'![138]

The Grand Tour made by Henry Ellison Jnr. (fig. 90) in 1764–5 set the seal on the family's accession to gentility. As the eldest son of Henry Ellison Snr., Henry received an education typical of a young gentleman at this period; he went

Fig. 90 *Henry Ellison*, copy after Pompeo Batoni,
oil on canvas, after 1764

to Eton and Cambridge, before going on to study law at the Inner Temple in London. As his family hoped that he might gain lucrative employment through his powerful Ravensworth relations, Henry remained in London rather than in the North, and it was perhaps because of these ambitions that he waited until the age of thirty before venturing abroad.

The Grand Tour was, however, very much an expected sequel for a young man whose perspective extended beyond provincial society to embrace life in the capital and beyond, and Henry Ellison left for the continent in February 1764, arriving in Rome by 25th April, where he was in time to enjoy the festivities which took place during the visit of the Duke of York, second son of George III.[139] From Rome, Ellison visited Naples and Capua, returning north through Florence and Bologna; his travelling companion was a fellow former Cambridge student, Dr Wilkinson Blanchard, who preferred 'not to have his profession noticed'.[140]

It seems likely that Ellison's *cicerone* was James Byres, as he visited Tivoli with Byres and the diarist James Martin on 18th June 1764. The connection with Byres would have led, almost inevitably, to Batoni's studio, and, during his stay in Rome from April–June 1764, Henry Ellison sat to Batoni for a portrait which shows him standing in front of the Colosseum; fig. 90 is a contemporary copy after Batoni. The original epitomises Batoni's half-lengths of the early 1760s, in which the robust figures of his British clients still very much fill the frame, and the view of ancient Rome is restricted to a 'window' behind and to one side of the sitter. The emphasis here is on good breeding and gentility, on the good sense and tranquil nature which the great historian Edward Gibbon, with whom Ellison dined in Florence at Sir Horace Mann's, noticed in his fellow visitor: 'c'est un homme de mérite. Il possede le bon sens, des connaissances et un caractère qui paroit doux et tranquille'; Gibbon's reading of Ellison's character was probably an acute one, as the Master of Henry's Cambridge college had singled out similar characteristics in his pupil.[141] Although Ellison's letters from Italy do not survive, we know from his later correspondence that he was 'almost surfeited with Paintings' on his Italian tour.[142]

On his way home in early 1765 Henry Ellison was taken dangerously ill with an 'ugly Fever' in Paris.[143] He recovered, however, and, despite the probability that he acquired a mistress here, who later appealed for his help over maintenance from another lover,[144] he went on, like his predecessors, to marry carefully and well. As he also inherited his uncle Cuthbert Ellison's estate at Hebburn, where he built an imposing new mansion in the classical style, he had become, by 1785, one of the most important landowners in the whole of the North East. Unlike later generations of Ellisons, however, Henry maintained his links with Newcastle's business life; as industrial Tyneside grew, his successors moved to the rural south, leaving Hannah Ellison to unite the family with the Carrs. Ellison's commitments in the North did not, however, prevent him from returning to the

continent in later life: he made two further visits to Paris, and was among the earliest tourists from the North to see the Swiss glaciers, on a tour of around 1772; these 'made so strong an impression on my mind' that the 'stupendous Scenes…cannot be effaced'. While he was in Switzerland it seems almost certain that Ellison also visited Ferney and its 'old Professor' as he termed Voltaire.[145]

Sometimes, continental travel was undertaken for reasons quite other than recreation or the pursuit of culture. Henry Ellison Jnr's younger brother Robert (1738–83), a merchant banker and poet, had to retire to Switzerland in 1781 when his business failed, and he spent the rest of his short life in exile abroad, bearing his severe 'trials', in the opinion of his friends, with 'a becoming and a manly resignation' and fortitude.[146] On this very different journey, Robert was obliged to take the public coach or *diligence*, travelling from Paris to Lyons, and then on to Geneva. The political situation here was, however, far from ideal, and in 1782 Robert moved to Lausanne. His letters are of considerable interest because of two tours he made in 1782–83 to see, respectively, the Swiss glaciers – almost certainly on his brother's recommendation – and La Grande Chartreuse; on the former he was accompanied by an Englishwoman who, unlike his admiring sister back at home, seems to have had a head for danger, and, perhaps, for heights, while on the latter Ellison noted the stark contrast between two 'smooth & oily & fat' monks, with 'contented Countenances', and 'a half starved shaking servant old, weak & withered'.[147] Perhaps even more interesting than the tours themselves is the fact that Robert's appreciation of nature both in her 'most majestic & awfull form', and in her changing aspects, is proto-Romantic: on an evening walk near Geneva in 1782 he described the sun going down 'behind those mountains [the Jura] – The shadow on the hills gradually changing from light & misty grey to darker, till they became a deep and glossy blue in some parts verging to a purple'.[148]

THE RIDLEY FAMILY AND OTHER TOURISTS, 1760–80

From 1765–7 the young Sir Matthew White Ridley, 2nd Bart. (1745–1813), son of Matthew Ridley of Heaton Hall, rounded off a typically fashionable southern education at Westminster and Oxford with a year spent at the Academy at Angers, followed by a tour of southern France. An old Northumbrian family, the Ridleys had long been prominent in Newcastle mercantile and political life: with diverse interests in coal, salt, glass and pantile manufacturing, and brewing, Ridley's father served as Mayor of Newcastle on four occasions, and as M.P. for the city from 1747–74, having held it for the Hanoverians during the 1745 rebellion. However, his son's accession to a baronetcy, and the estate at nearby Blagdon, on the death of his uncle, Sir Matthew White in 1763, just prior to his Grand Tour, marks the family's transition to the status of major landowners. On the whole, the twenty year-old Ridley seems to have been decidedly unimpressed with what he saw abroad, complaining in letters home of 'Fleas and Buggs' and especially of the stench of the streets: 'The People in general [are] worse than Scotland as they don't wait for the cloak of darkness but empty their chamber pots with great ease out of the windows at midday and eat garlick like pigs'. As a result, Ridley informed his father, 'you cannot walk in the streets without a handkerchief at your nose…no wonder that Marseilles has been troubled with the Plague'.[149]

Ridley's tour included a number of the popular English gathering places in the South of France: Aix en Provence (where he met 'Mr. & Mrs. Swinburn who were very civil and desire [their] compliments to you'), Montpellier, Nîmes, Marseilles and Avignon, but he does not appear to have visited Italy. The conclusion he drew from his travels, 'I must own that as yet I have found nothing that wd. make me prefer France to my own country', was one that was shared by many tourists.[150] Ridley's later contribution to national and local life was, like his father's, considerable. From 1774 he sat as a Whig M.P for Newcastle through eight successive parliaments, his support for liberty, and, in particular, for a policy of conciliation towards the American colonies, winning him both the approbation of the Newcastle guilds, and, reportedly, the affection of his constituents. However, since 'local representation…mattered to [the Ridleys] more than political ambition',[151] Ridley retained his role in Newcastle

affairs as Governor of the Merchant Adventurers' Company, as Mayor on three occasions, and as a partner in the city's first banking house.

Sir Matthew's later correspondence with his sons makes it clear that he was active as an art collector and connoisseur, and that his taste in pictures had been conditioned by his Grand Tour, although, given the lack of an early inventory, it is in most instances impossible to establish if the Dutch or Italian Old Master paintings formerly in the collection here or in London were acquired by him or by later members of the family.[152] At Blagdon, the 2nd Bart. employed James Wyatt from 1778–91 to make alterations to the east front and the interior, and to build the fine stable block and lodges to the park, while, appropriately for a former tourist – albeit one who had not journeyed as far as Italy – the monument to Sir Matthew by Flaxman in St. Nicholas, Newcastle, shows him in 'senatorial and magisterial' mode, garbed in a Roman toga.[153]

Ridley's elder half-brother, Major Richard Ridley (1736–89), also went on the Grand Tour in the early 1760s, shortly after the ending of the Seven Years War, in which he had served with the army in Germany. As the only son of Matthew Ridley's first marriage to Hannah Barnes – which appears not to have been publicly acknowledged in her lifetime – rather than of his second to Elizabeth White, heiress to Blagdon, Ridley did not stand to inherit a major estate, and he appears to have ceded his right to his father's less substantial property at Heaton Hall to his younger half-brother, possibly in exchange for an army commission. However, by July 1764 Richard Ridley was in Italy, travelling with another army officer, John Holroyd, later 1st Earl of Sheffield, from County Meath, and Holroyd's fellow countryman Theophilus Bolton.[154] The companions visited almost all the principal Italian cities, including Turin, Florence, Rome and Naples; on their return through Genoa in 1765, Bolton died there of consumption. Ridley's tour is memorable for its connection with the young Edward Gibbon, whose contemporary tour of Italy was arguably the most important of the century, given that 'the idea of writing the decline and fall of the city [Rome] first started to my mind' as he sat 'amidst

the ruins of the Capitol' in October 1764.[155] On their way through Florence only a month previously, Ridley and his two companions had dined with the future historian, whose lifelong friendship with Holroyd had begun earlier on this same tour, in Geneva, in 1763. Gibbon's letters make it clear that with Ridley, too, he was on familiar terms. He wrote to Holroyd in Berlin in October 1765, asking: 'Is Ridley with you? I suspect not: but if he is, assure him I do not forget him tho' he does me' – a letter which leaves open the possibility that Ridley accompanied Holroyd on his later travels in Austria and Germany.[156] Both Ridley and Holroyd later became members of Gibbon's Roman Club.

From Gibbon's contemporary letters, and Holroyd's tour journal – Ridley's own papers do not survive – it is possible to gain an insight into the tours made by these highly intelligent and witty free-thinkers, whose views Ridley seems likely to have shared. Writing to Holroyd apropos of the Viennese court, Gibbon warned him: 'Princes, like Pictures, to be admired, must be seen in their proper point of view, which is often a pretty distant one', and Ridley's travelling companion certainly stood in awe neither of popes nor royalty, comparing the Pope in his vestments to a 'Tortoise with a little Head standing out'.[157]

Such sentiments stand in stark contrast to those of the majority of tourists. They would certainly not have appealed to another Northumbrian traveller of the mid-1760s, whose Grand Tour also brought him into contact with one of the pre-eminent figures of the age. Henry Errington (?1738–1819) came from an ancient Catholic Northumbrian family, which had owned land at Beaufront near Hexham since 1585, and which, although Jacobite in inclination, had, like the Swinburnes, but unlike the Radclyffes, managed to avoid ruin in the 1715 rebellion. As a second son, Henry Errington, like Henry Swinburne himself, perhaps ventured abroad only after inheriting another family estate at nearby Sandhoe from an uncle in August 1765.[158]

In Italy, Errington became the travelling companion of the consumptive author of *Tristram Shandy*, Lawrence Sterne, who was abroad for his health, and whose letters document this

Fig. 91 *Elevation of the House at Haggerston Castle, Northumberland*
by G.A.D. Quarenghi, pen and watercolour, about 1777

tour. The two men, who were already acquainted, met in Rome in December 1765 and travelled together to Naples, where they spent a 'jolly laughing winter', attending 'nothing but operas – Punchinellos – festinos and masquerades'.[159] Here, Errington evidently offered to pay Sterne's travelling expenses if he would accompany him on the return journey to England, thus initiating a change in the indigent author's plans. Instead of sailing home, Sterne agreed to accompany Errington northwards, outlining their intended route (after Rome for Holy Week and Venice for the Ascension) through Vienna, Saxony, Berlin and Holland. By the time they had reached Monte Cassino, where they were treated at the monastery 'like Sovereign Princes', various 'cross accidents' had been met by the duo with 'sporting and Laughter', and from Rome, on Easter Sunday 1766, Sterne reported 'We are passing as merry a Spring as hearts could wish'.[160] Although Errington, as a 'gentleman of fortune', was paying the bills, the author clearly felt affection for this 'good hearted young gentleman', and he told John Hall Stevenson (p. 91) that 'I am persuaded we shall return home together, as we set out, with friendship and good will'. Despite such amity, the two men's travel plans did not mature, and they travelled home separately from Rome. Sterne's original companion on his Italian tour, who travelled with Errington and Sterne from Rome to Naples, but who was obliged to stay behind there owing to ill health, was the so-called 'Marcellus of the North', Sir James Macdonald of Sleat on the Isle of Skye, who was said at twenty-one to have the 'learning and abilities of a professor and statesman', but was condemned by Walpole as 'rather too wise for his age and too fond of showing it'.[161] Clearly, Errington moved in highly cultivated circles during his tour; however his last recorded meeting with Sterne is at race week in York in August 1766 soon after their return.

Having made an advantageous marriage to the widow of a baronet, Lady Broughton-Delves, Henry Errington later returned to Italy with her in 1774, visiting Florence, Rome, Milan and Venice. Some years later, in 1785, this Northumbrian Catholic witnessed the secret marriage of his niece Maria Fitzherbert to the Prince of Wales. It was his elder brother John, however, who inherited the family's main seat at Beaufront, and with whom Henry Swinburne dined in September 1779 during a brief Northumbrian interlude in his six-year Grand Tour. Judging John to be 'as cracked as ever man was. I wonder he is still allowed to be at large', he linked his 'mania of fancying he has been created Duke of Hexham' with his Jacobitism, explaining: 'A foreign title is his idea, for a foreign crown is over his door'.[162] Swinburne's doubts as to John's continuing liberty proved well-founded. John died a

lunatic, while his much more successful tourist brother Henry, who had an estate in Hampshire, and died in London, predeceased him, leaving no children, and the Errington estates were passed on through the female line.

Henry Errington had travelled abroad only in his late twenties. However the education of young Catholics abroad also continued apace in these decades, the most notable product being Henry Swinburne himself. Like their father and grandfather before them, the young Carnaby (1756–1831) and Thomas (d.1829) Haggerston made the Grand Tour escorted by a priest-tutor.[163] Having left Haggerston on 4th July 1776, they were in Rome in the winter of 1777–8, where they learnt of their father's death; it was presumably the new baronet's accession to the family property and titles which led him to commission designs for an ambitious new house at Haggerston from the Italian neo-classical architect G.A.D. Quarenghi (fig. 91). Sir Carnaby did not have to look far in his choice of architect: Quarenghi, who was dubbed 'Palladio's shade', had formed one of the circle around Winckelmann and Anton Raphael Mengs, and Haggerston was by no means his only Grand Tourist client. Quarenghi's designs for Haggerston were, however, characteristically grandiloquent – a thirteen bay house with a rusticated ground floor and an octostyle colonnade and pediment above – and it is hardly surprising that they never left the drawing board. There were also plans for a Coffee House (which itself would have been larger than Lord Burlington's villa at Chiswick) and Stables. The scheme, although unexecuted, is of particular interest as being the only architectural project known to have been commissioned in Italy by an 18th-century Grand Tourist from the North; later, from 1808, Sir Carnaby added wings to the house at Haggerston built by his father prior to 1771.[164] Another young Catholic was Edward Smythe (1758–1811) of Eshe in County Durham, who, like Henry Swinburne, studied at the Academy in Turin, and who, following in his father's footsteps, toured Italy from around 1779–80.

The most important Catholic tourist of this generation, however, with the exception of Henry Swinburne himself, was Henry Howard (1757–1842) of Corby Castle near Carlisle,[165] whose parents, Philip and Ann Howard, had travelled extensively in France earlier in the century; they were admirers of Jean-Jacques Rousseau, and friends of the Comte d'Antraigues, who based the heroine in his unfinished novel, *Henri et Cecile*, on Mrs Howard.[166] After being educated at Douai from 1767–73, and under a Benedictine tutor in Paris, Henry Howard studied at the Theresian Academy in Vienna from 1774–7 (where, like the Swinburnes, he received 'marked personal courtesy and kindness' from the Empress Maria Theresa), and in Strasbourg, eventually returning to Corby in 1784. His soujourn abroad was intended to fit him for a military career, which, however, as a Catholic – and despite the personal intercession on his behalf of the British minister in Vienna – he was not allowed to pursue once back in England. However, it also included a visit to Voltaire's home, Ferney, near Geneva, shortly after the great man's death, during which Howard 'was privileged to sleep in the 'yellow stuff' bed of the French *philosophe*'.[167] Henry Howard made two further tours in 1815 and 1831. By now he had become a noted writer and campaigner for Catholic emancipation, numbering among his correspondents Louis Philippe, whose portrait he owned, and his successor Charles X. Like Henry Swinburne's, this Grand Tour seems to have opened up a lifetime's contact with the Catholic crowned heads of Europe.

Other tourists in this decade included two men whom R.W. Grey had probably met in Paris in 1767, Thomas Charles Bigge, and a member of the Cuthbert family, possibly John Cuthbert (1731–82) of Witton Castle, Durham, to whom Piranesi dedicated a plate in his *Vasi, Candelabri Cippi* in 1778. Cuthbert suffered from gout, and apparently travelled principally for his health, but his fellowship of the Royal Society and the Society of Antiquaries suggests that he also engaged in cultural activities abroad.[168] Fortunately, we know more about Grey's other Parisian contact, Thomas Bigge (*c*.1739–94), son of William Bigge of St. Andrew's, Holborn and of Benton near Newcastle, who came from a gentry family which, originating in southern England, and retaining interests both there and in London, had, by the early

18th century, acquired extensive estates and collieries in Northumberland as well. Although Hodgson claims that Bigge travelled abroad for his health in 1759, and from 1763, his recorded Grand Tour took place when he was in his early twenties, from 1764–5, six years after inheriting his father's estates; William Bigge had been a close friend and near neighbour of Matthew Ridley of Heaton, whose son made an exactly contemporaneous tour.

Travelling with letters of introduction to Sir Horace Mann in Florence and to the influential Scottish Catholic, the Abbé Grant, in Rome, Bigge's outward route can be traced via Turin, Florence, Rome and Naples. His occasional companions – notably during his three-month stay in Rome in early 1765, when they visited the Scottish painter George Willison together – were Godfrey Bagnall Clarke from Derbyshire and a Mr. Jameson, (a tourist, and not to be identified with Carnaby and Thomas Haggerston's priest-tutor, p. 113). Bigge later visited Parma with his companions, and Florence on his own. Perhaps it was this seemingly unremarkable tour which left him 'highly cultivated, and richly stored with every species of polite and useful learning'; certainly he was one of several Northern tourists of this generation to become, with his travelling companions, a member of Gibbons' Roman Club on his return, while, as a Whig, he was a 'warm advocate of civil and religious liberty', as well as being an 'active magistrate' and High Sheriff of Northumberland in 1771.[169]

The recent appearance, however, of a hitherto unrecorded, half-length portrait of Bigge by Anton von Maron, signed and dated 1765 (Appendix 1 fig. 7), has belatedly lent much greater artistic significance to his Italian travels.[170] He now joins the long line of Northerners who are known to have sat for their portraits in Rome in the 1760s, although, unlike his neighbouring landowners, Bigge opted, not for Batoni, but for Anton von Maron, who was continuing in Rome the style of his master and brother-in-law, A.R. Mengs, following the latter's departure for Spain. Both compositionally, and in its handling of the white lace cravat and cuffs, von Maron's portrait suggests that this was a – notably successful – attempt to rival both Batoni's Grand Tour format, and his *bravura* handling of paint. The painting appeared at Sotheby's together with a fine neo-classical portrait by Angelica Kauffman of Bigge's wife, Jemima Ord (d.1812), whose nephew would make a major Grand Tour in the Napoleonic era. In the early 19th century this hung in the Dining Room at Linden Hall, the Greek-revival Northumbrian house built by the couple's tourist son, C.W. Bigge; it must belong, however, not to Kauffman's Roman period, but to her years in England, perhaps not long after the couple's marriage in 1772.

Although Sir Henry Grey, 2nd Bart. (1722–1808) of Howick Hall, Northumberland, is not recorded as having travelled abroad, a striking Grand Tour portrait of the 1760s survives at Howick from the school of A.R. Mengs.[171] Grey's nephew and successor at Howick was the future Prime Minister, Charles, 2nd Earl Grey. Perhaps surprisingly, given their status as major landowners, who played a leading role on the national stage, the Greys were not notable as connoisseurs or collectors, but during Sir Henry Grey's tenure at Howick the medieval tower house was rebuilt in the classical style by the Newcastle architect, William Newton.

Different from any of the other tours made from the North were the travels of the society beauty, Anne Liddell. Only daughter of the 1st Lord Ravensworth, relative of the Ellisons, and favourite of Horace Walpole, she toured Italy in 1761–2 some years after her socially advantageous marriage to Augustus, 3rd Duke of Grafton, with their four-year-old daughter, Georgiana. The tour, ostensibly for the Duchess's health, or because the Duke had 'ruined himself at play', was perhaps in reality 'to retrieve a floundering marriage', but Walpole was not optimistic: 'The Duke goes with her, and as it is not much from inclination that she goes, perhaps they will not agree whither they shall go next'.[172] In Turin, the Duchess encountered Louis Dutens, whose attention to their amusements considerably prolonged her stay, while in Rome, in February–April 1762, the Duke, but intriguingly not the female members of the family, sat to Batoni, and the Duchess's life was 'miraculously' saved by her preference for cards over a concert at which the roof fell in; her 'violent itch

for play'[173] seems to have been a contributory factor in the later breakdown of her marriage.

On their return northwards, the Graftons stayed for three weeks in Florence, when the British resident, Sir Horace Mann, at last met the paragon long presaged in Horace Walpole's letters to him: 'my charming Duchess' and 'a passion of mine, – not a regular beauty, but one of the finest women you ever saw'.[174] Mann had been hoping to convince the Graftons of his ambition to 'make this place agreeable to them', and when the Duchess eventually arrived in April 1762 he wrote to Walpole: 'I immediately fled to her…The knowledge she must have had of your goodness to me, or her own amiable character, abridged much of the ceremony in approaching and making acquaintance with so great a lady', and he was delighted that her first 'sortie' would be to attend one of his *conversaziones*. Mann was also proud to be able to show off to the Florentine ladies 'so much dignity and affability, so much sweetness in her countenance and ease in her behaviour, and in short so many amiable qualities assembled in one person. She has corrected the ideas that people had formed here of our English woman'. Despite this, he was not entirely satisfied. Evidently preferring social events to sightseeing, the Duchess would not 'let me attend upon her so much as I could wish to see the curiosities in the town, and has absolutely declared off from taking any airings…as she says that going in a coach in the afternoon hurts her and makes her unfit for any assembly or able to hold out at the theatre'. Excusing her on the grounds that 'her health is preferable to everything', Mann noted that at least 'She passes her afternoon much more profitable it's true, in studying Italian and music'.[175] Taken together with Harriet Carr's stay in Florence, the Duchess's pursuits here suggest that if women's ambitions abroad for 'self-improvement' were less rigorously linked to sightseeing than men's, a number of them took the concept of study abroad seriously, whether they opted for artistic, musical or linguistic endeavours.

Mann thought that the Duchess 'seemed to wish to prolong' her stay in Florence, but she was 'certainly harried out of Italy [by the Duke] contrary to her inclinations'.[176]

On their way home, the Graftons paused in Geneva, visiting Voltaire, who did not return the compliment, while Mann fretted about the Duchess's 'amusements', since the Duke 'hates everything of a public nature; she only loves to step aside from public diversions into retirement, which she employs in music, writing, and much reading, adorning by those means her mind as much as her person is by nature'.[177] Their tour having ended by 1st September 1762, the Graftons went on to visit her father, Lord Ravensworth, in the North of England. When the Duchess afterwards called on Horace Walpole in London, he was unimpressed with the effects of the tour on his favourite's appearance, telling Mann 'you have not returned her as you received her. I was quite struck at seeing her so much altered'. Three years later, in 1765, the Graftons separated, and the Duchess later 'found it convenient to spend some time abroad' in the wake of her divorce and subsequent re-marriage in 1769 to another former tourist, the Earl of Upper Ossory, following the birth of an illegitimate child by him – a scandal which, in the annals of the 18th century, is eclipsed only by that created, in the next generation, by the ménage à trois formed by the Duke and Duchess of Devonshire and Lady Elizabeth Foster.[178] The new Countess's father, Lord Ravensworth, never spoke to her again, and she disappears from the correspondence of her Northern female cousins, the Ellisons, for whom she represented a connecting link between the gentry of North-East England and the British aristocracy at its most powerful.

It is worth adding as a postscript that one of the most important, intellectually formidable and independent-minded of all 18th-century travellers, Lady Mary Wortley Montagu (1689–1762), whose reasons for spending time on the continent, like the later travels of Lady Anne Liddell, related to her ambiguous marital status, had strong links with the North of England. Lady Mary's husband, Edward Wortley Montagu, was a Yorkshire landowner, who was the partner in the Durham coal trade of George Bowes of Streatlam Castle and Gibside (see pp. 85–6) and of Sir Henry Liddell, and Lady Mary certainly knew members of the Bowes family, as well as the Newcastle feminist Mary Astell (1668–1731), in

the early years of her married life. Astell's later enthusiastic preface to Lady Mary's (still unpublished) letters in 1724, desiring that 'the World shou'd see to how much better purpose the LADYS Travel than their LORDS, and that whilst it is surfeited with Male Travels…a *Lady* has the skill to strike out a New Path',[179] suggests a continuing intimacy between Lady Mary and this Northern intellectual, as well as – incidentally – offering an amusing counterblast to the male travels on which so much of this book is based. Although Lady Mary never saw her husband or his Northern contacts again after her departure for the continent in 1737, where she lived, mostly in Italy, for the next twenty-three years, the links between the North of England, and a woman who had first visited Italy as early as 1718, on her return with her husband from his two-year embassy to Constantinople, is a reminder that the apparent isolation of the North of England from continental Europe at this period should not be exaggerated. This is surely confirmed by the friendship between two other women intellectuals, the bluestocking Elizabeth Montagu, who had a house at Denton near Newcastle, and the Northerner Elizabeth Carter – praised by Dr Johnson as the translator of the Greek stoic philosopher Epictetus who could still turn her hand to making puddings. They travelled together in France in 1763, when, 'with the same facility with which she translated Epictetus from greek into English', Elizabeth Carter 'translated her native timidity into French airs, and French modes'.[180]

END NOTES

1 For a discussion of the numbers of British tourists from 1700–1800, see Black, pp. 7–12. Given that no official records exist to give an overall tally, estimates have to fall back on the references to numbers found in contemporary letters and diaries, a highly unreliable method of accounting.

2 The first major figure in the North who is always said to have visited Italy and absorbed its art and culture is John, Lord Lumley (1535?–1609), of Lumley Castle, Durham. However, although his father-in-law, Henry Fitzalan, 12th Earl of Arundel, did indeed go to Italy in 1566, all the documentary evidence points to Lumley having stayed in England to take care of the Earl's interests in his absence. Despite this, Lumley's decorative programme at Lumley Castle included the *Lumley Horseman* (on loan to Leeds Castle), a highly significant example of his interest in things Italian, based as it is on the wooden statues of *condottiere*, which the Venetian state erected in honour of foreign soldiers who fought on its behalf during the early 16th century. See Katie Barron, *Classicism and Antiquarianism in Elizabethan Patronage: The Case of John, Lord Lumley*, M. Litt. thesis, 1995, University of Oxford. Unfortunately this early and fascinating example of Italian influence on the North of England falls outside the remit of this book. Equally, the tours made from the North in the seventeenth century, many of which were connected with the education abroad of the sons and daughters of wealthy Northern Catholic families, represents a separate topic which cannot be considered here. To all intents and purposes, the history of the Grand Tour in the North begins around 1700.

3 For this tour, see Ingamells, p. 52.

4 Haggerston MSS., Record Office, Berwick on Tweed: see *Bibliographical Note*.

5 Op. cit., John Thornton S.J. to Francis Anderton S.J., Bourges, 5th June 1714.

6 Ibid.

7 Op. cit., Sir Carnaby Haggerston to Francis Anderton, Rome, 20th July 1718.

8 Op. cit., Sir Carnaby Haggerston to his mother, Rome, 22nd November 1718, and Antwerp, 23rd May 1719.

9 Leo Gooch, *The Desperate Faction?, The Jacobites of North-East England 1688–1745*, University of Hull Press, 1996, p. 26.

10 Op. cit., p. 180.

11 Haggerston MSS., Sir Carnaby Haggerston to his mother, Rome, 22nd November 1718; Haggerston to Francis Anderton, Rome, 26th November 1718.

12 Gooch, p. 17. This book includes details of the links between the Radclyffes and many other Jacobite tourists and the continent.

13 Ingamells, pp. 793–4.

14 Op. cit., p. 794

15 Gooch, p. 17.

16 Margaret Wills, *Gibside and the Bowes family*, Newcastle upon Tyne, 1995, p. 2, quoting from the Bowes papers at Glamis Castle.

17 Loc. cit., quoting BL Add MS. 40747, Bowes MSS. II f. 142. For Bowes's tour, see also Ingamells p. 113 and Hughes, vol. I, p. 402. Ingamells suggests that he was the 'Mr Boles' travelling with Hay and a Mr. Foster.

18 Wills, p. 3.

19 For Carr's tour, see Ingamells, p. 186.

20 Purdue, 1999, p. 83.

21 For this tour, see Ingamells, p. 601 and Black, pp. 149, 162,185.

22 Allgood MSS., Northumberland Record Office: see *Bibliographical Note*. For the quotation, see Purdue, 1994, p. 122.

23 Allgood MSS., Lancelot Allgood to Mrs Widdrington, Montpellier, 13th May 1737; ibid.

24 Ingamells, p. 16.

25 Allgood MSS., Lancelot Allgood to Mrs Widdrington, Turin, 10th October 1738.

26 See, for example, Anne French, *Gaspard Dughet, called Gaspar Poussin, A French Landscape Painter in Rome*, Greater London Council, 1980, pp. 11, 14.

27 Pevsner and Richmond, 1992, p. 74.

28 *Proceedings of the Society of Antiquaries of Newcastle upon Tyne*, VI, 1894, no. 22, pp. 166–7; this is the principal source for Dagnia's tour. The information on Dagnia's assumption of a pseudonym derives from Spearman's letters to Sir Cuthbert Sharp, Sharp MSS., vol. 71. See also Ingamells p. 265, and the file on Dagnia in the Brinsley Ford Archive, Paul Mellon Centre.

29 Robert Surtees, in his *History of Durham*, says that John Dagnia acquired Cleadon in 1738; quoted in the *Proceedings of the Society of Antiquaries of Newcastle upon Tyne*, VI, 1894, no. 22, p. 165.

30 These commissions constitute the only firm record of Dagnia's stay in Italy; see Ingamells, p. 265.

31 *Proceedings of the Society of Antiquaries of Newcastle upon Tyne*, VI, 1894, no. 21, p. 167, quoting Spearman's letters to Sir Cuthbert Sharp, Sharp MSS., vol. 71.Dagnia's biographer niece was Miss Deer, who married Terence Knight, a captain in the navy, and died in 1806 or 1807. The book was privately printed.

32 Op. cit., p. 165. The then owner was Bryan Abbs. Fourteen trees had apparently been brought back from Italy, of which five survived; the author of the *Proceedings* wrongly presumed that the tourist was John, not James, Dagnia.

33 Op. cit, p. 167, quoting Mackenzie's *Northumberland*.

34 The *Proceedings*….. , p. 167, quoting Spearman's letters to Sir Cuthbert Sharp, Sharp MSS., vol. 71, says, confusingly, that Dagnia was 'patronised by earl Mallox, afterwards earl of Rockingham [presumably Charles Watson-Wentworth, Earl of Malton, later 2nd Marquis of Rockingham, see Ingamells p. 631], the earl of Denbigh [either William, 5th Earl (1697–1755) or Basil, 6th Earl (1719–1800)] and the duke of Cleveland' [William, 2nd Duke, d. 1774]. Of the three men, only Rockingham (who made the Grand Tour later than Dagnia) visited Italy (in 1748–50), and it seems likely that any patronage of Dagnia by these aristocrats took place in England rather than abroad.

35 Ellison MSS., see *Bibliographical Note*, 3419/A/28, letter from Henry Carr to Henry Ellison, December 15th 1739; ibid; ibid; ibid.

36 Op. cit; letter from Henry Carr to Henry Ellison, 7th May 1740.

37 Purdue, 1999, pp. 54–55.

38 For this generation of Haggerstons abroad, see Maxwell-Constable MSS., Hull University Library, DDEV/60/85, II, I, and Joyce, pp. 175–192.

39 Joyce, p. 187.

40 Ingamells, p. 875.

41 For the only two records of Surtees's Italian tour, see Ingamells, p. 914.

42 According to H Conyers Surtees (see note 43 below), George Surtees also supported Robert's two brothers, Ned, whom he put into the Six Clerk's Office, but who died of 'dissipation', and Bill, who went to Batavia, but died there as a result of the climate.

43 Brigadier-General H. Conyers Surtees and the late H.R. Leighton, *Records of the Family of Surtees…*, Newcastle-upon-Tyne, 1925, p. 93.

44 Loc. cit.

45 George Taylor, *A Memoir of Robert Surtees Esq., M.A., F.S.A., A New Edition…*, The Surtees Society, Durham, London and Edinburgh, 1852.

46 For Surtees's paintings at Mainsforth Hall, see H. Conyers Surtees, 1925, p. 93; the most notable was apparently a group of 'Robbers Carousing'. Works by Surtees also survived at another family house,

Redworth. However, most of Robert Surtees's paintings appear to have been sold at auction, together with the rest of the contents of Mainsforth Hall, by George Walker of Durham, from 12th to 16th December 1836 to 2nd January 1837, following the death of Robert Junr. The library was sold from 2nd January 1837, while Robert Jnr.'s coins and medals were sold in London by Leigh Sotheby on 17th to 19th July 1837. There is no indication as to whether any of these had formerly belonged to Robert Snr. The Christie's sale was on 28th January 1983.

47 Although dated 1768, the album includes drawings with dates between 1766 and 1799; Christie's, London, 18th March 1980.

48 Ingamells, p. 896, and Sterne, *Letters*, passim.

49 Grey MSS., Northumberland Record Office, see *Bibliographical Note*; letter from R.W. Grey Snr. to his son, 22nd September 1767.

50 Craster, p. 35. I am indebted to this book for the information included here on George and Olive Craster's life before and after their Grand Tour.

51 Craster MSS., see *Bibliographical Note*., ZCR Box 20, 'Wife's Memorandum Book', loose sheets inside.

52 Op. cit., ZCR Box 20, 'Wife's Memorandum Book', Naples, 13th January 1762; An Account of Antiques & Curiosities etc., loose double sheet.

53 Op. cit., ZCR Box 20, double sheet folded with price lists; loc. cit; An Account of Antiques & Curiosities etc., loose double sheet.

54 Ibid. The artists referred to are the neo-classical painter Gavin Hamilton (1723-98) and the landscapist Solomon Delane (c.1727–1812), who also worked for Lord Warkworth (pp. 74–5).

55 These would have been brought out to Rome from England by the sitters; see *Pompeo Batoni and his British Patrons*, The Iveagh Bequest, Kenwood, 1982, p. 21.

56 See A. Busiri Vici, quoted in D. Goodreau, *Nathaniel Dance*, Greater London Council, 1977, cat. 7. For Russel's recommendation of George Dance, see Ingamells, p. 832.

57 D. Goodreau, op. cit, Introduction, n. p.; R.I.B.A letter, 3rd February 1762, quoted in Goodreau, op. cit., Introduction, n.p.

58 Dance letters, R.I.B.A., quoted in Bowron, 1985, cat. 256.

59 For the artificial flowers, see, for example, Craster MSS., Box 20, 'A list of flowers bought at Genoa', December 1761, loose double sheet. The Holbein is today in the National Gallery, London.

60 Olive Craster refers to 'Sigra Tibaldi' being best 'for miniture [sic] & fan painting'; Craster MSS., ZCR Box 20, loose double sheet. The artist was either Maria Felice Tibaldi-Subleyras or one of her two sisters Isabella or Teresa, both of whom also worked as miniaturists. For a discussion of the Crasters' miniatures as images introduced onto jewellery, and the economic and sentimental value of such items, see Marcia Pointon, 'Surrounded with brilliants: miniature portraits, artefacts and social practices in 18th century England', *Art Bulletin*, vol. LXXXIII, number 1, March 2001, p. 56.

61 Craster MSS., ZCR Box 20, loose double sheet; loc. cit.

62 The artist specialised in painting animals and birds on Sèvres porcelain.

63 Craster, op. cit., p. 43.

64 Op. cit., p. 42.

65 Suggestion kindly made by a member of the family.

66 Craster, p. 44.

67 A carriage with facing seats.

68 Craster, op. cit, p. 45.

69 Op. cit., p. 46.

70 Grey MSS., see *Bibliographical Note*; letters from R.W. Grey Snr.
of 17th September and 27th December 1767.

71 For Bigge and Mr. Cuthbert in Paris, see Grey MSS., letters from
R.W. Grey Snr., 22nd September and 27th December 1767. Bigge
and Cuthbert's travels abroad are discussed on pp. 113–14.

72 Grey MSS., letter from R.W. Grey Jnr., 25th June 1774; letter from
R.W. Grey Snr., 22nd August 1774.

73 Op. cit., letter from R.W. Grey Snr., 15th November 1774.

74 Op. cit., letters from R.W. Grey Snr., 18th December 1774,
11th April 1775.

75 Op. cit., letters from R.W. Grey Snr., 7th April, 10th February 1775.

76 Op. cit., letter from R.W. Grey Snr., 19th April 1776; letter from
R.W. Grey Jnr., 29th April 1776; letter from R.W. Grey Snr.,
10th June 1776.

77 Description of Orde in Venice for the Ascension Day ceremony, 1773,
by Patrick Hume; included in the file on Orde, Brinsley Ford archive,
London.

78 Three of these, together with other caricatures by Orde, are in the
collection of the British Museum.

79 Russell, p. 817, points out that notebooks of parts of Orde's tour
(of France and Switerland in 1772 and of Flanders, Holland and
Germany in 1774) survive at Bolton Castle, Yorkshire, Orde's home in
later life; it has not been possible to consult them for this publication.
See note 84 for a photostat copy of part of Orde's Italian tour; the
rest of the Italian journal, notably the section on Rome, is missing.

80 For Orde's visit to Ferney, see Sir Gavin de Beer and André Michel
Rousseau, 'Voltaire's British visitors' in *Studies on Voltaire and the
Eighteenth Century*, XVIII, Geneva, 1961, Second Supplement,
pp. 251–2; p. 237 of this publication lists in all 113 British visitors to
Ferney.

81 Op. cit., p. 252.

82 Op. cit., p. 251. De Beer and Rousseau point out that one copy
of Orde's etching of Voltaire was at Ferney in 1897, and that the copy
in the British Museum was acquired from William Bull (1738–1814),
a Congregationalist minister who was a friend of Cowper; the
catalogue of *Social and Political Satires in the Collection of the British
Museum*, vol. 5, no. 5071, identifies the collector instead as Richard
Bull. The quotation in the British Museum catalogue from Bull,
suggesting that the etching was made instead in Turin, cannot
be correct, as there is clear evidence, summarised in de Beer and
Rousseau, that Orde's print was made at Ferney.

83 Quoted in the catalogue of *Social and Political Satires in the Collection
of the British Museum*, vol. 5, no. 5071.

84 This can be consulted in a photostat version in the Lewis Walpole
Library, Farmington, Connecticut; copy in the Brinsley Ford Archive,
London. All the following quotations on Orde's Italian tour are taken
from this journal.

85 Orde Journal, 11th November 1772, photostat copy, pp. 2–3, 4, 5.

86 Op. cit., pp. 5-6.

87 See Brinsley Ford, 'James Byres, Principal Antiquarian for the English
Visitors to Rome', *Apollo*, vol. 99, pp. 453–4, figs. 6,7. See also
Ingamells, p. 723. The other sitters in the group portrait including
Orde were: James Byres (?), John Staples, Richard Aldworth Neville,
later Baron Braybrooke (who had almost certainly been with Orde

on his visit to Ferney to see Voltaire) and William Young. Other
members of the same party of tourists appear in the companion
portrait, where the sitters are: James Byres (?), Mr. Corbet (? John
Corbet), Mr. Tollemache, John Chetwynd Talbot, later Earl Talbot,
Sir John Rous, Mr. McDouwall (? William McDowall) and – once
again – John Staples. As Ford has noted, the identity of Byres is
uncertain; the two men said to be Byres in the two compositions do
not resemble each other, although the man in the Orde conversation
(far left) certainly resembles the known portrait of Byres as shown
in fig. 25. For the *Lion attacking a Horse*, see Haskell and Penny,
pp. 250–1. They note that the group was much admired by
18th-century visitors to Rome, and reproduced in paintings, and
in bronze and plaster reproductions.

88 Ford, p. 453.

89 This is not, however, confirmed by the provenances of the two
surviving versions of each composition. While Staples owned a
version of the conversation including Orde, now in the collection
of the National Trust at Springhill, Northern Ireland (a second
version, which belonged to Richard Neville, is now at Audley End),
he is not recorded as having owned a version of the other
conversation piece, which exists in versions painted for
Mr. Tollemache at Ham House, and in a private collection.

90 Clark & Bowron, 1985, note that the volumes (like the notebooks,
see note 79 above) are preserved at Bolton Hall, Yorkshire.

91 The paintings are discussed fully in Kidson, pp. 80–2.

92 The Rev. John Romney, quoted in Kidson, p. 111; Kidson's text
discusses Orde's commission in depth.

93 See Jones, Diary, p. 88 for the landscape Burdon commissioned, and
p. 90 for his meeting with Burdon. The landscape is discussed in
Ann Sumner and Greg Smith, *Thomas Jones (1742–1803)*, *An Artist
Rediscovered*, New Haven and London, 2003, pp. 71, 215. Of the
three Jones paintings of the Bay of Baia, two survive. Sumner and
Greg, listing the client only as 'a Mr. Burdon', suggest plausibly that
the smaller version reproduced on p. 109 is probably his.

94 For Burdon's acquisitions, see Clark & Bowron p. 346, and
Ingamells, p. 156. See also Bolton, pp. 27–9, for Burdon's letter,
dated Newcastle, 4th April 1780, to his former travelling companion,
John Soane, who had remained in Italy after Burdon's departure:
'You mention Jones's picture and leave me in the dark with resp't to
every thing else'. Evidently, Burdon considered his friend was being
dilatory in overseeing his Italian commissions, and consequently
'wrote to Mr Byres in hopes of having my commission executed thro'
that channel'.

95 Ingamells p. 156; see du Prey pp. 112–3, 139–142, for a full account
of his tour; du Prey, pp. 120, 276 for the Castle Eden designs;
Burdon to Soane, 13th August, 20th May 1835, 13th August 1836,
quoted in Bolton, pp. 531–2.

96 Ingamells, p. 157.

97 Tristram, p. 15; Fordyce, vol. II, p. 368.

98 Tristram, p.16.

99 Op. cit., p. 18.

100 Fordyce, p. 368.

101 See Wharton MSS., no. 160, for an undated notebook with detailed
pen and ink drawings of the Tuscan, Doric and Ionic orders made by
Wharton. He also made some costume drawings (p. 106).

102 These two works are: *Lettres Persanes* (*Persian Letters*, 1721) and

De L'Esprit des Lois (*On The Spirit of the Laws*), 1748.

103 Wharton MSS., letter 131 to Thomas Wharton, Dijon, 13th June 1775; letter 126 to Thomas Wharton, 19th May 1775; letter 131 to Thomas Wharton, 13th June 1775.

104 Wharton MSS., letter 130 to his mother, 16th June 1775; letter book 1, letter to W.L. Baker (cousin), 20th May 1775.

105 Wharton MSS., letter to Thomas Lloyd, 30th June 1775; letter book 1. Wharton's letters, and a rudimentary Journal survive. For Wharton's account of a child urinating on the heads of some ladies in a box at the theatre, the laughter of the audience, and Wharton's subsequent conversation with a French Abbé, who said that 'these things are natural & necessary and it is therefore absurd to think of concealing them', see letter 125 of 18th May 1775 to his mother.

106 Black, p. 299, points out that those, like Wharton, who criticised other tourists, 'could not be described as being at the highest reaches of society'.

107 Black, p. 106, cites Wharton as an example of this trend.

108 Wharton was lucky enough to travel from Calais to Lille in a chaise offered to him by the innkeeper at Calais, transferring to the public *diligence* at Lille.

109 It is not clear which members of this well-travelled family (pp. 37–58) Wharton refers to here.

110 Wharton MSS., letter 114, 17th March 1775; 10th April 1775; letter 112, 5th March 1775.

111 Op. cit., letter 109, 26th February 1775; letter 114, 17th March 1775; letter book 1, 167, fol.3, 29th February 1775; letter 117, March 25th 1775.

112 Op. cit., letters 113 and 117, 12th and 25th March 1775. This major subject painting, known today as *The Meal at the House of Simon*, or *Mary Magdalene at the Feet of Christ*, was painted for the convent around 1653, and is today in the Accademia, Venice, having been ceded to the Austrian government in exchange for a Veronese.

113 Op. cit., letter 117, 25th March 1775; letter 121, 19th April 1775; letter 117, 25th March 1775; letter 119, 9th April 1775.

114 Part of Wharton's original intention in touring Southern France, apart from improving his French, was to transact business for his uncle, Thomas Lloyd.

115 Wharton MSS., letter 128, 29th May 1775; ibid; letter 131, 13th June 1775; letters 126, 19th May 1775 and 132, 19th June 1775; letter 141, 1st August 1775.

116 Op. cit., letter 154, 7th October 1775; ibid.

117 Op. cit., letter 133, 19th June 1775, to Brand. There are considerably fewer letters from Wharton from Italy than from France, presumably because of the unreliability of the postal system, and our picture of his Italian tour is therefore less than complete.

118 Op. cit., letter book 2, 168, fol. 7v, 23rd October 1775; letter book 2, 168, 27th October 1775; ibid; letter 155, 15th November, 1775; ibid.

119 Op. cit., letter 156, 29th November 1775; letter book 2, 168, 8th November 1775 (Wharton qualifies his opinion about Byres's abilities by adding 'at least with regard to Rome & its Environs'); letter book 2, 168, 24th January 1776.

120 Op. cit., letter book 2, 168, 18th November 1775. The guide books Wharton recommends are: the 'Abbé Richard', presumably Jean-Claude Richard, Abbé de Saint-Non, although his *Voyage pittoresque à Naples et en Sicile* was published only in 1781–6. For local description, J. J. De Lalande (*Voyage... en Italie*, 1769) for 'scientifical' accounts of Italy and Rome, and Nardini (author of *Roma Antica*, Rome, 1704) for antiquities; see letter book 2, 168, 24th January 1776.

121 Op. cit., letter book 2, 168, 20th December 1775.

122 Op. cit., letter 156, 29th November 1775; letter book 2, 168, 20th December 1775; letter 162, 5th November 1775; letter book 2, 168, 23rd December 1775; ibid; tourists of this period were not aware that the dome of St Peter's was completed by Giacomo della Porta and Carlo Fontana.

123 Op. cit., letter 158, 20th March 1776.

124 Op. cit., letter book 2, 168, 8th November, 1775; ibid, 18th November 1775; letter 155, 15th November 1775 (to Brand). Giacomo da Vignola (1507–73), one of the foremost Italian Renaissance architects, is renowned for his treatise on the five orders of architecture (1562); based on Vitruvius, this was regarded by succeeding generations as providing definitive rules for proportioning the classical orders in Roman buildings. Charles-Alphonse Du Fresnoy was the author of *De Arte Graphica* (Paris, 1668), translated into both French and English, first by John Dryden Jnr., and then by William Mason, as *The Art of Painting*. Charles-Nicolas Cochin, a connoisseur and art adviser, wrote the first systematic listing of Italian painting.

125 Op. cit, letter 155, 15th November 1775; letter book 3, 169, 3rd April 1776.

126 Op. cit., letter 157, 6th January 1776; letter book 3, 169, 26th February 1776; letter book 2, 168, 24th January, 1776; ibid.

127 Op. cit., letter book 2, 168, 23rd December 1775; letter book 3, 169, 5th April 1776; ibid; letter book 2, 168, 6th December 1775.

128 Op. cit., letter book 2, 168, 24th January 1776; ibid, 6th February 1776; letter book 3, 169, 7th March 1776.

129 Op. cit., letter 158, 20th March 1776. For Wharton's views on the Carracci, see letter 161, containing his notes on Italian painting. Wharton makes it clear that his admiration for them stemmed from their imitation of nature: 'The Carracci, after studying the antique & the greatest masters of the time learnt that nature was the true object of imitation'.

130 Op. cit, letter book 3, 169, 10th May 1776; letter 164, 3rd June 1776.

131 Op. cit., letter 165, 10th June 1776.

132 Op. cit., letter book 3, 169, 17th May 1776.

133 Sources for Brand's letters are listed in detail in Ingamells, p. xx. The correspondence between the two men, not all of it, however, related to the Grand Tour, comprises about 570 letters. They shared a love of music, and Brand married Wharton's cousin.

134 Wharton MSS., letter 134, 22nd June 1775.

135 For the Ellison MSS., see *Bibliographical Note*. I am also greatly indebted in what follows to Bill Purdue's account of the Ellison family (1999).

136 The house, now surrounded by 19th-century development, still survives; it was built in 1723 for William Cotesworth, and later enlarged by James Gibbs for Cotesworth's son-in-law, Henry Ellison Senr., in 1730–1.

137 Purdue, 1999, p. 83.

138 Op. cit., p. 43.

139 Ellison MSS., 3419/A22, letter from Cuthbert Ellison to Henry

Ellison Snr., 12th May 1764,. Unfortunately, none of Henry Ellison Jnr.'s Italian letters survive, although we know a little of his stay in Paris on his return journey (Ellison MSS., 3419/A14), and his Italian itinerary can only be gauged from references made by other travellers, and from this remark in his uncle's letter.

140 Ingamells, p. 337.

141 Batoni's original portrait of Henry Ellison survives in a British private collection. For Gibbon's view of Ellison, see Ingamells, p. 338. For Ellison at Cambridge, see Hughes, vol. 1, p. 368: 'He seems to be a youth of good parts and abilities, of a sweet temper and a sober and studious disposition'.

142 Ellison MSS., A11, letter to Robert Ellison, 13th June 1781.

143 Op. cit., A22, letter from Cuthbert Ellison, 29th January 1765.

144 Op. cit., A11, letter from Henry to Robert Ellison, 3rd February 1782.

145 Op. cit., letter from Henry to Robert Ellison, 7th October 1781.

146 Op. cit., A62, letter from Baron Hotham to Robert Ellison, 14th June 1781.

147 Op. cit., A3, letter from Elizabeth to Robert Ellison, 30th September 1782; 'Robert Ellison, Account of Journey', E1.6.

148 Op. cit., E1.3. A number of Robert Ellison's papers are in Tyne & Wear Archives, but Hughes, vol. 1, p. 111, notes that his Swiss Journal and some of his letters are in Columbia University Library, New York.

149 Ridley MSS., Northumberland Record Office, ZRI 30/3, see Bibliographical Note; letters of 10th August, 8th and 30th July 1766.

150 Op. cit. 10th August 1766; ibid. The 'Mr and Mrs Swinburn' might be presumed to be members of the Swinburne family of Capheaton, as Ridley refers to them as acquaintances. However, Henry and Martha Swinburne were married only in 1767, and a 'Mr and Mrs Swinburn', who appear not have been related to the Northumbrian Swinburnes, were seen by Robert Grimston in Aix in 1766–7. Mrs. Swinburn's brother was a Mr. Hobart, whereas Martha Swinburne's maiden name was Baker, and it is surely also significant that Grimston describes Mrs Swinburn as being 'like a mother' to him; Martha Swinburne was then only nineteen years old.

151 Ursula, Viscountess Ridley, Blagdon and the Ridleys, reproduced by the Historical Manuscripts Commission, 1965, p. I.

152 The 1890 typed inventory, with manuscript additions, 'Pictures, Statuary and Bronzes at Blagdon and in 10, Carlton House Terrace, 1890' lists a judicious mix of Dutch, Flemish and Italian paintings. Some are known to have been acquired after the 2nd Bart.'s death. Two paintings which were certainly bought during his lifetime are paintings then attributed to David Teniers (in 1811) and Jan Weenix (in 1801). Of those paintings which could have entered the collection at any time, there are works then attributed to artists including Rembrandt, Rubens, Van Goyen, Borgognone, Rosa, Van Dyck, Berghem, and a Calm and a Storm by Vernet. The scant evidence suggests that much of the Old Master collection was built up through the London saleroom, although the 3rd Bart. would become a major patron of artists in Rome (pp. 223–9). A document among the Ridley papers (ZRI 33/13) of c.1800, which lists paintings belonging to two major collectors of this era, Richard, 1st Earl Grosvenor (d.1802), and Walsh Porter (d.1809), confirms the 2nd Bart's active interest in acquiring Old Master paintings. There is no indication as to which member of the family acquired an antique

Head of Jupiter, and two casts of Apollo and Diana from works in the Vatican. The 2nd Bart's London house was in Portland Place; later, the family acquired 10, Carlton House Terrace.

153 The Newcastle Literary Magazine and Northern Chronicle, January 1st 1824, p. 14.

154 For Ridley's parentage, see Welford, vol. 3, p. 320. For his tour with Bolton and Holroyd, see Ingamells, pp. 813, 513–4, 103.

155 Ingamells, p. 398.

156 Rowland E. Prothero, Private Letters of Edward Gibbon, vol. 1, 1896, p. 81.

157 Op. cit., p. 80; Ingamells, p. 514.

158 Ingamells says, however, that Errington had already spent at least a year abroad before meeting Laurence Sterne in Rome in December 1765, so Errington may have set off abroad before his inheritance materialised.

159 Sterne, Letters, pp. 275, 269. For this tour see also Ingamells pp. 340, 894.

160 Op. cit., pp. 273, 275.

161 Op. cit., pp. 271, 269, ibid, 264.

162 Swinburne, Courts, vol. 1, p. 289.

163 For this tour, see Joyce, pp. 188.

164 For Quarenghi's passion for Palladio, see Ford, 1974, p. 449. His plans for Haggerston are discussed in the R.I.B.A. Drawings Collection Catalogue; entry on Quarenghi, quoting John Harris. For executed work at Haggerston Castle, see Lowery, p. 60.

165 For this tour see Henry Lonsdale The Worthies of Cumberland, 1867–75 pp. 67–72.

166 See Colin Duckworth, 'D'Antraigues and the Quest for Happiness: Nostalgia and Commitment', in Studies on Voltaire and the Eighteenth Century, vols. 151–155, 1976, p. 625ff, and Colin Duckworth, 'D'Antraigues and Feminism: Where Fact and Fantasy Meet', Women and Society in Eighteenth Century France, 1979, pp. 166ff.

167 Henry Lonsdale The Worthies of Cumberland, 1867–75 pp. 67–70; op. cit, p. 71.

168 For this tour, see Ingamells, p. 264.

169 Hodgson, part II, vol. II, p. 99.

170 Sotheby's, London, 8th June 2006.

171 I am indebted to Lord Howick for information on this painting, and its attribution to Mengs by Ellis Waterhouse; see also the file on Sir Henry Grey in the Brinsley Ford archive. Waterhouse suggested that the lilac coat worn by the sitter was added to the painting at a later date; it has not been possible to examine the portrait to confirm this.

172 Walpole, vol. 9, pp. 363, 361, Ingamells, p. 415; Walpole, vol. 21, p. 506.

173 Op. cit., vol. 10, p. 23.

174 Op. cit., vol. 21, p. 506.

175 Op. cit., vol. 22, pp. 27–28, 29.

176 Op. cit., vol. 22, p. 39.

177 Op. cit., vol. 22, p. 40.

178 Op. cit, vol. 22, p. 80; Purdue, 1994, p. 123.

179 Robert Halsband, ed., The Complete Letters of Lady Mary Wortley Montagu, Oxford, 1965, vol. 1, p. 466.

180 Black, 2003, p. 7; Dolan, p. 244.

The Last Two Decades
1780–1800

The years from 1780–1800 saw some of the most important tours from the North, notably those made from 1791–4 by the brother and sister John and Harriet Carr, from Dunston Hill, Northumberland, and, at the very end of the century, by William Henry Lambton of Harraton Hall in County Durham, with his wife and young children. Both of these families, as Purdue wrote of the Carrs, 'must be numbered among the élite of tourists who had strong intellectual and cultural interests together with a genuine desire to gain experience of foreign societies'.[1] Although both tours were made for reasons of health, they ended very differently: the twenty-year old Harriet Carr recovered, and went on to work as an amateur artist throughout her life, whereas Lambton died of consumption in Pisa in 1797 at the age of thirty-three, his Grand Tour commissions still unfinished. A year later the French armies marched into the Papal States, bringing the golden age of the Grand Tour to an abrupt conclusion.

Despite the political upheavals of a decade which saw France and Britain fighting on opposing sides in the American War of Independence, large numbers of British tourists continued to visit the continent in the 1780s, especially in the years after the Treaty of Versailles in 1783,[2] which represented one of the peak periods of travel from the North. Even the French Revolution in 1789, which made travel through France unsafe, and the beginning of the French Revolutionary War in 1792 (which Britain joined the following year), did not entirely dampen the number of British travellers to Italy; indeed, both nationally, and from the North of England, tourism in the 1790s seems to have continued at a surprisingly high level given the very real dangers of travelling on a continent beset by war. John Carr's letters home from Italy between 1791–4,

where he and his sister were trapped by the political situation, are littered with references to the 'shoals' of British visitors, and in February 1793 he wrote: 'there were never known so many English families as there are this year in Italy'. A reliable indicator of the greater number of Northern tourists at this period is provided by the number of references in contemporary diaries to meetings abroad with other travellers from the region.[3]

Although the tours from the North made by William Henry Lambton, William Harry Vane, later Duke of Cleveland, or Charles, future Earl Grey, show that tourism from this region remained largely the prerogative of the aristocracy and the landed gentry, families newly enriched by industrial, mercantile and other entrepreneurial developments on Tyneside also began to travel abroad, notably the Carrs and Major George Anderson, whose scholarly passion for Gothic architecture was little short of revolutionary for its time, but whose tour, given that his surviving tour diaries all date from the Napoleonic era, falls into a later chapter. Travel by tourists on more moderate incomes also now became more frequent. The greater popularity of the Imperial capital in Vienna, and of Switzerland, with its 'sublime' scenery, is a feature of this period, during which travel moved noticeably closer to our own experience: in the letters of William Blackett, ices at cafés in St Mark's Square, and mixed parties of ladies and gentlemen travelling together for companionship, have replaced the infestations of bugs, and focus on tutor-pupil relationships, of the earlier 18th century.

Although it has been suggested that in this age of sensibility, with the dawning of Romanticism, travel also became an adventure of the self, crossing symbolic as well as actual boundaries, and that the later years of the century also saw the beginnings of the dichotomy between the cold north and the warm south which would later feature so largely in English literature,[4] the goals of Northern tourists do not seem to have differed greatly from those of their earlier counterparts.

THE VANES OF RABY CASTLE

One of the region's most powerful landed families, the Vanes had purchased the great medieval fortress of Raby in County Durham in 1626, some fifty years after the collapse of the Neville dynasty. By the mid 18th century, they had, in successive generations, played a prominent part in national and local political life, and had become Barons Barnard and Earls of Darlington.

The family's links with the continent can be traced back to the early 17th century, when the Puritan Sir Henry Vane had studied in Leyden and Geneva, and the 1st Baron Barnard was among the earliest Grand Tourists from the North in 1701. However, the most important tour by a member of the family was that made in 1784–7 by William Harry Vane, Viscount Barnard (1766–1842), who would later, as 3rd Earl of Darlington and 1st Duke of Cleveland, take the family even closer to the centre of national life and political power.

No hint of Lord Barnard's later distinguished career can, however, be deduced from his Grand Tour notebooks,[5] which offer one of the most complete extant accounts of a young aristocrat abroad, but which shed little light on cultural aspects of the Grand Tour; although, as Earl of Darlington, Vane would later tour the picture galleries of Paris (p. 209), he showed, at this early stage in his life, almost no interest in the visual arts, and the only item he is known to have brought back from his Grand Tour is of horticultural rather than artistic interest: a White Ischia fig tree which still stands in a specially constructed house in the Castle gardens.

Vane's comprehensive three-year Grand Tour, probably undertaken with a tutor, Mr Randolph, followed on from a year at Oxford, embracing the south of France; a rather unusual sea voyage around the coast of Spain; Switzerland; Germany and Austria; Poland; and, of course, Italy, where, in Rome, his *cicerone* was Thomas Jenkins. This was a tour played out at the highest social level. Vane's position as a young aristocrat opened most doors, and his companions abroad included the Duke of Gloucester, son of George III, the young 5th Earl of Chesterfield, nephew of the author of the *Letters*, and the Duchess of Albany, illegitimate daughter of the Young Pretender. It was, however, Vienna, that was the social apogee of this tour. Arriving in the Imperial capital in April 1786, Barnard's acquaintances included the Emperor himself, and a

number of German and other princes and foreign dignitaries; his days were spent in a whirl of entertainments including picnics, tennis, billiards, opera and concerts.

Vane appears to have sat twice for his portrait, once, in Nice, to an unnamed artist –when sittings were fitted into his morning routine, together with language lessons, while the afternoons were given over to real tennis and society – and again in Rome. In October 1786 his mother, Lady Darlington, 'Tho' I hope eer long to be Blessed wh seeing the Original' was nevertheless 'impatient fr the Arrival of the Picture we were promised shd come in Novbr from Rome'; there is no trace of either portrait today.[6] The diaries are, however, fascinating from the standpoint of the social historian: few other travel journals chronicle as vividly as these – perhaps all the more so for the rather laconic style in which they are written – the feelings and day-to-day activities of a young man who was intent on enjoying the convivial aspects of the Grand Tour. Barnard had admitted while at Oxford that 'I like the Ladies' Society so much, that I can never be really happy amongst a number of men for 3 weeks together', and much of his time in southern France was occupied with the courtship of a young English girl, Louisa Pitt,[7] and his subsequent liaison with a French actress. Barnard wrote home to his father to excuse his conduct over the latter: 'consider, pray, pray consider … Had I not better be possessed of someone who will prevent me from injuring my health, who will occupy my time, when I possibly might be induced to gamble, to drink or [commit] many other kinds of debauchery?', adding disingenuously 'It is the sure method of learning me the best French…!' Barnard's 'very particular attachment' to his cousin and future wife, Lady Katherine Powlett, also began abroad, while later, in Vienna, he conducted yet another romance, with the famous opera singer Anna Storace, Mozart's first Susanna in *The Marriage of Figaro*, dining with her composer brother Stephen, whilst he was temporarily in jail, on 21st February 1787.[8]

There was a lavish welcome home from this Grand Tour in July 1787 for the young heir on his coming of age: the Entrance Hall at Raby Castle, most spectacular of the North's

Fig. 92 *William Bankes* by Pompeo Batoni, oil on canvas, 1777

medieval fortresses, had been remodelled by John Carr, and the Baron's Hall was lit by a 'myriad of tiny oil and cotton lamps, arranged in columns down the windows or festooned across the walls, and in the centre, a large transparency below a viscount's coronet'.[9]

Intriguingly, the exceptional Grand Tour portrait by Pompeo Batoni which hangs at Raby Castle today (fig. 92) is not of William Harry Vane, but of William Bankes (1751–1800) of Winstanley Hall in Lancashire, who had made the Grand Tour a few years earlier in 1777, and who later became a member of the Society of Dilettanti. Although it has been suggested that Bankes travelled on the continent with

W. H. Vane's uncle, the Hon. Frederick Vane (1732–1801), second son of the 3rd Baron Barnard, there is no record of Frederick Vane – who was considerably the elder of the two men – having made the Grand Tour, and a much more likely, although more prosaic, reason for the portrait to have hung at Raby since the late 18th century is the family tie between the two men through Vane's first wife, Henrietta Meredith.[10]

There can be few more archetypal Grand Tour compositions than Batoni's portrait of *William Bankes* (fig. 92), painted in Rome in 1777. Leaning on a classical pedestal with a relief of the *Weeping Dacia*, Bankes gestures to the so–called Temple of Minerva Medica – a ruin particularly prized by British 18th-century tourists for its picturesque sense of decay. The rather attenuated silhouette of the sitter, resplendent in a brilliant green waistcoat and contrasting plum-coloured coat, is typical of Batoni's portraits of the 1770s, as is the rather pale overall colouring, and the portrait, like that of Thomas Orde (fig. 87), is a striking example of Batoni's continuing re-interpretation of Van Dyck, albeit in a less Baroque key than in the preceding decades: this glittering image, redolent of gentility, elegance and social refinement, is at the same time expressive of an aristocratic reserve or hauteur.

SIR JOHN TREVELYAN OF WALLINGTON HALL (1761–1846)

One of the most discerning Grand Tour patrons associated with the North, the future Sir John Trevelyan, 5th Bart, almost certainly made his Grand Tour of 1781–2 from the main family seat of Nettlecombe in Somerset. A few years previously, however, in 1777, his father had inherited Wallington Hall in Northumberland from an uncle, Sir Walter Calverley Blackett, and in 1791 he gave Wallington to his son on the latter's marriage to Maria Wilson. Although John seems to have infinitely preferred his Elizabethan home in the south, returning there (without Maria) after his father's eventual death at the ripe age of ninety-six in 1828, he spent much of his adult life at Wallington, and the aftermath of this tour, if not the tour itself, undoubtedly forms part of the North's cultural heritage.

Only a few details survive of John Trevelyan's 1781 tour,

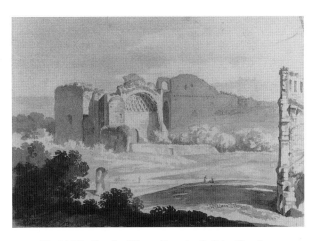

Fig. 93 *The Temple of Venus, Rome* by Sir John Trevelyan, wash drawing, 1782

which was made with a Mr. Leman, surgeon to an Irish regiment. Trevelyan was in Switzerland in April, when he perhaps bought the set of engravings of the Alps by Carl Hackert dated 1781 which survive at Wallington. By July, he and Leman were probably in Naples,[11] where Leman dined with the artist Thomas Jones, and on 21st October they were about to leave Venice for Rome; Trevelyan had certainly arrived there by February 1782, when he made two competent wash drawings of the *Temple of Venus* (fig. 93) and *The Tiber near Rome*, in a (now dismembered) sketchbook at Wallington; his one surviving Italian sketchbook, which features a typical Grand Tour mix of ruined buildings, views and architectural details in southern Italy, Tuscany, the Roman *campagna* and Elba, mostly in pencil, is undated, and probably belongs to a later, unrecorded tour.[12] We know, however, that Trevelyan's 1781–2 tour also included Vienna, as in 1804 Leman wrote to remind him of their stay there.[13]

According to one source,[14] John Trevelyan collected Dutch paintings while on the Grand Tour, but what is certain is that he was a major patron of Nathaniel Marchant, the most important British engraver of *all'antico* gems in the late 18th century. Marchant worked in Rome from 1772–88, gradually replacing the Italian J.A. Pichler in popularity with British tourists, owing to what Gertrud Seidmann has described as his

Left: Fig. 94 *Achilles*, cast from a gemstone of 1773–88 by Nathaniel Marchant

Far left: Fig. 95 *A Female Figure, Dressed as a Vestal*, cast from a gemstone of 1773–88 by Nathaniel Marchant

Fig. 96 *Infant Dionysus, Young Satyr, Horse's Head, Female Head, Eros, A Sphinx.* Group of antique and later intaglio gems formerly at Wallington Hall

Fig. 97 *Fragment of a female head: Hygieia,* marble, 2nd century A.D.

Fig. 98 *Statue of Hygieia (The Hope Hygieia),* marble, Roman copy after a Greek original of the 4th century B. C.

almost 'puritanical' approach to antiquity; he used only 'authentic, preferably unhackneyed, ancient works of art as models', and engraved them in intaglio, rather than cameo.[15] Trevelyan owned three important Marchant gems, *A Female Figure, Dressed as a Vestal,* an *Achilles* (figs. 94–5), and a *Bacchant and Faun*. These have been dated by Seidmann to his Italian period, and it seems probable that they were bought, or at least commissioned, by Trevelyan in Rome in 1782. The two men appear to have been close friends, as Marchant later bequeathed to Trevelyan two important Grand Tour books, his *Museum Capitolium* and *Monumenti Inediti* by Winckelmann.[16]

Further evidence of Sir John Trevelyan's interest in antiquities is surely provided by a group of six classical and later intaglios (fig. 96) and a marble fragment of a female head (fig. 97), which his son, Sir Walter Calverley Trevelyan – himself a major tourist, and hence another possible purchaser – later gave to the British Museum.[17] The head has recently been identified[18] as a Hadrianic copy of a full-length statue of Hygieia (the Roman goddess of health), known as the Hope Hygieia, after the statue now on loan to the J. Paul Getty Museum in Malibu (fig. 98); this is itself a Roman copy after a famous Greek original.[19] The Trevelyans thus offer a rare exception to the fact that, apart from the Dukes of Northumberland at Alnwick, and the mid-19th century collection of

the Earl of Lonsdale at Lowther Castle, almost no Northern tourists seem to have acquired antique sculpture abroad.[20]

John Trevelyan was also the patron of the Cumbrian watercolourist John 'Warwick' Smith (see pp. 158–60); his commissions from the artist represent the only known 18th-century example of the Grand Tour patronage of a Northern artist by a client who also hailed from this same region. Trevelyan's first recorded visit to Rome took place around October 1781, just after Smith had left Rome for England in August 1781 with his great contemporary, Francis Towne (fig. 8), after a five-year stay in Italy, thus leaving it doubtful as to whether the two men actually met abroad. However, the Library at Wallington contains an album of watercolour *Views of Italy* by 'Warwick' Smith, inscribed with John Trevelyan's name. These small-scale reproductions of Rome, Florence, and the south coast are typical of the sets of views that artists made up for Grand Tour clients after their return to England, based on the sketches they had made abroad.[21]

A much more important group of Grand Tour watercolours by 'Warwick' Smith, almost certainly also commissioned by Sir John, was later acquired by the British Museum from his son; among the subjects is a view of the crater of Mount Vesuvius, almost certainly painted in Naples around 1778 (fig. 99).[22] With its stark, close-up view of the volcano, and use of lurid flashes of green and orange to represent the 'large cakes of sulphur of many different hues'[23] that contrast with the slate grey of the volcano rim, this is one of 'Warwick' Smith's finest and most original watercolours. Trevelyan also owned a copy of Smith's popular Grand Tour book, *Select Views in Italy*, published in London between 1792 and 1799.

The studies made abroad from 1767–77 by the Scottish artist David Allan (figs. 100–101) of Italian costumes, street vendors and strolling musicians are well known to historians of the Grand Tour.[24] In the years following his return to Scotland, Allen made a large number of copies of these highly marketable records of Italian life and customs for British Grand Tour clients, eventually becoming rather tired, as he himself confessed, of a vogue he had done so much to create: as he wrote to Lord Hopetoun in 1782, 'I fill up the time in

Fig. 99 *The Summit and Crater of Vesuvius* by John 'Warwick' Smith, watercolour, about 1778

Drawing a Collection of Italian and French dresses between Roma and Paris and Procita… from the Sketches I did from Nature …in all I have upwards of fifty [to do], but in doing a set of so many I find it tiresome in tracing them over and over'.[25] To the copies which Allan made, probably all deriving from his album of sixty-one watercolours entitled *A Collection of Dresses mostly from Nature* (1776), now in the collection of Aberdeen Art Gallery and Museums (fig. 40), can now be added a set of forty-two studies in the Library at Wallington, which survive in their original album (figs. 100–101).[26] Although these cannot be linked definitely to John Trevelyan, one drawing is dated 1785, not long after his tour, and it seems highly likely that, like the rest of the earlier Grand Tour material in this house, they belonged to him.

Perhaps the most fascinating aspect of the Wallington and Aberdeen albums is the inclusion of twelve costume studies set on the island of Procida off the Neapolitan coast. Allan's focus on Procidan dress is not accidental; it was famous at this period as being a relict of the simple forms of Greek classical dress, and Francesca Irwin has argued persuasively that Allan was encouraged, perhaps even commissioned, by Sir William Hamilton, whose interest in all surviving forms of Greek civilisation is legendary, to make these studies with a publication in mind.[27] In the event this was not forthcoming,

Far left: Fig. 100
Neapolitan family by
David Allan,
watercolour, 1785

Fig. 101
A Man Feeding Cats
by David Allan,
watercolour, around
1785

but Allan found a new use for the drawings in his Grand Tour albums, where they joined portraits of street criers – lemon sellers, fishmongers and even a man feeding cats (fig. 101) – strolling musicians, street entertainers such as Palone players, and costumes studies from the Alps, Rome, Florence, Venice and northern Italy.

WILLIAM BLACKETT, (1759–1816)

William Blackett, whose Grand Tour lasted from 1784–6, came from a prominent Northumbrian family which had acquired its wealth and title at the end of the 17th century through interests in mining and collieries. Like many Northern families who made the Grand Tour, the Blacketts had long-established trading connections in Newcastle, and played a prominent part in the city's life as aldermen, mayors and (Tory) Members of Parliament. By the time William Blackett came to make the Grand Tour, however, the family had long

made the transition to landed status; although William was descended, not from the senior branch of the family at Wallington Hall, but from a cadet line founded by Sir Edward Blackett, 2nd Bart., his family could certainly be numbered, as Bill Purdue remarks, among the first rank of the Northumbrian gentry, having acquired extensive estates at Matfen and nearby in the 1750s to add to their already substantial Northumbrian holdings.[28] Their major Yorkshire property, Newby Hall, purchased in the late 17th century and sold in 1748 to the Weddell family, subsequently became, under the ownership of William Weddell, one of the most important of all English monuments to the Grand Tour. Much later, in 1830, William Blackett's son Edward would marry Julia, daughter of the Napoleonic era tourist Sir Charles Monck; their wedding tour, which included a meeting with Monck himself in Naples, was spent on the continent. The fourteen surviving letters which William wrote home to his

father[29] are among the most informative – and certainly the most amusing – penned by a Northerner; here was a young man who could appreciate culture, but who knew how to enjoy himself, whose xenophobia did not stand in the way of his observation of continental habits, who became an art patron, but would not allow himself to be conned.

Blackett's tour, which appears to have been un-accompanied, given his father's scant respect for tutors, began in Lausanne in 1784, where he bought some thirty engraved views of Switzerland,[30] and proceeded via Turin and Bologna to Florence, where his acquisitions continued in more serious mode with small-scale copies of Raphael's famous *Madonna della Sedia* in the Pitti Palace (cf. fig. 79) and of a 'fine picture' by Carlo Dolci. Blackett also sat to the Irish artist Hugh Douglas Hamilton for one of the crayon portraits in which he specialised (fig. 102), considering that he took 'the strongest likenesses [I] ever saw'; from his later annoyance over the high rate of duty charged to his father, it appears that this had arrived back safely in England by March 1786.[31] In Naples, Blackett had little time for Sir William Hamilton, who, he considered, was of little use to the English as he was always with the King, or for the King himself, who preferred shooting 'every Sparrow he can find' to any other activity. At Pompeii, however, he was fascinated to be able to walk 'in streets and into Houses which were inhabited 17 hundred years ago…'; like other intelligent tourists, he related the past to the present, noting that the walls are 'painted in the Manner of the Adams… from which they [the Adams] have taken many of their designs'.[32] Although he had some thoughts of going to Sicily, which, largely as a result of Henry Swinburne's guide (pp. 45–6), was now on the tourist map, Blackett was dissuaded by more than one compatriot, who thought that 'what is to be seen does not repay you for the trouble which consists only in some temples of Grecian Architecture'.[33]

In Rome, where he lodged with a group of young English tourists at Margherita's hotel near the Piazza di Spagna, including Mark Davis, who had probably travelled with him in Florence and Naples, Blackett more than made up for his former lack of zeal for antiquities, employing, however,

probably with Davis, a 'cut-price' *cicerone* instead of the expensive James Byres. He also made the round of artists' studios; considering that 'in painting the English carry it', he went on to name two Scottish artists, Jacob More and Gavin Hamilton, as the 'best landskip & history painters' in Rome,[34] acting on his own recommendation by commissioning twelve drawings from More.[35] The choice of medium is, however, significant; Blackett's funds were not without limit, and while recommending anyone with a 'large house & a long purse to have a couple of Moore landskips in oil',[36] on the (mistaken) surmise that after the artist's death his works would be nearly as valuable as Claude's, his own Roman purchases were 'in my little way in prints & drawings' which nevertheless 'runs away with a good deal of money, they are sufficient, however to give

Fig. 102 *William Blackett* by Hugh Douglas Hamilton, crayon, about 1785

Strangers a good idea of the buildings & Antiquities of this place'.[37]

After spending Holy Week in Rome, Blackett moved on to Venice for Ascension Day, returning home via Mantua, Milan, Turin, Switzerland (where he and his party stayed at La Grand Chartreuse, dressing the only woman of the party, Mrs. Welldon, in breeches so as to gain her entry to this sequestered monastery), Munich and Vienna. Although he was a second son, William Blackett later inherited the title as 5th Baronet; his elder brother Edward, who predeceased him, appears to have spent much of his life abroad. Following his marriage, William lived for much of the time at the Surrey villa of Thorpe Lea near Egham, bought by his father. However, Matfen, as his principal Northumbrian residence, was the repository of several of his Grand Tour purchases, including a bronze copy of the Apollo Belvedere, a sculpture of Mercury, a 'Portrait of the Virgin copied from a Carlo Dolci at Florence' (which must be the Hugh Douglas Hamilton copy that Blackett bought in Florence in 1784) and his own portrait by Hamilton (fig. 102), which is the only one of Blackett's Grand Tour purchases identifiable today; these and other Grand Tour works are, however, recorded in Alethea Blackett's list of works at Matfen in the 1880s.[38]

A SCANDINAVIAN TOUR

The most bizarre of all tours from the North was that made by Sir Henry George Liddell (1749–91), nephew of the 1st Baron Ravensworth, who left Ravensworth Castle in County Durham on 24th May 1786 for a tour of Scandinavia with two companions, 'Mr. Bowes' (probably Henry Bowes of Durham), and Matthew Consett, who later published their travels as *A Tour through Sweden, Swedish-Lapland, Finland & Denmark* (1789), with plates by the great wood engraver Thomas Bewick; the text, which took the fashionable form of a series of letters, was ghost-written by the Rev. J. Brewster. Perhaps unsurprisingly, Consett prefaced his Tour with the comment: 'You and perhaps our other friends are smiling at our romantic Expedition, you are laying your heads together and consulting how three mortals, like Sir H.G.L. Mr. B. and

myself can expect to subsist upon Lapland mountains, or how we ever formed the resolution of undertaking as enterprizing a Journey'.[39]

Scandinavia was, indeed, a highly unusual destination for 18th-century travellers, and a visit there, as Consett indicated, was perhaps deserving of some explanation. However, although he refers intriguingly to the 'motives which induced Sir HGL' to bring 'two female Adventurers' home from Lappland, to 'fulfil a particular Engagement which he had made' being 'sufficiently known',[40] there is no contemporary evidence for the story which later grew up around this tour, to the effect that it was the result of a wager made by Sir Henry that he could go to Lappland and bring back two reindeer and two Lapp women to attend them. Liddell, indeed, wrote that he was setting out for Sweden 'from a desire to see the Northern parts of Europe'.[41]

The tour began in Gothenburg on 28th May 1786, and Liddell and his companions spent some time in Stockholm, and in the university town of Uppsala, before making the long journey north up the coast of the Gulf of Bothnia through Swedish Lappland to Tornao, on the border with Finland, eight hundred miles from Stockholm; here, at the northern-most point of their journey, they viewed the midnight sun (fig. 103). In Stockholm, Uppsala and even in Tornao itself (where Consett found the society not 'unpolished'), the tourists mixed with the diplomatic and merchant expatriate community, and visited churches and palaces, Consett finding the King's palace at Stromsholm 'a very poor mansion for Royalty' and his stables little better than 'our Yorkshire barns', while the paintings at Drottingholm Palace were more 'adapted to an attic story or lumber garret than to be used as the ornamental decorations of a Royal Palace'.[42]

The tour of Lappland itself, however, was very different. Regularly experiencing damp beds, dirty inns, and bugs, and on one occasion being obliged to stay in their coach for twenty-eight hours without food, Consett and his companions saw for themselves the extreme poverty of the inhabitants. There was no bread, and, owing to the shortage of corn, the Lapplanders often had to mix the crop with fir tree bark. The

accommodation was equally spartan: the people lived in timber huts, and the travellers observed a baby lying in a cradle covered with moss and reindeer skin. Only the reindeer themselves could partially remedy such deficiencies, supplying the population with milk, cheese, meat and skins; even the 'nerves' were utilised for tying boards together. Having reached Tornao, Liddell and his companions returned from Lappland along the route they had come, relieved to return to clean sheets in Stockholm, and paying a short visit to Denmark before sailing home.

Although his motives for recruiting them remain obscure, it was on his return journey, at Igsund, that Liddell found two Lapp girls, Sigree and Anea, who, apparently satisfied that his attentions were honourable, were 'easily prevailed upon to leave' their homes and make the six hundred mile trek with five reindeer to Gothenburg, where the English tourists met them; Consett attributed their agreement to the lack of suspicion found in people in a 'state of nature'.[43] The expanded party arrived at Shields harbour on the Northumbrian coast sometime after 12th August 1786, and at Ravensworth Castle that same night.

The importation of these exotic women, who wore trousers of coarse cloth and carried knives, tobacco pipes and sporting apparatus, finds obvious contemporary parallels both in the context of the slave trade, and in the attention paid to a chieftain like Omai from the South Sea islands; 'lively and chearful', 'graceful and unaffected', Sigree and Anea were regarded in England as great curiosities, and introduced to 'all ranks of people'. They were, Consett tells us, so 'easy in their address' that 'instead of their Lapland mountains you would have imagined their Education had been in the Drawing room'![44] Although Consett clearly felt it necessary to scotch rumours as to the nature of their relationship with Liddell, Sir Henry is said to have treated them with great humanity, and they seem to have avoided the fate of many contemporary overseas immigrants, perhaps because, wisely, they were hurried home before infection, and the 'over bountiful fare which they met with at Ravensworth Castle', could cause their demise;[45] after a few months' stay at the castle, they returned

to Sweden with £50 in their pockets, and many 'bountiful presents of trinkets' which came to be much in demand for the decking out of Lapp brides.[46] The reindeer were less fortunate. Although, according to Consett, they seemed set to confound naturalists' predictions that they would 'never thrive or breed in any country but Lapland', the herd at Liddell's Northumbrian seat at Eslington having become 'very prolific' by 1789, they appear to have died out in the course of a few Northern winters.[47]

To judge from his *Tour*, Consett was probably a keen naturalist, and this may explain his inclusion in Liddell's party, which otherwise remains something of a mystery. The rather deferential nature of the Preface suggests that he did not consider himself Liddell's social equal, and it seems unlikely that he acted as a Grand Tour tutor or scholar; when the party was accosted in Latin by the Dean of Bogde, it was Liddell, not Consett, who came to the rescue, nor was Consett, on his own admission, a connoisseur of paintings. The later involvement in his *Tour* guide of the Welsh traveller, Thomas Pennant, who wrote forwarding material from the late Carl Linnaeus – the great Swedish botanist who in *Species Plantarum* (1753) established the botanical naming system we use today – surely confirms the bias towards natural history of this tour. Linnaeus himself had explored Lappland from his base at the University of Uppsala in 1731, taking an interest in the region's culture as well as in its *flora*, and it seems possible that this tour was quite consciously following in his footsteps.[48]

Apart from the tour itself, the principal interest of Consett's book lies in its inclusion of a series of engravings by the young Thomas Bewick, who later confirmed in his autobiography, *A Memoir of Thomas Bewick* (1862), that he had engraved the plates for this publication.[49] Two engravings of the travellers entering the town of Uppsala in their landau, and of Liddell, his companions, and his Swedish servant, Charles Brandt,[50] viewing the midnight sun at Tornao (fig. 103) – Liddell is perched on the steps of the windmill, watch in hand, to indicate the hour – seem to have been taken from pictures painted in Stockholm by 'Mr. Martin' (the Swedish painter, Elias Martin, 1739–1818). These were still at

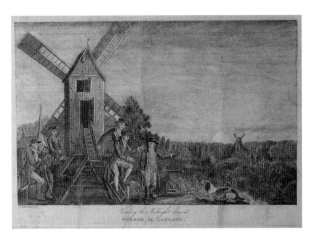

Fig. 103 *Sir H. G. Liddell, Henry Bowes and Matthew Consett viewing the midnight sun at Tornao*, engraving by Thomas Bewick after Elias Martin, 1789

Ravensworth Castle in 1827, together with four watercolours by Martin, two of Gothenburg and two of Stockholm.[51]

Not all of the plates, however, were based on works made on the tour itself. Bewick's engraving of Sigree and Anea is said to have been taken from portraits of the two girls which he made at Ravensworth Castle, while Bewick also drew, at Ravensworth, one of the reindeer and the Lapp sledge which Liddell had brought back home 'as a curiosity'.[52] In addition, Bewick supplied engravings of several of the game birds the travellers had seen – and indeed eaten – on their tour, taken from drawings by a young, self-taught artist who was nephew to the housekeeper at Ravensworth Castle.[53] These, in turn, would almost certainly have been made from the skins of birds brought back from the tour.[54] Reliance on skins was a practice Bewick disliked, and his later fame as an engraver would rest on the fact that his illustrations were made instead from live birds or animals. It is therefore no accident that the engraving of the reindeer, which Bewick proudly states on the plate was 'Drawn from the living Animal' is the finest of the natural history illustrations in Consett's book; as the animal's horns, however, were covered with hair, Bewick copied the antlers from a pair of reindeer horns 'collected by Liddell on [his] tour'.[55]

JOHN (1764–1817) AND HARRIET (1771–1848) CARR

The Carrs were a 'Newcastle merchant family who had, during the 18th century, become rich, thanks to the financial ability of Ralph Carr, whose diverse interests included ship-owning, under-writing, landowning, the import and export of goods to Europe and America', coal-mining and banking. As Bill Purdue has pointed out in his two recent studies of the Carr family, by the time of the Grand Tour made by John and Harriet Carr in 1791–4, the family's landowning status and 'their country seats at Dunston[56] and at Hedgeley in north Northumberland' (a recent purchase of 1784), in addition to their town house in Charlotte Square, had given the Carrs 'a claim to gentry as well as merchant status'.[57]

Ralph Carr (1711–1806) had made a professional tour of the commercial capitals of Europe from 1737–8, which offers a forcible contrast to the Grand Tours made by his landed contemporaries, and he was clearly broad-minded enough to perceive the benefits of foreign travel in widening horizons, for in 1746 he encouraged his nephew and apprentice, John Widdrington, to make a tour abroad, with the permission of the Newcastle Merchant Adventurers' Company, which was by no means solely confined to business interests.[58]

However, the continental tours made by Ralph's eldest son John from 1788–90, and then from 1791–4 with his vivacious sister Harriet, a talented amateur artist whom her father – making use of commercial vocabulary which belies his evidently strong affection for her – called 'one of my richest jewels',[59] were very different from those of their father and his apprentice. The brother and sister were now members of the county's social elite, and, as a result of their enforced stay in Italy during the French wars – which is extensively documented in the series of letters John, in particular, providing regular bulletins on his sister's health, wrote home to their parents – they would come to mix with foreign aristocrats on terms of equality.

John Carr's Grand Tour of 1788–90, also well documented in his correspondence, followed on naturally from his position as eldest son and heir to a landed estate; although he had been educated at a Yorkshire school rather than at Eton, in 1781 he

had gone up to Christ Church, Oxford – a decision, as Purdue remarks, that stands as a 'deliberate but natural assertion of gentry status'. The same could be said of his first tour itself, which, in its initial stages, was made with a fellow Oxford student, Richard Meyler, and, perhaps, with a Fellow from Merton College, Mr. Hammond.[60]

Carr was a more enquiring tourist than most, and, after acquiring a 'tolerable knowledge' of French, and making a tour of southern France on the advice of Louis Dutens, he spent sixteen days in northern Spain, walking, he estimated, two hundred of the three hundred miles they covered. Although Spain had recently been the subject of Henry Swinburne's travel guide, which John consulted, finding, however, that his descriptions fell 'far short of the beauty of Barcelona, and the wonder of Montserrat', it was still not visited by the majority of tourists, but John told his brother 'I never laid out my money and time more to my satisfaction than I did in this journey'. Even when he rejoined the main tourist route in southern France in early 1789 he was careful, unlike W. H. Vane a few years earlier, not to 'associate too much with the English', although he spent some time in Lyons with his fellow Northerner and friend, Sir Charles Monck.[61] Carr's letters home, focusing as they often do on the agricultural and economic aspects of the landscapes he travels through, provide an illuminating contrast to those of most tourists: these are letters to a father whose interests lay in commerce and land management rather than in culture.

John Carr's tour included Switzerland, where he made some purchases for his artistic younger sister, including some studies of Swiss costumes by Christian von Mechel (1737–1817) that would later inspire Harriet to make her own costume studies abroad.[62] Later, in Germany, and now in the care of a professional tutor, Mr. Dillon, and his charge, Mr. Portman, following Richard Meyler's return home, he was received at the princely courts, reporting to his elder sister Annabella that 'we have been living with the great ones of the Land, we have been dining with Princes and Dukes, and supping with Kings and Queens. I sometimes think of ye sudden elevation of Sancho to ye ranks of Governors of

Provinces, but make no applications'.[63] In Göttingen Carr dined with the three youngest sons of George III, then studying at the University there; undoubtedly, he had moved a long way from his Northern roots. However, a planned tour of Italy was cut short in Vienna in the winter of 1789–90, when he was struck down with malaria.

Only a year after his return, John was preparing for a second tour abroad, this time accompanied by his twenty-year old sister Harriet, who had developed a tubercular cough and was considered to be in 'danger of her life'. While John was delighted to have this second chance of visiting Italy, it was clearly only extreme concern over Harriet's health that led his parents to sanction, or even consider, continental travel at this time. Since the beginning of John's first continental tour, the French Revolution had changed the political map of Europe, and, as brother and sister prepared for their departure in London in the summer of 1791, they heard disturbing news for travellers who might be regarded by the French in the light of aristocrats: of the French Royal family's flight and recapture at Varennes. As John wrote, these were 'wonderful days when we see Kings flying from their own subjects as from their greatest enemies, and afterwards brought back in chains to their palace'.[64]

Although, in the event, travel through revolutionary France passed, as John had anticipated, without 'the least molestation', he took the precaution of erasing their coat of arms from their carriage, and of investing in four cockades as 'our safeguard through France'. Because the priority was to improve Harriet's health – John was expected to send regular bulletins home as to his sister's diet, exercise, and symptoms – the travellers headed straight for Italy, although they were held up in Geneva for a few weeks when Harriet fell ill there with a bilious complaint; as she convalesced, she was already spending time drawing, wishing for the 'pencil of a Smith or a Pocock'.[65]

For the Carrs, their journey over the Alps with their servants, Stephen and Dolly, provided a 'peep into a new world', and Harriet attempted to sketch the mountains, expressing her astonishment that none of the landscape painters 'who travel in search of subjects…make Savoy their choice' – a failure soon to be remedied by Turner. By the time

they had reached Turin, Harriet had already abandoned her invalid status, and she spent hours visiting the King of Sardinia's picture collection and his 'charming statues, innumerable busts, of undoubted antiquity & the finest collection of medals & antiques in Italy'. She also attended a 'Grande Chasse' given by the King at which she was presented with a foot of a stag, which John intended to bring home as a trophy. Three days in Bologna were spent by Harriet in raptures over the 17th-century masters who were still, in the 1790s, at the pinnacle of their fame with British connoisseurs: the heightened language she uses to describe them is familiar from other tourists' accounts of their Grand Tour experiences: 'I dare not suffer myself to describe one picture, as there are hundreds beyond description excellent; and it is a subject that I cannot speak reasonably on, suffice it to say, that I scarce thought myself on earth'.[66]

The Carrs arrived in the 'Empress City of the World', as Harriet called Rome, in December 1791, and stayed – apart from a brief excursion to Naples – for almost six months. Their passage into Roman society was assured by their introduction to Thomas Jenkins, already 'prepossessed' in their favour by letters from their friend and fellow Northerner, Sir John Dick, formerly British consul at Leghorn, and Harriet soon became friendly with Jenkins's niece. Like William Blackett, the Carrs now made the round of artists' studios; unlike him, they had a knowledgeable guide in their Northumbrian friend – and another amateur artist – Edward Swinburne,[67] who knew most of the artists personally. Harriet's status as an artist was clearly already attracting some attention, as on 25th March 1792 Mrs. Flaxman, wife of the sculptor, and Mrs. Hare-Naylor, herself an amateur artist, called to see her drawings. Her social success also seems to have been assured: John dubbed one of her evening parties 'a squeeze', given the number of English visitors there, and Harriet's riding was 'the admiration of all the Roman ladies who never venture out of their carriage'.[68]

On the Carrs' visit to Naples in January and February 1792, Harriet, like other intelligent tourists, saw the surrounding landscape in terms of the classical poets and authors with whom it was associated: 'Here it is that Horace laugh'd, that Pliny died, that Cicero fell'. Her letters further betray an imaginative sympathy with the vanished classical sites themselves, albeit expressed in highly florid terms: 'Here are…. Pompeia, Herculaneum; Here are! ah no! they are here no longer, but only to be trac'd thro' the ashes & lava of Vesuvius, & thro' the dirt & weeds of Naples: the wonders of nature in these Fields of fire, (as they were not inaptly term'd by the antients) are no less conspicuous; but far exceeding my powers of description, suffice it to say, that it seems a Fairy Land'.[69] During her stay in Naples, Harriet met Emma, Lady Hamilton, 'whom I admire allmost to Idolatry', and painted a miniature of her, now lost, which, although she had only one sitting, on 11th February 1792, was judged to be 'at least as like as any portrait that has been done of her'. On the back of what was presumably her own (smaller) copy of the miniature Emma wrote: 'I had the happiness of my dear Miss Carr's Company all day – but alas the day was too short'.[70] Harriet also painted Emma, 'from memory, but like', in a whole-length watercolour (fig.104) which survives in an album of Grand Tour drawings that Harriet retained herself; it is perhaps expressive of her 'idolatry' that in this composition she chose to portray Hamilton's former mistress as 'la Santa Rosa', in white classicising robes with a saintly expression and a halo, gesticulating in front of a wooden crucifix in a Salvator Rosa-like landscape.[71]

The Carrs had intended to leave for England in the spring of 1792. However, the declaration of war between France and Austria in April decided them, like other British tourists, against travelling home that year, and they returned to Florence, where the air was considered suitable for Harriet's health – and which also had the merit of being on the way home. By that winter, John, unlike his Northern contemporary William Henry Lambton, was shuddering at the prospect of the 'modern Gauls' becoming masters of Rome; despite the French army's vaunted protection of the arts, he considered that 'If ye gauls go there, farewel arts'.[72] The political situation remained highly unstable throughout 1793, and in the event John and Harriet were obliged to stay yet another year in Italy.

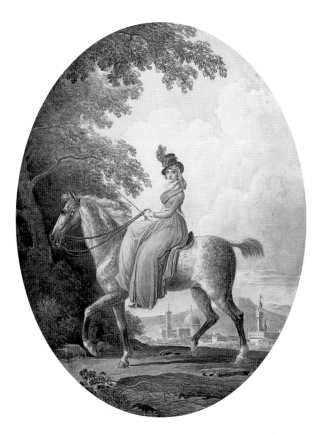

Fig. 110 *Harriet Carr on horseback in the Boboli Gardens, Florence*
by Jean-Baptiste Thian, pencil and watercolour, 1794

scarce ever interrupted. She is the idol of the Italian Ladies, who all distinguish her as she deserves. She has scarce a hat a cap or a gown that they have not beg'd to have as a copy, and seeing her and Lady Hervey on horseback every morning, many of them have attempted to ride in the English way'.[92] Behind her can be seen the city of Florence with the cathedral and Palazzo Vecchio. This fine watercolour by a little-known artist who was possibly Swiss, from the circle of Franz Kaisermann (cf. fig. 30), also re-surfaced at Christie's in 2005, and is now in a private collection.

In December 1793, the Carrs paid a final visit to Rome before their departure (again via Florence) for England. Harriet left Florence, according to John, 'universally regretted', and, in her own words, 'as if quitting a second native country'. This was, however, a very different visit to Rome from their previous one: the Princess Santa Croce had 'charged herself with the trouble of presenting us every where' and by now, as John wrote, 'Having been so long in Italy we are looked upon as half naturalised, and find every door open to receive us' – a claim verified by the collection of visiting cards the Carrs received in Rome (fig. 111).[93] Many of these cards from aristocratic Roman families such as the Doria

Fig. 111
The Temple of Vesta, Tivoli, and *St. Peter's, Rome,* visiting cards received by John and Harriet Carr in Italy, 1791–4

from Rome to Florence to avoid retaliation by the Italian mob. That same year, she received official recognition of her talent – 'my academical Honours' as she called them – presumably her election to the Academy of either Florence or Pisa: for her presentation drawing she chose a subject from the great Italian poet, Ariosto, of a 'Knight delivering a damsel from two Ruffians'.[90] On her brief return to Florence in 1794, Harriet herself sat for a watercolour portrait to Jean-Baptiste Thian (d.1816), fig. 110, which shows her out riding on her much-loved horse[91] in the Boboli Gardens, wearing a pale lilac riding habit and a striking, feather-trimmed hat; the portrait offers a close visual parallel to John's descriptions of his fashionable sister's appearance out riding: 'Her daily rides have been

Pamphili, the Borghese or the Altieri, engraved with views of well-known Roman monuments or neo-classical reliefs, are themselves part of the visual history of the Grand Tour.

On their eventual return home in the summer of 1794 the Carrs were obliged to take a circuitous route across Europe so as to avoid the French armies. On 1st September, John wrote to announce their safe arrival at Harwich after a Grand Tour lasting three years: he could reflect with satisfaction that the 'great end of our journey' had been answered in the re-establishment of Harriet's health.[94] Harriet was greeted by a munificent gift from her brother Ralph, who was a warm supporter of her artistic pursuits; a veritable library of forty books on art, assembled at his request by their literary friend William Seward, himself a tourist.[95]

Although Harriet's mother had become concerned in late 1793 that she would find life in the North of England dull on her return, and even suspected that she had formed a romantic attachment abroad, Harriet had assured her that she would 'sit down contented for the remainder of my life, & be thankfull for having had an occasion for emprevement & entertainment, that has been the lot of very few'.[96] On her return to the North-East, she seems, temporarily, to have done just that, and in 1798 she made what her family considered to be an eligible marriage to Colonel, later General, Cheney (d. 1820), ADC to Prince William of Gloucester, who had been stationed in the North East with the Militia.

Harriet's long widowhood was spent partly at Badger Hall, Salop, an estate inherited by her son Robert Henry, where she continued her artistic pursuits, decorating the dining room and library with medallions of the Seasons and a classical frieze. She also, at various stages of her life, made numerous sketches of friends, often in classical and allegorical guises; flower studies; and 'voluminous' illustrations of the *Iliad* and *Paradise Lost* – all very much the type of subjects one might expect from a woman amateur, whose formative years artistically were the late 18th century, and whose artistic repertory was shaped by the Grand Tour. The classicising frontispiece Harriet provided in 1799 for William Sewards's *Biographiana*,[97] which the author dedicated to her, is suggestive

of the considerable intellectual and artistic credentials she had gained as a result of her Grand Tour; Seward was the 'best compiler of anecdotes except Horace Walpole', and a member of the literary circle around Dr Johnson and Mrs Thrale.[98]

However, the latter part of Harriet's life was also shaped much more directly by her Grand Tour. From 1820 onwards following her husband's death, most of her time seems to have been spent as an expatriate, moving in intellectual and artistic circles in Italy with her younger daughter, Harriet Margaret, and her two elder (bachelor) sons, Robert Henry and Edward. Robert Henry, was, like his mother, a talented watercolour painter, while two Italian sketchbooks by Edward also survive, making the Cheneys yet another example of those elite British families who produced voluminous numbers of drawings under the influence of professional masters; one of their tutors was perhaps William Leighton Leitch.[99] If Harriet's Grand Tour of 1791–4 had essentially been typical of its day, although unusual in its duration, and in her artistic achievements, such extended residences abroad were not uncommon among the leisured classes in the early 19th century.

Visiting Naples in 1823,[100] the family subsequently moved to Rome, renting the Palazzo Sciarra on the Corso; later, in 1830, Robert Henry was sharing the Villa Muti at Frascati, former home of the Cardinal Duke of York, last of the exiled Stuarts, with his, and Edward's, friend Henry Edward Fox, later 4th Lord Holland.[101] Surviving Italian drawings by Robert Henry and Edward date principally to 1823, 1833 and 1837–8. Among the Cheneys' contacts and friends in Italy[102] were the great antiquary and archaeologist Sir William Gell, the Duchess of Sermoneta, one of the first to take an interest in Etruscan art, Hortense, former Queen of Holland, the artists Thomas Hartley Cromek and Edward Lear, and Sir Walter Scott, for whom the Stuart memorabilia at the Villa Muti during the Cheneys' tenancy represented the highlight of this visit abroad in his old age. Robert Henry and Edward Cheney both spent time in Venice in the 1830s, and by the 1840s Edward was established there, living in the Palazzo Soranzo Piovene on the Grand Canal, and becoming a friend of the great archivist and historian Rawdon Brown, and of

Effie, but not John, Ruskin, who disliked his classicising artistic tastes. Here he pursued literary and artistic interests, his publications including a novel, *Malvagna, or, The Evil Eye* (1836), set in Sicily, while he was also a highly distinguished collector of both paintings and works of art, notably of pictures by Guardi and of oil sketches and drawings by Tiepolo, a consultant to the National Gallery, the founder of the Burlington Fine Arts Club and a distinguished early photographer.[103]

Harriet seems to have shared her sons' lives abroad; in Italy in 1827, she sought an introduction to the Durham-born artist, William Bewick, telling him that 'she belonged to Newcastle, and knew T. Bewick, the "celebrated engraver"'. Bewick wrote that Mrs. Cheney's 'taste seemed to be held in high esteem', and her drawings he found 'quite exquisite. She is a true artist, and is drawing and painting every day of her life'.[104] He noted, however, that she 'lived in high state here with her family', a claim borne out, not only by what we know of the Cheneys' lifestyle abroad, but by the studies, principally of British visitors, with an admixture of Italian sitters, which Harriet now included in two further albums of watercolour portraits; these were probably mostly painted in Italy from around 1835–40.[105] Although, in keeping with their date, they are less neo-classical and more ostentatious in style than her former studies, showing the influence both of Venetian art and of Van Dyck, the basic format, in which sitters, accompanied by classical or musical props, are set against a background of Italianate interiors or landscapes, remains the same. In 1836 a cameo portrait was made of Harriet in Rome by Sauli, showing her in profile, her forehead encircled with a classical diadem; this derived from a marble bust, taken from life in that same year by the leading British neo-classcial sculptor of his era in Rome, John Gibson (1790–1866), who later produced a monument to her in Badger Church, Shropshire, showing her with easel and brushes by her side.[106]

Although, like his sister, John Carr had the intellectual capacity to appreciate continental life and culture, he was not, as he himself admitted, strongly interested in the visual arts. He did, however, form a collection of books in the aftermath of his Grand Tour which included early editions of classical and later Italian literature.[107] Although Carr preserved a London dimension to his life, he seems to have readjusted to life in the North of England on his return from Italy.[108] Through his marriage in 1802 to the heiress, Hannah Ellison, he brought the family further landed estates, and united two of the most important of the North's Grand Tour families. Four years later, his father's death confirmed him as one of the region's major landowners, and Carr became active as a magistrate and Chairman of the Quarter Sessional law courts, serving as High Sheriff of Northumberland in 1813, and taking an active interest in the improvement of his houses and estates. However, Carr's friendships, affiliation to the Whig party, and recreations bring him close to other former Northern Grand Tourists and suggest that his experiences of the continent helped to shape his life in the North on his return. His closest friends, the graecophil Sir Charles Monck, Sir John Edward Swinburne and Charles Bigge had all made the Tour, and all four men were closely associated, either as Vice-President or President, with the early development of the Newcastle Society of Antiquaries; founded in 1813, this offers another example of the importance clubs and societies had increasingly come to occupy in the development of North East 'polite' society and leisured pursuits in the early 19th century.

A final, and very direct link between the Carr family and the Northern Grand Tour is provided by John and Harriet's father, Ralph, who in 1804 purchased from his close friend, Sir John Dick, his collection of oil paintings and antique sculpture, formed during his many years abroad as British consul at Leghorn. Although this collection, which may have descended to Dick's godson, Ralph Carr junior, but which hung at Dunston Hill and Hedgeley by 1893, has long since been dispersed, the presence of such a highly important Grand Tour collection would have been unique in Northumberland at this date.[109]

WILLIAM HENRY LAMBTON (1764–97) AND LADY ANNE LAMBTON (d. 1832)

'One of the richest private gentlemen in England',[110] William Henry Lambton of Lambton and Harraton Hall in County

Durham, who inherited from his father an estate said to be worth £35,000 a year, was the most significant art patron to hail from the North of England. During the single year he spent in Italy before his death in Pisa in November 1797 he commissioned a large number of works from contemporary artists; one commission in particular, from William Artaud, was closely linked to Lambton's political radicalism, which had already shown itself in the impassioned speeches he made in the House of Commons as a Whig M.P. for Durham, and in his active membership of groups such as the Association of the Friends of the People, and the Friends of the Liberty of the Press. Lambton, who was a bitter opponent of slavery, was also a prominent Freemason, acting as Provincial Grand Master of the County of Durham from 1787 until his death – a commitment he shared with a number of other Northern Grand Tourists, and with Prince Augustus, Duke of Sussex (fig. 121).

The Lambtons had been prominent in Durham since the time of the Crusades. Among the earliest families in the North to turn to Protestantism at the Reformation, they had been enriched from the early 17th century onwards by their involvement in the developing coal industry, while W. H. Lambton's grandfather transformed the family fortunes still further with his marriage to the heiress to Harraton, the adjoining coal-producing estate to Lambton on the opposite bank of the River Wear. As one might expect of an elder son in this position, W. H. Lambton had already made a tour of France, Switzerland and Spain as a young man in 1784–5.[111] This second tour, which was undertaken with his wife, Lady Anne Villiers, daughter of the 4th Earl of Jersey, their three young children, and the children's tutor, Mr. Manby,[112] two years after inheriting his father's estates, was almost certainly intended as a last attempt to arrest the consumption from which Lambton was suffering. Certainly this was a highly unstable time to be travelling abroad, and it may have been the political situation, as much as the urgent need to try to re-establish Lambton's failing health, which caused the family to sail straight to Naples, where they arrived in October, 1796; soon, Lambton was well enough to 'take a peep at the crater' of Vesuvius, and attend a Neopolitan court hunt.

Here the Lambtons were painted some months later in their apartment, with Mount Vesuvius visible through the open window, by the Neapolitan court painter, Augusto Nicodemo (fig. 112), shortly after the birth of a fourth child, Hedworth, on 26th March 1797. A British tourist living in Naples at the time, Eugenia Wynne, commented that she had never seen 'anything so pretty and so much like'[113] as this delightful family group, which, with its deceptive simplicity, was painted by an artist with impeccable neo-classical credentials. The Greek vases on the mantelpiece may reflect acquisitions made by the Lambtons abroad, but the whole tenor of the painting, with its simple wall-hangings and furniture, classically inspired carpet and Mrs. Lambton's elegant, white gown, the flowing lines of which are inspired by antique sculpture, is a reminder of the way in which neo-classicism informed every aspect of the arts and even fashion at this time. The portrait also reflects the spirit of the times in a rather different way. William Artaud would later comment that if Lambton were to die 'his Lady' would suffer the loss of 'a most under[standing] & attentive husband, his Children [an] affectionate Father & Society one of its most usefull amiable & energetic members', and, in this first group portrait to be painted of a family from the North of England in Italy, we can sense the rise of the 'affective' family unit which was such an important feature of the second half of the 18th century, and which can be sensed from the now untraced letters Lambton wrote home to his brother; apparently silent on the subject of art, the extracts now available from them also movingly convey Lambton's struggle against illness and his frustration at his enforced political inaction at a time of such volatility.[114]

It was in Naples that Lambton met his almost exact contemporary, William Artaud, who, after a successful early career in London as a history painter, was now spending three years in Italy, having won the Royal Academy's travelling studentship in 1795, and who told his father that his trip to Naples had turned out to be extremely fortunate, as it had been the means of making him acquainted with

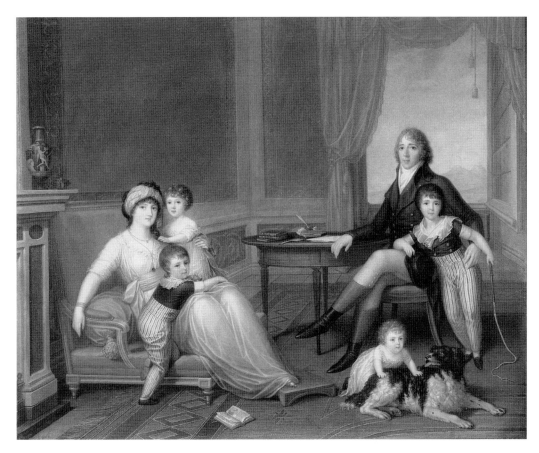

Fig. 112
*The Lambton
Family at Naples* by
Augusto Nicodemo,
oil on canvas, 1797

W. H. Lambton, 'one of the richest and what is better one of the most independent and upright characters in our House of Commons'.[115] The two men were almost certainly drawn to each other through their shared interest in radical politics. Although Artaud had fled temporarily to Naples from Rome in anticipation of the 'lawless violence which ever precedes the entrance of a hostile army into a City', he was described by the diarist Joseph Farington as a 'violent democrat', and later demonstrated his support for the French revolutionary armies after their entry into Rome, talking of the 'Roman Republick now successfully re-established'; he would have agreed with Lambton's verdict on the rulers of Naples as 'weak, foolish, purile tyrants' – albeit deserving 'the rod more than the guillotine'.[116] It is possible that the artist and his future patron were introduced by a mutual friend, the amateur artist and Northern tourist Edward Swinburne, who makes frequent appearances in Artaud's letters at this time. Having met Prince Augustus, however, and been invited to dine at his Royal Neapolitan Club, which was composed of 'all the English Noblemen & Gentlemen [who] were travelling in Italy and resident some time at Naples',[117] Artaud was moving in circles where he would almost certainly have met Lambton even without such an introduction.

It was not until the Lambtons' arrival in Rome, however, in June 1797, that Artaud came to know the family well,[118] when his offer to act as Lambton's *cicerone* – presumably made in an

attempt to cultivate such a potentially important patron – was accepted. Artaud promised 'every information in my power respecting either the Pictures or Antiquities', advice on any purchase Lambton 'might wish to make in the way of Art', and offered to become Lambton's 'conductor to the galleries'.[119] This last, as he himself recognised, was something of a thankless task in this year, as the city prepared for the French invasion: 'To the Man who has seen Rome in her first splendor she now appear[s] as Milton describes Satan in his fallen s[tate], like the sun eclipsed, shorn of her brightes[t] beams, her museums & churches are strip[p]ed of their choicest ornaments, Miserable copys or cast[s] in Plaster substituted for the most exquisite oringinals'.[120]

Artaud also made himself useful to the family in a number of other ways, trying to obtain a copy of *Robinson Crusoe* for some of the Lambton children, 'who were just beginning to read', and helping Lady Anne Lambton in her attempts at oil painting; after her departure, he found 'her ladyship's palet', which he promised her husband to forward to her, adding that whenever she was 'sufficiently settled to attend to her oil Painting I will send her the little compendium of instructions relative to its mecanical Process, which I promised her'.[121] According to Artaud's own account, Lambton treated his new acquaintance with 'the utmost cordiality and friendship' and 'I have been almost a constant guest at his table'. The artist also commented on the couple's ability to 'dissipate by their frankness and affability, the idea of that superiority to which their Rank & fortune entitle them', and make a visitor feel 'perfectly at his ease'. After Lambton's death Artaud wrote feelingly to Manby of 'the generous frankness & unaffected condescension' of Lambton's manner, and the 'rectitude & manly energy' of his principles, adding 'Indeed he had no acquaintances; they were all his friends'.[122]

Meanwhile, Artaud's hopes of finding an enlightened patron were realised when W. H. Lambton commissioned from him around August 1797 a major series of works, although the artist remained only too well aware of the 'very precarious foundation' of his connection with Lambton, owing to the latter's ill-health.[123] Lambton's request for three copies

Fig. 113 Study for *Liberty tearing the Veils of Ignorance and Superstition from his Eyes* by William Artaud, pen and ink with red chalk over graphite, 1797

(portraits of Raphael and Perugino from the *School of Athens* in the Vatican, and one of Machiavelli, the latter perhaps a rather curious choice for a patron with revolutionary leanings) would not have been unexpected: Artaud's letters constantly express his intense frustration at the fact that, owing to the highly unsettled political situation, he had been forced to abandon the 'Plan of Study which I had laid down when I first departed', when he had intended to copy 'little or nothing' and instead 'to [have] warmed me mind & improved my taste' by contemplating the works of the 'most celebrated Masters', focusing on the production of 'original compositions'.[124]

Fortunately for Artaud, W. H. Lambton, unlike the artist's other clients, also invited Artaud to paint two just such original compositions. The first was a 'very singular' portrait of the Lambtons' infant son, Hedworth, who was 'represented intirely Naked and I have taken two views of him one of the back and the other of the front; so that it is like two little children reposing on a bed. A Guardian Angel accompanied by a choir of little cherubs is watching over them'.[125] Far more important, however, was Lambton's commission for a major history painting, 'illusive to the French Revolution', 'partly allegorical and political', which artist and patron must have discussed at length, and which was in effect a summation of their political

philosophy.[126] This was *Liberty tearing the veils of superstition from his eyes* (fig. 113), which was to illustrate a passage from Erasmus Darwin's poem *The Botanic Garden*. As Kim Sloan has convincingly shown, the passage chosen was 'well known to be a paean to Liberty, in support of the American, and French revolutions'.[127] Greatly pilloried in the conservative press, it shows the moment when the male figure of Liberty, long asleep and bound with a triple veil, breaks his bonds.

Because the subject was of such central importance to Lambton, he was evidently anxious for its completion, presumably all the more so given his deteriorating health, and Artaud had been 'particularly obliged to gratify his impatience' by beginning work 'immediately' on the preliminary sketches for the composition, setting aside in the meantime work for another patron on the grounds that a 'connection with a Man of Mr Lambton's consequence' could not be ignored.[128] A sketchbook in the British Museum includes several of Artaud's early ideas for the figure of Liberty; a series of dramatic pen and ink drawings with red chalk, somewhat in the style of Fuseli (fig. 113). The more finished study which survives in the Victoria and Albert Museum brings the figure of Liberty rather closer to the poem by showing him in a more prostrated pose, strongly reminiscent of Michelangelo. Lambton's death only months after the commission was made suggests that Artaud almost certainly never began work on the canvas itself; if his other ambitious history paintings are anything to judge by, this would probably have been on a colossal scale. This project remains, however, among the most fascinating and unusual to be commissioned by any British Grand Tourist.

Most of Lambton's other commissions in Rome were arranged through Artaud's agency. Many of the artists chosen, including the sculptor John Deare (1760–98), who produced a chimneypiece for Lambton's library, or the miniaturist and dealer Alexander Day (1773–1814), whose miniature of Lambton had the 'good fortune to please her Ladyship', were among Artaud's friends in Naples and Rome.[129] Artaud was also the intermediary for four topographical drawings of Rome ordered by Lambton from the Swiss watercolourist, Franz

Kaisermann (cf. fig. 30), a pupil of Louis Ducros, and for his commission of a neo-classical history painting, *The Mother of the Gracchi and her Children*, from Vincenzo Camuccini (1773–1844).[130] It is possible that the rather uneven quality of Lambton's patronage abroad, which included artists not even recorded today such as 'Frederigo the German', can be explained in part by Lambton's reliance on his *cicerone*, although Artaud was apparently not responsible for the two Roman views that Lady Anne Lambton commissioned from

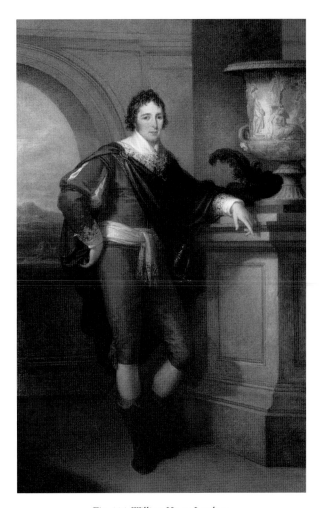

Fig. 114 *William Henry Lambton*
by Angelica Kauffman, oil on canvas, 1797

her drawing master, the brother of the family's language teacher, Guntatarde.[131] Some at least of all these commissions must have been completed, as on 25th October 1797 Lambton sent home seven landscapes, three portraits and two history paintings.[132]

Among the paintings W. H. Lambton exported may have been the two full-length portraits of himself (fig. 114), and of his daughter Frances (fig. 115), painted in Rome in 1797 by the famous Swiss-born portrait and history painter, Angelica Kauffman, who was now nearing the end of her long career. Having spent the formative years of her life in Rome in the 1760s, in a decade which saw the forging of the neo-classical style, Kauffman had returned to Italy in 1781 after spending many years in England. Here she painted major historical commissions for leading aristocratic patrons throughout Europe. Like Batoni before her, Kauffman also had 'from our British travellers constant employment' as a portraitist, and at least half of her documented portraits are of British sitters.[133]

Kauffman's portrait of *William Henry Lambton* in Van Dyck dress (fig. 114) is one of the most ambitious of all Grand Tour portraits: painted on the eve of the French invasion of Rome in 1798, it is also one of the last examples of this genre. Lambton is shown leaning on a pedestal which supports the famous *Medici Vase*, with the so-called Temple of Minerva Medica (fig. 27) in the background; there is a view of the Roman *campagna* behind. William Artaud was, however, perceptive enough to see that although this was 'the best resemblance there has been done [of] him; still, it fails of his true Phisionomical character. An attempt at softening the Features and giving a certain kind of prettiness ever destroys in my opinion the energy of her Male Portraits and makes them all appear to me to be emasculated'.[134]

The portrait of the Lambtons' only daughter, Frances (fig. 115), shows her as Psyche, the beautiful maiden in Apuleius's *Metamorphoses* with whom Cupid fell in love, but who was forbidden to look upon his face. Kauffman's painting, which Artaud considered 'a ver[y] pretty fancy Picture, but not like her',[135] probably refers to a later moment in the story when Psyche, forced to endure a series of trials in

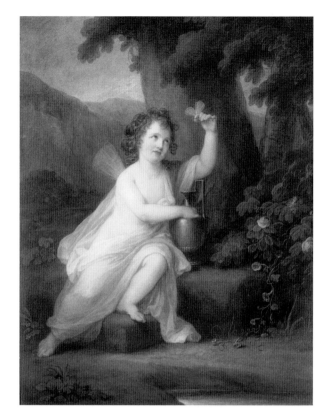

Fig. 115 *Miss Frances Lambton as Psyche* by Angelica Kauffman, oil on canvas, 1797

order to win back her husband, has to fill a jug with water from the River Styx in Arcadia. However, the inclusion of a night creature, a moth, on which the child's attention is riveted, harks back to Psyche's earlier discovery by lamplight of Cupid's identity. Given that she also worked as a history painter, Kauffman's portraits are often allegorical in nature. However, like many of her productions for British clients, this is essentially a decorative painting, classical only in its subject matter and in the flowing white drapery worn by the child. By the following year, Angelica was painting 'citizens' rather than aristocrats, and although she was allowed by the French administration to keep her studio, these were years of distress and financial hardship.

Lambton himself left Rome shortly after sitting to Kauffman, and died only two months afterwards, in Pisa, on 30th November 1797; Artaud records that his life at its close was 'a continual series of efforts to render those around him happy'.[136] He was buried in the Protestant cemetery at nearby Leghorn; there were plans, never executed, to order a simple monument from John Deare. William Artaud's somewhat high-flown sentiments of concern and regret, expressed in letters to Lambton himself, in the closing days of his life, and afterwards to the Lambtons' tutor, Mr. Manby, confirm his considerable degree of intimacy with the family, and it seems clear that Lambton's death acted as a body blow to Artaud's career; although some at least of his commissions appear to have reached England,[137] this source of patronage was effectively at an end, and no patron of similar importance emerged to replace him. As a result, William Artaud, whose early works had been exhibited in London beside those of Fuseli, Hamilton and West, was unable to resurrect his career after his return to England in 1799 – either because patrons like Lambton who shared his revolutionary sympathies were hard to find, or because the vogue for large scale history pictures did not survive long into the new century.

Whether William Henry Lambton also followed the example of most of his wealthy contemporaries, and purchased Old Master paintings abroad, is uncertain; although the Lambton Castle sale in 1932 included a number of Italian pictures, these could have been purchased by his son (see below) or one of his successors.[138] What seems almost certain, however, is that the exceptional collection of Grand Tour books dating from the late 18th century, which was also included in this sale, was assembled by Lambton himself; not only does Artaud mention the shipment of a case of his patron's books back to England in a letter of 1798,[139] but the volumes in the sale included seminal books which Lambton would surely have owned, such as Sir William Hamilton's magnificent *Campi Phlegraei*, 'Baron' D'Hancarville's *Antiquités Etrusques, Grecques et Romaines* (fig. 34) and Henry Swinburne's travels in Spain and Sicily (figs. 50, 52). Lambton is also one of very few Northerners known to have been actively planning major architectural alterations to his country seat during his absence abroad, although in his case this activity was somewhat tangential to his Grand Tour itself, as he seems to have decided to rebuild Harraton Hall – which he had turned into the family's principle residence on his accession in 1794 – prior to his departure, using an English architect of Italian extraction, Joseph Bonomi. As a former Adam assistant, Bonomi's plans for an embattled exterior, and contrasting neo-classical interiors, were in a tried and tested Adam mode. Unfortunately, the Grand Tour correspondence relating to this commission can no longer be traced, and, as with Artaud's own commissions, Lambton's early death seems to have put paid to the scheme, although Lambton's executors retained Bonomi to carry out more modest alterations to Harraton from 1797–1801.[140]

Lambton's eldest son, John George (1782–1840), who in Nicodemo's painting (fig. 112) stands at his father's knee playing with a riding whip, inherited both his father's consumption, and his zest for travel and political reform. 'Radical Jack' Lambton, as he was known to his contemporaries, was one of the key promoters of the Reform Bill, and, nearer to home, was noteworthy among early 19th-century employers for his attempts to improve safety for his workforce in the Lambton Collieries. His distinguished diplomatic career as the creator of liberal imperialism culminated in two embassies to Russia, and in his appointment as Governor General of Canada in 1833. As 1st Earl of Durham, he was the author of the *Durham Report* (1839), which led eventually to the formation of the Commonwealth. Lambton made a second tour of the continent after Waterloo, following the death of his first wife; her successor, Lady Louisa Grey, was the daughter of another even more distinguished Northern tourist – and Prime Minister – Charles, Earl Grey (see below), who shared his son-in-law's enthusiasm for reform. Another close political, personal, and Masonic friendship, with the Duke of Sussex (fig. 121), had been formed when Lambton was in Naples as a child, and in 1822 this well-travelled member of the Royal family came, as Lambton's guest, to lay the foundation stone for the newly

formed Literary and Philosophical Society in Newcastle, with Lambton himself, and Sir John Edward Swinburne, as Provincial Grand Masters of Durham and Northumberland respectively, assisting. In the audience, as one might expect at the inauguration of this Northern cultural icon, were several other tourists, notably Sir Charles Monck, Sir Matthew White Ridley and C.W. Bigge.[141] When in 1844 a memorial was erected by the citizens of Newcastle to John George Lambton on Penshaw Hill near Lambton Castle, it took the form of the temple of Theseus in Athens – the same Doric temple chosen by Sir Charles Monck as the model for Belsay Hall. Today, Penshaw Monument stands, with Belsay, as the North's most thorough-going architectural tribute to the Grand Tour.

OTHER TOURISTS, 1780–1800

Among the other Northerners known to have made the Grand Tour from 1780–1800 were William Henry Lambton's close friend – and his son John George's future father-in-law – Charles, later 2nd Earl Grey (1764–1845), son of the Grey family of Falloden near Alnwick in Northumberland. Grey was also the heir of his uncle, Sir Henry Grey, of nearby Howick Hall, and it was Sir Henry who financed his nephew's travels abroad after university in 1785–6.[142] At Cambridge, Grey had paid 'far more attention…to the politics of ancient Greece and Rome than to the niceties of the Tragic choruses or the difficulties of Terentian metres'.[143] Now, however, the effect on him of his Grand Tour through southern France, Switzerland and Italy, during which he spent part of his time in the suite of the Duke of Cumberland, was both political and literary, but decidedly not artistic; while emerging with a 'lifelong skill in the language and literature of Italy',[144] Grey's pleasure in two Veronese paintings he saw in Verona derived solely from their 'faithful representation of nature in her true colours', and he had 'no pretensions to taste, or to the knowledge necessary to be a connoisseur'. Grey also passed over the controversy concerning the age of the famous amphitheatre there, not 'troubling myself to enquire in what year or by what hand the first stone was laid'.[145]

Instead of an aesthetic awakening, Grey underwent a transformation of a different kind. Having left England a Tory, his 'political notions' were modified by a tour made just before the French revolution, when 'the continent was giving unmistakable signs of the approaching tempest'.[146] Invaluably, Grey also learnt to regard foreign countries 'not as pawns in the diplomatic game, but as places inhabited by human beings with rights and aspirations of their own'.[147] On his return to England in 1786 to take up a seat in Parliament, he joined the radical wing of the Whig party, supporting Charles James Fox over the abolition of the slave trade and Catholic emancipation, and becoming the lover of the fashionable Whig society hostess, Georgiana, Duchess of Devonshire, who, as we have seen, in 1791 travelled abroad to give birth discreetly to their illegitimate daughter, Eliza Courtney, maintaining a clandestine correspondence with Grey (masquerading as 'Mr. Black') while she was away. After more than twenty years out of office, Grey became Prime Minister in 1830, and piloted the Reform Bill through Parliament in 1831–2.

A second young Northern aristocrat to travel abroad only slightly later than Grey was Charles, Lord Ossulston (1776–1859), future 5th Earl of Tankerville, of Chillingham Castle, Northumberland, whom William Artaud met in Rome in December 1797, and whose presence there coincided with that of French troops early in the following year.[148]

Two members of the Eden family of Durham also toured the continent in these decades.[149] Sir Frederick Morton Eden, 2nd Bart., of Truir, was in Italy in 1790; later he became the author of a major book on the *State of the Poor*. His kinsman, Morton Frederick Eden (1752–1830), youngest son of Sir Robert Eden, 3rd Bart., of West Auckland, and later 1st Baron Henley, made a tour of Italy in 1788 while on a year's leave from his diplomatic post in Dresden, with his wife Lady Elizabeth Henley and their son. A brilliant diplomat, Eden later became minister in Berlin and Vienna (in which capacity he was able to aid William Artaud in his troubled exodus from Italy in the midst of the French invasion of Rome in 1798) and British ambassador in Spain. Four small oval portraits by 'Schmidt', painted in Dresden of Eden's children

Plate 1 *Henry Swinburne* by Pompeo Batoni,
oil on canvas, 1779

Plate 2 *Sir Thomas Gascoigne* by Pompeo Batoni,
oil on canvas, 1779

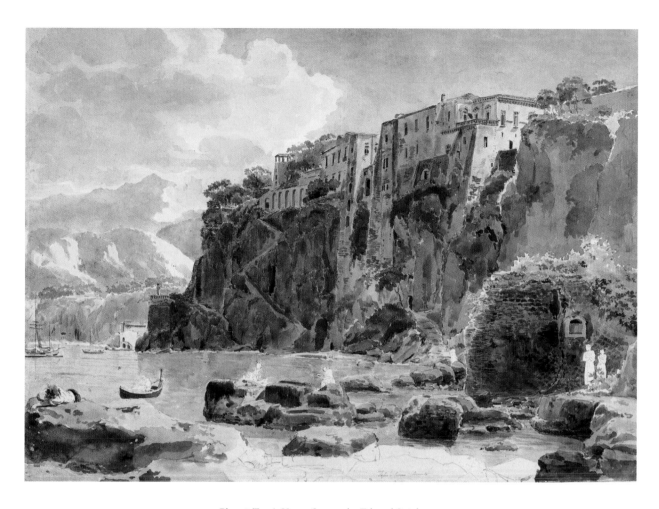

Plate 3 *Tasso's House, Sorrento* by Edward Swinburne,
watercolour and pencil, about 1797

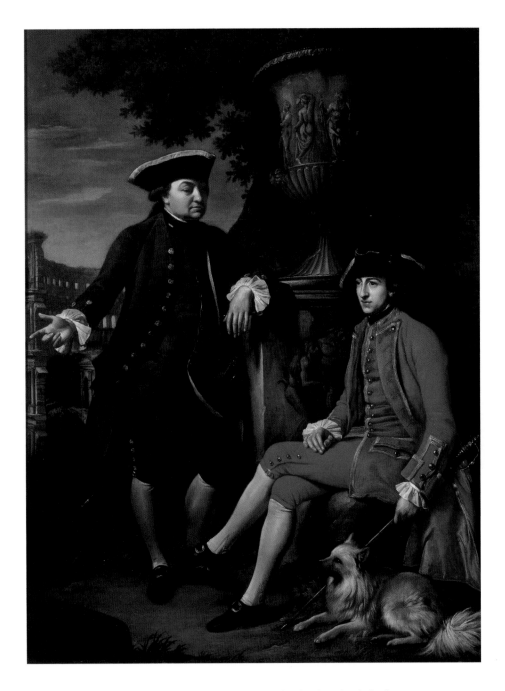

Plate 4 *Hugh, Lord Warkworth, later 2nd Duke of Northumberland
and the Rev. Jonathan Lippyeatt, with a View of the Colosseum,*
by Nathaniel Dance, oil on canvas, 1763

Plate 5 *Capriccio View of Rome with the Arch of Constantine*,
attributed to Viviano Codazzi, 1606/11–1672, oil on canvas

Plate 6 *Lord Algernon Percy, later 1st Earl of Beverley, with Louis Dutens*
by Anton von Maron, oil on canvas, 1769

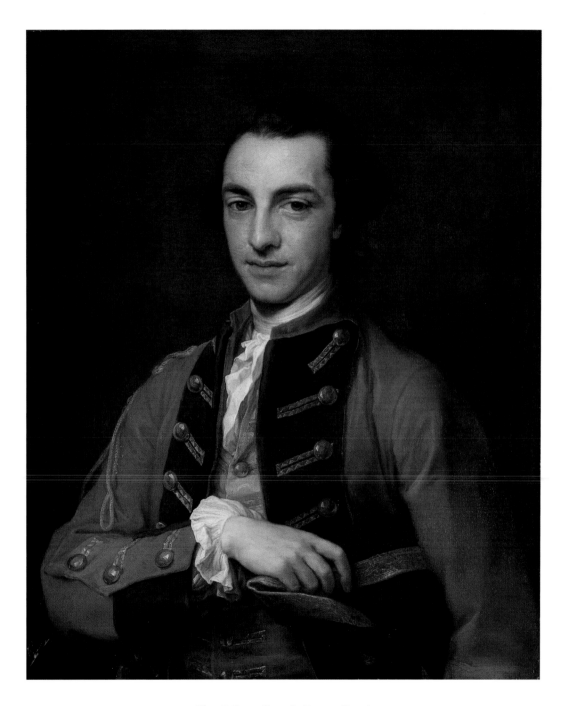

Plate 7 *George Craster* by Pompeo Batoni,
oil on canvas, 1762

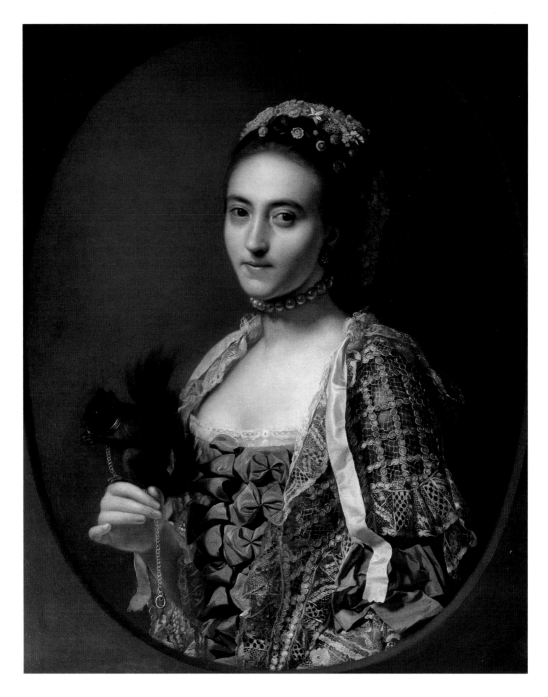

Plate 8 *Olive Craster* by Nathaniel Dance,
oil on canvas, 1762

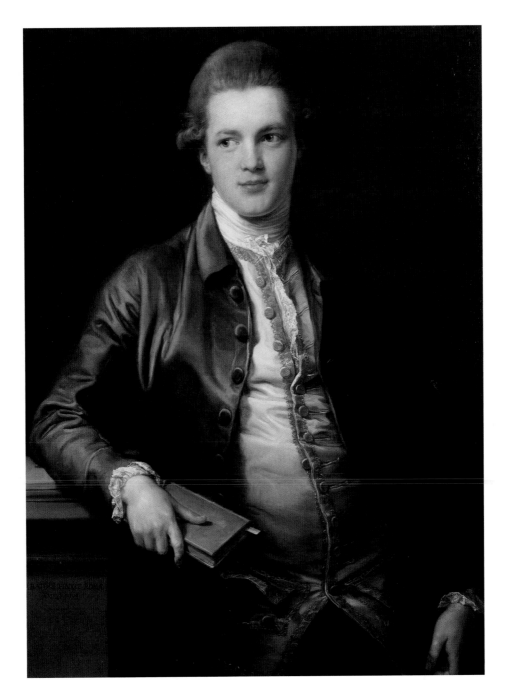

Plate 9 *Thomas Orde, later 1st Baron Bolton* by Pompeo Batoni,
oil on canvas, 1773

Plate 10 *Georgiana, Duchess of Devonshire* by Harriet Carr,
watercolour, 1793

Plate 11 *The Lambton Family at Naples* by Augusto Nicodemo,
oil on canvas, 1797

Plate 12 *The Summit and Crater of Vesuvius* by John 'Warwick' Smith,
watercolour, about 1778

Plate 13 *The Bridge of Augustus at Narni* by Jacob Philipp Hackert,
oil on canvas, about 1802–5

Plate 14 *The Bucintoro returning to the Molo on Ascension Day* by Giovanni Antonio Canal, called Canaletto,
oil on canvas, 1730s

Plate 15 *The Return of the Prodigal Son before a Palace,*
by Sebastiano and Marco Ricci, oil on canvas, early 18th century

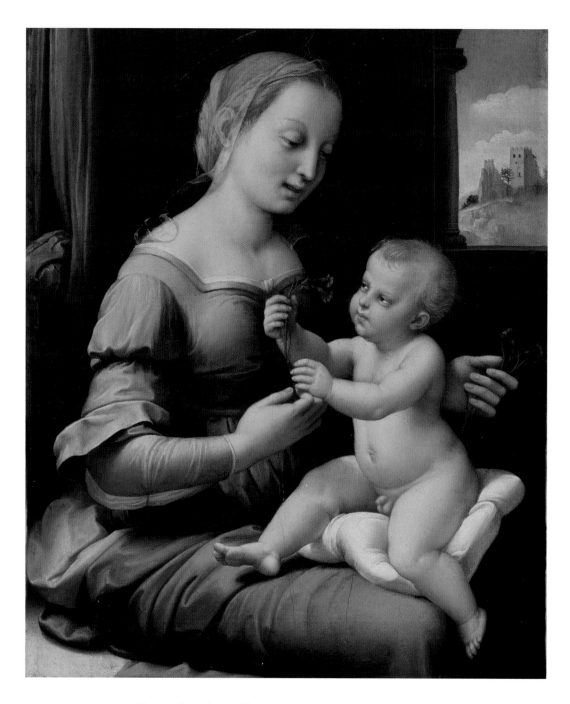

Plate 16 *The Madonna of the Pinks (Madonna dei Garofani)* by Raphael,
oil on panel, about 1506–7

in 1799, survive in a private collection,[150] while the *Sèvres Plate* (fig. 116) known to have belonged to a member of the Eden family may well have been his. Another tourist who presumably set off on the Grand Tour from Durham was the antiquarian Francis Henry Egerton (1756–1829), younger son of the Bishop of Durham, who made an Italian tour including Turin, Milan and Rome in 1782–3. Egerton, however, was a scion of an aristocratic southern family, and later succeeded his brother as 8th Earl of Bridgewater, bequeathing the Egerton manuscripts to the British Museum.[151] Thomas Wallace, son of James Wallace of Featherstone Castle, Northumberland, travelled in Italy for his health in 1790; as Baron Wallace he later returned there with Sir Charles Monck. [152] Beyond the Schmidt portraits and the Sèvres plate, no artefacts associated with any of these tours are known, but John Ingram (1767–1841) of Staindrop Hall in County Durham, who was perhaps in Rome and Venice around 1790, formed a highly important collection of paintings by Francesco Guardi which is discussed on pp. 211–13.

Charles John Brandling (1769-1826) was the eldest son of a Catholic landowner who, like many other Northern families at this time, had been enriched by his interests in coal mining. Brandling senior had married an heiress, apostised from his faith in order to hold public office, and employed James Paine to build at Gosforth House, around 1760, one of North-umberland's finest classical mansions. His son's Grand Tour of 1791, which included Naples, and subsequently Rome, can be seen as an inevitable step in the family's resurgence; Brandling's sisters' marriages into three other important tourist families was surely part of this same process. Like the Carrs, Charles John travelled with introductions from their fellow Northerner Sir John Dick to Thomas Jenkins. Later, Brandling's younger brother John also made the Grand Tour.[153]

Young Catholics continued to be sent abroad with their tutors during these decades, as was Henry Joseph Swinburne, son of Henry and Martha, who travelled in Italy with the Abbé Campbell in 1792–3, aged twenty. In Naples, Swinburne's beauty was admired by all the ladies, including Emma

Fig. 116 *Plate, from a service belonging to the Eden family of Durham,* soft paste porcelain, Sèvres, France, about 1780

Hamilton;[154] sadly, this young paragon was drowned on a voyage to Jamaica in 1800, as Henry Swinburne's letters movingly relate.

An alternative method of educating Catholic boys was to send them to study in Rome under the Benedictine Procurator, who, as the century progressed, became both a host to English Catholic visitors and tutor to English students. From 1783–5 Thomas Horsley Riddell and his brother Edward, from Swinburne Castle in Northumberland, were escorted around Rome by the then Procurator, Placid Waters, who had befriended Henry Swinburne in Rome a few years earlier. The brothers (whose father had married a great Catholic heiress, Elizabeth Widdrington, and both rebuilt, and later extended, his Northumbrian castle) were not the first members of this family, which had been prominent in Newcastle as merchants and civic dignitaries since the 16th century, and had acquired land at Swinburne a century later,

to be educated abroad. Armed with Nathaniel Hooke's *Roman History*, the Riddells now drew some of the monuments. However, while twenty-one year old Thomas became 'an excellent cicerone and a great Virtuoso' under the tutelage of James Byres, his sixteen-year old brother had 'no relish for improvement or study' and had to be 'hawled out of bed & ready for the first master', to the point where Waters, accompanying the Riddells to Naples, decided to avoid the Royal court, for fear of Edward making a fool of himself. Despite also escorting his pupils home at the end of their tour via Austria and Holland, Waters was not paid immediately for his services; like other Catholic parents, the boys' father found himself almost bankrupted by the fashionable education he had elected to give his sons.[155]

Perhaps understandably, rather more Catholics chose to educate their sons in French or Belgian seminaries, nearer to home. William Thomas Salvin of Croxdale, near Durham, a friend and later brother-in-law of both Riddells, who married his sisters, studied at Liège, and at the English seminary in Paris, from 1785–7, meeting a veritable network of Grand Tourists, including members of the Weld and Blount families;[156] according to the Durham tourist Robert Wharton, members of this family were also in Paris during the Revolution, when they were perceived to be 'violent democrats'– a somewhat unusual political affiliation for a Catholic family from the North to hold at this date.[157]

A tour of which only the bare outlines are known, but which stands out from most of those made at this time on account of his social standing, was that of Thomas Colpitts Jnr., descendant of two generations of eponymous managers to the vast Bowes family estates in County Durham: Colpitts himself later became the third successive member of his family to occupy this position, from 1799 to 1819. Thomas Colpitts Snr. seems to have had considerable pretensions to gentility; having married the heiress to a coal owner with a £15,000 dowry, he sent one of his daughters to a finishing school near Richmond, and his son's Grand Tour can be seen as an important part of this process of gentrification. From a family diary,[158] we know that Thomas Colpitts Jnr. sailed for Gibraltar

on 22nd May 1788, and had returned to London by 2nd March 1789, although whether from Leghorn (Livorno) or from France remains uncertain.

The cultural impact of the tour of John Tweddell (1795–9), whose very early travels in Greece preceded even those of Sir Charles Monck (pp. 194–9), was largely negated by his death in Athens at the age of thirty; this tour, and its extraordinary aftermath, are discussed in Appendix 3 (pp. 194–9).

END NOTES

1 Purdue, 1994, p. 138.
2 Black, p. 166.
3 Carr MSS., 22nd February 1793. See also Carr's letters from Florence, 24th September and 11th October 1792. On his tour of 1784–7, for example, William Harry Vane met a trio of Durham neighbours, William Henry Lambton, Morton Frederick Eden, then a Minister in Vienna, and Henry Swinburne, as well as his own kinsman, Mr. Vane, and 'Trevelyan', almost certainly John Trevelyan, pp. 124–8.
4 Jeremy Black, interviewed on BBC Radio 4.
5 In the archive at Raby Castle, Durham.
6 Ingamells. p. 52. As there is no mention of a Roman portrait in the diaries, it remains just possible that the two portraits are one and the same, and that the French portrait was despatched to England from Italy.
7 Quoted in *Country Life*, 8th January, 1970, p. 68. A Marcia Pitt, daughter of John Pitt, was in Rome in the later 1770s, where she was painted by Batoni: Bowron says that she was an only child. It is possible, as Louisa's sister was called Marcia, that this was the same family.
8 Quoted in *Country Life*, 8th January, 1970, p. 68; ibid.
9 Op. cit., p. 69
10 Henrietta Meredith was the sister of Sir William Meredith, 1st Bart.; Bankes's mother, Anne Meredith, was presumably their sister. However, if this relationship accounts for the portrait's presence at Raby, one might have expected the painting to have passed from the sitter to Vane, perhaps on Bankes's death in 1800. In fact, according to an old inscription on the back, which provides the evidence for the sitter's identity, the reverse was true: the portrait belonged initially to Vane, who stipulated that it should be delivered to Bankes after his death and that of his wife. The possibility that there is therefore some more direct Grand Tour connection between Batoni's portrait and its descent at Raby than has yet been uncovered remains a tantalising possibility. I am grateful to Alistair Laing for his help over the provenance of this portrait.
11 Trevelyan's presence in Switzerland is confirmed by the City of Berne issuing him with the certificate of membership of a military society on 12th April 1781. For Leman in Naples see Thomas Jones, *Diary*, p. 106.
12 Confirmation of this is provided both by the fact that the dates on

drawings in Trevelyan's three surviving sketchbooks in the Trevelyan papers, Newcastle University Library, WCT 273, of which this is one, range from 1792–1804, and by the fact that the Italian sketchbook is not close in style to the (presumably) earlier Roman sketches at Wallington. One distinctive feature of Trevelyan's British views seems to have been a focus on Gothic architecture.

13 Trevelyan letters, Somerset Record Office, vol. 80, DDWO.

14 Trevelyan, 2004, p. 42.

15 Seidmann, p. 10.

16 These gems were bequeathed to the British Museum in 1879 by Trevelyan's son: the *Bacchant and Faun* was destroyed in World War II. See Seidmann, p. 39, for Marchant's bequest to Trevelyan.

17 Together with other miscellaneous antiquities; they seem likely to have come from Sir John's collection, rather than from his son's, given the greater vogue for antiquities at this earlier date. According to H.B. Walters, *Catalogue of Engraved Gems and Cameos in the British Museum*, 1926, the gems are: *Infant Dionysus*, sard, *Young Satyr*, red jasper, *Horse's Head*, sard, now thought to be 18th century, *Female Head*, lapis lazuli, *Eros*, nicolo, *Sphinx*, black jasper.

18 By Dr Peter Higgs of the British Museum, in conversation with the author.

19 See Geoffrey B. Waywell, *The Lever and Hope Sculptures*, Berlin, 1986; I am greatly indebted to Professor Waywell for his help.

20 Another exception is Henry Swinburne, who purchased a Roman altar abroad; see p. 49.

21 Some of the drawings in the album are dated 1792, 1794 and 1795.

22 Others are of: *The Glacier des Boissons, Chamounix, The Cascade at Terni, The Gulf of Salerno* (1786), the *Bay of Pozzuoli*, the *Bridge of Augustus at Narni* and *Vietri*. Sir John Trevelyan probably also owned two now very faded Alpine watercolours still at Wallington, *Near Glarus, Switzerland* (1785), and *In the Grisons*.

23 Quoted in Sloan & Jenkins, p. 171, from Smith's own *Select Views in Italy*, 1792–98.

24 See Francesca Irwin's fascinating discussion of these Grand Tour productions: 'Drawn Mostly from Nature: David Allan's record of Daily Dress in France and Italy, 1770–76', *Costume*, No. 32, 1998; I am greatly indebted to her research.

25 Op. cit., p. 16, note 1.

26 These are not included on Irwin's list of other sets by Allan.

27 As Irwin points out, another artist in Hamilton's circle at this time, Pietro Fabris, dedicated his own publication on costume and street traders from the Naples area, including Procida, to Hamilton in 1773.

28 For this branch of the Blackett family, see Purdue, 2004, pp. 77–128.

29 Blackett MSS., see *Bibliographical Note*.

30 An unsigned letter in the Blackett papers referring to the system of tuition at the University of Göttigen leaves open the possibility that Blackett studied there before beginning his tour. The prints were by the Swiss artist and engraver, Johann-Ludwig Aberli.

31 Blackett MSS., letters of 8th January 1785, 6th March 1786; the portrait is now in a British private collection.

32 Blackett MSS., 20th January 1785; 8th January 1785.

33 Blackett MSS., 21st February 1785.

34 Blackett MSS., undated letter, March 1785.

35 Ingamells, p. 95.

36 Blackett MSS., 29th March 1785.

37 Ibid.

38 Alethea Blackett MSS., collection of Charles Sebag-Montefiore; see Purdue, 2004, pp. 154–5, *passim*. Other Grand Tour works on Alathea Blackett's list may have been bought either by Sir William or by his son; they include two alabaster vases copied from the Borghese and Medici vases, a painting of St. Catherine 'bought at Florence', and 'Raphael's Mistress Fornerina painted by one of Raphael's pupils'.

39 Consett, p. 2. The 'Mr. B' referred to is not Stoney Bowes, as is usually suggested, as he was at this time in London involved in a court case. Nigel Tattersfield, in *Bookplates by Beilby and Bewick*, 1999, has recently identified the traveller as Henry Bowes. However it is Thomas Bowes who features among the list of subscribers. The information that Consett's book was ghost-written by the Rev. John Brewster is provided in G.T. Fox's *Synopsis of Newcastle Museum*, 1827, p. 290.

40 Consett, pp. 148, 102.

41 Hughes, p. 403, note 4.

42 Consett, letter IV, 8th June 1786; letter XXX, 10th July 1786.

43 Op. cit., p. 151.

44 Op. cit., pp. 153–4.

45 Fox, 1827, p. 289.

46 Consett, pp. 155–7; see also Fox, loc. cit.

47 Consett, p. 152; see also Fox, loc. cit.

48 Linnaeus himself was not the first to take an interest in Lappland: in 1674 John Scheffer, Professor of Law and Rhetoric at the University of Uppsala had published in Oxford a *History of Lapland* and its people. Linnaeus's own tour was eventually published in English in 1811 as *Lachesis Lapponica* by Sir J.E. Smith.

49 *A Memoir of Thomas Bewick written by himself*, London, 1862, facsimile edition, 1974, p. 142. Bewick's engravings for Consett's Tour were, with one exception, in copperplate rather than his preferred medium, woodcut. Despite his claim to authorship, the engravings of Swedish birds are inscribed as by 'B & B', and are therefore presumably by Bewick and his partner Ralph Beilby.

50 According to G.T. Fox, 1827, p. 290, the tour 'in some measure originated' in Brandt's residence at Ravensworth Castle before its commencement; this is the only recorded example where a servant was perhaps a factor in determining a Northern tour.

51 The sole source of information on the portraits and watercolours painted for Liddell is Fox (see previous note), p. 290. According to Fox, the tourists sat for their likenesses in the painting of the midnight sun at Tornao.

52 Consett, p. 86.

53 Fox, 1827, p. 290. Two of these drawings survive in the collection of the Hancock Museum in Newcastle.

54 The poor, rather flat, draughtsmanship, surely confirms this supposition. I am grateful to two members of the Bewick Society, June Holmes, and Dr. David Gardner-Medwin, for much help over the natural history aspects of these drawings and engravings, and for pointing out that skins would have been used.

55 Bewick later owned these antlers, which appeared in the sale of Miss Bewick's collection by Davison and Son, February 1884, edited with an Introduction by Robert Robinson (lot 482, 'Reindeer Horns',

sold to E.B. Mounsey for £1.10.0, 'collected by Liddell on tour of Lapland').

56 Dunston Hill is now subsumed in the outskirts of Gateshead; although it is today only minutes from Newcastle city centre, it was then too far to commute.

57 Purdue, 1994, pp. 123–4. I am greatly indebted to Bill Purdue and to his two publications on the Carrs; much of the material contained in this section necessarily covers some of the same ground in the interests of clarity, although with a different perspective.

58 For these tours, see Purdue, 1999, pp. 135, 146. John Carr later corresponded with Widdrington on his own Grand Tour.

59 Purdue, 1999, p. 234.

60 Op. cit., p. 124. Carr & Carr, p. 104, say that Mr. Hammond travelled with Carr and Meyler on their tour; no evidence of this survives, nor of the possibility that he acted as their tutor, which his position as an Oxford Fellow suggests. However, Carr certainly knew him abroad; letter of 6th January 1790.

61 Carr MSS., see *Bibliographical Note*, letters of 15th and 25th December 1788 and 2nd February 1789.

62 Plates of Swiss costumes were recorded at Hedgeley in recent years. Carr also bought some engravings by Sigmund Freudenberger (1745–1801), and engravings, again by von Mechel (after Holbein's *Dance of Death*) at the latter's print shop in Basle.

63 Carr MSS., 7th September 1789. Neither Portman nor Dillon is recorded in Ingamells, so presumably their tour ended North of the Alps.

64 Op. cit., 1st December 1793; 27th June 1791.

65 Op. cit., 8th September 1791; 2nd September 1791; 2nd October 1791. Harriet is presumably referring to the watercolourists John 'Warwick' Smith (pp. 158–60) and Nicholas Pocock (1740–1821). Among the other British travellers who shared their lodgings in Geneva were Sir William Hamilton, whom John had already met in London, and Mr. Trevor, the English minister in Turin.

66 Op. cit., 9th October; 15th October; ibid; 23rd October 1791; 21st November 1791.

67 Ingamells suggests their companion was, instead, Henry Swinburne, who, however, was not in Italy at this time.

68 Carr MSS., 24th March 1792; 14th January 1792.

69 Op. cit., 24th February 1792.

70 Op. cit., letter of 24th February 1792. Emma Hamilton's comment on the sitting is quoted in Ingamells, p. 185. From Harriet's later letter of 4th August 1792 to her mother it is clear that, of the two versions of this miniature, she gave the smaller one to Emma Hamilton herself. This was probably the version sold at Sotheby's in 1905; both are today untraced; see also Purdue, 1999, pp. 222, 226.

71 This watercolour is discussed in Harriet's letter to her mother of 4th August 1792.

72 Carr MSS., 22nd February 1793.

73 Op. cit., 25th March 1789; 19th November 1792. John's concern about Harriet's intellectual leanings finds an interesting context in relation to their sister Annabella; the Carrs knew Elizabeth Montagu, who spent time in the North of England at her house, Denton Hall, and Purdue, 1999, suggests that this leading bluestocking perhaps stood as a role model for Harriet's intellectual sister.

74 Op. cit; letter of 4th August 1792.

75 Loc. cit. Ingamells, p. 185. The application to copy was, in fact, made when she was in Rome. In a letter of 4th August 1792, Harriet mentions that her copy in miniature, on ivory, after Titian's *Venus binding Cupid* has been done after a copy by Robert Fagan, which she preferred to the 'spoilt' original.

76 Purdue, 1994, p. 137.

77 Carr. MSS., December 24th 1792. Harriet's annotations to four portrait drawings in the Christie's album, and one in the Carr album in a private collection, identify this artist (who also sat several times to Harriet, notably as Iris and as Psyche) as Anne Bermingham (also spelt 'Birmingham' in some Grand Tour references to this family) of County Galway, later 2nd Countess of Charlemont.

78 This appeared at Christie's South Kensington on 12th October 2005, lot 46, together with other Carr material discussed later in this chapter. The album, now in a private collection, and labelled on the spine as Vol. I of Harriet's collected works, contains twenty-six watercolours.

79 As reported in the Farington *Diary* for 18th September 1794; Ingamells, p.186.

80 The sale took place on 12th October 2005, lot 43; the watercolours are now in a British private collection (Vol. I). In addition to this collection of Harriet's watercolours, an album assembled by Henrietta Carr in 1889, containing drawings by Harriet and other family members, now also in a private collection, includes another (double) portrait dating from Harriet's stay in Florence: this is of Miss Gascoigne and of Harriet's artist friend Miss Bermingham, later 2nd Countess of Charlemont, who also appears in the newly discovered album (see note 77 above). Harriet's collection of the visiting cards she received in Italy includes one from Miss Bermingham.

81 The sitter was the young Italian wife of the rather dissolute Irish artist Robert Fagan.

82 Private collection; see note 80 above.

83 Carr MSS., letter to her mother, 4th August 1792.

84 *The sun breaking through the clouds over the Bay of Naples* and *Figures on the waterfront at Naples* appeared at Christie's South Kensington on 12th October 2005, lot 84.

85 Harriet refers in her letters to 'a book, nearly full, of Ruins, Views, &c, some finished but most only outlines – a Book, copies from the antique, &c which I am now filling with the <u>Niobes</u>, Venus, the Whistlers, &c,&c,&c'; Carr MSS., letter to her mother, 4th August 1792. The watercolours of Paestum (*The Temple of Paestum, Naples* and *Cattle watering before the Temple at Paestum*), and the views of Rome and Tivoli were sold at Christie's on 12th October 2005, lots 85 and 78. Her landscape watercolours in the Carr album (see note 80), which was assembled by a later member of the Carr family, are mostly copied from prints.

86 Carr MSS., letter of 4th August 1792.

87 These are: *Mrs Fagan in the Character of Hebe* and *Teresa, Marchesa Morando as a priestess of Calypso* [?]. Although Harriet herself wrote that she finished only the heads and outlines of these second versions, both of these watercolours, notably the one of Marchesa Morandi, are only slightly less detailed than the prime versions pasted into the 1791–4 portrait album (Vol. I). Both versions of the Marchesa Morando were painted in 1794, as was the second version of Mrs. Fagan; the portrait of Mrs. Fagan in the album is undated, although we know that Harriet was working on this painting in 1792, so, although the album drawings appear to be the prime originals, this cannot actually be demonstrated.

88 We know from her letters home that Harriet had brought a stock of ivory with her from England; this later ran out, and she was obliged to work on vellum until she could obtain a new supply.

89 A very similar portrait to fig. 109, of a lady reading a book, signed by Harriet, was sold at Sotheby's on 24th January 1971 (84); its date, 1798, the year of her marriage, is suggestive, perhaps supporting a later dating for her ostensibly 'Grand Tour' self-portrait. A further oil painting by Harriet of her sister-in-law Hannah Carr, dated 1806, survives in a private collection. Rather more problematic is a portrait of the sculptress Anne Seymour Damer, said to be by 'Henry' Carr, and dated 1788, in the Scottish National Portrait Gallery. Although it relates very closely to the 1798 oil portrait, and even more to Harriet's drawings of Pompeian wall-paintings (fig. 106), it seems unlikely that Harriet would have been capable of painting this at the age of seventeen. This and the Sotheby's portrait were kindly drawn to my attention by Kim Sloan.

90 Carr MSS., 8th September 1793.

91 John Carr wrote to his father from Florence on 31st March 1793, discussing their possible return to England: 'She cannot bear the thoughts of selling her horse and I have promised her that he shall not be disposed of till the last day'.

92 Carr MSS., John Carr, letter to his father Ralph, Florence, 12th December 1792.

93 Op. cit., letters of 18th November and 1st December 1793. The cards have been pasted into an album and are now in a British private collection.

94 Op. cit., 1st September 1794.

95 Carr & Carr, *History of the Family of Carr*, p. 127.

96 Carr MSS., 18th November 1793.

97 Carr & Carr, p. 129. The frontispiece shows four allegorical figures in front of the pyramid of Caius Cestius.

98 D.N.B, vol. 51, London, 1897, p. 283.

99 Many of Robert Henry's Italian watercolours and sketchbooks, together with the two continental sketchbooks by Edward Cheney, were included in the sale at Christie's South Kensington on 12th October 2005; see note 80. Works by Leighton Leitch and T. H. Cromek painted for the Carrs also featured in the sale.

100 Sketches by Edward and Robert Cheney of the south coast and Naples, dated 1823, survive.

101 Fine watercolour portraits by Harriet of both Edward and Fox survive in Volume II of her portrait studies; Christie's South Kensington, 12th October 2005, lot 44, now private collection.

102 I am indebted to Huon Mallalieu's account, in the Introduction to the Christie's South Kensington sale, 12th October 2005, of the Cheneys' residence and friendships abroad. See also Charles Sebag-Montefiore, *Edward Cheney, Dictionary of National Biography: Missing Persons*, Oxford, 1993.

103 Sales of his collection were held after his death at both Sotheby's and Christie's from 29th April to 6th May 1885.

104 William Bewick, *Life and Letters*, ed. Landseer, p. 41.

105 These were also sold at Christie's South Kensington on 12th October 2005, lots 44 (thirty-two drawings) and 45 (fifty-eight drawings), and are now in a British private collection; Volume II is undated, but the second album (Vol. III) contains drawings dated between 1835 and 1840.

106 Carr & Carr, p. 129; the whereabouts of the bust, which formerly belonged to the Capel Cure family, is unknown; a cast after the Sauli cameo belonged to the Carr family in 1893.

107 Formerly in the library at Dunston Hill. See Carr, Vol. I, p.107.

108 For Carr's later life, see Purdue, 1999, pp. 227–9, 235, 241–45.

109 Carr & Carr, p. 58. The *Catalogue of Pictures by Ancient Masters*, exhibited at the Northern Academy of Arts in 1828, lists 57 pictures lent by Ralph Carr including works by Rosa, Guercino, Poussin, Titian, Watteau and Ruisdael.

110 Ingamells, p. 586.

111 Noted in *The Freemasons' Magazine*, January 1796, p. 4, in Reid, I, p. 17 and in Black, p. 256; W. H. Vane also records seeing him abroad. Lambton was accompanied by the Durham clergyman the Rev. William Nesfield, who was presumably his tutor.

112 The Lambton children were John ('Radical Jack'), p. 154, William and Frances (fig. 112). Both A.C. Sewter and Ingamells suggest that the tutor was perhaps John Manby, son of Edward Manby of Agmondesham, Bucks, who matriculated from Oxford University in 1782, and was later vicar of Lancaster.

113 Eugenia Wynne, quoted in Ingamells, p. 586.

114 Draft letter to John Landseer, undated, Sewter, p. 264; the extracts are quoted in Reid, I, pp. 28–37, see note 140.

115 Letter to his father, Rome, 28th October 1797; this and all following letters from Artaud in Italy are quoted in full in Sewter, Vol. 2.

116 Sloan, 1995, pp. 80, 84; her article, to which I am greatly indebted in the material on Lambton and Artaud which follows, provides a convincing analysis of Artaud's radicalism; Reid, I, p. 33.

117 Draft letter to Mr. Dennington, Rome, 18th July 1797.

118 The artist called on Lambton as he had been asked by a mutual friend to deliver to him a pamphlet by Thomas Erskine, a supporter of the French revolution, on *Causes & Consequences of the War with France*.

119 Draft letter to Mr. Hillary, Naples, 27th June 1797; letter to his father, Rome, 28th October 1797.

120 Draft letter to Mr. Wilson, answer to letter of 26th January 1797.

121 Draft letter to Christopher Hewitson at Naples, 27th June 1797; draft letter to W.H. Lambton, undated, but October or November 1797.

122 Letter to his father, Rome, 28th October 1797; ibid; ibid; draft letter to Mr Manby, 8th December 1797; ibid.

123 Draft letter to John Landseer, undated; Sewter no. 42.

124 Draft letter to Mr. Wilson, answer to letter of 26th January 1797. None of the copies is known today.

125 Letter to his father, Rome, 28th October 1797.

126 Ibid; draft letter to unknown correspondent, 27th August 1797. Although Artaud must have shared his patron's enthusiasm for this subject, both of the two letters cited here referring to the commission suggest that the choice of subject came from Lambton rather than Artaud, Artaud himself finding this subject, as well as that of the portrait, 'very singular'. There are, however, links thematically to a series of drawings from the Fuseli circle from around 1770–1800 on the Prometheus theme, and to Romney's *George Howard visiting a Lazaretto* (*c*. 1790–4), while William Blake's *Los and Orc* (around 1790–4) also treats of a Prometheus-like figure in a work with similar overtones of revolution (see *Gothic Nightmares*, Tate, 2006, cats. 16–18, 20, 25, and Kidson, cats. 130–1).

127 The relevant lines are:
'Touch'd by the patriot flame, he rent amazed,
The flimsy bonds, and round and round him gazed'.

128 Draft letter of 27th August 1797, to unknown correspondent.

129 Ibid. Deare had known Artaud in Naples, and Artaud had sketched his wife (British Museum).

130 A draft letter to Lambton (undated, but around November 1797) refers to a payment to Kaisermann and to a drawing of the Temple of Sibyl at Tivoli which appears to have been intended for Lambton. Artaud's later draft letter of 22nd December 1797 to Mr. Manby identifies Kaisermann's drawings for Lambton as: 'The Castle of St. Angelo, View of the Bridge, View of the Arch of Titus, The Sepulchre of Cecilia Mettalla [sic] or Capo de Bovi'. The subject of Camuccini's painting, which eulogised female virtue, was a popular neo-classical theme; Lambton may have intended a conscious reference to his own wife and sons. Artaud's draft letter of 27th August 1797 to an unknown patron says that Lambton and Artaud had visited Camuccini to see his large picture of the assassination of Caesar, and drawings from Raphael, and notes that he was expecting Lambton to give Camuccini a commission.

131 Draft letter to Mr. Hillary, Rome, 4th December 1797. The commission from Guntatarde, the drawing master, consisted of a 'View in the Villa Borghese' and a 'view of the Bridge of the Castle of St. Angelo': see Artaud's letter to Mr. Manby, 22nd December 1797. That from 'Frederigo the German' was for 'the Companion to the drawing of Joseph interpreting the dream of Pharaoh', namely 'Joseph interpreting his own dream to his Brethren'.

132 Ingamells, p. 586.

133 As Peter Grant put it in 1765, quoted in Roworth, p. 96; Roworth, loc. cit.

134 Draft letter to an unknown patron, 27th August 1797. Kauffman's portrait is closely modelled on one painted in c.1793 of one of Angelica's most important British clients, Thomas Noel-Hill, 2nd Lord Berwick, now at Attingham. It is listed in Kauffman's *Memorandum of Paintings*; the price Lambton paid, 220 zecchini (a zecchin was worth slightly over a guinea) is a measure of the portrait's scale and importance.

135 Ibid.

136 Letter to his father, Rome, 28th October 1797.

137 Letters to his father, 26th March 1799 ('Mr Lambton's Pictures and my Studies in oil have arrived safe at Hamburg') and 29th May 1799 (which suggests that Lambton's were perhaps damaged in transit).

138 Anderson & Garland, Newcastle upon Tyne, 1932.

139 Letter from William Artaud to his father, 7th August 1798; the Rev. John Manby (see p. 142) was handling the British end of the arrangements over this shipment for the executor, Ralph Lambton.

140 For Lambton's proposed alterations to Harraton, see *Country Life*, 24th March 1766, p. 667. Christopher Hussey notes that he had been unable to trace the Lambton correspondence from Italy referred to in Stuart Reid's *Life and Letters of Lord Durham*, 1906.

141 See R. Spence Watson, *The History of the Literary and Philosophical Society*, London, 1897 pp. 68–83.

142 See E.A. Smith, *Lord Grey, 1764–1845*, Oxford University Press, 1990, pp. 8–9. Grey's tour is also charted in Ingamells, p. 431. As regards the exact dates of his tour, G.M.Trevelyan, in *Lord Grey of the Reform Bill*, London, 1920, refers to Grey as being abroad for most of time from the end of his time at Cambridge to the beginning of his Parliamentary career in 1787, in other words from 1784–7 inclusive.

143 R.W. Martin (compiler), *The Greys of Falloden and Howick*, scrapbook, Longbenton, Northumberland, 1928, p. 279.

144 G.M. Trevelyan, op. cit, p. 11.

145 Smith, 1990, p. 9, quoting a letter to Ellison of 25th January 1782, Durham, Grey MSS., G. 14; this is Grey's only surviving Grand Tour letter.

146 Martin, p. 279.

147 G. M. Trevelyan, p. 11.

148 Draft letter from William Artaud to Mr Terry, 15th December 1797; see also Ingamells, p. 728.

149 For these tours, see Ingamells, p. 329; there is no record of either tour in the Eden archives at Durham Record Office.

150 Together with a portrait of the diplomat himself, and an Old Master painting purchased abroad.

151 See Ingamells, p. 332.

152 For this earlier tour, see Ingamells, p. 972.

153 Ingamells, p. 120.

154 Swinburne, *Courts*, II, p. 295.

155 Scott, pp. 187–9.

156 Salvin MSS., see *Bibliographical Note*, letters from Thomas Taylor, Walter Blount and Thomas Weld to William Thomas Salvin Junior, 1787–99, D/SA/C, 104, 109, 112. The Salvins are known to have travelled abroad as early as 1679, when a Royal Warrant signed by Charles II allowed Gerard Salvin, his wife Mary, William Salvin and their servants to travel abroad, as long as they did not include Rome in their itinerary. Like the Swinburnes, the Salvins seem to have spent much time on the continent over several generations, and it is surprising that no record of a major tour survives. A later Gerard Salvin and his family spent much time in France in the 1860s (p. 265).

157 Wharton MSS., see *Bibliographical Note*; quoted in Hughes, 1952, p. 403.

158 For the Colpitts family, see Strathmore Archive, Durham Record Office; all information on this family and its Grand Tour kindly provided by Roger G. Woodhouse. The only evidence of Colpitts' Grand Tour comes from the diary of his aunt, Mary Harrison (d.1792), daughter of Thomas Colpitts I; private collection, Great Britain.

Professionals Abroad
in the 18th century

At any one time in the 18th century, a significant number of members of the professional and other classes would be living abroad to service the needs and interests of Grand Tourists, and to pursue courses of artistic, architectural, musical or other study. Among this contingent of foreign residents, and those making only a limited stay abroad, were many talented individuals from the North of England who worked in a variety of roles: as artists, architects or art agents; as tutors or chaplains; as consuls; or as merchants. One feature of their life abroad is, however, common to almost all of them, except for those engaged in commercial activity; they were able to visit Italy and other continental countries only because of the patronage of individuals or groups, or, in the case of consuls such as Christopher Crowe or Sir John Dick at Leghorn (Livorno), because they held appointments which related to the flow of British tourists abroad. Many of the men whose tours or residence in Italy are discussed in this chapter – and there are, significantly, no women, except in a dependent position – combined more than one of the roles outlined above. Both Crowe and Dick, for example, operated as art agents as well as consuls, and both made a considerable fortune out of such activities.

The degree of freedom enjoyed by artists, architects and musicians abroad depended on the direct or indirect nature of the patronage which supported them. Although some patrons took artists abroad with them to record their tours, as was famously the case with J. R. Cozens and William Beckford, in which case the relationship could be highly prescriptive, other artists, such as the Cumbrian, John 'Warwick' Smith, were sent abroad by patrons who remitted money to support them, and, as a result, were able to enjoy considerable freedom, and build

up relationships with other Grand Tour clients. The *Memoirs of Thomas Jones* memorably convey the bohemian lifestyle, always threatened by financial insecurity, enjoyed by 18th-century artists abroad.

ARTISTS AND ARCHITECTS

RICHARD DALTON (?1715–1791)

The earliest artist from the North to visit Italy was Richard Dalton, son of the Rev. John Dalton of Darlington and brother of the Rev. John Dalton, poet and divine;[1] later, as art agent and librarian from 1755 to the Prince of Wales – soon to ascend the throne as George III – Dalton would become one of the most influential of all Grand Tourists. His career began rather unpromisingly with an apprenticeship to a coach painter in Clerkenwell, but, aided by his brother's connection with Algernon, future 7th Duke of Somerset and 1st Earl of Northumberland, he was soon studying in Italy,[2] working from 1739–43 in Bologna and Rome, where he specialized in making red chalk drawings after the antique; this fine copy (fig. 117) after what was perhaps the most highly prized of all antique statues, the *Apollo Belvedere*, is one of a series to survive in the Royal Library.

Dalton's second visit to Italy from 1747–50, when his travelling companion was the British artist Thomas Patch (fig. 28), was still made principally as an artist. While on a visit to Sicily in 1749, itself an unusual destination at this date, he was invited to join the Irish peer and art patron, James, 1st Earl of Charlemont, as draughtsman on his ground-breaking journey to Constantinople, Greece and North Africa, undertaken in a chartered French frigate, captured by the British, *L'Aimable Vainqueur*. The party on board consisted of Charlemont, his fellow Irishman Francis Pierpoint Burton, and their respective tutors, Edward Murphy and Alexander Scott. As has been pointed out, the alliance between Dalton and Charlemont was 'historically fortunate but personally unfortunate'.[3] Many of the drawings of Greece and Turkey Dalton made on this tour, although not of the highest aesthetic

Fig. 117 *Apollo Belvedere* by Richard Dalton, red chalk drawing, 1741–2

quality, are the earliest record by a British artist of sites and artifacts further afield than Italy, but the two men almost certainly quarrelled,[4] and Charlemont does not seem to have associated himself with any of the several publications Dalton produced in the aftermath of the tour, which culminated in his *Antiquities and Views in Greece and Egypt with Manners and Customs of the Inhabitants from drawings made on the Spot, A.D. 1751*, published in 1791. The quarrel may not have been one-sided: although Mrs. Delaney called Dalton 'the most impertinent, troublesome, prating man in the world', Charlemont's later 'epic' quarrel with Piranesi in Rome

suggests that he may not have been the most accommodating of patrons.[5]

Dalton's drawings on the tour, and later publications, surely reflect his patron's considerable interest in the customs and manners of the people rather than solely in the antiquarian pursuits preferred by so many tourists. Although he drew the sculptural reliefs at Halicarnassus 'for the first time in modern history'[6] – Charlemont thought, correctly, that these might be part of the Mausoleum, one of the 'wonders' of the ancient world, bribing the Governor with a gift of coffee so that Dalton could copy them without interruption – and made copies after the antiquities in Athens which predate the seminal visit of Stuart and Revett, Dalton also made detailed studies of Greek costume.[7] Perhaps even more unusual are his studies of Egyptian life, among them this fine watercolour of *Ethiopians on Floats coming down the Nile* (fig. 118), which depict recreations such as riding and shooting at water-pots, Mullahs teaching students, and women in the streets of Cairo. Such drawings were often difficult, if not dangerous, to make: the 'Inhabitants' had an utter aversion to being drawn themselves 'or even suffer[ing] their animals to be represented', and foreigners were prohibited from recording ceremonies such as the annual pilgrimage to Mecca and Medina.[8]

Given that Lord Charlemont later wrote a two-volume

Fig. 118 *Ethiopians on Floats coming down the Nile* by Richard Dalton, pen and watercolour, 1749–50

manuscript about his travels,[9] his tour can be traced in detail. From Malta, where Dalton joined the party, it sailed in June 1749 to Constantinople, where Charlemont was entertained by the ambassador, a fellow Irishman, James Porter. At a mosque in Constantinople, Lord Charlemont was so struck by an Iman 'expounding the Koran to a group of devout' followers that he 'could not help desiring Dalton, our painter to make a sketch of him and of his audience…where however justice is by no means done to the attitude of the orator' – a comment which may indicate at least one reason for the Irish peer's dissatisfaction with his draughtsman.[10] Also in Constantinople, Dalton drew the famous Dervishes, actually monks of the order of Mevlevis. The party's visit to Turkey was followed by a tour of the Greek islands; at Antiparos, they saw, and Dalton sketched, the famous stalactite cavern, and the travellers found to their consternation that they had no money left; their difficulties were compounded by the fact that their 'appearance was as poor as our pockets', especially Dalton's, who 'having had the misfortune to spill upon his coat a lampful of stinking oil, was now reduced to a waistcoat of green silk, formerly laced with gold, the back of which was pieced with the canvas remnant of an old picture…'.[11] Following this incident, the party made a daring foray to Alexandria, Rhodes, and the coast of southern Asia Minor, before continuing their tour of the Greek islands; from Kos, they visited Halicarnassus across the straits. They arrived in Athens, the climax of their tour, in November 1749, making a further excursion from here to Corinth, Thebes and other sites, before finally returning to Italy, via Malta, in 1750, where Dalton presumably parted company with his patron. Lord Charlemont himself remained abroad for another five years, his tour making him a 'key figure in the developing Graeco-Roman controversy'.[12] On his eventual return, his Grand Tour possessions, as well as including important works of art commissioned in Italy, a vast library of classical books, and an even larger collection of coins and medals, featured several pictures by Dalton and various artifacts which must have been collected on his eastern tour, among them an Attic stele and a bas-relief of Minerva from Alexandria.[13]

As Librarian to the Prince of Wales, to whom he had been introduced by the powerful courtier, John, 3rd Earl of Bute, Dalton returned to Italy in 1758–9, this time specifically to buy drawings, prints and medals to enrich the Royal Collection, and to acquire Old Master paintings for the great collector Sir Richard Grosvenor. In Bologna alone he bought forty-nine paintings for Grosvenor, while his greatest coup for his royal patron was the purchase of a collection of Guercino drawings, from his heirs, that is one of the glories of the Royal Library today. Dalton's subsequent role in the acquisition of the great collection of paintings by Canaletto and other 18th-century Venetian artists, formed from the 1720s onwards by Consul Joseph Smith, is uncertain: the impetus seems to have come from the Earl of Bute, whose brother, James Stuart Mackenzie, patron of Louis Dutens (figs. 77–8), handled the negotiations. However, Dalton was responsible for the packing and despatch of the collection from Venice in 1762–3, when he also visited Rome and Bologna, again buying extensively for his royal employer. Dalton paid two further visits to Italy, in 1768–9 with his wife and a Miss Robinson, when the Jesuit antiquarian Father Thorpe rather sourly reported that, with the King's purse, he 'buys up all over Italy', and in 1774–5. Although he was appointed Surveyor of the King's Pictures in 1778, the 'heroic days of acquisition' for the Royal Collection were by now over.[14]

On his visit to Italy in 1758–9, Dalton had examined the famous collection of gems and coins assembled by Baron Stosch, whose sulphur impressions after the antique would later be proposed to Elizabeth, future, 1st Duchess of Northumberland by her son's tutor, Jonathan Lippyeatt, as an attractive purchase. Dalton's reputation in this field evidently commended him to the Duchess, who in 1762 asked Lippyeatt to consign to him a set of sulphurs. Surprisingly, given his upbringing, this is the only occasion on which Dalton is recorded as having acted (with Sir John Dick) for a Northern tourist, and he does not appear to have retained his links with Northern England in later life.

Dalton's somewhat ill-defined personality, and his role in the formation of the Royal Collection, have been the subject of much debate. As Michael Levey has pointed out, contemporary references to him are rarely complimentary, and he was described as 'totally illiterate'[15] (which he was not), and even dishonest, numbering among his detractors Robert Adam, and Sir Horace Mann, who in 1761 believed 'that sad rogue' was trying to defraud him of an 'excellent original' by Castiglione (destined for Walpole), which Dalton had shipped back to England on his behalf. Although the picture was later duly delivered, Mann considered he had 'too much reason from his past conduct and from his character in general to suspect…a trick'.[16] How much of this animosity towards Dalton can be ascribed to professional jealousy is hard to determine. Certainly the antiquarian Father Thorpe, who had no particular axe to grind, thought him a 'capricious' judge of pictures, and there is no doubt that he used his position as buyer for the Royal Collection to form his own collection of Old Master paintings, Lord Nuneham writing in 1772 that Dalton 'not unfrequently retains for his own collection or his own profit the drawings and proof plates that are intended for his master.[17] However, although the impetus towards buying for the Royal Collection seems to have come from George III,[18] on whose accession the diarist Horace Walpole had written to Sir Horace Mann 'I imagine his taste goes to antiques too, perhaps pictures',[19] and his highly cultivated Prime Minister, the Earl of Bute, Dalton, as their principal agent, certainly acquired many exceptional works of art abroad, and his taste for Italian *seicento* paintings is still reflected strongly in the character of the collection today.[20]

JOHN 'WARWICK' SMITH (1749–1831)

The watercolourist John 'Warwick' Smith was born at Irthington, near Carlisle, where his father was gardener to the sister of Captain John Bernard Gilpin of Scaleby Castle. Fortunately for the young Smith, Gilpin was an amateur draughtsman, and father of two talented sons, the Rev. William Gilpin (author of several major books on the Picturesque), and the animal painter, Sawrey Gilpin. Evidently recognising Smith's talent, Gilpin recommended him as a drawing master to a school near Whitehaven, and subsequently sent him to

Fig. 119
The Baths of Caracalla
by John "Warwick" Smith,
pen and indian ink and
watercolour, 1776–81

study in London under his son, Sawrey Gilpin.[21] Captain Gilpin would later promote the career of another Cumbrian painter, Guy Head, and it is therefore not altogether a coincidence that two of the only three Northern artists known to have made the Grand Tour came from the vicinity of Carlisle.

In 1776 Smith left for Italy,[22] where he stayed for five years, funded by George, 2nd Earl of Warwick. The relaxed nature of Warwick's patronage allowed Smith to 'bypass… the usual requirements of the topographical view',[23] which was made with one eye on publication, and he produced watercolours in Italy of astonishing freedom. While he was living in Rome, where he arrived in early 1778, Smith produced for his patron around 1780–81 an outstanding series of views of ancient and modern Rome, including this watercolour of the *Baths of Caracalla* (fig. 119), bathed in a Claudian glow. Many of the works in this series are remarkable for their dramatic, close-up views of the Colosseum and other Roman monuments. Both compositionally, and in their strong contrasts of light and shade, and new interest in atmosphere, they represent a decisive break with 'Warwick' Smith's earlier, carefully tinted wash drawings in the topographical tradition of Edward Dayes and Thomas Malton, and anticipate the work of Turner and Thomas Girtin.

'Warwick' Smith's sojourn in Italy coincided with that of three other talented British watercolourists who specialized in making views for Grand Tourists, William Pars (fig. 12), Thomas Jones and Francis Towne (fig. 8); several of Towne's magical Roman watercolours, notably of the Colosseum, were taken from almost exactly the same viewpoint as Smith's, and were almost certainly made on the same sketching expeditions. Much of our information on Smith's Italian years comes from the diary of his friend Thomas Jones, which records the 'many agreable Evenings with *Song and Dance &c*' they spent together in the summer of 1779 on the loggia of Smith's Roman apartment.[24]

During their respective visits to Naples from 1778–79 the two artists shared lodgings near the Arsenal, Jones

Fig. 120 *Otrano, Bay of Salerno*
by John Warwick Smith, watercolour, 1778–9

complaining that Smith 'came home so late in the Evening & went out so early in the Morning',[25] presumably so as to capture the quality of the light, that he failed to look after his temporarily sick friend! They made a number of sketching expeditions together to the classical sites and scenery along the south coast that most attracted Grand Tourists, notably Sorrento, Mount Vesuvius, Lake Avernus and the Elysian Fields. Smith also sketched at Vietri, where he took a house for two successive summers. His watercolour of *Otrano, Bay of Salerno* (fig. 120) comes from a sketchbook of Italian views.[26] Unlike the more finished watercolours that Smith produced for the Earl of Warwick and other Grand Tour clients, this close-up study of a small Italian hill town, unencumbered with classical framing devices, and painted in strong, vibrant colours, is astonishingly free, almost modern in feeling, and may well have been painted direct from nature.

'Warwick' Smith left for England in August 1781, travelling through the Swiss Alps with Francis Towne; as we have seen, he probably just missed meeting in Rome his future Northumbrian patron, John Trevelyan, who arrived in the city in October. On his arrival, Smith settled first in Warwick, and later in London. Although he became an important member, and occasional President, of the Society of Painters in Water-Colour, Smith's Italian experience remained the formative event of his life, and much of his later output, like the Grand Tour album at Wallington (see p. 127), was a reworking of his

Italian years; despite making regular sketching tours in Britain, he was unable to rise to the challenge of the new generation of artists led by J.M.W. Turner, who criticised his 'mechanically systematic' watercolours.[27] Although Smith's Northern patrons, the Gilpins, were instrumental in launching his career, John Trevelyan is, to date, his only known Northern client, although it is possible that he was the drawing master of Harriet Carr, whose Italian drawings, on her tour of 1791–4, are undoubtedly very close to his in style.

GUY HEAD (1760–1800)

The son of a Carlisle butcher, Guy Head, like John 'Warwick' Smith before him, was a protégé of Captain John Bernard Gilpin. In London, where he studied at the Royal Academy Schools, he came to the notice of Sir Joshua Reynolds, who is said to have taken him 'under his particular protection' and sent him to the continent,[28] presumably in the early 1780s. Nothing is known of this early visit abroad, but in 1787 Head travelled to Italy with his wife, Jane Lewthwaite, also an artist, and their young family. Here the Heads remained for twelve years, living from 1787–9 in Florence, Bologna, and Parma, where Head was elected to the prestigious Academies; his presentation pieces to the Parma and Bologna Academies confirm his high contemporary reputation abroad as a painter of ambitious history paintings in a neo-classical style which is closer to French than to British artists.[29] Head's election to the Florence Academy, however, was on the strength of his copies after Old Master paintings: he was already forming, as a potentially lucrative business venture, a 'valuable Gallery or Collection… for the Advantage of our Countrymen' by making 'the correctist Copies of all the celebrated Pictures of the greatest Artists' – paintings like Titian's Venus of Urbino, which would never leave Italy.[30]

In 1789 the Heads moved to Rome, where in 1792 Head was elected to the Accademia di San Lucca.[31] Despite his considerable reputation, however, he was unpopular with his fellow British artists, who were 'quite mad' at his commissions, and the picture dealer James Irvine depicted him as an outsider, 'determined to stand alone like a great colossus and

challenge the whole body of artists to combat and sweep all from the face of the Earth'. Head's only friends in the British artistic community seem to have been John Flaxman, and William Artaud, who corresponded with him during an absence from Rome, but his relations with the Italian community were apparently rather warmer: the Italian sculptor Vincenzo Pacetti, who lodged below the Heads in Strada Felice, was a close friend, and Head also knew Canova, with whom he dined at the Flaxmans.[32]

Like other British artists in Italy, Guy Head also made a living by painting portraits of tourists, and in May 1791 the Irish sculptor Christopher Hewetson reported that 'Mr Head has had several portraits to do'.[33] This striking but decidedly fleshy image (fig. 121) is of Prince Augustus, later Duke of Sussex, sixth son of George III, who lived in Italy in the 1790s both for his health, and because of his clandestine marriage to Lady Augusta Murray, dividing his time between Rome and Naples. The Prince knew several Northern tourists, including John Carr, and William Henry Lambton, who shared his 'dangerously liberal' political views. His encouragement of the arts and sciences – which included active support for the artistic community abroad – later led to his becoming President of the Society of Arts and of the Royal Society.[34]

Guy Head also worked as a landscapist, and this watercolour (fig. 122), showing the interior of the Colosseum with its dramatic arcades, is taken from the same viewpoint used by many of the British artists working in Rome in the late 18th century. More importantly, in this precarious time politically on the Italian peninsula, Head was able to form a major art collection abroad, which included Greek and Etruscan vases, Old Master paintings[35] and contemporary pictures by Jacob More, Angelica Kauffman, J.P. Hackert and Louis Ducros. There were also sculptures by his friends Flaxman and Pacetti, drawings by Vincenzo Camuccini, and coins, medals, and gems.

Few Grand Tourists can have made a more spectacular departure from Italy than the Head family, following the French invasion of Rome in 1798. Having managed, unlike Thomas Jenkins, to salvage their 'Principal things of value',

Fig. 121 *Portrait of HRH Prince Augustus, later Duke of Sussex* by Guy Head, oil on canvas, about 1798

Fig. 122 *The Interior of the Colosseum* by Guy Head, watercolour over graphite, 1787–99

presumably Head's own paintings and his collection,[36] they fled to Naples. From here they were evacuated, together with the King (whom Head considered 'a mere fool and depraved in the greatest degree'), the Queen, and Sir William and Lady Hamilton, to Palermo on the personal orders of Lord Nelson.[37] Probably here, rather than in Naples, Head painted an ambitious portrait of *Nelson receiving the French Admiral's sword after the Battle of the Nile*. This national hero also arranged for the family's passage home, and, presumably in gratitude for his timely help, as much as for his patronage, the Heads baptized their infant son Horatio Nelson Head.

The Heads arrived home in the summer of 1799, and that autumn Head visited the North of England for his daughter's baptism at Carlisle, moving on to Newcastle, where his mother and brothers now lived; among the friends he saw here was James Losh (fig. 126), a prosperous barrister and coal-owner whose family lived near Carlisle, and who was a warm supporter of early attempts to promote North-East societies in support of the visual arts.[38] Head was also busy establishing his reputation in London, showing two major subject pictures[39] and his *Portrait of the Duke of Sussex* (fig. 121) at the Royal Academy in 1800, and acquiring a large house in Duke Street St James, where he intended to show his copies after Old Master paintings. Whether these, and Head's history paintings, with their icily sensuous, and highly sculptural, form of neo-classicism, would have proved popular with British clients, including former tourists from the North, is, however, unknown, for Head died suddenly in December 1800. Although the rediscovery of more of his history paintings may yet reveal contacts with Northern tourists abroad, there is at present no evidence to suggest that any of his paintings entered a Grand Tour collection in the North of England.[40]

JAMES PAINE (1717–89) AND CHRISTOPHER EBDON (1744–1828)

Only two architects with Northern connections are known to have made the Grand Tour. James Paine worked extensively at Alnwick for the 1st Duke and Duchess of Northumberland, created the chapel at Gibside (based on Palladio's Tempietto at Maser) for George Bowes, and was the designer of several other important Northumbrian and Durham houses in the Palladian mode in the 1750s and 1760s.[41] He made a 'relatively modest' Grand Tour in 1755–6, by which time he was established as the leading architect of the North East in succession to Daniel Garrett, and Clerk of Works at Newcastle. Unfortunately, almost nothing is known of Paine's travels beyond his study of the work of Palladio in the Veneto, and his admiration of the 'elegant proportions... of the three columns in the Campo Vaccino in Rome'.[42] What is certain, however, is Paine's sceptical – and highly unusual – reaction to the Grand Tour; he attacked both archaeology itself, referring to the 'most despicable ruins of ancient Greece' and its effect on someone in his profession, writing that 'if by travelling [the architect] imbibes a blind veneration for inconsistent antiquated modes, and ...consequently neglects to make himself acquainted with the various necessary conveniences requisite for the country in which he is to exert his talents...[he] ... may be said to be a man of taste, but he will hardly be considered a man of judgment'.[43]

Christopher Ebdon, the son of a Durham cordwainer, was apprenticed to James Paine in 1761. By the time he came to make the Grand Tour in 1774–7, however, at the age of thirty, he had become the pupil of a very different architect, Henry Holland, writing from Florence in August 1776 to say that he was sending him seventy casts he had acquired during a recent visit to Rome. Ebdon seems to have enjoyed a successful stay abroad, as in 1777 he won a gold medal from the Florentine Academy for 'architectural designs submitted to the Grand Duke' [of Tuscany]. For at least some of his time in Florence, he was staying at the well-known Hadfield's Hotel with three British artists, the landscapists H.P. Dean and Thomas Jones, and the maverick John Brown, and in November 1776 he spent two days touring the Florentine sights with Jones and Brown, visiting Lord Cowper's collection as well as the Galleria and the Pitti Palace. Ebdon later exhibited views of Roman temples at the Society of Artists between 1778 and 1783. Perhaps because of his success on the Grand Tour, he had little contact with the region immediately following his

return, but in 1793, after working for three years as an assistant of Sir John Soane, he informed Soane that he was 'going down into the North again…to continue there for good'[44] Ebdon's recorded work in County Durham from before his Grand Tour includes drawings of Paine's *Chapel & Mausoleum at Gibside*[45] and a very early design around 1760 for a bridge at Croxdale Hall, seat of the Salvin family. In later life he became Surveyor of Bridges for Durham County, and also worked in a minor capacity for the Londonderrys at Wynyard Park.

MUSICIANS

CHARLES AVISON (1709–70)

Artists and architects were not the only professionals from the North to go on the Grand Tour in the 18th century. Charles Avison, a Newcastle composer of some note, and author of *An Essay on Musical Expression* (1752), which Dr Charles Burney recognized as the first English attempt at musical criticism,[46] is reputed to have made the Grand Tour as a young man,[47] before his appointment in 1736 as organist of St Nicholas Church; later the city's cathedral, this then served the fourth largest parish in England, and boasted an organ bigger than that at neighbouring Durham Cathedral. An 'ingenious, polite and cultivated man, who, having been in Italy, was more partial to the compositions of Geminiani and Marcello than to those of Handel',[48] Avison, both in his critical writings and in his own compositions, showed a strong, and highly controversial, preference for French and Italian music at the expense of the German school, notably Handel. Although proof of his visit to Italy is lacking, he almost certainly studied under Geminiani in London, and his sixty *concerti grossi* for strings were modelled on the Italian composer's work. As has been pointed out, Avison's 'far from superficial knowledge of Italian literature and fine art' is 'a supporting factor for the claim that [he] studied abroad'; his Essay is notable for a lengthy analogy between music and painting.[49]

From 1735, Avison organised in Newcastle a series of subscription concerts that place the city in the forefront of musical life in England at this time; among the *virtuoso* musicians from London and elsewhere who played here were the great astronomer William Herschel, and the premier violinist of the day, Felice de' Giardini. Confirmation of Avison's national rather than purely local reputation can also be found in his rejection of numerous key posts, including that of organist of York Minster, and in the support of men such as John Wesley and the poets Thomas Gray and William Mason. Avison's pupils among the Northumbrian gentry also connected him to a wider social circle. In 1760 Lady Milbanke invited him to play in front of the Duke of York at her Yorkshire seat, while Mrs. Anne Ord of Fenham Hall, Newcastle, held parties in London which were attended by the bluestocking Elizabeth Montagu[50] and the novelist Fanny Burney's sister Esther. Contacts such as these point to the growing cultural connection between Newcastle and London at this period, following the somewhat belated development of a 'polite' society in the North of England. Although Avison's music, which aimed to 'divest the soul of every unquiet Passion, to pour in upon the Mind a silent and serene Joy', fell out of favour with the advent of 'this torrent of confused sounds', as he characterised Romanticism, Robert Browning later revived the 'seeming dead music of Avison' in his poem *Parleying with Certain People*.[51] A more serious recent revival has established Avison as the most important English concerto writer of the 18th century. In 1776 his somewhat restless second son, Charles Jnr., applied for a sabbatical from his post as organist at St. John's church in Newcastle, which was to be spent in foreign parts for his improvement. He is known to have travelled to Russia.

WILLIAM SHIELD (1748–1829)

There are no comparable uncertainties about the Grand Tour made by Avison's former pupil, William Shield, who came from Swalwell near Gateshead. The son of a singing master, whose early death led to his son's being apprenticed to a boat-builder, Shield later became Avison's pupil, and built up a reputation as a violinist at his Newcastle subscription concerts

before moving to London in 1773. When Shield toured Italy from 1791–2 he was at the height of his fame as a composer of comic operas, having been appointed house composer at Covent Garden in 1778, and on 3rd November 1791, when Sir William Hamilton applied for a passport for him to visit Naples from Rome, he described him as an English Professor of Music.[52] Clearly Shield moved in intellectual and artistic circles in Rome, as a year later Mrs. Flaxman, wife of the sculptor, recorded that she had heard him perform at the house of the Scottish landscape painter Jacob More.[53] Over his career Shield wrote around forty-five operas for the London stage, and in 1817 he crowned a successful career by becoming Master of the Musicians-in-Ordinary to the King.

TUTORS, CHAPLAINS AND PRIESTS

BENJAMIN CROWE (c. 1689–1749)

The career of Benjamin Crowe, who came from Ashington in Northumberland, and was the brother of Christopher Crowe (fig. 172), British consul in Leghorn early in the 18th century, provides a classic illustration of the way in which the church could open up opportunities for ambitious young men abroad. In 1716 Christopher Crowe was trying to obtain the Chaplaincy of the British embassy at Leghorn for his younger brother, writing to the Dean of Peterborough that he 'should be very glad' if it 'might fall to my brother Benjamin's share who has been bred up in Queen's Colledge in Oxford that he might have an opportunity to see the world'.[54] The crucial link for professionals between a university education and Grand Tour travel could not be more succinctly, or indeed blatantly, expressed than in this successful application for patronage. No doubt the brothers hoped to be able to reinforce each other's presence in their key and related roles in a city which, for many British visitors, was their point of arrival in Italy, and which was also the major point of embarkation for Grand Tour goods. In the event, Christopher was recalled to England that same year, while Benjamin stayed on in Leghorn until 1729.

Like many other professionals abroad, including his own brother, Crowe was able to use his years in Italy to build up a 'fine collection of drawings, antique intaglio's, cameo's, and other curiosities'.[55] In 1722 the distinguished antiquarian Dr. Richard Rawlinson inspected his cameos and intaglios, though not his drawings and prints, and also offered a revealing glimpse of conditions inside the consulate during Crowe's chaplaincy: 'an upper room is sett aside for a chapell, in which are benches, a reading desk and a pulpit, here I heard an admirable discourse from the Revd Mr Crow the Chaplain'.[56]

After working unpaid for two years following disagreements over the payment of his salary, which came from a levy on Leghorn merchants, Benjamin Crowe returned to England in 1729. This was not, however, his last visit to Italy. In 1733–4 he acted as tutor to the young Yorkshire baronet, Sir Hugh Smithson, who would later, as 1st Duke of Northumberland, play such as crucial role in the neo-classical movement through his patronage of Robert Adam. Later, in 1742, he became rector of the parish of Gilling in Yorkshire.

LOUIS DUTENS (1730–1812)

Another tourist who combined the roles of clergyman and tutor, and who was also, but much later, employed by Hugh, 1st Duke of Northumberland to supervise a Grand Tour, was the Frenchman Louis Dutens (figs. 77–8), whose fascinating travels both individually, and with the Duke's second son, Lord Algernon Percy, are discussed on pp. 75–80. Dutens is a highly significant figure in the context of the Grand Tours made from the North of England, as he seems to have acted as unofficial adviser to many Northern tourists, including John Carr, and R.W. Grey, who was in great hopes of 'having a very agreeable companion…viz: Mr. Dutens' in 1774. Handwritten notes on Dutens's Grand Tour guidebook (see *Bibliographical Note*) also appear among the Swinburne papers,[57] suggesting that even the most travelled of all Northumbrian families relished his (published) advice. Certainly he fraternized with Henry and Martha in Italy in 1777, and their friendship seems to have survived into later life, as did Dutens's close rapport with Elizabeth, 1st Duchess of Northumberland, he even visiting her on her deathbed.

Given that he was acquainted with many of the leading literary, political and diplomatic figures of the day, Dutens's travels, however, also have a wider, national resonance, and this explains the importance Northerners attached to his input into their tours. R.W. Grey's verdict on him was shared by no less a personage than Sir Horace Mann, who told Walpole that he had 'lived in a degree of intimacy' with Dutens; his possession of an 'excellent memory', 'many curious anecdotes', and his having 'traveled much, and ... had opportunities of being acquainted with the principal people of many great courts' made him, for Mann, 'a very pleasant and most agreeable companion'. Although Mann also condemned Dutens's penchant for flattery – for which he was renowned – he did so in the context of a light-hearted rebuttal, to Walpole, of Dutens's praise of Mann himself.[58] Dutens also crossed paths – and indeed almost swords – with Lawrence Sterne, when he was placed next to him at a dinner in 1764 given by a cultivated former tourist, the Marquess of Tavistock. When the conversation turned on Turin, where Dutens had worked as a diplomat, Sterne, ignorant of the identity of his dinner companion, asked Dutens 'if I knew Mr. D[utens]'? On Dutens replying 'Yes, very intimately', the company began to laugh, which encouraged Sterne – presuming Dutens to be such a singular figure that 'the mention of the name alone excited merriment' – to invent stories about him 'from his fertile imagination'. Friendship between the two men ensued, however, when Sterne, learning of Dutens's true identity, came the next day to apologise, Dutens wittily assuring him that 'if he had known the man he had spoken of as well as I did, he might have said much worse things of him'!.[59]

PERCIVAL STOCKDALE (1736–1811)

Two fascinating tours of the late 1790s also involved Northern clergymen. From 1794–6 the Rev. Percival Stockdale, whose father was rector of Branxton, the site of the battle of Flodden, in Northumberland, acted as tutor to the young J.B.S. Morritt, owner of Rokeby Park, just over the Durham border in North Yorkshire, who is known today as the early owner of Velasquez' Rokeby Venus. Leaving on 27th February 1794, the two men made a new type of Grand Tour with Morritt's friend, the Rev. James Dallaway, which, beginning in Belgium, Germany, Austria and Hungary, and taking in Asia Minor and Greece before concluding in Italy, was, like so many others at this time, dictated by the movement of the French armies. Perhaps owing to Morritt's possessing 'the kindest and sweetest temper that ever graced a human being', this tutor-pupil relationship appears to have been successful, Morritt reporting in Vienna that, whereas he wore his corps uniform, 'Stockdale has sported a grave black dress coat, and looks *'Doctor Stockdale'* at least.[60] Stockdale, however, makes only infrequent appearances in Morritt's letters,[61] which show that the young landowner was already active as a collector, buying ancient bas-reliefs in Athens, 'a picture or two' in Rome, two cameos in Venice, and coins and medals in Athens and Naples. Stockdale's career, and his earlier, and perhaps equally fascinating, sojourn in Italy on his own in 1767–9 are discussed below.

The son of a Carlisle physician, Joseph Dacre Carlyle (1759–1804) was both a clergyman and a professor of Arabic. It was no doubt his learned credentials which recommended him to Lord Elgin, later the controversial owner of the Elgin marbles, who took him as chaplain to his embassy to Constantinople in 1799 (see p. 288).

DOM. GEORGE AUGUSTINE WALKER (1721–94)

One of the most influential Benedictine Procurators (or agents) in Rome was Henry Swinburne's tutor, George Augustine Walker; as well as effecting introductions between tourists and the resident Catholic community in Rome, including *cicerone* and artists, Walker also sometimes acted, during his twenty years there from 1757–77, as tutor to young British Catholics. Although he was born in Lancashire, and trained for the priesthood at St Edmund's in Paris, where he later became Prior, Walker served as chaplain to Thomas Swinburne at the seat of a cadet branch of this important Catholic tourist family, Tanfield Hall in Durham, from 1750–3. Here, in 1750, this future distinguished Benedictine wrote a paper concerning the latest scientific developments in

the North-East coal industry for a group of fellow intellectuals at St Edmund's, who had formed themselves into an academy 'dedicated to the pursuit of philosophical enquiry', also composing a 'long poem in classical form describing the neighbouring estate of Gibside'; in Rome he would later compose the Latin inscription on the pedestal of the Portland Vase.[62]

DIPLOMATS, MERCHANTS AND ARMY OFFICERS

CHRISTOPHER CROWE (1682–1749)

At different times in the century, two men from the North of England occupied key posts as consul at Leghorn (Livorno) – which, as we have seen, was a key port of entry or departure for British tourists in Italy. The Northumbrian Christopher Crowe, brother of Benjamin, was appointed consul here in 1705, having already worked in the town as a merchant. Like one of his successors, Sir John Dick, Crowe was also active as an art agent. When he assisted Sir John Vanbrugh in 1709 over the proposed purchase of twelve statues for the Saloon at Blenheim, however, the architect did not trouble to conceal his view of Crowe's subordinate role in the transaction, noting tersely: 'What is to be desir'd of Mr Crowe is: that he'll give himself the trouble of stepping over to Florence to treat for these statues'.[63] Other clients were the Earl of Strafford at Wentworth Castle, and James Stanhope, for whom he provided a copy of the antique *Wrestlers* in the Uffizi.

Probably during his first stay in Italy, Crowe was painted as a *virtuoso* (fig. 123) by the leading Italian portraitist of the early part of the century, Francesco Trevisani,[64] whose portraits of British tourists already show the principal ingredients of what would soon, with Pompeo Batoni, become the Grand Tour portrait. The consul's cultivated interest in antiquity is suggested not only by his gesture towards the backdrop of classical Roman ruins, but by the intaglio gem he holds in his other hand. Like his brother Benjamin, Crowe almost certainly assembled an important collection of paintings in Italy, which included four canvases by the most important Venetian view painter before Canaletto, Luca Carlevaris.[65]

Crowe may have intended to remain in Italy. However in 1716 he was recalled to England following his marriage to a divorced Catholic, Lady Charlotte Lee, daughter of the 1st Earl of Lichfield and former wife of the 4th Baron Baltimore; like other women occupying an ambivalent social position,[66] Lady Charlotte seems to have found in continental travel a solution to her uncertain marital status.[67] Although Crowe's short-lived marriage – his wife died in 1721 – clearly damaged his career prospects, Charlotte was the illegitimate grand-daughter of Charles II, and Crowe's Italian years, like those of Thomas Orde, ensured his assimilation into a higher social group: his new status is confirmed by his acquisition of the estate of Kiplin Hall in North Yorkshire in 1722.

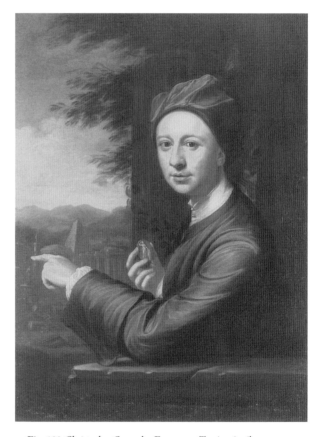

Fig. 123 *Christopher Crowe* by Francesco Trevisani, oil on canvas

SIR JOHN DICK (1719–1804)

It seems at least possible that one of Crowe's successors as consul at Leghorn may have had in mind the career of his Northern predecessor when deciding to work abroad. This was Sir John Dick from Newcastle, who would act as British Consul at Leghorn for over twenty years from 1754–76, after first working abroad as a merchant. Dick's motive in emigrating to Italy seems to have been to make his fortune, in which he succeeded: by 1770 a Scottish tourist, possibly Captain Thomas Riddell, could claim that Dick had 'made a great fortune by prizes in the french war to the amount of £100,000'.[68] Later, for his highly profitable revictualling of the Russian fleet during the Russo-Turkish wars of 1770–5, he received the tangible gratitude of the Empress Catherine the Great in the form of a medallion set with diamonds and the Order of St. Anne of Russia.[69]

The year after Dick's appointment, Robert Adam met him at Leghorn, characterizing him condescendingly as a 'clever little man…with a glib tongue, quick conception and good understanding, esteemed by all for his hospitality, genteel spirits and sweet behaviour', adding that his wife was a 'very agreeable woman'. Despite his hospitable nature, however, the consul occupied an uncertain position in expatriate and Italian society. According to James Adam, he lived with 'the splendour of a Minister', a comment corroborated by the Northerner Robert Wharton, who wrote that Dick had 'a Noble house and lives in great Elegance'.[70] However, Captain Riddell [?] pointed out in 1770 that Dick 'could not dine with the Grand Duke as being consul at Leghorn it not being considered as a Gentleman's Employment',[71] and Dick later found that his hospitality redounded on him back in England, when the tourists he had entertained abroad did not 'deign to recollect me';[72] the Carr family, whose friendship with Dick went back to his early years in Northumberland, formed an honourable exception to this rule. Dick's successful application in 1768 to revive a dormant Scottish baronetcy was surely the culminating act of a man obsessively preoccupied with social status.

Like the Crowe brothers before him, Dick was a

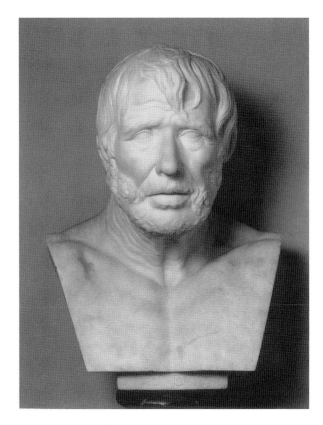

Fig. 124 *Bust of Seneca* by Francis Harwood, marble, 1763

considerable art collector, although very little is known today about his collection. Among his antiquities was a *Bust of Seneca*, which was clearly considered important enough for the British sculptor, Francis Harwood, who worked in Florence from 1753–83, and who specialized in making busts after the antique for Grand Tourists, to copy for the wealthy Yorkshire baronet Sir Lawrence Dundas (fig. 124).[73] Dick's collection of pictures, which impressed Captain Riddell [?] in 1770, included portraits of various of his friends abroad. After his return to England, Dick tried to commission a painting of Leghorn as a souvenir of his residence there. However, in 1787 his friend, the long-term Florence resident, Lord Cowper, wrote to say: 'I am sorry to say that there is no possibility of getting you a view of Leghorn: there is no such

thing as a Landscape painter here: they swank at Rome, but here none'.[74]

Like so many British diplomats abroad, Dick was also active as an art dealer, collaborating with Thomas Jenkins in 1766 over the classical statues being sold from the Palazzo Barberini in Rome, and asking for 'preference of any thing that was really good…that might fall into his hands'.[75] His position as consul at the port which handled the export of almost all Grand Tour wares meant that he must often have been asked to act as agent; certainly he handled export licenses for three consignments of antique sculpture in 1765–6. Dick was no less active over the acquisition of paintings, buying two pictures in 1765 for Thomas Anson's collection at Shugborough,[76] and corresponding with John Udny, the Venetian consul who in 1776 became his replacement at Leghorn, over the acquisition of works of art.[77] After his return to England, Dick also acted for his friend, Lord Cowper, over the mysterious disappearance of some diamonds which had been sent to a jeweller in Leghorn, Mr Dingwall, which Lady Cowper, who 'doats upon Jewls', was understandably anxious to retrieve.[78]

Dick's position at Leghorn brought him into contact with a very high percentage of all Grand Tourists, including royalty, in the person of the Duke of Gloucester, who stayed with Dick when he was taken ill in Leghorn in 1771. Although, over his years as consul, Dick knew, or acted for, several Northern tourists, including the Duchess of Northumberland (over the export of two boxes of sulphurs after the antique in February 1763),[79] the only one of these connections that can be traced back with certainty to his years in the North of England is his close friendship with the Carr family. Ralph Carr senior, father of the Grand Tourists John and Harriet, was a prominent Newcastle merchant and landowner, who is known to have been the formative influence on Dick's early career, having 'paid for his education, supplied him with money in his early days and provided him with introductions to foreign merchants'.[80] John and Harriet Carr would later find their path in Rome smoothed by Dick's introduction to Thomas Jenkins, while, in gratitude for Ralph Carr senior's help, Dick made

Carr's younger son, also Ralph, his heir, until, in old age, he was persuaded to make a new will.[81] The most important Grand Tour connection between the two families seems, however, to have been a business arrangement. In 1804, Ralph Carr senior is said to have purchased from Dick – perhaps, significantly, in the year of the latter's death – his 'collection of oil–paintings … and … marble statuary, all of which Sir John had collected during a long residence as British Consul at Leghorn';[82] this collection, whose impact on the North of England, if it became widely known, would have been incalculable, given that no comparable collection existed in the North at this date, has, however, disappeared almost without trace.

Sir John Dick had travelled widely in Italy from 1763–5 with his wife, Anne Bragge (d.1781), and was on familiar terms with long-term residents in nearby Florence, numbering Sir Horace Mann, as well as Lord Cowper (to one of whose children he stood as godfather) among his friends, and appearing with them and other *virtuosi* in 1772 in Zoffany's famous *The Tribuna degli Uffizi* (fig. 17); Dick stands on the left, next to Lord Cowper, in the group admiring Cowper's recently acquired Niccolini Madonna by Raphael, which is held up for inspection by Zoffany himself.[83] As has been pointed out,[84] the painting's division into three groups – those around Mann (in the centre), and Cowper, are contrasted with a younger gathering of tourists on the right ogling the Venus de' Medici – represents the different strata of Florentine expatriate society, and Horace Walpole wrote indignantly to Mann in 1779, complaining that the idea of a *conversazione* was 'absurd…rendered more so by being crowded with a flock of travelling boys, and one does not know nor care whom. You and Sir John Dick, as Envoy and Consul, are very proper…'.[85] If this endorsement, and Dick's inclusion in such a prominent position, his dignified stance enhanced by his wearing the Russian Order of St Anne, says much about the status conferred on him by his office,[86] Dick's relationship with both Cowper and Mann was professional as much as social; as well as acting for Cowper over art matters, he also lent him a considerable sum of money in return for an annuity.[87] Dick

also knew the two principal British artists working in Florence at this time, the view painter and caricaturist Thomas Patch (fig. 28), who, during an illness in 1778, sent a message via Horace Mann to say that he was 'extreme sensible and thankfull for the concern you express', and who included him, at the harpsichord, in his *Musical Party*, and the sculptor Francis Harwood (fig. 124).[88] Following his resignation as consul in 1776, Dick returned to England, owning a house in central London and buying a villa at Mount Clare, Roehampton, near Richmond. In later life he became successively Comptroller of Army Accounts and Auditor of Public Accounts, both lucrative and influential offices.

Most of the professionals working in Italy in the 18th century occupied a close, even symbiotic, relationship with Grand Tourists. It is perhaps therefore not surprising to find that rather fewer Northerners worked as merchants. Christopher Crowe and Sir John Dick, however, both began their careers abroad in this way, while Thomas Wilson, from Carlisle, worked as a merchant in Leghorn from around 1746 until his death in 1773.[89] Rather more colourful and unusual is the case of Anne Curry (d. 1811), from Newcastle, who is first recorded in Italy under the chaperonage of Mrs. Tobias Smollett in 1764–5, and who went on to marry George Renner, of the British Factory at Leghorn, in Florence in 1769. Anne subsequently lived both at Leghorn and in Florence until her death. The Renners' marriage had been witnessed by none other than Smollett himself, whose disrespectful views on Italian art in his *Travels through France and Italy* (1766) represent an entertaining departure from the views of most tourists, and George Renner later acted as the novelist's agent in Leghorn, also owning an (anonymous) miniature of him. The Renners' link with the Smolletts continued after the novelist's death from consumption in 1771; his widow Nancy, left in reduced circumstances, lived with them until she died twenty years later, and, on her own death in 1811, Anne was buried in the same grave in the Protestant cemetery at Leghorn. Given their shared Newcastle origins, and residence in the same Italian city, it is not surprising to find a link between Anne Renner and Sir John Dick, and indeed, in 1773,

when she sailed back briefly to England, Anne took with her some clothes for Dick's sister in Durham. The continental tours made by two other Northern merchants, Dick's mentor Ralph Carr senior, and Carr's apprentice, John Widdrington, in 1737–8 and 1746, are discussed on p. 132. Ralph Carr senior also recommended another protégé (and perhaps cousin) of his, James Walker, to Sir John Dick as consul, when he settled in Leghorn in 1771 – yet another illustration of the way in which this prominent North East merchant opened up links between this region and continental Europe.[90]

The only recorded visit to Italy of a soldier from the North on active duty is that of Sir Henry Belasyse (*c*. 1647–1717), whose father owned property at Ludworth in Durham, and who journeyed through Milan and Turin to Genoa in 1712 with his fellow commissioners after being appointed to a commission of enquiry into the state of British forces stationed in Spain and Portugal.[91]

ACADEMICS, INTELLECTUALS AND WRITERS

ANTHONY ASKEW (1722–74)

Most professional writers and academics tended, like artists, to visit the continent in the company of wealthy patrons, as did Joseph Carlyle with Lord Elgin in 1799. However, two either wholly, or largely, unescorted tours from the North were undertaken around mid-century by men of moderate means and considerable abilities. Anthony Askew, eldest son of a well-known physician, Dr Adam Askew of Newcastle, made a highly unusual three-year tour of Hungary, Athens, Constantinople and Italy around 1748, having spent several years studying medicine at Cambridge and Leiden universities. Although, in Constantinople, Askew formed part of the entourage of the ambassador, Sir James Porter, for the remainder of his stay abroad he seems to have been travelling on his own. That he was not only fully *au courant* with the latest developments in neo-classicism, but taking an active part in the movement, is confirmed by the father of the well-known painter and antiquarian, James Russel,[92] whom Askew

had met in Rome. On Askew's delivering to Russel senior, back in England, an important Grand Tour book on the early discoveries at Herculaneum,[93] Russel reported to his son that Askew had 'the reputation here of being a great Grecian and has brought home with him a large number of inscriptions, never taken notice of before, which he collected in the islands of the Archipelago'.[94] The sale of Askew's collection after his death confirms that he at least owned 'two very ancient marbles, which [he] brought from Greece'.[95]

On his return from the Grand Tour, which led to his being regarded back in England as 'no ordinary person, but one who had enjoyed most unusual advantages, and very rare opportunities of acquiring knowledge',[96] this intellectual from the North-East settled in London. Although he became Physician to St Bartholomew's and Christ's Hospitals, and a fellow of the Royal Society and of the Royal College of Physicians, it was rather as a classical scholar, and especially as a bibliophile, that Askew was known to his contemporaries, and that he is remembered today. The foundation of his collection of books and manuscripts, the *Biblioteca Askeviana*, had been laid in Paris on his return home from the Grand Tour; Askew's aim is said to have been the inclusion of every edition of a Greek author, and his house in Queen Square was 'crammed full of books...even our very garrets overflowed'.[97] According to his biographer, Askew 'was the first who brought bibliomania into fashion', and his tomes were regarded as 'rare, magnificent, giants, imperial, atlas, elephant, princes of editions'.[98] The scale of his library was such that the sale in 1775 after his death lasted an astonishing twenty days; its quality can be gauged not only from the claim in the introduction itself that this was 'the best, rarest and most valuable collection of Greek and Latin books that were ever sold in England',[99] but from the fact that the principal purchasers of its 3,570 volumes included Dr Hunter, the British Museum, and the kings of England and France.[100] Although Askew's collection of prints and drawings was less distinguished, it included, amongst other works after Old Masters, twenty-five drawings after paintings by Raphael in the Vatican.

PERCIVAL STOCKDALE (1736–1811)

The two year stay in Villafranca from 1767–9 by the Northumbrian clergyman, the Rev. Percival Stockdale (1736–1811), a man with 'considerable pride in his unrecognised literary abilities', during which, being without church employment at the time, he 'seriously sate down to [his] studies',[101] perhaps anticipates the inspiration Italy would later provide for writers of the 19th and early 20th centuries. Stockdale, who from around 1759 had mixed in London with men such as Dr. Johnson, David Garrick and Oliver Goldsmith, led a somewhat chequered career, in which he combined the holding of three livings[102] with the writing of poetry, political letters (under the pseudonym 'Agricola'), and an unsuccessful tragedy, *Ximenes*. According to him, a commission to write the *Lives of the Poets*, was, by some 'strange misunderstanding', given instead to Dr Johnson![103]

Stockdale returned to Italy as a Grand Tour tutor in 1795–6, a post for which he had some qualifications, having translated the *Antiquities of Greece* from the Latin of Lambert Bos (1772) and Sabbathier's *Institutions, Manners, and Customs of the Ancient Nations*, as well as *The Amyntas of Tasso* (1770), in which he 'endeavoured... to express the sentiments of Tasso as he would have done had he been an Englishman'.[104] His last years were spent at his living at Lesbury, near Alnwick, seat of another former tourist, Hugh, 2nd Duke of Northumberland, whose father had also presented Stockdale with a second Northern living. Stockdale's *Memoirs*, which 'I know... will live and escape the havoc that has been made of my literary fame',[105] were presumably written during this Northumbrian retirement, and were published in 1809; given his 'unbounded egotism',[106] it is perhaps not altogether surprising that he makes no mention in these of his second tour abroad escorting J.B.S. Morritt (p. 165). Another clerical Grand Tour protégé of the 1st Duke, Louis Dutens, who lived within reach of Stockdale at Elsdon, was also penning his *Memoirs* at this period.

AN ARTIST AND A SCULPTOR ABROAD
IN THE EARLY 19TH CENTURY

WILLIAM BEWICK (1795–1866)

Given the current acceptance accorded to the idea of a 'long 18th century', it seems logical to include here the career of a portrait and historical painter from the North of England who surely epitomizes this concept, and whose career abroad coincides with the last flowering of Northern Grand Tour art patronage around 1830. This was William Bewick, the son of an upholsterer from Blackwellgate, Darlington, who left for London at the age of twenty to study as an artist; although regarded today as a minor figure, his success with contemporaries, at least in the earlier part of his career, can be gauged from his contact with many of the leading poets, novelists and critics, as well as artists, of the Romantic movement. From 1817–20 Bewick became a pupil of Benjamin Robert Haydon, and a passionate supporter of Haydon's grandiose historical works, which were then beginning to lose ground with contemporary patrons. His long-held ambition to study in Rome was finally gratified in 1826 when Sir Thomas Lawrence, then President of the Royal Academy, decided to commission from him full-sized copies in oil of Michelangelo's prophets and sibyls in the Sistine Chapel.[107] Lawrence had intended to present these to the Academy to mark his Presidency. His death instead, in January 1830, entailed Bewick's immediate return to England, and was a blow from which his career never recovered.

Bewick's tour took him first to Genoa, which he memorably described by moonlight, noting that 'the pale moonlight renders defects that time has made upon the decorations less distinct', and then via Pisa and Florence to Rome.[108] His letters home from Italy to his family in Darlington are unusual in that his artist's eye for detail enabled him to focus on points that escaped most tourists, such as that Italian floors were usually made of brick ('no carpets in this country – good houses have marble or painted stucco'); that 'every cottage, barn, or palace must have its exterior decorations of painting, sculpture, or earthen

ornament'; and that 'there is no such thing as paper for rooms. They are all either painted with landscapes, figures, and ornaments, or in the best houses hung with…damask'.[109] Bewick must have had plenty of opportunities to observe the 'best houses' personally, as his social success with British aristocrats and members of the gentry, including Harriet Carr (now Mrs. Cheney) was considerable.

Even this 19th-century tour, however, had its dangers and difficulties. At sea, Bewick's ship was accosted by a French corvette, and, given the risk of contracting malaria during the summer in Rome, he opted to stay on in Florence, despite the impossibility of getting scaffolding to copy a picture at the Pitti Palace. Bewick's problems with scaffolding were to be compounded on his eventual arrival in Rome in September 1826. The scaffolding in the Sistine Chapel, which he obtained permission to erect so as to make his copies after Michelangelo, had to be dismantled every time the Pope conducted a religious ceremony there, given that the pontiff was 'so particular about the smell of paint and varnish';[110] this involved Bewick in considerable expense as well as inconvenience. Bewick's attempts to buy Old Master drawings in Naples in 1828 for Sir Thomas Lawrence's great collection were, likewise, girt with difficulties: not only had the French 'carried away everything that was at all worth taking', but 'so many English' had subsequently bought and taken away pictures that Bewick considered 'the gleanings are scarce'. In a Neapolitan villa, however, he saw works of art which, although not of the highest calibre, clearly reminded him of home: prints of fox hounds belonging to two former Northern Grand Tourists with whom he had contacts, Lord Darlington and Lord Durham.[111]

It was surely Bewick's belief, inherited from Haydon, in the importance of studying Raphael, Michelangelo and Greek art (particularly the Elgin marbles, of which Bewick made drawings for Goethe), as well as his Northern origins, which recommended him to the attention of a patron such as Sir Matthew White Ridley, for whom he painted a study of an Italian peasant. This took some time to complete 'in consequence of my labours at the Sistine Chapel'.[112] Another

Northern patron, Lord Durham, commissioned, perhaps while he was in Paris in 1828, what, to Bewick's regret, was only a small painting of *Cornelia and her family*. The subject, taken from Roman history, concerned a Roman lady exhibiting her jewels to Cornelia, 'who in reply shows her her two boys'. It had been cleverly chosen by the artist to appeal to his patron and his wife as the parents of a 'beautiful and interesting family'.[113]

After his return to England, Bewick eventually gave up his attempts to sell his Michelangelo copies (fig. 125) in the wake of Lawrence's death,[114] and forge a reputation in London, retiring instead to Darlington, where he had spent some of the earlier years of his career. Here, with the exception of one

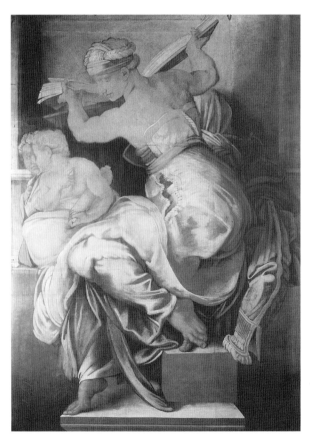

Fig. 125 *The Libyan Sibyl*, copy after Michelangelo by William Bewick, bodycolour laid down on canvas, 1826–30

further brief interlude in London from 1839–42, he painted portraits – sometimes jokingly heading his letters 'Michael Angelo Studio'[115] – and seems to have become assimilated into the local gentry. By 1850 he had built a house in the village of Haughton-le-Skerne, which contained a gallery to house his Michelangelo copies. Although his collection is said to have included works by artists such as Titian, Van Dyck, Rembrandt, Rubens and Velasquez, doubts as to their authenticity were expressed even at the time of the sale of his pictures after his death, and only a small number of works in his collection can be identified today.[116] A painting of the Italianate landscape garden at Castle Eden which appeared in the same sale perhaps suggests that Bewick was also patronized by yet another former Durham Grand Tourist, Roland Burdon, whose home this was, while he is also known to have visited Raby Castle, seat of Lord Darlington, and one of the Durham houses most profoundly affected by the Grand Tour. In striking contrast, therefore, to earlier artists from the North of England who spent time abroad, Bewick seems to have taken pains to cultivate the major tourists and art patrons of the North of England both while he was abroad, and in later life.

JOHN GRAHAM LOUGH (1798–1876)

The son of a blacksmith from Shotley, County Durham, who later became a small farmer, the classicising sculptor John Graham Lough[117] is said to have attracted the attention while still a young man of the Durham tourist George Silvertop, who saw in the garden of the Lough family home 'hundreds of models, legs & arms lying about' and invited Lough to visit him at Minsteracres. Although apprenticed to a local stonemason, Lough soon persuaded the captain of a collier to take him to London, where he arrived, 'panting' to see the Elgin marbles, and soon began sculpting his most famous work, *Milo* (1826).[118] Meeting him at this early point in his career, Benjamin Robert Haydon, no stranger himself to want, saw in Lough the epitome of genius struggling with poverty and low social origins: 'Can any man help being enthusiastick when he sees a Farmer's Son fresh from sheaving corn, in a

back room in a dirty shop, obscure, starving, & building up such a production as this? Impossible'.[119] Haydon considered him 'one of the greatest sculptors since the best age of Greece – with no exception – not even Michel Angelo' – a remark which links Lough closely, in terms of his sources, to his fellow tourist William Bewick, another Haydon protégé and fellow Greek and Michelangelo enthusiast (fig. 125).

In May 1827 Lough's financial troubles seemed to have come to an abrupt end, when *Milo* was exhibited in London, and its creator was proclaimed an 'extraordinary genius' by the press. Among the distinguished clients who now presented themselves, headed by the Duke of Wellington, were the Northerners Hugh, 3rd Duke of Northumberland – Haydon believing that the Duke's patronage 'confers immortality' on him – Charles, 2nd Earl Grey,[120] and Sir Matthew White Ridley, 3rd Bart,[121] whose eponymous son would later become Lough's greatest patron. A second exhibition, however, failed to reap comparable rewards, and, having now a wife and family to support, Lough, like so many sculptors of this generation, decided to try his luck in Rome, where he arrived in November 1834, staying for just under three years.[122]

Lough's years in Italy are, unfortunately, not recorded in detail. However, we know, both from the obituary in the *Art Journal* in 1876, and from Lough's own surviving letters from Rome, that his tour was made possible 'through the kindness of the late Duke of Northumberland and Lady Guilford', the 3rd Duke paying Lough an allowance of £100 for three years – an arrangement similar to that made much earlier between the Earl of Warwick and John 'Warwick' Smith.[123] Given Lough's 'well-grounded confidence in his own powers', he seems to have 'pursued his studies, unaided by the counsel or direction of any master',[124] and the contacts he must have had with the British artistic community in Rome, including sculptors such as John Gibson, have gone unrecorded. Although the *Art Journal* claims that he enjoyed the support of several British aristocrats while in Rome, Lough's correspondence confirms that, at least in his own estimation, the sculptor had been 'most truly unfortunate in the period I have selected for visiting Italy'. Not only had no 'patrons of

art…visited Rome since I have been here'[125] – a declaration supported in part by a study of Lough's works, very few of which date to his Roman years,[126] but certainly exaggerated, since he features prominently in the pages of Pauline and Calverley Trevelyans' Roman diaries – but young, unmarried sculptors were able to undercut his charges. The financial hardship which ensued was exacerbated by a disastrous visit in 1837 to Naples, where Lough – ironically as it turned out – had gone for a three-week tour for his health, and to study 'the splendid collection of bronzes in the gallery there'.[127] Instead, there was an outbreak of cholera, and, after spending three months in quarantine in Naples, the Loughs were forced to return to Rome by a circuitous route during which they were detained still further, and even incarcerated for ten days in a *lazzaretto* (leper house). As a result, Lough's bank account became heavily overdrawn, and he told the former tourist – and his current patron – William Ord, 'I know not what will become of us if I do not get some commission from London'.[128]

Lough was, however, highly fortunate in his principal patron. Not only did Hugh, 3rd Duke of Northumberland advance his annual payment for 1837 earlier than agreed, in an attempt to ameliorate Lough's financial difficulties. He also seems to have converted the sculptor's gift to Duchess Charlotte Florentia of what Lough himself described as 'a small group' in 'beautiful marble' – the *Infant Lyrist taming Cerberus* now in the Hatton Gallery in Newcastle – into a paid commission, while a second Lough marble, a *Boy giving water to a dolphin*, exhibited at the Royal Academy in 1838,[129] was executed in Rome for the Duke himself.

Although another Northern patron, Charles, 2nd Earl Grey, is also said to have commissioned works from Lough abroad, Lough's recorded works for him all date from an earlier period in his career. One other major commission in Rome is, however, firmly associated with the North of England. This is the statue at the Literary and Philosophical Society in Newcastle (fig. 126) to the anti-slavery campaigner James Losh, showing him as a Roman orator, which, signed and dated 'Rome 1836' is, unsurprisingly, in the neo-classical

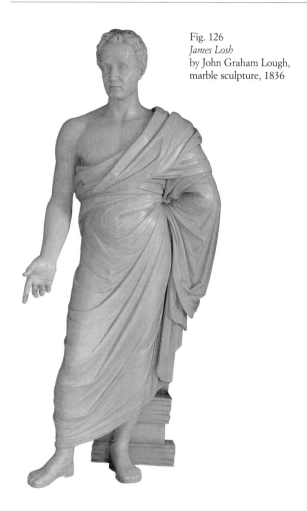

Fig. 126
James Losh
by John Graham Lough,
marble sculpture, 1836

mode.[130] Letters relating to the commission survive from Lough both to the committee charged with its installation, and to William Ord, who appears to have been its chairman. Given the close correlation over several generations between the Society's membership and Northern tourists, this dialogue, involving a prominent Northern patron, and an artist from the same region, is illuminating, although the Losh statue is, of course, primarily a civic, rather than a Grand Tour, commission. It confirms that Lough was distinctly more successful than his 18th-century predecessors in cultivating and maintaining links with Northern clients,[131] assuring the Losh Committee of the 'strong sympathy I feel for all

connected with the County in which I drew my first breath'.

Although Lough had intended to remain in Italy until 1840, he was obliged, like Guy Head before him, to make a sudden exit in August 1837 'to save myself & family from a fearful disease and an expected rebellion' – the cholera epidemic had now reached Rome itself, and the city was in danger of revolution. When Lough wrote to the Duke of Northumberland on 15th August, he and his family were the 'very last English left in Rome; even the English doctor has left', and 'everything is here considered as completely broken up for the next two years. Rome is now a complete desert'[132] – a description reminiscent of William Artaud's powerful account of Rome on the eve of the Napoleonic invasion (p. 144). On their homeward journey in August and September 1837, however, the family, accompanied by their maid, managed to make a tour of northern Italy which included Verona, Mantua, Venice, Florence and Bologna, returning to England via Switzerland, Germany and Brussels.

Despite the difficulties circumscribing his tour, Lough must have gained valuable experience abroad – 'he supremely revered Michael Angelo, and he spoke eloquently of his long sojourn in Rome'.[133] However, his Grand Tour did not have the desired effect on his career: on his return to England, his former patrons had largely forgotten him, and Lough's survival in the early 1840s was owing to the largesse of Sir Matthew White Ridley, 4th Bart, son of his former patron, whose exceptional enthusiasm for sculpture, and belief, comparable to Haydon's, in Lough as the greatest sculptor since Michelangelo, caused him to fill his London house at 10, Carlton House Terrace (and later his gardens at Blagdon in Northumberland) with Lough's work;[134] a letter from Cecilia, Lady Ridley, however, opens up the possibility that Ridley's commissions, which continued over more than twenty years, may have been in part charitable in nature: 'Literally now he lives upon what he gets from Matt and Lough hurries on his things much more than we wish really because he has no other hope'.[135] The sculptures Lough produced for Ridley were idealised in nature and often grandiloquent in scale, including classical, historical, religious and especially

Shakespearean subjects – what one visitor referred to as Ridley's 'Shakespeare Gallery' – although Lough also sculpted portrait busts of the Ridley family.[136] Given Lough's years in Rome, these commissions from the 4th Baronet should perhaps be seen as a continuation of his father's neo-classical sculpture commissions in Rome on his tour of 1828–30.

Following the inclusion of two models in an exhibition of sculpture for the new Houses of Parliament in 1844, Lough's career began to re-ignite, and his former patron, Hugh, 3rd Duke of Northumberland, purchased a model of *The Battle of the Standard* – a bizarre, Italianate interpretation of one of Edward I's battles, based on Leonardo da Vinci's famous *Battle of Anghiari*. Although Lough also received a major commission in London – statues of Queen Victoria and Prince Albert for the Royal Exchange – three of his large-scale commissions, the Gothicising church monument to Robert Southey at Crosthwaite, Cumbria, the bronze statue of George Stephenson near the High Level Bridge in Newcastle, and the statue on the memorial at Tynemouth (designed by John Dobson) to the North's great admiral, Lord Collingwood, are all Northern commissions, and Lough's later career shows the same careful cultivation of his Northern patrons that had marked his years in Rome. He ended his life as an 'eminent Victorian', financial vicissitudes behind him, 'in manner, as well as in mind, a gentleman'.[137] If the Grand Tour had contributed to this social transformation of a farmer's son from County Durham, it contributed less, perhaps, to Lough's stylistic development; in the years after his tour, his work, never strictly neo-classical in presentation, gradually moved towards a more romantic and picturesque style.

END NOTES

1 His father later became Rector of Dean in Cumberland.
2 Under Agostino Masucci in Rome, by 1731. Somerset was the father of Lady Elizabeth Percy, and owner of the Percy estates in Northumberland, so a clear Northern link is indicated here.
3 Stanford and Finopoulos, pp. 3–4. This publication provides a definitive account of Lord Charlemont's tour, and the material below is deeply indebted to it.
4 To judge from a letter written by Charlemont's step-father-in-law, Thomas Adderley, in 1755. See Historical Manuscripts Commission, Twelfth Report, Appendix, Part X, *The Manuscripts and Correspondence of James, 1st Earl of Charlemont, Vol I., 1745–1783*, London, 1891, pp. 200–201, letter from Adderley to Charlemont, 28th January 1755. Adderley (who, however, had his own disagreements with Charlemont), wrote to defend his conduct over a quarrel with Dalton concerning his subscription to five sets of Dalton's prints. Dalton accused Adderley of non-payment, and Adderley was then told by Mr. Scott (presumably Alexander Scott, who was a member of the expedition) that Dalton had 'not only treated me, but him [Mr. Scott] and even your lordship ill…'.
5 Stanford and Finopoulos, p. 232.
6 Op. cit., p. 8.
7 Two of the costume drawings survive in the Royal Library at Windsor Castle. Lord Charlemont is known to have owned what were presumably other Greek costume studies by Dalton.
8 Richard Dalton, *Remarks on Prints*, 1781, n. p. With the exception of the drawings in the Royal Library, and those in the Department of Greek and Roman Antiquities at the British Museum of the frieze of the mausoleum at Halicarnassos and of the Parthenon, Dalton's drawings are known today mainly through the engravings which illustrate his travel books, notably *Graecum et Aegyptiacum or Antiquities of Greece and Egypt…* (1751), and later publications such as *The Ceremonies and Manners of the Turks*, and *A Selection from the Antiquities of Athens*. The definitive edition, *Antiquities and Views in Greece and Egypt with Manners and Customs of the Inhabitants from drawings made on the Spot, A.D. 1751*, was published in 1791, and contained seventy-nine prints and etchings. Dalton's books remain among the most fascinating of Grand Tour productions.
9 Charlemont's record of his travels was supplemented and revised by him long after his tour; his actual tour journals on which they are based are lost.
10 Stanford and Finopoulos, pp. 168–9.
11 Op. cit., p. 66.
12 Ingamells, p. 197.
13 A fuller list of Charlemont's Grand Tour purchases is given in Stanford and Finopoulos, p. 10.
14 Ingamells, pp. 270, 269. Michael Levey points out, p. xxxix, that although Dalton was not the prime mover in the purchase of Consul Smith's collection, his contact with Smith in the early 1750s over Zuccarelli's visit to England may well have proved crucial in determining the eventual sale of Smith's collection to the Royal Library.
15 Walpole, vol. 21, 17th February 1761, p. 478; letter from Sir Horace Mann.

16 Walpole, vol. 21, pp. 521, 524.

17 *The Harcourt Papers*, ed. W.H. Harcourt, 14 vols., 1880–1905, III, p. 107. Dalton's collection was sold on 11th April 1791.

18 Levey sees George III as playing a very important role in the formation of the collection, whereas Ingamells considers the 3rd Earl of Bute to have been the prime mover. For Bute, see Francis Russell, *John, 3rd Earl of Bute*, 2004.

19 Quoted in Levey, p. xxxvii.

20 Among his greatest acquisitions were Annibale Carracci's *Il Silenzio*, and Guercino's *Libyan Sibyl*. As is pointed out in Grove, vol. 8, p. 474, his focus on Italian pictures may have been to counteract Bute's personal interest in Dutch painting.

21 Iolo A. Williams, *Early English Watercolours*, Bath, 1970 edition, p. 83.

22 Joseph Farington's Diary for 14th February 1777, which notes Smith's presence in Italy in 1776, is the only evidence for Smith's being in Italy before 1778.

23 Anne Lyles and Andrew Wilton, *The Great Age of British Watercolours 1750–1880*, London and Washington, 1993, p. 82.

24 Jones, *Memoirs*, p. 90.

25 Op. cit., p. 82.

26 Now in the Tate Gallery.

27 Grove, vol. 28, p. 883.

28 Pressly, p. 69.

29 The presentation pictures, which have recently been rediscovered and published by Frank Salmon, were: *Oedipus and Antigone*, Parma Academy, and *Erminia writing the name of Tancred*, Bologna Academy. Other major history paintings of these years were Head's *Venus giving her girdle to Juno*, also recently rediscovered, by Ann Gunn, and *Echo flying from Narcissus* and its pendant, *Iris carrying the Waters of the River Styx to Olympus*. See *Bibliographical Note*.

30 Head also commissioned copies from other artists. Many of his copies were sold in London after his death; see note 40.

31 His presentation piece was *Iris carrying the Waters of the River Styx* (note 29 above).

32 James Irvine, quoted in Ingamells, p. 480. For Guy Head's relationship with William Artaud, see Sewter, Artaud letter 11, p. 20, when he dined at 'a Mr. Head's', probably soon after his arrival in Italy in 1795, and especially Artaud's draft letter to Guy Head, 4th August 1797, when Artaud sends 'my most friendly greetings to Mrs. Head', and asks to be remembered to Christopher Hewitson (p. 49) and Thomas Jones; perhaps Head was not as isolated in his friendships as some contemporary comments suggest.

33 Ingamells, p. 479. As well as fig. 121, these included a portrait of Head's friend John Flaxman (National Portrait Gallery).

34 Head's portrait of the Duke is undated, but was certainly painted abroad. Sussex's friendship with W.H.Lambton's tourist son, John George, led to his visit to the North of England, a Whig stronghold, in 1822, when he was hailed as 'Sussex for ever, friend of the people'.

35 By or attributed to Parmigiano, Guercino, Veronese, van Dyck, Domenichino, Poussin, Titian, Tintoretto and Rembrandt. The posthumous sale catalogues of his collection between 1801–38 are listed in Gunn, p. 512. They also include some of the antiquities purchased by Head.

36 These were despatched in more than seventeen cases on board ship the day the French entered Rome; Ingamells, p. 480.

37 The evacuation is noted in a (much later) letter from John Head,

29th November 1820: PRO Adml.07/53 f.1. Information kindly provided by Malcolm Stewart. For Head's disparagement of the King, see James Losh, *Diaries*, 2nd November 1799, Carlisle Local Studies Library.

38 Head's brothers John (1757–1824), a ship and insurance broker, and Thomas (1765–1814), a timber merchant, were certainly in Newcastle by 1797, when their mother Isabella went to live with them. I am most grateful to Malcolm Stewart for his information on Head's North-East contacts in 1799; Head's visit to Newcastle in October is 'certified' in the 1820 letter from John Head cited above (note 37).

39 His *Echo* and *Iris*, see note 29.

40 The several sale catalogues of Head's collection after his death, of which there are copies in the National Art Library, offer little additional information; most of the works offered for sale were copies by Head after Old Master painters.

41 These include Gosforth Park (1755–64) for Charles Brandling, whose successors later went on the Grand Tour. Paine also built in Northumberland Belford Hall for Abraham Dixon, 1754–6, and Bywell Hall, 1766, for William Fenwick. His Durham commissions include Axwell Park, 1758, and the remodelling of Raby Castle, c.1752–60.

42 Leach, p. 26; Ingamells, p. 731.

43 Leach, p. 32; Ingamells, loc. cit.

44 Jones, *Memoirs*, p. 51; Colvin, p. 329.

45 The Gibside drawings were included in James Paine's *Plans, Elevation Sections of Noblemen's and Gentlemen's Houses* (1767).

46 The *Essay's* importance is attested by the fact that it went into three editions, and that there was a German translation of the first edition in 1775.

47 Both Charles Burney, quoted in Lyall Wilkes, *Portraits from the North*, 1991, p. 12, and the *Gentleman's Magazine* for July 1808 say that Avison studied in Italy.

48 *Gentleman's Magazine*, loc. cit.

49 P.M. Horsley, 'Charles Avison: The Man and his Milieu', see *Bibliographical Note*. Avison's Essay certainly confirms that he was *au fait* with fine art, although his use of terms such as 'Off-Skip', for example, suggests that he did not readily use the language of contemporary connoisseurship. Another intriguing link between Avison and the Grand Tour is the statement in Groves' *Dictionary* that Colonel John Blathwayt, of Dyrham Park, Gloucestershire, gave Avison support in musical development; Blathwayt, a talented musician, made the Grand Tour as a teenager in 1706–8; see Ingamells, pp. 98–99.

50 Elizabeth Montagu's husband inherited Denton Hall, Newcastle, near Fenham, so this London bluestocking also had Northern connections.

51 Charles Avison, *An Essay on Musical Expression*; Charles Avison, *Preface to the third set of Six Sonatas*, op. 8, London, 1764; for a discussion of Browning's poem on Avison, see Horsley, pp. 22–3.

52 Ingamells, p. 855.

53 Mrs. Flaxman Journal, quoted in Ingamells, loc. cit.

54 Ingamells, p. 257.

55 The antiquary Edward Wright saw this in his house in 1721; Ingamells, loc. cit.

56 Ingamells, loc. cit.

57 For both the Grey and Swinburne MSS., see *Bibliographical Note*. The

Swinburne family notes on Dutens's tour are in a private collection.

58 Walpole, vol. 25, p. 627.

59 Dutens, *Memoirs*, 1806, vol. II, pp. 5–8; quoted in Sterne, *Letters*, pp. 251–2.

60 Morritt, *Letters*, see *Bibliographical Note*; letter of 22nd May 1794.

61 Op. cit. For this tour see also Tregaskis, pp. 34–7 and the file on J.B.S. Morritt at the Paul Mellon Centre, London. The Yale Center for British Art, New Haven, holds the manuscript of Morritt's tour to Greece and Asia Minor from 1794–5. Several Grand Tour works remain at Rokeby.

62 Geoffrey Scott, *Northern Catholic History*, no. 15, Spring 1982, p. 4.

63 Honour, p. 222.

64 According to *Masterpieces from Yorkshire Houses*, York City Art Gallery, 1994, Crowe's close contacts with Italy were renewed after the death of his wife, so the dating of this portrait remains uncertain.

65 Two of the Carlevaris paintings were sold at Christie's, 26.11.1971. Eighty paintings, mostly Venetian, North Italian, Flemish and Dutch were listed at Kiplin Hall in 1771.

66 For example Lady Mary Coke.

67 She was in Venice in 1713–14.

68 Riddell MSS., December 12th 1770; see *Bibliographical Note*.

69 Ingamells, p. 298.

70 Loc. cit.; loc. cit.; Wharton MSS., 23rd October 1775.

71 Riddell MSS., 12th December 1770; see *Bibliographical Note*.

72 Ingamells, p. 299.

73 See Hugh Belsey, *The Burlington Magazine*, vol. 122, 1980, p. 65, and Ingamells, pp. 298–9.

74 Sir John Dick correspondence, private collection, letter from Lord Cowper to Dick, Florence, 4th September 1787. I am grateful to Hugh Belsey for drawing this correspondence to my attention.

75 Ingamells, p. 298.

76 Information kindly provided by Alastair Laing and Dr. Viccy Coltman. Anson's correspondence with Dick is in the Staffordshire Record Office, D615/P (A)/2.

77 Ingamells, p. 298. The two men corresponded after Dick's return to England about a collection of pictures which Udny had bought in Ferrara, and which he was hoping, if Dick interceded on his behalf, to sell to the Empress Catherine II of Russia. The tone of the correspondence suggests that Dick and Udny had regular dealings over works of art.

78 Sir John Dick correspondence, see note 74 above; letter from Lord Cowper to Dick, Florence, 31st March 1778, and *passim*.

79 Dick had a duplicate bill of lading for two boxes of sulphurs Lippyeatt had sent to the Duchess of Northumberland by 11th February 1763. Percy Letters & Papers, loc. cit.

80 Purdue, 1999, p. 232. At the back of the Carr album of visiting cards (p. 146) are several letters to Ralph Carr senior from Dick, dating from 1786–90; later, Carr would confide to Dick his loneliness after his family had grown up and dispersed. See Carr, I, p. 54 for the suggestion that Carr may have been Dick's guardian.

81 Purdue, 1999, p. 232. Under its terms, Ralph stood to inherit only a quarter of Dick's estate.

82 Carr, I, p. 58. This may not have been an isolated act of art collecting, as Carr also seems to have been interested in china. In 1738 he wrote to a friend in Rotterdam asking ' his wife ..[to] get him some of that old china if she can'; Carr, loc. cit.

83 Now in the National Gallery of Art, Washington DC. Zoffany acted as art agent for Lord Cowper over this and other purchases, and the inclusion of this particular Raphael represents an intriguing sub-plot of the painting: as Sir Oliver Millar points out in *Zoffany and the Tribuna*, 1967, Cowper later tried to give the painting to George III in exchange for his being created a Knight of the Garter, and Cowper and Zoffany may have hoped to arouse the king's interest in the painting by displaying this saleable work by Raphael in the context of his masterpieces in the *Tribuna*. The attempt, however, proved unsuccessful.

84 *Grand Tour*, Tate Gallery, 1996, p. 136.

85 Walpole, vol. 11, 1904, pp. 48–9.

86 Millar points out, however, that the figure of Dick was introduced into the circle on the left 'at some stage', implying that his inclusion was perhaps not intended from the start.

87 Mann's letters to Dick from 1777–78, and Cowper's from 1777–87, survive, see note 74.

88 Letter from Sir Horace Mann to Sir John Dick, January 9th, 1778, see note 74. The Patch painting is in the Yale Center for British Art, New Haven.

89 The only information on his career derives from his tombstone; see *Inscriptions in the Old British Cemetery of Leghorn*, transcribed by G. Milner-Gibson and F. C. Macaulay, Leghorn, 1906; Ingamells, p. 1008.

90 For the Renners and the Smolletts in Italy, see Ingamells, pp. 806, 873–4. For James Walker, see Carr, I, p. 50.

91 Ingamells, p. 74.

92 Ingamells, p. 31, points out that Russel dedicated to Askew a plate in the second volume of his (anonymous) *Letters from a Young Painter abroad*, 1750.

93 Marquis Niccolo Venuti, *Descrizioni delle prime scoperte dell'antica citta d'Ercolano* , Rome, 1748, also Venice 1749, London 1750.

94 Ingamells, p. 31.

95 Askew sale, see *Bibliographical Note*, p. 149: 'Dua Marmora Antiqua, 1. Tabula Marmorea Anaglyphica 2. Tabula Altera Marmorea Rotunda'.

96 *The Gold-Headed Cane*, p. 120; see *Bibliographical Note*.

97 DNB, vol. 2, London, 1885, p. 193; *The Gold-Headed Cane*, pp. 125–6.

98 *The Gold-Headed Cane*, p. 126.

99 Askew library auction catalogue, sold Lyon & Turnbull, Pallinsburn, 4th May 2005.

100 DNB, vol. 2, London, 1885, p. 193.

101 Ingamells, pp. 899–900; Percival Stockdale, *Memoirs*, 1809, vol. 2, pp. 25ff.

102 One in Hertfordshire and two in Northumberland at Lesbury and Long Houghton.

103 DNB, vol. 54, London, 1898, p. 391. The account of Stockdale's later career is drawn from this source, and from his *Memoirs*.

104 *The Amyntas of Tasso*, translated from the original Italian by Percival Stockdale, London, 1770.

105 D.N.B., vol. 54, London, 1898, p. 392.

106 Loc.cit.

107 Lawrence had hung two of them in his room by March 1829; *Bewick Letters*, ed. Landseer, p. 115. See note 116 for Bewick copies after other artists.

108 *Bewick Letters*, ed. Landseer, p. 289. On the voyage to Italy Bewick shared a cabin with a young tourist called Le Mesurier, son of the vicar of Haughton-le-Skerne near Darlington. Bewick later moved to Haughton, and his links with the Le Mesuriers continued in later life.

109 Op. cit., pp. 290, 294, 298–9.

110 Op. cit., p. 86.

111 Op. cit., pp. 109, 96. In Naples Bewick also copied a Michelangelo drawing for Lawrence. According to Fothergill, Bewick had been introduced to Lady Darlington on his arrival in London through a Mrs. Chaytor of Croft-on-Tees.

112 Ridley MSS., letter from William Bewick to Sir Matthew White Ridley, 27th December 1829.

113 *Bewick Letters*, ed. Landseer, pp. 115, 95. Bewick reports in a letter from Rome of 1st January 1828 that Lambton had written to him from Paris, presumably to discuss the commission for the painting of Cornelia. Bewick also met one of the Ellisons in Rome in 1828 (*Bewick Letters*, p. 89), although he does not appear to have been a patron.

114 According to Kirkland and Wood, four large Michelangelo copies were sold as part of Lawrence's estate, instead of being presented to the Academy as he had intended. Despite an appeal in the *Art Union* that Bewick's drawings should be purchased for the country, the studies remained on Bewick's hands. After his death, at the sale of *The Bewick Gallery of Pictures* held by Thomas Watson & Sons on 9th –10th November 1870, eleven (presumably in fact twelve, as this was the number later sold) cartoons after Michelangelo were bought by a Durham dealer and sold to the Dean and Chapter of Durham Cathedral. These were sold following a sale at Christie's on 2 June, 1978 (lots 212–223). Of the six oil copies which Bewick also made from the Sistine Chapel, which were half the size of Bewick's cartoons, and one quarter the size of Michelangelo's originals (see Fothergill, p. 120), one, the *Libyan Sibyl*, was sold at Christie's on 19th October, 2000 (fig. 125). Another, *Jeremiah*, survives in Darlington Art Gallery. *The Libyan Sibyl*, and Bewick's untraced studies of the prophets David and Ezekiel, are said by Kirkland and Wood to have hung at one time in the billiard room of a club in Duke Street; the subsequent fate of the two latter is unknown. Sir David Wilkie was also in Rome copying Michelangelo's sibyls in the 1820s.

115 Fothergill, p. 119.

116 See Fothergill, p. 120, for information on these Old Master paintings. Those Bewick pictures which had not been given away by his wife, who is said to have dissipated his inheritance (Kirkland and Wood, p. 41), were auctioned at the 1870 sale of Bewick's pictures (see note 114 above). Bewick's own paintings in the sale included copies of *The Three Maries* after Carracci, and after Correggio's *St Jerome* in Parma.

117 For this sculptor, see T.S.R. Boase, 'John Graham Lough: A Traditional Sculptor', *Journal of the Warburg and Courtauld Institute*, vol. 23, 1960, pp.277–90 and J. Lough and E. Merson, *John Graham Lough 1798–1876: A Northumbrian Sculptor*, Woodbridge, 1987.

118 There is a later bronze version of this at Blagdon, Northumberland, dated 1863.

119 According to *Particulars supplied to the writer by Mrs. Lough*, 1893,

the Durham tourist George Silvertop, offended by Lough's refusal to take up his offer of sponsoring him to study in Rome, 'left him to his unaided resources'. Later repenting of his harshness, he called on Lough to ask how he was getting on, to which Lough replied: 'Oh, very well, sir; I am working away here and living on bread and water'; quoted in Lough & Merson, p. 7.

120 A marble *David*, produced for Grey, dates to 1829, while *Milton invoking the Muse*, also in marble, was exhibited in 1834.

121 Lough's long connection with the Ridley family seems to have begun with his successful *Duncan's Horses*, shown at the Royal Academy in 1832. The 3rd Baronet bought a cast, also commissioning an Orpheus in this same year. In 1833 Lough carved a portrait bust of Ridley himself.

122 This may not have been his first visit abroad, as a contemporary source, quoted in Lough & Merson, p.13, suggests that Lough had already made a trip to France.

123 Quoted in Lough & Merson, p. 23. No details of Lady Guildford's support of Lough in Italy survive.

124 *Newcastle Daily Chronicle*, 3rd October 1862; quoted in Lough & Merson, p.23.

125 Letter to Hugh, Duke of Northumberland, 8th February 1837; quoted in Lough & Merson, p. 26.

126 Both Lough's surviving and recorded works are listed in Lough & Merson, pp. 81–9.

127 Letter to Hugh, Duke of Northumberland, 8th February 1837; quoted in Lough & Merson, p. 26.

128 Letter to William Ord, 19th January 1837; quoted in Lough & Merson, p. 25.

129 For Lough's sculptures for the 3rd Duke and Duchess of Northumberland, see Lough & Merson, p. 82. A third marble, *Cupid and Psyche*, shown at the Academy in 1839, and also executed for the Duke, might also have been carved in Rome.

130 For this commission see Boase, pp. 281–2.

131 It was presumably with an eye to further commissions that he donated a cast of *Milo* to the Literary and Philosophical Society.

132 Letter to Hugh, Duke of Northumberland, 15th August 1837; quoted in Lough & Merson, p. 28.

133 Camilla Toulmin, *Landmarks of a Literary Life*, quoted in Lough & Merson, p. 29.

134 Of Lough's works for Ridley, a number survive at Blagdon, others are dispersed among other collections, and some pieces, given by the 4th Bart.'s son to the Corporation of Newcastle, were eventually destroyed. Lough's recorded works are all catalogued in Merson, pp. 81–9.

135 Quoted in Boase, pp. 283–4.

136 The Shakespearean pieces included a vast frieze for the staircase at 10, Carlton House Terrace. The visitor was Gertrude Sullivan in 1844; Boase, p. 283.

137 *The Art Journal*, quoted in Boase, p. 290.

The Napoleonic Era

Although Napoleon's first invasion of Italy in 1796 severely disrupted the progress of the Grand Tour, it was the ceding in the following year of the centuries-old Venetian republic to Austria that sounded the death knell of the most important phase of this extraordinary cultural pilgrimage. The Golden Age of the Grand Tour finally ended when the French armies entered Rome in February 1798, causing not only tourists, but many long-term British residents, including artists, to return home. *A View of the Projected Foro Bonaparte, Milan* by Alessandro Sanquirico (1801) illustrates a vast public square to be named after Napoleon in the centre of Milan, based on an ancient Roman Forum (fig. 127); it is a graphic illustration both of Napoleon's imperial designs in Italy, and of the peninsula's new state of dependency.[1]

Many of Italy's greatest art treasures were removed to Paris, in what has been seen as the 'culminating act of "tourist" collecting'.[2] At the National Institute, for example, in one of the brief interludes of peace in 1802, the Northumbrian

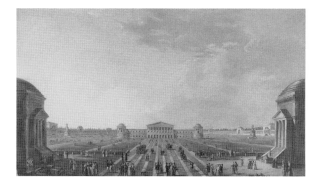

Fig. 127 *View of the Projected Foro Bonaparte, Milan*
by Alessandro Sanquirico, oil on canvas, 1801

traveller Major George Anderson saw 'all the fine statuary brought from Italy, they only want The Venus de Medici to complete the collection'.[3] Meanwhile the opening of the Louvre in 1793, which would subsequently be augmented with every new conquest by Napoleon, meant that British tourists needed to seek no further than Paris to study Italian painting. Having reached Italy itself, both Anderson, and his Northern contemporary, William Ord, made constant reference in their diaries to 'missing' works of art.[4] Even some of the Grand Tour sights no longer existed as such; in February 1815 Ord noted that the ruins of the villa of Maecenas at Tivoli were 'made into an Iron works & belong to Lucien Buonaparte'.[5]

Some of the artists working in Italy during the late 18th century, notably Angelica Kauffman and J.P. Hackert, survived briefly into the new era. However, it was the Italian sculptor, Antonio Canova (1757–1822), whose work really spanned the previous century and the new: having worked for British clients since the late 1780s, his chaste version of neo-classicism, together with that of his slightly younger Danish contemporary, Bertel Thorvaldsen (1770–1844), now dominated artistic life in Rome, and in 1815 it was Canova whom the Pope sent to Paris to sue for the return of cultural artefacts. Equally, portraiture and subject painting in Rome was now the province of the Frenchman J-A-D. Ingres (1780–1867), who lived there from 1806–20, and made numerous drawings of British tourists.

In Paris itself, evidence of the Napoleonic era was everywhere to be seen, even for those tourists who arrived just after Napoleon's exile to Elba in 1814: at the Tuileries, Major Anderson noted, 'The letter "N" is introduced so often as to become quite disgusting', and he saw countless paintings of the Emperor and his battles, while the Empress's apartments at St Cloud were 'very handsome, but more tinsel than taste'.[6] In Italy, too, at the marble quarries at Carrara, and in Rome, sculptors like Canova were fuelling the demand for Napoleonic imagery, which was usually conceived on an heroic scale. Not all reactions to the new era were, however, negative. British tourists recognised the benefits provided by

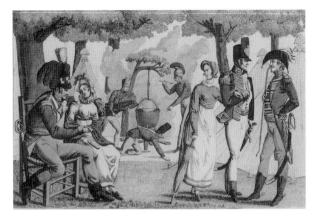

Fig. 128 *Bivouac Anglais au Champs Élisées (An English Camp on the Champs Élisées),* published by Genty, coloured engraving, 1815

Fig. 129 *Athens: The Acropolis from Museum Hill* by Thomas Hartley Cromek, watercolour

Napoleon's new roads, notably the one over the Simplon pass into Italy, and William Ord was not the only tourist to feel that Paris had improved owing to Napoleon's transformation of the city: 'the crooked crowded narrow streets with a river of mud flowing down the middle of them' contrasted strongly, in his opinion, with the 'prodigiously improved' area between the Louvre and the Tuileries.[7]

Although the Europe seen by British travellers was now so

profoundly changed in character, the overall pattern of tourism from the North of England in the early 19th century did not greatly vary, and it must remain highly questionable as to whether, certainly for Northern tourists, the turn of the century represented a terminal date for the Grand Tour, or merely something of an hiatus. Certainly the transition to the new age was by no means as abrupt as is often suggested; the Peace of Amiens in March 1802 saw very large numbers of British travellers returning to the continent, among them Major Anderson, whose tour journals and highly important art purchases abroad exhibit the same pattern of leisurely, cultivated travel enjoyed by late 18th-century tourists from the region.

War with France resumed in 1803, suspending tourism once again, but Napoleon's banishment in 1814 brought a second wave of British travellers back to the continent. Some Northern tourists, notably the Andersons and the Ords, were actually abroad when Napoleon escaped from Elba, and had to remain there throughout the conflict between Britain and France in 1815. With Napoleon's defeat at the Battle of Waterloo, however, the threat from France, which had dogged British tourists for much of the previous century, was at an end; the Allies' occupation of Paris in 1815 is satirised in a French print, *Bivouac Anglais au Champs Élisées* (fig. 128), and many tourists visited the battlefield of Waterloo, which rapidly became the centre of a thriving tourist industry.[8]

Although traditional Grand Tours continued, however, tourism after 1800 the intermittent war with France caused British Tours to develop in different directions. In particular and despite the fact that travelling in the Ottoman empire could be hazardous, British travellers began to take a new interest in Greece, as a later watercolour by Thomas Hartley Cromek, *Athens: The Acropolis from Museum Hill*, (fig. 129), shows. Among the Hellenists who promoted the new Greek Revival style in Britain was the Northern tourist Sir Charles Monck, who made what was nominally a wedding tour to Greece in 1801–3. Tourism within Europe also took on new dimensions: the great cathedrals of France, severely damaged in the Revolution, began to be rebuilt, and the century's new

interest in medieval architecture found expression in the travel writings of Major Anderson, whose earliest tour focusing on this subject had actually taken place in the pre-revolutionary era. Although most travellers still visited the great cities of the Italian Grand Tour, the lakes of Garda and Como (fig. 187) also became popular destinations, owing in part to the presence at Como, from 1815, of the exiled Princess Caroline, wife of the Prince Regent. By now the Alps, admired by the Romantic poets, and painted by Turner, were no longer seen as a barrier to be crossed, but, increasingly, as a goal in their own right; in addition to the peaks themselves, there were

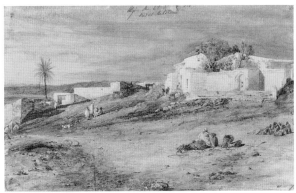

Fig. 131 *Mosque of Sultan Selim, Scutari* by Thomas Allom, watercolour, 1830–60

Fig. 130 *View in Algiers: Babizoun* by William Wyld, watercolour, 1833

excursions to the Swiss lakes, glaciers, and the 'sublime' falls at Schaffhausen and Reichenbach. Travellers in Switzerland often moved on to Germany and the Rhine valley.

Napoleon's invasion of Egypt in 1798 was followed by the beginnings of tourism there, although the first traveller from the North would not arrive until the late 1820s, and travellers also began to visit the Near and Far East (fig. 131) and North Africa (fig. 130). For the first time, Italy was no longer the supreme goal of British tourists.

J.M.W. TURNER (1775–1851) AND
NEWBEY LOWSON (1773–1853)

Among the Northern travellers who flooded abroad after the Peace of Amiens was the Durham squire and amateur artist, Newbey Lowson, who came from Witton-le-Wear near Bishop Auckland. This tour's exceptional significance stems not just from the fact that Lowson is the only Northerner recorded as having taken with him an artist as travelling companion, but from the fact that the artist concerned was none other than the young – but already celebrated – J.M.W. Turner, who toured Switzerland and Savoy in Lowson's company in 1802. This was not only Turner's first visit to the continent; it represented his first exposure to the 'sublime' scenery of the Alps, and the tour led to some of his greatest paintings and watercolours.

Until recently, Turner's tour has always been regarded as an independent venture, in which the artist, having already travelled in Scotland and Wales, now sought out the much more spectacular mountain scenery of Europe. However, the discovery of Lowson's involvement by Cecilia Powell, in a brilliant piece of detective work,[9] has profoundly altered this perception, and Turner's tour now emerges, like those earlier visits to the Alps by J.R. Cozens in the company, successively, of Richard Payne Knight and William Beckford, as, in effect, a Grand Tour made in the company of a wealthy patron – although in this case a tour curtailed (presumably) by the political situation. We know from the diary kept by Newbey Lowson on a later European tour of 1816 that this patron, who came from a 'milieu used to the professional services of

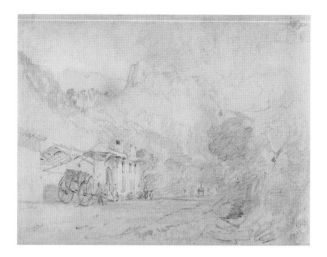

Fig. 132 'Entrance to the Petit Chartreuse' with Voreppe Post House, by J.M.W. Turner, pencil, black chalk and gouache, 1802

artists and drawing masters', was an amateur draughtsman of quite exceptional enthusiasm, and it seems almost certain that Turner, who had recently turned down an invitation from Lord Elgin to go to Athens, was here entering into a similar contract for paid employment – although presumably one which he found much more congenial.[10]

As it happened, the gap in social standing between Lowson and Turner was not as wide as that between many artists and their benefactors; Lowson was the son, not of an established landowner, but of a well-to-do Durham merchant, who had left his son a medieval house, Witton Tower, and other property in the village of Witton-le-Wear.[11] The two young men perhaps had other things in common beyond their shared artistic interests; they were of a similar age, even resembling each other physically, and, in the event, neither was to marry.[12] There can surely be little doubt, however, that Lowson, as paymaster, rather than Turner himself, took charge of the itinerary, timetable and practical arrangements for the tour. If Turner occupied a subordinate position, it was one that would produce considerable advantages, not solely in terms of his material comfort, but of his development as an artist as well.

It now seems almost certain that Lowson's role in Turner's

1802 tour was not an isolated act of patronage, but that it can be linked to a Northern network of art patronage connected more than tangentially to the Grand Tour. It has long been known that Turner's study of Old Master paintings in Paris in 1802 – something he undertook once his tour of Switzerland and Savoy was completed – was sponsored by a triumvirate of noblemen, among them the Yorkshire aristocrat and future owner of Turner's work, Lord Yarborough, who acted as referee for Turner's passport application in July 1802.[13] Cecilia Powell has now suggested convincingly that a second member of this syndicate was Lowson's friend, neighbour, and future Grand Tour travelling companion, William Harry Vane of Raby Castle, former insouciant tourist, but now 3rd Earl of Darlington and later an important Turner patron.[14] Given that it was Darlington who acted as sponsor for Newbey Lowson's own passport application, which was processed only five days before Turner's, it seems reasonable to conclude that Lowson's tour with Turner was not the result of a chance meeting between the two young men, but that it had been well planned in advance.[15] Possibly Lowson, although not a member of the syndicate himself, had been 'deputed to represent its interests and manage its funds' abroad. It was Lowson, however, rather than the syndicate, who appears to have acted as paymaster for the Alpine part of Turner's tour.[16]

We are indebted to Turner himself, through the medium of Joseph Farington's *Diary*,[17] for the copious information we possess about the tourists' preparations before their departure. Unlike Turner's later tours on his own, when he was obliged to make use of public transport, Lowson and Turner adopted the method of transport preferred by aristocratic travellers, buying a coach which could then be sold at the end of the tour. Although they were 'well accommodated' in their cabriolet, this way of travelling had other, more important, advantages for Turner, offering him the freedom both to stop and sketch almost at will, and to carry with him the large-scale sketchbooks which would enable him to do full justice to the stupendous scenery he saw.[18] Lowson's largesse, however, could not shield the travellers from the harsh Alpine conditions. For much of their journey, faced with

mountainous terrain, the two men were unable to make use of their cabriolet, Turner reporting 'much fatigue from walking', and also 'bad living and lodgings'; one of Turner's drawings (fig. 132), however, shows their vehicle at the Post House, Voreppe.[19] Lowson's pocket book for the tour, which reappeared briefly in the mid 1890s,[20] is said to have contained not only the travellers' expenses, but 'many sketches, taken by the way, of Italian peasantry, characters, and views, both in pencil and in colours', which had 'evidently been done by a master hand'.[21]

As we have seen, in the latter half of the 18th century, the Alps had become an increasingly popular destination for tourists educated on theories of the 'sublime'. Guidebooks appeared; areas such as Chamonix and Mont Blanc became relatively well known; a hut on the Montanvert, overlooking the Mer de Glace, was set up in 1779 by Charles Blair of Geneva for the benefit of tourists; and seven years later Mont Blanc was scaled for the first time. Although the number of people in England who had visited the Alps was still to be numbered only in hundreds,[22] former tourists included Thomas Gray as early as 1739, and William Wordsworth in 1790, while Goethe himself visited the Alps twice, in 1779 and 1797. Perhaps more relevant for Turner were the visits made by a number of fellow British artists of the previous generation, notably William Pars (1770), John 'Warwick' Smith (1776), Francis Towne (1781, fig. 8) and J.R. Cozens (1776 and 1782–3).

Although Turner was by no means the first British artist to depict Alpine scenery, this mountainous terrain had changed in one highly important respect since the visits made by his predecessors; it had been fought over during the French invasion of Italy, and Turner and his patron were in some cases following in the tracks of Napoleon's crossing of the Alps in 1796–7. The artist would later translate his experiences of a country devastated by war, and still occupied by French troops, into some of his most memorable paintings, notably *Snowstorm: Hannibal and his Army crossing the Alps*.[23] Canvases like these, and his greatest Alpine watercolours, confirm that Turner not only grasped the 'beauty… savagery and… tragic

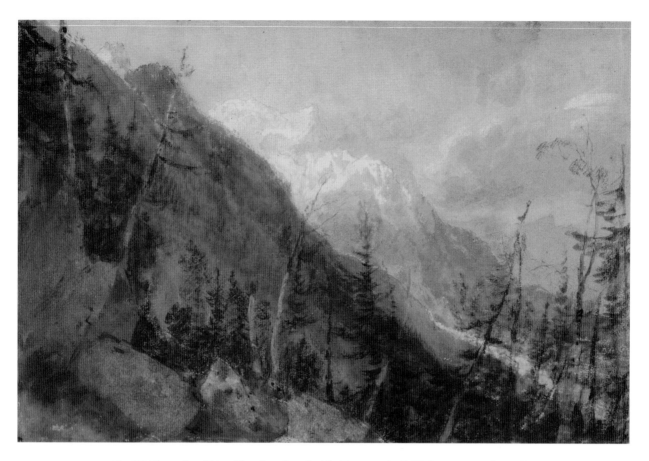

Fig. 133 *Chamonix and Mont Blanc from the path of the Montanvers* by JMW Turner, watercolour, 1802

loneliness' of the Alps, but showed an understanding of the 'dynamics of chaos and upheaval', and a 'Romantic sense of doomy and unpredictable destiny' which illustrates just how far he had travelled from the Alpine views of even those as talented as Towne or Cozens.[24]

Turner and Lowson left Paris around 26th July, heading south through France and Savoy to Switzerland, and following, on this first part of their journey, the route well-trodden by Grand Tourists crossing the Alps. However, in Val d'Aosta, and within a day's journey of Turin, the companions doubled back to concentrate on Switzerland; although it is tempting, with hindsight, to see Turner as the first British artist to regard the Alps as an end in themselves, we know that this was a decision he would later regret, and he would now wait many years before seeing Italy.[25] Many of the sights the two men saw on their tour have entered the collective imagination, often largely through their association with Turner; although some were relatively well-known at the time, others, such as Courmayeur, were not. They began by visiting Grenoble, then moving on to the isolated monastery of La Grande Chartreuse, long a place of pilgrimage for Grand Tourists, but now, its monks expelled, a cannon foundry for Napoleon's

troops. The seminal moment of the tour, however, came after leaving Geneva, as the travellers approached the peaks around Mont Blanc; faced with the 'jagged forms of the ice flows, scattered rocks, and dead or twisted trees' of Chamonix and the Mer de Glace, Turner found that 'no previous style or technique' could encompass such scenery. As a result, he 'wiped the slate clean and began afresh', becoming, in the process, 'a modern artist –the *first* modern artist' (fig. 133)[26]

The travellers' route back from Val d'Aosta led over the Great St. Bernard Pass, where they slept at the Hospice, and then along the eastern shore of Lake Geneva, where Turner, with an eye on the lucrative market for drawings of castles and other antiquities, sketched the famous Château de Chillon (fig. 63). The area around Lake Thun, Unterseen, Grindelwald and Brienz proved fruitful sketching territory, but it was the St. Gothard Pass, where Turner's views of the fragile arc of the Devil's Bridge thrown across the Schöllenen Gorge create a sense of 'dizzying instability' that is quintessentially 'sublime',[27] which represented the other high point of the tour; Lowson would later sketch here in 1816 (see p. 210). The final stages of their journey took Turner and Lowson through Zurich, and the Falls of the Rhine, to Basel, and then back to Paris, where Turner had arrived by 30th September.

Turner's working method on this tour, during which he filled eight sketchbooks with over five hundred sketches, was to make quick pencil memoranda on the spot, the more successful of which he then worked up into more detailed studies using white highlighting, black chalk, and in some cases watercolour, on ready tinted paper.[28] On his return to England, or even before, Turner transferred many of the better sketches into a large album which he then utilised to show to prospective clients; the sequence of the drawings appears to have followed that of the tour itself,[29] and he was careful to include titles. Many of the great finished watercolours which resulted, in the aftermath of the tour, from this careful planning, were bought by Turner's Yorkshire friend and patron, Walter Fawkes; the view of Chillon in fig. 63, however, may have belonged to the Northern tourist Edward Swinburne, who was a friend both of Fawkes and of Turner himself.

Although Newbey Lowson was clearly an important benefactor of Turner's early career, he remains a rather shadowy figure, whose role in the 1802 tour can be gauged only by piecing together fragmentary references in diaries, account books, and early writings on Turner. Nothing survives to document the two men's association on the tour itself, and even the highly pertinent question as to their relations, friendly or otherwise, remains ambiguous; an early and puzzling suggestion that 'Turner suffered his [Lowson's] company only on condition that he never sketched any view he himself chose', and that he 'did not show his companion a single sketch', cannot, however, be correct, as it is surely 'contrary to the economics of the whole enterprise'.[30]

Fortunately, Lowson's 1816 diary not only sheds considerable light on his slightly irascible, perhaps even peevish, disposition, but also touches on his memories of his earlier tour, and confirms him as a single-minded sketcher in the picturesque mould. Beyond a few costume studies in this diary – which are copies after the originals – none of Lowson's sketches are known today, but it is possible that his 'picturesque' view of nature, although tempered by an interest in the 'sublime', may explain one mystery posed by the tour, the fact that Lowson does not appear to have commissioned from his artist companion any record of their travels: the new artistic language Turner was developing on this tour might well have proved inimical to a man accustomed to viewing landscape through the lens of the picturesque. However, if Lowson did not actually acquire Turner's drawings, his role in the tour may well have been crucial in determining Turner's working method, as David Blayney Brown points out: Turner's recording of landscape in both smaller and larger sketchbooks (the latter including more fully worked up compositions) is unique to this tour, and may have been governed by the fact that some of the drawings were originally intended for Lowson as a record; their execution in two stages perhaps relates to Turner's probable additional role as Lowson's drawing master.[31]

If Lowson never became a major patron, Turner is said to have given him a watercolour as a keepsake of their tour, and the two men's continuing association is confirmed by

Lowson's subscription to Turner's mezzotint, *The Shipwreck*, in 1807.[32] More significantly, Lowson's name appears among a list of Turner patrons in 1817–18,[33] almost certainly in connection with three watercolours, including one of Lord Darlington's seat, Raby Castle, which the artist produced for the *History and Antiquities of the County Palatine of Durham* (1820) by Robert Surtees. Turner visited Raby in the summer of 1817, immediately after his tour of the Low Countries and the Rhine, sketching the castle and surrounding area in his 'Raby sketchbook', and producing one of the grandest of his 'house-portraits',[34] and it seems almost inconceivable that he would not have met his former travelling companion, and Lord Darlington's intimate friend and neighbour, again on this occasion, particularly as there is early evidence to suggest that Turner did indeed visit Lowson at Witton-le-Wear.[35] Cecilia Powell has even raised the fascinating possibility that the itinerary of Turner's 1817 tour may have been influenced by Lowson's own, second, European tour with Lord Darlington the year before (pp. 208–11);[36] certainly the two men visited many of the sights soon to be sketched by Turner.

Although Lowson evidently fitted well into the pattern of life in County Durham on his return from his two Grand Tours, becoming a magistrate, Deputy Lieutenant of the county, and a member of the local hunt,[37] there are other indications, beyond his association with Turner, to suggest that he retained his artistic interests in later life. He is said to have possessed 'no mean skill as an amateur' draughtsman, and to have been a subscriber to antiquarian and topographical publications.[38] It is perhaps a measure of these cultivated interests that, on his death, an obituary appeared in the *Gentleman's Magazine* as well as in the local press.

MAJOR GEORGE AND MRS. LUCY ANNE ANDERSON

Another traveller at this time, who did not even wait for the Peace of Amiens to be signed before setting off, was Major George Anderson (1759–1831), who from 1801-3 made a wedding tour abroad with his wife, Lucy Anne Croft. A man of strong cultural interests, whose xenophobic leanings led to a constant inveighing against the cost of foreign travel, and a

strong preference for English architecture which sometimes interfered with his - considerable - scholarship, Anderson was the son of a successful Newcastle builder who had bought from the Blackett family in 1783 the great Newcastle mansion, the Nuns, then the largest house within a walled city in England, which his son afterwards re-named Anderson Place.

This was not Major Anderson's first tour abroad. According to the preface to his 1820 book on Norman architecture, he had already made a tour before the Revolution, which he had researched meticulously in advance, and during which he had ridden on horseback through Normandy so as to be able to visit towns and churches which were off the normal post route. Of this first tour, no record of which survives, Anderson later explained that his purpose, apart from seeing the country, was to research the origins of what he called the 'pointed' style, his thesis being essentially that Gothic architecture originated in Britain rather than in France. Such a focused interest in medieval architecture from a North country landowner is astonishing at this early date, and, despite those prejudices which led him to say that he had 'two insuperable objections' to French Gothic cathedrals, namely the lack of a central tower – which left them 'like a ship without a mainmast' – and transepts which 'hardly deserve the name', Anderson can now be regarded as an important pioneer of the Gothic revival. His activities closely parallel those of the Society of Antiquaries at this time, and he shared both his enthusiasms and prejudices with the Society's principal recorder of medieval ecclesiastical architecture, Dr John Carter.[39]

The Andersons' wedding tour of 1801–3,[40] which included France, Italy, Austria, Hungary, Germany and Denmark, was, likewise, one of the most important to be made from the region. Although these were to be travels much more in the Grand Tour mould, they would result in the publication, in 1812, of the first of Anderson's two books on French medieval architecture (p. 192),[41] and the tour's prologue in East Anglia, with visits to Lincoln and Peterborough cathedrals, and to King's College Chapel in Cambridge, is yet another pointer to the strong interest in Gothic architecture that characterises this and Anderson's later continental tour of 1814–16, and

sets his travel diaries apart from those of other travellers from the North – and indeed elsewhere.

The Andersons arrived in Calais on December 10th 1801. Although they took the long-established post route to Paris, Anderson's clear priority was to see those northern French towns with important abbeys or cathedrals, such as Amiens, Beauvais and St. Denis, although he was very critical of the soaring quality of the interior elevations which most people today would regard as the distinguishing characteristic of French Gothic architecture. At Amiens, for example, he thought that the arches 'run up to an astonishing height and therefore appear <u>too narrow for their height</u>'.[42] Anderson must have drawn and studied St. Denis in considerable detail, as in 1812 he published six plates and an accompanying text on the Abbey, which, as the burial place of the French kings, had felt the 'full force of the democratic spirit in the early period of the revolution', and which he consequently found 'despoiled of its ancient splendour of stained glass windows, monuments, and of its architectural ornaments'.[43]

In Paris, where the Andersons saw both Napoleon himself, reviewing his troops, and the works he had plundered from Italy, Anderson admired the Old Masters in the Louvre, now an essential port of call for all Grand Tourists. However, he disliked at least one great contemporary picture, David's *Intervention of the Sabine Women*, which the artist had placed on public display in Paris, condemning the figures of the men as 'extremely indecent and disgraceful'. Despite his verdict that Sèvres porcelain was 'not … near so perfect as our Worcester', the purchase of this *Urn and Cover* (fig. 134), although clearly postdating the tour itself, may have been inspired by the Andersons' visit to the Sèvres factory during their stay in Paris. The Andersons' priority, however, was to see the city's Gothic architecture. Immediately after their arrival

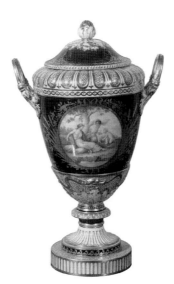

Fig. 134 *Urn and cover,* Sèvres porcelain, France, mid 19th century

they visited Notre Dame, where Anderson's appreciation of the stained glass in the 'three Catherine Wheel windows' as 'blue and finer than any we have yet seen', is highly unusual for its time, and Ste. Geneviève where, in addition to the abbey church, they saw the tombs of Voltaire and Rousseau.[44] That Major Anderson also shared the developing interest in Egypt is suggested by his visit to the house of Dominique-Vivant Denon (1747–1825), author of *Voyage dans la Haute et dans la Basse Egypte*, where he was shown the prep-aratory drawings for this seminal publication.[45]

Most 18th-century travellers would have turned south on leaving Paris. The Andersons, however, turned north to see the great cathedrals of Soissons and then Laon, where Major Anderson found the Gothic architecture of the towers 'superior to any that we have yet seen'. They then moved on to Switzerland, deciding in Basel against buying a set of those 'dresses of the different Paysants' which were so popular with tourists at this time (eg. fig. 149),[46] but seeing the city's outstanding collection of Holbeins (including his famous *Dance of Death* woodcuts) which were, increasingly, a draw to 19th-century tourists. They also visited the falls at Schaffhausen, and Fernay, where Voltaire's house had now been turned, in effect, into a museum to the great *philosophe*. Instead of crossing the Alps into Italy, however, the Andersons returned to France, visiting the great Romanesque abbey of Cluny near Mâcon, where Anderson made a drawing, plan and measurements of the abbey – although there is nothing in his diaries to confirm that he was already planning his later publications, this was a practice he applied not only to St. Denis but to several, perhaps most, of the major churches he visited.

From southern France, the Andersons took the sea route to Italy, arriving in Genoa in June 1802. Here they began what was very much a classic Grand Tour, based around visits to

Fig. 135 *The Bridge of Augustus at Narni,* by Jacob Philipp Hackert, oil on canvas, about 1802–5

palaces, churches and picture collections; although they saw some great treasures, they were constantly frustrated by the removal of important works of art to Paris; in Bologna, for example, Anderson found 'only one [picture] of any great merit left by Guido [Reni], St Peter'.[47] On their arrival in Florence in July 1802, they began to visit artists' studios, calling on the elderly German landscape painter, Jakob Philipp Hackert, who had fled from Naples when it was conquered by the French in 1799.

Hackert had dominated landscape painting in his adopted country in the last decades of the 18th century, and his landscapes (fig. 135), which came increasingly to be modelled on the paintings of Claude Lorrain and Gaspard Dughet, appealed strongly to British clients. Hackert's success, indeed, provoked much irritation among British artists: whereas his friend Goethe admired his paintings for their fidelity to nature, Thomas Jones considered that 'like most German

artists' Hackert studied 'more the Minutiae than the grand principles of the art'.[48] The Andersons' visit to Hackert's studio on 20th July 1802 was followed by an order for two landscapes, *The Falls of Terni*, and *The Bridge of Augustus at Narni* (fig. 135, col. pl. 13), which were finally shipped to London in June 1805.[49] Although not pendants, these were perhaps chosen as representing the two contrasting types of landscape that were most familiar to British connoisseurs: *The Falls of Terni*, closely modelled on Gaspard Dughet's views of the cascades at Tivoli, is an example of 'sublime' landscape, whereas *The Bridge of Augustus at Narni*, with its poetic evocation of Roman ruins, and sunlit distance, is based instead on Claude.

If Major Anderson's patronage of Hackert reflects the taste of the previous century, the same can be said of the only one of his Old Master purchases that can be linked to his Grand Tour. In Florence he saw 'some good battle scenes' by Jacques

Courtois, called Bourgognone (1621–76), a 17th-century specialist in this genre, whose pictures, full of action and drama, were, like those of the classical landscapists, highly popular with British collectors.[50] Although Anderson's purchase of this fine example of Borgognone's work (fig. 136) is not recorded, it seems likely to have been made on, or as a result of, this tour. Anderson's later purchase of two great *veduta* paintings by Canaletto (figs. 137, 138, col. pl. 14) on his return journey through France is a more spectacular example of the enduring influence of the 18th-century Grand Tour on this new generation of collectors.

In Naples, the Andersons visited the usual Grand Tour sights at Pompeii, Herculaneum and Pozzuoli, climbed up to the crater of Mount Vesuvius, which Mrs. Anderson, a prodigious mountain climber, 'did with great ability', and met the Swiss watercolourist Louis Ducros (1748–1810), whose works, usually highly popular with British collectors, Anderson dismissed as 'no great things'. Few tourists of the previous century, however, would have sailed on to Malta and then to Sicily; according to her admiring husband, 'Mrs. A.' was 'the first woman ever on the summit' of Mt. Etna.[51] Although their tour took in the classical temples recommended in Henry Swinburne's guide, they also visited the monastery of

Monreale with its Byzantine mosaics, where Anderson disliked the 'Sarasenic' arches, but noted (correctly) that there was 'perhaps more mosaic in this church than any in Europe' – Swinburne's guide maintaining a complete silence on this, the most outstanding feature of the church to modern visitors.[52] Returning to the mainland, Anderson displayed, on a visit to Paestum, the same scientific approach to antiquity that characterises the almost exactly contemporary tour of Sir Charles Monck, not only drawing the Greek temples, but, as with the medieval churches he studied, making ground plans, and taking measurements and details of the capitals.

The Andersons arrived in Rome in November 1802, where, like their 18th-century predecessors, although apparently without the once ubiquitous *cicerone*, they toured the city's collections of antique sculpture and its *palazzi*.[53] The artists Anderson singles out for praise – Titian, Guido Reni, Salvator Rosa and Claude Lorrain – confirm his predilection for those artists most admired during the previous century, and still highly regarded by connoisseurs. Few 18th-century tourists, however, would have taken such an interest in works of the Baroque period by Bernini and Caravaggio.[54] Like earlier British tourists, the Andersons met both the Pope, Pius VII, who was 'extremely affable and easy in his address', and

Fig. 136 *Battle Scene* by Jacques Courtois, called Borgognone, oil on canvas, 17th century

Cardinal York, brother of Prince Charles Edward Stuart, who, by contrast, still 'seems to keep up a good deal of Royal Ettiquet I observed in particular he had a separate Tureen of Soup'. Introductions of a different kind were to the elderly Angelica Kauffman, and to Antonio Canova, who 'answered everything said to him with much civility of manner and seemed flattered when we said we felt ourselves fortunate in seeing him in person'.[55]

It was, however, Venice, where the Andersons arrived in March 1803, that was the high point of this tour. Here, their stay was more akin to that of modern tourists with a strong interest in visual culture than to that of 18th-century visitors, who tended to arrive for the Carnival, and pay scant attention

to Venetian art. Anderson's enthusiasm for Venetian painting seems to have been second only to his passion for medieval architecture, and his diary waxes eloquent on the subject of the paintings by Veronese and Tintoretto he saw on his several visits to the Doge's Palace. There were also expeditions to other Venetian churches to see paintings by Veronese; to the Frari to see the Titian altarpiece of the *Assumption*; and to the Scuola di San Rocco to see the Tintorettos, whose bold originality he recognised.

What was to prove the Andersons' most significant act in Venice was, however, not cultural at all: on 26th March they saw the 'famous Bucentoro that the Doge used to go in when he wedded the Adriatic on Ascension Day'.[56] Since the French

Fig. 137 *The Bucintoro returning to the Molo on Ascension Day* by Giovanni Antonio Canal, called Canaletto, oil on canvas, 1730s

Fig. 138 *A Regatta on the Grand Canal* by Giovanni Antonio Canal, called Canaletto, oil on canvas, 1730s

conquest of Venice this ceremony had been abandoned, but Anderson's visit to see the barge was surely responsible, at least in part, for his most important Grand Tour purchases, which are, indeed, perhaps the most exceptional artefacts brought back by any Northern tourist – the two great paintings by Canaletto, *The Bucintoro returning to the Molo on Ascension Day* and *A Regatta on the Grand Canal*, now in the Bowes Museum (figs. 137, 138, col. pl. 14). Family tradition – gaining some credibility from the Major's distinct eye for a bargain! – asserts that Anderson acquired these two vast canvases, which had probably hung in a nearby French château throughout the revolutionary period, actually on the quayside of one of the

French channel ports, as he was about to sail home in 1803; having previously seen them at a picture dealer's, where he had declined to pay the price asked, the dealer is said to have pursued him to the port with a reduced offer.[57]

Since Ascension Day and the Regatta were the two great Venetian festivities of the 18th century, Canaletto produced several pairings of these events for British Grand Tourists, notably those in the Royal Collection, at Woburn Abbey, in the National Gallery (from the collection of the Duke of Leeds), and these versions acquired by Major Anderson long after the artist's death. Like Canaletto's other variants on this theme, Anderson's paintings belong to the 1730s, when Canaletto was

at the height of his popularity, and when, to quote Michael Levey in reverse, the artist had not yet withered within the craftsman.[58] In *Ascension Day*, the Doge's state barge can be seen returning to the quayside after the ceremony, during which he cast his ring into the Adriatic. Major Anderson estimated that 10,000 people used to celebrate Ascension Day in its heyday, and the water here is crowded with gondolas, many of them displaying coats of arms; as the prominent craft in the foreground carries the French Royal arms it has been suggested that the painting was commissioned by the French ambassador to Venice, the Comte de Gergy, who died in 1734.[59]

The Regatta was likewise a highly theatrical event, the race taking place against a backdrop of the palaces lining the Grand Canal; in Canaletto's canvas the standing oarsmen in the plain black gondolas are the competitors, while the highly decorated craft called *bissone* (cf. fig. 42) belong to wealthy spectators, many of whom sport the white mask and black cape worn at Carnival time. The mood of public recreation and spectacle abroad is nowhere better expressed than in this magnificent canvas, which is perhaps not strictly speaking a pendant to Ascension Day, as the blue and white colours of the oarsmen show that it must date to slightly later, during the reign of Doge Alvise Pisano (1735–41).[60] Anderson, however, almost certainly had both canvases reframed before displaying them together as pendants at Anderson Place.

It was not until almost a decade after his return home in 1803 that Anderson published his *Plan and Views of the Abbey Royal of St. Denys, The Ancient Mausoleum of the Kings of France* (1812), justifying his choice of subject by citing the Abbey's antiquity and magnificence, its housing of the ashes of the Kings of France, its association with illustrious men and celebrated actions; and especially its 'late melancholy fate and catastrophe'. Anderson hoped that his book would appeal not only to tourists who had seen 'that once most magnificent pile' before the revolution, but to connoisseurs and antiquaries, at a time when the 'ancient' architecture of England was 'fast approaching into vogue'; it seems likely that the book had some success, since one copy was acquired for George III.[61]

Anderson also hoped, by comparing the abbey's various phases of construction with English ecclesiastical buildings, to ride two personal hobbyhorses; in addition to his conviction that the Gothic arch originated in England, he was also insistent that, although English travellers might be 'struck with the blaze of beauty' produced by French cathedrals, whose stained glass 'dazzles the eye, and intoxicates the mind', the elegant proportions of English Gothic cathedrals should 'yield the palm' to England.[62] Anderson's history of the Abbey was accompanied by six plates after his own drawings, 'taken on the spot', by the established engraver Bartholomew Howlett.[63] Unlike a number of the drawings of Normandy which Anderson published in his later book of 1820, these are strictly architectural views, unencumbered with picturesque details.

Evidently the Andersons did not lose their appetite for foreign travel. As soon as the threat from Napoleon had apparently subsided in 1814, they sallied forth again to the continent, and remained abroad throughout the period covering Napoleon's escape from Elba and the Battle of Waterloo.[64] Although this third tour, which lasted until October 1816, and included France, Germany and Switzerland, was, like the first, conducted very much in the leisurely manner of an 18th century Grand Tour, it was more specific than its predecessor in its concentration on the study of French Romanesque and Gothic churches, particularly those in Normandy.

Anderson's standard practice on this later tour was to draw and measure the cathedrals and churches he visited, which included Rheims and St. Denis; since his visit to the latter in 1801, the cathedral had been restored 'following the original style'. Unfortunately, since their visit to Brittany and Normandy was clearly the most interesting and unusual aspect of this tour, it is difficult to trace the Andersons' itinerary from October 1814 to March 1816.[65] Certainly, by January 1816 they were in Brittany, a province visited by very few tourists in the previous century,[66] where Anderson found the capital, Rennes, almost destroyed by twenty-five years of revolution: the Abbey of St Georges had been 'converted into a Barrack... for the cavalry' and the 'church wherein many of

the first familys were formerly buried' had become a stable.[67] Anderson's interest in the province's prehistoric remains was remarkable for its time.

Normandy, with its Channel ports of Le Havre and Dieppe, was much better known to British travellers; few of them stayed, however, as did the Andersons, to study the architecture. To understand their itinerary, however, one must turn, not to Anderson's diaries, but to his *A Tour through Normandy in the Year 1815; describing The Principal Cities, Towns and Antiquities, The Great Monasteries, Abbeys, Cathedrals and Churches of that Province*, published in Newcastle in 1820. This remarkable publication, illustrated with engravings produced from Anderson's own drawings (fig. 139), represents, as he explains in his Preface, the culmination both of his pre-revolutionary tour, and of his recent visit with his wife. The book is notable, not so much for its detailed, though prolix, descriptions of the well-known churches in Caen or Rouen, as for Anderson's diligence in describing almost every church of note in the province (it seems likely that he had seen many of the more obscure ones on his earlier tour alone on horseback), and because his aim was to 'snatch from oblivion the more early specimens of Monastic Architecture, as they appeared about the time of the Conquest'.[68] This establishes him as a pioneer of the Romanesque, as well as of the Gothic, revival.

Unfortunately for Anderson's pioneering credentials, there were delays on the part of the engravers (Bartholemew Howlett, illustrator of his earlier book on St Denis, and William Woolnoth) he had employed to produce a companion volume of plates from his drawings,[69] and, probably as a result of their procrastination, he turned to expertise nearer to home, commissioning two plates reproducing Norman capitals and ground plans either from the great Northumbrian engraver, Thomas Bewick, or from his son, Robert, who had a particular aptitude for architectural draughtsmanship.[70] Five years after his tour, in 1820, Anderson evidently decided to accept the publication's appearance in an incomplete state, with only eight plates inserted at the back of the text volume.[71] Crucially, however, the delay meant that he now 'found my

ideas and observations anticipated by others',[72] notably the great Norfolk artist John Sell Cotman: although, on his three visits to Normandy between 1817 and 1820, Cotman produced for his patron, Dawson Turner, a series of architectural drawings which are outstanding in the history of British art, his tours certainly postdate Anderson's own.

Anderson appears to have known nothing of Cotman's

Fig. 139 *Abbaye de Saint Ouen, Rouen* by Major George Anderson, pencil, pen and grey wash drawing, 1814–16

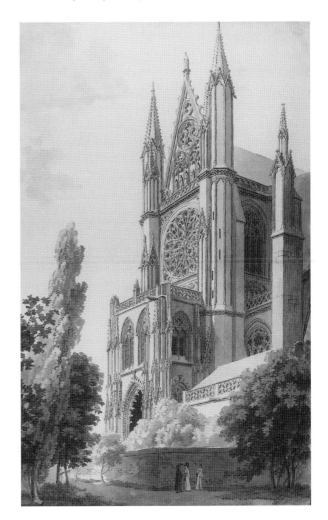

drawings until his own book was at an advanced stage of preparation, claiming, disarmingly, that, had he known of Cotman's 'superb work' he would have felt 'considerable hesitation in proceeding'. Although Anderson refers tantalisingly to the 'time those drawings were put into my hands', thus raising the possibility that he had seen Cotman's originals, what he is presumably referring to are the plates after Cotman illustrating Dawson Turner's *Letters from Normandy*, a book published in the same year as Anderson's own; Cotman's own *Architectural Antiquities of Normandy* appeared only in 1822.[73] Although Anderson's *Tour through Normandy* was not published until after the artist's tours of the province, and, unlike his earlier book on St Denis, probably had only a limited local circulation, Cotman would surely have seen Anderson's *Tour* before the publication of his own *Antiquities*. Taken in this context, Anderson's tours, and subsequent publication, have a significance extending well beyond the purely local.

Anderson's drawing of the south transept of the Abbaye de Saint-Ouen, Rouen (fig. 139),[74] is typical of the drawings he produced on his tours,[75] which are in the tradition of late 18th-century topographers who also worked for the engraver. It seems probable that, as a former military cadet, Anderson had learnt to draw at the Woolwich Academy,[76] where from 1768–96 the drawing master was Paul Sandby, and it is surely not accidental that these drawings come closest to the work of Michael 'Angelo' Rooker, who was also a Sandby pupil. Although clearly the productions of an amateur, they are recognisably by a contemporary of Turner: if the scene is enlivened by a group of fashionably dressed figures, the recording of the church itself is accurate rather than picturesque, and there is a sense, so powerfully expressed by Anderson's professional contemporaries, of man being dwarfed by the great buildings of the past.

If Major Anderson made a significant contribution to the emergent Gothic revival, he was also one of the most important Northern collectors of Old Master and 18th-century pictures, and a major patron of contemporary art. Although only a small number of the paintings known to have

been in his collection can be linked directly to his Grand Tour, his acquisition of a Gaspard Dughet storm scene, a ruin piece attributed to Panini, and a number of religious paintings by Luca Giordano, Carpione and others, in addition to the Bourgognone *Battle Scene* and the two Canalettos (figs. 136–8, suggests a taste in paintings shaped by his experiences abroad. Anderson also commissioned from the leading marine artist in the North-East in the first half of the 19th century, John Wilson Carmichael, a major painting entitled *Ascension Day on the Tyne* – a record of Newcastle's own civic ceremony, based on its Venetian predecessor, which was clearly inspired by Anderson's Canaletto, and was surely intended to hang in close relation to it at Anderson Place.[77]

It is perhaps not surprising to find that Anderson also become a leading and highly colourful figure in early 19th-century Newcastle, presenting to the church of St. Andrew one of his greatest – and largest – acquisitions in the Grand Tour manner, Luca Giordano's *Last Supper*, becoming the patron of the eminent local historian, John Hodgson, and inviting the Newcastle-born artist George Gray to accompany an expedition through Iceland as botanist, geologist and draughtsman.[78] Although this pillar of the establishment – whose Grand Tour diaries abound with tales of financial sharp practice by hoteliers, postillions and shop keepers, which he seems to have been more than able to circumnavigate – achieved notoriety in 1811 for pulling the nose of the Town Clerk, Nathaniel Clayton, he was hailed by a deputation of Freemen on his release from a brief imprisonment for his 'great and generous services to the public of this town in promoting...measures for the greater convenience of the inhabitants and bettering the condition of the poor'.[79]

SIR CHARLES MONCK (1779–1867) AND BELSAY HALL: A GREEK TEMPLE IN THE NORTH

If Major Anderson's studies of continental architecture were essentially of antiquarian interest, his contemporary, and near neighbour, Sir Charles Monck, of Belsay Castle, made from 1804–6 the only tour from the North that would have a major impact on the region's architecture, building at Belsay, on his

return, one of the most important Greek revival houses in Britain.

In 1804 Monck married his first cousin, Louisa Cooke, and this Grand Tour (made by a young man whose family, the Middletons, had lived at Belsay since medieval times, but had recently been enriched both by his father's marriage to a wealthy heiress, and by the inheritance of land in the Northumberland and Durham coalfields) was, at least superficially, a wedding tour: the couple's eldest child, Charles Atticus, was born in Greece in the summer of 1805, and named after the country of his birth. Monck was, however, one of a new generation of travellers to prefer the purity and severity of Greek buildings to the Roman temples most tourists had admired in the 18th century – another was Lord Elgin, purchaser of the Elgin marbles – and his son's name almost certainly also reflects Monck's real purpose in travelling abroad: to indulge his almost obsessive admiration for Greek architecture.

Fortunately, Monck's illustrated journal survives[80] to document a tour which, right from the beginning, differed significantly from the more traditional type of Grand Tour still being undertaken by Northerners – perhaps as much because of Sir Charles's highly eccentric personality as because of his passion for Greek architecture. Much of Monck's energy would be directed to criticism of life abroad: among his targets were all aspects of the post system, 'dirty' Opera Houses, 'slovenly' gentlemen's seats, wet beds at inns (which he counteracted by insisting that his wife cover herself in flannels) and, more importantly, 'bad architecture', which lay in an abandonment of Greek principles; one attack, for example, was inspired by seeing 'columns without any fluting'.[81]

The Moncks sailed for Denmark from Harwich in October, 1804, travelling with Lady Monck's elder brother and his and their own three servants; their tiny cabin was shared with two other men and with Louisa's maid, and only a piece of canvas divided the women's sleeping quarters from the men's at night. On their arrival in Berlin, Monck had a brief glimpse of German neo-classicism: his considerable knowledge of architectural vocabulary, and his belief in a 'correct' standard of classicism against which all buildings must be judged, are already evident when he describes the Brandenburg Gate as 'pretty correct except that the columns have bases. between the triglyphs are copys from the frieze of the Parthenon and Thesion'. After visiting Dresden, where they found their expectations of Meissen porcelain disappointed – 'no-one need come from England to Dresden to see or buy porcelain' – they moved on through Bohemia to Prague and then Vienna through appalling winter conditions in which their servants' coats froze as they rode on the outside of the carriages.[82]

Like other tours made during the Napoleonic period, this one had to be tailored to the military situation, and, on reaching northern Italy, the Moncks were obliged to travel to Venice, rather than, as they had planned, to Naples. Although, for them, Venice was no longer a goal in itself, but rather the point of embarkation for the Greek island of Zante (Zakynthos), delays in their passage meant that the Moncks had to linger here for some time, and, despite an active social life among the émigré aristocrats who thronged the city, Monck was soon 'very tired of Venice'. As a fervent classicist, he was unimpressed with Venetian architecture, finding it not 'to the credit of the Venetians who have had Athens in their possession to have professed Aegyption and Mauresque style in their buildings', and noting that there was 'not an Athenian column to be seen'! St Mark's cathedral, predictably, he disliked, and, although he admired the Doge's Palace, he thought it a pity that Tintoretto and Veronese 'should have been employed upon no better subjects than some of the most absurd and superstitious corruption of Christianity, or the representation of an old doge kneeling upon a cushion'.[83]

The Moncks[84] finally sailed for Greece from Trieste in a convoy protected by a British frigate,[85] arriving in Zakynthos on 31st March 1805. Once on Greek soil, Monck's humour improved: 'a more rich, beautiful and enchanting prospect I never beheld' was his verdict on the island. Here, in the midst of 'barbarity and seclusion' they found a thriving expatriate community, which included a Count Macci, who offered them the use of his coach, the only one on the island; his house

boasted a drawing room with English paper, but the dining room 'was very little better than the town hall of Morpeth', and there were fleas 'skipping about in all directions', even in their hostess's hair![86] Although news reached the Moncks here in early April that the plague had been reported in Thebes, they sailed for the Greek mainland later that month, arriving in Athens itself on 3rd May, where they had their first sight of the temple on which Belsay would be based, the 'Theseion'.

In Athens, the Moncks met the group of highly-cultivated people with whom most of their time here would be spent: the antiquary Sir William Gell, Edward Dodwell, another member of the 'Cambridge Hellenists' and an accomplished artist, and William Baker of Bayfordbury in Hertfordshire, who, like Monck, would transform his house into a 'Doric palace' on his return home; it seems possible that the inspiration for both houses originated with discussions held in this antiquarian circle abroad.[87] On the day after his arrival, Monck visited the Acropolis with Gell and another member of this set, the gifted Italian watercolourist, G.B. Lusieri, who was in Athens completing the purchase of the Parthenon marbles for Lord Elgin.[88] Although Monck noted that 'the ruins altogether far exceeded my expectations in beauty and magnificence', it is intriguing, in view of the controversy, then and now, surrounding the marbles' removal, to find that even he, as one of Lord Elgin's British contemporaries, and a fellow purloiner of Greece's cultural heritage, considered that 'the Parthenon is much lessened by Lord Elgin's depredations on the temple'.[89]

Often with his companions, Monck now settled down to study, draw (fig. 140), and occasionally measure the antiquities. By mid July, when Charles Atticus was born, he was spending an increasing amount of time sketching the 'Theseion',[90] which he concluded was 'the finest building extant as the Parthenon is the finest ruin'; it was perhaps for this reason that the temple presented itself as a particularly appropriate model for a new house back at home. Another Athenian building that would directly influence Belsay was the Tower of the Winds, which Monck visited with Baker on 21st June. Despite his reservations as to the tower's construction – he considered it 'very rudely worked within'– he later based

Fig. 140 *An extract from Sir Charles Monck's diary, including his sketch of the colossal Roman statue at Porto Rafti, Attica*, pen drawing, 1805

the lantern of his stable block at Belsay on this building.[91]

Not all of Monck's time in Athens was dedicated to scholarly pursuits, however. Like most of his contemporaries, he was not above having a taste for the picturesque, describing the cedar and mastic trees which grew up through the ruins of the great Doric temple on Aegina as 'enriching the scene by contrasting their lively green with the sober Grey of the stone

temple', and many of his Greek drawings were probably picturesque rather than analytical in nature.[92] Some of Monck's activities in Athens, if carried out under the banner of scholarship, were even distinctly dubious. On one occasion he and William Baker went to Piraeus to open graves, retrieving an 'earthenware child's coffin' and 'some small ordinary funereal vases'; such activities, as they must have known, were illegal, and the workmen they employed were beaten by the Turkish authorities. Monck roundly condemned the Turks, however, for this and other obstructions which stood in the way of would-be excavators, also expressing his dislike of the population, made up of Greeks, Albanians and Turks, and concluding that even 'Christianity here is far from amiable'.[93]

The dangers of living in Athens at this time must have been ever present to the Moncks. Although Louisa gave birth safely to Charles Atticus, another British visitor, Mrs. Russell, died in childbirth here at the same time, and in the temple of Theseus at Philopappos Monck saw a 'tumulus like a grave in an English church-yard' – 'the grave of [John] Tweddell [Appendix 3] who died here of a fever'. Many of the expeditions he and his friends undertook involved considerable discomfort, as when he and Sir William Gell slept in Salamis 'under a fur in the court of the monastery for fear of fleas indoors'; other sleeping accommodation included church floors, clumps of bushes, caves, and the ruins of the temples themselves.[94] There were, however, moments in Athens when life, with its round of chess, social visits, walks, and reading newspapers, reverted to something closer to the Italian Grand Tour.

The Moncks left Athens on 6th October 1805, Monck riding on horseback to Corinth with his infant son propped on a pillow on his knee.[95] From here, he made a brief excursion alone to Mycenae, where he sketched the famous Lion Gate, before sailing with his family from Patras back to Zakynthos, where news reached the travellers in December of Nelson's victory at Trafalgar. However, dangers at sea remained, as the French refused to respect the Ionian republican flag, and the Moncks were obliged to sail home via Malta, Sicily, and Gibraltar; on the way they were threatened by a French gunboat, and braved a storm which confined them to their bunks for four days without candlelight, and it was not until 5th April 1806 that the party finally landed safely at Plymouth.

On his return to England, Sir Charles Monck used his experience of Greek architecture to design at Belsay a highly important new Hall in the Doric style, only a few hundred yards east of the existing medieval pele tower with its modest Jacobean and Georgian additions: no other site in Northumberland illustrates so forcibly the impact of the Grand Tour as this transition from medieval fortified house to Greek villa. Unlike many amateur architects of the 18th and early-19th centuries, Sir Charles was an accomplished draughtsman, and did not need to employ a professional to make detailed working drawings from his sketches; although his Athens companion, Sir William Gell, provided a drawing for the interior hall inspired by the caryatids on the Erectheion, this was not used, and the design of the house, which was built from 1807–17, appears to have been Monck's alone.[96]

The most obvious features at Belsay to derive from Greek architecture, as Richard Hewlings has shown in an illuminating article on the sources for Monck's villa,[97] are the massive triglyph frieze, the raising of the façade on a podium, and especially the giant order Doric columns of the Entrance Front, seen in a preliminary drawing by Monck which provides a different solution for the frieze from the one finally adopted (fig. 141). Although the columns were modelled on the 'Theseion' in size as well as in appearance, their grouping *in antis*[98] at the centre of a plain façade was almost certainly inspired both by Anglo-Baroque houses, then enjoying a revival in Britain through the medium of John Soane, and by Monck's recent visit to Berlin. Here, amongst other neo-classical buildings, he would probably have seen the Landhaus Mölter by Friedrich Gilly, which has important affinities with Belsay in terms of its central columns, proportions, and use of plain, undecorated windows. Similarly, although Monck's spartan use of ashlar instead of plaster for the interior walls appears to link Belsay closely with its Greek prototypes, British baroque houses such as Castle Howard have comparable stone halls,[99] while the Pillar Hall essentially

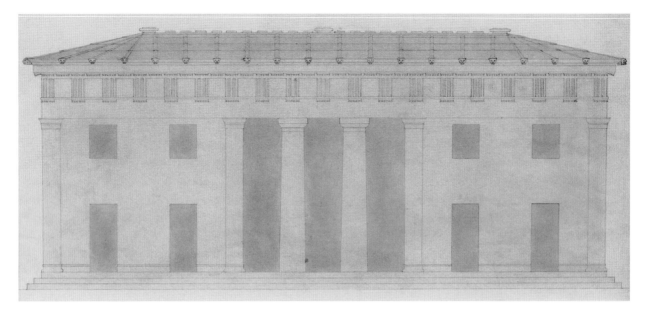

Fig. 141 *Design for the East Front of Belsay Hall* by Sir Charles Monck, pencil and wash drawing, about 1807

derives from the courtyard of a Roman villa, albeit roofed in concession to the Northumbrian climate; the casts here are after Flaxman, of Greek women holding lamps.

Remarkably, Monck is known to have owned every single contemporary publication on Greek architecture, and many aspects of the design at Belsay are based on published sources rather than on direct observation.[100] Although he had made a number of measurements of Greek temples abroad – albeit on one memorable occasion making use of his handkerchief – the dimensions he adopted for the columns of the 'Theseion' almost certainly came from Stuart and Revett's well-known *Antiquities of Athens*, published in several volumes from 1762. Other details such as bookcases, columns, and friezes, like this one for Lady Monck's Sitting Room (fig. 142), also derived from books in Monck's comprehensive library.[101]

The synthesis at Belsay of Monck's Grand Tour experiences in Greece and Germany, his study of books on Greek architecture, and his knowledge of Roman buildings and of Baroque and later country houses in Britain, produced a building which, although by no means the earliest Greek revival house in England,[102] is undoubtedly a minor architectural masterpiece. Unlike The Grange in Hampshire, built only three years earlier by the leading neo-Grecian architect in England, William Wilkins, Belsay's affinity with Greek architecture does not rest on the application of a temple portico to a British villa. Instead, it is the spartan simplicity and severity of the façade and the symmetrical 100ft square measurements which underpin it, that lend Belsay its

Fig. 142 *Design for the Frieze of Lady Monck's Room at Belsay Hall* by Sir Charles Monck, pen, pencil and wash drawing

distinctive character, and that are most in harmony with its Greek prototypes.

Both in its design, and the standard of its craftsmanship, which was closely supervised by Monck himself, Belsay exerted a major influence on the neo-classical houses of the North of England designed in the first half of the 19th century by the Newcastle architect John Dobson. This, rather than a second Greek revival house, Linden Hall, built in 1811–12 for Monck's Northumbrian friend, and another Grand Tourist, Charles Bigge, was Belsay Hall's real legacy to the North of England.

The Grand Tour references at Belsay do not end with the Hall itself. The famous Quarry Garden which Monck also designed – forming a 'dramatic canyon'[103] out of the area used to quarry stone for the house – was no afterthought, but an integral part of his scheme. It is a highly important exercise in the fashionable 'Picturesque' mode, with an admixture of the 'sublime'; elements of the design at Belsay are notably close to the landscapes of Salvator Rosa. There is, however, a more direct Grand Tour source in the quarries the Moncks had visited at Siracusa in Sicily, which inspired the highly dramatic rock arch. Monck's second wife, Lady Mary Elizabeth Benet, daughter of the 4th Earl of Tankerville (d. 1851), was an enthusiastic amateur artist and pupil of John Varley. Her oeuvre includes continental watercolours as well as British views.

Sir Charles Monck's tour of Greece, his Doric Hall at Belsay, and his habit, during his years as a Whig member of Parliament, of addressing an exasperated House of Commons in classical Greek, are all suggestive of a man, who, belonging to a circle of *cognoscenti*, spent his life in the study of Greek architecture and civilisation. In fact, Monck does not appear to have kept in touch with his Athens companions after 1807,[104] and, after an eventful Grand Tour, he settled down to a life which, his creation of Belsay Hall apart, was very similar to that of his landed contemporaries; even his passionate interest in Greek architecture had only this one outlet.[105] Monck's gradual abandonment of the intellectual friendships he had formed abroad in favour of 'county' society in

Northumberland can be seen as yet another illustration of the comparative isolation of the North at this period – although it should be remembered that his 'Northern' friends were powerful men like the Prime Minister, Lord Grey, or another prominent Whig, Sir Matthew White Ridley, both of whom had also made the Grand Tour. In the end, it was his isolation from the Cambridge Hellenists and other architects and scholars, and concentration instead on the fruits of a few, highly productive years abroad, that make Belsay such a highly original contribution to British architecture.

WILLIAM ORD (1781–1855), HIS WIFE AND SON

Another Northumbrian tourist who, like Major Anderson, took advantage of Napoleon's exile to Elba was William Ord, who toured France and Italy from 1814–17 with his wife Mary and son William Henry (1803–38). Like Major and Mrs. Anderson, the Ords became caught up in the events following Napoleon's escape from Elba, and were obliged to remain in Italy throughout 1815. To judge by their leisurely return home in 1816–7, however, this may always have been intended as a lengthy Grand Tour.

William Ord came from a family which had acquired considerable estates in Northumberland between the late 17th and mid 18th centuries, notably at Whifield, following his grandfather's pioneering involvement in deep shaft mining. By the time of his tour, he could be numbered among the most powerful Whig landowners in the county, and had sat as M.P. for Morpeth for over a decade. Ord's support, over the forty-seven years he sat in Parliament, for the 'cause of enlightenment and freedom' can perhaps be gauged from his Grand Tour diaries, which are unusual for their time in their concern for social conditions abroad: crossing the Alps in 1814, he noted that the poverty of the 'wretched inhabitants take off all one's pleasure of the scenery'. Ord's libertarian tendencies caused him to have a particular distaste for what he saw as the enforced celibacy of the Catholic priesthood and his Protestant wrath was aroused on more than one occasion by the sight of nuns 'imprisoned for life'.[106] A highly cultivated and discerning tourist, and a talented amateur draughtsman

who made a remarkably complete record of his tour in watercolour (figs. 143–4, 146, 149–150), Ord had a strong interest in books, manuscripts and natural history as well as in the fine and decorative arts, and his diary breathes a spirit of enquiry and scepticism characteristic of the new century.

Ord's father had died in 1789, when he was still a child, and in 1802 his mother, Eleanor Brandling – sister of another Northern tourist, Charles John Brandling (p. 149) – made a second marriage to the diarist Thomas Creevey, who was perhaps responsible for adding a European dimension to the lives of this Northumbrian family. While the Ords were making their Grand Tour, the Creeveys, together with William Ord's two sisters, rented a house in Brussels, and, as Mrs. Creevey was an invalid whose 'nerves are stout', they stayed on in the city after Napoleon's escape from Elba in February 1815: Creevey's papers provide a highly important account of the countdown to Waterloo, and Ord's sister Elizabeth reported to her brother that, on the eve of the battle, 'Anne and I never took off our cloaths', as they were 'expecting the French every moment'.[107]

William Ord and his family began their tour at Calais, arriving 'more dead than alive'[108] on August 27th 1814, and taking the usual post route to Paris, where they met another Northumbrian – and fellow amateur artist – Edward Swinburne, with whom they dined at Nicolle's, went to the opera, and ate ices afterwards on one of the Boulevards. During his stay in the French capital, Ord's interest in books and manuscripts took him to the Royal Library and the Library at Ste. Geneviève, but his chief recreation in Paris was the Louvre. His initial impression of the paintings plundered from Italy was that many were 'terribly damaged by their removal & have been almost painted over again', but on leaving Paris he wrote of the gallery: 'I part from it as from a friend it has afforded me so many delightful hours'.[109] Like Major Anderson, however, William Ord was unable to come to terms with the generation of French revolutionary painters represented by David,[110] and he also shared his fellow Northerner's conviction of the superiority of British porcelain factories over Sèvres.

Although the Ords were warned 'not to risque going into Italy till things are more settled', they were soon heading for Switzerland – where, at the frontier, their luggage was searched, purportedly because the authorities had 'lately detected some correspondence with Joseph Bonaparte'[111] – and the Simplon pass; it appears to have been while travelling through Switzerland that William Ord began to record his tour visually, beginning with Lake Geneva.[112] Like other tourists at this time, the family was able to benefit from Napoleon's new alpine roads: although the ascent over the Simplon required seven horses, the Ords no longer needed, like their 18th-century predecessors, to be carried in chairs. The family's first major stop in northern Italy was in Milan, where they spent nine days, visiting the 'cathedral of White Marble' and the Ambrosian Library, and going twice to the Refectory of the Convent of Santa Maria della Grazie to see Leonardo da Vinci's *Last Supper*, which, 'even in its present almost obliterated state produced a greater effect upon one than any picture I ever saw'. Ord, who already knew the painting from the well-known print by Raffaello Morghen (1758–1833), noted the contrast between this and the original: 'the one is all starts & violence & the other all repose and dignity', and he also noted, prophetically, that 'The picture will soon be effaced as the damp seems completing the destruction begun by ignorant cleaners & continued by monks soldiers etc'.[113]

Everywhere in northern Italy, and notably in Bologna, the Ords, like the Andersons before them, found that 'all the fine pictures' had been 'carried off to Paris', a circumstance that Ord, interestingly, did not altogether regret, given 'the dark uncomfortable places that these must have been to look at them in'. There were changes, too, in Florence, where they spent three weeks in November 1814, and where Ord made a number of sketches,[114] including a view along the Arno of the kind popularised by Thomas Patch many years earlier (fig. 18); here, as elsewhere on his tour, Ord's interest was in sketching the landscape, not in copying Old Masters or other works of art. In the Uffizi, Canova's *Venus* had been added to the *Tribuna*: 'tho' very flashy & well executed', Ord found it 'affected and certainly not worthy of replacing the Venus de

Fig. 143 *View of St Peter's, Rome, from Monte Mario* by William Ord, pencil and watercolour, 1814–5

Medicis', which had been removed to Paris in 1803. By the early 19th-century, connoisseurs were beginning to take an interest in early Italian painting before Raphael, and that Ord had at least looked at the earlier paintings in the Uffizi, even if he looked only to criticise, is shown by his comments on a painting by Perugino, who 'certainly made a wonderful progress from the artists who immediately preceded him & of whom there are some curious specimens in this collection Cimabue & Giotto particularly'.[115]

As for their 18th-century predecessors, Rome was the principal goal of these Grand Tourists, and the Ords' visit lasted from December 1814 until March 1815. Although they lost no time in examining 'the various wonders of Ancient & Modern Rome', there were significant differences in their appreciation. The almost religious awe with which many earlier tourists had regarded the Eternal City was replaced by a rational spirit of enquiry, that was not afraid to judge for

itself, and often to criticise: Ord recorded that 'we were in many [cases] very disappointed for many of the Ruins have little or no trace of... magnificence', and the church of San Paolo fuori le Mura he considered to be a 'ruinous barn in which are crowded the magnificent columns of the mausoleum of Adrian [Hadrian] & one can only regret that they are so wasted'. As with the Andersons, there is no mention of the once ubiquitous *cicerone*, or of the rather rigid itinerary followed by 18th-century tourists, and, although they visited the usual classical sites, Ord, like Anderson, had an eye for the Baroque: in Santa Cecilia in Trastevere he noted the 'good statue of the saint lying dead by Bernini' – today known to be by Stefano Maderno – that is surely one of the most moving of all Baroque sculptures.[116] Ord's accomplished sketches of Rome are perhaps more conventional, focusing principally on subjects which had been popular with British artists and amateurs from the mid-18th-century onwards; as well

as views in the Medici or Borghese gardens, or panoramas of Rome from the Ponte Molle, the Villa Madama or from Monte Mario (fig. 143) his album includes those sites in the *campagna*, such as Tivoli, Castel Gandolfo and Lake Albano, Lake Nemi and Arriccia, that had attracted generations of British artists and tourists following in the wake of Claude Lorrain.

The Ords also visited Canova's studio, where they were shown several of the statues that Major and Mrs. Anderson had seen over a decade before. While they admired a number of these, including *The Three Graces*, William Ord considered that Canova's funeral monuments were 'deficient in thought & composition'.[117] Unlike the Carrs, the Ords did not mix much with the Italian aristocracy 'during our stay at Rome for they are generally speaking very inaccessible', but they attended a concert at Lucien Bonaparte's, and William Ord was granted an audience with Pope Pius VII, finding him, as Major Anderson had done, 'cheerful & unaffected'; at a mass at St. Peter's he seemed to be 'the only person present who seemed at all aware that he was performing a religious ceremony. The cardinals were talking & taking snuff'.[118]

From Rome the Ords headed for Naples, meeting on their journey the exiled Caroline, Princess of Wales who 'got out of her carriage & walked with us along the road', expressing her alarm at what Ord called the 'volcanic state of public affairs'– Napoleon's rumoured escape from Elba. The Ords stayed in Naples from March to June 1815, long enough to see the usual sights, and for Ord to make a large number of sketches of Naples and the usual south coast sites, but unable at first to get any reliable news of the political situation. In the museum at Portici, Ord was particularly impressed with the 'vast number of pieces of painted walls taken chiefly from Pompeia & which greatly exceed in beauty any idea I had formed of ancient painting'. It seems possible that he and his wife were able to take home a souvenir for themselves, as on 12th April they attended a dinner at Pompeii given by Queen Lucia, second wife of Ferdinand IV, to which all English visitors were invited, and at which 'several antique utensils, vases, busts etc. were dug out' and presented to the tourists.[119]

In this same month, news reached the Ords of Napoleon's

landing in France, and they made an abortive attempt to sail to Livorno, but in the end travelled north by land instead, which, they felt, was safer 'owing to the quantity of military' around.[120] They arrived back in Rome on 26th June, just after Waterloo; curiously, although news of the battle must have reached them around this time, Ord does not refer to the victory in his diary, but in July a letter announcing the family's safety reached his anxious mother and sisters in Brussels. The family now began a leisurely journey north through Tuscany, following in the alleged footsteps of Milton by making an expedition to Vallombrosa, where they found the former Benedictine convent cold, damp, and empty of monks, who had been dispersed by the French.

Despite his famous reference to Vallombrosa in *Paradise Lost*, it now seems almost certain that Milton never visited this remote Italian convent. Instead, the legend that he had done so 'merged with a rapidly evolving European travel literature of the late eighteenth century' and 'spawned its own literary tradition, stimulating countless cultured, and subsequently less cultured tourists to follow in the allegedly holy bard's supposed footsteps'.[121] The Ords can perhaps be numbered among the former category: although, by the time of their visit, the vogue was well underway, Vallombrosa and its Miltonic associations appearing in standard travel literature, in novels, and, early on, in William Beckford's extraordinary *Dreams, Waking Thoughts and Incidents* (1783), the banker-poet Samuel Rogers asserted two years after the Ords' visit that 'nobody I know has been to Vallombrosa'. They were certainly in advance of William Wordsworth, who wrote in 1820 of his longing to 'slumber' in the 'shadiest wood' of Vallombrosa, but did not actually do so until 1837;[122] among other famous pilgrims were the Brownings and Mary Shelley. If Ord paid due tribute to the site's Miltonic associations, not least by making two sketches (fig. 144), he was unimpressed with the convent itself, concluding that 'Vallombrosa certainly owes more of its celebrity to Milton than to any merits of its own & is (divested of its associations) certainly not worth the <u>eight</u> hours Labour of getting to it'.[123]

The Ords now moved on to Pisa, where Ord admired the

Fig. 144 *View of the Convent at Vallombrosa* by William Ord, pencil and watercolour, 1815

medieval cycle of Last Judgement frescoes in the *Campo Santo* that had attracted the attention of Henry Swinburne many years before, and sketched the view along the Arno, and Livorno, where they inspected the alabaster and marble factory, Ord complaining that 'execution seems a greater object than the beauty of form', and concluding scathingly that one could not expect superior taste 'among the merchants of Leghorn'.[124] Like the Andersons, the Ords also visited the great marble quarry at Carrara, where many contemporary sculptors kept a studio. Evidence of the grandiloquent commissions of the recent Napoleonic era was everywhere around them: Canova's studio, for example, housed 'a colossal figure of Bonaparte & about 50 Busts of Him'.[125] Although Ord was offered some marbles by a dealer at inflated prices, and also inspected Flaxman's *Ino and Athemas and their children*, in a warehouse at Leghorn, finding it 'nearer the antique than any modern production I have seen in Italy',[126] there is no evidence that he bought any neo-classical sculpture abroad.

Arriving in Venice in August 1815, Ord found himself viewing Venice through the eyes of Canaletto, even if his own private record of Venice in his sketchbook is considerably more contemporary in its atmospheric treatment of light: although the Grand Canal was 'very striking...the representations of it by Canaletti are so accurate that it is scarcely new to one'.[127] Although Ord does not record their purchase abroad, it seems likely that a set of three paintings from the school of Canaletto, depicting three of the artist's most popular and often-repeated compositions, *A View on the Grand Canal, A View of the Palazzo Ducale towards the Entrance to the Grand Canal*, and *The Entrance to the Grand Canal and the Dogana to the left*, (fig. 145), were purchased as a result of this visit.

This Grand Tour, however, was still far from over. We know from Ord's correspondence with his mother and sisters in Brussels that he and his family were enjoying their stay in Italy enough to consider remaining another year, and, instead of heading back over the Alps, the Ords moved on to the Italian lakes, whose importance to tourists of this era is confirmed by the many studies that Ord included in his sketchbooks, and then to Genoa, where he painted this fine record of the

Fig. 145 *The Entrance to the Grand Canal and the Dogana to the left,* from the studio of Canaletto, oil on canvas, early 18th century

harbour and its *feluccas* (fig. 146). Returning to Florence for the winter of 1815–16, the Ords found the *Venus de' Medici*, recently returned from Paris: 'The Venus in a good light & with dark Curtains behind her looked so different from what she did at Paris placed as she was there before a window & surrounded by colossal statues of white marble…that I was quite astonished that I had not been more struck with her beauty when I saw her in the Louvre'.[128] Given both its art treasures, climate and society, Ord, like others before him, left Florence in May 1816 with regret, and set off at a leisurely pace for the Mt. Cenis pass, where he made one final Italian sketch – having paused on the way at Bologna and Padua to see paintings that had also been repatriated. In Turin, not only

works of art, but the King of Sardinia, too, had returned.

The Ords arrived back in Paris[129] just behind an even more prestigious exile, Louis XVIII, who was returning to the capital for the first time since Waterloo; although his arrival at Melun was greeted by 'flags, inscriptions, fleurs de lys, triumphal arches etc.', in Paris itself, Ord noted, he was received in silence. As the Creeveys were still living in Brussels, the Ords afterwards visited them there; at Waterloo, where the tourist trade was already thriving, and where Ord sketched the village, but not the battlefield, they were 'beset by children with various relics of the battle, buttons & other military ornaments for sale'.[130] The final stages of their journey are somewhat obscure,[131] but they passed through Belgium (where

the coal-fields between Valenciennes and Brussels 'strongly reminded us of the neighbourhood of Newcastle'), toured Germany in the autumn of 1816, and returned again to Paris, before finally setting out for Calais on 20th January 1817. The diary ends in Abbeville, where the 'filets de Turbot, [and] the perdrix with magnificent poulet....filled us with dismal anticipation of the "Beef for steaks to mutton for Chops" of an English Inn'![132] Ord made a later tour of France, the Rhine and Switzerland in 1825 (see below, p. 257).

Although William Ord's diaries do not mention the acquisition of any major works of art abroad, they certainly confirm his strong interest in the visual arts, and it therefore seems highly likely that, in addition to the *veduta* paintings of Venice (fig. 145), Ord also purchased on, or following, his Grand Tour two exceptional paintings which are known to have belonged to the family: *The Return of the Prodigal Son before a Palace* and *Christ and the Centurion amidst classical Ruins* (figs. 147, 148, col. pl. 15). The acquisition of these pendants by the Venetian figurative painter, Sebastiano Ricci (1659–1734), and his nephew Marco (1676–1729), who specialised in landscapes, would be entirely consistent with what we know of Ord's taste in Old Master paintings, still rooted, like Major Anderson's, in the Grand Tour tradition: the Riccis' work had been popular in Britain throughout the 18th century, and Marco Ricci's ruin scenes were highly redolent of the Grand Tour, offering a more painterly alternative to the Roman *capricci* of G.P. Panini (fig. 13). Given that events in the Old Testament were considered to prefigure and parallel those in the life of Christ, artists often painted pairs of scenes from the Old and New Testament, but the real subject of these paintings is to be found in their settings, which contrast the flourishing Italian Renaissance palace in the *Prodigal Son* with the ruined classical buildings in *Christ and the Centurion*.

William Ord's own talent as an artist was considerable, and his folio sketchbook was almost certainly assembled by Ord himself, both from the various small sketchbooks (containing pencil, wash and watercolour drawings) he presumably used on the spot, and from the more finished watercolours and wash drawings he worked up afterwards. Ord's sketchbook

Fig. 146 *View of Part of the Harbour at Genoa* by William Ord, pencil and watercolour, 1815

Fig. 147 *The Return of the Prodigal Son before a Palace*,
by Sebastiano and Marco Ricci, oil on canvas, early 18th century

Fig. 148 *Christ and the Centurion amidst Classical Ruins*,
by Sebastiano and Marco Ricci, oil on canvas

represents the most important and complete visual record of a Grand Tour made from the North, and gains considerable importance from the fact that he was a pupil (and major patron) of John Varley, whose North of England tour of 1808 had included visits to Ord and his other Northern clients,[133] and whose style can be seen behind most of the compositions in this album.[134] Ord's album not only comes close to Varley in style. Having trained under a drawing master who belonged to the new generation of professional watercolourists headed by Turner, Ord's interest was in recording famous Grand Tour sites, together with Alpine, lake and coastal scenery – in his case interspersed with a handful of travel sketches of postillions, coachmen (fig. 150) and peasants in native dress (fig. 149). In distinct contrast to the Grand Tour output of

Harriet Carr over twenty years earlier (pp. 132–141), there are no portraits, and no studies after the antique or after Old Masters paintings.

The importance which William Ord attached to this visual record of his tour is attested by the considerable care he took over its assembly. Each drawing is titled in pencil at the top of the paper; when the sketches came to be pasted into the album, a new title was inscribed underneath in pen, almost certainly by Ord himself.[135] Although the drawings are presented in a logical geographical sequence, they represent an 'ideal' tour through Tuscany and Rome to the south coast of Italy and back again, rather than the actual route adopted by the Ords, which, given the political situation, was somewhat more haphazard.[136]

Figs. 149, 150, *'Peasants of Macon'/'Dress of a Peasant at Troyes'*
and *'Carriole de Lyon'* by William Ord, pencil and watercolour, 1814–7

SIR WILLIAM EDEN, 4TH BART (1803–73)

Thirty years apart, in 1814 and 1844, Sir William Eden inherited two Durham baronetcies. Members of both branches of this intellectually gifted family (including his father, Sir Frederick Morton Eden) had made the Grand Tour in the late 18th century, and Eden's first experience of the continent seems to have been as a child of eleven, when he visited Paris with his uncle in December 1814 – a visit which provides further confirmation of the exodus abroad in that year.[137] In that same month William's elder brother was killed in action, and, perhaps so as to educate the younger son who now inherited the title, the visit appears to have been educational rather than enjoyable, although Eden did see what, for a boy of eleven, must have sounded promising entertainment: the translation of the bones of Louis XVI and Marie Antoinette from 'some d'unjon where they were buryed to Saint Denis's'.[138]

A gifted classicist and linguist, Eden had a 'natural taste for the fine arts', and is known to have painted in watercolour.[139] He spent much of his early adulthood travelling in the Americas and the West Indies as well as France, Italy, Spain, Austria and the Near East. These were the years of the Greek War of Independence, and Eden seems to have spent some

time on a British frigate, searching for Lord Cochrane, who was 'expected to come to the assistance of the Greeks'. On board a *trabakolo* from Ancona to Corfu, he met a man who had seen Lord Byron constantly while he was dying at Missolonghi, and who was able to reveal to Eden the reason for his separation from his wife: 'elle était trop chaste pour moi'. Despite his involvement in liberal politics, Eden was, essentially, like other affluent tourists at this period, travelling for enjoyment and instruction. He seems to have spent much time abroad both in the 'examination and purchase of pictures in Italy and Spain',[140] and his tour journals, had they survived, would have provided an invaluable source of information on the early 19th-century tours made from the North.[141]

What is, fortunately, recorded, is Eden's purchase in Naples in 1836 of one of the most important Old Master paintings to enter a Northern collection as a result of the Grand Tour: *A View of Delft with Musical Instrument Seller's Stall* (fig. 151) by Carel Fabritius (1622–54), an intriguing and unusual combination of a still-life and a townscape by this short-lived Dutch pupil of Rembrandt, not many of whose works survive.[142] Eden was also a friend of one of the greatest of 19th-century travellers, Richard Ford, who dedicated to him his *Handbook for Travellers in Spain* (1845). When they were in

Fig. 151 *A View of Delft; with a Musical Instrument Seller's Stall* by Carel Fabritius,
oil on canvas, stuck to walnut panel, 1652

Seville together early in their acquaintance in 1832, Ford wrote: 'we are all crazy here about pictures, such buying & selling – the market will be cleaned out...I did not suspect that he [Eden] was such an amateur and collector',[143] and Eden's collection is known to have included works by Murillo and Ribalta as well as Italian paintings by Veronese and Guercino. According to family tradition, Ford later visited Eden in the North of England, when Eden took him on a visit to nearby Rokeby Park in North Yorkshire: 'On their way Ford happened to speak of a Velasquez which he was anxious to trace. He knew that it had been sold out of Spain but had no idea what had since become of it. On entering the drawing-room, in the act of greeting his host, he suddenly stopped and, pointing to the picture over the mantelpiece, exclaimed: "By Gad! There it is!"' This was the famous *Rokeby Venus*, acquired by J.B.S. Morritt in about 1814, and now in the National Gallery.[144]

WILLIAM HARRY VANE, 3RD EARL OF DARLINGTON, LATER 1ST DUKE OF CLEVELAND (1766–1842) AND HIS FAMILY, WITH NEWBEY LOWSON

The former Grand Tourist Lord Barnard, now 3rd Earl of Darlington, was among the many Northern travellers who joined the stream of English visitors returning to the continent after Waterloo, when he made a three-month tour in 1816 through France, Switzerland, northern Italy, Germany and Belgium. With him were his second wife, Elizabeth Russell,[145] his eldest daughter Lady Augusta Vane (her younger sisters remaining with their governess in Boulogne) and his friend and neighbour Newbey Lowson, companion of Turner's 1802 Alpine tour; this mixed party of different ages and sexes could stand as a paradigm for the direction taken by tourism in the new century. The party left Cleveland House in London on 9th June on a tour where the desire for comfort appears to have been paramount; two coaches were needed to convey the Darlingtons and their retinue of servants, consisting of

two lady's maids, two men-servants, and a Mr. Storey.

Both Lord Darlington, who masterminded the arrangements, and Newbey Lowson, kept detailed journals of their tour,[146] and although, as Lord Barnard, the Earl had shown little or no interest in the visual arts, his 1816 diary reveals that, in the interim, he had developed a considerable enthusiasm for Old Master paintings. Lowson, on the other hand, although often appreciating the collections he saw, and even going so far on one occasion as to seek out a remote Capuchin convent containing a Holbein of the dead Christ 'certainly taken from a figure laid out for an anatomical dissection',[147] had not been raised in circles imbued with a knowledge of the 18th-century Grand Tour. Instead, he reserved his enthusiasm for the Alps, which, as in 1802, he seems to have viewed from the standpoint of the picturesque, intermixed with that of the 'sublime', and which he sketched with an almost obsessive determination – both his active and passive appreciation seem likely to have their roots in his earlier tour with Turner.

Visiting Paris in July 1816, the tourists saw the principal sights, among them the Louvre, Notre Dame, St. Sulpice (where a woman greatly disturbed Lowson by feeding two caged and extremely noisy linnets), and the Tuileries, where Lowson was struck by the Gobelins tapestries and gilt furniture, but unimpressed with the Dining room, whose table 'would disgrace an English Ale House'. In the Salon de la Paix he saw the 'large statue of the Goddess of Peace in massive silver' presented to Napoleon by the city of Paris on his concluding the Peace of Amiens.[148] At the Luxembourg Palace both men singled out for praise the paintings by Rubens, together with those of the great French marine painter of the last century, Claude-Joseph Vernet.[149] The collection at Raby includes one of Vernet's finest storm scenes, an early work painted in Rome in1741 (fig. 152), at a time when the artist's interpretations of 'sublime' or hostile nature, so attractive to the Pre-Romantic sensibility, had yet to be reduced to a formula. Although this was purchased much later (in 1861) by Darlington's son, Henry, 2nd Duke of Cleveland (1788 –1864),[150] the 2nd Duke (as Lord Barnard) was also abroad in

1815, and it seems at least possible that the liking for Vernet was an enthusiasm shared between father and son.

Like the Andersons, the party also visited Dominique-Vivant Denon, seeing his cabinet pictures and the curiosities he had brought home from his expedition accompanying Bonaparte to Egypt 'as one of the Savants'; on learning that she was forming a collection, Denon politely presented Lady Darlington with 'the tooth of an unknown animal'.[151] Visits to the Cabinet d'Histoire Naturelle in the Jardin des Plantes and to the Academie Royale de la Musique were perhaps undertaken to please Lady Darlington and her step-daughter, while among the tourists' lighter activities were evenings at the theatre and opera, attendance at a balloon ascent, and visits to see some panoramas and to admire the 54 ft high 'model of an immense Elephant which stood on the site of the Bastille as a memorial to Napoleon's imperial ambitions'. The party also went to Tortoni's on the Boulevards, 'where the best Ice and the best company in Paris are supposed to be found', while the men gambled at the Salon des Jeux.[152]

With Newbey Lowson as their companion, it was hardly surprising that the Darlingtons should now move on to see the 'sublime' scenery of Switzerland, accompanied by a Dalmatian courier whom Lord Darlington hired in Paris. However,

Fig. 152 *A Shipwreck* by Claude-Joseph Vernet, oil on canvas, 1741

confirmation, if any were needed, that Switzerland could no longer be regarded as an adventurous destination was provided in Paris, when Lowson learned that the country was 'completely filled with English'. Once in the Alps, Lowson, whose first tour had been undertaken in an open cabriolet with a single, like-minded companion, found the Darlingtons' commodious method of travelling highly uncongenial, suffering 'much mortification' at 'being obliged to travel with the carriage shut up thro' scenery which beggars description' and on one occasion claiming that he had almost dislocated his neck 'in attempting to get a peep at the grandeur which surrounded us'. Only occasionally, as when the party saw 'the spires of Berne peeping over a rich wood', with the Alps in the distance, or the glaciers of Unterwald and Lauterbrunnen, did the travellers descend from their carriage to admire the view, Lowson noting a trifle acidly on the latter occasion that the river Aare and the glaciers formed a picture which even 'the coldest of us could not help admiring'.[153]

In his enthusiasm for sketching, Lowson often got up at dawn on this part of the tour to draw the scenery before the coach started for the day. This gentleman amateur's passion for sketching, however, had its limits: rain prevented him from sketching Mont Blanc at dawn, and on one memorable occasion he was forced to abandon an expedition after finding that he had left his hat behind in Lord Darlington's room. Among his subjects were views of glaciers, a cascade, and the famous Devil's Bridge on the St. Gothard pass; he also subscribed to the vogue for making sketches of peasants in native dress, and a small number of pen and ink copies after his original drawings survive in his journal, some showing them wearing hats of which the 'top resembles a bee hive'.[154] Lowson's other subjects can be guessed at from his admiration for 'Villages cottages water mills & figures of the most picturesque description in short everything a painter could wish to constitute the finest scenery'. However, if this list confirms him principally as an exponent of the picturesque, his appreciation of 'Rocks...sometimes perpendicular with cascades tumbling down the sides – a river rushing at our feet', and sketching of the Devil's Bridge itself, suggests that he was

also well versed, through his association with Turner, in Edmund Burke's other category of the 'sublime'.[155]

The party's route, which was essentially made in the reverse direction to Lowson and Turner's 1802 tour, took them through Basel, where, like most tourists of this era, they paused to visit the major series of works there by Hans Holbein the Younger, while, near Berne, the grandeur of the Grand Val compared favourably, in Lowson's view, with his memory of the scenery around La Grand Chartreuse fourteen years before. Passing through Lausanne, and then Geneva (Lowson observing, on the other side of the lake from the English colony, Lord Byron's villa, where he was said to 'pass his life... in an extraordinary manner') the party now set off for Chamonix and Mont Blanc in hired char-à-bancs (light carriages), ascending the Montenvers on mules, and passing close to the Glacier du Bois and the Mer de Glace. On this leg of the journey, where the travellers were more or less retracing the steps of Lowson's earlier tour, Lowson noted that although 'the sublimity of scenery is indescribable – the road is frightful'. Events bore him out: the ladies' carriage came within an inch of disappearing over a precipice, the party's luggage 'rolled on the road', and 'half of the peasantry of the county', had to turn out to assist them over the seemingly impassable Torrent Noir, the ladies being carried in the guides' arms.[156] Whereas in 1802, however, Lowson and Turner had turned back on the threshold of Italy, Lord Darlington's party now crossed the Alps, using, like the Ords, the Simplon pass on the road constructed by Napoleon, which Lord Darlington, perhaps more sanguine than Lowson, considered to be 'un chef d'oeuvre'.[157] Their destination, however, was not Rome, but Northern Italy, including Milan and the lakes of Lugano and Como, where Lowson found the Princess of Wales's house unremarkable.[158]

The party returned from this new, curtailed type of Grand Tour through the St. Gothard pass, seeing the falls of the Rhine at Schaffhausen, which failed to impress Lord Darlington, and then travelling home though Germany and Belgium. On their way they paused to visit the battlefield of Waterloo (where Lady Augusta Vane 'picked up' some

memorabilia which were later accomodated in the Barons Hall at Raby)[159] and to breakfast in St. Omer with the Earl's son and daughter-in law, Lord and Lady Barnard. The Darlingtons made a second tour of northern Italy in 1817, probably accompanied this time by the Earl's two younger daughters, progressing as far as Venice. The seven further continental tours that Lord Darlington, by now a prominent politician, and promoter of the Reform Bill, made between 1821 and 1837 correspond to our own, shorter, holidays abroad rather than to the lengthy tours of the 18th century.

The Old Master paintings at Raby Castle are outstanding, and can be compared with the North's other great collection of Old Masters – that assembled in 1853 by Algernon, 4th Duke of Northumberland at Alnwick Castle. Both collections, with their predilection for Italian Renaissance and *seicento* paintings, continue into the second half of the century the tastes of earlier British collectors, shaped by the Grand Tour, and the strong representation of Dutch genre paintings at Raby, notably of works by David Teniers, also reflects earlier preferences.[160] Among the Italianate paintings are the *Embarkation of the Queen of Sheba* after Claude and two exceptional *capricci*, one attributed to Antonio Joli and the other to Sebastiano and Marco Ricci,[161] while the collection also includes several copies after famous paintings that would have been on most Grand Tourists' itineraries.[162] Like the Vernet, however (fig. 152), many of the finest paintings at Raby are known to have been purchased, not by the 3rd Earl of Darlington, whose tour journals survive in such profusion, but by his son, Henry, 2nd Duke of Cleveland, whose travels on the continent in 1815 are, sadly, only hinted at in his father's journal.

JOHN INGRAM (1767–1841)

Another Durham 'tourist' of this generation was John Ingram, who was born at Staindrop, in close proximity both to Lord Darlington's's seat at Raby and to Newbey Lowson at Witton-le-Wear. Although Ingram remains a somewhat elusive figure, he seems to have spent much of his adult life in Italy, and some years ago he emerged, in a seminal article by Francis

Haskell,[163] as a major collector of the works of Francesco Guardi (fig. 153) which he may have commissioned direct from the artist, and which he was seeking permission to export from Venice in 1819. Despite objections from the Accademia, the application was agreed on the grounds that there were enough Guardis remaining in the city, and because Guardi, even twenty years after his death in 1793, was still not regarded as important enough to justify an official intervention to retain his paintings in Venice.[164]

Ingram, whose birthplace was a manor house in the Durham village of Staindrop, not a large country house, is typical of the very different type of clients who patronised Guardi, as opposed to Canaletto. Wealthy Grand Tourists seeking accurate, 'picture postcard' views of Venice turned almost automatically to the work of Canaletto; indeed, many British tourists even saw Venice filtered through his eyes. Few of such men had even heard of Guardi; those who had were bemused by the supremacy in his work of 'fantasy over intelligence', and by his freedom of handling, which one perceptive contemporary recognised as Guardi's 'particular manner; which is spirited and quite his own'.[165] It was almost universal in the late 18th century to compare Guardi unfavourably with his great contemporary, and the long-held belief that large numbers of Guardis entered British collections during this period has been dispelled as something of a myth: there is an almost total lack of references to him in British 18th-century travel literature and inventories.[166]

Those who did patronise Guardi were therefore going against an established trend, and Francis Haskell has shown that the artist's British and Italian clients were drawn from very different, more modest, backgrounds than Canaletto's, whose patrons were principally the great British *milordi*. Guardi's Italian clients, such as Dr Giovanni Vianelli, canon of Chioggia cathedral – who is known to have admired the movement, colour, vivacity and sparkling lights in his paintings, qualities which remain central to his appeal today – or the Spanish Vice-Consul in Venice, Don Giacomo della Lena, were professional men with an interest in the arts, living either on the fringes of the scholarly world, or with some

Fig. 153 *A View of the Lagoon at Venice from the Piazzetta* by Francesco Guardi,
oil on canvas

pretensions to scholarship themselves.[167]

Similarly, Guardi's English clients, of whom Ingram was among the most important, were usually residents in Venice, rather than tourists just passing through. Ingram's first experience of the continent may have been from around 1791–3, when he can perhaps be identified with the tourist listed variously in the Venetian state archives for these years as 'Ingrin' or 'Engrim'.[168] Later, he undoubtedly lived abroad for lengthy periods, settling first in Venice, where he is recorded in 1819, and where he formed 'a most valuable collection of bronzes, Coins, Pictures etc.....The fruits of several years' continued residence' in the city; this was apparently lost at sea in 1828.[169] By the 1820s he had moved to Rome,[170] living, according to tradition, with his family at Palazzo Mignanelli, where his Guardi painting of the Doges' Palace and the Piazzetta is said to have hung.[171] Although he was back in

London in 1831, Ingram had returned to Rome by 1840, and he died there the following year.

If the not altogether flimsy tradition that Ingram bought his Guardi paintings direct from the artist is true,[172] his acquisition at a young age of Guardi's astonishing late works (fig. 153), which Haskell has characterised as 'feverish, almost frenzied', marks him as a patron of exceptional distinction. When Guardi died in 1793, Ingram was still only in his twenties, yet he had apparently been prepared to buy paintings which not only went against prevailing taste, but which could be appreciated only by those who were 'prepared to understand something about the city that must inevitably have baffled the hurried tourist and aristocrat'.[173] Although by the 1820s the vogue for Guardi's work in England was well underway,[174] Ingram appears to have been considerably in advance of his aristocratic contemporaries in his appreciation of a painter

who 'has some claim to be the first of the 'misunderstood' artists'.[175]

Today, it is possible to identify three paintings formerly in Ingram's collection, two of which, *A View of the Lagoon at Venice from the Piazzetta* (fig. 153) and a *View of the Entrance to the Grand Canal from the Piazzetta*, are now in public collections[176]. So, too are a number of the Guardi drawings which once belonged to him.[177]

THE RIDLEY BROTHERS AND CHARLES WILLIAM BIGGE

The two sons of the former Grand Tourist Sir Matthew White Ridley of Blagdon, 2nd Bart., both of whom would later pursue political careers, also travelled abroad in these years. The tour through Hanover, Brandenburg, Saxony, Bohemia, Austria, Hungary and northern Italy made in 1800–1 by his eldest son, Matthew White Ridley (1778–1836), took place just before the Peace of Amiens once again opened up the more usual Grand Tour routes. Recorded in a series of four notebooks, it included a seven-month stay in Berlin, and is of particular interest as Ridley later became a major art patron and collector. His letters,[178] together with those of his brother, Nicholas (1779–1854), later Lord Colborne, stand out from among those written by Northern tourists in that they chart an active attempt to buy Old Master paintings abroad. It is clear from Ridley's correspondence that his father had already formed a collection of Old Masters, which included a painting by Claude, and these are letters written from one connoisseur to another, as Ridley negotiated to buy a second Claude in Berlin, which, it transpired, was 'not one of his best, tho' without doubt an original and had certainly had the assistance of Mr Birch in the sky and some parts of the trees', and which, at seventy guineas, he asked the vendor to 'keep… safe for another purchaser'.[179]

Ridley's friend and travelling companion for much of his tour, Charles William Bigge (1773–1849), was also close to his brother Nicholas and to Sir Charles Monck, who later designed for him a second Greek revival house in Northumberland at Linden Hall, and in later life Bigge would join this group of prominent Northumbrians in membership of

the North's most prestigious cultural institutions, notably the Literary and Philosophical Society. Although, viewing the picture gallery and casts after the antique in Dresden, Bigge found the former 'food for innumerable visits', he was, according to Ridley, 'surrounded to his ears in pebble stones' (gemstones) during his tour, and it was left to Ridley, in tune with the new century's focus on paintings rather than antiquities, to pursue a taste for the arts that had 'not yet spread beyond a picture or a print'. He even judged those he met on his travels according to their abilities as a connoisseur, dismissing the King of Prussia as 'neither more nor less than a drill sergeant, to talk to him of a Claude, a Reubens, a Titian or a Terniers he is completely in nubibus'![180] He concluded regretfully, however, that the time for buying pictures cheaply following the French revolutionary wars was now past, and, beyond some prints, and a copy after Correggio, he does not seem to have bought anything on this tour. Nor was he, apparently, a proficient artist himself, as in the Tyrol he regretted not being a 'good master of the pencil'.

Ridley returned from the continent in August 1801 'perfectly convinced that real comfort & happiness is only to be found in England'. Although he later represented Newcastle in the House of Commons for twenty-four years, where, like so many Northern tourists, he was a proponent of Reform, he also spent a considerable amount of time abroad, principally owing to his wife's health, and the journals of his highly important tour of 1827–9, survive. Apart from the works discussed on pages 120 (note 152) and 227, however, it is in most cases impossible to determine which of the Old Master paintings formerly at Blagdon, and at the Ridley's London home at Carlton House Terrace, were acquired by the 3rd Bart, as opposed to his tourist father.[181]

Despite Charles Bigge's predilection for 'pebble stones', the catalogue of the sale held at Linden Hall after his death suggests a collection influenced even more decisively by Grand Tour tastes; among the paintings and prints included were landscapes by Nicolas and Gaspard Poussin (Dughet), Annibale Carracci and Orrizonte, an 'Architectural Piece' by Panini, a 'fine old copy' of Raphael's Galatea, views of the

Colosseum in oil and copies of Raphael's cartoons. As with Matthew White Ridley, however, these may well reflect the tastes of Bigge's tourist father rather than his own; also on the walls were several portraits of other Napoleonic era tourists, notably of Ridley himself, and his brother Nicholas.[182] Nicholas Ridley made the Grand Tour slightly later than Matthew White Ridley and Charles Bigge, just after the Peace of Amiens in 1802, and, as a result, was able to include France and Rome in his itinerary. Like his brother, Nicholas Ridley preferred Old Master paintings to sculpture, and his discussion of the arrangement of works at the Louvre, where the pictures of one school could be viewed together,[183] shows an early awareness of display in a public museum. Equally fascinating is his account of the over-cleaning of some of the paintings there, and his comparison of Veronese's *Marriage at Cana* with 'the figures in the picture at Blagdon'; this is not the only time in his correspondence when Ridley was able to relate Old Master paintings he had seen abroad to works in his Northern home.[184] It seems possible that he later acquired something of a reputation as a connoisseur, since at the 1832 Royal Academy exhibition, when he considered buying *The Falconer* by Joseph Severn, the sculptor Richard Westmacott noted that he was 'much looked up to', apparently in reference to his artistic as opposed to his political abilities.[185]

Nicholas Ridley's letters are also a mine of information on other contemporary travellers from the North, among them Charles Bigge's brother John (b. 1780), later Chief Justice of Trinidad, and John Brandling (1773–1847) of Gosforth Park. Brandling, who came from a prominent family of landowners and pit owners, was the younger brother of a slightly earlier tourist, Charles John Brandling. Like his brother's political opponent, Sir Charles Monck, he appears to have travelled in Greece.

OTHER TOURISTS 1800–20

Other tourists at this time included Sir Walter Calverley Trevelyan (1797–1879), son of Sir John Trevelyan of Wallington Hall, whose travels in Scandinavia in 1820–1 focused on natural history rather than culture.[186] Trevelyan would later

make an extended wedding tour abroad from 1835–8 with his gifted wife Pauline, and the Trevelyans' travels abroad, and patronage and friendship with the Pre-Raphaelites and their champion, John Ruskin, are discussed on pp. 229–40.

'Radical Jack' Lambton, later 1st Earl of Durham, who had already made the Grand Tour as a child, embarked on a second tour after the death of his first wife, Henrietta Cholmondely, in 1815.[187] Among the Catholic tourists of this generation were another former tourist, the writer Henry Howard of Corby Castle, Cumbria, whose tour of southern France for his health, accompanied by his wife Catherine and their family, was interrupted in March 1815 when they heard with 'the greatest dismay and horror' of Napoleon's escape from Elba,[188] and William John Charlton of Hesleyside (1784–1846), whose family had lived in the remote North Tyne valley since the 14th century, and had married two generations earlier into the Swinburne family (pp. 37–58). Charlton's tour followed in the wake of his father's education abroad at Douai from 1761–7.[189]

The continuing differences between the Grand Tours made by Northern Catholics in this generation and their Protestant contemporaries is highlighted in the life of George Silvertop (1775–1849), a friend and protégé of Henry Howard, who became an important figure in the movement to integrate Catholics into English political and civic life in the early 19th century. Silvertop came from Minsteracres near Hexham, an estate acquired by his grandfather, who had effected this family's transition from the coal trade to landed status. If the remoteness of Northern estates, even as late as 1784, is suggested by the disparaging comments made in that year by the resident Catholic chaplain, who found Minsteracres a 'wild, uninhabited place' where he lived 'almost as much retired as any of the ancient hermits', the links of this powerful Northern Catholic family to the continent were considerable; when the ten-year old George was taken abroad by his father, John Silvertop, to be educated at Douai, the president of the college waiting to receive them was none other than the Rev. William Gibson, who had spent fifteen years as chaplain at Minsteracres, and had tutored John as a child.[190] Silvertop's

studies at Douai were, however, interrupted when the college was attacked during the revolution by soldiers with drawn swords, who assumed that the boys were unwilling prisoners. George and two other English students saved the day by shouting 'Vive la nation!', whilst encouraging the soldiers out into the streets.[191] Fortunately, Silvertop and his brother returned home shortly afterwards, just before the declaration of war between France and England.

After commanding one of the volunteer corps formed during the Napoleonic wars to protect against invasion, Silvertop joined the general exodus abroad in 1814, visiting France and Italy, where, as a 'young man of high intelligence and polished manners, and an English Catholic of wealth and influence, he was admitted into the best society'. His travels even included an interview with Napoleon himself on Elba; however, the improbable suggestion that an incautious remark from Silvertop to Bonaparte, to the effect that the French government would renege on its promise of a pension, was one of the reasons behind Bonaparte's decision to quit Elba, belongs to the realm of myth;[192] when this event occurred, however, Silvertop found himself temporarily stranded in Italy between the Neapolitan and Austrian armies.

Silvertop's diplomatic skills, as suggested by this anecdote, evidently improved with age, as Lord Liverpool later selected him as his emissary to the Pope. He was also active in Whig politics and the Reform movement, and his support for Catholic emancipation led to his becoming, after its achievement in 1829, the first Catholic High Sheriff of County Durham. Silvertop's patronage of the classicising sculptor John Graham Lough, who was born at Shotley, near Minsteracres, and whose works lined the staircase there, confirms that he shared the tastes of other Northern tourists, notably another major Lough patron, Sir Matthew White Ridley 4th Bart.; although Silvertop wished Lough to go to Rome, however, 'to study the models of the great Italian sculptors', offering to 'defray his expenses',[193] Lough refused, and his eventual visit there was not made under Silvertop's auspices.

In common with many Northern tourists, Silvertop's tour seems to have impelled him towards building, as Minsteracres was enlarged, by John Dobson, in 1816, soon after his return. To judge by Lough's reactions on his first visit there, Minsteracres may also have housed an art collection of considerable importance: Benjamin Robert Haydon reported that 'to see Canova's works did not prick him, but Michael Angelo affected him deeply',[194] while much earlier, in 1788, under George's father, the family's Catholic chaplain had been alarmed enough at the nakedness displayed in some of the paintings to consult a relative as to what attitude he should adopt towards their display.[195] Unfortunately, no evidence links any of the Silvertops' purchasing activities with George's Grand Tour. Like other Northern Catholic families, however, they had concrete links with the continent through religious and military service abroad, and George's youngest brother Charles became a Colonel in the Spanish service, receiving from Ferdinand VII the Supernumerary Cross of the Order of Charles III.

END NOTES

1 The projected square, designed by Giovanni Antolini, was abandoned in 1802. See Carroll William Westfall, 'Giovanni Antolini's Foro Bonaparte, Milan', *Journal of the Warburg and Coutauld Institutes*, vol. 32, 1969, pp.366–85.
2 *Grand Tour*, Tate Gallery, p. 272.
3 Anderson MSS., 1st January 1802; see *Bibliographical Note*.
4 For William Ord's diaries, see *Bibliographical Note*.
5 Ord MSS., 24th February 1815.
6 Anderson MSS., 600/15/3, 31st July 1814.
7 Ord MSS., 3rd September 1817.
8 In April 1816, Major Anderson, who had served under the Duke of Wellington in the Peninsular War, visited Waterloo, and either here or in Paris purchased a map of the battlefield on which he recorded the names of the officers of the 2nd Light Battalion killed there. This was: *Théâtre de la Campagne de 1815*, engraved by Martin, and published in Paris by Genty.
9 *Turner Society News*, No. 54, February 1990, pp. 12–15. For the information on Turner's and Lowson's tour which follows, I am indebted to her publication, and those of David Blayney Brown and David Hill; see *Bibliographical Note*.
10 Brown, p. 13. See, however, Brown, pp. 29–30 and p. 185 above for the puzzling story related by Turner's early biographer, Walter Thornbury, which suggests that the two men's relations were far from friendly.

11 A sure sign that the family had only recently acquired landowning status – which at this period went hand in hand with membership of the established church – can be found in the young Lowson's Methodism.

12 See Powell, p. 13; Hill, p. 21. As Hill points out, Lowson celebrated his twenty-ninth birthday in Switzerland in September 1802. A sketch of Lowson survives in the University of Durham Library.

13 His application was processed on 12th July.

14 Powell, p. 13: see p. 186 above for Lord Darlington's patronage of Turner.

15 Turner had, of course, passed through County Durham on his tour of the North of England in 1797.

16 Brown, pp. 12–13.

17 22nd – 23rd November 1802; quoted in Powell, p. 12.

18 For Turner's presumed sketching habits, and the transport of large-scale sketchbooks such as the *St. Gothard and Mont Blanc* books, see Powell, p. 12. Another example of the benefits of Turner's escorted tour is provided by the hire in Paris of a Swiss servant, or guide. His presence enabled Turner to record the names even of the less familiar sites he visited, a practice he would not repeat on later tours.

19 Farington *Diary*, 1st October 1802; quoted in Hill, p. 8.

20 According to the local journalist and historian Matthew Richley, writing in the *Auckland Times and Herald* for 22nd November 1894 in his weekly column, 'Our Local Records', the pocket book was then in the collection of George Pears. See Powell, pp. 12–13. She notes on p. 14 that she has tried without success to trace it.

21 We know from Farington's *Diary* (23rd November, 1802) that their expenses averaged seven shillings a day, with an additional half guinea for the travel costs themselves; quoted in Powell, p. 12. Whether the sketches in the pocket book were the work of Turner himself, of Lowson, or the combined work of the two, is uncertain. Lowson certainly made sketches of peasant costume on his 1816 tour (p. 185), so the sketches of 'Italian peasantry' may well have been his.

22 Hill, p. 11.

23 Tate Gallery, London.

24 Brown, pp. 14, 21.

25 Op. cit., p. 14.

26 Op. cit., pp. 27–28, 26.

27 Andrew Wilton, *Turner and the Sublime*, 1980, p. 116.

28 On 22nd November 1802, Turner told Farington: 'Most of sketches slight on the spot, but touched up since many of them with liquid white, and black chalk'. Quoted in Brown, p. 23.

29 John Ruskin, however, later dismembered the album, also detaching their labels. See Brown p. 24.

30 Quoted in Powell, p. 13; Brown, p. 30.

31 Brown, p. 29.

32 For the watercolour apparently given to Lowson by Turner, see Powell, pp.12, 14; by 1862 this belonged, according to Walter Thornbury, to Lowson's housekeeper, Elizabeth Garthwaite. According to Matthew Richley in 1894, this was painted by Lowson but finished by Turner. Richley gives the provenance as follows. The picture is said to have been given by Lowson to an old woman in the village. It afterwards 'fell into the hands' of his Housekeeper Elizabeth Garthwaite, and subsequently appeared in the late Mrs. Cannay sale, then being sold via a dealer to a canon of Durham Cathedral. By 1894 it was hanging

in the drawing room of a 'respected townsman', in Bishop Auckland, Mr G.W. Jennings. For the mezzotint, see Powell, p. 14.

33 In Turner's *Guards sketchbook*, now in the Tate Gallery (TB CLXIV).

34 Exhibited at the Royal Academy in 1818, and now in the Walters Art Gallery, Baltimore. The sketchbook is in the British Museum.

35 Matthew Richley, writing in the *Auckland Times and Herald* for 22nd November 1894 in his weekly column, 'Our Local Records'; quoted in Powell, p.14.

36 Powell, p. 15

37 Intriguingly, Turner's sketches of Raby include one of the hunt there.

38 According to Matthew Richley, see note 20.

39 Anderson, 1820, p. i; 1812, p. 11. Anderson's references in his books (1812, pp. 7, 10, 1820, pp. i, ii) to his sources confirm that he was well read on the subject of medieval architecture. His first source was Carter himself – another eccentric but talented antiquarian, who, like Anderson, believed, wrongly, that the pointed arch had originated in England. However, Carter's antiquarian credentials are impressive. Following his introduction to the Society of Antiquaries in 1780, he began work on a project to publish all the medieval ecclesiastical buildings of England: *The Ancient Architecture of England* was published from 1795–1814. Carter's drawings of St Stephen's Chapel in the Palace of Westminster in 1795 represented 'the first serious archaeological reconstruction of an English Gothic building', and Anderson's familiarity with his work confirms that he was *au courant* with the latest developments in his chosen field of study. See below, note 75 for Carter's probable influence on Anderson's own ecclesiastical drawings. For Carter, see Grove, *The Dictionary of Art*, 1996, vol.5, p. 890. Anderson's other principal source was Mr. Whittington, who took the opposite, and correct, view that the Gothic arch originated in France.

40 Anderson MSS., see *Bibliographical Note*.

41 This was first drawn to my attention by Alastair Laing.

42 Anderson MSS., 14th December 1801.

43 Anderson, 1812, p. iv.

44 Anderson MSS., 19th February 1802; op. cit., 27th March 1802; 19th December 1801. The church was pulled down the following year.

45 The book was published in the following year; three years after the Andersons' visit, in 1804, Napoleon appointed Vivant Denon director-general of French museums, including the 'Napoleon Museum', now the Louvre. Anderson's interest in Egyptian antiquities is attested not only by this visit to Denon, but by his later interest, at the Bibliothèque Royale, in 'a magnificent book on the Egyptian Temples at Philai'.

46 Anderson MSS., 8th, 21st April 1801. Of the costume drawings, Anderson notes: 'We saw Monr. Hogness the Painter's General works, views of the Lakes – dresses of the different Paysants etc we should have bought some but he asked so extravagant a price – they were not very capital'. Slightly earlier, in Basel, on 12th April, the Andersons appear to have visited the same studio patronised by John Carr in 1789, that of the well-known Swiss engraver, publisher and dealer Christian von Mechel (1737–1817), whom Anderson refers to as Mr. Michel.

47 Anderson MSS., 5th July 1802.

48 Jones, *Memoirs*, p. 117.

49 The Andersons saw 'all his paintings viz. 2 views of St. Francis cave at Vallentrosa that he asks 300 secquins for. 2 others of a lesser size

40£ each & 2 others of rather a smaller size again 30 guineas each'. Fortunately, the receipt and shipping bill for this transaction, dated London, 1st June 1805, survives. Hackert was paid £60 for the two landscapes, which suggests that Anderson had chosen the smallest of the three sizes he was offered; the total cost, including packing, carriage to Leghorn, shipping on the *Rebecca*, quarantine and wharfage charges in London, and duty was £74 –14 – 6. By this late stage in his career, Hackert was clearly recycling earlier compositions: Anderson's painting of Narni is closely related to a drawing of around 1776, while his view of the falls at Terni is close to a Hackert oil of 1779; see Nordhoff & Reimer cats. 1296 and 131.

50 Anderson MSS., 17th July 1802.

51 Anderson MSS., 660, Box 1, uncatalogued: 13th September 1802; 14th September 1802, and continuation of 2nd diary, 660, Box 1 uncatalogued, 27th April 1803.

52 Anderson MSS. 5th October 1802; see also Swinburne, 1785, II, pp. 219–221.

53 Anderson's only purchase in Rome seems to have been a set of four watercolours by the Swiss topographical artist, Franz Kaisermann (fig. 30), who continued into the early 19th century the tradition of Grand Tour views.

54 Among the several references in Anderson's diary to both artists, see especially 4th December 1802 for Bernini's *Apollo and Daphne*, which he considered would 'appear as a masterpiece were the others [classical statues at the Villa Borghese] not there', and 16th January 1803 for the Caravaggios in the Palazzo Giustiniani. Caravaggio's reputation had originally suffered by comparison with Bolognese classicism, and, following the criticism of Bellori in 1672, he was demonised for painting the '"vile" things of unidealised nature' (wwwgroveart.com, Caravaggio, V, Critical reception and posthumous reputation, p. 2). However, after a century out of fashion, his work began to be admired again around the time of Anderson's tour, with the advent of Romanticism and its belief in individual genius. Reactions to Bernini from the 18th century onwards, although almost equally critical, were somewhat different. To the Age of Enlightenment, his *Ecstasy of St Theresa* appeared to traffic in false emotion, while the Neo-Classicists considered he had violated Classical ideals 'in favour of sensuous appeal' (www.groveart.com, Bernini, IV, Critical reception and posthumous reputation). His work remained unfashionable right up to the 20th century, so Anderson's appreciation was perhaps somewhat in advance of his time.

55 Anderson MSS., 26th November, 5th December 1802, 18th January 1803. On a previous visit to Canova's studio, on 22nd December 1802, they saw a *Hebe* and *Amor & Psyche*, both for Madame Bonaparte, a colossal statue of the Queen of Naples as Minerva, and a *Hercules* for the Marquis Torlonia.

56 Anderson MSS., 26th March 1803.

57 I am grateful to Emma House at the Bowes Museum for providing this information from the museum's files. Given that Anderson's diary ends in Copenhagen in August 1803, a large question mark must remain over whether he in fact sailed back to England from France, or from Scandinavia.

58 Quoted in *Canaletto, Paintings and Drawings*, Queen's Gallery, London, 1980–81, p. 21.

59 Elizabeth Conran (et al.), *The Bowes Museum*, London, 1992, p. 49.

60 It thus postdates the Royal Collection version of the Regatta, which carries the arms of the previous Doge, Carlo Ruzzini (1732–5).

61 Anderson, 1812, p. 5; Preface p.iii; see *Bibliographical Note*. His volume on St. Denis, unlike his later *Tour through Normandy* (pp. 193–4 above), had a London publisher, J. Taylor; the copy formerly in the Royal Library is now in the British Library (202.f.11).

62 Op. cit., pp. 10, 10–11.

63 Op. cit., Preface, p. iii.

64 Anderson afterwards visited the battlefield of Waterloo, where he picked up a French cavalry sword, which survives in a private collection.

65 The difficulty stems from the fact that Major Anderson seems to have abstracted the notes in his diary for use in his 1820 publication on the churches of Normandy.

66 Black, p. 24

67 Anderson MSS., Diary, 1815–16, 660/15/4, undated (between 27th January and 2nd February 1816).

68 Anderson, 1820, p. 12.

69 Many of Anderson's original grey wash drawings survive in a private collection, as do a number of the copper plates engraved from them, surely confirming that other plates were intended.

70 I am grateful to colleagues in the Bewick Society for pointing out the probability that the plates are by Robert Bewick.

71 Several of the plates are clearly unfinished, lacking details such as the titles, and the names of the engraver.

72 Anderson, 1820, Preface, p. iii.

73 Ibid.

74 I am grateful to Alastair Laing and Dr. Lindy Grant for this identification.

75 John Carter, whose writings on Gothic architecture probably influenced Anderson's own (see note 39 above), also produced a number of drawings of English cathedrals between 1797 and 1813, to accompany his Society of Antiquaries publications. These included detailed plans, elevations and views, and may well have provided the model for Anderson's own.

76 I am grateful to Alastair Laing for suggesting that Anderson would have trained at Woolwich; Sloan, 2000, points out that drawing lessons were an essential part of a cadet's training.

77 Anderson was a major patron of Carmichael. A series of the drawings he owned, including Carmichael's finished sketch for Ascension Day (now in the Laing Art Gallery), was exhibited at the Dean Gallery, Newcastle upon Tyne in 1991.

78 Marshall Hall, *The Artists of Northumbria*, revised edition, 2004, p. 145. Interestingly, the artist declined the offer, owing to the 'subordinate opposition he would have had to accept'. Although Gray was hardly a tourist in the usual mode, this scientifically-minded artist visited North America from 1787, and was later employed by a Prince Pontiatowsky to report on the geology of Poland; loc. cit.

79 The Giordano painting is still in the possession of the church, and has recently been confirmed as an autograph work by the artist. For the episode concerning the Town Clerk, see Welford, vol. 1, p. 61.

80 See *Bibliographical Note*.

81 24th October 1804; 14th November 1804; 15th November 1804; 24th October 1804.

82 Op. cit., 19th and 24th October 1804.

83 Op. cit., 16th January 1805; 2nd December 1804; loc.cit.; 24th January 1805.

84 No longer accompanied by Lady Monck's brother, George Cook, who had returned home from Venice.

85 Monck noted on 13th February 1805 that the frigate's captain was likely to be Captain Bennett, brother of Lady Swinburne, Monck's near neighbour in Northumberland.

86 Monck Journal, 2nd April 1805; 16th April 1805; 7th April 1804; loc.cit.

87 For the identification of the man Monck refers to throughout as 'Baker', see Richard Hewlings' article on Monck and the building of Belsay (details in *Bibliographical Note*), p.18.

88 Lusieri arrived in Athens 1800 in with a team of craftsmen. By the time Lord Elgin himself first visited Athens in 1802, much of the material had been removed and crated. When Elgin's embassy ended in January 1803, he visited Athens on his way home and took most of the artists he was employing home with him; only Lusieri remained, continuing to collect until 1805. The last consignment left in 1811.

89 Monck Journal, 4th May 1805.

90 This is today known to be instead a temple to Hephaestus and Athena.

91 Monck Journal, 18th August 1805; 21st June 1805.

92 To judge by those which survive in his Journal. For the Aegina temple, see Monck Journal, 5th July 1805. Another example of Monck's picturesque approach to ruins can be found in his description of how the appearance of the columns of the Temple of Jupiter Olympius was heightened by a flock of goats taking shade amongst them (*Journal*, 12th May 1805).

93 Monck Journal, 22nd May 1805; 18th June 1805.

94 Op. cit., 24th May 1805; 10th July 1805.

95 On this return journey Monck commissioned a mould in gypsum of a Greek well, later buying, back on Zakynthos, a classical cameo of Hercules, and taking plaster impressions of other gems belonging to a Greek collector there.

96 Over two hundred of his drawings for Belsay survive in the Northumberland Record Office. It seems possible that Sir Charles rejected the caryatid design because of doubts as to the ability of local craftsmen to carve them in local sandstone; see Roger White, *Belsay Hall, Castle and Gardens*, 2005, p. 15.

97 For Hewlings' article, see *Bibliographical Note*; the account given here on the building of Belsay is greatly indebted to his work.

98 That is, in the same plane as the wall, as opposed to projecting; Monck was aware that projecting porticos were used in Greece only for temples; see White, p. 40.

99 As regards Belsay's relationship to the Landhaus Mölter, Hewlings has shown that Monck sketched the Brandenberg Gate only a few yards away, so he must have seen it. In the Landhaus Mölter, however, the columns do not rise through two storeys, as at Belsay; instead they are combined with an overhead lunette. For stone halls, Hewlings has pointed to links between Belsay and Packington Church, Warwickshire, which also had a stone interior, and was owned by the Earl of Aylesford, a friend of Henry Swinburne, even suggesting that Aylesford, via Swinburne, may have persuaded Monck to visit Greece – a possibility that should not be discounted.

100 Hewlings notes that the Library frieze, for instance, was based on the Temple of Nemeisis at Rhamnos, which Monck did not visit, but which appears in the 1817 publication by his former Athens companion, Sir William Gell, *Unedited Antiquities of Attica*.

101 Where no Greek precedent existed, as with the Pillar Hall, Monck sometimes had to content himself with a Roman or modern Italian solution; the imitation marble chimney piece in the Library, and the alabaster vases that originally topped the bookcases, were supplied by the Livorno firm of Michali and Co; see White, p. 11.

102 No less than thirty-six other Greek revival houses had been erected between the earliest recorded example in 1758, and Monck's Northumbrian villa; see David Watkin, *Thomas Hope and the Neo-Classical Idea*, 1968, p. 246. The house occupies a more secure footing, however, as one of the earliest buildings in the North to be erected in the new Greek manner; see Hewlings, p. 8. Another important local building in this style is All Saints, Newcastle, 1786–96, by David Stephenson.

103 White, p. 43.

104 Hewlings, pp. 17–20.

105 White, p. 39, points out that he was as likely to record birds, trees or fruit in his diary as to make architectural observations.

106 Welford, vol. 3, pp. 238–9; Ord Diary, see *Bibliographical Note*, 15th October 1814; 29th September 1815; for Ord's continuing concern about nuns taking the veil see also 12th November 1815; confirmation that his reaction was one shared by other tourists can be found in Black, p. 240.

107 Creevey Papers, ed. H. Maxwell, typescript, British private collection, Vol. IX, 1815. Mrs Whitbread to Creevey, 24th March 1815; Elizabeth Ord to William Ord, 9th July 1815; Thomas Creevey to Charles Ord, 25th June 1815.

108 Ord Diary, 27th August 1814.

109 Op. cit., 5th, 23rd September 1814.

110 He wrote that David's paintings 'have merit in the drawing' but 'they are totally deficient in mind & composition'. Ord Diary, 15th September 1814.

111 Ord Diary, September 10th 1814; 7th October 1814.

112 To judge from the surviving record of the tour later pasted into an album; see pp. 205–6.

113 Ord Diary, 21st October 1814; 22nd October 1814; 24th October 1814; 22nd October 1814.

114 Some of these Florentine watercolours and drawings may date from the Ords' return journey through Florence in the winter of 1815–16.

115 Op. cit., 3rd November 1814; 7th November 1814; 14th and 15th November 1814.

116 Op. cit., 5th – 9th November 1814; loc.cit; 13th December 1814.

117 Op. cit., 13th December 1814. As William Ord saw 'the Graces' in December, the version concerned must have been the one ordered by Josephine de Beauharnais, not the second one ordered very shortly afterwards by John, 6th Duke of Bedford in January 1815, and now owned jointly by the National Gallery of Scotland and the Victoria and Albert Museum.

118 Op. cit., 25th December 1814.

119 Op. cit., 12th March 1815; 23rd March 1815; 12th April 1815.

120 Op. cit, 17th June 1815.

121 Chaney, 1998, p. 281. See pp. 278–313 for his definitive study of Milton's supposed visit to Vallombrosa, and its impact on later tourism. Chaney notes that visits to Vallombrosa were underway by the mid to late 1780s; among the earlier visitors was J.R. Cozens in 1783. By 1815, the Ords would have been able to consult popular guides and travelogues such as those by Joseph Forsyth and John

Chetwode Eustace, both based on 1802 tours but published in 1813. The vogue for visiting Vallombrosa continued into the late 19th century.

122 Chaney, p. 289.

123 Ord Diary, 15th July 1815

124 Op. cit., 26th July 1815.

125 Op. cit., 12th August 1815.

126 Op. cit., 26th July 1815. This was presumably the famous marble on this same subject, the *Fury of Athemas*, commissioned by the 4th Earl of Bristol in 1790, and today at Ickworth, where it dominates the Hall; although commissioned in 1790, it had been confiscated by Napoleon's troops, and was still in Italy at the time of the Ords' visit.

127 Op. cit., 23rd August 1815. Other tourists also saw the city through Canaletto's paintings: in 1785 Mrs. Piozzi's first sight of Venice 'revived all the ideas inspired by Canaletti', 'we knew all the famous towers, steeples, &c before we reached them'; *Canaletto, Paintings and Drawings*, The Queen's Gallery, London, 1980–1, p. 23.

128 Op. cit., 12th November 1815.

129 Clearly, Ord relished his return to French soil; his first drawing of France is inscribed: 'La Belle France!'; the family's route northwards to Paris was through Lyon, Macon and Troyes.

130 Ord Diary, 16th June 1816; 5th July 1816. Some Waterloo *memorabilia* acquired by Ord survives in a private collection.

131 There is a gap in the diaries between September 1816 and January 1817, only partially filled by Ord's sketches, which confirm that they visited Spa, Aix-la-Chapelle, Coblenz, Bonn, Mayence and St. Goar; he also made a number of sketches along the Rhine.

132 Ord Diary, 22nd June 1816; 21st January 1817.

133 Ord bought two important Varley watercolours at The Water Colour Soceity in 1805. Other Northumbrian patrons were Sir John Edward Swinburne (pp. 52–3), the Countess of Tankerville and her tourist son, Lord Ossulston (p. 148).

134 For example, Ord's finished drawing of Ariccia, which also comes close to much earlier views of Ariccia by Jonathan Skelton and others.

135 The album, which is titled simply 'Sketches', in black pen, on the marbled covers, has a leather spine and includes the original (damaged) ties; the sketches are pasted onto grey-beige paper, and are in remarkably fresh condition.

136 For example, the Florentine drawings, which date from two separate stays in the city in 1814, and in the winter of 1815–6, all appear together, early in the album, while the convent of Vallombrosa, visited only on the Ords' return north in July 1815, is included as one of the earliest drawings in the album, just after their crossing of the Alps and first visit to Florence in 1814.

137 Newbey Lowson (pp. 208–11) also met a Miss Eden in Milan on 1st August 1816.

138 Eden, p. 4.

139 Eden, p. 3. I have not been successful in tracing any of these works.

140 Op. cit, pp. 3, 6, 3.

141 As with the drawings, it has not proved possible to trace these; presumably they have not survived.

142 The painting was in the collection of Eden's son in 1909, and was presented to the National Gallery in 1922. See also Eden, p. 6.

143 *Country Life*, 8th January 1970, p. 76.

144 Eden, p. 7

145 As they had married only recently, this may have been intended principally as a wedding tour.

146 Lord Darlington's Journal is in the archive at Raby Castle; like some of his earlier journals, it is written in French. The Lowson Journal is in Durham University library. According to a note on folio 1 (recto) of the ms, it is a copy from one by Lowson in the possession of Mr. R. D.Ward and given by Lowson to Mrs. Ward (formerly Miss Bowser, whose guardian he was). The Journal has no date, but can definitely be dated to 1816 from the events mentioned in it, and from a comparison with Lord Darlington's dated tour journal. See *Bibliographical Note*.

147 Lowson Journal, p. 71, 8th August 1816. This was presumably the famous picture today in Basel.

148 Op. cit., p. 20, 2nd July; ibid.

149 Darlington Journal, 2nd July 1816: 'rien ne peuvent être plus beaux que les Tableaux de tous les deux'. Lowson Journal, 2nd July 1816: 'There is also another gallery called the Gallery of Vernet which contains several good pictures of that master'. The Vernets they saw were the 'Ports of France' series.

150 According to Catherine Vane, Duchess of Cleveland, *Handbook of Raby Castle*, 1870.

151 Lord Darlington and Newbey Lowson journals, 2nd July 1816.

152 Lowson Journal, 21st June 1816; 25th June 1816. For the Napoleonic elephant see Simon Schama, *Citizens*, pp. 3–5.

153 Op. cit., 26th June 1816; 30th July 1816; 11th July 1816; ibid; 15th July 1816.

154 Op. cit., 18th July. Although Lowson, on leaving Berne, complained that the peasants were no longer picturesque, being 'little distinguishable from the lower orders in England', he did show some concern for the conditions under which they lived, noting near Wurtemberg that, owing to the destruction of crops by hail, the inhabitants might be reduced to 'living in a great measure on black beetles' 17th July, 14th August 1816.

155 Op. cit., 11th July 1816; 30th July 1816.

156 Op. cit., 21st July 1816; 26th July 1816; 24th July 1816.

157 Darlington Journal, 29th July 1816.

158 The Princess bought the Villa Gavoro, Como, in 1815.

159 Lowson Journal, Preface, p. iv.

160 The 1870 *Handbook of Raby Castle* lists a large number of Dutch paintings attributed to de Hooch, Teniers, van Huysum, Miereveldt, Jan Steen, Ostade, van Mieris, Dou and Van der Neer.

161 There were other Italian works by or attributed to Carlo Dolci, Maratta, Guido Reni, Daniele da Volterra, Leandro Bassano, Orizzonte, and Bonifacio.

162 *The Marriage of St Catherine*, copy after Caravaggio in the Louvre; *St. Peter and St. Paul interposing to protect Leo II from Attilla*, copies from Raphael's fresco in the Vatican; *Head of St. John*, copied from Raphael's *Madonna della Seggiolo* in the Pitti Palace.

163 For this seminal article, see *Bibliographical Note*. The material on Ingram that follows is greatly indebted to it.

164 Haskell, p. 258.

165 Haskell, pp. 262, 269 (quoting John Strange, who served as British resident in Venice, 1774–86).

166 Op. cit., p. 266, and note 48 on pp. 266–7.

167 Op. cit., pp. 263 (Vianelli), 261 (della Lena).

168 Ingamells, pp. 541–2. A tourist called Ingram is also recorded in Naples in 1792.

169 Haskell, p. 271, quoting *A Catalogue of the Pictures, Busts, Bronzes etc., at Hendersyde Park*, 1859, p. x. The source for the statement that the collection was lost at sea is the author of the Preface; unfortunately he gives no details of its contents.

170 He arranged dancing lessons for his children in 1822, and his son applied for a hunting license in 1826; Haskell, note 68, p. 271.

171 Op. cit., p. 271, note 66; the painting was bought by Langton Douglas from Miss Lilian Godfrey, a descendant of Ingram.

172 Langton Douglas, the buyer of eight of Guardi's works at a sale at Christie's on 15th March 1929, records that he had bought some pictures 'painted for Ingram, the English dilettante, who was a friend of Guardi'; Haskell, p. 271, note 66.

173 Haskell, p. 272.

174 The vogue is epitomised in the astonishing purchase, the day after his arrival in Venice in 1828, of ninety-six of the artist's paintings by the Hon. George Agar-Ellis, later Lord Dover (Haskell, p. 273).

175 Haskell, p. 275.

176 Three paintings by Guardi appeared in the sale at Christie's on 15th March 1929 referred to in note 172 above. They were almost certainly consigned by the Godfrey family, one of whom had married Ingram's daughter Augusta, a pupil of the Venetian engraver Francesco Novelli. See Haskell, p. 272, note 71, who gives the full provenance and details of these. Today two of the paintings are at Temple Newsam and in the Houston Art Gallery, Texas. The third, a view of the *Doges' Palace and the Molo from the Bacino di S. Marco* was in the collection of Capt. H.E. Rimington-Wilson in 1954/5. Two further Ingram Guardis were sold in 1938; in 1985 they were in a private collection in Paris.

177 The collection of drawings at the Royal Museum, Canterbury given by Ingram's descendant, Ingram Godfrey, in 1899, includes nine drawings by Francesco and three by Giacomo Guardi, as well as twelve drawings by Domenico Tiepolo and a small group of Canaletto etchings.

178 For both diaries and letters see Ridley MSS. in *Bibliographical Note*.

179 Ridley MSS., Matthew White Ridley, letter to his father, 2nd April 1801.

180 Loc. cit.

181 Ridley MSS., ZRI 32/3/2. See note 152 on p. 120 for a discussion of the Old Master paintings in the Ridleys' collections, and their purchasers.

182 *Catalogue of sale of the contents within Linden House, Northumberland* by Mr Samuel Donkin, Alnwick, 1861.

183 When Dominique Vivant Denon became Director-General of the Louvre, he decided to arrange works chronologically and by school so as to maximise their educational potential. Ridley's visit, however, just precedes his appointment in 1804.

184 Nicholas Ridley had also seen Guido Reni's *Nessus and Deinira* (sic) of which his father had bought a copy by J Serragninga. Ridley's letter to Lady Ridley (Ridley MSS., 20th April 1802) suggests that she, too, had travelled abroad: 'Venice is not half so gay as it must have been when you was here'. Although it is known that her husband, the 2nd Bart, had made the tour as a young man in 1765–66, this is the only evidence to suggest that he probably made a later tour with his wife; this is surely inherently more likely than that Lady Ridley made the tour before her marriage (as Sarah Colborne). To judge from the references to Old Master paintings in Nicholas Ridley's letters to his father, the 2nd Bart's taste in paintings was conditioned by his tour or tours abroad.

185 Sharp, p. 172. Ridley, now known as Mr Ridley Colborne, 'stood before it a long time lately and enquired all about it'; letter from Richard Westmacott to Joseph Severn, June 1832.

186 Trevelyan's tour journal is in the Northumberland Record Office; see *Bibliographical Note*.

187 Bro. John Webb, 'John George Lambton, The First Earl of Durham', *Transactions of Quatuor Coronati Lodge*, 9th May 1996, p. 119.

188 Howard, II, p. 146.

189 William Charlton is recorded at St Gregory's, Douai in 1763; see Ann M.C. Forster, *Ushaw Magazine*, vol. LXXII, no.215, July 1962; Hodgson's pedigree, however, gives the dates of his education abroad as 1761–7. Records of William John's 1803 tour are in a private collection. Like other Northern Catholic families, the Charltons also had a network of contacts with the continent in terms of both education, residences and marriages abroad; at least one other family member, Edward, had been educated abroad, in this case as early as the 1670s, while William's grandfather, father and aunt lived at Dunkirk for some years before 1736, and two of William John Charlton's daughters married into the Italian aristocracy.

190 Frank Dobson, *The Life and Times of George Silveretop of Minsteracres*, Newcastle upon Tyne, 2004, pp. 26–7, 39.

191 Op. cit., pp. 44–5.

192 Welford, vol. 3, pp. 396, 396–7.

193 George Neasham, *Views of Mansions & Places of Interest in the Lanchester & Derwent Valleys*, Durham, 1884.

194 Dobson, p. 156.

195 Op. cit., p. 153.

Later Tourists
1820–70

Fig. 154
Miss Jemima Morrell's party on Cook's first Swiss tour,
sepia photograph, 1863

Fig. 155
Group of tourists at Pompeii,
sepia photograph, 1868

Fig. 156
Group of tourists in Egypt,
sepia photograph, 1890

Thomas Cook's first tour abroad in 1855 marked the ending of a period in which travel was confined to a privileged minority and the beginnings of tourism, if not yet for everyone, then at least for the middle classes, in an age which saw incomes in Britain soar as a result of the industrial revolution. Group tours like the ones of Switzerland, Pompeii and Egypt illustrated here (figs. 154–6) led directly to the package holidays of today.

The introduction of the steamboat, and regular passenger services by sea, and the rapid development from 1825 onwards of a rail network throughout Europe, greatly reduced the difficulty and cost of travel abroad and the enormous savings in time created by these developments meant that tourists could now make short trips abroad as a relaxation from the workplace. Few paintings could give more of a flavour of the tourism of the new railway age than one by Edward Frederick Brewtnell (fig. 157), which shows a Victorian couple, almost certainly on their honeymoon, pouring over the map of Europe to decide *Where Next?*

The expansion of the British Empire under Queen Victoria in the second half of the 19th century to include India and Africa also had a major impact on tourism. Although many British visitors went to these countries to work, the lifestyle abroad for those who could afford it was both leisured and exotic, and writers from Rudyard Kipling to Somerset Maugham and Paul Scott have left memorable accounts of it. The development of the ocean liner meant that regular travel now opened up between Britain and America, and this was the age of economic migrants both to the United States and to Australia, seeking, as in Ford Maddox Brown's *The Last of England*, to escape harsh working conditions in industrialised Britain.

Fig. 157 *Where Next?* by Edward Frederick Brewtnall, watercolour and bodycolour

In 1820, however, many of these developments were still in the future, and most, though not all, later tourists from the North, particularly in the decades from 1820–1840, still followed the leisurely pattern of travel and art collecting established in the 18th century; for Northern tourists, indeed, 1840 provides a much more convincing terminus for the Grand Tour than the Napoleonic invasions of Italy in the closing years of the 18th century, embracing the travels of Sir Matthew White Ridley, the wedding tour of Walter Calverley and Pauline Trevelyan from 1835–8, which led to the recreation, back at Wallington, of the courtyard of an Italian *palazzo* in Northern climes, and the extraordinary journeys – often on foot – made by Dr. Edward Charlton, scion of a Catholic landed family.

The North's greatest collection of Old Master paintings, the Camuccini collection, was acquired by the 4th Duke of Northumberland in 1854 following a visit to Rome, while John Bowes, co-founder, with his wife Josephine, of the Bowes Museum at Barnard Castle, also began as a collector in the Grand Tour tradition after an early soujourn abroad. The formation of the North's only important collection of classical sculpture, by William, 3rd Earl of Lonsdale, at Lowther Castle near Penrith – although geographically outside the remit of this book – also occurred at this time. One of the very last collections in Britain to focus on the antique, it was assembled from around 1848 until the Earl's death twenty years later, and housed in two galleries at Lowther Castle specially designed to

receive the sculptures; perhaps fortunately, the grandiose schemes of another Northern collector, Sir Matthew White Ridley 4th Bart, to house replicas of the Elgin marbles at Blagdon did not, in the event, materialise.

As in the 18th century, large numbers of British artists still lived in Rome, catering to the needs of tourists such as Sir Matthew's father, the 3rd Bart., or the Trevelyans; many of the earlier arrivals came on the recommendation of the President of the Royal Academy, Sir Thomas Lawrence. Although Canova died in 1822, the other great 19th century sculptor, Bertel Thorvaldsen, remained in Rome until 1838, his studio acting as a magnet for tourists, while for the flourishing contingent of British neo-classical sculptors this was something of a golden era, as patrons turned increasingly to contemporary practitioners to fill the sculpture galleries that, as at Chatsworth, had become an important component of the British country house at a time when the supply of high quality antique marbles had finally dried up. Among the sculptors drawn to Rome by the fact that 'Sculpture....carries away all the patronage'[1] were John Gibson, Laurence Macdonald and Jospeh Gott, all of whom worked for Northern patrons. Painters included Joseph Severn, remembered by posterity as the friend who accompanied the dying Keats to Italy in 1820. During this period the long-lasting vogue for the classical landscape finally mutated into a new penchant for brightly coloured landscapes filled with 'anecdotal or picturesque incident', and for genre scenes of Italian life.[2] These were practised by artists such as Severn himself, Penry Williams and Thomas Uwins.

If the Italian tours of Charlton, Sir Matthew White Ridley, 3rd Bart., and the Trevelyans illustrate the perpetuation of the Grand Tour, with its corollary taste for Old Master paintings and antiquities, well into the 19th century – although, significantly, Ridley belonged to an older generation, whose experience of foreign travel had been formed when the Grand Tour was at its height – some of the tours made in this period by the North's cultured elite reflect instead the changing patterns of 19th century tourism. Tours further afield, which had begun during the Napoleonic period,

continued to grow in popularity. In 1842 the well-travelled Trevelyans made a pilgrimage to Greece, while Algernon, Lord Prudhoe, later 4th Duke of Northumberland, became a pioneering tourist in Egypt from 1826–9. Other developments of the Napoleonic era also continued unabated: as the period progressed, the search for Alpine sublimities led to the development of a new sport: mountaineering. Not only the peaks themselves, but the Rhine valley, with its dramatic falls at Schaffhausen, spectacular setting for Sherlock's Holmes's eventual demise, drew many travellers; the Italian lakes were the other most popular destination for those making shorter tours.

THE GRAND TOUR CONTINUED

SIR MATTHEW WHITE RIDLEY, 3RD BART., (1778–1836)

Around 1828–30 the fifty-year-old baronet Sir Matthew White Ridley, 3rd Bart, made a second major tour abroad.[3] Interspersed with a short visit to London and his Northumbrian seat at Blagdon in the summer of 1829, this embraced Rome, Naples, southern France and Switzerland.[4] Almost certainly, Ridley was accompanied by his wife, whose ill-health he cited as the principal reason for his travels when accused of absenteeism during the 1830 election campaign. Although Ridley's earlier letters confirm him as being a serious would-be collector of Old Master paintings, there is no suggestion in them of the strong interest in contemporary painting and sculpture that would lead him to commission from 1828–34 a major series of works from the new generation of British and Italian artists working in Rome.[5]

Most of the British artists patronised by Ridley belonged to a close-knit literary and artistic circle, well-known in its day, which included the sculptor Joseph Gott and the painters Seymour Kirkup and Thomas Uwins. However, perhaps the pivotal figure among them was Joseph Severn (1793–1872), who had settled in Rome following Keats's death, spending the next twenty years there; as he himself recognised, the fact that 'my name is so interwoven with his [Keats's] friendship

and death'[6] was largely responsible for the fact that, by the time of Sir Matthew White Ridley's commission of a major subject picture in 1828–30, he was painting entirely on commission, having no less than seventeen pictures in hand in 1829 alone. Severn's painting for Ridley, *Vintagers returning*,[7] illustrating the new vogue among British patrons for picturesque genre scenes featuring idealised Italian peasants, was not the first of his works inspired by the harvest at Ariccia; its importance in the artist's oeuvre is confirmed by the fact that Severn exhibited the painting in Rome in 1831 and then at the Royal Academy the following year.[8] One of Severn's letters to his patron makes it clear that Ridley had played a major part in determining the iconography: 'I have adopted much to my own satisfaction the idea suggested by you of the Goats and Goatherds coming down the lane. It is approved by everyone'.[9]

From Severn's friend, the painter and connoisseur Seymour Kirkup (1788–1880), who had come to Italy for his health, and whose long and successful career there included the discovery in Florence of a lost portrait of Dante, Ridley ordered a painting of Desdemona in a Venetian setting, Kirkup reporting to his patron that his picture had 'aimed at Paul Veronese', who was 'not only Venetian but splendid'.[10] Thomas Uwins (1782–1857) specialised in colourful scenes of modern Neapolitan life, although, as a staunch Protestant, he also painted scenes attacking the incarceration of nuns and the

manufacturing of religious images.[11] Also a friend of Severn's following their meeting in Italy in 1824,[12] where Uwins would work for the next seven years, he produced for Ridley a highly abstruse painting which fuses a religious subject with an Italian peasant scene. His models for *The Zampognari playing before the Virgin* were the Italian shepherd bagpipers whose ancestors, according to legend, had entertained the Virgin Mary in Bethlehem: as the 'pipers', he told Ridley, had 'no notion of keeping their attitude or expression unless I keep them playing', his neighbours had to suffer the 'horrible musick'. Poor eyesight, however, prevented him from completing two other Neapolitan scenes which Ridley had commissioned.[13] Later, back in England, Uwins became Keeper both of the Queen's Pictures and of the National Gallery. A less well-known British artist who also worked for Ridley (and for Algernon, 4th Duke of Northumberland) but was perhaps not linked to this set, was Thomas Dessoulavy;[14] the landscape he painted for his Northumbrian patron, illustrating a theme from Sophocles' *Oedipus at Colonus*, was, to judge from his surviving works,[15] probably typical of the Roman landscapes in the classical mould that he produced from around 1829 – 1853.

The only painting executed for Ridley in Rome of which a record survives – albeit in an earlier version produced for a different patron (fig. 158) – is an early work by Penry Williams

Fig 158
*Festa of the
Madonna dell'Arco
at Naples*
by Penry Williams,
oil on canvas, 1830

(1798–1885), the Welsh landscapist and genre painter who became one of the most prominent British 19th century artists in Rome. His 'beautiful Neapolitan festival for Sir M. Ridley' was inspected by Walter Calverley Trevelyan on 2nd August 1836, just after its completion.[16] Williams' painting can surely be identified also both with the 'beautiful composition' that the sculptor Richard James Wyatt reported him as beginning in a letter to Ridley of 25th June 1834, and with the painting exhibited at the Royal Academy in 1837 as *Festa of the Madonna dell'Arco at Naples*.[17] Williams' relationship with Ridley seems not to have begun as promisingly as it perhaps ended; in 1829 he supplied the 3rd Baronet with a drawing which caused him 'much displeasure'.[18]

These commissions,[19] with their echoes of Venetian painting and of the classical landscape tradition inherited ultimately from Claude and Gaspard Dughet,[20] suggest that Ridley was perpetuating, in his art patronage, predilections inherited on his earlier Grand Tour, albeit tempered by the new penchant for more anecdotal landscapes and for genre scenes. This conclusion is reinforced by the career of another artist to benefit from Ridley's largesse, William Bewick, who was in Rome copying Michelangelo's Sistine Chapel frescoes for Sir Thomas Lawrence (fig. 125). Bewick's importance to this book stems from the fact that he, too, was a Northerner, and his career abroad, and his relations with Ridley and other Northern patrons, are discussed separately on pp. 171–2.

Like other visiting aristocrats to Rome at this period, notably the 6th Duke of Devonshire, Ridley was also an active patron of neo-classical sculpture, commissioning works from two of the most prominent members of the community of British sculptors in Rome, Richard James Wyatt (1795–1850) and Joseph Gott (1786–1860), both of whom had recently established their reputations in the city. Wyatt had arrived here in 1821 on the recommendation of Sir Thomas Lawrence, as a pupil first of Canova and subsequently of Thorvaldsen; by 1830, shortly after Ridley's visit, he was positively 'loaded' with commissions from British and other patrons, and Ridley was only one of a number of aristocratic clients. Although Wyatt's highly finished work, closely inspired by the antique,

Fig 159 *A Nymph of Diana returning from the Chase* by Richard James Wyatt, marble sculpture, 1820s to 1840s

was 'softened by an interest in modern poetic and narrative subjects',[21] his contribution for Ridley – 'a statue in marble of a nymph of Diana returning from the chase'[22] – was entirely classical in theme; Ridley's sculpture was almost certainly a version of the composition generally called *A Nymph of Diana* of which there are versions in the Royal Collection and elsewhere (fig. 159).[23]

Fig. 160 *Italian Greyhound and Puppies*
by Jospeh Gott, marble sculpture, 1825

The work of Joseph Gott, who had trained under John Flaxman, and moved to Rome in 1822, was more pastoral and less classical than his rival's, as can perhaps be deduced from the rather sentimental title of a marble statue he produced for Ridley, a *Catholic Girl telling her Rosary to the Madonna*. Gott's popular animal groups gained for him the soubriquet the 'Landseer of marble',[24] and Ridley's *Italian Greyhound and Puppies* seems to have been only one of numerous versions;

the earliest was produced for the 6th Duke of Devonshire (fig. 160).[25] Having been born in Leeds, Gott managed to maintain, through visits back to England, a network of Yorkshire clients, and it was surely his North country origins which procured for him another aristocratic Northumbrian patron, Algernon, Lord Prudhoe, later 4th Duke of Northumberland (pp. 249–57), who may also have commissioned sculptures from Gott while abroad.[26]

Ridley's receipts also document the commission of a marble statue, *The Guardian Angel*, in which an angel directs 'innocence in the shape of a child to avoid a snake lieing in its way',[27] from one of the leading Italian neo-classical sculptors of his day, Luigi Bienaimé (1795–1878), who from 1827 was in charge of Thorwaldsen's studio; Bienaimé combined work on his own, often prestigious, commissions with finishing and making authorised copies after his master's pieces; his more thorough-going form of classicism stands in marked contrast to that of his British counterparts.

This major series of painted and sculpted commissions in Rome[28] was almost certainly destined, not for Sir Matthew's Northern seat of Blagdon, but for his newly acquired London house at 10, Carlton House Terrace, designed by Nash.[29] It has been suggested that Ridley and his wife may have found their

Fig. 161 *Christ washing the Disciples' Feet* by Jacopo Robusti, called Tintoretto, oil on canvas, about 1547

previous London home in Portland Place 'too small or too unpretentious' for their needs,[30] and Ridley's Italian purchases would have complemented perfectly Nash's spacious classical interiors, comprehensively altered for Sir Matthew by the Durham architect, Ignatius Bonomi. One can perhaps suggest a parallel here with Hugh, 1st Duke of Northumberland's much earlier choice of the classical style for his southern home, Syon House, in the1760s: like the Duke before him, Ridley may well have felt that his London home, where he would have entertained the more intellectual and cultivated of his friends, was the most appropriate setting for his latest imports from Rome. Although, as we have seen, versions of some of his purchases, produced for other patrons, survive to illustrate his taste (figs. 158–60), none of the works Sir Matthew ordered can be traced today, and it seems likely that they were sold on the expiry of the lease on Carlton House Terrace in 1924.[31]

Long before his second visit to Italy, Sir Matthew was already a considerable collector of Old Master paintings. Not only does his earlier correspondence show him actively seeking to acquire major paintings abroad, but we know that he had purchased in 1814[32] a major Tintoretto, *Christ washing the Disciples' Feet* (fig. 161), which he later gave to the church of St. Nicholas in Newcastle; two other early acquisitions were a *Portrait of an old Man* by Cuyp and a *Holy Family* by Teniers.[33] However, the high price of Old Masters by the late 1820s may have determined Ridley to focus on his 1828 tour and its aftermath on contemporary acquisitions, his agent warning him that 'good paintings in Italy increase in value every year in consequence of the number diminishing', and 'I can do nothing for you in the way of purchase at the prices you name'.[34] Despite this, Ridley's correspondence affirms his interest in acquiring at least two paintings from Italy, by Jacob Jordaens and Guido Reni.[35] That Sir Matthew was a discriminating collector – already apparent from his early Grand Tour letters – is confirmed by the amusing account he received from Thomas Uwins in December 1829 of the purchasing activities of two other British tourists: 'The dealers are delighted with the prospect of getting all their Rubbish

Fig. 162 *Bacchus reclining playing with a Young Panther*. Wall painting, Roman decorative surround with later figurative work

conveyed to the British shires and exchanging matter of no value at all for good English guineas'. Uwins added, however, that he had seen 'nothing this season that I could recommend to you'.[36] Unfortunately, the various purchases made by the 2nd, 3rd and 4th Sir Matthew White Ridleys are not readily distinguishable, and Ridley's importance as an Old Master collector is consequently difficult to estimate.[37]

Ridley probably also bought in Italy a number of antiquities, which his son later gave to the British Museum. Two wall paintings, *Bacchus reclining playing with a Young Panther* (fig. 162) and *Venus embracing Anchises*(?), are, however, graphic illustrations of the risks associated with such purchases; the art market, then as now, included a large number of fakes, and although the fragments were said to have come from Pompeii, only the decorative surround to the painting of Bacchus is now thought to be Roman in origin.[38] Perhaps more interesting is the reference in Ridley's notebook to the acquisition of some Etruscan works of art – a vogue new to this era, and one soon to be shared by the Trevelyans.[39]

SIR MATTHEW WHITE RIDLEY, 4TH BART (1807–77)

Other members of the Ridley family were also abroad in 1829–30, although not always travelling in convoy with Sir Matthew himself. Ridley's son, also Matthew White Ridley, later 4th Bt., was following in his father and grandfather's

footsteps by making a Grand Tour after graduating from Oxford. A brilliant linguist, he kept a wryly amusing diary[40] detailing his tour of Switzerland, Germany, France and Italy, part of which was spent with his mother and sisters. Clearly, this occasional family pilgrimage was by no means to his liking: 'nothing but vexation can attend the wanderings of the Ridley family in Switzerland', he wrote, 'and the sooner they are out of it on the straight road for England the better', even underscoring a memo to himself 'Never to leave England with any lady for the purpose of seeing Switzerland'. Whether or not Ridley's notoriously difficult mother, whose restlessness in moving from one house to another was proverbial, and who often wintered abroad, especially after her husband's death in 1836, had anything to do with his frustration he does not, however, record.[41]

In common with many other Northern tourists, Sir Matthew was an amateur artist, and, like earlier members of this intellectually gifted family, he seems to have been a confident connoisseur, dismissing Titian's *Assumption* in Verona as not a 'favourable specimen', whereas another, a *Woman taken in adultery* in Bellagio, he pronounced 'exceedingly good'.[42] Similarly, Ridley castigated Canova's *Mars and Venus* and several 'ugly' or 'frightful' cathedrals, but in Venice his appreciation of the flamboyant baroque of the Salute sets him apart from many less discerning travellers. His admiration of the paintings by Holbein in Basel, which would later appeal to George Howard, is, however, in accord with the tastes of this new age.[43] Despite such judgements, connoisseurship was not exempted from the wry humour Ridley applied to other aspects of his tour: of Schleissheim Castle near Munich, home to the collection of the Kings of Bavaria, which boasted forty-five rooms filled with pictures, he wrote drily: 'a person who is not fond of pictures need not go to Schleipheim [sic] and a connoisseur may go there many time[s]'.[44] From what we know of Ridley's own later Old Master purchases, which included a Gaspard Dughet landscape and a Borgognone battle piece, his tastes, like those of his father, seem to have represented a continuation of the 18th century tradition.

Ridley's tour is also noteworthy for his enthusiasm, shared by other contemporaries, for the Italian lakes, and for his ascent of the Rigi in Switzerland, the mountain so memorably painted by Turner. On a visit to the Accademia in Venice, which had opened to the public in 1817, he found himself treading in the footsteps of Lord Byron, since the *custode* was Byron's former 'Laquai de Place'. Ridley's reaction to Venice itself is in the Byronic – or perhaps more accurately the Keatsian – mould. Of the moonlight on the Grand Canal he wrote: 'the palaces start as if by Magic or Fairy touch from the Water and the Dark Gondola with its mysterious awning and the figures which conduct them with that luxurious and gliding motion are most singular against the transparency of moonlight'[45] – a description, fine as it is, shortly to be surpassed by an adopted Northumbrian, Pauline, Lady Trevelayan. Similarly Romantic was Ridley's new consciousness of Venice's melancholy 'desolation' and 'decay'.

In later life, Ridley seems to have set aside several thousand pounds per year 'for art'.[46] Clearly influenced by his Grand Tour, his taste in contemporary pictures, like his father's, was for Italian landscapes, often with historical overtones – this time by F. Lee Bridell and the aptly named, but unrelated, 'Etruscan' Matthew Ridley Corbett among others.[47] He also collected scenes of Italian life; one of the most striking pictures in the collection was a version after Ernest Hébert's famous *Malaria* (1850), which shows an Italian family fleeing a disease which continued to be the scourge of tourists.[48] Given that both Bridell and Hébert (a cousin of Stendhal's) spent extended periods in Italy, where Hébert was for many years Director of the Academie de France in Rome, it seems clear that Ridley had inherited his father's tendency to look to Italy to cater for his artistic needs; indeed, his taste in Italianate paintings is often difficult to disentangle from his father's, given that the careers of several of the artists patronised by the family spanned the generations of father and son.[49] Possibly, Ridley painted as well as sketched himself; the collection included a *Landscape with Bridge* by (this?) Sir Matthew White Ridley, while views of Italy and Palermo by his contemporary Charles John Bigge, son of his father's

companion abroad, confirm that the Ridleys' friendships with other Northern Grand Tour families were productive in more ways than one.

Ridley, however, reserved his greatest enthusiasm for sculpture, in the person of John Graham Lough, considering this Durham-born tourist (pp. 172–5) to be the greatest sculptor since Michelangelo, and becoming his most munificent patron, peopling his Northumbrian home and garden, and 10, Carlton House Terrace, with Lough's broadly neo-classical Shakespearian and mythological creations in a variety of media, principally marble. However, Sir Matthew's even more ambitious plan after his father's death to build at Blagdon two vast galleries to house replicas of the Elgin marbles was never realised;[50] the project finds a context in the galleries created by other aristocrats at this time to display classical and neo-classical statues, in this very late phase of the fashion for the antique.

SIR WALTER CALVERLEY (1797–1879)
AND LADY (PAULINE) TREVELYAN (1816–66)

The tours by a Northumbrian landowner which had the widest impact on the North of England at this period were undertaken by Walter Calverley Trevelyan, eldest son of the tourist Sir John Trevelyan (pp. 124–8) of Wallington Hall, who from 1835–8 made an extended Italian honeymoon with his gifted bride Pauline Jermyn, and subsequently toured Europe with her from 1841–42. Trevelyan's earlier, year-long tour of Shetland, the Faroe Islands and Denmark from 1821–22 would soon be echoed in the expeditions of another Northern tourist, Dr. Edward Charlton (pp. 240–9).[51]

The fact that Calverley and Pauline Trevelyan's leisurely tours, comparable to those of 18th century tourists in their extent and duration, would differ so markedly from the norm could perhaps have been predicted from their unusual characters, and courtship. Significantly, Pauline – the gifted, precocious daughter of a clergyman – and her wealthy Northumbrian suitor, nineteen years her senior, met, not at a social gathering, but at the British Association for the Advancement of Science meeting in Cambridge in 1833,

where the seventeen-year-old Pauline astonished those attending by making notes of the conference which surpassed the official report in accuracy. Pauline had already formed a number of friendships with distinguished older men, and her relationship with the high-minded and 'fiercely intellectual' Trevelyan, a respected geologist with a 'relentless' thirst for knowledge', who believed in science both as the 'key to self-knowledge [and] the means of treating less fortunate human beings in a more humanitarian manner'[52] perhaps began in this same vein.

Besides his scholarship, Trevelyan was known for his pacifism, his belief – a hundred years ahead of his time – in state education for rich and poor, and his opposition to capital punishment, flogging, wine and tobacco; dubbed while in Rome the 'Apostle of Temperance', he later translated Wallington into a 'dry' estate. Pauline herself, although tempering her husband's eccentricities, was even more unusual. A brilliant linguist, published poet, travel writer and talented amateur artist, she shared with Calverley that intense intellectual curiosity which makes the Trevelyans among the most important of all Northern tourists – although in her case with a bent towards the arts, literature and, having the eye of a potential novelist, people. Pauline's passionate appreciation of Turner, and of medieval architecture in Venice, pre-dated her meeting with the champion of both, John Ruskin, in 1843, and she was to move on terms of intellectual equality with the leading artists of the day, becoming a close friend of Ruskin[53] (whom she idolised) and of the Pre-Raphaelites.

Although the Trevelyans clearly relished the opportunity to travel, their lengthy 'honeymoon' may have been in part a solution to a family problem. Separated from her husband – who preferred his estate of Nettlecombe in Somerset – Trevelyan's formidable mother, Maria, refused to relinquish Wallington to the heir, and Pauline seems to have persuaded Calverley instead to spend the beginning of their married life in Rome.[54] Similarly, their later travels up to 1846 were made from Edinburgh, which remained both their home and their intellectual base until Maria finally left Wallington in 1848; after shouldering the responsibilities of (two) large estates,

their travels abroad ceased entirely until their final tours in 1865–66, in the last year of Pauline's life.

Fortunately, both partners in this marriage of minds – William Bell Scott later speculated that their marriage was unconsummated – were confirmed diarists, although their styles, and indeed often their subject matter, could hardly have been more different. Their respective writings [55] highlight the wide gap between journals – Calverley's formal records of his tours – and the much more spontaneous diaries kept by his wife. Witty, preternaturally curious, highly emotional, and occasionally absurdly prejudiced, Pauline often wrote in an entertaining, anecdotal manner, whereas her mathematically precise husband, who exhaustively recorded every 'church, palace, significant work of art, Greek or Roman temple, aqueduct, olive grove', insect or plant they either saw or visited,[56] was factual rather than enthusiastic, tending towards stock responses in aesthetic matters, and only rarely straying into the bye-ways of life abroad. After making due allowance, however, for such widely differing personalities, one of the fascinations of these tours is that they allow us, as with John and Harriet Carr in 1791–4, to view travels from both a male and female perspective.

Wedding tour, 1835–8

Following their marriage in May 1835 the Trevelyans left for the continent on 14th August – not, however, before Pauline had taken drawing lessons in London from John Varley. Arriving in Normandy, they viewed the Bayeux tapestry – 'kept on a cylinder of wood & unrolled when exhibited' – and encountered Beau Brummell at a Table d'Hôte in Caen, where Pauline sketched the city, and the couple toured the Romanesque churches and picture gallery, and bought the carriage in which they would make the rest of their tour. After a foray to Brussels (where Pauline made her 'first essay in lithography'), and where they visited galleries, and the field of Waterloo, the Trevelyans headed south, lingering in southern France before moving on to Italy. Unlike earlier tourists, they travelled, not by sea, but on the newly opened and 'perilous' coast road to Genoa and Pisa. After pausing, like William Ord

before them, to see the sculpture workshops in Carrara, where Calverley noted 'a team of 40 oxen conveying thro the town on a sledge' a single block of marble, they arrived in Rome on 30th March 1836, to a ready-made circle of Calverley's intellectual friends.[57]

Like so many earlier tourists, but for more specific reasons, the Trevelyans had timed their arrival to coincide with the Easter services; attracted by the spirituality of the Oxford 'Tractarian' movement, and soon to become, under the influence of Dr. Wiseman, Principal of the English College at Rome, herself a Tractarian, Pauline had a love of Catholic ritual, and this would be only the first of her attendances at the Christmas and Easter services in St Peter's and the Sistine Chapel. The liturgy they now heard had 'so much grace dignity & solemnity' that it would, she felt, 'draw feeling & admiration from a Quaker'. However, she was 'disgusted and ashamed' at the 'abominable', 'hoydenish' behaviour of the English women present; even in the midst of the Passion there were 'execrable whispers all the time'. Calverley, drier and more judicious than his bride, concentrated instead on the architectural merits of St. Peter's: finding the exterior disappointing, since 'the high façade hides entirely the dome', the interior was, by contrast, 'exceedingly grand', although 'the celebrated high altar' (or presumably its *baldacchino* by Bernini) he dismissed as 'ugly'. Nor did Calverley warm to Michelangelo's frescoes in the Sistine Chapel: '… his figures I think are often outré & made to exert all those muscles in doing nothing'. Perhaps predictably, the Raphael and Giulio Romano frescoes in the Vatican proved more congenial.[58]

Although the Trevelyans thoroughly explored classical Rome, hiring a *cicerone* (whom they finally discharged in April 1837 when he had become 'much more expensive than his [services] were worth'), their two lengthy stays in the city on this first tour – from March 1836 to April 1837, and December 1837 to May 1838 – differed in emphasis from those of earlier visitors, with their focus on antiquities. Instead, Calverley and Pauline toured the picture collections and frescoes in private Roman villas and palaces: Palazzo Chigi (where drawings on canvas let into the walls had, with

the fortunate exception of Giulio Romano's *Battle of the Standard*, 'totally disappeared from the attacks of insects'); the Villas Doria Pamphili, Farnese, Madama and Albani (where Winckelmann himself had arranged the sculpture); the Camuccini collection, soon to be purchased by a Northern neighbour, which Calverley considered 'the best selected in Rome'; or 'that almost inaccessible place the villa Ludovisi'.[59]

Predictably, Calverley and Pauline also spent much of their time in intellectual pursuits, attending scientific and archaeological meetings such as those of the Archaeological Institute[60] and the Academia di Lincei (which had admitted Galileo in 1611) and lectures, among them one on 'painted vases' and another on basilicas both Christian and heathen. Calverley's scientific interests led him to visit private collectors of insects and minerals, and a Professor Scarpellini at the Capitol, whose telescope with a 'black marble reflector' the two men compared with Calverley's Blaniscope. While Pauline studied Egyptian hieroglyphics, Calverley's antiquarian interests extended to recording 'English sepulchral Inscriptions' in Rome prior to the French invasion of 1798, among them those to the Northerners Francis Fenwick (1694) and Henry Swinburne's daughter Martha. On a visit to the Vatican Library, the Trevelayans were shown 'autographs of Dante, Petrarch, Tasso, Boccaccio etc'.[61]

Given that Pauline was a keen amateur artist, she naturally spent a considerable amount of time sketching, often while out walking (another Trevelyan pursuit), for example in the Borghese Gardens, in the Colosseum and in the *campagna*. Here, expeditions with Calverley to Albano, Nemi, Frascati and Tivoli often combined painting with two other principal Trevelyan hobbies, 'botanising' and the collecting of lepidoptera, as when they 'stopped to sketch & take butterflies near Horace's fountain'. At Albano, however, Pauline was prevented by a 'swarm of beggars, who unexpectedly sprung up' from sketching on the summit of the volcanic crater.[62] Walter, too, made drawings. As, these, however, were primarily records of fact, focusing on rock formations, archaeology, architectural ground plans or details such as columns, masonry or inscriptions, they were reserved firmly for the pages of his diary.

In addition to their own artistic pursuits, the couple dedicated a large percentage of their time to visiting Rome's resident colony of artists, often managing, with formidable stamina – notably in the days following their arrival in 1836 – several studios per day. The names of the artists sprinkled liberally throughout the pages of Calverley's diary suggest that they must have viewed a high percentage of the city's entire complement of studios – no mean feat, given that he lists 58 sculptors, 129 historical and portrait painters, 67 landscape painters, and 69 cameo & metal cutters.[63] However, the artists with whom they seem to have associated most closely were the painter Robert Scott Lauder, a friend and protégé of Sir Walter Scott, and the sculptors John Graham Lough, Lawrence Macdonald (1799–1878) and William Ewing (active 1820–72). All three sculptors squired the Trevelyans around Roman studios, palaces or villas, as well as dining with them or taking tea; on August 1st 1836, for example, Macdonald took them to visit John Gibson, Joseph Severn, Bertel Thorwaldsen and the Italian Pietro Tenerani (1789–1869), soon to become the leading sculptor in Rome on Thorwaldsen's departure. Although Macdonald's studio was filled with 'the peerage done into marble',[64] both Lough and Ewing were considerably less well-known, and such preferential treatment surely had its origins in shared Scottish and – in Lough's case – Northern English connections; both Lough and Ewing had worked for Sir Matthew White Ridley, 3rd Bart, who may have recommended them. However, despite the Trevelyans' admiration of Macdonald's 'good busts & statues', and Calverley's energetic enumeration of the qualities of several works by Lough, including a 'beautiful statue of one of Mr Hedley's sons',[65] some 'sketches in clay' showing 'great talent & originality' and the statue of James Losh (fig. 126), the no doubt hoped-for commissions did not materialise, and of the four artists only Ewing and Scott Lauder benefited from the Trevelyans' largesse.[66]

On their studio visits the Trevelyans inspected almost the entire range of the sculpture, paintings, watercolours and drawings, prints, gems, sulphurs, medals and even wooden models offered for sale in Rome. As we have seen, their

earliest artistic contacts were with established artists whose names survive today, such as Thorwaldsen,[67] John Gibson, Lawrence Macdonald and Joseph Severn, whose 'well composed' picture of 'crusaders first seeing Jerusalem' they saw on 4th February 1838.[68] At various times the Trevelyans also admired the Venetian and other drawings of William Leighton Leitch (1804–83) painted for their friends the politician Sir Thomas Dyke Acland and the Northerner John Ingram; the productions of the leading Italian gem engraver, Giuseppe Girometti (1780–1851), 'a very clever cutter of cameos in pietra dura'; the religious paintings of Filippo Agricola (1776–1857), destined for Roman churches, and

Fig. 163 *Walter Calverley Trevelyan*
by Robert Scott Lauder, oil on canvas, 1836–8

inspired by 16th century masters and the antique; and a 'ferry boat in the Pontine marshes' by Penry Williams.[69] Some of their associations, however, were more adventurous and – occasionally – less discerning. Although in January 1837 they sought out two young neo-classical sculptors with a future ahead of them, Thomas Crawford (?1813–57), the first American sculptor to settle permanently in Rome, and the Edinburgh sculptor William Calder Marshall (1813–94), other of their enthusiasms have not stood the test of time, notably one for 'Marco the Hungarian', from whom they purchased a 'little picture' in January 1838.[70] Like Sir Matthew White Ridley and Sir Thomas Acland they also fraternised with and approved the works of that late exponent of the classical landscape, the today little-known Thomas Dessoulavy.[71]

These studio visits resulted, over the course of Calverley and Pauline's two lengthy stays in Rome, in the commissioning, or purchase, of a large number of works of art, including, first and foremost, a group of portraits of the Trevelyans themselves. Only four days after their first meeting on 9th May 1836, Calverley sat to William Ewing for one of the 'casts from small medallion heads in ivory in which he much excels his works in marble';[72] the preliminary wax model took about a fortnight, requiring about 'six or eight sittings of an hour'. The fee was 10 guineas.[73] Later, on 20th December 1836, Ewing began a companion medallion of Pauline.[74] On that same day, Calverley reported that Robert Scott Lauder (1803–69), had begun 'a picture of me at his own request' (fig. 163), for which sittings continued in January 1837; it was completed in a second series of sittings from March 1838, after which Lauder embarked on 23rd April on a portrait of Pauline which cannot be traced today.[75] During his stay in Rome from 1833–8, Lauder studied the Old Masters – whilst earning his living painting portraits – and his image of Calverley is a romantic essay in the Titian-esque mould, closely resembling the description of him at a masked ball in Rome in 1838 by Dr. Edward Charlton. This perhaps offers an explanation as to Lauder's fascination with Trevelyan as a subject: 'Looking round I saw an extremely handsome profile with light moustache and long flowing hair descending cavalier

fashion to the shoulders. I could scarcely credit my eyes that this was the philosophic Trevelyan'.[76]

A third portrait of Calverley paid even more conscious homage to Old Master painting. On the Trevelyans' return visit to Rome in February–March 1838 he sat to the German diplomat, collector and writer August Kestner (1777–1853), who had made his home in the city. Although an important collector of Italian paintings and Egyptian antiquities, Kestner also drew and painted himself,[77] and his head and shoulders drawing of Calverley in 'black & red crayon' was 'in imitation of the style of Holbein' – an artist who aroused considerable interest in intellectual circles at this time.[78]

The Trevelyans also commissioned or purchased a number of works as Grand Tour souvenirs of Rome, its environs and its antiquities. Among the works on paper they acquired were views of Rome and Paestum by a Swiss artist, the late Franz Kaisermann (1765–1833), a popular choice also with Napoleonic tourists (cf. fig. 30); a 'beautiful drawing…done for P[auline]. of St Peter's with Ponte S. Angelo – at sunset' by Arthur Glennie (1803–90), who had probably been introduced to them by Sir Thomas Acland;[79] and drawings or watercolours from 'Strutt jnr' ordered after inspecting his sketchbooks.[80] A more significant contact was the artist Isaac Atkinson (1813–77), who arrived in Rome in 1838, working under the first of two aliases as 'William Nugent Dunbar'. In view of Dunbar's later conversion to photography – he became the principal photographer of Rome and its antique sculpture for the tourist market – it is intriguing that Trevelyan

was not satisfied with 'the Drawing you have done me the high distinction to select, as a sample of my poor performances', and Dunbar wrote placatingly to say that he had 'borne in mind the criticism you passed on it, and have done my best to make it what you desired'.[81]

Calverley and Pauline also made purchases after the antique. A 'clever composition of the battle of the Pyramids… for a frieze… men and animals engaged in chasing & chased', survives at Wallington (fig. 164,); this high-quality grey wash drawing by Marichiallo Fuschini di Ravenna epitomises the 19th century's more scientific approach to antiquity.[82] The subject for another purchase, an ivory by William Ewing of *Andromeda* from a 'bas relief in Capitol', was chosen by Calverley and Ewing during a visit on 25th April 1838 to the gallery of casts at the French Academy.[83] Although the Trevelyans do not appear to have made any major purchases from the new generation of classical sculptors working in Rome, the collection at Wallington includes an important book on Thorvaldsen, and two statuettes after his *Mercury*, modelled in 1818.[84] Other, miscellaneous, acquisitions included Roman cameos, coins, mosaics, 'some specimens of giallo antico & of red porphyry' marble, and numerous prints – many of which they selected at the weekly fairs in Piazza Navona.[85]

More significant, as reflecting the developing taste for 14th and 15th century Italian painting at this period, soon to be reflected in the Trevelyans' decision to build up their own collection of early Italian Masters, was the purchase of 'several

Fig. 164 *A Frieze with a Battle of the Pyramids* by Marichiallo Fuschini di Ravenna, grey wash drawing after the antique, 1834

lithographs & engravings' after drawings by the German painter Friedrich Overbeck. A leading member of the Nazarenes, whose study in an empty monastery in Rome, belief in the religious mission of art, and conversion to Catholicism surely appealed to the Tractarian Pauline, Overbeck himself had left Rome in 1830. However the Trevleyans visited his studio on 7th July 1836, the ever well-informed Walter noting that he was 'a successful imitator of Perugino'.[86]

In addition to their fine art purchases, the Trevelyans acquired a number of important books, which again reflected their scientific and antiquarian interests, finding a copy of Galileo's *Il Saggiatore* (also at the fair in Piazza Navona), as well as a catalogue of the medals in the Papal mint, 'Brochi's fossil conchology, scarce in Italy' and a copy of 'the Dutchess of Devonshire's Virgil' owned by the late Dr. Bomba. A more bulky purchase was of part of a botanical library, which included a list of the flora growing in the Colosseum.[87]

In the midst of what must have been an often gruelling schedule, Pauline nevertheless found time to give brilliant parties – some at their favourite Roman apartment in Palazzo Cefarelli above the Forum – which became a meeting place for 'European and American intellectual celebrities of the day'.[88] She and Calverley also dined with the Durham-born resident in Rome, John Ingram, in January 1838, attending a ball given by this great patron of Guardi shortly afterwards. Other social contacts with Northerners included the Cheneys, with whom they dined in 1838 in company with the sculptor John Gibson and the genre painter Penry Williams, and Dr. Edward Charlton and his friend Dr. Errington – a fellow enthusiast of Calverley's, since he had 'geologised in Pyrenees'.[89]

Although Rome remained their principal base, the Trevelyans left on 8th April 1837 on an eight-month tour of Tuscany and Umbria with the consumptive son of Edinburgh friends, Mr. Scott.[90] While this included the same lengthy stay in Florence that had been *de rigueur* for earlier tourists, Calverley and Pauline's enthusiasm for the Tuscan and Umbrian hill towns where British tourists congregate today, and for the sites of the ancient Etruscans nearly a

century before they famously attracted the attention of D.H. Lawrence, is a development specific to this generation of tourists. Among the hill towns they visited[91] was San Gimignano, where Pauline's highly amusing entry in her diary for September 1837 confirms that, whilst admiring its ritual, she could nevertheless be very critical of aspects of the Catholic church. Although disparaging the 'quarrelsome nobles' who built the famous city towers, she reserved her chief ire for the 'monomania' of the local saint, Santa Fina, 'a nasty dirty creature' who 'chose to lie for some years upon a board without ever washing herself or rising up – the consequence whereof may be imagined…her body wrought many miracles – so it seems she was of more use after her death than during her lazy & dirty life…she died young as might be expected – instances of miserable deranged creatures like this girl being sainted & worshipped wd make one hate the Catholic religion if it were not certain that the Saints…. of all churches are equally mad'.[92]

Calverley and Pauline arrived in Florence on 9th May 1837, taking in the familiar sights of the 18th century Grand Tour as well as climbing up to see the Romanesque gem of San Miniato ai Monti and riding to Fiesole – an excursion familiar to readers of E.M. Forster's Italian novels. Although they saw some 'Urbino' and della Robbia ware, and purchased specimens of 'the so-called Raphael ware',[93] the main expenditure on their Tuscan tour had yet to come when, on 8th July, they left for Elba. Here the relentless pace of this Grand Tour slackened temporarily, as Calverley and Pauline sketched, 'bathed, walked, caught butterflies, & wrote letters'. Ever curious, however, they paused in Pisa on their return to call on a professor of botany to ask him to identify the plants they had collected, also visiting the Natural History Museum 'to name our Elba insects'.[94]

By the time the Trevelyans returned to Florence on 13th September 1837, Pauline had persuaded Calverley to form a collection of Italian Renaissance masters to hang one day at Wallington, and a brief but frenetic period of collecting commenced within days of their return, Calverley's journal for September and October 1837 offering a tense and exciting

Fig 165 *Virgin and Child enthroned with Four Angels*
by Piero della Francesca, oil on panel, about 1460–70

record of the chase. A Florentine dealer, Papi, having 'engaged to get me a good della Robbia', one by Luca della Robbia was duly bought.[95] On 13th October the Trevelyans purchased from a dealer on the Lung'Arno a 'beautiful female head, probably by Raphael', which Papi optimistically advised them was 'a portrait of his Beatrice'. Calverley, however, was also 'in treaty' for a veritable masterpiece, Piero della Francesca's monumental 'Madonna & child & 4 angels … formerly in the gallery of Gherardi' in Sansepolcro (Piero's birthplace), and today in the Sterling and Francine Clark Institute in Williamstown (fig. 165); on the day after purchasing the 'Raphael', the deal, for 315 crowns, was clinched, Calverley

commenting with justified pride that 'there is but a very poor specimen of this master' in the Uffizi, and none in the Pitti.[96]

Other successful purchases included a Domenichino, a Ghirlandaio and a painting then attributed to Il Sodoma.[97] However, the Trevelyans' somewhat grandiloquent plans as to the future scale of their collection would not be fulfilled. Calverley's diary for 20th March 1838 recounts the breakdown of negotiations begun in Florence, and continued after Trevelyan's return to Rome by his Northumbrian friend Mr Ellison,[98] to acquire the Florentine Del Chiaro collection of around one hundred paintings. This 'harrassing and vexatious affair' failed when a third party sprang up after the Trevelyans' offer had been accepted.[99] Even more sadly, none of their major Old Master purchases remain at Wallington today.

Before leaving for Rome in late November 1837, the Trevelyans made another short tour from Florence, this time of Northern and North-Eastern Italian cities which included Bologna, Ravenna, Rimini and Urbino, although cholera prevented them from including Venice in their schedule. By 2nd December they were back in Rome. Four months later, after another period of intense and fruitful interaction with artists, they left on a five-week visit to Naples which represented the first stop on their journey home. Here, sometimes on foot or by boat, they toured the usual sites, Pauline's sketches including Mount Vesuvius and the columns of the enchanting medieval cloister at Amalfi – made whilst Calverley produced a diagram of the cloister arcade. Not for the last time, the couple's opinions diverged, Pauline entering into the spirit of life in southern Italy, while Calverley disliked Naples. However, she managed to persuade him to 'take her out in a boat by moonlight and climb Vesuvius on muleback', while, returning from Paestum, she danced the tarantella at Salerno 'with local men and women on the terrace of the inn'.[100]

By 14th June 1838 the Trevelyans were en route back to England. Shortly afterwards, in September, Pauline saw Wallington for the first time, also admiring the Doric exterior of Sir Charles Monck's nearby house at Belsay. Awaiting them at Wallington were 'nine packages from Italy', including

books, prints and 'the pictures which we were glad to find quite safe'.[101] Denied, however, the use of Wallington itself as their home, Calverley and Pauline now settled in Edinburgh, then dubbed the Athens of the North. Their initial stay would not be a long one. Among their new acquaintances here was the Swiss geologist Louis Agassiz, and, when Pauline fell ill in the winter of 1840, and her doctors advised travel abroad, the Trevelyans decided to take up Agassiz's invitation to go to Neuchâtel as a prelude, perhaps, to travels in Greece and the Near East. On their way through London before setting out on their second major tour, Pauline saw her drawing master, John Varley, who approved of her Elba sketches. More importantly, she also paid her first visit to Turner's studio, responding eloquently to 'those brilliant pictures all glowing with sunshine and colour – glittering lagunes of Venice, foaming English seas and fairy sunsets'.[102] Soon, with these still firmly in her memory, she would see Venice itself.

Second and third tours, 1840s

Calverley and Pauline's second tour began on 2nd July 1841, with a steamer to Ostend. This time, however, their rapid progress through Germany to Switzerland was undertaken principally by rail, a form of transport which they applauded on account of its democratising tendencies; in an entry that neatly pinpoints the revolutionary changes then taking place in continental transport, Calverley noted that they travelled the stage between Colmar and Basel by post as the railway was not yet completed. On their way to Neuchâtel the Trevelyans, like other tourists of this generation, paused in Basel to see the paintings that resulted from Hans Holbein the Younger's two extended stays there from 1519–26 and 1528–32.[103] Once in Neuchâtel, science, not tourism, became the order of the day; Agassiz, Calverley and others in the party studied glaciers, and Pauline was frustrated by Calverley's refusal to allow her to spend the night in the 8,000 ft. observation hut on the Aar glacier with a group of all-male scientists. Following their Swiss tour, the Trevelyans spent another lengthy period in Rome,[104] during which Pauline continued her sketching, working in a looser style than during her earlier stay (fig. 166),[105] also

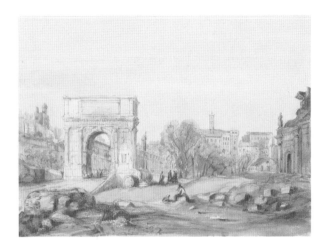

Fig 166 *The Forum, Rome, with the Arch of Titus* by Pauline Trevelyan, watercolour, 1841

earning the nickname 'La Cittadina' owing to her republican sympathies.

This tour, however, was more wide-ranging than its predecessor. Leaving Rome in March 1842, the Trevelyans sailed to Corfu from Ancona. Arriving on 5th April 1842, they were soon invited to leave their modest hotel for the comforts of the Palace, presided over by the High Commissioner, James Stewart Mackenzie, whose teenage daughter Louisa become Pauline's lifelong friend. On Corfu, Pauline made the first of her *Sketches made in Greece April – July 1842*, later assembled into an album now in the British Museum (figs. 167–8). She also admired the 'Albanians in shaggy cloaks & pistols at their girdles', finding the contrast between such 'oriental costumes & faces. with the English…. very curious & striking'; transported by romance, she even decided that the 'Greek tailors & other workmen' could have been 'cut out of the Arabian nights'. Although sharing her interest in costume, Calverley's comment was, typically, more prosaic: 'the population Albanian & Greek has a very novel appearance mixed with English Soldiers'.[106] He also commented on the 'idleness' and 'immorality' of the native population, the picturesque, but unproductive, olive trees and the poor state

of the prisons, by which he seems to have meant that the prisoners were well fed and idle

The Trevelyans spent late April and early May of 1842 in Athens where, like Sir Charles Monck before her, Pauline drew the 'well-preserved' 'Theseion' (fig. 167), together with the Portico of the Agora, the Odeion [Theatre] of Herodes Atticus, the Temple of the Winds and the Acropolis.[107] Calverley's approach to recording ruins was rather different, and predictably more scientific. A close friend at Harrow of Henry William Fox Talbot, he shared his passion for photography, and husband and wife were able to combine their artistic and scientific interests in several drawings of Pauline's in Athens and at Sunium 'outlined with camera lucida by WCT'.[108] This photographic drawing aid, lent to Calverley by William Ewing, clearly fascinated the Trevelyans; the different media preferred by husband and wife are surely symbolic of their widely differing responses to their continental experiences. While touring classical Athens with Pauline, Calverley also had an eye to contemporary developments, noting that 'of the old town of Athens all that appears to remain are the churches…the houses appear all new & others springing up – most of the streets unfinished', while at the Acropolis 'the side of the Propylea bears woeful

Fig 167 *'Temple of Theseus', Athens*
by Pauline Trevelyan, watercolour, 1842

marks of shattering by canon balls'. Calverley, however, praised the restorations then taking place, hoping that 'as much as can be will be restored'. He also, echoing Sir Charles Monck many years before, but not the more ethical Lord Prudhoe, deplored the 'absurd government regulations regarding the discovery of antiquities' and the prohibition on their export.[109]

Unlike Monck's, the Trevelyans' Greek itinerary featured a full-scale tour of the Peloponnese on horseback, as well as another, much shorter, excursion northwards to Thebes, Delphi and Daphne, undertaken with the first of two guides, Jani Adamopolmas, who cut 'a very picturesque figure in turco grecian costume'. In the Peloponnese, the Trevelyans had to be accompanied by a guard to protect against robbers, encountering dangers and discomforts which included extreme heat, a near shipwreck, sleeping in olive groves and in a barn with silkworms munching overhead, and traversing a road, 'if such it could be called', 'not two or three inches wide with a precipice below'. In addition, the teetotal Calverley was obliged to abandon goat's milk in favour of Retzina – 'probably a good tonic but not very palatable'.[110] Although Pauline made drawings of many of the archaeological sites they visited, which included Corinth, Sparta, Mycenae and Epidaurus, as well as the remote temple of Apollo at Bassae, the Byzantine frescoes at Mistra and the great temple of Aphaia on Aegina,[111] her wide-ranging interest in everything she saw, already apparent from her diary, is confirmed by the subjects in her sketchbook, which included views of the mountains, villages, churches, convents, Turkish buildings, fortifications and harbours through which they passed. In addition, a number of delightful colour studies of coastal scenery represent a tribute to Turner (fig. 168).

If the Trevelyans 'cut short' their Grecian tour, owing to the illness of Calverley's father Sir John Trevelyan, they can hardly be said to have hurried home. Sailing from Athens to Trieste, they spent two more months revisiting many of the Umbrian, Tuscan and northern Italian towns they had seen in 1837, notably Florence, Bologna and Perugia (where they admired an old favourite, Baroccio's *Descent from the Cross*),[112] and

Fig 168 *Chalcis, Euboea* by Pauline Trevelyan, watercolour, 1842

some new ones, such as Mantua. They also paused in the Italian lakes before finally crossing the St. Gothard on 22nd September through the newly created tunnel. Highlights of this final visit to Italy included Siena, to see the *Palio*, which Pauline, predictably, enjoyed, and Calverley found 'pretentious', and Rome, where they arrived on 20th August for a ten-day visit, renewing contact with William Ewing, Lawrence Macdonald and Dr. Wiseman. Driving one evening through the Forum, they found 'the temples look small after those of Greece', while there was also a pilgrimage to the Capitoline Museum to 'admire for the hundredth time the dying gladiator', still amongst the most revered of all classical sculptures. Their last evening in Rome was surely more congenial to Pauline than to her husband: with her sculptor friends she hired a carriage, and went splashing round the flooded Piazza Navona. Everyone was drenched'.[113]

Undoubtedly the pinnacle of this Italian tour, however, was the Trevelyans' first – and only – visit to Venice, where they arrived at dawn on 24th July 1842. Although Calverley remarked simply 'About sunrise saw the Domes & spires of Venice', Pauline's first sight of the city provoked an explosion of Romantic, indeed Byronic, ecstasy. As she swept past 'palaces, and gardens, and porticos, & stairs, and sculptured magnificence', she reflected in her diary on 'that strange mysterious Venetian past. where all that is gay & festive, song & revelry & carnival & procession, blend with torture & tyranny – midnight murder & hopeless imprisonment – where Tassos verses echoed over moonlight waves – where Titian made beauty immortal…& where…hundreds, ever the best & the bravest of this ungrateful city, sunk into their bloody tombs'. Like all good travel writers, however, Pauline undercut her emotional response to Venice with humour, directing some sharp, even unkind, social comedy at the crew of the steamer which had brought her here: 'the Captain [was] an ugly old fellow & the steward still older & still uglier kept fidgeting in & out the ladies cabin… every man in this boat was old and hideous – "ancient mariners" every one'.[114]

If Pauline was a latter-day Romantic, and, with Calverley, an indefatigable sightseer – on 28th July alone they explored six churches and one palace – she also saw Venice with quintessentially modern eyes, becoming the first Northern tourist to abandon the by now hackneyed vision of Venice through the canvases of Canaletto. Instead, she favoured Turner's more impressionistic record of the city, not as mathematically precise but changing in different light and atmosphere. In this she prefigures Ruskin in *Modern Painters* (1843–60); writing of a 'streak of sunshine, like burnished gold [which] broke through the cool shadows', she announced 'we had before us another proof of the truth of Turners matchless paintings: Canaletti has painted the body of Venice, but Turner has given us her soul'. Pauline also anticipates Ruskin – whom she had yet to meet – in her appreciation of medieval Venice, soon to become the subject of Ruskin's majesterial *The Stones of Venice* (1851–3); her description of 'the statues the pinnacles the mouldings & capitals' of St Mark's, 'beautifully executed in the richest gothic-byzantine style' is as fulsome, if not as poetic, as his, and she noted perceptively that it is in 'its dark rich gorgeous interior that it excels all other churches'.[115]

On their way home, the Trevelyans stayed for three weeks in Paris. Calverley's journal ends in London – where they arrived on 1st November 1842 – with vociferous complaints about a rigorous customs search at Margate which had

disarranged his packing. Four years after their return, in February 1846, Calverley and Pauline sailed from Southampton for Portugal – still as in Henry Swinburne's day the most 'untrodden ground of any in western European' – and south-western Spain.[116] Their tour, which included Lisbon,[117] Cadiz, and Seville, and which they had planned to extend into Sicily, was cut short by Sir John Trevelyan's death on 4th July; Calverley, now officially Sir Walter, inherited both his father's Wallington and Nettlecombe estates, thus becoming one of the North's most important landowners. Despite the privations and even dangers involved in exploring the Portuguese countryside – travel by donkey, having to 'lie at night on the boards of inns to which you would hesitate in England to consign a favourite dog' and a robbery by armed men who stole Calverley's watch – Pauline reacted with excitement to her experiences. During her stay in Cadiz, she also 'conceived a – temporary – passion for Murillo', while Calverley ordered large quantities of camellia plants to send to England; in the famous portrait at Wallington of Pauline in 1864 by William Bell Scott she is portrayed holding flowers picked from these plants.[118]

The Italianate scheme at Wallington

The Trevelyans finally gained possession of Wallington from Calverley's formidable mother in 1849, and from 1852–3 it became their permanent home. If their tours abroad would now be suspended for a decade, they poured the understanding they had gained of Italian art, architecture and literature into Wallington instead. And the artists best qualified to recreate their Italian experiences in a truthful, contemporary manner were not far to find: Pauline's friendship with Ruskin had soon widened to include the Pre-Raphaelites, whose work she had previously reviewed in *The Scotsman*. Among the artists who worked here were William Bell Scott, head of the government School of Design at Newcastle, and a friend of Rossetti's, the sculptors Thomas Woolner – an original member of the Brotherhood – and Alexander Munro, and even Ruskin himself, who, on his ill-fated visit to Scotland via Wallington with Effie and her future

Fig 169 *The Hall, Wallington, Northumberland*, photograph

husband John Everett Millais in 1853, visited Capheaton with the Trevelyans, admiring Sir John Edward Swinburne's Turners.

The Hall (fig. 169) which Pauline and Calverley now created out of the courtyard of the earlier house, with the aid of the North's leading architect, John Dobson, was intended as a *salon* for entertainment and for the display of works of art – including, at gallery level, their Italian Old Masters. It was, too, a statement of the Trevelyans' high moral purpose, and belief in the civilising power of art, expressed in the room's – eventual! – centrepiece, Thomas Woolner's sculpture of a mother and child, *Civilisation*. However, if the Hall, begun in 1853, was conceived as 'that archetypal Victorian instrument of instruction, the museum',[119] it also represents a reinterpretation, in Northern climes, of the courtyard of an Italian Renaissance *palazzo*, with painted instead of actual flowers and plants (some by Pauline herself and one by Ruskin); a balustrade copied from details of Murano Cathedral in Ruskin's *Stones of Venice*; and a high relief *tondo* portrait of Pauline by Alexander Munro.[120] Although the inclusion in the lower spandrels of the central Hall of medallion portraits of eminent figures is also Renaissance in

conception, the subjects were taken from Northumbrian history, while the famous cycle of paintings by William Bell Scott again illustrates, not Italian themes, but the Northumbrian past – and present. Bell Scott, however, misjudging his patrons' magnanimity over funding, wrote to Pauline announcing that, in preparation for the scheme, he intended to go 'walking the palaces and galleries of Venice and Rome', and the scheme's Italianate inspiration is not in doubt.[121]

Final tours, 1863–66

If the Wallington *salon* took up Pauline Trevelyan's time and energies from 1853–61, she remained not just an important art patron, but a key figure in the mid-Victorian artistic and literary world. Tragically, by the early 1860s, although she was not yet fifty, her life-long ill-health had declined into serious illness, and in 1863 the Trevelyans visited the Auvergne, which appears to have been not entirely a success. It is their final tour, however, in April and May 1866, by which time Pauline was in constant pain and largely confined to a wheelchair, which so memorably illustrates her passion for continental travel, on a tour from which she may have realised she would perhaps not return. Prompted by Ruskin's wish to escape from his unhappy love for the teenage Rose La Touche, Pauline suggested that she and Calverley should join him abroad, taking in Paris, Switzerland and the Italian lakes, where the Trevelyans planned to meet Pauline's friend Louisa Stewart-Mackenzie, now Lady Ashburton.

In late March 1866 Ruskin wrote to Pauline to 'hope that Baveno and Lugano, with Monza, & Luini[122] everywhere…will be more health giving than the ashes of Auvergne. Coming *down* on the Italian lakes is delicious'. 'As for the sorrowful little fear' (that she might die abroad), 'I hope it will disappear in a day'. In fact, having developed constant diarrhoea and vomiting after only a few days in Paris, Pauline got no further than Neuchâtel; on her journey there, when she had to travel in an invalid carriage arranged by Ruskin, 'it was touching to see how enthusiastically she admired a view of the alps, which she was able to see from her couch'. After being raised in bed by Calverley on 12th May for a last glimpse of nature – a

rainbow – she died the next day, with Ruskin as well as Calverley at her bedside. Calverley, after writing movingly of the loss of 'one of the best wives and of friends', recorded, with masterly understatement: 'An unhappy tour this has been so far… a time of suffering to Pauline and of watching and anxiety to me – I was unhappily persuaded to bring her abroad, when she was not in a fit state to travel'; her life, he wrote, was 'shortened I have no doubt by the fatigues of travelling'.[123]

After an autopsy, which revealed ovarian cancer, and hence the uselessness of the green walnuts and other 'remedies' prescribed by continental doctors, Pauline was buried at Neuchâtel in a cemetery appropriately commanding a view of lake and mountains. A few weeks later Ruskin returned there to make a pen and ink sketch of her grave, which he used as the basis, back in England, for a drawing for Calverley, which today hangs at Wallington with Pauline's own watercolour of *An Alpine Scene*, and drawings of the Alps by Ruskin.

Unfortunately, the Wallington watercolour represents a rare survival, with the exception of her Greek sketchbook, of Pauline's drawings in this country. Most of the drawings from her two major tours are today in Kansas City together with her diaries, pasted into two sketchbooks, one featuring quick sketches and the other larger, more finished watercolours – a working method she adopted also in Greece. Although Pauline received both advice and help from Ruskin with her drawings, which he found 'courageous, persevering and faithful', they met for the first time only after her principal tours had been made, and the main influences on her travel drawings seem to be those of her early tutor, John Varley, and, of course, on her second tour, of Turner himself.[124]

DR. EDWARD CHARLTON (1814–74)

An even more intrepid and perhaps equally unusual and intellectually gifted tourist was Dr. Edward Charlton, son of the tourist William John Charlton of Hesleyside.[125] As the younger son of a Catholic landed family, Charlton's travels could not, however, stand in starker contrast to the Trevelyans'. His principal tour, during which he walked

hundreds of miles through Switzerland and Austria with his knapsack and stick, also taking dangerous rafts down the Rhine and the Danube, and the *diligence* (where he revealed himself as an early opponent of smoking on public transport), took place in 1837–8, in the interval between obtaining his doctorate from Edinburgh University and beginning his medical practice in Newcastle. His European travels here, and in Norway and Denmark in 1836, were prefaced by tours from his base in Edinburgh of the 'savage North', which took him to Shetland in 1832 and 1834, and western Sutherland in 1833, and saw him following, to some extent, in the footsteps of Walter Calverley Trevelyan's own earliest tour.[126] That natural history was the motivating factor behind these early Scottish tours is confirmed by Charlton's choice of companions: his cousin Henry Cholmeley, the 'sporting naturalist or fowler to the expedition', and 'Mr. Procter of the Durham Museum, whom I had long known as a most zealous naturalist and an admirable auxillary in these wild enterprises'.[127]

As one might expect from a trained doctor, Charlton's interests on his continental tours were similarly, and despite his own talent as an artist, scientific rather than artistic and a context for these and his Scottish tours is offered by the fact that all took place in the decade of the 1830s when the reputation of Charles Darwin, during his five-year voyage on the *Beagle*, was beginning to filter back to England. Not only was Charlton's major tour of 1836–8 made at the precise moment when Darwin was evolving his theory of natural selection, acquiring a celebrity in scientific circles which would not have been lost on the young doctor. Darwin, too, albeit briefly, had studied medicine at Edinburgh University, and his study of marine animals on the Firth of Forth, work on the collections of the Museum of Edinburgh, a planned natural history tour following graduation, and anatomical pursuits, all offer interesting parallels with Charlton's own career.

Although Charlton would in due course become an authority on British antiquities, he later reflected of his visit to Mainz in 1837 that 'Alas, I had no antiquarian zeal in those days, and therefore failed to appreciate the narrow lanes and…old fashioned houses'. Similarly, his future reactions to Italy can be gauged from his opinion of the abbey church of Einsiedeln in Switzerland: 'Little as I love in general Italian architecture' he wrote, 'nothing in that style ever appeared to me in so favourable a light', but he nevertheless found its 'heavy Italian architecture, so inferior to our noble Gothic…'.[128] Instead, Charlton visited salt and silver mines, the anatomical and natural history museums of Scandinavia, Holland and Germany, and walked for nearly a month through the Alps in temperatures of over 90° Fahrenheit, revealing himself as a pioneer of mountaineering – a sport which would not develop fully until the 1850s.[129]

A 'multi-layered' tour record

Charlton's unusual qualities as a tourist, which caused him, right from the outset, to record his tours more completely and systematically than any other Northern tourist, probably stem from a combination of three factors: his exceptional memory; his gift for languages, which often caused him to act as unofficial interpreter for less well-prepared tourists; and his ability as a draughtsman. Despite their location up the remote North Tyne valley, Charlton and his siblings had benefited from tuition from no less an artist than John Sell Cotman, and Charlton used 'drawings on his travels as a modern tourist would use a camera'.[130]

The multi-layered record, both written and visual, that Charlton left of his tours was clearly intended, if not for posterity, then at least for his family, to stand alongside his voluminous published writings; although his journals must derive from diary entries made at the time, they represent a re-working, from a later perspective, of Charlton's experiences instead of being vivid, immediate records of daily events like those found in Pauline Trevelyan's diaries; events, in other words, 'recollected in tranquillity'.[131]

Charlton's 'Journal of a walk through Norway and Denmark 1836', the only early journal which I have been able to consult in the original, is written and illustrated in his own hand; the drawings record not only Scandinavian scenery, including lakes and fiords, but hotels, mills (fig. 171), store

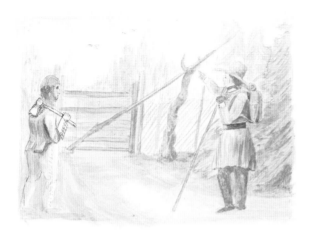

Fig 170 *Dr. Charlton conversing with a woodman*
by Edward Charlton, watercolour, 1836

houses, towns, churches, mountain passes, women in costume, boats, doctors and professors, and the author himself, with walking stick, straw hat and rucksack, conversing with a woodman (fig. 170). Not content, however, with this near-contemporary record of his tour, Charlton later compiled a second journal entitled 'Norway & Sweden by E. Charlton Esqr. MD'. This large and handsome leather-bound volume,[132] with a title page designed to resemble a Gothic illuminated manuscript, was completed by 1862. It contains a fair copy by his first wife, Eliza Kirsopp, of his 1836 tour, supplemented by accounts of his eight-day visit to Norway in 1856, his four-week final excursion to Norway in 1859, and his last tour of Shetland in 1852. The fascination of this later journal lies principally in the illustrations, which include seven copies of Charlton's 1836 drawings by the leading Newcastle landscapist of this generation, T.M. Richardson junior (1813–90). Given that Richardson's drawings (fig. 72) appear in the section of the book devoted to the 1836 tour, and that he moved to London in 1843, it seems likely that Charlton commissioned these soon after his tour; his 1856 visit to Norway was illustrated instead by a less well-known local artist, John Robert Mather (1834–79).[133] The practice of involving professionals to illustrate his tours was one which

Charlton employed right from the start; his record of Shetland in 1832 includes drawings by Richardson's short-lived brother George (1808–40) and others.[134]

Norway and Denmark, 1836

Charlton's continental travels began with visits in 1835 to Paris (perhaps to join his parents, who shut up their house at Hesleyside following the death of Charlton's grandmother and spent two years abroad), and Switzerland.[135] However, no journal survives, and his first recorded European tour is of Norway[136] and Denmark from 1st August to 20th September 1836, after completing his doctorate: 'the long, tiresome ceremony of conferring the doctor's cap is at length finished, and… I am preparing for as wild a tour, as can in the space of two months be accomplished' he wrote. The direction of this tour, across the North Sea, rather than south to France and Italy, confirms the link between Scotland and Scandinavia – Charlton sailed from Grangemouth – that had existed for centuries. Nevertheless, Charlton's choice of Norway in particular was highly unusual: 'At that time', he later wrote, 'all but a very small portion of this singular land was a terra incognita to the rest of Europe, and particularly to Englishmen', and indeed of earlier Northern tourists, only Sir Henry George Liddell (pp. 130–2) had ventured across the North Sea. Just twenty years later, however, 'the grand scenery of the Western fiords had been explored by several English travellers', and only the lengthy sea voyage, and 'dread of finding insufficient accommodation', prevented Norway, in Charlton's opinion, 'from becoming a second Switzerland to our summer tourists'.[137]

Charlton's travels took him along the east coast of Norway. More daringly, dressed in tartan with a Highland bonnet on his head, he also made his way 'alone and on foot for sixteen days through the [interior of] the country', the most arduous day's journey involving a forty-mile walk from 5am to 9pm, 'with not an hour's rest altogether', over rough, even dangerous, terrain. Although there was a serious medical purpose behind this tour, to study 'medical practice' in Scandinavia, and, more specifically, a form of leprosy extinct elsewhere in Europe,

Fig 171 *Saw Mill on the Aggers Elv*
by Edward Charlton, watercolour, 1836

Fig 172 *Saw Mill on the Aggers Elv near Christiania*
by T.M. Richardson junior after Edward Charlton,
watercolour, around 1836–43

Charlton had also come to 'learn the language…[and] above all to look upon mountain scenery equal, if not superior, to what I had seen in Switzerland'.[138] Visits to leading doctors and professors,[139] and to hospitals, took place alongside others to the natural history, anatomical and mineral collections and botanical gardens that would form the staple diet of his later tours, while at the mines of Kongsberg Charlton saw silver nuggets as big as walnuts.[140] Once in Denmark, he also found time to admire the works of Thorvaldsen, Christiansburg Palace, and a painting by Nicolas Poussin – as well as the 'fair sex', encountered both whilst enjoying an active social life in Copenhagen and, earlier, in Christiania (Oslo). Despite formidable later competition, Norway remained Charlton's favourite country: 'Thus terminated the most delightful journies I ever made', he wrote of a later visit in 1856.[141]

From Holland to Italy, 1837–8

Charlton's epic tour of 1837–8, which included Holland, Germany, Switzerland, Austria and Italy,[142] can – given its purpose, duration and extent, although not the 'budget' manner in which it was made – be regarded as a Grand Tour more in the usual mode. From the outset, Charlton's record of activity was impressive. The twelve hours he had to fill up in

Hull before sailing to Rotterdam saw him seeking out the collection of a taxidermist, touring the Museum of the Philosophical Society, attempting to view 'Mr Fielden's museum', and spending time in the Botanical Garden – a menu which sets the tone for a tour where intellectual curiosity, especially concerning scientific matters, was paramount.

Charlton's tour of Holland, where he arrived by steam packet, encountering on board his eccentric cousin, the explorer and fellow ornithologist Charles Waterton, was undertaken sometimes on foot (when his luggage followed by *diligence*) and sometimes by the *diligence* itself. His purpose was clearly to explore the principal cities; from Rotterdam he moved on to The Hague, Leyden, Haarlem, Amsterdam, Utrecht and Nijmegen. On 7th July, soon after his arrival, and still in the company of Waterton, Charlton paid a visit both scientific and artistic to The Hague, being 'dragged instantly [by Waterton] to worship Paul Potter's bull' in the picture gallery, 'and thence in breathless haste to the Natural History department, to inspect the mermaid'. Although they arrived after closing time, the 'janitors' re-opened the collection at a word from Waterton, and Charlton was able to dissect this 'clever deception', as he unerringly labelled the mermaid with the dispassionate rationalism appropriate to a contemporary

of Darwin, noting that it 'consists of a female face perhaps really human…and of a fish's body neatly joined together'.[143]

This was to be only the first of many similar museum visits. In Leyden, Charlton viewed the Museum of Natural History and Dr. Siebold's Japanese Museum, which was 'wondrous' – 'Holland alone has the means of procuring anything from that distant country' – also seeing, in Haarlem, 'a collection of philosophical instruments' and minerals and the 'jaw bones of the great fossil animal… from Maastricht'. Later, in Utrecht, he 'revelled for two or three hours amid the wax models of Kooning' in the Museum of Comparative Anatomy, but lamented the 'usual paraphernalia of lank, melancholy stuffed beasts and birds'; from his later comment on the Museum of Natural History in Heidelberg, which consisted of 'three or four hundred wretched specimens in dark rooms all cased after the ancient fashion and totally useless to the student', it is clear that he had come not merely to spectate but to study, and that he expected museums to conform to rigorous scientific standards.[144]

Charlton seems to have relished botanical gardens only one degree less than museums. However, he also had an eye for other features of Holland, enjoying the remarkable headdresses worn by the peasant girls at the Kirmess (or annual fair) in Utrecht, in which 'large plates of gold covered the cap, and transformed it into a sort of helmet', crossing the river Lek on a 'flying bridge' of boats, and visiting a celebrated Amsterdam liqueur establishment, Wynand Folking's: 'so potent were the fumes' that only three of the six, including, inevitably, Charlton himself, met the next morning to visit the Botanic Garden. Charlton also noted the prevalence of the English, informal, style of gardening, while on his first sight of the Rhine he was acute enough to see beyond the picturesque appearance of the scene to its roots in commercial activity, writing of 'ships… in full sail, and the banks…studded with windmills…erected for the sawing of the timber brought down from the forests of Switzerland and Germany'. An excursion with a party of 'jolly woolcombers from Leeds' took him to Saardam, famous for its association with Peter the Great, where Charlton wryly corrected the legend of the Csar's

lengthy residence here: 'The chief lion of the place is the house where Peter the Great resided during his three days' stay as a ship's carpenter'.[145]

Right from its commencement, Charlton's staunch Catholicism informed his attitude to his tour in a way that an earlier Catholic's, such as Henry Swinburne's, did not. At an organ recital in Haarlem Cathedral he was shocked to find 'ladies talking and the gentlemen with their hats on, as they would not have done in a theatre', while during a visit to a wealthy banker's garden in Brock near Amsterdam he deplored not only 'hideous lay figures seated in arbours and statues' but, in a cave, 'oh! hideous profanation! a hermit telling his beads'. Encountering pilgrims singing hymns on a dangerous stretch of the Rhine between Schaffhausen and Basel, Charlton waxed lyrical over their 'boat… decorated with flowers, each pilgrim held a rosary, it was a scene of the middle ages, and showed that Catholic faith and piety still flourish in Germany', while in the canton of Glarus in Switzerland, where the 'improved state of the roads and the more moneyed look of the inhabitants' indicated his arrival in a Protestant area, Charlton countered the implied criticism of Catholicism by suggesting that 'the Protestant is more alive to the hoarding up of riches in this world', which may explain 'his superior worldly prosperity'.[146]

After Holland, Charlton crossed into Germany, following the course of the Rhine (often by steamer, but also hiring a *vetturino* and sometimes on foot) from Cologne to Freiburg. After following it still further into Switzerland, he wrote: 'this mighty river had been more or less my guide', and he 'had now in a manner traced [it] upwards from its disappearance into the ocean till it now showed as a silver thread in the valley of the Grisons. Among the more notable sights were the mineral collection at Popplesdorf Castle 'under the superintendence of Professor Goldfuss' (together with the professor himself, 'wandering in true professorial negligé through the various appartements'), while at Darmstadt the Grand Duke of Hesse Cassel was 'playing at military achievements with the handful of fellows he designates his army'. At Baden Baden the 'nasty water' of the hot springs tasted like 'weak chicken broth', and

Charlton also walked – on a Sunday! – 'into the great salon to view the monster vice of gaming in all its hideous attraction'. His description of 'two English girls... lovely but somewhat passé and already on their brow was stamped the haggard anxiety of the gamester' almost exactly parallels our first sight of George Eliot's ante-heroine Gwendolen Harleth at Leubronn in her last great novel *Daniel Deronda* (1876).[147] However in Frankfurt and Heidelberg (where even Charlton was moved to comment on the picturesque nature of the town) he could reprise the now familiar pattern of his Dutch visits, visiting natural history and anatomy museums, botanical gardens, and an anatomical theatre, and talking medicine with the Assistant Physician at the hospital in Frankfurt.

Once in Switzerland, Charlton's tour became, in effect, a walking holiday, with the notable exception of a trip down the Rhine to Basel by raft – a perilous enterprise undertaken with some 'lighthearted, merry and gentlemanlike' countrymen, 'probably Oxford students', with a keen interest in fishing. Given that his enthusiasm for mountaineering seems to have been second only to his love of science, Charlton's first sight of 'the whole range of the Alps from Schaffhausen to Mont Blanc' was climactic: 'In my whole life I never felt a moment of intense enthusiasm equal to this'.[148] From Zurich, Charlton walked to the shrine of Our Lady of Einsiedeln, 'perhaps now after Rome the chief resort of pilgrims in Catholic Europe'. Shortly afterwards, however, the dangers of Alpine walking became apparent when he found himself alone at nightfall in 'one of the darkest forests and among the wildest precipices I ever trod. At all times a pine wood is dark and gloomy, but ...tonight there was no moon, while the huge rocks on my left hand effectually shut out the stars and the sky. The road too... hung over the most dismal precipices', and the scene was not improved by hints received earlier from local peasants about 'böse Leute' ('evil disposed persons') lurking in the neighbourhood, Charlton noting that 'it was certainly a most fit locality for a ruthless bandit'. Eventually, arriving by moonlight at a wayside shrine where the paths diverged, he threw himself on his knees before a crucifix and 'earnestly besought the Mother of that Crucified God to guide me

aright', regaining the right path a few minutes later.[149]

Other Alpine difficulties included being hampered by 'deceitful red wine', which left Charlton badly prepared the next day for crossing a mountain pass where the path often 'consisted merely of a few sticks laid upon the face of the shelving precipice'. On the same occasion he also had to contend against a 'a field of untrodden snow which seemed... to terminate abruptly in a fearful precipice...The snow lay upon an angle as steep as that of the opposite bank... and it seemed as if a body once set in motion on its perfectly smooth and glittering surface would be carried with unerring certainty over the frightful precipice below'. Aided by a guide, however, Charlton learned how to glissade over the snow, using his Alpenstock (or staff) to slow his downward progress.[150]

After becoming 'rather footsore from travelling... thirty miles a day' in sweltering summer temperatures, Charlton finally arrived in Austria, where his walking tour continued unabated: in ten days he covered another two hundred and fifty miles to Hallein, where he viewed the salt mines after yet another perilous journey, following his guide 'across small valleys twenty or thirty feet below us, while there was not a rope or a handrail of any kind to save us'. At the mine itself, Charlton had to slide for 350 ft. down shafts into its depths; near the bottom he found 'a vast saloon, the floor of which was a still and treacherous lake', with a hundred tapers around the sides to show its vast proportions'. In this underworld cavern Charlton's classical education, albeit tempered by scientific curiosity, came to the fore: 'We were ferried in a primitive looking boat over this enchanted sea, while from the roof shot rays emanating from veins of red, blue, white and purple salt....our Charon was invisible till at the further side he exhibited himself in the shape of a merry bluff miner, who had towed us across by a rope fastened to the prow'.[151]

Only in Salzburg did Charlton's resolve weaken, and his walking tour effectively come to an end, when he considered 'going direct by *diligence* to Vienna, for my shoes were completely worn out, and my feet too began to suffer a little'. Instead, he journeyed to Linz where, joining another great European river, the Danube, he 'determined to float down to

Vienna' on a 'primitive conveyance', the Munich raft. Although actively dangerous, the captain pausing to implore the 'blessing of Heaven on his perilous navigation' before embarking, this had the merit of being extremely cheap. Despite the primitive accommodation and safety on board – the only protection against the heat for deck passengers like Charlton was to hide in 'huge empty packing boxes', while the centre of the raft sank so much at times that passengers were wading 'half a foot deep in the water' – Charlton could not 'neglect the glorious scenery' even 'amid the tumult and roar' of two whirlpools, as the raft 'drove past castles, palaces and convents' including 'a castle well known in history as the prison of Coeur de Lion, the celebrated walls of Durrenstein'.[152]

Italy, 1838

Although Charlton's interests lay in medicine and science rather than in art and antiquities, it was perhaps to be expected that – with the exception of an all-night visit to Vesuvius – his tour of Italy would be more conventional than his earlier travels. After spending the winter of 1837–8 in Vienna, and having purchased a warm Hungarian cloak lined with lambskin, Charlton left on 26th January 1838 by *diligence* with two Scots, Cadell and Boyd – his companions for most of his Italian tour – on a 'fearful journey' through Slovenia, much of it by night, in the course of which their vehicle overturned in a snowdrift. Charlton's usual powers of observation were numbed, 'so confused was my mind and so weakened were my energies'. At Laybach, a 'merry little voiturier' took the trio on to Trieste through countryside plagued by 'an organised band of robbers under the command of a Hungarian Robin Hood', one of whose most notorious exploits had been to impersonate the Bishop of South Hungary in front of the (real) Bishop of Warasdin, tie him to a sofa, and make off with 17,000 florins.[153] By the time Charlton reached Trieste he was ill with a severe swelling of the face. Undaunted, he soon set off for Venice, spending a week sightseeing before moving on to Rome via Padua, Ferrara, Bologna, Florence and Siena with his companions and, on the latter part of the journey, an unnamed French artist.

Charlton arrived in Rome on 21st February on foot; as one of a new generation of tourists who wrote of the *dolce far niente* character of the Italians, a prejudice which persists today, he wrote amusingly of his parting with their *vetturino* who dramatically pointed out St Peter's with the single word 'Roma' – after which his vehicle broke down beyond the Ponte Molle. The usually indefatigable diarist found 'It was in vain to attempt to keep a journal after I began sight-seeing in Rome. Objects of all kinds crowd so thickly upon one's notice that there is no time for breathing'. Fortunately, however, Charlton's letters home, later copied into his journal, offer a glimpse of his first, four-day stay in the city during the Carnival, in which he participated to the full. With his artist travelling companion he paraded on the Corso dressed as a black bear – his 'Hungarian bunda [cloak] with the black lambskin turned outside': 'Oh how they did pelt our unprotected faces with sugar plums, or rather with pellets of mud rolled in whitening'. He also attended a masked ball at the theatre, encountering Walter and Pauline Trevelyan in the next box: 'I was soon welcomed by him and introduced likewise to his wife, of whose talents I had heard much'. As a Catholic, however, Charlton understood the 'sudden transition, so incomprehensible to Protestants', by which at 'Precisely at a quarter before twelve the ball ceased, the soldiers cleared the theatre and….the gay multitude of the Carnival was transformed into the penitents of Lent'. He also seems to have renewed another Northern connection when he 'dined…at Ingram's'; this was surely John Ingram, the now elderly Guardi patron from County Durham, who had settled in Rome, and also offered hospitality to the Trevelyans.[154]

After the carnival, Charlton left for Naples in a party which included his two Scottish friends and his Northumbrian contemporary Henry Matthias Riddell (1815–95), son of Ralph Riddell of Felton. Here too, as in Slovenia, bandits posed a major threat. Charlton's confidence that the Pope had 'cut up the bands of brigands who infested this route' turned out to be misplaced when he learned that a robbery had taken place 'only last Monday', and he and his companions had not been 'five minutes' in Naples before they were pick-pocketed

for – of all things – their pocket handkerchiefs, then a luxury item. Later, on the road to Paestum, Charlton noted that, following a double murder in 1824, trees had been cleared a certain distance from the road to protect travellers, while the Government had 'bought or took possession of the ground on which Paestum stands, with the view of preventing the commission of any more acts of violence and of preserving the glorious ruins, which had now become so great an attraction for travellers'.[155]

Charlton responded warmly to some of the qualities of Naples which had disturbed earlier tourists, and having 'been here a fortnight…would willingly remain as long again'. He loved the crowds ('such a stunning noise, such a mighty tumult, everyone is in full action and, except on the beach among the fishermen basking in the sun, you would hardly find a trace of the famous indolence of the Neapolitans'); the 'stalls filled with all manner of eatables, soups, frogs, figs, macaroni, oranges and grapes'; 'asses laden with two enormous panniers', steered by the tail; and the herds of cows and goats which roamed from door to door so that the driver could dispense milk to the 'donna di casa'. Above all, he was attracted to the 'merry Calabrians': 'With such a climate and with abundance of food they have few cares and do not require to work, and when reproached for idleness they very sensibly reply "Why should we work? We are contented and happy without it…". It is only in the cold, unfriendly Britain that real misery exists'.[156] Such views herald those of early 20th century novelists such as D.H. Lawrence, E.M. Forster or the Capri resident Norman Douglas, who in their Italian novels deliberately contrast the warm, passionate south with cold English conventionality.

From Naples, Charlton made the usual excursions; to Paestum and Pompeii; to Vietri, Amalfi and Sorrento by boat with a 'padrone' who rejoiced in the 'euphonious name of Andrea della Volpe'; and to the Blue Grotto on Capri, re-discovered only a few years before in 1826,[157] in dangerous seas, in which they had to shoot through the opening with waters rising almost to the top of the cave's mouth. Charlton's sketch was presumably made when safely back on dry land.

Another visit was to Baiae and Pozzuoli, where they were shown the intensely hot and steamy Baths of Nero by a 'half naked, wild looking man, the Genius of the place', who boiled some eggs for them in a pool of water. Later, at the equally bizarre Grotto del Cane, the custode demonstrated the effect of poisonous 'vapour of carbonic acid gas' on a 'poor dog… which meekly submitted to his fate'.[158]

If most earlier tourists had climbed Vesuvius, Charlton went one better: on his second visit he spent the night on the volcano with his Scottish friends as 'their cicerone and guide'. Nearing the summit after seeing the sun set over the Bay of Naples, they felt the rocks begin to shake every ten or twenty seconds beneath their feet, and there followed 'a roaring sound, not unlike a cannon shot but resembling the escape of steam under enormous pressure (as indeed it was), and directly after this we saw projected into the air above the mist hundreds of large stones… All was then still for a moment… then came the crash of their impinging on the hardened lava below, which sounded like a troop of heavy dragoons galloping rapidly down a paved street'. Nor were these the only dangers: Charlton and his party were also exposed to 'fumes of muriate of ammonia', which caused him to feel 'confused and giddy', while 'the rocks in the crater were almost too warm to form seats for our party and Cadell, who had incautiously sat down over a steam jet, jumped suddenly with a hideous yell…'.[159]

However, the party's reward was to see the crater by night, watching a 'column of bright flame, bearing with it huge masses of burning lava', shoot high into the air: 'The fearful glare of red light which the flames… shed upon the barren rocks around, the hissing sound of the molten masses as they cleaved their way through the air, the momentary stillness when they reached their greatest elevation, followed by the heavy crashes of their fall on the rocks below, all contributed to the grandeur of the scene, which remains as vividly impressed on my mind as on the night that I witnessed it'. Daringly, Charlton and his party even descended into the cone to examine the lava flow, which 'resembles most closely a huge coke heap, such as we see at our railway stations, moving forward by some mysterious agency'. 'Saving the intense heat

that it emitted, there was no danger in approaching it and I was able to plunge my walking stick into the ductile mass and to work portions out of the soft lava, into which I impressed various coins and bore them off thus encased as memorials of my visit.[160]

After three weeks in southern Italy, Charlton returned to Rome for a more leisurely visit, and for the Easter celebrations, staying with another Northerner, Dr. Michael Errington – not the first member of this family to make the Grand Tour – and spending a fortnight sightseeing, visiting artists' studios as well as museums and picture galleries. Although he saw the Colosseum by moonlight, this Catholic visitor preferred it 'one hot afternoon when I saw a Capuchin friar preaching to a crowd at the foot of the Cross planted in the centre of the arena, in the very spot where the Christian martyrs shed their blood'. Charlton also made an excursion into the *campagna*, visiting Albano, the restored Domenichino frescoes at Grottaferrata, Frascati, the Villa of Lucien Buonaparte and the ruins of Tusculum. At Tivoli, the 'waterfall so immortalised by painters is no longer there, the course of the stream has again been diverted'.[161]

Like the Trevelyans, and fortified by the 'admirable manuscript lectures on the Holy Week' lent him by their friend Dr Wiseman, Charlton attended the Easter ceremonies in the Sistine Chapel, presided over by the 'tremendous but most unchristian Last Judgment of Michaelangelo'. Here, thanks to his Catholic connections, Charlton was 'admitted within the screen', sitting opposite Bonaparte's uncle, Cardinal Fesch. On Palm Sunday he was placed next to an American naval officer who, as a non-Catholic, resented his ineligibility to receive 'a palm from the Pope's own hand', which, Charlton surmised, 'would be a prize to show in American society'. Charlton's own more privileged position, however, nearly led to disaster when he almost lost his balance in kneeling to receive his palm, recovering 'myself in sufficient time to avoid a most disagreeable collision with the Head of the Church'. Not long afterwards, on Friday April 27th, Charlton and his new travelling companions, the Whebles, had an audience with Gregory XVI; as the Pontiff could not understand

French, Charlton was 'forced to take up the conversation in Italian' after only 'two months or so in Italy'; rather pointedly, Pope Gregory remarked that he, who had been 'the shortest time in Rome' spoke better Italian than his companions.[162]

Travelling with the Whebles in their 'delicious' carriage, Charlton now began his journey northwards via the Falls of Terni, Perugia, Lake Trasimeno, Arezzo and Florence. From here he took the *diligence* through Pisa and Genoa to Milan and then Como – a mounted patrol accompanying them for safety. After parting with his friend Cadell (Boyd had already left), Charlton sent his trunks on to Munich, and 'with only my knapsack to carry and a stout blackthorn stick which I had bought in Milan', began on 19th May to walk alone over the Stelvio Pass, encountering on his thirty-six mile walk a wall of snow twenty-five feet high and an avalanche of stones. The next day, at the top of the Brenner Pass, 'Dripping with rain and so exhausted with the cold that I could scarcely speak', he was turned away by the hostess at the post house with the words: 'We have no accommodation for such as you'.[163]

After Innsbruck, Charlton moved on by *diligence* to Munich, where he lingered for a 'delightful month' 'in the museums and picture galleries and hospitals'; his introduction to 'the Catholic literary world of Munich [was] a privilege rarely enjoyed by Englishmen'. One collector, showing Charlton his 'magnificent collection of minerals', and discovering that he was an English Catholic, 'took out a magnificent crystal of Peliom and presented it to me, saying that I was the first English Catholic physician he had ever met with'. Charlton now travelled through Regensburg, Nuremberg and Frankfurt, ending his tour by taking a steamboat down the Rhine and sailing home from Rotterdam to Hull; 'on the 10th of July [I] reached my home with just half a crown in my pocket. I had been absent from England thirteen months, had travelled much and I hope not without profit to my mind'.[164]

Not surprisingly, this enterprising and enquiring man went on to have a highly distinguished career as a physician in Newcastle, lecturing at the new Medical School, founded 1832, and eventually becoming Professor of Medicine,

President of the College, and even, in 1870, President of the British Medical Association. Living in Eldon Square in central Newcastle, Charlton was a 'real polymath': a scholar, scientist and antiquary. Remarkably, he contributed more articles on subjects as disparate as natural history, volcanology, local history, archaeology and the literature of Northern Europe to publications including *Archaeologia Aeliana*, the *Dublin Review* and the *Tyneside Naturalists' Field Club Transactions* than he wrote on medicine itself.[165] He also served as President of the Natural History Society of Northumberland and Durham, as Co-Secretary (with Dr. Bruce) of the Newcastle Society of Antiquaries, and as Vice-President of the Literary and Philosophical Society. Given his busy later life, which included two marriages, firstly to Eliza Kirsopp, daughter of a Northumbrian Catholic landowner, and recorder of his tours, and secondly to Margaret Bellasis, with whom he had six children, it is perhaps not surprising that his travels were mostly concentrated into his student years.

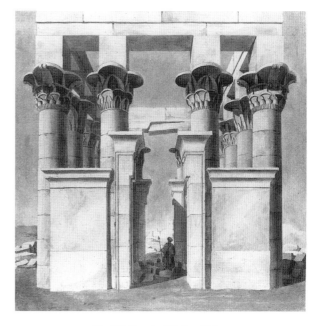

Fig 173 *Temple of Trajan, Philae*
by Major Orlando Felix, pencil and grey wash, 1826–9

FROM EGYPT TO ITALY: ALGERNON, LORD PRUDHOE, LATER 4TH DUKE OF NORTHUMBERLAND (1792–1865)

EGYPT, 1826–9

Interest in Egypt as a destination for tourists dates from Napoleon's Egyptian campaign in 1798, when he was accompanied by Dominique-Vivant Denon, whose *Voyage dans la Haute et dans la Basse Egypte* (1802) was instrumental in launching the Egyptian Revival. Algernon, Lord Prudhoe (1792–1865), second son of another Grand Tourist, Hugh, 2nd Duke of Northumberland (pp. 71–5), was among the early British pioneers, making a tour of Egypt, Nubia and the Levant in 1826–9,[166] some twenty years before he inherited the Dukedom of Northumberland.

A naval officer during the Napoleonic wars, Lord Prudhoe, whose abiding hobbies were travel and archaeology, was a talented amateur Egyptologist, and on his two journeys up the Nile by boat from Cairo, from February to April 1827, and

from December 1828 to April 1829, he visited all the major temples, sketching a number of them and carefully copying the hieroglyphic inscriptions he saw in a series of eleven notebooks.[167] He was accompanied on this tour by the amateur artist and army officer Major Orlando Felix (1790–1860), who had journeyed up the Nile once before, and who now recorded the temples, pyramids and other antiquities in a series of over one hundred watercolours and drawings.[168] Although Lord Prudhoe's notebooks show little of his feelings for the monuments he visited – of the colossus of Ozymandias, which inspired Shelley, he says simply 'gigantic statue, the largest of all the Colossi'– he was clearly capable of appreciating what he called 'the massy rudeness of this style'. However, it was left to Felix, in drawings such as the *Temple of Trajan, Philae* (fig. 173), to respond to the colossal size and grandeur of these buildings in a way that is typical of the Romantic movement, and that anticipates by a decade the work of the well-known orientalist David Roberts. Felix's

delightfully informal letters from Egypt to his commanding officer, Lieutenant Colonel Brown, in Malta, also survive, giving a flavour of a tour on which Felix hoped he would be spared by 'the Plagues in Egypt, the Arabs and the Deserts'.[169]

Lord Prudhoe seems to have been entirely *au courant* with the latest developments in Egyptology, preparing diligently for his two journeys by reading J.F. Champollion's recent decipherment of hieroglyphic script, *Précis du Système Hiéroglyphique* (1824), but without relying entirely on his source: 'he has certainly much more knowledge on the subject of hieroglyphics than any man living, but I fear he is not entirely to be trusted'. Felix, predictably, went further, announcing that 'I differ very much from Monsr Champollion in the Chronology of the Kings', and pointing out that chronology 'is really of interest to Egyptian Travellers as it enables the different styles of Architecture to be traced from the Earliest Ages to the time of the Greeks and Romans'; Felix found it 'much more certain' than the chronology of the kings of England. The two men also learnt Arabic: as Felix put it 'I am bewildering myself with hieroglyphics', while 'Prudhoe is hard at Arabic'.[170]

These were journeys with dangers and privations beyond the scope of those experienced by travellers in Europe. On one occasion, Prudhoe and Felix were accompanied to a temple by men armed with muskets and spears who sat – politely! – whilst they copied inscriptions. On another, Prudhoe saved Felix's life when he tried to separate two combatants and was threatened by men with axes. Their discomforts included wet beds, having to carry canvas for a tent when there was no shade from rock or tree, sending nine hours for water, and having to shoot a marauding lion. At least by some of their compatriots abroad, it was considered necessary to wear native dress so as to avoid repercussions against Christians, Felix rather nonchalantly noting that as 'Davison wished to turn Turk I did not like to baulk his Fancy', and in Cairo Felix suffered from fever and found a 'longbearded Doctor, who by dint of starvation will turn me out in a few days I hope, as good as new'. The travellers were, however, undaunted, Felix summing up their position as

Fig 174
Statuette of Amenophis I and his mother Ahmose Nofretiry, dark steatite tablet, with high relief, 12th/13th century B.C. (the head is a modern replica.)

offering: 'just enough privation to make us enjoy good things when we got them, and just as much talked of dangers as kept us on the qui vive of interest'.[171]

Unlike the more opportunist Sir Charles Monck (p. 197), Lord Prudhoe deplored the plunder of ancient graves, writing: 'Thousands are the mummies crumbled to dust annually for the chance of some idols, papyri or trinkets, which travellers as well as students greedily purchase & thus countenance a system of spoliation'.[172] Such sentiments did not, however, prevent him from acquiring in Egypt the famous Prudhoe lions, which he later gave to the British Museum, nor from forming, after his return in 1829, the important collection of Egyptian antiquities which was later displayed at Alnwick

Castle and is now in the Oriental Museum, Durham. Prudhoe was fortunate in receiving advice over his acquisitions from the 'father of Egyptology', Sir Gardner Wilkinson, whom he had met on his tour, and who later visited Alnwick on several occasions: Wilkinson's *Manners and Customs of the Ancient Egyptians* (1837–41) was dedicated to Prudhoe's brother, Hugh, 3rd Duke of Northumberland,[173] while the monumental Arabic *Lexicon* (1863) of Edward William Lane, whom Prudhoe had also met in Egypt in 1826, was dedicated to Prudhoe himself who, as 4th Duke, was its 'constant and main supporter' over twenty-three years.[174]

Many of Lord Prudhoe's Egyptian antiquities are known to have been in his possession by 1832, when a catalogue of the collection listing over 2,000 objects was published by Samuel Birch, another distinguished Egyptologist and Keeper of Oriental Antiquities at the British Museum.[175] Prudhoe is said to have valued the objects he collected 'chiefly for their contribution to our knowledge of the manners and the condition of bygone times and people';[176] and among the important pieces which can be identified with certainty as having belonged to him at this early date are a *Statuette of Amenophis I and his mother Ahmose Nofretiry* (fig. 174), founders of the XVIIIth dynasty, when Egypt was one of the most powerful nations in the world. Birch's catalogue records that the statuette was found at Luxor in 1828, when Prudhoe was in Egypt; the missing head was reunited with it in 1974.

ITALY: 1822 AND 1853–4

As well as touring Egypt, Lord Prudhoe, in common with most young aristocrats of his generation, also visited Rome, recording in his diary the powerful, albeit orthodox, impression made on him in 1822 by the Italian capital: 'On entering Rome the mind is naturally awakened to the recollections of the former Power & Magnificence of the former Tyrant of the World'.[177] Twenty-five years later, in 1847, Algernon inherited the Dukedom of Northumberland from his brother Hugh (1817–47) – whose links with the continent included attendance as George IV's personal representative, at the Coronation in Paris of Charles X, when the King

presented him the huge Sèvres vase now at Syon – together with vast estates and coal mining interests which made him among the very wealthiest aristocrats of his day. Enlightened and philanthropic in outlook, he became known locally as the 'Good Duke', and his support of Egyptologists, and scientists such as Sir John Herschel, lends some concrete support to an obituarist's otherwise inflated comment that he 'had so great a regard for science and genius that he seemed to estimate the splendour of his position chiefly by the number of men of learning whom he could bring around him'.[178]

From July 1853 Duke Algernon made a second, year-long, European tour, this time with his Duchess, Eleanor, daughter of the 2nd Marquess of Westminster. This, like the Trevelyans', and indeed the Boweses' (pp. 257–62), was a childless marriage, and the couple perhaps felt free to indulge in plans for 'improvements'. Following visits to Paris, Weisbaden and Frankfurt, a short but 'delightful tour of Switzerland' and stays in Milan and Florence, the Duke and Duchess wintered in Rome, where they had planned to be waited on by their own servants from England, using plate sent out from their Yorkshire house, Stanwick – a decision, as regards the servants, they reversed on reaching Milan. Nor were the Northumberlands devoid of other creature comforts available to wealthy tourists at this period; their steward, Thomas Williams, regularly forwarded the newspapers from Paris, a subject on which the Duke, generally considerate to his employees, was exacting, while the need to keep in touch with matters on the Northumberland estates gained assistance from the 'Poste Restante' system for forwarding mail to foreign cities to await a tourist's arrival; if some frustrations remained, the endlessly delayed letters of the 18th century were a thing of the past.

From Rome, in early March 1854, the Northumberlands left on the traditional short excursion to Naples, where their arrival coincided with that of the Crown Prince of Prussia. Anxious to entertain two such distinguished sets of guests in style, the King of the Two Sicilies responded – like his predecessors in comparable situations – by ordering a *scavo* (excavation), in honour of the visit. This proving

'unproductive', however, in terms of unearthing suitable souvenirs for his guests, the King presented the Duke instead with 'several objects which had been found previously [from Pompeii] & placed in the Museo Borbonico' – a gift hardly conforming to good museum practice today! To judge from the items which the Duke added to his collection of Roman and other antiquities at Alnwick (already at this date formed into a museum), these included Pomeiian frescoes, a series of Roman glass vessels, a terracotta statuette, a small collection of lamps, and a fascinating series of bronze cooking vessels and other kitchen equipment – although we know that

Northumberland also purchased frescoes and bronzes to supplement the King's gifts.[179]

Unfortunately, the Duke and Duchess's cultural activities in Rome itself, where they arrived in November 1853, remain tantalisingly obscure.[180] However, the city undoubtedly acted as a catalyst, and turning point, in the Duke's plans for the renovation of Alnwick Castle. So impressed was he with the 'princely grandeur of the palatial palaces', and the fact that 'seicento furnishings were to be found in medieval buildings' that he wrote to his architect, Anthony Salvin, to announce that the rooms at Alnwick would be designed 'in the Italian

Fig 175 *Eleonar, 4th Duchess of Northumberland*, portrait bust by Laurence Macdonald, marble, around 1853

Fig 176 *Algernon, 4th Duke of Northumberland*, portrait bust by Laurence Macdonald, marble, around 1853

style of the fifteenth and sixteenth centuries',[181] despite the fact that Salvin was then remodelling the exterior in the rugged, castellar mode for which he was renowned, and which his employer, with Victorian zeal, must have considered much more authentic than Adam's earlier, more whimsical Gothic. Given that the Duke would purchase the Camuccini collection of Old Master paintings – in its entirety! – just over a year after his return, he and the Duchess must also have viewed this famous collection in Palazzo Cesi. However, all that we know in concrete terms of their cultural occupations in Rome is that they sat to that veteran purveyor of *al' antico* marble busts of the British aristocracy, Lawrence Macdonald (figs. 175, 176).[182] They also purchased some antique coins,[183] and presumably the 'Tapestry Hangings and two mosaic tables' which were to be exported from Civita Vecchia in the spring of 1854.[184]

Much of the Duke's correspondence with Thomas Williams on the Northumberlands' homeward journey from April to July 1854 via Florence, Genoa, Venice, Milan, Lucerne and Paris concerns the 'packages' from Italy, which had now been supplemented by 'some drawings… sent to me both from Venice & from Florence'. The Duke stipulated that these should be placed in the Entrance Hall of Northumberland House to await his arrival; consternation, and some condemnation, ensued when it transpired that the steward had misunderstood the Duke's instructions, and opened some packages in error.[185]

Also to be laid out at Northumberland House were any architectural plans forwarded during his absence by Anthony Salvin, who came from a Catholic gentry family in County Durham,[187] and had previously worked for Algernon's brother Hugh, the 3rd Duke. Clearly perturbed by Duke Algernon's *volte face* in Rome over the decoration of the interiors, Salvin now voiced his doubts as to the 'propriety, as well as of the practicability, of introducing Italian art into a Border Castle'. Other leading architects, notably Gilbert Scott, were less tactful: 'the result was this – that, happening at the time to winter in Rome, his Grace became enamoured of the interiors of Renaissance palaces, and fostered the infelicitous idea of making his ancestral residence a feudal castle without and a

Roman palazzo within'.[188] In persisting with his decision to use the Italian *cinquecento* style for the inside, sweeping away in the process Adam's fine interiors for the 1st Duke and Duchess, the Duke had, therefore, taken on the architectural establishment of his day. Unsurprisingly, given his position, he won. If, as Lord Prudhoe, he had therefore begun as a tourist in a pioneering vein, for this, the most important artistic choice of his life, the Duke reverted to the period of Italian art and architecture most admired by preceding generations of

Fig 177 *Marble Chimneypiece, State Dining Room, Alnwick Castle* by Giuseppi Nucci and Giovanni Strazza (detail of Bacchante and Faun), 1850s

British tourists, and Alnwick confirms the still powerful influence of Italian culture on the North of England in the mid-19th century

The team of distinguished Italian architects and artists who worked here must have been recruited by the Duke during his tour, as, less than five months after his return, he wrote requesting immediate notification of the arrival in London of those 'engaged to do the works at Alnwick Castle'.[189] Although operations were led briefly by the prestigious Italian architect and archaeologist, Commendatore Canina, Director of the Capitoline Museum in Rome, whom the Duke had met abroad, Canina died in Florence on his return from a visit to Alnwick in 1856, and it was his talented collaborator, Giovanni Montiroli (1817–91), a specialist in Renaissance art and decoration, who supervised the remainder of the ten-year scheme. The other key Italian figure was the painter Alessandro Mantovani (1814–92), who had worked extensively on the Papal palaces, and who painted the exceptional friezes in the Drawing Room and the Saloon, while the group also included the sculptor Giovanni Strazza (1818–75), who, with Giuseppe Nucci, created the monumental classical figures for the chimneypieces (fig. 177), and the gifted young Florentine woodcarver Anton Leone Bulletti (c. 1824–85), who moved to Newcastle after the completion of the works at Alnwick; among his Northumbrian clients was another tourist family, the Silvertopps.

Fig 178 *Detail of a ceiling with painted medallions* by Giovanni Montiroli, wash drawing, about 1856

Giovanni Montiroli's preparatory drawing, *Detail of a Ceiling with Painted Medallions* (fig. 178) illustrates the style of High Renaissance decoration adopted for the state rooms; the classical figures, scroll-work, and other motifs were inspired by famous 16th century decorative schemes in Rome such as Raphael's Vatican *Loggie*. Although much of the work, for example the Carrara marble chimneypieces, was carried out in Rome and shipped to Alnwick, one of the Duke's conscious intentions in introducing Italian architects and designers at Alnwick was thereby to raise the standards of English art, and many of the craftsmen who worked on the interiors were local; the Alnwick school of carvers, trained by Bulletti, was the outstanding product of this cultural interchange. If the Duke – unlike other Northern tourists, including his own brother Hugh, the 3rd Duke, who was a major patron of the sculptor John Graham Lough (pp. 172–5) – preferred to patronise Italians, as opposed to British artists working abroad, he turned to one of the leading British neo-classical sculptors in Rome, John Gibson, for two key statues of *Action and Repose* at the foot of the main staircase.

Duke Algernon's Italophile leanings went beyond those of any preceding Northern tourist in this creation of a series of wholly Italianate interiors on English soil, and in the employment of a veritable galaxy of Italian craftsmen. In 1855, however, he went even further, finalising the single most outstanding purchase of Old Master paintings ever to be made by a Northern collector when he acquired from Rome the Camuccini collection, comprising no less than seventy-four paintings. This had been formed at the beginning of the century by the brothers Vincenzo and Pietro Camuccini, at a time when, because of the Napoleonic wars, many great works of art from Roman and other collections had come onto the market. The collection, in its turn, became one of the sights of early 19th century Rome, and its move to Palazzo Cesi in 1851 only served to increase its accessibility and renown.[190]

The Duke's acquisition of the paintings from Baron Camuccini, son of Vincenzo, perhaps discussed initially as early as 1850, was conducted under the utmost secrecy by the German archaeologist and art dealer August Emil Braun

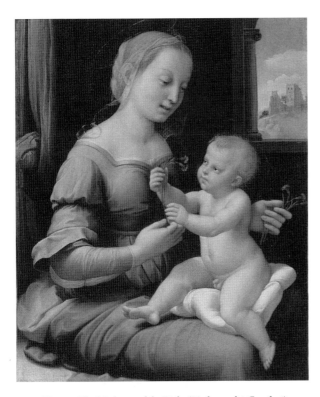

Fig 179 *The Madonna of the Pinks (Madonna dei Garofani)*
by Raphael, oil on panel, about 1506–7

(1809–56), between March and June 1855. So sensitive was this 'delicate transaction' that not only was the Duke's 'great name' withheld (to prevent a rise in price), but Braun encouraged the vendor to believe 'that the Gallery is destined for Mexico or some other Transatlantic State', and funds for the purchase were sent as a blind to Paris, to avoid 'national jealousy'. Braun was, however, aided by the 'well disposed Papal Commission of the Arts & Antiquities', and by the new Electric Telegraph. The price finally agreed, after Camuccini rejected the 100,000 scudi which had been offered by another interested party 'before the collection had the present extensions', and which the Duke had considered a 'just & reasonable price', was 125,000 Roman scudi. By 19th June 1855 the purchase was complete, and the paintings, packed – without their frames – into two chests were heading via Livorno for Liverpool. Evidently fearing difficulties right up to moment the ship sailed, the Duke and Braun had agreed that payment would be made only 'when the Bill of Lading is handed to the banker'; loading then 'takes place under the protection of the English flag'.[191] Baron Camuccini must have been well pleased with the transaction; he purchased a castle near Rome on the proceeds.

The Camuccini purchase[192] was clearly intended specifically to complement the Italianate scheme of decoration at Alnwick, thus creating at a stroke a palace of Italian art in the North, and it must have been this acquisition, as much as the Italianate interiors, which led the Archbishop of Canterbury to suggest that the Duke would be entitled, in the estimate of future generations, to the name 'Duke Algernon the Magnificent': a comparison with the patronage of Lorenzo de Medici he surely relished.[193] Among the gems of the collection were Giovanni Bellini's *Feast of the Gods*, completed by Titian, now in Washington D.C., of which Braun wrote to the Duke on 19th June 1855 with justifiable pride: 'it seems to me like a dream that that magnificent picture by Giovanni Bellini has in reality happily left behind it the walls of Rome and the boundaries of the States of the Church…in truth there exists scarcely another work of art of that great age in such admirable presentation'.[194] Other important purchases included Guercino's *Esther before Ahasuerus*, today in Ann Arbor, while among the many paintings still at Alnwick are a Guido Reni *Crucifixion*, Andrea del Sarto's *Portrait of a Young Man*, a fine early Claude *Seaport* commissioned by Pope Urban VIII, and Nicolas Poussin's vast copy of Titian's great *Bacchus and Ariadne*. Although some attributions have, inevitably, not stood the test of time, many have, and Raphael's *Madonna dei Garofani* (fig. 179), regarded as the '*gloire*' of the collection at the time of its purchase has, after a century of neglect, recently been restored to its status as an autograph work.[195]

In June 1856 the Duke seized the opportunity to expand the Old Master paintings collection at Alnwick still further when pictures from the exceptional Manfrini Gallery in Venice, which included Giorgione's *Tempesta*, came onto the

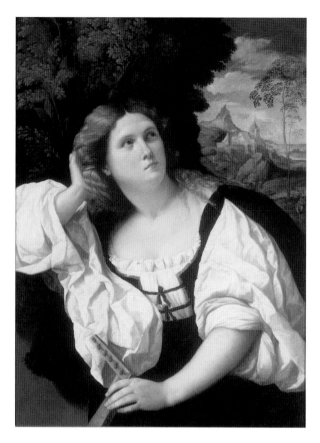

Fig 180 *Lady with a Lute* by Palma Vecchio,
oil on canvas, early 16th century

market.[196] Among the highly important works he now acquired were Bernardino Licinio's *A Sculptor's Family*, considered at the time to portray Pordenone and his pupils, and *The Lady with a Lute* (fig. 180), then attributed to Giorgione, but now recognised as a masterpiece by his almost equally talented Venetian contemporary, Palma Vecchio. However the haunting Manfrini 'Giorgione' *Conversazione* or *Triple Portrait*, today ascribed to a follower of Titian, which inspired some of Byron's least memorable lines, in *Beppo* (1817),[197] was not certainly in the Northumberland collection until 1865.[198] The Duke also acquired at the British Institution in 1853 three fresco fragments, including *The Visitation*; although belonging to the Rev. W. Davenport-Bromley, these had been removed from the walls of Santa Maria della Pace in Rome, and, if hardly in pristine condition, are by no less an artist than Sebastiano Del Piombo.

Duke Algernon maintained his strong cultural interests in later life, becoming a fellow of the Royal Society and of the Society of Antiquaries, and a Trustee of the British Museum. From Athens in 1836 he wrote to offer his considerable collection of coins to the newly formed Numismatic Society.[199] Although his travels in Greece are not recorded in tour journals, a major Turner at Alnwick, *View of the Temple of Jupiter Panhellenios on Aegina* (1814), purchased from Colnaghi sometime before 1856, offers an illuminating insight into his Graecophile inclinations.[200] Closer to home, the Duke was the patron of the Newcastle Society of Antiquaries; surveys of the Roman Wall, of the Roman Watling Street and a map of prehistoric Northumberland, were conducted or produced under his aegis. Although he spent much time improving his estates, and on charitable work, also serving briefly as 1st Lord of the Admiralty in 1852 (where colleagues ruffled his dignity as 'uncrowned king of Northumberland' by dubbing him 'The Doge'),[201] his passion for travel remained. A series of important 17th and 18th century tapestries for the medieval Percy border stronghold at Warkworth Castle were acquired during continental visits of the 1860s, while, at the celebrations for what proved to be the Duke's final birthday, the Duke's friend, Lord Ravensworth, commented that his travels 'recalled to mind the wise hero of Homer in the Odyssey';[202] in addition to Europe and Asia, his destinations included America and South Africa.

If, during his lifetime, the Duke was compared by admiring (and occasionally less admiring) contemporaries with Lorenzo de' Medici, the Venetian Doges and Odysseus, one obituarist, not to be outdone, concluded there was much in his character 'that recalled the grandeur of the Roman patrician, and displayed a Roman loftiness of soul'.[203] Although sycophantic comparisons such as these with Homeric or Renaissance princes may seem absurd today, they show contemporaries striving to evaluate, through the classical vocabulary of the day,

the achievements of a man who, in addition to being a pioneering tourist, was an active, enlightened art patron on a scale commensurate with his vast wealth and pre-eminent social position in the North.

SHORTER TOURS, 1820–40

Sir Matthew White Ridley, 3rd Bart., was not alone in revisiting the continent many years after his original Grand Tour. His friend, neighbour, and former Whig associate, Sir Charles Monck, also made a second tour abroad, although without the cultural repercussions of the first, this time of France, Switzerland and Italy, from October 1830 to February 1831. Once again proving an indefatigable diarist, he was accompanied on this occasion by his son Charles Atticus (soon to marry Sir Matthew's daughter Laura) and his Northumbrian neighbour Lord Wallace (1764–1844) of Featherstone Castle, another former tourist, whose success on the national political stage had earned him a barony two years previously. Monck also visited Sicily on his own. In Naples, where they were attending tableaux and theatricals, and visiting Pompeii, he was able to rendezvous with his daughter Julia and her Northumbrian husband Sir Edward Blackett (1805–55), son of another former tourist, on their wedding tour; their meeting confirms that not only individual tourists but whole families were now regularly travelling abroad. Whilst in Rome, Monck visited Thorvaldsen's studio, finding his 'stile wanting', and saw *The Guardian Angel*, recently ordered by Sir Matthew White Ridley from Luigi Bienaimé. His new son-in-law was perhaps less passive in his appreciation, acquiring a painting depicting the siege of Troy and two marble topped tables in Italy; other seemingly Grand Tour works recorded at Matfen in the 1880s could have been purchased either in England or abroad by Sir Edward or his tourist father.[204]

Another Napoleonic era tourist, William Ord (pp. 199–208), also made a second, shorter, tour in these years, once again keeping a detailed journal of his travels through Belgium, France, the Rhineland and Switzerland from 23rd June to 20th August 1825.[205] This eight-week holiday, on which Ord, like the Trevelyans, could benefit from the steam packet now operating across the channel, could stand as a paradigm of the curtailed tours which had by now become popular. Apart from a fortnight's stay in Paris, its focus was on the scenery of the Rhine valley and Switzerland, highlights including the falls at Schaffhausen, Chillon, Mont Blanc and Chamonix. Although Ord's search for sublimities caused him to be impatient of 'detestable' Swiss towns, he paused in Germany to take in the picture collections in Darmstadt and Frankfurt – where his principal enthusiasm, however, was for the *Ariadne* of the Stuttgart court sculptor and friend of Schiller, Johann Heinrich von Dannecker (1758–1841). Although its execution was 'far from the finish of Canova', Ord preferred this to 'any modern sculpture I ever saw'.[206] Given that Dannecker's enthusiasm for antique art had caused him to travel on foot to Rome, where he was known as 'Il Greco', Ord's admiration confirms the strong interest in neo-classical sculpture already apparent on his earlier tour.

FINAL TOURS

JOHN (1811–85) AND JOSEHINE (1825–74) BOWES: THE FOUNDING OF A NORTHERN COLLECTION ABROAD

John Bowes was the illegitimate son of the 10th Earl of Strathmore, whose title combined a Scottish earldom with the Durham estates of his mother, Mary Eleanor Bowes, heiress to a family which had owned land in Teesdale since shortly after the Norman conquest and which had long been prominent as servants of the Crown, and as tourists. Although, following his father's death-bed marriage to his mother, John Bowes went on to inherit his father's vast estates, including the Durham seats of Streatlam Castle and Gibside, he inherited neither his title, nor his assured position in society – a fact which would profoundly influence both his life and his art collecting. Educated at Eton and Cambridge, where he became friendly with Thackeray, Bowes's earliest trip abroad was in the

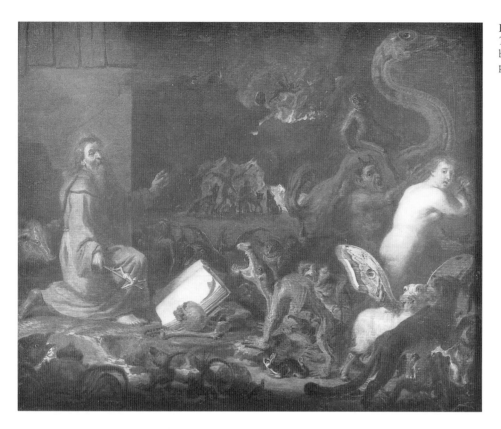

Fig 181
The Temptation of St. Anthony
by Cornelis Saftleven, oil on
panel

summer of 1830, when he travelled in The Netherlands, Germany and Switzerland with the Rev. Arthur Pearson, a man eight years his senior who appears to have been a friend as well as, perhaps, a tutor.[207] Like so many tourists at this time they toured the battlefield of Waterloo, and also saw in Brussels the house where the Duchess of Richmond had held her famous ball. Bowes and his companion resembled other early 19th century tourists, too, in their admiration for Switzerland – climbing the Rigi and descending by William Tell's chapel was almost *de rigueur* at this time – and in visits to the German cathedrals at Strasbourg and Cologne, although Bowes went one further, visiting the church of St Ursula with its 'Bones and skulls of 11,000 virgins', a sight which horrified him: 'Mem. Never to go near it again'.[208] Already, he was taking a keen interest in painting, noting in his pocket book works by Rubens and Van Dyck in Antwerp, and a collection of pictures

to be sold at Aix-la-Chapelle, and on this tour he bought his first Old Master painting, a *Temptation of St Anthony* by Cornelis Saftleven (fig. 181), then attributed to the well-known genre painter David Teniers the Elder. Another early purchase, in 1840, Claude-Joseph Vernet's *Italian Coast Scene with Bathers* (fig. 182) of 1771, also illustrates Bowes's conservative taste in pictures at this stage in his career: Vernet's combination of vaguely classical figures, idyllic Mediterranean coast scenes and shipping was a formula which had proved lastingly popular with British collectors.

These purchases suggest that John Bowes began collecting very much in the tradition of other Northern Old Master collectors who had made the Grand Tour: by 1830 Alnwick Castle already contained a notable collection of paintings, soon to be augmented by the acquisition of the Camuccini pictures from Rome. And although many of the finest

paintings at Raby Castle, seat of Bowes's friend, contemporary and neighbour Henry, 2nd Duke of Cleveland, were not purchased until around 1860, the collection was already strong in Dutch and Flemish paintings, and Cleveland would soon augment it with three genre scenes by Teniers. By 1844 Bowes had already assembled fifty-seven paintings, many of them Italian religious paintings of the 16th and 17th centuries. However, his taste in Old Masters had begun to differ from that of his contemporaries in one important respect: the pictures he bought were of interest rather as 'records of people, places or events in past or contemporary history' than for their intrinsic artistic merit.[209]

By 1847 John Bowes had given up the seat he had held in Parliament since 1832 as liberal M.P. for South Durham, his views on religious toleration having proved too radical for his supporters. Instead he settled for a more relaxed mode of life in Paris, where in 1852 he took the unusual step of marrying his mistress, the French actress and amateur artist, Benoîte-

Joséphine-Coffin-Chevallier (1825–74). Their marriage, like the Trevelyans' and the Northumberlands', was childless, and it was perhaps this which allowed John and Josephine Bowes the leisure to build up a comprehensive collection of fine and decorative arts. This has many parallels, notably with the Wallace Collection, formed in Paris by the 4th Marquess of Hertford at this same period.[210] The Bowes's collection is, however, unique among 19th century collections in that, certainly from 1861–2, it was assembled 'not merely… for their own amusement but… with the view of founding a public museum'. Because of this they 'systematically set themselves to acquire works of art which should be adapted to this purpose, in being representative of various classes of art and of various styles and periods'.[211]

The result was an encyclopaedic collection very different from the aristocratic collections of the day, illustrating different types of painting from portraiture, landscape and historical works, to genre scenes, still life (fig. 183) and

Fig 182
Italian Coast Scene with Bathers by Claude-Joseph Vernet, oil on canvas, 1771

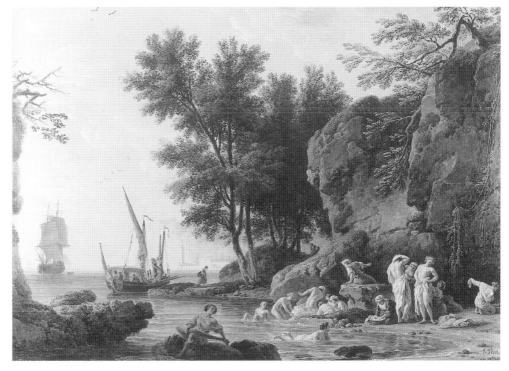

Fig 183 *Still Life with Lilacs and other Flowers*
by Pieter Faes, oil on canvas, 1796

admirers of the Impressionists, and it is noticeable that their collection did not include any 17th or 18th century British painting, or the works of the Pre-Raphaelites then being assembled so avidly by collectors on Tyneside. There were also representations of almost every European porcelain factory, from Sèvres and Meissen and this lovely 'Capodimonte' Naples Grand Tour ware (fig. 186)[212] to little-known factories such as Chantilly or St. Cloud, together with examples of Delftware, Italian Maiolica, and stoneware. The collection also included European silver, glass, embroidery, sculpture, clocks, stained glass, weapons, coins, medals, costume and furniture.

After Josephine's death in 1874, John Bowes said that 'the idea and project of the Museum and Park originated entirely with her', and perhaps the principal reason for the different

Fig 184 *St. Agabas* by Juan Bautista Maino,
oil on canvas, about 1611–13

religious paintings (fig. 184). At the same time, the aim seems to have been to include works from all the principal European schools of painting, Spanish (fig. 184) as well as Italian, French, Dutch and Flemish. Like many collectors today, but unlike their contemporaries, John and Josephine seem to have particularly enjoyed purchasing small, informal sketches, such as Luca Giordano's *The Triumph of Judith* (fig. 185), rather than always concentrating on finished works. Although they also bought works by living artists such as Courbet, Boudin, Corot, and Fantin-Latour, they were not among the early

Fig 185
The Triumph of Judith
by Luca Giordano,
oil on canvas, about 1700

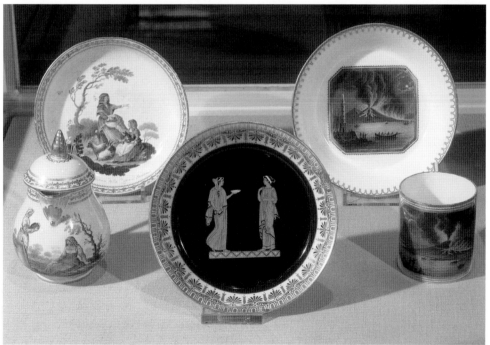

Fig 186
*Group of Naples porcelain
including a cup and saucer
with scenes of Mount
Vesuvius in eruption,*
soft paste porcelain,
Naples, 1775–80,
together with a *Saucer
decorated with Pompeian
figures,* Vienna porcelain,
about 1790.

character of this collection, as compared with John's early assemblage of Old Masters, is the crucial role played in its formation by Josephine. As has been pointed out, she seems to have preferred the act of acquisition to that of selection, choosing from the large basketfuls left almost daily for her perusal by the two Parisian dealers who acted as her principal agents, and her collecting activities have been associated rather with an extension of the principle of shopping for luxury goods in the new department stores of the period, that occupied the bourgeoisie, than with the collection of individual works of art by aristocratic collectors. By 'taking the unusual step of gearing her collection towards an historical view of the development of the fine and decorative arts', however, Josephine 'gave her collecting a purpose beyond mere "accumulation"'.[213]

This type of collection, albeit assembled abroad, was very different from those made on, or as a result of, the Grand Tour, which had been purchased for private enjoyment rather than public instruction and which were therefore much less inclusive and catholic in their nature. It was, moreover, formed in a very different way. Like their British counterparts, but starting from their base in Paris, this Northern Englishman and his French wife made a number of continental tours, notably on their honeymoon in 1852, and again in 1868, when they travelled through Bavaria and Austria to Cracow, returning via Saxony and The Netherlands. However, only a few items in the collection, notably the Meissen bought in Dresden that year, and the exceptional portrait of *Cardinal Ottoboni* by Francesco Trevisani which John Bowes purchased on one of two Italian tours he made in 1875–6 after Josephine's death, were acquired on their continental travels. The rest of the collection was built up in Paris itself. Although the Bowes's collection can therefore hardly be described as 'Grand Tour', it remains perhaps the most grandiloquent example of the cultural interchange between the North-East and the continent.

Although John and Josephine Bowes lived principally at their house in central Paris and, until 1862, at the château at Louveciennes, which was John's wedding present to

Josephine, and which was sold in that year to provide the necessary capital to fund a museum, they made annual visits to Streatlam Castle in the North of England, and when, in 1864, they came to select a permanent site for their museum, they chose land adjacent to their estate in Teesdale. The building, which was in the French Renaissance style, was begun in 1869; the joint architects were a Frenchman, Jules Pellechet, and John Edward Watson of Newcastle. Josephine Bowes did not live to see its completion, but her desire, together with that of her husband, to share her wide experience of European art with the people of Teesdale, resulted in one of the most remarkable of all British museums.

GEORGE (1843–1911) AND ROSALIND (1845–1921) HOWARD, 9TH EARL AND COUNTESS OF CARLISLE

The tours of Italy, Egypt, Africa, India and the West Indies made by yet another remarkable couple, the talented amateur artist, George Howard, 9th Earl of Carlisle and his formidable wife Rosalind, whose interests included Women's Suffrage, Temperance, liberalism, local politics, and estate management, are illustrative of the far-ranging travel that became possible towards the end of the 19th century. George Howard was the nephew of the 7th and 8th Earls of Carlisle, whose 18th century predecessors had made highly important Grand Tours, bringing back to Castle Howard in Yorkshire some of the greatest of all Grand Tour artefacts.[214] Although George eventually inherited Castle Howard in 1889, he and Rosalind infinitely preferred the wilder landscape of their Northern seat, Naworth Castle in Cumbria, which they visited regularly from 1864, and where they entertained the painters and *literati* of the day, including Burne-Jones, Holman Hunt, Browning, Matthew Arnold and Tennyson.

As a young man, George Howard had studied at the Royal College of Art, where he became a friend and patron of the Pre-Raphaelites, whose style profoundly influenced his own, and he later exhibited his work at the progressive Grosvenor Gallery, which acted as a showcase for the work of Burne-Jones and the Aesthetic movement. Howard was seldom without his sketchbooks on his tours abroad and many of his

Fig 187 *Como* by George Howard, 9th Earl of Carlisle,
watercolour, 1866

long after their marriage. On this visit, however, Howard met in Rome the painter who would influence his whole later approach to painting from nature: Giovanni Costa, leader of the Etruscan group of landscape painters. For the Etruscans, including Howard, landscape painting was not simply a scientific record of nature. Instead, the landscape inspired them because it was the setting for mythical, historical, and literary events; both the title of the group, and its aims, point to its kinship with the classical landscape tradition, modelled as it was on an appreciation of Italy and its classical antiquities.

Howard first explored the Roman *campagna* with Costa in 1866, and he and Rosalind later wintered in Italy year after year, living 'in hotels, pensiones and rented rooms in different parts of the peninsula' – Rosalind, despite being hampered by the presence of large numbers of children, often hunting through towns to secure cheap lodgings. Most of George Howard's paintings from 1877–85 were of Italy, and his subjects, which included the Tiber, the Villa Borghese, or St. John Lateran, are highly redolent of the Grand Tour. In this oil sketch of *The Red Fort* (fig. 188), painted further afield in

studies from nature survive. This watercolour of *Lake Como* (fig. 187), which, with its bold patches of vivid colour, and feeling for the underlying structure of a landscape, shows him still working under the influence of the Pre-Raphaelites, was painted on an early tour of Italy with Rosalind in 1865–66, not

Fig 188
The Red Fort
by George Howard,
9th Earl of Carlisle,
oil on panel, about 1885

India, Howard's use of simple shapes and clear bands of colour to build up a strong sense of atmosphere, and the 'spirit' of a particular place, is a fine illustration of the Etruscans' approach to landscape.

The diaries of Rosalind Howard chart the Howards' family holidays both in Italy and on the French Riviera, still then composed of fishing villages rather than palatial hotels. The family 'took their antiquities and their art galleries very seriously' and on one occasion Rosalind memorably read Ruskin's *The Stones of Venice* to her children in the Piazza San Marco.[215] However, there was a different side to this highbrow approach to culture. In 1885, the family made a walking tour through Switzerland; although, like earlier 19th century tourists, they called at Basel so that George 'did not lose his Holbeins', this tour, which saw the Howards and their children wading ankle deep through marshes, and toiling up mountains, is noticeably closer to the family holidays of today.

Among the paintings which the Howards later gave or sold to the nation were two paintings which had hung in the Music Room at Naworth, and were then attributed to Giovanni Bellini and Mabuse, *The Circumcision* and *The Adoration of the Kings*, and Annibale Carracci's *Dead Christ Mourned*;[216] a Byzantine cistern in the courtyard at Naworth was acquired on a visit to Venice in 1882.

THE RIDDELL FAMILY AND OTHER TOURISTS ABROAD, 1820–70

Probably in the late 1830s or early 1840s, Thomas Riddell (1802–70) and his wife Mary Throckmorton (d.1843)[217] of Swinburne Castle, Northumberland, were painted by two pupils of Jacques-Louis David, Jean Sebastian Rouillard (1789–1852) and Claude-Marie Dubufe (1790–1864). Riddell was the head of a leading Northern Catholic family, two of whose members had made the Grand Tour in the late 18th century, and it has always been assumed that the family tradition that these portraits were painted in Paris, on the first of two continental tours he made with each of his wives, was

correct;[218] Dubufe was a highly fashionable portraitist in the Paris of the 1820s and 1830s, and this delightful image of a woman in mourning dress, looking back over her shoulder at the viewer (fig. 189), not only illustrates his stock-in-trade of 'marketable beauty'[219] but has much in common with Ingres' famous, slightly later, *Vicomtesse Othenin d'Haussonville*. However, Alastair Laing has pointed out that Dubufe also painted a series of portraits of the Chichester-Constables, Catholic relatives of the Riddells, at around the time *Mrs. Riddell* was probably painted,[220] and the artist's connection with Britain is also attested by his Royal Academy submissions from 1828–31. Rouillard's portrait of Thomas Riddell,[221] is, however, more problematical in terms of its British origins,

Fig 189 *Mrs Mary Riddell*
by Claude-Marie Dubufe, oil on canvas, 1830s(?)

and it remains possible that both portraits were indeed painted in Paris. Certainly the Riddells, as a Catholic family, tended to look abroad for their portraits: a later portrait of Riddell's second wife, Laura, by the Italian artist, Alessandro Capalti (*c*.1810–68), seems likely to have originated in Rome.[222]

The continuing tendency of the aristocracy and landed gentry to make leisurely tours abroad in the years from 1820–40, already seen in the travels of the Ridleys, the Trevelyans, and Dr. Edward Charlton, is confirmed by two further tours which, however, are not recorded in depth. Henry Howard of Corby Castle, Cumbria, and his wife, Catherine Mary, followed up their earlier continental travels with a two-year tour from 1829–31 which, typically for this period, included Germany, the Rhine and Holland,[223] while Frances Anne, Marchioness of Londonderry, of Wynyard Park, Durham was adventurous enough to reach Moscow and St. Petersburg on a tour of 1836–9;[224] surprisingly, this is the first recorded Grand Tour by a member of this Durham family, which played such an outstanding part in national political life.

Other leading Northern landowners, notably William Harry Vane, 3rd Earl of Darlington (pp. 122–4, 208–11), created 1st Duke of Cleveland in 1833, adopted the developing fashion for shorter European tours, notching up as many as seven between 1821 and 1837. Although hardly this well-travelled, the former tourist John George Lambton, soon to become Earl of Durham, was in Naples in 1827, vying with other rich Englishmen 'as to who shall produce the greatest novelties' in terms of entertainments including fancy dress balls, French plays, tableaux and charades.[225] A later Northumbrian tourist in Egypt in the 1860s, Lord Armstrong, was the great Tyneside industrialist and builder of Cragside. Like many Catholic families, the Salvins had a closer rapport with the continent than their Protestant counterparts, and Gerard and Winifred Salvin from Croxdale, near Durham, lived near Tours on the Loire for much of the 1860s, even taking their silver with them on their travels; account books detailing their expenditure on items ranging from champagne to game, snuff, candles and 'pictures set in alabaster' survive.[226]

POSTSCRIPT

A fitting postscript to this account of Northerners abroad is offered in the career of Sir William Eden, 7th Bart (1849–1915), who seems to have inherited the zest for travel which characterised the whole Eden family. His travels in Egypt, India, China, Japan and America, like the Howards', typify the much more far-ranging tours made in the later 19th century by intellectuals from landed families. Eden was an amateur watercolourist of some ability in the manner of Hercules Brabazon Brabazon, an exhibitor at the New English Art Club, and a collector of works by Corot, Renoir and Degas long before they became fashionable in England.[227] His life, according to the highly colourful account of it given by his son, Timothy Eden, in *Tribulations of a Baronet*,[228] seems to have been a constant struggle between his Northern landed background and his artistic inclinations: his admiration of Italian gardens such as those at Tivoli, made of 'yews, cypress, statues, steps' and rejection of bright colours in favour of 'the subtle beauty in a grey day'[229] finds a strong parallel, not only among artists of the Aesthetic movement, but in the contemporary Italian novels of Henry James, who parodies this viewpoint – in its extreme form – in the narrow aesthetic predilections of Isabel Archer's expatriate husband, Gilbert Osmond, in *The Portrait of Lady*.

Like James himself, Eden felt an abhorrence for the crowds of middle-class tourists now reaching all parts of Europe, and his assumption of a mantle of cultural and intellectual superiority represents the defensive reaction of the cultured elite to this 'invasion' of places previously accessible only to a few. Of Lake Como, Eden wrote 'Why did God create a lake and atmosphere and people in the same breath?' and centres of the 18th century Grand Tour, such as Venice, had now become 'impossible':[230] 'The Salute! Especially made for young ladies to paint!' 'Sickert, Sargent, Sunshine and the Salute have ruined Venice'.[231] We are not far, here, from E.M. Forster's fine Italian novel, *A Room with a View* (1908), which features the ultimate rejection of Eden's view of Italy by the young, middle-class tourist, Lucy Honeychurch. On her

first visit to Italy, with her Baedecker guide, symbol of the new tourist age, firmly in hand, Lucy is courted by the aesthete, Cecil Vyse. However, Forster finally settles, through his heroine, for a broader interpretation of Italy as the home, not of art, but of freedom from conventional restraints, and of sexual fulfilment.

If the late 19th century saw a major expansion in tourism, both in terms of the social classes now able to travel abroad, and their destinations, the 20th century produced a yet more dramatic revolution. The invention of the aeroplane and the creation of a global industrialised society now brought even very remote parts of the world within the reach of most tourists. With the advent of the new millennium, however, and the emergence of low cost airlines, which has placed ever-greater pressures on the Mediterranean basin, most people now accept that the 'hypermobility' that Simon Jenkins predicted in an article in *The Times* in 2000 would be the 'occupational disease' of the 21st century cannot continue indefinitely, as congestion increases and energy resources diminish. So as to avoid gridlock, Jenkins then concluded, 'travellers should pay the price they impose on society as a whole'. Although the fuel crisis of 2000 and more recent opposition to plans to impose road pricing suggest that only a minority in Britain today would relish such a solution, ironically, this would mean that the history of travel would come full circle: 'As in the Middle Ages', Jenkins concluded, 'mobility will once again be a rare and treasured gift. Shanks's pony and the Internet are for Everyman. Travel is for the rich'.[232] The current (2008) oil shortages and consequent sharp rises in price suggest that Jenkins' predictions may be fulfilled sooner in the new millennium than he expected. With global warming now a front page issue, climate change may, however, provide an even more seismic shift. If in 1776 'The grand object of travelling', according to Dr. Johnson, was 'to see the shores of the Mediterranean', rising temperatures and sea levels suggest that, even if travel remains affordable, the huge annual migration from northern to southern Europe, in which the Grand Tour played so important a part, may shortly be 'consigned to the scrapheap of history'.[233]

END NOTES

1 J.M.W. Turner to Sir Francis Chantrey, quoted in Friedman & Stevens, 1972, p. 10.

2 *Imagining Rome: British Artists & Rome in the 19th Century*, Bristol City Museum & Art Gallery, 1996, p. 104.

3 Ridley had also made a shorter continental tour, which included The Netherlands, Germany and Paris, in the summer of 1822.

4 Ridley's tour seems to have begun in Italy in 1828. Although his pocket diary for this year has not survived (unlike those for 1829–30), it is clear from his later correspondence that he visited both Rome and Naples. By 1st January 1829 Ridley was in Nice, returning home via Lyons, Paris and (following a gap in the diary from 21st February–18th May) Calais. After spending May to August 1829 in London and at Blagdon, Ridley left again for the continent on 2nd September on a tour of Switzerland (in part with his son and other family members). Although he crossed into northern Italy, by October he was back in Nice; he remained abroad until February 1830.

5 These purchases are recorded in a notebook, and letters to Sir Matthew from artists in Rome. Ridley MSS., ZRI 33/5; see *Bibliographical Note*.

6 Sharp, p. 152.

7 The cost appears to have been £250; letter from Severn, April 1829 , ZRI 33/5.

8 Severn's earlier *Italian Vintage* (1824–5) was exhibited at the Royal Academy in 1830. Sharp, pp. 165–66, comments that the Ridley *Vintagers* was among the artist's most admired works of 1830. Together with most of the other paintings Ridley commissioned in Rome (see below), *Vintagers Returning* cannot now be traced.

9 Ridley MSS., letter from Joseph Severn to Ridley, 2nd September 1830, ZRI 33/5.

10 Op. cit, letter from Seymour Kirkup to Ridley, 23rd September 1831, ZRI 33/5.

11 Uwins also painted copies after Italian paintings, some of them for Sir Thomas Lawrence.

12 Given their friendship, it seems possible that Severn's painting for Ridley may have owed something to Uwins's earlier record of the (Burgundian) grape harvest in 1817. The closeness of this Roman artistic circle is further illustrated by the fact that Joseph Gott (p. 226) later produced a sculpted *Vintager* (1843–7).

13 For these commissions see *A Memoir of Thomas Uwins, R.A... by Mrs. Uwins*, Vol. II, London, 1858, p. 238 (Letter to Severn, Naples, 3rd February 1829), and Ridley MSS., ZRI 33/5. Today, the Zampognari still play the bagpipes at Christmas in the squares of Rome, Calabria and the Abruzzi. Although *Dressing the Kitten for the Masquerade* and *The Fiesta*, were casualties of the artist's failing eyesight, Uwins was attempting in December 1829 to finish a drawing for Lady Ridley.

14 For Northumberland, Dessoulavy produced *The Temple at Metapantium*, *An Italian Landscape with a Viaduct*, and *A Mountainous Landscape and Distant Lake*; none of these purchases can be linked to a known tour by the Duke.

15 Although Dessoulavy is hardly recorded in standard dictionaries, several of his paintings are on file at the Witt Library, London. His landscape for Ridley was still at Blagdon in 1890 (as by 'Depoulavy'),

but was sold at Christie's in February 1909, as 'Classical Landscape, near the Coast'.

16 Trevelyan MSS., WCT 259 II.

17 Williams also sent a *Scene at the Festa of the Madonna del Arco* to the Royal Academy in 1833; perhaps the version reproduced here, signed and dated 1830, which was exhibited in *The Victorian Vision of Italy*, Leicester Museum and Art Gallery, 1968 (44). Ridley's version must have been completed for the 4th Bart., as the 3rd Bart. died in 1836. It is recorded on the Ridley inventory of 1890 but was sold at Christie's in 1909. Thomas Uwins also produced paintings on this theme (Royal Academy, 1830, 1835).

18 Ridley MSS., ZRI 33/5, letter of 13th July 1829.

19 Although Ridley's papers do not record their acquisition, it seems likely that the *Bay of Naples, Moonlight* (1829) and *Landscape, Paestum* by the Swiss artist Johann Jakob Ulrich (1798–1837), together with Henry Howard's study for a *Birth of Venus*, all at Blagdon in 1890, were also acquired on this tour. As a late exponent of the Reynolds manner of history painting, Howard (1769–1847) seems a likely candidate to have caught Ridley's eye. However, Ulrich was a more adventurous artist, specialising in unusual light effects, and working *en plein air* while in Italy in 1828.

20 Ridley's suggestion of adding goats and a goatherd to his *Vintagers* by Severn was surely made in the knowledge of classical landscape painting, where this motif had been standard since the 1630s.

21 Grove Art Online, Wyatt, (7) Richard James Wyatt, p. 1; ibid.

22 Wyatt's receipt for a £50 advance on £140 is dated Rome, 18th April 1829; Ridley MSS., ZRI 33/5.

23 Wyatt also produced a very similar sculpture showing a nymph returning from the chase with a greyhound and a dead leveret. Given the number of versions of both this and the *Nymph of Diana* which survive (Witt Library files), it seems likely that Ridley was commissioning versions of existing compositions, instead of wholly new works – a pattern repeated in his other sculptural commissions.

24 This was coined by the 6th Duke of Devonshire, a Gott patron, in 1844; Friedman & Stevens, p. 49.

25 Both Ridley's diary (ZRI 33/2/24) and his notebook (ZRI 33/5) confirm that Gott was paid £255 for the two works. They are not included on the list of Gott's surviving and recorded works complied by Friedman & Stevens in 1972 (see *Bibliographical Note*), which includes several other Greyhound and Puppy groups; see also Joseph Gott file, Witt Library. Ridley's *Greyhound* group was probably a version of the popular Chatsworth composition of a greyhound suckling two puppies, although Gott produced a variant, showing a greyhound and puppies at play. The 1890 Ridley inventory included *Greyhounds*, but not the *Catholic Girl*. Gott also produced a case of fifteen 'Terra Cotta Models' for Lady Ridley, selecting those which 'seemed most to please her Ladyship when looking over them' (Gott to Ridley, 1st December 1829).

26 See Friedman & Stevens nos. G 95, G120, and perhaps also G134 and no.40, although the two latter may have been executed instead for Algernon's brother Hugh, the 3rd Duke.

27 Diary of Sir Charles Monck, who saw the sculpture in Bienaimé's studio on 23rd November 1830 (ZMI B/52/3/1-3/4). The price was 2000 crowns (ZRI 33/5). *The Guardian Angel* was one of Bienaimé's most successful sculptures; the original plaster is today in Carrara and

two marble versions are recorded in the Witt Library. Ridley was therefore once again commissioning a version of an existing sculpture, presumably from a plaster model viewed in the artist's studio. The Bienaimé was still at Carlton House Terrace in 1890, but is now untraced.

28 Ridley made other sculptural purchases in Rome. These included a marble chimneypiece, with busts of Euripides, Plato, Phocion and Zeno after the antique and a reduced sized copy of the 'figure of a Sacerdotal Camillus' by William Ewing (Monck diary, 23rd November 1830) which may be identifiable with Ewing's copy in marble of a draped bronze ('one of the Carmelli'), ZRI 33/5. Ridley also seems to have acted as agent over the purchase for George IV of some alabaster tables in Naples (W. Knighton to Ridley, 29th December 1828, ZRI 33/5), and he purchased (apparently for a Mr. Turner, although the work is recorded at Blagdon in 1890), a small-scale copy by 'Severus' of the *Aristides* (ZRI 32/3/24, 14th November 1829 and ZRI 33/5, letters of 1st December 1829 and 17th January 1830). The original marble (Museo Nazionale, Naples), reached the height of its fame in the early 19th century. In addition to the *Aristides*, the 1890 Ridley inventory records two other 'reduced' copies of Flora and Minerva 'from the Vatican'. Sir Matthew and Lady Ridley also bought other Grand Tour artefacts, including cameos, a small marble table, a mosaic of butterflies, and an Italian snuff box.

29 Sir Matthew acquired the site in Carlton House Terrace in 1827; see Ridley, 1965, p. IX.

30 Ridley, 1965, p. IX.

31 Information kindly provided by Matt Ridley. The Bienaimé, and Gott's *Greyhounds*, together with the Dessoulavy (note 15), are, however, known to have been in the Ridley collection in 1890.

32 From Phillips, London; see Ridley, 1965, p. XI.

33 A second Cuyp of a *Man on a Grey Horse* was perhaps added by Ridley around 1832. These paintings appear on the Ridley inventory in 1890.

34 Letter to Sir Matthew White Ridley, Naples, 1st December 1829, from Warmington, ZRI 33/5. The artists William Ewing and Thomas Uwins also gave Ridley advice on Old Master purchases.

35 Ridley MSS., ZRI 33/5, letter from Ewing, 28th November 1829; letter from Warmington, November 1829. Ridley may also have acquired a portrait of a cardinal by Sassoferrato or Sustermans, listed on the 1890 Ridley inventory as having been acquired at the Duke of Miranda's sale. However, the surviving correspondence, although mentioning a 'Haymaker' acquired from the same collector, does not refer to this painting. (Warmington to Ridley, 12th May 1829, ZRI 33/5).

36 Thomas Uwins to Ridley, Naples, 29th December 1829, ZRI 33/5.

37 Besides the Teniers and Cuyps bought by the 3rd Bart., and those certainly acquired by his predecessor (see Northerners Abroad, page 111 and note 152), we know only that Gaspard Poussin's *A Hilly Landscape with a Cascade*, once in the Baring collection, was acquired by the 4th Bart. in 1851; it was sold at Christie's in February 1909, together with other Ridley Old Masters. Further Ridley paintings were sold, also at Christie's, on 28th July 1926.

38 I am grateful to Dr. Ian Jenkins for confirming the dating and status of these frescoes.

39 ZRI 33/5, 7th October 1828, receipt from Nastri, Florence.

40 Ridley MSS., Northumberland Record Office, ZRI 32/5/1–2.

41 Op. cit., ZRI 32/5/2, 31st May, 29th May 1830; see Ridley, 1965, p. X, for the continental wanderings of Ridley's mother. At the end of his 1829–30 tour, Ridley joined the rest of the Ridley family in Nice.

42 Op. cit., ZRI 32/5/1, 24th April ff.

43 Op. cit., ZRI, 32/5/1, Basel, 2nd October 1829: 'saw in the pubic library some Holbeins very good'.

44 Op. cit., ZRI, 32/5/2, 22nd May 1830. By the reign of the Prince Elector Maximilian II Emmanuel (1679–1726), the 'new' castle at Schleissheim already housed 1,000 paintings. This vast art collection of the Electors and Kings of Bavaria later formed the basis of the Alte Pinakotek, Munich.

45 Op. cit., ZRI 32/5/1, 7th May 1830.

46 Ridley, 1965, p. XII.

47 Bridell's *Ave Maria at Bolzano* and *Olive Groves at Varenna*, Corbett's *San Giovanni e Paolo* and a view of Tivoli by William Oliver, all listed on the 1890 Ridley inventory, were almost certainly commissioned by the 4th Bart; the artists concerned were all too young to have worked for his father.

48 The original is in Paris, on loan from the Louvre to the Musée Hébert.

49 This applies to four Italian landscapes on the 1890 inventory by William Linton (1791–1876), who visited Italy in both 1829 and 1840 and painted actual and imaginary landscapes, often in the Richard Wilson mould (although Linton's *Caius Marius in the Ruins of Carthage* was certainly acquired by the 4th Bart. in 1865), and to views of Lake Maggiore and the Gulf of Spezzia by George Edwards Hering (1805–79), whose output was almost exclusively of Italian scenes.

50 For Ridley's comparison of Lough to Michelangelo see Ridley, 1965, p. XII and Ridley MSS 33/8; for the proposed gallery see Ridley, 1965, p. IX.

51 'MS. Diary by Walter Calverley Trevelyan of his visit to Shetland, Faro [sic] and Denmark, May 1821–April 1822, WCT 249/12. The tour appears to have had its origins in an invitation to accompany a Professor Forchammer of Holstein on a mission to examine the mineralogy of the Faroe Islands.

52 Trevelyan, pp. 13, 19.

53 See Victoria Surtees (ed.), *Reflections of a Friendship, John Ruskin's Letters to Pauline Trevelyan 1848–66*, 1979.

54 Trevelyan, p. 20.

55 These tours have already been discussed, albeit more briefly, in Trevelyan (1978) and Batchelor (2006). Although I have consulted Walter Calverley Trevelyan's journal and other papers in the Special Collections Library, Newcastle University, I have not had access to Pauline Trevelyan's 44–volume diary in the Kenneth Spencer Research Library, University of Kansas, and the following account is greatly indebted to both of these sources for their account of Pauline's tours, and for more general information on the Trevelyans' lives.

56 Batchelor, p. 35.

57 WCT 259 II, 19th October, 2nd December 1835, 18th March 1836.

58 Batchelor, pp. 18–19; WCT journal, 259.II, 30th March 1836, 8th April 1836; ibid.

59 WCT 260 (2), 8th April 1837, 8th July 1836, 9th January 1837.

60 This had been founded in 1829 'for making antiquarian researches in Italy'; WCT 259 II, 13th April 1836. Calverley received a diploma as a member on 5th January 1838, WCT 260 (2).

61 WCT 259 II, 30th July 1836; inserted between entries for December 9th and 10th 1836; WCT 259 II, 8th April 1836.

62 WCT 259 II, 13th October, 10th June 1836.

63 WCT 259, II, 17th October 1836; Calverley's list also records 19 chasers in metal, 47 miniaturists, 49 architects, 55 engravers in copper, 52 mosaicists and 22 print shops.

64 Grove online, articles, Macdonald.

65 This was surely the Northumbrian family with whom the Trevelyans had dined on their way through Nice (WCT 259 II, 20th February 1836).

66 For these and other works by Lough mentioned by Trevelyan, see WCT 259, II, 10th May, 21st July 1836, and WCT 260 (2), 25th January 1837; for Macdonald, see WCT 259, II, 6th April 1836.

67 They also visited the studios of two other sculptors closely associated with Thorwaldsen, Luigi Bienaimé (p. 226) and the late Mathieu Kessels (1784–1836), a Flemish sculptor whose numerous patrons had included the 6th Duke of Devonshire.

68 WCT 260 (2).

69 WCT 259 II, 17th October 1836; WCT 260 (3).

70 WCT 260 (2), 7th January 1837 and 14th February 1838, WCT 260 (2), 25th January 1837, WCT 260 (2), 19th January 1838.

71 Trevelyan saw sketches of Tivoli by 'De Soulavey' on 2nd May 1836; WCT 259 II. Other artists they admired who are barely recorded today were the watercolourist John Byrne (1786–1847), son of the engraver William Byrne, who travelled on the continent in the 1830s, and whose portfolio of French and Italian sketches was shown to the Trevelyans by William Ewing on 22nd September 1836, and two German artists, 'Elsacer' (Friedrich August Elsasser, 1810–45, or, less probably, Julius Albert Elsasser 1814–59), both of whom painted interiors of Roman palaces and churches.

72 WCT, 259, II, 10th May 1836. This Scottish artist is recorded in Gunnis (*Dictionary of British Sculptors 1660–1851*), as having executed portraits on ivory of Canova and of Pope Pius VII in Rome in 1820, exhibited at the Royal Academy in 1822, together with a copy of the head from the *Antinous* in the Mueso Borbonico, Naples. Two of Ewing's (much later) sculpted busts survive in the collection of Inverclyde Council. However his name is not otherwise recorded in standard dictionaries, or in the Conway Library, Courtauld Institute of Art. Trevelyan also records that Ewing executed a bust of Sir William Gell, and the tombstone to his friend Rolland in the Protestant Cemetery in Rome (10th May 1836 and 10th February 1838).

73 WCT 259 II, 13th May 1836, WCT 252.121, WCT 252.119: 'Received of W. C. Trevelyan Esquire the sum of ten guineas for a medallion likeness in ivory carved by me. William Ewing Rome May 28th 1836'.

74 Neither is know today.

75 WCT 259 II, 20th December 1836, WCT 260 (3), 23rd April 1838.

76 Edward Charlton journal, Italy, 26th February 1838, typescript, p. 172.

77 The Kestner museum in Hanover has drawings and paintings by him, together with works from his collection, some of which are also in the Niedersachsisches Landesmuseum in Hanover.

78 WCT 260 (2); the portrait was begun 9th February 1838. Kestner showed the drawing to the Trevelyans on 25th February, but it was clearly not yet completed, as on 20th March Calverley sat to Kestner again. At the same time, Kestner was drawing in crayon '3 good heads for the orphan lottery, Handel, Holbein & Schiller'; WCT 260 (3), 20th March 1838.

79 WCT 259 II, 15th July 1836. The Trevelyans had admired watercolours by Glennie belonging to Acland (not to be confused with their close friend Henry Acland, Regius Professor of Medicine at Oxford, and also a friend of Ruskin's) on 9th April 1836; later, on 17th November 1838, they saw Glennie's 'sketches about Subiaco & Horace's villa near Licenza'. A series of Glennie's traditional but attractive 1836 Roman sketches appeared at Sotheby's, London, on 15th November 1973 (205).

80 This was almost certainly the miniaturist William Thomas Strutt (1777–1850); see WCT 260 (3), 13th March 1838.

81 WCT 252.127; undated letter but evidently sent while both Dunbar and the Trevelyans were in Rome. Presumably the changes he made met with the Trevelyans' approval, as during the 1848 revolutions he painted for Pauline 'The Castle and Episcopal Palace at Ostia' (WCT 114.66), also providing drawings for her portfolio in 1850, 'worked from nature as you had desired' (WCT 114. 61), which were probably part of the same commission. In reply to a letter from the Trevelyans in England requesting further drawings, Dunbar also talks of the few Italian sketches 'I could part with… those taken in the neighbourhood of Rome and consequently able to be replaced'; WCT 114.64, undated letter.

82 For Fuschini, see WCT, 259 II, 12th August and 31st August 1836; he was making a copy for Calverley after a frieze the Trevelyans had admired in his studio. Rather oddly, Fuschini's drawing at Wallington is dated 1834. Possibly, Walter and Pauline eventually purchased the original instead; more probably, Fuschini simply gave the Wallington copy the date of his original composition. I have not been able to trace this artist.

83 WCT 260 (3).

84 Ferdinando Mori, *Le Statue e li Bassirilievi inventati e scolpiti in marmo dal cavaliere Alberto Thorwaldsen*, Rome, 1811. The Mercury exists in full-sized marble versions in the Thorvaldsens Museum, Copenhagen (1822), in the Prado, Madrid (1824), at Chatsworth, and at Potsdam. Other smaller-sized version are known, by H. E. Freund (1820) and by or after Pietro Tenerani, who was in Rome at the time of the Trevelyans' visit.

85 WCT 259 II, 25th July 1836. Among the smaller scale classical works the Trevelyans purchased were an antique cameo 'in Pietra dura of beautiful workmanship' from a dealer, Pestrini, together with a 'fine shell cameo by his brother', of Guido Reni's *Aurora* (WCT 259 II, 20th November 1836), and a neo-classical cameo by Giovanni Diez (WCT 259 II, 27th June 1836).

86 WCT 259, II, 7th July 1836; ibid. The Overbeck prints were acquired from Schultz, a German dealer. For Overbeck's stay in Rome, see Grove online/articles/ Overbeck. The Trevelyans' liking for early Italian painting is also reflected in their interest in a *Madonna and Child* by the British Nazarene William Dyce (1806–64), which they saw in Joseph Severn's studio. Like Overbeck, an admirer of his work, Dyce had spent time in Rome in the 1820s.

87 WCT 259 II, 27th July, 12th November 1836; WCT 260 (2),

14th January, 3rd February 1837; WCT 259 II, 5th December 1836.

88 Trevelyan, p. 19.

89 WCT 260 (2), 2nd February, 17th April and 26th March 1838. For Gibson's bust of Harriet Cheney see p. 141.

90 Calverley attended Scott's funeral in Rome on 10th April, 1838; WCT 260 (3).

91 This visit took place slightly later, not on their route north.

92 Batchelor, pp. 20–21.

93 WCT 260 (1), 23rd and 30th June, and 1st July 1837. Urbino was a centre for *maiolica* production in the 16th century. Although Raphael's work was frequently reproduced on Urbino ware during the first *istoriato* (narrative) phase, Trevelyan is referring specifically to the popularity of his work during the third *istoriato* phase, when historical or mythological scenes were 'framed by friezes or grotesques'; see Grove online, Italy, VII, Maiolica (ii), 1500 and after, pp.1–2. The famous tin-glazed terracotta sculpture produced by the della Robbia family of Florentine sculptors and potters ranged from Luca della Robbia's blue-and-white Madonna and Child compositions of the 1420s onwards to the later, polychrome effects of his nephew Andrea and other family members.

94 WCT 260 (1), 20th–21st July 1837; op. cit., 10th–11th September 1837.

95 Calverley's interest in the della Robbia family, evident from his first arrival in Florence (note 93) is also shown in a numbered diagram he made of the Giovanni della Robbia terracotta in S. Lucchese at Poggibonsi; WCT 260 (1), 3rd October 1837.

96 WCT 260 (1), 13th, 11th and 14th October 1837.

97 Trevelyan, p. 21. The 'Sodoma', *The Dead Christ supported by Angels*, is now in the National Gallery, London; having been attributed in recent years to Giulio Cesare Procaccini it is now ascribed to the little-known Fra Paolo Piazza da Castelfranco.

98 For this family, see pp. 108–10.

99 WCT 260 (3), 20th March 1838. Trevelyan notes that the collection included predella panels by Piero della Francesca, a large Salvator Rosa landscape, and works by Filippo (or Filippino?) Lippi, Carlo Dolci and Cristofano Allori. The Trevelyans had also viewed the Bellanti collection of around 260 paintings in Siena, but apparently without making a purchase.

100 Trevelyan, p. 21.

101 Sir Walter's will of 1879 divided his estates of Wallington and Nettlecombe amongst different members of the Trevelyan family, and many of the Grand Tour works purchased for Wallington by Calverley and Pauline were transferred to Nettlecombe.

102 Trevelyan, p. 24.

103 Many of the artist's most famous works, including his portrait of Erasmus, passion scenes and *Dead Christ* remained in the city, while his *Dance of Death* woodcuts (cut in 1522–6, but, owing to the vicissitudes of the Reformation, only published, anonymously, in 1538) were also a draw for tourists.

104 Unfortunately, there is a gap in Calverley's journal between 28th July 1841 and 23rd March 1842, when they were about to leave Rome for a tour of Greece.

105 See Batchelor, p. 35.

106 Batchelor op. cit., WCT 261/1, 5th April 1842.

107 WCT 261/1, 27th April 1842 and 'Sketches in Greece in 1842 by Lady Trevelyan', British Museum, 200.c.8.

108 With this instrument, a prism suspended at the end of a metal rod projects an image onto paper, which can then be traced using a pencil. Pauline and Calverley's *camera lucida* drawings are included in her British Museum sketchbook. Ingres was among professional artists to utilise this device.

109 WCT 261/1, 25th and 28th April, 4th May 1842.

110 WCT 261/1, 9th May 1842; Trevelyan, p. 26; WCT 261/1, 11th June, 18th May 1842.

111 This was then thought to be a Temple to Jupiter Panhellenios.

112 Trevelyan, p. 27.

113 WCT 261/2, 22nd , 29th August 1842, Raleigh Trevelyan p. 27. The flooding of the Piazza Navona, with carriages circling the piazza, is shown in a painting by Panini of 1756, reproduced in Hibbert, fig. 87.

114 See Batchelor, pp. 38–41 for a detailed discussion of Pauline's reaction to Venice; Batchelor, p. 39, ibid.

115 Batchelor, pp. 39, 40.

116 Trevelyan, p. 32.

117 Pauline wrote a travel article, 'Landing in Lisbon', for *Chambers' Journal*.

118 Trevelyan, p. 32; ibid; ibid, and Wallington guide p. 12.

119 Batchelor, p. 234.

120 Munro also produced a similarly classical oval of Sir Walter Trevelyan, in low relief, reproduced in Trevelyan, 2004, p. 15.

121 Other aspects of the Wallington scheme confirm its inspiration from abroad: Alexander Munro's sculptures, *Paolo and Francesca* (1851) and the *Study of a Babe* are inspired respectively by Dante's *Inferno* and the Greek legend of Hyacinthus, killed prematurely by Apollo.

122 The Leonardesque style of Bernardino Luini was highly popular with British connoisseurs from c. 1790 to the late 19th century. Luini came from Lombardy and executed important works in Milan, as well as in Lugano, Como and near Monza; hence Ruskin's reference to 'Luini everywhere' in this area.

123 Surtees, p. 255; Batchelor p. 230; Trevelyan, p. 234.

124 Batchelor, p. 38. I am indebted to this book for information on Pauline's Kansas sketchbooks.

125 I am greatly indebted to William E. Charlton, Edward Charlton's descendent, for kindly allowing me to study the original material in his possession, and for providing me, additionally, with transcripts of Charlton's other tours.

126 Edward Charlton, 'Journal of an Expedition to the Shetland Islands in 1832' (1843), copied by his son W. L. Charlton, 1909, p. 1. Trevelyan's 1821–2 tour prefigures Charlton's early travels not just in focusing on Shetland, and parts of Scandinavia, but in its interest in geology and natural history.

127 Edward Charlton, op. cit., p. 1.

128 Edward Charlton, 'Hull to Vienna 1837', typescript, p. 139.

129 The Alpine Club was founded in 1857.

130 Unpublished biographical note by William E.Charlton, p.1. For Cotman as Charlton's drawing master, see Barbara Charlton, *The Recollections of a Northumbrian Lady*, 1949, p. 140.

131 The journals' later production and book-like status is emphasised both by their division into sections with sub-headings and by the inclusion of instructions to the binder concerning where major illustrations should fall to complement the text. Smaller illustrations were, however, pasted directly into the manuscript.

132 The cover is stamped in gold with an elaborate border and title, 'Norway in 1836–1856–1859. Shetland in 1852', and there are marbled covers inside.

133 The drawings are inscribed 'JRM'; for Mather, see Hall, 2005, p. 230. A large watercolour by Mather, *On the Coast of Norway: Twilight after Storm* (1860), is in the Shipley Art Gallery, Gateshead. There are also drawings by two other (unidentified) hands in this section of Charlton's book.

134 Other illustrations are by W. Cameron and W. Broderick.

135 Charlton mentions his visit to Switzerland in 1835 in 'Norway, 1836', typescript, p. 1.

136 Charlton's habit of revising his tour journals, and the importance he attached to these records, is illustrated by the fact that the Norway journal exists in two versions, one in his own hand, and one in that of his first wife, the latter edited (presumably by Charlton himself) 'with an eye to a wider, more critical readership'; Charlton, 'Norway 1836', typescript, p. 1, note 1.

137 Edward Charlton, 'Norway', 1836', typescript, p. 1; Edward Charlton, 'Norway & Sweden, MSS., 1862, p. 59.

138 Ibid, Edward Charlton, 'Norway, 1836', typescript, pp. 35, 1.

139 In Gothenburg, Charlton delivered a parcel for Baron Berzelius, the leading Swedish chemist of his day, from Professor Johnstone of Durham – a confirmation both of links between scientists in the North East and Scandinavia, and of Charlton's own developing scientific standing in North East England.

140 Charlton noted that a previous visitor to the mine was a Mr. Bowman from Newcastle, who was on a botanical tour.

141 Charlton, 'Norway & Sweden' MSS.,1862, p. 192.

142 This tour is covered in two Charlton journals: 'Holland & Germany', 1837, and 'Italy & the Tyrol', 1838. The manuscript for the former is now lost; that for the latter is in a private collection. In both cases I have consulted the typescript version in the possession of William E. Charlton. Charlton appears not to have kept a diary during his lengthy stay in Vienna.

143 Charlton, 'Hull to Vienna', 1837, typescript, pp. 124, 125.

144 Op. cit., pp. 126, ibid, 129, 134.

145 Op. cit., pp. 129, 128, 125, 128.

146 Op. cit., pp. 127, ibid, 138, 141.

147 Op. cit., pp. 145, 131, 133, 135, 134.

148 Op. cit., pp. 137, 135.

149 Op. cit., pp. 147–8.

150 Op. cit., pp. 142, 144.

151 Op. cit., pp. 150–3.

152 Op. cit., pp. 153, 156, ibid, pp. 159, 157, 159, 160.

153 Op. cit., pp. 166, 167. William E. Charlton points out in his 'Biographical Note on Charlton' (see *Bibliography*), a fascinating parallel between the bandits Charlton actually encountered in Italy, and Alexandre Dumas's *The Count of Monte Cristo*: in the novel, 'the Count spread his net for Albert de Morcerf at the Carnival in Rome, and… Morcerf joked sceptically about bandits. The dramatic date of this was 1838, and Charlton's journal not only describes the Carnival that year, but has a good deal to say about bandits both in central Italy and in Slovenia, then part of Austria'.

154 Charlton, 'Hull to Vienna', 1837, typescript, pp. 171–2.

155 Op. cit., p. 173, ibid, p. 175.

156 Op. cit., p. 174, ibid.

157 It had been known to the Romans; antique statues were found there on its re-discovery in 1826.

158 Charlton, 'Hull to Vienna', 1837, typescript, pp. 175, 177, 178.

159 Op. cit., pp. 178, 180, ibid, 181.

160 Op. cit., pp. 180–1, 181, ibid.

161 Op. cit., pp. 182, 184.

162 Op. cit., pp. 182, ibid, ibid, ibid, ibid, pp. 182–3, 185.

163 Op. cit., pp. 187, 189.

164 Op. cit., pp. 189, 190, ibid. Charlton appears to have shortly afterwards 'proceeded to Paris, where he entered the famous school of medicine in that capital', and 'produced a work … on "Pneumonia as it Affects the Aged"'; see J. Embleton Smith, *Newcastle Weekly Journal and Courant*, 3rd July 1909.

165 Unpublished Biographical Note on Edward Charlton by William E. Charlton.

166 This is published in Ruffle,1988, pp. 75–84; the text which follows owes a great deal to this and other publications by John Ruffle on Lord Prudhoe.

167 These are preserved in the Alnwick Castle archives (DNP. MSS. 766). Ruffle notes that Prudhoe and Felix tended to focus on the less well-known sites, such as those in Sinai and Nubia, not yet much explored by tourists.

168 These, like Lord Prudhoe's notebooks, are also at Alnwick; DNP. MSS. 742.

169 Letter of 23rd December 1826; Felix's letters are in the National Library of Scotland. There are additional papers in the British Museum, Add. MSS. 25658, ff.79–83, Add. MSS. 25651 with papers by J. Bonomi (see note 173 below).

170 DNP. MSS. 766, Notebook I, 20th January 1828; Felix letters, 20th June 1828. In 1830 Felix published *Notes on Hieroglyphics*.

171 Felix letters, 17th October 1826, February 1828 and 25th April 1829.

172 DNP. MSS. 766, Notebook V, 16th March 1827.

173 The book was illustrated by the Durham architect Joseph Bonomi, who had worked for the tourist W. H. Lambton; Bonomi's son Ignatius worked for Sir Matthew White Ridley, 3rd Bart.

174 *Dictionary of National Biography*, Vol. 43, 2004, pp. 684–5.

175 An earlier manuscript catalogue by Prudhoe himself is at Alnwick (uncatalogued).

176 *In Memoriam, Obituary Notices*, 1865, p. 7.

177 Prudhoe, Diary, 1822, p. 1.

178 *In Memoriam, Obituary Notices*, 1865, p. 14.

179 For these antiquities see J. Collingwood Bruce, *A Descriptive Catalogue of Antiquities, chiefly British, at Alnwick Castle*, Newcastle upon Tyne, 1880, nos. 691–736. A letter from the Duke to his Steward from Florence on 22nd April 1854, DP/D3/III 32, notes that two boxes of antiquities, perhaps these, were to be sent from Naples. Later, the Duke's letter of 28th May from Venice refers to another parcel from Naples including mosaic stones, and some (illegible) acquisitions numbering '3 or 6 dozen' of what were presumably other small antique items.

180 The Duke's letters home to his steward, discussing practical and business matters, form the only record of this tour; DP/D3/III 32, Alnwick Castle archives.

181 Allibone, p. 84. The Duke's correspondence from abroad shows that he was already making concrete plans about the Alnwick interiors; his steward was instructed to forward plans of the servants' rooms, with the principal walls carrying chimneys marked.

182 Macdonald also sculpted a bust, signed and dated Rome, 1856, of Henry, 5th Marquess of Londonderry (sold Sotheby's 16.11.1952 (28)), a commission which provides another indication (see p. 265) as to the travels of this leading Northern family, who do not seem to have made tours in the 18th century.

183 After the Duke's return to England he continued to add to his coins collection, making purchases from Naples and Rome via his agent Emil Braun from March 1855 to February 1856; DP/D4/I/11.

184 Correspondence with Thomas Williams; Alnwick Castle archives, DP/D3/III 32, 22nd April 1854.

185 Op. cit., letters of 4th June and 2nd July 1854.

186 The Duke also refers to plans to be submitted by another leading architect, Sir Charles Barry, who, in the event, was not involved at Alnwick.

187 Although Salvin himself made a continental tour in the late 1820s, his primary interest was in English Gothic, and, as Allibone points out, he made only a handful of continental sketches as compared with hundreds recording the English medieval past. Salvin had family links to an earlier Durham tourist, Rowland Burdon, who recommended him as a young architect to Sir John Soane; see Allibone, p. 12.

188 Allibone, p. 84.

189 Correspondence with Thomas Williams; Alnwick Castle archives, DP/D3/III 32, letter of 6th September 1854.

190 A catalogue of the collection was produced around this time by T. Barberi, *Catalogo ragionnato della Galleria Camuccini*; copy in Alnwick Castle archive, DNP. MSS. 810–811.

191 Correspondence between Emil Braun in Rome (many of the letters in German, but with some copy translations) and Algernon, 4th Duke of Northumberland, Alnwick Castle archives, DP/D4/I/11, March–June 1855. Negotiations for the price of the Camuccini frames were conducted separately, and, although some were 'contracted for', most of the paintings are displayed today in the frames carved for them at Alnwick, suggesting that Braun purchased only a limited number of originals for the Duke.

192 The collection was kept in storage at Northumberland House until the state rooms at Alnwick were completed. It was exhibited at the British Institution in 1856.

193 *In Memoriam, Obituary Notices*, 1865, p. 11.

194 Letter from Emil Braun to Algernon, 4th Duke of Northumberland, Rome, 19th June 1855; Alnwick Castle archives, DP/D4/I/11.

195 By Nicholas Penny, see *Bibliographical Note*. The painting is now in the National Gallery, London.

196 When John Cam Hobhouse saw the Manfrini collection (with Lord Byron) on 2nd December 1816 he considered it to be 'by far the noblest private collection I ever saw'; www.hobby-o.com (Hobhouse's online diary, edited from BL. Add. MSS. 56537–8). The Duke's interest in the collection is discussed in a letter from Sir Charles Lock Eastlake, 13th June, 1856; Alnwick Castle archives, DP/D4/I/5.

197 'And when you to Manfrini's Palace go,
That picture (howsoever fine the rest)
Is loveliest to my mind of all the show…

'Tis but a portrait of his son, and wife,
And self; but *such* a woman! love in life….'.

198 The 1865 Alnwick guidebook clearly identifies the painting as at Alnwick in that year. Collins Baker, however, (cat. 755, as 'Venetian school, 16th century'), suggests that the painting was not purchased for the collection until 1874.

199 *In Memoriam, Obituary Notices*, 1865, p. 13.

200 For this painting and its pendant, *The Temple of Jupiter Panhellenius Restored*, see Martin Butlin and Evelyn Joll, *The Paintings of J.M.W. Turner* (revised ed., New Haven & London, 1984, text vol., pp. 97–100). Exhibited together at the Royal Academy in 1816, they represented ancient and modern Greece, and reflected the campaign for Greek independence among British artists and intellectuals. As Butlin & Joll point out, Collins Baker's assumption that the Duke acquired his Turner simply as an example of the artist's work may well not be correct, and the paintings' associations would surely not have been lost on a man acquainted with C.R. Cockerell, who excavated the temple in 1810; see Tregaskis, p. 108. Cockerell, who advised the 4th Duke on the restoration of Alnwick, was also an associate of Turner, and of Commendatore Canina. The temple on Aegina is now known to be dedicated to Aphaia.

201 DNB, Vol. 43, 2004, p. 685.

202 *In Memoriam.Obituary Notices*, 1865, pp.7–8.

203 Op. cit., p. 14.

204 See also *The Last Two Decades*, note 38, for other works which could have been purchased by either father or son.

205 Ord MSS., NRO 324 A.15; see *Bibliographical Note*. Although he does not specifically say so, it seems likely that, as on his previous tour, Ord was accompanied by his wife; he makes frequent use of the plural pronoun.

206 Ord MSS., NRO 324 A.15, 4th July 1825. This may have been the work showing Ariadne astride a panther, today in the Staatsgalerie, Stuttgart, which is generally regarded as the artist's masterpiece.

207 For this trip, recorded in a pocket book, which included sketches by Bowes (among them one of what was presumably their barouche 'with two horses all ready for a journey'), see Hardy, p. 34. Pearson had probably acted as a junior master at Mareham-le-Fen, the school Bowes had attended in East Anglia.

208 Op. cit., p. 35.

209 Op. cit., p. 139. Kane, p. 173, points out that although Bowes owned an early painting by Sassetta, *A Miracle of the Eucharist*, and an altarpiece by the Master of the Virgo inter Virgines, these early examples of the taste for Italian and Flemish primitives probably owed their presence in the collection to the advice of a discriminating dealer, Edward Solly.

210 They shared an interest in French rococo, Dutch and Spanish paintings, and the decorative arts.

211 Kane p. 175; ibid. The second quotation above regarding the Boweses' intentions comes from the later words of their solicitor; no statement by them has survived. The catalyst for the creation of the collection seems to have been the sale of the Conde de Quinto's collection of paintings in 1862; the Boweses eventually bought 75 of the 217 pictures.

212 Although the term 'Capodimonte' is often considered synonymous with porcelain made in Naples, at the time these pieces were produced the original factory had been moved to Spain, and King Ferdinand IV had re-started a Neapolitan factory in 1771.

213 Kane, pp. 177, 177–8.

214 Although the Howards owned Naworth Castle in Cumbria as well as Castle Howard itself, the early Grand Tour history of the family is inextricably bound up with Castle Howard, and, unlike the Dukes of Northumberland, the Earls of Carlisle do not feature prominently in the tour diaries of their Northern contemporaries. For both of these reasons, the tours made by members of the Howard family in the 18th century are not included in this book. I am grateful to Dr. Ridgway, Curator of Castle Howard, for his help over clarifying this matter.

215 Roberts, p. 152.

216 The Bellini is now known to be a school work, while the 'Mabuse' is actually by Jan Gossaert; see National Gallery, London, *Illustrated General Catalogue*, 1999. Although the careers of Bellini and Mabuse span the 15th and 16th centuries, and these purchases cannot therefore be associated with the developing 19th century taste for Italian 'primitives', they do suggest a change of emphasis, as compared with the preference of earlier tourists for works by Raphael and his Bolognese heirs. The Howards' Carracci, however, exemplifies the continuation of this earlier vogue.

217 Mary Riddell later died abroad, at Montmorency.

218 No documentary evidence has, however, been found to support this.

219 *Citizens and Kings*, London, 2007, p. 40, quoting Gustave Planche at the Salon of 1831.

220 The portrait can only be dated approximately, based on the age of the sitter. The Chichester-Constable portraits are today at Burton Constable, Humberside.

221 This is not certainly a pendant to the portrait of his first wife.

222 Capalti also painted portraits of the family of Prince Filippo Andrea Doria-Pamphili, whose English wife was a relative of Laura Riddell. These are today in the Palazzo Doria, Rome. Information kindly provided by a member of the Riddell family.

223 Howard, I, 1836, p. 5.

224 Londonderry MSS., Durham Record Office. Letter from Frances Anne, Marchioness of Londonderry to Henry Liddell, D/LO/C.

225 *A Memoir of Thomas Uwins, R.A., by Mrs. Uwins*, Vol. I, London 1888, p. 392.

226 Salvin MSS., Durham Record Office, D/Sa/F. 290, 291; see also D/Sa/C. 280–83, 295, 301–2.

227 It was Eden who was Whistler's opponent in the famous 'Bart and Butterfly' lawsuit in 1875.

228 See *Bibliographical Note*.

229 Article in the *Saturday Review*, quoted in Lyall Wilkes, *The Aesthetic Obsession*, 1985, p. 61.

230 Eden, pp. 145, 146.

231 Letter to the *Saturday Review*, 9th August 1913; letter to Lady Londonderry, 1st January, 1913, both quoted in Lyall Wilkes, *The Aesthetic Obsession*, 1985, pp.59, 58.

232 Simon Jenkins, *The Times*, May 26th, 2000.

233 Quoted in Tregaskis, p. 5; *Holiday 2030*, report produced for Halifax Insurance, 2006, by Professor Bill McGuire, University College, London.

Appendix 1
Additional photographs

This *Appendix* reproduces images which were unavailable until just before this book went to press. It includes the following six works associated with the tours of Elizabeth, 1st Duchess of Northumberland, and an exceptional portrait by Anton Von Maron of *Thomas Charles Bigge* sold recently at auction; the corresponding text is in the following chapters.

Duchess's retinue. These were later assembled into a volume entitled *A Series of Sketches, Views of Great Britain, the Continent and America 1772–8* (Alnwick Castle). It was surely also the Duchess who acquired a view in the Northumberland collection of *Hof Vijker in the Hague* by Paulus Constantijn La Fargue, dated 1769, to record her visit that year.

THE 1ST DUKE AND DUCHESS OF NORTHUMBERLAND AND THEIR TWO SONS

Fig. 1. *'Prince of Orange's House in the Wood near the Hague'* by J. Bell, watercolour, 1760s.
The Duchess made several visits to The Hague in the 1760s, and mentions these, and the Huis ten Bosch (The House in the Wood), in her diaries; see pages 66–70. This watercolour is one of the picture-postcard-sized images of the Grand Tour made abroad by J. Vilet, J. Bell, and other artists in the

Fig. 2. *'Abbaie de la Repaille en Savoy'* (La Grande Chartreuse), anonymous watercolour, probably 1772.
See *A Series of Sketches* (above) for the provenance of this drawing. The Duchess's somewhat traumatic visit to this famous monastery is discussed on page 69.

Fig. 3. *Franciscan Hermit* attributed to Karel Beschey, oil on canvas, before 1771.
The Duchess visited the studios of the Beschey brothers in Antwerp in 1771. Although she only records in her diary purchasing one picture, of a hermit in his cell, not recording which of the five brothers this was by, four closely related

pictures attributed to Karel Beschey of a Franciscan hermit remain in the Northumberland collection, together with one by him of a *Scholar sharpening his quill*; the Duchess's visit and 'bargain' purchase is discussed on pages 67–8.

Fig. 5. *Frederick II, Landgrave of Hesse-Cassel, or his eldest son*, German school.

One of four portrait reliefs in coloured and gilt wax, with paste jewellery, of members of the Hesse-Cassel family, given by them to Elizabeth, 1st Duchess of Northumberland when she visited them on one of her European tours. The waxes are recorded on the Duchess's 'List' of pictures in her collection (Appendix 2). The 'List' also records a watercolour of Prince Charles of Hesse-Cassel and another wax portrait, of the Elector of Cologne.

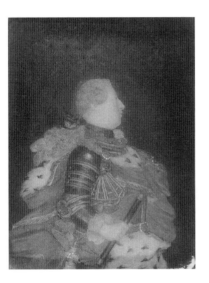

Fig. 4. *A Fishmonger's Stall near a Coastal Town* from the circle of Mattheus van Helmont, oil on canvas.

This painting is typical of the 1st Duchess's 'bargain buys' resulting from her tours of the Netherlands in the 1760s; it appears on her list of paintings in 1770 as by 'Teniers'. As she was so often actuated by financial considerations when making a purchase, many of her attributions have not stood the test of time

Fig. 6. *Cabinet at Alnwick Castle*, designed by Morel and Hughes for Hugh, 3rd Duke of Northumberland in 1823–4 to house some of the ivories acquired abroad by Elizabeth, 1st Duchess of Northumberland (see page 68).

Most ivories in the collection are 18th century rather than earlier, and are highly sentimental in character; scenes of *putti* at play far outnumber the Duchess's other preferences, for classical reliefs, or hunting scenes. Many of the ivories are Flemish; others are Franco-Flemish, Austrian, German, French, Italian or from the Tyrol.

NORTHERNERS ABROAD, 1700–1780

Fig. 7. *Thomas Charles Bigge* by Anton von Maron, oil on canvas, 1765.

This Northumbrian sitter was painted in Rome; see page 114.

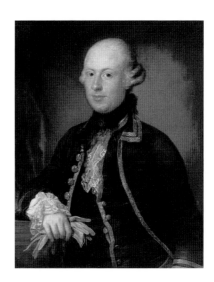

Appendix 2
The 1st Duchess of Northumberland's 'Museum Catalogues' or 'Lists'

Note: Given the large number of artists and makers listed by name in this Appendix, only those who are relatively obscure are detailed in the text or in footnotes. In other cases, they are often mentioned only by their surnames, as found in the original 'Lists'.

Elizabeth, 1st Duchess of Northumberland (1716–76) was an avid collector, many of the works of art she acquired being bought on, or otherwise related to, the Grand Tour. Although her diaries and letters provide invaluable information both about her tours, and her purchases abroad (see pp. 65–70), our knowledge about the Duchess's Grand Tour tastes and acquisitions is greatly expanded by the 'Lists' which she drew up around 1770–5 in an attempt to itemise and rationalise her collection. Not only do many of the works recorded on individual lists relate specifically to Europe and to her European travels. More importantly, they confirm the whole concept of the collection as essentially Grand Tour, attesting to the Duchess's Europhile (and specifically Francophile) tastes. A context for her collection is found, however, not in the great art collections of the 18th century, but in the 'cabinets of curiosities' of 17th century collectors; like theirs, hers is not confined to art, but exhibits a wide range of more scientific interests, expressed particularly in her acquisition of large numbers of samples of woods and marbles from Europe and beyond.

The Duchess's lists echo the same wide-ranging, but essentially superficial and acquisitive, as opposed to analytical or filtered, enthusiasm for every aspect of life abroad that is apparent from her diaries, focusing on a principle of aggregation which was perhaps apparent to her son's Grand Tour tutor Louis Dutens, who relates slightly condescendingly in his *Memoirs* that the Duchess 'amused herself by collecting prints and medals, and by making other collections of different sorts';[1] he was probably in an excellent position to judge, as he is known to have helped his employer form her exceptional collection of medals – and may, by implication, have helped with other areas of her collection as well. The Duchess's compulsive, magpie-like, collecting parallels her determination to see every site of interest on her travels, and to record what she had seen in exhaustive detail in her diaries. The lists also ride a number of personal hobby horses, notably her 'fondness for pomp and show'[2] and the snobbery which made her delight in collecting information about foreign royalty in a variety of media.

The 'Lists', on gatherings of paper, were later bound into the 'museum catalogues' in eight volumes now housed in the archives at Alnwick Castle.[3] Each 'List' is devoted to works in different media, ranging from paintings, drawings and pastels to prints, medals, antiquities, marbles, bronzes, porcelain, Japan work, specimens of wood, and books, and most of the writing is in the Duchess's own hand; although some 'Lists' contain later additions, this is essentially a collection formed by one woman,[4] and it offers a snapshot of a collection formed

within a fairly narrow time frame, probably principally in the 1760s.

Some items relate quite specifically to the Duchess's travels. In addition to those Dutch and Flemish paintings she is known to have bought abroad, the 'Lists' itemise other Grand Tour purchases such as the 'Two Landskips in Marble' she won in a lottery at Bonn, the 'Huntings, Carv'd Relief, Ivory, bought at Bonn', 'A sleeping Cupid' and 'A figure of Aesop', both acquired in Paris, or 'a circular Egyptian pebble, B[ough]t. of Maison Neuve'. Other specific Grand Tour links are an antique onyx cameo of 'The Fall of Phaeton given me by the Elector of Cologne' and an alabaster 'Bas relief of Augustus and Livia given me by Sir Thomas Robinson' – the Grand Tourist, and architect-owner of Rokeby Park, just over the border from Durham in North Yorkshire. Of particular interest are two gifts from employees: the 'Petrified wood from Piedmont' from Louis Dutens, and the ivory 'Jupiter' given to the Duchess by her Grand Tour draughtsman and valet, Jean Vilet.

The Duchess's avid collecting of Dutch and Flemish cabinet pictures is discussed in detail on pp. 66–8 and is not included here. The 'List of Pictures' (Vol. 1), however, confirms other aspects of her collecting, in particular her penchant, like other keen tourists, for buying views to commemorate places she had visited; the collection included a *View of the Hague with many figures in a Garden*, said to be in part by Breughel, and *A View of Paris* by Martin Grevenbroeck, as well as views or *capricci* of famous Grand Tour sites in Italy that she had not in fact seen: a pair of Paninis (*Antiquities of Rome with statue of M. Aurelius* and *Ditto with the Pantheon, its Companion*); *Le Tre Fontane at Rome* and the *Piazza di Spagna, its Companion* by Van Lint; *A View in Rome* by Van Nieulandt;[5] the *Antiquities of Rome with a procession* and its companion by Valerani; and a set of four watercolour *Views of Rome & its Environs* by G. B. Busiri. The Duchess also recorded a gift from her husband of an (anonymous) view of Venice.

This interest in recording sights abroad continues in the Duchess's 'Catalogue of Prints' (Vol. 2).[6] Her vast collection, sold in 1951, but recently traced in part to several major museum collections including the British Museum and the Metropolitan Museum, New York,[7] included large numbers of sets of prints (often numbering hundreds). Among them were: 'Small views in Holland', 'Views of Amsterdam', 'Views of Old Castles in France', 'La Magnifique du Royaume de France', 'Views of Versailles and other Places of France' after Perelle, 'L'Hôtel des Invalides', 'Prospects of Venice and Naples [etc]' after Canaletto, 'Vestigi delle Antichità di Roma' and 'Churches & Palaces of Vienna'.

As well as reflecting the same predilection for Dutch and Flemish works of art as her picture collection, in particular for 'almost all the great figures of Antwerp print production' of the late 16th and early 17th century,[8] the list of prints also reveals the enthusiasm for all aspects of life abroad which operates throughout the Duchess's whole collection, exhibiting a fascination with continental tradesmen, armies, costumes, feasts, art galleries and artists' works: included are studies of 'Dutch trades', 'Cryes of Bologna', the 'Borghese galleries after Carrachi', 'Feasts given at Strasbourg to Louis XV', 'Bloemaert's Drawing Book Compleat', 'The Vatican Bible' after Raphael, 'Landscapes after Rubens', 'The Passions' after Le Brun, 'Statues after Michelangelo', Heads of the Medici, a set of prints of the 'Royal Gallery at Dresden', prints by Stradanus[9] of horses belonging to Don John of Austria, costume prints of 'Hanoverian & Prussian Light Troops', and 'German Dresses on Cards'. Also listed are books of prints which offer more standard Grand Tour fare, such as Bartolozzi's series of etchings after the famous Guercino drawings in the Royal Collection. Even the category entitled 'Fables, Emblems and Metamorphoses' has the same continental flavour, with 'Italian Fables' after Titian; prints illustrating the *Iliad*, and works by Virgil and Juvenal; Holbein's *Dance of Death* series; Tempesta's illustrations for Tasso's *Gerusalemme Liberata*; and, inevitably, Ovid's *Metamorphoses* themselves. Surprisingly, classical landscape prints after Claude, Poussin and Rosa, much collected by her contemporaries, are conspicuous by their absence.[10]

Given that the Duchess also had an insatiable appetite for people, and an active passion for royalty, it is not surprising

that she also collected portraits and prints of those she probably or certainly met on her travels, including a set of waxes of the Hesse-Cassel family (Appendix 1, fig. 5) and of the Elector of Cologne,[11] and prints of Frederick II, King of Prussia, of the Prince of Mechlenburg-Strelitz (brother of Queen Charlotte, whose Lady of the Bedchamber the Duchess was), and of Voltaire, whom she had visited at Fernay. Her print collection also included large numbers of images of her distinguished contemporaries, and of eminent figures from the continental past.

The Duchess acquired some of her continental prints from the great library of Robert Harley, Earl of Oxford,[12] and others from auction houses or dealers in London, among them Thomas Snelling, who, conveniently, was also the leading London dealer of the day in a second category favoured by the Duchess – medals.[13] Although a complete trawl of her unpublished diaries would be necessary to establish where she purchased the remainder of her prints, her long list in 1766 of print dealers in Paris surely offers a useful guide, given the large numbers of French prints in the collection, and it seems reasonable to assume that the pattern of acquiring Netherlandish cabinet pictures abroad was repeated in the sphere of print-collecting. However, whether her prints were acquired in England or abroad, their continental bias is not in question, nor is the Duchess's direct involvement in their acquisition and subsequent assembly, indicated by the amateurish and instantly recognisable system she adopted of fixing prints into albums.[14]

The List of 'Medals and Coins' (Vol. 3) continues the Duchess's penchant, already apparent from the print colletion, for assembling large numbers of portraits of continental contemporaries and historical figures of importance – especially if they were royal. As well as a gold medal of Louis XV, who had entertained her personally at Versailles, a very large array of silver medals, both historical and contemporary, record foreign kings, emperors, princes and counts, listed by family. These include the Polish royal family; Louis XIII, XIV and XV of France and Marie de Medici; the Kings of Spain and Sweden; German Princes and Electors; and a

comprehensive set of the Popes. In each case the Duchess lists the occasions on which the medals were struck – among them deaths, births, coronations, battles, marriages, appointments, raising sieges and victory over the Turks – together with details of the medals' reverse, date and price. When her cabinet of medals was sold at Sotheby's in 1980–1, the catalogue noted that it represented two centuries of European history as portrayed by the greatest medallists of the post-Renaissance period, in mint condition, and judged it to be probably the most exceptional collection in private hands in Britain, perhaps in the world.[15] Given Louis Dutens's involvement in acquiring medals for her collection in Italy (p. 77) and 191 Danish medals from a sale in Copenhagen in 1773,[16] and his known expertise in related areas,[17] it seems probable that he acquired other medals on the Duchess's behalf, and that this may explain the quality of the whole collection.

The same continental inclinations are apparent in the porcelain listed in the catalogue of 'Antiquities, Historical Curiositys, Miscellaneous Ditto, Manuscripts, Japan, Porcelain, glass &c' (Vol. 6). Having spent much time in Paris, the – select – collection of porcelain included several pieces from Sèvres (including 'A little caisse of Sèvres Blue/green', two coffee cups decorated with vines and roses and a biscuit-ware 'Group of a school master & two girls'. Other leading European manufactories from which the Duchess purchased pieces include Frankfurt, Frankenthal[18] and Chantilly, while there was a particularly strong representation of Meissen, for example 'A small Apollo', '2 large cows', six chocolate cups, a duck and two pomatum pots decorated with flowers and insects. Many of these pieces remain in the collection today.

The Duchess's large collection of marbles and woods in her 'Petrefactions, Fossils, Ores, Spars, Christals, Earths, Woods, Marbles, Gems &c' catalogue (Vol. 8) confirms her insatiable appetite to acquire specimens in all available fields. The numerous foreign marbles and other stones came mostly from Italy, but also from France, Sicily, Spain, Corsica, Ireland, Flanders, Cyprus, Malta, and as far away as Egypt and Africa. Materials included alabaster, gold ore stone, and granite, as well as marbles such as Boccanaglia from Carrara, Breccia

from various locations and Cocksfoot from Naples,[19] which were variously flowered, veined, spotted and differently coloured in blacks, greens, and reds. The 52 gems included agate, lapis lazuli, garnet, aquamarine, emerald, pink diamond, bloodstone, onyx, topaz and cornelian; although some were in jewellery settings, others, such as the 'large agate in the shape of a Bear' were perhaps enjoyed for themselves. The lengthy (26-page) section on woods features specimens from France, Germany, Switzerland, Saxony, Spain, Portugal, Jamaica, Bengal, the West Indies and Virginia, with a particularly large number of specimens coming from Bendeleber Gardens and Forest in Thuringia. Wood types (listed alphabetically) included almond, bengal wood, cayenne, wild chestnut, ebony, crab, silver fir, pine, juniper, mahogany, red mulberry, plane, whitten tree, pomegranate, walnut and willow.

As one might expect, the Duchess's 'Catalogue of the Cameos, Intaglios, Bas Reliefs, Bronzes, Busts, Statues &c' (Vol. 5) is more specific in its Grand Tour emphasis, although several items in each category were inherited from her parents or from her tourist brother, and – unlike the rest of her collection – it is difficult to disentangle her role here from the Duke's, given his known involvement in purchasing antiquities for Syon House. Nevertheless, the Duchess emerges as a significant collector, although her cabinet of cameos and intaglios certainly does not bear comparison with the famous one later formed by her son (p. 80). Among her 37 cameos were antique gems of the 'Head of Britannicus' from the collection of the Duke of Mantua, a head of Caesar in a Ring and 'Cleopatra with ye Asp' (all gifts from the Duke); a 'Jupiter and Juno'; and 'A female head in an old gold setting'. However, most of this section comprised a set of 22 enamels after the antique from the collection of Dr. Quin.[19] Similarly, of the 19 intaglios, very few of those which seem to have been acquired by the Duchess herself are listed as certainly antique, a 'Bacchante' in beryl given to her by the Duke proving an exception; appropriately, she also owned a 'Head of Ld Northumberland [the Duke] a L'Antique' in white cornelian.

Amongst the other antiquities on the Duchess's list (which is difficult to interpret, since, similarly to other 'Lists', it combines 'the function of an inventory with that of an index', and the same item is therefore listed more than once),[20] were 21 bas reliefs, including a 'Triumph of Silenus', the 'Profile of Augustus and Livia' from Sir Thomas Robinson referred to above (p. 277) and four ivories with classical scenes, as well as a series of eight ivories after Teniers. Only 9 of the 24 bronzes reflect Grand Tour tastes, notably 'Hercules accompanying the boy Hylas' from the collection of Mr. Newton, 'A small antique Bacchus' and four bronze busts of Roman emperors. Eight separately listed 'busts' include 'A Boy supposed Britannicus antique, plaister, Lord Rock[ingham]s', and ivory heads of Louis XIII and Anne of Austria. The Duchess also lists 31 'Statues', including 'The hermaphrodite of the Villa Borghese' in marble, a bronze copy of Antinous after the antique, and a small antique 'lyon found in Turkey, appears to have been the crest of a helmet', while amongst the ivories are a Venus and a Meleager. As suggested above, the Duchess seems on the whole to have regarded her collections as separate from the Duke's – and it is perhaps significant that a small group of classical antiquities at Stanwick, and at Syon, including the Valadier bronze copy of the *Dying Gladiator* or the *Germanicus when a Boy* from the collection of Lord Halifax'(fig.69), although cited by Collins Baker as in her ownership, do not feature on this list.

Two further lists of 'Antiquities, Historical Curiositys, Miscellaneous Ditto, Manuscripts, Japan, Porcelain, glass &c' (Vol. 6, discussed above in relation to porcelain) and 'Arms, Habits, Utensils, Ornaments and Curiosities of Different Nations' (Vol. 4) illustrate the wide range of the Duchess's interests, but are less relevant to her Grand Tour travels. However, amongst the British antiquities and items such as 'Queen Elizabeth's gloves' listed in Volume 6 is a 'History of the King of Prussia in a Box, his head at the top', while at least two manuscripts have continental links: a missal in Greek which had belonged to the Abbess of St. John the Baptist at Antwerp and a second missal from a French 17th century collection.

Although one might expect the Duchess's 'Books' (Vol. 9) to be less directly related to the Grand Tour, this 'List' in fact

does more than almost any other to confirm the Europhile nature of her (and her husband's) tastes – and, by implication, those of the British aristocracy at this period. The library is not only strong in the classics, and in material directly related to European travel. It also contains a very large amount of material published in French rather than in English,[21] while major sections are devoted to French literature, history and memoir. Here was a family as well versed in French literature and culture as in English, and indeed perhaps almost bilingual.[22] Even the section on lighter reading – novels and romances – contains only eight pages of English titles, as opposed to ten of French.

Among the volumes relating to the classical world are the type of works one might expect from a late 18th century English library, ranging from poetry and plays by Homer, Hesiod, Virgil, Terence, Horace, Plautus and Ovid to reference works such as *Histoire des Grecs*, *Customs and Manners of the Ancient Romans*, *Lives of the Ancient Philosophers*, a *Life of Cleopatra*, Livy's *Roman History*, *Memoirs of Socrates*, *Caesar's Commentaries*, Potter's *Antiquities*, Leigh's *History of the Greek & Roman Emperors*, North's *Plutarch's Lives* and Pliny's letters.

However, it is perhaps the non-classical works that are more revealing of the Duchess's tastes. French literature is represented by the *Fables* of La Fontaine and de la Motte, and the works of Molière and Voltaire, but it is the sections on 'Letters' and on 'History and Lives' that show the strongest bias towards French culture. Books range from a history of Madame de Pompadour, the memoirs of Sully and the letters of Madame de Maintenon, the Marquise de Sévigné and Jean-Louis Guez de Balzac to a large number of volumes associated specifically with the French monarchy, including *Memoires de la Cour France, 1688–9* and 'memoirs' 'histories' or letters of the French kings (and less frequently queens), among them Henri III and IV, François I, Louis XI, and Louis XIII and Anne of Austria. There was also a monumental 23-volume *Les Vies des Hommes Illustres de France*. Many books in the library, however, reflect wider European interests as well. A section on Italian literature includes Ariosto, Petrarch,

Tasso, Guarini's *Il Pastor Fide*, and the comedies of the Duchess's contemporary, the great Venetian playwright Carlo Goldoni, while the 'History and Lives' section includes an *Introduction à l'Histoire des Principales États de l'Europe, Imperial History, Illustrious Persons of the East, Life of Catherine Empress of Russia, Florentine History*, Manley's *History of Denmark, History of the Popes, La Guerre de Flandre, La Vie de Stanislas Roy de Pologne, Les Vies des Hommes & des Femmes Illustres d'Italie* and a *Military History of Charles 12th King of Sweden*. Specifically relevant to the Duchess's Grand Tour travels are the *Memoirs of the House of Brandenburg*, and *Lives of the Princes of Orange* – both families she visited abroad.

It is, however, the large section of the library entitled 'Miscellanies' that brings us closest to the Duchess's Grand Tours. Indeed, this might more aptly be named 'European travel', and many titles sound as if they were acquired to take on tours in France or the Netherlands (Italy she visited only very briefly with the Duke towards the end of her life in 1773), or at least used in preparation for them, or in their aftermath. They include *Journey from London to France, Liste générale des Postes de France, Voyage Pittoresque de Paris, Description de la Ville de Bruxelles, Amusements des Bains de Bade, Observations made on a Journey thro' the Low Country, Délices de Brabant, Journal of a Tour to Italy* and *Description de la Ville de Rome*, as well as more general works such as *Atlas Maritime*, a *Travellers' Companion* and a *Foreigners' Guide*. Still other books may relate to projected, but not accomplished, travels, while there is also much evidence of 'armchair reading' about places either more exotic, or at least further afield than the Duchess's usual travel destinations, including *Les Délices de l'Espagne et du Portugal, Histoire de la Cour de Madrid, Grammaire Espagnol, Voyage to Lisbon, Voyage du Levant, History of the Ottoman Empire* and *Account of Denmark*.

END NOTES

1 Louis Dutens, *Memoirs of a Traveller now in Retirement*, Vol. II, pp. 100–1, 97.

2 Greig, p. viii.

3 See *Bibliographical Note*; although there are only eight volumes, the lists are, confusingly, numbered from vols. 1-9. Each gathering has entries only on the opening pages, with the remainder of the pages blank.

4 Although some of the antiquities may have been bought jointly with the Duke, the internal evidence of the lists suggests that the Duchess on the whole kept her collections separate from his.

5 A pair of paintings by Van Nieulandt survive in the collection: *The Piazza del Popolo, Rome* and *A Capriccio of Roman Ruins*.

6 See Anthony Griffiths, 'Elizabeth Duchess of Northumberland and her album of prints', in *Dear Print Fan: A Festschrift for Marjorie B Cohn*, ed. C. Bowen and others, Cambridge, Mass., Harvard University Art Museum, 2001, for a discussion of the purchase and assembling of these albums of prints by the 1st Duchess, their dispersal, and his discovery of the present whereabouts of many of the Netherlandish prints.

7 The sale was at Sotheby's on 11th April. Griffiths, p. 140, lists the present locations where known.

8 In the category devoted to artists' prints there are works by Adriaen or Hans Collaert, Anthonie Wierx, Willem or Magdalena van de Pass, Hendrik Golzius, Galle, Stradanus (see note 9) and the Sadeler family of engravers. Griffiths assumes that the Biblical subject matter must have been what attracted the Duchess to prints which would no longer have been recent or fashionable. I would suggest instead that the attraction lay in her enthusiasm for the artistic productions of the Low Counties.

9 A Flanders-born Mannerist also known variously as Giovanni Stradano, Jan Van der Straet or Straat or Stratesis (1523–1605), who worked mainly in 16th century Florence.

10 However, two large sets of landscapes engraved by Vivares may well have included works by Claude, Dughet and their contemporaries, while the Duchess also owed 30 etchings after Locatelli.

11 The collection at Alnwick today also includes a wax of the Electress of Cologne.

12 Two major sets of Netherlandish prints by the Sadeler family and by Stradanus; see Griffiths, pp. 140-3.

13 Griffiths, p. 144.

14 She used 'tabs of unfolded paper' extending 'above the margin of the print'; see Griffiths, p. 139.

15 *European Historical Medals from the Collection of His Grace the Duke of Northumberland*, 3rd December 1980 and 17th June 1981. Although Sotheby's was unaware of the 1st Duchess's 'List', the catalogue rightly deduced that the collection must have belonged to the 1st Duke or Duchess, given that virtually all the medals were struck before 1786, the date of the Duke's death.

16 See Alnwick archives, H/1/5, 'Account of Medals bought at Count Shinkin's Auction for Ralph Woodford Esqr'. This mentions a bill of Woodford's [Envoy Extraordinary at Copenhagen] on Dutens.

17 He was certainly an expert on Greek medals; see his *Explication de Quelques Médailles*, 1773.

18 The Duchess visited the Frankenthal factory in 1772; Greig, p. 185.

19 I have not been able to identify this collector. As the entry in the 'List' is in the Duchess's own hand, he cannot be identified with an otherwise likely contender, the Dubliner Henry George Quin (1760–1805), probably the illegitimate son of the Earl of Dunraven, who made the Grand Tour in 1785–6, and bequeathed the 'Bibliotheca Quiniana' to Trinity College, Dublin; Quin was only a child at the time the 'Lists' were written.

20 Griffiths, p. 142.

21 Even volumes on the classics are often found in French translations.

22 In Holland in 1766 the Duchess noted in her diary that she was 'pleas'd at finding I understood the Play', which was performed in French, 'perfectly well'; Greig, p. 73.

Appendix 3
The Grand Tour and literary and artistic 'Remains' of John Tweddell

The charismatic and idiosyncratic John Tweddell (1769–99), a brilliant classical scholar who in 1792 was elected a fellow of Trinity College, Cambridge, and attracted abroad the attention of Madame de Staël ('I have met few people whose character was more endearing and whose conversation was more interesting'),[1] was the son of a small landowner who owned the estate of Threepwood near Hexham, and was educated at a school near Richmond, where his 'rare endowments' were soon discovered. His father preferred the law for this talented eldest son, who however felt a 'singular aversion' for this profession, and, rejecting the advice of friends to adopt a political career, nurtured leanings towards the diplomatic service only because he felt the need of a vocation.[2] Although his unusual, four-year tour[3] from 1795 through Germany, Austria, Switzerland, Poland, the Ukraine, Russia, Sweden, the Crimea and Asia Minor to Greece, where he died in 1799, was therefore hardly a step towards the latter career (from St Petersburg in June 1797 he wrote that it was 'now too late' for any profession) he certainly intended to gain 'a knowledge of the manners, policy and characters of the principal courts and most interesting countries of Europe' then accessible – given the Napoleonic wars – to an Englishman,[4] and his intellect opened many doors. Among his contacts and friends among the European elite were the Comte de Choiseul-Gouffier, 'author of the celebrated work on Greece' who gave him 'some most useful documents upon my projected tour',[5] Jules, Duc de Polignac, widower of Marie Antoinette's favourite (and, according to rumour, lesbian lover) Gabrielle de Polastron, and their daughter the Duchesse de Guiche; the American-born scientist Count Rumford, Minister of War and Chamberlain to the Prince-Elector of Bavaria; and Jacques Necker, finance minister of Louis XVI and Necker's daughter, Madame de Staël herself.

The principal reason, however, for Tweddell's extended travels from the age of twenty-six – rather later than those of most young men – was probably to recover from an unhappy love affair,[6] and his four years abroad, documented in detail in his letters to his parents, to his closest friend James Losh (fig. 126), later a leading Northern lawyer and social reformer, and others[7] seem to have left him world-weary and melancholic, perhaps not least because Losh's health precluded his joining his friend abroad. If his correspondence confirms his initial preference for study and intellectual companionship over parties or the 'tumultuous bustle' of the carnival in Berlin, the early months of his tour changed this temporarily, and from Basel John wrote 'I now go every where with eagerness, where the snow-ball rolls', confiding to his sister – with the same amazement experienced a few years earlier by John Carr at his own propulsion into elite social circles abroad – 'Who would have said last year…that I should now be dancing every other night at a court, and playing at cards two or three times a week at a minister of state's'.[8]

Although, by the time of his seven-month stay in Athens, John had decided to publish his travels, especially his

researches in Greece, even the prospect of authorship now left him feeling jaded. Instead, he had concluded that happiness was to be found only in retreat, and his letters are unique among Northerners' in charting a response to the continent by a tourist suffering, perhaps, from some form of depression which suggests that, even had he survived, Tweddell's brilliant academic promise might not have been fulfilled. In common with other intelligent travellers, however, John had no time for squandering his hours in 'pleasures and dissipation' like 'the other English in Vienna', 'who live entirely together, and get drunk every day with astonishing perseverance', and was concerned instead to 'wait upon the men of information most celebrated' in any place he visited. Having parted in Hamburg from his proposed tour companion, Mr. Webb, whose projected itinerary was much less thorough than his own, Tweddell assiduously took both French and German lessons in Germany, also receiving sketching lessons from a master recommended by his friend, Madame de Flahaut, and employing a fencing master, largely for his health. Although his letters contain very few references to Old Master paintings, beyond his admiration for the picture gallery in Dresden, it is probable that he reserved such comments for the diligent record of his tour assembled in his (lost) notebooks: 'I always carry pen and paper in my pocket, write my observations on the spot, and transcribe them in a book before I go to bed. I have filled *four small quarto books with such remarks*'. John's often-repeated wish to his parents that 'one day I hope that you will have pleasure in travelling over again with me this country [Switzerland] upon paper' gives a clear indication as to the uses to which many Grand Tour diaries were eventually put.[9]

These were perhaps the most adventurous travels from the North before 1800. Tweddell's tour is also significant, however, in revealing a web of contacts with other Northern tourists. In addition to James Losh himself, John was a friend of the aristocrat Charles Grey,[10] while another, closer, friendship, and Grand Tour correspondence, was with Thomas Bigge, cousin and near neighbour of a – future – tourist C.W. Bigge, for whom Sir Charles Monck designed the Grecian villa at Linden Hall following his own slightly later travels in Greece. The networks through which Northern tourists and their relatives shared information about the continent can be glimpsed in a letter from Tweddell to his father concerning James 'Athenian' Stuart, in which he tells him: 'should you be at Benton-House soon, you will find this work [*The Antiquities of Athens*] in Mr. Bigge's library'.[11] John Tweddell's determination to visit Greece had earlier been confirmed when he met another adventurous and serious-minded tourist, J.B.S. Morritt, owner of Rokeby Park on the Yorkshire-Durham borders, in Vienna in early 1796; having just returned from Greece, Morritt was able to assure Tweddell that 'ruined as is Athens, yet still, in point of magnificence, there is nothing at Rome which can compare with the grandeur of its remains'.[12] John Tweddell also inherited in Hamburg the former Italian servant of William Henry Lambton, a tourist he clearly knew; met abroad the Durham-born diplomat Sir Morton Frederick Eden;[13] and, in one of his final letters, refers to his hopes of meeting another diplomat, John Spencer Smythe – with whom he had become friendly in Constantinople – at the Ottoman Club in London, which Smythe had formed. Among its members were two Northerners, Morritt himself, and his former tutor Percival Stockdale.[14]

Like Robert Wharton's – but more completely – John Tweddell's tour also offers a fascinating glimpse of a Grand Tour travelling library. We know that he owned[15] two popular and often-reprinted late 18th-century guidebooks, H.A.O. Reichard's *Guide des Voyageurs* and Louis Dutens's *Itineraire des Routes les plus frequentées*, as well as two specifically eastern travel books, *A Journey through the Crimea to Constantinople* (1789) by the notorious Elizabeth, Lady Craven and the *Travels* of the Irish bishop Richard Pococke in 1743–5. Other Grand Tour reading matter included *Memoires d'Italie*, *Roads of Italy*, *Instructions pour voyager en Suisse*, *Le Maître Allemand*, *Roma Illustrata* and a German grammar. A predictably strong representation of classical texts featured Hedericus' Greek *Lexicon*, Tacitus' *Annals* or *Histories*, Lucretius' *De Rerum Naturae*, volumes of Roman lyric poetry by Catullus, Tibullus

and Propertius and – surely appropriately in this case! – the *Odyssey*. Tweddell's most valued texts, however, in an era when no modern guidebook to Greece existed, must have been Pausanias' *Description of Greece* (2nd century A.D.) and the Abbé Barthelemy's *Voyage du jeune Anacharsis en Grèce*; published in 1788, this described the journeys of the younger Anacharsis in the 4th century A.D., but also included invaluable information on Athenian history, customs and lifestyle.

According to his brother, John Tweddell enjoyed excellent relations with his servants, and his letters are more informative than any other Northerner's concerning employees abroad, from the black servant with whom he had to part reluctantly at Tulczyn because the cold weather had produced 'an internal discharge of blood' (John sent him back to Vienna to recover) to the 'courageous' and experienced servant he employed in Russia; originally from Germany, but now an ex-Russian dragoon, in eight years of continuous travel this courier had 'been in 30 different governments of the russian empire' and had written down 'all particulars relating to battles, sieges, roads, inns, horses &c' – the only reference among Northern papers to a servant's Grand Tour writings.[16]

Although war between England and France meant that France was effectively closed to British travellers of the later 1790s, Tweddell had originally intended to travel from Germany via Switzerland to Italy. However, like other contemporaries, including Morritt and Sir Charles Monck, he was prevented from crossing the Alps by the military situation: 'The French have ordered it otherwise – and the French are supreme'.[17] His tour therefore, after Hamburg, began in effect (as later did Monck's) in Berlin, and continued with Dresden, Vienna, Prague, and a visit to the salt mines in Munich. Like a later tourist, Dr. Edward Charlton,[18] however, the earlier part of his itinerary is memorable for a walking tour of Switzerland, during which 'I have travelled where neither carriage nor horse could have followed my route'.[19] Tweddell seems to have placed a particular value both on the tour journal he kept here, and the later one of his travels in the Crimea; sadly, as we shall see, almost all his Grand Tour possessions disappeared under

circumstances little short of sensational.

As a passionate classicist, Constantinople was, for John, a goal from the beginning, and, had he lived, he had intended, like Morritt and other contemporaries, to sail from Greece via the Greek islands to Naples at the end of his tour, so as to see what was possible, in safety, of Italy. In Switzerland, however, his tour took an unexpected turn when he met Jacques Necker and Madame de Staël, and they invited him to stay at Coppet near Geneva, famous for the *salon* she held here. Like other tourists of intellect, the Grand Tour now began to open doors for this Northerner from a modest gentry background, and soon he found himself invited for a three-month stay in Poland by the Duc de Polignac, whose house there was not yet habitable, but who lodged him with a neighbour, Countess Potozka; here John met the great Russian commander Marshal Suvarov, who teased him about a French invasion of England. Although he had never imagined 'when I left England, that I should ever have made the tour of Russia', he now moved on to do so. Attending in Moscow the coronation of the Emperor Paul I, despised son of Catherine the Great, supping with the King of Poland and generally mixing in high society, he nevertheless felt very isolated here: 'I feel as if I were writing to the winds. God knows if you will ever receive this letter'. Tweddell also visited St. Petersburg, and is the only Northern tourist of the 18th century to consider visiting Egypt, albeit rejecting this course as it would be too 'cheerless travelling alone'.[20]

John Tweddell's enthusiasm for collecting continental drawings – a habit he seems to have inherited from his father, who had also made a European tour – seems to have begun in Switzerland; from here he sent home a portfolio and books containing a large number of Swiss drawings and prints which were perhaps the only Grand Tour items, with the exception of his letters, that were received safely back in Northumberland. Having 'visited every canton', and 'made acquaintance with all the painters of the different towns', John chose, with a view to his family forming 'some faint idea of those picturesque beauties which feasted my eyes and my imagination', 'those views with the justice and execution of which I was most

satisfied'.[21] In practice, however, the artists he selected came from a group of Swiss painters and engravers who worked largely for the tourist market, specializing in Alpine views and costume studies, and who were connected through friendships or apprenticeships, as well as through their promotion of a Swiss pastoral idyll inspired by the ideas of Jean Jacques Rousseau; Tweddell's purchases included a book illustrating Rousseau's island residence on Lake Bienne.

From his favourite Swiss artist, Heinrich Rieter (1751–1818), John commissioned a drawing of a 'characteristic' Swiss cottage, and purchased prints of the Jungfrau, the Reichenbach Falls and a general view of the Alps. He also bought a book of printed views by Rieter and the late Johann Ludwig Aberli (1723–88),[22] of the canton of Berne and of Lake Bienne; Aberli's work was exceptionally popular with Grand Tourists, not least because he had invented a medium which combined watercolour washes with etching and engraving. Both men were influential on another artist Tweddell particularly admired, Johann Jakob Biedermann (1763–1830), from whom he bought a selection of his popular views of the capitals of the Swiss cantons. John also acquired engravings of Swiss costume by Sigmund Freundenberger (1745–1801),[23] a companion of Aberli's on his Swiss tours, and prints showing the successful ascent of Mont Blanc in 1787 by Mr. de Saussure, to give his family an idea of how travellers, John included, ascended and descended the glaciers. He also bought 52 engravings by the 'celebrated' Salomon Gessner (1730–88)[24] who aimed to free pastoral landscape from the late Baroque by linking it to nature and the 17th century classical landscape tradition. If such portfolios[25] were affordable for a traveller of modest means, works in oil were too expensive to contemplate; from Moscow, Tweddell wrote that he wished he could afford to send home his portrait, naming Elizabeth Vigée Lebrun – whose portraits bye-passed the attention of other Northerners, but were well-known in the French expatriate circles in which he moved abroad – as 'decidedly the best portrait painter in Europe', while Angelica Kauffman's had 'an air of effeminacy' and 'do not please me'.[26]

After crossing the Gulf of Bothnia in a hurricane, during which he was obliged to sit on deck throughout in his carriage, Tweddell arrived in Sweden via Finland in August 1797, where he found the iron, copper and silver mines of the greatest interest. By the time he had returned to St. Petersburg a month later he was 'on the eve of pursuing those projects, about which I have talked so long and against which I have been so strongly dissuaded by many of my very good friends': 'France and Italy are out of the question; I must see the East now or never'.[27] The crucial decision of his tour having now been taken, John set off on horseback for a tour through the Crimea, where he began to copy Greek inscriptions – later a central occupation of his in Athens – also forming 'a pretty collection of drawings... a part of them by myself, and a part [costume studies of 'Tartars, Cosaks, Calmucks &c'] by a painter employed by Professor Pallas', the 'most distinguished man of letters in Russia', with whom John stayed at Sympheropol.[28] Before embarking for Constantinople from Odessa, he returned to the Ukraine, staying with the Polignacs, and resting for some time as he waited for the Black Sea to become navigable in the height of winter. Here he adopted a vegetarian diet on grounds of principle ('We have no right to sacrifice to our monstrous appetites the bodies of living things') which must have seemed the height of eccentricity to most 18th-century observers, albeit not, as it happened, to his current hosts.[29]

Once arrived in Constantinople, John was 'at once in the centre of the theatre of grecian splendour'.[30] Here he became friendly with the English chargé d'affaires[31] John Spencer Smythe, who would later play a crucial role in the saga of Tweddell's 'Remains'. Initially, as he lingered in Constantinople – where he was holed up owing to the plague, venturing out only when the streets were deserted, and having his clothes disinfected with vinegar – John was disappointed to find no view painters in the city, and had to rely on his own drawings as a record. In due course, however, he invited Losh 'to felicitate me on a considerable acquisition': 'I have met here with a celebrated painter' – Michel Francois Préaux – who, Tweddell proudly pointed out, had been on the point of

being appointed King's painter when the Revolution intervened, and who, currently unemployed, had now 'agreed to accompany me in my tour through Greece, and Asia and the islands'.[32] With Préaux's active assistance, Tweddell's 'portfolio' of drawings in Constantinople augmented rapidly, and, by the time of his departure, it contained 120 'dresses of the inhabitants' and drawings or views of 'almost every interesting spot in the neighbourhood, as well as of the capital itself'; these included 'eight or nine views of the greatest beauty' by Préaux, which were perhaps the drawings praised by John where 'the water-colour is pushed to the perfection of oil'.[33]

The decision to enroll Préaux as his draughtsman proved, even more than his decision to journey eastwards, to be the defining event of John's tour. As he told Losh, 'This will induce me to visit subjects of both architecture and landscape with greater minuteness; and, perhaps, to extend and lengthen my travels'. More importantly, he was now thinking of writing a travel guide on his return to England. Although John's habitual melancholia afterwards re-asserted itself, and he came to view the 'fame of authorship' as only one of all those 'projects of vanity and ambition' which were now 'dead within me', concluding that the 'most solid profit' he had reaped from his travels was 'a precious stock of indifference... to whatever may befall me', the final months of his life, certainly from his arrival in Athens, became an almost frantic race against time to assemble a collection, and to record his experiences in his notebooks, so that he could return home as soon as possible – something that, after well over three years, he now longed to do.[34]

Athens itself was Tweddell's 'great object' and, when he and Préaux arrived in December 1798, John, with 'restless ardour' and 'unremitted application', now set about 'faithfully delineating the remains of art and science discoverable amidst [Greece's] sacred ruins'. In addition to producing a large number of costume studies, he intended that 'Not only every temple, and every archway, but every stone and every inscription, shall be copied with the most scrupulous fidelity', so much so that 'those who come after me will have nothing to glean'.[35] Soon, as a result of an impressive programme of study with Préaux, which involved rising early and dining at five pm, with 'the whole interval' employed in drawing or in 'considering the scenes of ancient renown', he had filled two volumes with copies of ancient Greek inscriptions, and considered that he had assembled 'the most valuable collection of drawings of this country … ever carried out of it'. While acknowledging James 'Athenian' Stuart's four-year residence in Athens, and the 'laborious investigations' of Julien Le Roy, John firmly believed that his own collection of drawings would 'represent many objects in a new and much better light'.[36]

Evidently with a future publication in mind, John planned his collection carefully. Most of the drawings were to be uniform in size at 30" wide, with ten larger ones – almost certainly by Préaux – of the main temples measuring from 4½ to 5 feet; perhaps owing to his heavy expenditure abroad, Tweddell, not naturally mercenary, had an eye to finance, valuing the larger watercolours at 30 guineas each. As well as his own drawings, and Préaux's, John's portfolio included works by another Frenchman, Louis Fauvel, who agreed to sell forty to fifty of his – expensive – drawings only because of his temporary incarceration in an Athenian gaol. As before, John also made a point of collecting smaller-scale scenes representing the 'manners, usages, dresses and attitudes' of the inhabitants; he shared with a later tourist, Pauline Trevelyan, a particular admiration for the 'piquant' Albanian dress. Although he managed to find ten sheets of paper in Athens for the larger drawings, he had to send to England for the 'best vellum paper for drawing', 30–40 pencils and a box of watercolours, as well as for engravings by the French marine artist Nicolas-Marie Ozanne (1728–1811) to assist in his production of 'sea views'.[37]

Unlike Lord Elgin, whom he had met in Berlin, or his Northern successor in Athens, Sir Charles Monck, Tweddell's approach to Greece was essentially that of a scholar, and he was no despoiler of Greece's cultural heritage, although he did form a small collection of eighteen ancient lamps, also making, despite not having 'much zeal in that pursuit', the occasional

purchase of an antique medal. Like Monck's, however, John's researches were hampered by the Turkish authorities, who, despite his carefully bribing them with presents, made access to the Acropolis difficult, and, almost as intemperately as Monck himself, John despised Athens's modern inhabitants, being satisfied with 'all that is here dead and inanimate', but not with 'those scoundrels called men'.[38]

Tragically, the very considerable cultural legacy of this learned and otherwise sensitive Northerner was not destined to see the light of day, just as John's rightful place in the history of the Grand Tour as one of the earliest and most important of the new generation of scholars and tourists to visit Greece remains unsecured. On 25th July 1799 he died in Athens from a 'double-tertian fever', following a tour of Northern Greece, contemporary opinion rumouring that his 'incautious' determination to treat himself with Dr. James's Fever Powders was responsible.[39] However, he may also have been consumptive,[40] while a contributory factor was perhaps over-work; since leaving the Ukraine he had 'not had one entire day of relaxation', and his travels in Northern Greece, which included Thebes, Thermopylae and Delphi, had involved 'excessive fatigues'.[41] He was buried, at his own wish, in the 'Theseion', then consecrated as a Christian church, and Lord Byron was among those who later managed to arrange for the conversion of the 'small oblong heap of earth' still visible during Monck's stay in 1805, that was not even safe from scavenging animals, into a classical grave using blocks of Pentelic marble from the Parthenon that had been 'saved from the bas-reliefs intended for the ambassador [Lord Elgin]'. This was something of an achievement, given the feuding and rivalry in the Athenian artistic community over 'who should … accomplish the work', and disagreements with Elgin's agent, the watercolourist G. B. Lusieri, over rival inscriptions for the tomb.[42] Later, in 1814, William Haygarth invoked readers of his poem, *Greece*, to:

'Pause on the tomb of him who sleeps within;
Fancy's fond hope, and learning's fav'rite child,
Accomplish'd Tweddell…'.[43]

The story of John Tweddell's possessions proved, in a curious way, almost sadder. His earlier friendship with Lord Elgin in Berlin led after his death to an unseemly episode in which Elgin, now ambassador in Constantinople, was accused by Tweddell's family of absconding with his possessions, which had been forwarded after his death to his friend John Spencer Smythe in Constantinople. Although shipwrecked on the way, these were retrieved from the sea and delivered in November 1799. Unfortunately, Smythe's tenure in charge of British affairs in Constantinople had ceased with Elgin's arrival, and, on Elgin's orders, Tweddell's trunks were now taken to the English palace, where they lay unopened for eight weeks in the cellars; when they were finally examined, the English 'panorama' artist in Constantinople, Henry Aston Barker,[44] was commissioned to save what he could from the mildew that had inevitably formed, and the drawings were separated and dried – with what success was later disputed – although, when they were inspected by Lusieri on Elgin's behalf, he decided that they were mostly recoverable.

A second batch of Tweddell's earlier Grand Tour material, which had been left in Constantinople with an English merchant, Thomas Thornton, and hence escaped the shipwreck, as well as a fire that had ravaged the city, was now also delivered up to Elgin as ambassador, given Tweddell's death, intestate, in the Turkish dominions. What happened next became something of a cause célèbre, but Smythe's letters at the time to Tweddell's father Francis – surprisingly frank for a diplomat – make it clear that Elgin did indeed appropriate this important collection of Grand Tour notebooks and drawings, although a different, and equally scathing, view[45] was that he would be unlikely to purloin any property unless 'he could convert it into money'. In the end, Francis Tweddell was obliged to let the matter rest, writing to James Losh in May 1803 that the 'transaction is highly dishonourable to his lordship, but of any redress I much doubt'.[46]

If John Tweddell's clergyman brother Robert, who later, and more vigorously, took up the task of recovering his brother's possessions, is to be believed, John's effects were

now taken to Elgin's palace outside Constantinople, where they were inspected both by Elgin's retinue and by visitors (one of whom reportedly took John's Grecian journal as a *vade mecum* on his travels). The *Naval Chronicle*, a vociferous champion of the Tweddell cause, maintained that 'certain persons in the ambassador's retinue', especially 'two of the clerical order', were employed to make copies of the journals and sketches, and indeed Elgin's chaplain Dr. Philip Hunt (an antiquarian who played a key role in the acquisition of the Elgin marbles) later admitted he had made notes of 'such passages [of the papers] as I thought likely to guide me'. The comment in May 1800 by Thomas Thornton that the 'whole hive are extracting from poor Tweddell's papers, whatever is worthy of his lordship's patronage' seems to come closest to explaining the motives of those involved.[47]

With the exception of a small number of copies of Tweddell's costume studies, John's Grand Tour material, which the *Naval Chronicle* dubbed 'one of the most classical portfolios formed by any modern traveller'[48] now disappeared entirely until 1816, the year after the publication of the bizarre *Remains of John Tweddell*, by his brother Robert. An argumentative and highly repetitive tract, this investigates at disproportionate length the 'extraordinary disappearance' of Tweddell's Grand Tour possessions,[49] bitterly accusing the Earl of Elgin of 'irregularly attach[ing] the whole of my brother's property' and suffering 'a portion of it to be injured for want of timely examination', and alleging that, having 'constituted himself a trustee', Elgin was 'negligent of the obligation'.[50]

Robert's re-opening of the Tweddell family's attempts to retrieve John's Grand Tour possessions had begun in 1810, when hints were thrown out in the *Naval Chronicle* as to the dispersal of John's property, and in 1814 an investigation was opened by the Levant Company. Forced onto the back foot by the weight of evidence against them, Elgin and his supporters, including Philip Hunt, responded by accusing Robert of libel, 'scurrility' and defamation of the Earl's character, throwing as much blame as possible onto Tweddell's servant and those present at the shipwreck itself, and asserting that his possessions had been shipped from Constantinople back to England aboard the *Duncan*[51] by the distinguished professor of Arabic at Cambridge, J. D. Carlyle who had accompanied Lord Elgin to Constantinople as embassy chaplain in 1799 (p. 165), came from the North of England and knew Tweddell's friend James Losh. No evidence of any shipment was, however, produced, and Robert Tweddell was supported – albeit in more measured tones – by several of those who had witnessed events at Constantinople in 1799, including Spencer Smythe, Thomas Thornton, and the sister of the now deceased Professor Carlyle.

In a dramatic denouement in 1816, Elgin discovered some of Tweddell's Turkish costume studies among his possessions, following a revelation from his former father-in-law, William Hamilton-Nisbet, who had travelled home from the East with Carlyle, that he had brought back with him a parcel of Tweddell's drawings, had them copied in Naples, and then delivered the originals to Elgin, unaware that they were the property of the Tweddell family. When the box containing these was duly unpacked at the Foreign Office in the presence of representatives from both sides it was found to contain ninety-eight drawings of Greek and other costume, fourteen other drawings, and some of Tweddell's notes, thus apparently vindicating the Tweddell family's position. Elgin, however, insisted that he had an entirely innocent explanation for the material's reappearance; as a prisoner of the French from 1804–6, he had not, he argued, known that these drawings had found their way into his possessions back in England.

Unfortunately, the subsequent history of John Tweddell's literary and artistic 'remains' is as mysterious as the seventeen-year temporary disappearance of that small portion of them rediscovered in the boxes opened in London, apparently caused by a man then caught up in a much more serious controversy, over the Elgin marbles. Although none of Tweddell's papers or drawings can be identified today, Lord Elgin's – admittedly fluctuating – interest in his 'Remains' is surely in itself confirmation of the major contribution they would have made to Neo-Classicism.

END NOTES

1 Tregaskis, p. 38.
2 Tweddell, pp. 3, 196.
3 The principal source for this is the Rev. Robert Teddell's *Remains of John Tweddell* (1815). Quotations from this book are from the 2nd edition, 1816, which contains additional material; see note 49. I am also indebted to Hugh Tregaskis's discussion of Tweddell's tour; see *Bibliographical Note*.
4 Tweddell, pp. 162, 9.
5 Op. cit., p. 134. The Count was the author of *Le Voyage pittoresque de la Grèce* (3 vols., 1776–1822).
6 See Tweddell, p. 196, where John Tweddell refers to having 'lost on the side of happiness'. In Constantinople in May 1798 he told James Losh that turtle doves 'woo their mates, and build their nests' outside his window, adding: 'This, my friend, were a fitter residence for you [Losh had recently married] than for me'; Tweddell, p. 223.
7 Tweddell's Grand Tour correspondence is published in Robert Tweddell's *Remains*. Apart from James Losh and Tweddell's parents and family, his principal correspondents were the Northerner Thomas Bigge and the Hon. Stephen Digby.
8 Tweddell, pp. 49, 105, 60.
9 Op. cit., pp. 194, 131, 93, ibid.
10 Unfortunately, none of Tweddell's Grand Tour letters to Grey survive.
11 Tweddell, p. 268. Bigge lived at the White House, Little Benton, very near to his cousin, the future tourist C. W. Bigge at Benton House; it is not certain which of these Bigge houses Tweddell refers to here.
12 Op. cit., p. 85.
13 Tweddell travelled with letters of introduction to him at Vienna, see Tweddell, p. 32, and from Berlin John wrote that he was engaged in copying a dispatch of Eden's for Lord Elgin; op. cit., p. 59.
14 For the membership of this club, see the footnote in Tweddell's *Remains*, p. 337.
15 From the inventory of his effects taken after his death, reproduced in Tweddell, p. 569.
16 Op. cit., pp. 169–71.
17 Op. cit., p. 83.
18 Charlton, pp. 240–9, also resembles him in taking a keen interest in mining.
19 Tweddell, p. 92.
20 Op. cit., pp. 193, 141, 84.
21 Op. cit, p. 148; ibid.
22 Aberli's works were also purchased by another Northerner, William Blackett.
23 For Freundenberger see also *The Last Two Decades* chapter, note 62.
24 The reference is almost certainly to the more famous father, Salomon, rather than to his son Johann Konrad (1764–1826), who produced landscapes for tourists but was not principally a landscapist.
25 Tweddell's other purchases were six prints by 'Meyer' copied 'in the manner of Gessner'; prints by a young but promising artist, Zehender, of a 'village maid' and a view of the Isle of Schwanau on Lake Lowertz, where Tweddell had spent three days with a hermit; two views by Aberli retouched by Rieter; and some prints of landmarks such as the Devil's Bridge which Tweddell considered 'ill-coloured but exact'; see Tweddell, pp. 148–53.

26 Op. cit., p. 155. For Artaud's criticism of Kauffman's portrait of Lambton, see p. 146 of this book.
27 Op. cit., pp. 179, 180.
28 Op. cit., pp. 199, 188, 184. Peter Simon Pallas was a German zoologist and botanist who worked in Russia and was a favourite of the Empress Catherine II; she bought his large natural history collection, which, however, he was allowed to keep for life.
29 Op. cit., p. 215.
30 Op. cit., p. 193.
31 Smythe was later made Minister Plenipotentiary.
32 Tweddell, p. 261.
33 Op. cit., pp. 255, 248, 261. At the time of the supposed loss of his drawings in a fire in Constantinople, after he had left for Greece, John claimed he had 50 views of Constantinople and its environs with him in Greece, and 100 that he feared burnt. He also had 50 views of the Crimea (not burnt), 40 views of Athens and 150 views of the 'ceremonies', 'usages', and dresses of the people of Greece; see Tweddell p. 317.
34 Tweddell, pp. 261, 283, 284, 319.
35 Op. cit., pp. 268, 9, 321, 9, 268.
36 Op. cit., pp. 281, 282, 288. Julien David le Roy was the author of *Ruines des plus beaux Monuments de la Grèce* (1758).
37 Op. cit., pp. 288; ibid; 273–4.
38 Op. cit., pp. 266, 319.
39 Op. cit., pp. 397, 457.
40 From his tour of Switzerland onwards, Tweddell referred in several of his letters to pains in his chest, and his two Athenian doctors agreed that the breaking of a blood vessel in his chest had caused his death.
41 Tweddell, p. 397.
42 Op. cit., pp. 12–13, quoting from Dr. E. D. Clarke, *Travels in Greece*, Vol. 3, p. 534.
43 Op. cit., p. 392.
44 H. A. Barker was the son of Robert Barker, an Irish panorama artist, who, with his son's assistance, had opened an exhibition in Edinburgh in 1787 featuring a panoramic view of the city.
45 This was Professor Carlyle's (see main text below), as reported by James Losh.
46 Tweddell, pp. 460, 590.
47 Op. cit., pp. 445, 515, 561.
48 Op. cit., p. 445.
49 The book also contains 'a selection of his correspondence' and a 'republication of his Prolusiones Juveniles', while the Appendix gives 'some account of the author's collections MSS. Drawings &c'. The second edition has additionally 'a vindication of the editor against certain publications of the Earl of Elgin and others'.
50 Tweddell, p. vi.
51 Some years later, Elgin somewhat conveniently decided that another ship, the *New-Adventure*, had been involved instead.

Appendix 4
Maps

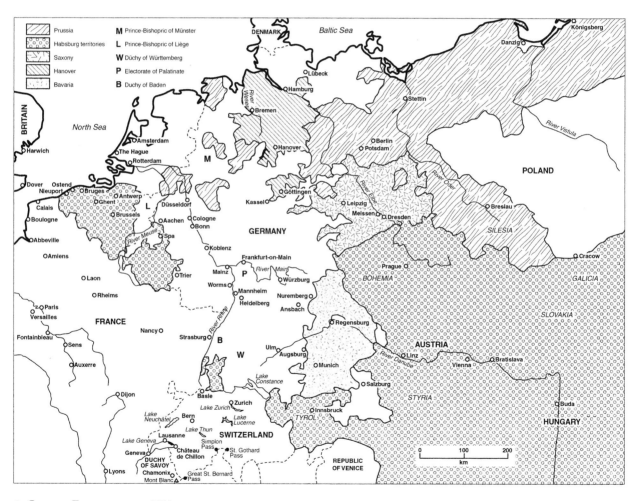

1 CENTRAL EUROPE, ABOUT 1786

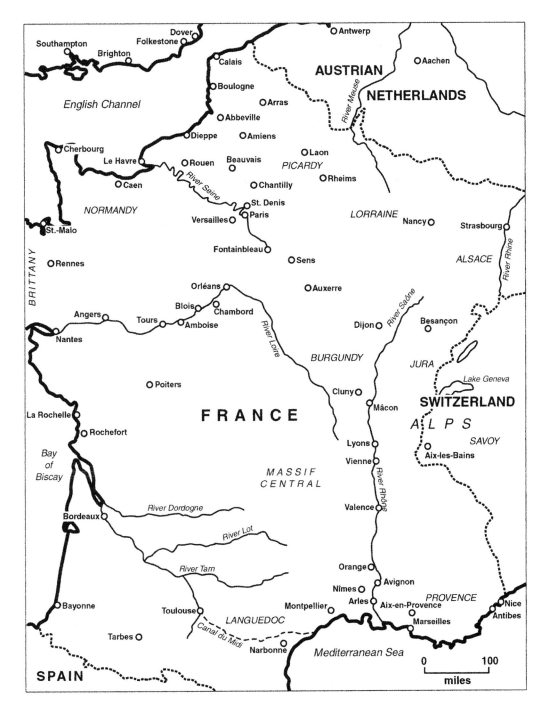

2 18TH-CENTURY FRANCE

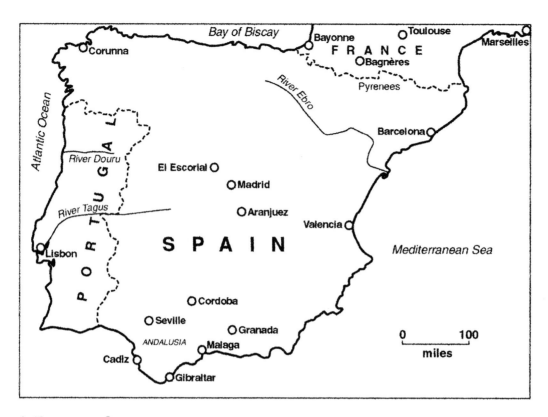

3 18TH-CENTURY SPAIN

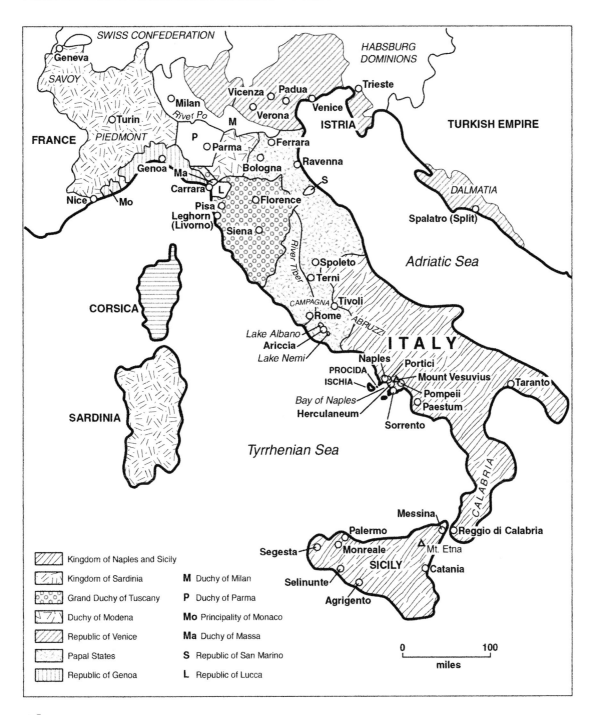

4 Italy in the mid-18th century

Bibliographical Note

Note: the place of publication is London, except where otherwise stated.

ARCHIVAL SOURCES

Most of the papers relating to the individual families cited in this book are lodged in the Northumberland and Durham Record Offices. Of these, the following records have been consulted:

Northumberland County Record Office

Allgood MSS: letters from Lancelot Allgood to his aunt, Mrs. Widdrington, 1737 (ZAL 35/4).

Anderson MSS: Tour Journals, 1801–3 (660/15/1 and Box 1 uncatalogued), and 1814–16 (660/15/2, 660/15/4, 660/15/1).

Blackett MSS: Letters from William Blackett, later 5th Bart., to his father Sir Edward Blackett, 4th Bart., 1784–7 (ZBL 239).

Carr-Ellison MSS: Letters from John Carr, 1788–90, and from John and Harriet Carr, 1791–4 (ZCE 855).

Craster MSS:
'Wife's Memorandum Book of things bought etc. in France & Italy' listing expenses from 1760 to 1762, and loose double sheet inside, folded with price lists, including 'An account of Antiques & Curiosities etc', 'A list of flowers bought at Genoa' (1761) and notes on cities, citing diplomats, artists, antiquities etc. (ZCR/ Box 20).
Account of the Dauphin's marriage, 1770 (ZCR/Box 13).
Printed pocket books of George Craster for 1769–71 (ZCR/Boxes 17, 20).

Grey MSS: letters from the Grey family of Backworth House, 1767 (NRO 753, old reference P (x)).

Haggerston MSS: Letters from Sir Carnaby Haggerston and John Thornton, S.J., to Francis Anderton, S.J., and Lady Haggerston, 1711–20 (ZHG VII/I, Berwick on Tweed Record Office).

Monck MSS: Sir Charles Monck, Journal in Germany, Venice, Greece 1804-06 (ZMB 52/1), and 1830 tour (ZMI B 52/3/1-4).

Ord MSS: Diary of William Ord, 1814–17 (324/A12, 324/A13, 324/A14), and 1825 (324 A/15).

Ridley MSS:
Letters from Mathew White Ridley to his father Mathew Ridley, 1765–66 (ZRI 30/3).
Letters to Sir M.W. Ridley, 2nd Bart., mostly from his son, 1800–1801 (ZRI 30/7).
Letters from Nicholas William Ridley, 1802 (ZRI 1802, 30/8).
Letters and notebook concerning the art purchases of Sir M.W. Ridley, 3rd Bart. (ZRI 1828–34, 33/5).
Tour journals of M. W. Ridley, later 3rd Bart., 1800–01 (ZRI 32/3/3, 32/3/1, 32/3/27, 32/3/2. Shelf-marks are out of sequence; the various journals follows the order given here).
Pocket diaries of Sir M.W. Ridley, 3rd Bart., 1829–30 (ZRI 32/3/24–25) and 1822 (ZRI 32/3/13; other diaries in this sequence contain no continental tours).
Diaries of M.W. Ridley, 4th Bart., 1829–30 (ZRI 32/5/1–2).

Swinburne MSS:
Accounts of Sir John Swinburne, 1745–62 (ZSW 456).
Manuscript extracts from accounts of travellers (ZSW 643).

Note: Although members of the Riddell family made the Grand Tour from Northumberland, the Riddell MS., Journal of a tour in Italy November 20th – March 13th. 1770–1771 (ZRW 62, 63) was in fact written by an as yet unidentified Scottish member of this large Catholic family.

Durham County Record Office

Londonderry MSS: Letter from Frances Anne, Marchioness of Londonderry to Henry Liddell (D/LO/C) concerning her tour of 1836–9.

Salvin MSS: correspondence (D/Sa/C 104, 109 (1787, 1790); F 181 (1679); F 290, 29 (1865–6, 1868–9).

Tyne and Wear Archives Service

Ellison MSS (Acc. 3419):

Ellison family letters, 1761–66, including letters from Henry Ellison to his father (A14).

Letters from General Cuthbert Ellison to his brother Henry Ellison senior, 1764–5 (A22).

The diaries and notebooks of Robert Ellison, 1781–2 (3419 E1, E3).

Letters from Henry Ellison Jnr. to Robert Ellison abroad, 1781–2 (A11).

Letters from Elizabeth Ellison to Robert Ellison, 1781–2 (A3).

Letters from Lord Harrowby and Baron Hotham to Robert Ellison, 1781–2 (A62).

Note: Henry Thomas Carr's letters to Henry Ellison from Rome, 1739–40 (3419 A28), are also included among the Ellison papers.

The Trevelyan papers are in the Special Collections, Robinson Library, University of Newcastle upon Tyne, and include three surviving sketchbooks by Sir John Trevelyan (WCT 273) and the exceptionally important papers of Sir Walter Calverley Trevelyan, principally his wedding tour of 1835–8 (WCT 259 (2), 260 (2), 260 (1), 260 (3), 260 (4), in that order) and his second major tour from 1841–2 (WCT 260 (7), 261 (1-3)). Other papers include the 'MS. Diary by Walter Calverley Trevelyan of his visit to Shetland, Faro [sic] and Denmark, May 1821–April 1822' (WCT 249/1); miscellaneous letters and papers relating to Italy, including correspondence with William Ewing, 1836–41 (WCT 252); and letters from William Nugent Dunbar to Lady Trevelyan (114.61–66). Unfortunately, I have not had access to Pauline Trevelyan's monumental, 44-volume diary in the Kenneth Spencer Research Library, University of Kansas, but her 'Sketches in Greece in 1842 by Lady Trevelyan' are in the British Museum (200.c.8).

The correspondence of Robert Wharton, including letters to his mother, uncles and his cousins Miss Raine and Miss Mary Lloyd, and his Journal (used as an aide mémoire for his letters), are in Durham University Library, mostly of 1775–6; of nearly 900 items in the Wharton collection, stored in ten boxes, these include: Letters (nos.108–69); Letterbook I (copies of 18 of Wharton's letters); Letterbook II (15 letters); Letterbook III (14 letters). Also in the University Library is Newbey Lowson's journal of his tour with Lord Darlington (Surtees Raine MS. 24), undated but from 1816, which complements Darlington's own account (see p. 296).

The Richard Brinsley Ford archive, Paul Mellon Centre, London is invaluable for supplementing information in John Ingamells' published volume; the photostat copy of part of the Italian tour journal kept by Thomas Orde (the rest of this journal is missing) is of particular importance. The letters of William Artaud, which include much material on his relations abroad with his Northern patron, William Henry Lambton, are in the John Rylands Library, Manchester. The Maxwell-Constable MSS. (Hull University Library, DDEV/60/85), contain correspondence relating to the tours abroad of Thomas, William and Edward Haggerston in the 1740s and 1750s. Orlando Felix's eleven letters from Egypt to Lt. Col. Brown when he was touring the sites with Lord Prudhoe from 1826–9 are in the National Library of Scotland. The Townley MSS. in the British Library (7/1483/4/5/6) contain information on Henry Swinburne, while Martha Swinburne's eve of Revolution letters to Henry Swinburne from France are also in the British Library (Add.MSS. 33121, ff.5–17).

A number of key archives, notably the exceptional Archives of the Duke of Northumberland at Alnwick Castle, are still in private hands. The Duke of Northumberland papers (DNP, also called Percy Letters & Papers) contain the following: the diaries of Elizabeth, 1st Duchess of Northumberland (DNP. MS.121); her *Museum Catalogues* or 'Lists' (DNP. MS.122a, 122b, 122, 123, 124, 125, 126, 127, 8 vols., but confusingly numbered from 1-9, with no vol. 7); the letters of the Duchess, her husband, and her tourist sons, Hugh, Lord Warkworth and Lord Algernon Percy (DNP. MSS. 32–35, 43–45; an unfinished tour journal of Lord Algernon Percy's *Voyage to Tunis, Smyrna* [etc.] in 1773 (DNP. MS.140); the eleven notebooks of Lord Prudhoe's journeys in Egypt, comprising five journals, five copies of inscriptions, and one containing notes on history (DNP. MS 766); and the Egyptian drawings of Orlando Felix which also document this tour (DNP. MS. 742).

A separate set of Ducal Papers (DP) includes the correspondence of Algernon, 4th Duke of Northumberland with his steward Thomas Williams (DP/D3/III/32), documenting his 1853–4 tour; with Emil Braun, 1855-6 (DP/D4/I/11) over the purchase of the Cammuccini collection; and with Sir Charles Lock Eastlake, 13th June, 1856 (DP/D4/I/5). Lord Prudhoe's Rome Tour Journal of 1822 is numbered DNA.G/11/3–4.

Other private papers include: 'Letters of the Carr family of Dunston Hill', 2 vols., and (part of the same archive), 'Letters from Distinguished Personages and others to Sir John Dick', the tour journals at Raby Castle, Durham, of William Harry Vane, Lord Barnard, later 3rd Earl of Darlington and 1st Duke of Cleveland, dated 1784–6,1816–18, and later years; the Alethea Blackett MSS. (see below under Purdue, 2004); and papers relating to the Swinburne family. Among these are: the accounts of Sir John Swinburne, 3rd Bart. (1745–62); the tour journals of Sir Edward Swinburne (1763, 1770–71,1774–6); a Journal and Memorandum of Sir John Edward Swinburne (1781–2, 1786); and the letters of Edward Swinburne (1814). In addition, the Swinburne papers contain a small number of letters by Henry Swinburne himself, and notes taken by a member of the family on Louis Dutens's Grand Tour guidebook (see below). Just before going to press, Henry Swinburne's original letters, which form the basis of *The Courts of Europe* (see below), surfaced at Fonmon Castle in Wales. Edward Swinburne's drawings from his Italian tours of 1792–3 and 1797 are also in private hands.

The voluminous tour journals of Dr. Edward Charlton survive in typescripts and in some cases in the original (private collections). They include: 'Hull to Vienna 1837', 'Italy 1838', 'Denmark 1836', 'Norway 1836' and 'Norway & Sweden', 1862. Kept together with the typescripts is an unpublished 'Biographical Note on Edward Charlton' by William E. Charlton.

EARLY AND MODERN PRINTED SOURCES

General

Much of the information on Northern tourists has already been made accessible in highly succinct form in John Ingamells' *A Dictionary of British Travellers in Italy 1701–1800* (New Haven and London, 1997), a bible for all Grand Tour enthusiasts. The *Dictionary* is itself based on a lifetime's research on the British in Italy undertaken by the late Sir Brinsley Ford, which now forms the Richard Brinsley Ford archive at the Paul Mellon Centre, London; this contains much additional material for which there was not space in the *Dictionary*. The author is greatly indebted to the entries on Northern tourists in the *Dictionary*, researched by Carol Blackett-Ord, which provided an invaluable starting point for all tourists, and, in the case of a few less important tourists, there has

been little to add to the illuminating digest of tourists' activities found there. In the interests of clarity, archival and other material quoted in the *Dictionary* often needs to be repeated here.

Of the many admirable recent books on the Grand Tour, Jeremy Black's *The British Abroad, The Grand Tour in the Eighteenth Century* (Stroud and New York, 1992), has been an indispensable companion, while his *France and the Grand Tour* (Hampshire & New York, 2003) offers a corrective to the often Italianate bias of Grand Tour studies. Black's *Italy and the Grand Tour* (New Haven and London, 2003) adopts a similar approach to his ground-breaking 1992 book, but with the focus solely on Italy. I am also greatly indebted to Edward Chaney's *The Evolution of the Grand Tour* (1998, and revised paperback edition, 2000). Two Grand Tour catalogues have proved indispensable: the Tate's *Grand Tour, The Lure of Italy in the Eighteenth Century*, ed. Andrew Wilton and Ilaria Bignamini (1996), and Ian Jenkins and Kim Sloan's *Vases & Volcanoes, Sir William Hamilton and his Collection* (British Museum, 1996).

Of earlier books, Christopher Hibbert's entertaining *The Grand Tour* (1987) includes copious illustrations which cover most aspects of Grand Tour life, while Hugh Tregaskis's, *Beyond the Grand Tour, The Levant Lunatics* (1979) was particularly helpful for my later chapters. Andrew Moore's *Norfolk and the Grand Tour* (Norfolk, 1985), set a stimulating precedent for examining the Grand Tour regionally. Other key sources have been Anthony Clark's monograph on Pompeo Batoni, edited by Edgar Peters Bowron (New York, 1985); Bowron's earlier exhibition catalogue, *Pompeo Batoni and his British Patrons* (Kenwood, London, 1982); his magisterial *Art in Rome in the Eighteenth Century* (Philadelphia Museum and London and New York, 2000, with Joseph J. Rishel); and his recent book accompanying the exhibition held at Houston and at National Gallery, London, *Pompeo Batoni, Prince of Painters in Eighteenth-Century Rome* (New Haven and London, 2007). Lindsay Stainton's *British Artists in Rome 1700–1800* (Kenwood, London, 1974), Francis Haskell and Nicholas Penny's *Taste and the Antique* (New Haven and London, 1981) and Francis W. Hawcroft's *Travels in Italy 1776–1783,* based on the *Memoirs* of Thomas Jones, (Manchester, 1988) have been other key sources, while the *Memoirs* of Thomas Jones themselves (*The Walpole Society*, XXXII, 1946–48) were indispensable.

The well-known articles by Brinsley Ford, 'James Byres, Principal Antiquarian for the English Visitors to Rome' and 'Thomas Jenkins, Banker and Dealer and Unofficial British Agent', *Apollo*, Vol. 99, June 1974, pp. 446–61 and 416–25 and Denys Sutton, 'Aspects of British Collecting II', *Apollo*, December 1982, remain highly pertinent today, while 'Lost and Found, A Cargo of Grand Tour Souvenirs', *Country Life*, 8th May 2003, pp. 126–30, analyses a rediscovered cargo.

A highly important summary of Grand Tour literature is provided by Edward Chaney in the *British Art Journal* (I, 2, Spring 2000, pp.113–4 and II, 1, Autumn 2000, pp.98–102), and in the 2000 paperback edition of his book listed above. Brian Dolan's, *Ladies of the Grand Tour* (2001) offers a welcome introduction to this fascinating topic, while *Imagining Rome: British Artists & Rome in the 19th Century* (Bristol City Museum & Art Gallery, 1996) includes many artists who worked for 19th century Northern tourists. The beginning of mass tourism is helpfully summarised in Piers Brendon's *Thomas Cook, 150 Years of Popular Tourism* (1991). Kim Sloan's invaluable *'A Noble Art', Amateur Artists and Drawing Masters, c.1600–1800* (British Museum, 2000) casts considerable light on many amateur sketchers, notably Henry and Edward Swinburne, while Gertrud Seidmann's 'Nathaniel Marchant, Gem-Engraver, 1739–1816', *The Walpole Society*, LIII (1987) helped with several Northern collectors. Horace Walpole's correspondence, ed. W.S. Lewis *et al* (New Haven, 1937–83) was, as ever, a mine of information, particularly for Lady Anne Liddell and the Swinburnes, while many tourists' lives both before and after their tours are usefully summarised in the Oxford Dictionary of National Biography. Grove's Dictionary and Grove Art Online have helped to solve many of the more intractable problems regarding the identity of minor artists who worked for Northern tourists. The recent catalogue by Elizabeth Eger and Lucy Peltz of the exhibition *Brilliant Women, 18th-Century Bluestockings* (National Portrait Gallery, 2008), was helpful for two leading tourist bluestockings, Elizabeth Montagu and Elizabeth Carter.

Local sources: general

The recent volume edited by Helen Berry and Jeremy Gregory, *Creating and Consuming Culture in North-East England, 1660–1830* (Hampshire and USA, 2004), together with Edward Hughes' two earlier publications, *North Country Life in the Eighteenth Century.Vol. I, The North East 1700–1750* (Oxford University Press, 1952), and *Cumberland and Westmorland, 1700–1830*, (Oxford, 1965) have all been invaluable in different ways in providing an overview of cultural life in the region. Phoebe Lowery's 'Patronage and the Country House in Northumberland' in *Northumbrian Panorama, Studies in the History and Culture of North East England*, ed. T.E Faulkner (1996) has cast light on the many parallels between country house building and tourism, while T.E. Faulkner and Phoebe Lowery's *The Lost Houses of Newcastle and Northumberland* (York, 1996) was invaluable for those Grand Tour houses which no longer exist. Even more important were their unpublished notes on Northern houses which Dr. Faulkner kindly allowed me to consult. Of course, no book on the region would be possible without the Rev. John Hodgson's *A History of Northumberland* (Newcastle upon Tyne, 7 vols., 1820–58), whose pedigrees have enabled me to identify many lesser tourists, and to disentangle the complex intermarriages between tourist families, or Robert Surtees's *The History and Antiquities of the County Palatine of Durham* (1826–23). R. T. Welford's anecdotal but unreliable *Men of Mark 'twixt Tyne and Tweed* (London & Newcastle, 3 vols.,1895), Nikolaus Pevsner's two volumes on *Northumberland* (revised by John Grundy, Grace McCombie etc., 1992) and *Durham* (revised by Elizabeth Williamson, 2000), and Marshall Hall's *The Artists of Northumbria* (Newcastle upon Tyne 1982, revised ed. 2004) and *The Artists of Cumbria* (Newcastle upon Tyne, 1979) are other key local sources. Lawrence and Jeanne C. Fawtier Stone's *An Open Elite?* (1984) analyses the changing composition of the region's elite at the time its members were making the Grand Tour. Bill Purdue's two splendid books on the Carrs and the Ellisons, and on the Blacketts, are listed below under works on individual tourists, but go far beyond this in offering an understanding of merchants and gentry in North-East England when the Grand Tour was at its height.

Catholicism in the North.

Ann C. Forster made an important study of Catholics in the diocese of Durham (then including Northumberland) in 1767 in the *Ushaw Magazine*, LXXII, July 1962, no.215, pp.78–89, and on the Catholic church in the North-East from 1688–1720 in *Northern Catholic History*, no. 10, Autumn, 1979, pp.10–16, while J.A. Hilton has written on 'The Cumbrian Catholics' in *Northern History*, xvi, 1980, pp.40–58. Geoffrey Scott's *Gothic Rage Undone* (Bath, 1992) and Mark Bence-Jones' *The Catholic Families* (1992), both offer important information on the North's Catholics. *The Desperate*

Faction? The Jacobites of North-East England 1688–1745 by Leo Gooch (Hull, 1996), discusses the links between Catholicism and Jacobitism, and includes much incidental information on the North's Catholic Grand Tour families. The *Biography of the English Benedictines* by Athanasius Allanson (Saint Lawrence Papers IV, Ampleforth Abbey, 1999) gives an important overview of the considerable number of Northern Catholic boys who entered the priesthood after their education abroad, while 'Materials towards a biographical dictionary of Catholic history in the British Isles', *Biographical Studies 1534–1829* by A.F.Allison and D.M. Rogers, and *Lamspringe, An English Abbey in Germany, 1643-1803*, Saint Lawrence Papers VII, Ampleforth Abbey, 2004, also helped to identify Northern tourists. The *Downside Review*, 105, no. 361, October 1987 by Jeremy Black and Dom. Aidan Bellenger usefully summarises the boarding school options available on the continent in 1766. Important information on Henry Howard is included in *The Worthies of Cumberland* by Henry Lonsdale M.D. (1867).

Individual studies on or by Grand Tour artists and patrons.

Major George Anderson

George Anderson, *Plans and Views of the Abbey Royal of St. Denys, The Ancient Mausoleum of the Kings of France* (1812).
George Anderson, *A Tour though Normandy in the Year 1815; describing The Principal Cities, Towns and Antiquities, The Great Monasteries, Abbeys, Cathedrals and Churches of that Province* (Newcastle upon Tyne, 1820).
Claudia Nordhoff and Hans Reimer, *Jakob Philipp Hackert, 1737–1807: Verzeichnis seiner Werke*, 2 vols. (Berlin, 1994).

Dr. Anthony Askew

S. Baker & G. Leigh, York St., Covent Garden, *Bibliotheca Askeviana, sive Catalogus Librorum Rarissimorum Antonii Askew, M.D.*, 13 February–7 March, 1775 (BL 821.g. 9).
S. Baker & G. Leigh, Booksellers, York Street, Covent Garden, *A Catalogue of the Library of Thomas Jekyl, Esq;...to which is added, the Collection of Prints and Drawings of Dr. Anthony Askew, deceased.*, 1775 (BL 1477.c.13).
Lyon & Turnbull, Askew library auction catalogue, Pallinsburn, 4th May 2005.
William Macmichael, *The Gold-Headed Cane* (London, 1827).

Charles Avison

Charles Avison, *An Essay on Musical Expression* (1752).
The Gentleman's Magazine, vol. LXXVIII, part 2, 1808.
P. M. Horsley, 'Charles Avison: The Man and his Milieu', *Music and Letters*, LV (1974, 5).
Lyall Wilkes, *Tyneside Portraits* (Gateshead, 1971).

William Harry Vane, Lord Barnard, later 3rd Earl of Darlington and 1st Duke of Cleveland

Raby Castle, guidebook (Heritage House Group Ltd., 2001).
Catherine Vane, Duchess of Cleveland, *Handbook of Raby Castle* (1870).

William Bewick

George A. Fothergill's Sketch-Book, Part V (Darlington, 1903–4).
J. Kirkland & M.R. Wood, *William Bewick of Darlington*, n.d. (Newcastle Local Studies Library, L759 B572).
Thomas Landseer (ed.), *Life and Letters of William Bewick*, 2 vols. (1871).
Thomas Watson & Sons, sale of *The Bewick Gallery of Pictures* (Haughton House, Haughton-le-Skerne, 9th–10th November 1870).

Charles William Bigge

Catalogue of sale of the contents within Linden House, Northumberland by Mr. Samuel Donkin (Alnwick, 1861).

William Blackett

A.W. Purdue, *The Ship that came Home, The Story of a Northern Dynasty* (2004).

John and Josephine Bowes

Elizabeth Conran and others, *The Bowes Museum* (1992).
Charles E. Hardy, *John Bowes and the Bowes Museum* (Bishop Auckland, 1970).
Sarah Kane, 'When Paris meets Teesdale: the Bowes Museum', *Northumbrian Panorama, Studies in the History and Culture of North East England*, ed. T.E. Faulkner (London, 1996).

William Blakiston Bowes

Gibside, Gateshead, guidebook, The National Trust (1999).

Rowland Burdon

Arthur T Bolton, *The Portrait of Sir John Soane R.A.* (1927).

William Brockie, *Sunderland Notables* (Sunderland, 1894).

William Fordyce, *The History and Antiquities of the County Palatinate of Durham*, Vol. II, 1857, pp. 367–8.

Pierre de la Ruffinière du Prey, *John Soane, the making of an architect* (Chicago and London, 1982).

Pierre de la Ruffinière du Prey, *John Soane's Education, 1753–80* (Ph.D. thesis, Princeton University, 1972).

Bill Rhodes, *Castle Eden and Hesleden* (typescript, Durham County Council, 1996).

John Soane, *Memoirs of the Professional Life of an Architect* (1835).

Ann Sumner and Greg Smith, *Thomas Jones (1742–1803), An Artist Rediscovered* (New Haven and London, 2003).

H.B.Tristram, *Records of the Family of Burdon, of Castle Eden* (privately printed, 1902).

The Carrs

Anne Amison, *The Sage at Badger, John Ruskin's Visits to Shropshire, 1850 and 1851*,
www.localhistory.scit.wlv.ac.uk/articles/Albrighton/Ruskin/Ruskin.htm

R.E. and C.E.Carr, *History of the Family of Carr* (1893).

Christie's South Kensington, *Watercolours of the Grand Tour from a private collection*, 12th October 2005 (catalogue of works by Harriet Carr [Cheney] and her sons).

A.W. Purdue, 'John and Harriet Carr: A Brother and Sister from the North-East on the Grand Tour' (*Northern History*, Vol. XXX, 1994, pp. 122–38).

A.W. Purdue, *Merchants and Gentry in North-East England 1650–1830, The Carrs and the Ellisons* (University of Sunderland Press, 1999).

William Seward, *Biographiana* (1799).

The Crasters

Sir Edmund Craster, 'The Craster Family – Three Generations', *Archaeologica Aeliana*, 4th series, XXXI, 1953, pp.23–47.

David Goodreau, *Nathaniel Dance 1735–1811* (Kenwood, London, 1977).

Christopher Crowe

Hugh Honour, 'English Patrons and Italian Sculptors in the first half of the eighteenth century', *The Connoisseur*, Vol. 141, Jan–June 1958, pp. 220–6.

Masterpieces from Yorkshire Houses (York City Art Gallery, 1994).

James Dagnia

Mrs. Terence Knight, *The Adventures of Jemmy Gosemore Dagnia*, privately published, n.d.

Proceedings of the Society of Antiquaries of Newcastle upon Tyne, VI, 1894, no. 22, pp. 163–7.

Richard Dalton

Richard Dalton, *Antiquities and Views in Greece and Egypt…A.D. 1749* (1791).

Michael Levey, *The Later Italian Pictures in the Collection of Her Majesty the Queen* (Cambridge University Press, 1991).

W. B. Stanford and E. J. Finopoulos, eds., *The Travels of Lord Charlemont in Greece & Turkey 1749* (1984).

William Harry Vane, 3rd Earl of Darlington, later 1st Duke of Cleveland

See under Lord Barnard.

Sir John Dick

Sir Oliver Millar, *Zoffany and the Tribuna* (1967).

Louis Dutens

Louis Dutens's numerous publications, the most popular of which went into several editions in both French and English, were written from his Northumbrian vicarage in Elsdon; almost all relate directly to his Grand Tours. His travel guide, *Itinéraire des Routes les plus fréquentée ou Journal d'un Voyage aux Villes principles de l'Europe, en 1768, 1769, 1770, 1771 and 1777* (3rd ed., 1779), translated into English as *Journal of Travels made through the Principal Cities of Europe* (1782), is based principally on his lengthy tour with Lord Algernon Percy from 1768–71 (pp. 75–80) It provides details, more or less in chart form, of the post routes (measured by a 'Perambulator' fixed to the chaise), inns, prices, population, currency and 'curiosities' they encountered.

In his polemical *Inquiry into the Origin of the Discoveries attributed to the Moderns* (1767), published in French as *Recherches sur l'Origine des Découvertes attribuées aux Modernes*, Dutens sought to prove that modern philosophers, including Descartes, derived their theories from the ancients, while his *Explication de Quelques Médailles Greques et Phéniciennes* (London and Paris, 1773) was inspired by the gift from Hugh, 1st Duke of Northumberland (praised in the dedication for his knowledge on this subject) of a collection of Greek medals from the Ruzini family in Venice. Dutens's Grand Tour *Memoires d'un voyageur qui se repose* (1806) form the basis for our knowledge of his tours with Lord Algernon; quotations from the *Memoires* in this book are from the French edition. Other publications include *Des Pierres Précieuses et des Pierres Fines* (Paris, 1776).

Christopher Ebdon
Howard Colvin, *A Biographical Dictionary of British Architects 1600–1840*, 3rd ed. (New Haven and London, 1995).

The Edens
Sir Timothy Eden, *Tribulations of a Baronet* (1933; reprint, Stocksfield, Northumberland, 1990).
Lyall Wilkes, *The Aesthetic Obsession: A Portrait of Sir William Eden Bart.* (Stocksfield, 1985).

The Ellisons
A.W. Purdue, *Merchants and Gentry in North-East England 1650–1830, The Carrs and the Ellisons* (University of Sunderland Press, 1999).

Henry Errington
Lewis Perry Curtis, *Letters of Laurence Sterne* (Oxford, 1935).
Valerie Irvine, *The King's Wife, George IV and Mrs Fitzherbert* (London & New York, 2005).

Charles, Lord Grey
E.A. Smith, *Lord Grey, 1764–1845* (Oxford University Press, 1990).
G.M.Trevelyan, *Lord Grey of the Reform Bill* (1920).

Ralph William Grey of Backworth
Proceedings of the Society of Antiquaries of Newcastle upon Tyne, 4th series, VI, no.3, 1933, pp. 124–5.

The Haggerstons
M.B Joyce, 'The Haggerstons: The Education of a Northumbrian Family', *Recusant History*, XIV, 1977–88, pp. 175–92.

Guy Head
Ann Gunn, 'Guy Head's "Venus and Juno"', and Frank Salmon, 'Guy Head's "Oedipus", in the Academy at Parma', *The Burlington Magazine*, CXXXIII, August, 1991, pp.510–513 and 514–517.
Nancy L. Pressly, 'Guy Head and his "Echo flying from Narcissus": A British Artist in Rome in the 1790s', *Bulletin of the Detroit Institute of Art*, LX, 1982, pp. 68–70.

George and Rosalind Howard, 9th Earl and Countess of Carlisle
Christopher Newall, *The Etruscans, Painters of the Italian Landscape 1850–1900* (Stoke on Trent, 1989).
Charles Roberts, *The Radical Countess*, (Carlisle, 1962).

Henry and Catherine Mary Howard of Corby Castle
Catherine Mary Howard, *Reminiscences for my Children*, 3 vols. (privately printed, Carlisle, 1836–8).

John Ingram
Guardi, Tiepolo and Canaletto from the Royal Museum, Canterbury and elsewhere (The Royal Museum, Canterbury, 1985).
Francis Haskell, 'Francesco Guardi as *Vedutista* and some of his Patrons', *Journal of the Warburg and Courtauld Institutes*, 23, 1960, pp. 256–276.

The Lambtons
Lambton Castle sale, Anderson & Garland (Newcastle upon Tyne, 1938).
Stuart J. Reid, *Life and Letters of the First Earl of Durham*, 2 vols. (1906).
W. W. Roworth (ed.), *Angelica Kauffman, A Continental Artist in Georgian England* (1992).
A. C. Sewter, *The Life, Work and Letters of William Artaud* (M.A. thesis, University of Manchester, 1951; copy in National Art Library). This includes a typescript of Artaud's Journal from 1795, thirty-one letters from 1795–99 and drafts of forty letters from 1797–8. It also includes material on Edward Swinburne.
Kim Sloan, 'William Artaud: history painter and "violent democrat"', *The Burlington Magazine*, February, 1995.

Bro. John Webb, 'John George Lambton, The First Earl of Durham', *Transactions of Quatuor Coronati Lodge*, 9th May 1996.

Lady Anne Liddell, Duchess of Grafton

Walpole correspondence; see above under general sources.

Sir Henry George Liddell

Matthew Consett, *A Tour through Sweden, Swedish-Lapland, Finland & Denmark* (London and Stockton, 1789).
G. T. Fox, *Synopsis of the Newcastle Museum* (Newcastle, 1827).
The Monthly Chronicle of North Country Lore and Legend, Newcastle upon Tyne, 1887, pp.14–150.

John Graham Lough

T. S. R. Boase, 'John Graham Lough: A Traditional Sculptor', *Journal of the Warburg and Courtauld Institute*, vol. 23, 1960, pp. 277–90.
J. Lough and E. Merson, *John Graham Lough 1798–1876: A Northumbrian Sculptor* (Woodbridge, 1987).

Newbey Lowson and J. M. W. Turner

David Blayney Brown, *Turner et les Alpes 1802* (Switzerland, 1999).
David Hill, *Turner in the Alps, The Journey through France and Switzerland in 1802* (1992).
Cecilia Powell, 'Turner's Travelling Companion of 1802: A Mystery resolved?', *Turner Society News*, No. 54, February, 1990, pp.12–15.

Sir Charles Monck

Richard Hewlings, 'Belsay Hall and the Personality of Sir Charles Monck', in Roger White and Caroline Lightburn (eds.), *Late Georgian Classicism*, Papers given at the Georgian Group Symposium, 1987, 1988, pp. 7–27.
Roger White, *Belsay Hall, Castle and Gardens* (English Heritage guidebook, 2005).

The 1st Duke and Duchess of Northumberland and their two sons

Adriano Aymonino, forthcoming Ph.D. thesis on the art patronage of the 1st Duke and Duchess of Northumberland, University of Venice and the Warburg Institute.
W. Collins Baker, *Catalogue of the Pictures in the Collection of the Duke and Duchess of Northumberland* (typescript, 1930).
Geoffrey Beard, *The Work of Robert Adam* (1987).

European Historical Medals from the Collection of His Grace the Duke of Northumberland (Sotheby's 3rd December 1980 and 17th June 1981).
John Fleming, *Robert Adam and his Circle* (1962).
David Goodreau, *Nathaniel Dance* (Kenwood, London, 1977).
James Greig, ed., *The Diaries of a Duchess, Extracts from the Diaries of the First Duchess of Northumberland, 1716–1776* (1926).
Anthony Griffiths, 'Elizabeth, Duchess of Northumberland, and Her Album of Prints', in *Dear Print Fan: A Festschrift for Marjorie B Cohn*, ed. C. Bowen and others (Cambridge, Mass., Harvard University Art Museum, 2001).
David N. King, *The Complete Works of Robert and James Adam* (1991).
Alfred E. Knight, *The Collection of Camei and Intagli at Alnwick Castle, known as the Beverley Gems* (privately printed, 1921).
James Lees-Milne, *The Age of Adam* (1947).
Michael Liversidge, '"…A Few Foreign Airs and Graces…": William Marlow's Grand Tour Landscapes', in Clare Hornsby, (ed.), *The Impact of Italy: The Grand Tour and Beyond,* The British School at Rome, London, 2000, pp. 83–99.
Michael Liversidge and Jane Farington, eds., *Canaletto in England* (1993).
Noble Patronage (The Hatton Gallery, Newcastle upon Tyne, 1963).
Victoria Percy and Gervase Jackson-Stops, 'The Travel Journals of the 1st Duchess of Northumberland', I-III, *Country Life*, 31st January, 7th and 14th February 1974.
Frederick Poulsen, *Greek and Roman Portraits in English Country Houses* (Rome 1968).

Algernon, 4th Duke of Northumberland

Jill Allibone, *Anthony Salvin, Pioneer of the Gothic Revival* (Cambridge, 1988).
T. Barberi: *Catalogo ragionato della Galleria Camuccini*, c.1851; copy in Alnwick Castle archives.
J. Collingwood Bruce, *A Descriptive Catalogue of Antiquities, chiefly British, at Alnwick Castle* (Newcastle upon Tyne, 1880).
In Memoriam, Obituary Notices which were published on the death of the most noble Algernon, Duke of Northumberland, K.G. (Newcastle upon Tyne, 1865).
Nicholas Penny, 'Raphael's "Madonna dei Garofani" rediscovered', *The Burlington Magazine*, February 1992, pp. 67–81.
John Ruffle, 'The Journeys of Lord Prudhoe and Major Orlando

Felix in Egypt, Nubia and the Levant 1826-1829', in P. and J. Starkey, eds., *Travellers in Egypt*, London, 1998, pp. 75–84.
John Ruffle, 'Lord Prudhoe and his Lions', *Sudan and Nubia Bulletin*, no. 2, 1998, pp. 82–9.
John Ruffle, 'Lord Prudhoe and Major Felix, hiéroglyphiseurs décidés, in *Encounters*, American University in Cairo Press.
Colin Shrimpton with Clare Baxter, *Alnwick Castle*, guidebook (2004).

Lady Mary Wortley Montagu
Robert Halsband, ed., *The Complete Letters of Lady Mary Wortley Montagu* (Oxford, 1966-7).

William Ord
H. Maxwell (ed.), *The Creevey Papers* (typescript, Vol. IX, 1815, private collection).

Thomas Orde
Sir Gavin de Beer and André Michel Rousseau, 'Voltaire's British visitors' in *Studies on Voltaire and the Eighteenth Century*, XVIII (Geneva, 1961), Second Supplement, pp. 251–2; page 237 lists, in all, 113 British visitors to Ferney.
Alex Kidson, *George Romney, 1734–1802* (2002).
Francis Russell, 'A Recently Discovered Portrait of Thomas Orde by Pompeo Batoni', *The Burlington Magazine*, December, 1970, p.817.

James Paine
Peter Leach, 'James Paine' in *Studies in Architecture*., ed. John Harris and Alistair King, vol. XXV (1988).

The Ridleys
'Biographical Sketch of the late Sir Matthew White Ridley, Bart', *The Newcastle Literary Magazine and Northern Chronicle*, 1st January 1824, pp. 8–16.
Terry Friedman & Timothy Stevens, *Joseph Gott 1786–1860, Sculptor*, exhibition catalogue (Leeds and Liverpool, 1972).
'Pictures, Statuary and Bronzes at Blagdon and in 10, Carlton House Terrace, 1890', typed inventory with manuscript additions; private collection.
Ursula Ridley, *Blagdon and the Ridleys*, with a handlist of Ridley (Blagdon) MSS. by H. A. Taylor, Historical Manuscripts Commission for the National Register of Archives (1965).

William Sharp, *The Life and Letters of Joseph Severn* (1892).
Sarah Uwins, *A Memoir of Thomas Uwins, R.A*, 2 vols. (1858, and facsimile re-issue, 1978).

John 'Warwick' Smith
Francis W. Hawcroft, *Travels in Italy 1776–1783* (Manchester, 1988).
Thomas Jones, *Memoirs*; see above under general sources.
Anne Lyles and Robin Hamlyn, *British Watercolours from the Oppé Collection* (Tate Gallery, 1997).
Walker's Quarterly, 1926-27.
Iolo A. Williams, *Early English Watercolours* (reprint, Bath, 1970).

George Silvertop
Frank Dobson, *The Life and Times of George Silvertop of Minsteracres* (Newcastle upon Tyne, 2004).

The Rev. Percival Stockdale
G.E. Marindin (ed.), *The Letters of John B. S. Morritt of Rokeby, Descriptive of Journeys in Europe and Asia Minor in the Years 1794–1796* (1914).
The Memoirs of the Life and Writings of Percival Stockdale... Written by Himself, 2 vols. (1809).

The Swinburnes
Dr Terry Friedman, 'Sir Thomas Gascoigne and his Friends in Italy', *Leeds Art Calendar*, No. 78, 1976, pp. 16–23.
David Hill, *Turner Society News*, 23 (1981).
The Life of Hannah More with selections from her correspondence (1856).
Sale of drawings by Henry and Edward Swinburne, Sotheby's, London, 22nd November 1979.
Sale of Henry Swinburne's library, Leigh and Sotheby, 1802.
Henry Swinburne, *Travels through Spain in the Years 1775 and 1776* (1779).
Henry Swinburne, *Travels in the Two Sicilies in the Years 1777, 1778, 1779, and 1780* (1783).
Sir John Swinburne sale, Christie's, London, 8th June 1915.
Charles White (ed.), *The Courts of Europe at the close of the last century. By the late Henry Swinburne* (1841); although poorly edited, this is invaluable as the only published record of Swinburne's letters from abroad.
Andrew Wilton, *The Life and Work of J. M. W. Turner* (1979).

Philip C. Yorke, *The Diary of John Baker* (1931); Baker was Martha Swinburne's father, and the principal source of information on her early life.

For Edward Swinburne, see also under Lambton (William Artaud).

George Surtees

Brigadier-General H. Conyers Surtees and the late H. R. Leighton, *Records of the Family of Surtees* (Newcastle upon Tyne, 1925).

George Taylor, *A Memoir of Robert Surtees Esq., M.A., F.S.A., A New Edition* (The Surtees Society, 1852).

The Trevelyans

John Batchelor, *Lady Trevelyan and the Pre-Raphaelite Brotherhood* (2006).

Francesca Irwin, '"Drawn Mostly from Nature": David Allan's Record of Daily Dress in France and Italy, 1770–76', *Costume*, No. 32, 1998, pp. 2–17.

Master Class: Robert Scott Lauder and his Pupils, exhibition catalogue (National Gallery of Scotland, 1983).

Ferdinando Mori, *Le Statue e li Bassirilievi inventati e scolpiti in marmo dal cavaliere Alberto Thorwaldsen* (Rome, 1811).

John 'Warwick' Smith, *Select Views in Italy* (1792–9).

Victoria Surtees (ed.), *Reflections of a Friendship, John Ruskin's Letters to Pauline Trevelyan 1848–66* (1979).

Raleigh Trevelyan, *A Pre-Raphaelite Circle* (1978).

Raleigh Trevelyan, *Wallington, Northumberland*, The National Trust (2004).

See general section, Seidmann, for Nathaniel Marchant's gems for John Trevelyan.

John Tweddell

The Rev. Robert Tweddell, *Remains of John Tweddell* (2nd edition, 1816).

Dom. George Augustine Walker

Geoffrey Scott, 'A Monk's View of the Durham Coal Industry in 1750', *Northern Catholic History*, no. 15, Spring 1982, pp. 3–12.

Lenders to the 1999–2000 exhibition

Her Majesty The Queen, figs. 16, 43, 117–8

Aberdeen Art Gallery & Museums, fig. 40

Lord Barnard, Raby Castle, figs. 92, 152

Birmingham Museum & Art Gallery, fig. 19

Sir Brooke Boothby - Fonmon Castle Collection, figs. 51, 54

The Bowes Museum, Barnard Castle, figs. 6, 116, 137, 138, 181–6

The British Library Board, figs. 50, 52

The Trustees of the British Museum, figs. 2, 5, 7, 11, 23, 33, 37, 39, 41, 62, 94–97, 99, 113, 119, 122, 128, 162, 167, 168

John and Katie Carr-Ellison, figs. 106, 109, 111

Sir Richard FitzHerbert, Bt., fig. 28

The Syndics of the Fitzwilliam Museum, Cambridge, fig. 38

Glasgow Museums, fig. 24

Hatton Gallery, University of Newcastle, fig. 1

The late Lord Lambton, figs. 112, 115

Leeds Museums and Galleries (Lotherton Hall), figs. 55–8

National Galleries of Scotland, figs. 25, 31, 35–6, 67

National Maritime Museum, Greenwich, fig. 10

National Portrait Gallery, London, fig. 121

The National Trust, figs. 27, 93, 100–1

Collection of the Duke of Northumberland, Alnwick Castle, figs. 70, 72, 78, 173, 178, 180, Appendix 1, figs. 1, 2

Collection of the Duke of Northumberland, Syon House, figs. 69, 71, 73, 75–6

Northumberland Record Office, figs. 140–2

Oriental Museum, University of Durham, fig. 174

Private Collections, figs. 21, 29, 34, 45-6, 48–9, 60–1, 64, 81–3, 187–9

Tate, London, figs. 4, 8, 15, 32, 120, 132

Tyne & Wear Museums, figs. 3, 12, 13 (former loan) 14, 20, 26, 50, 53, 127 (former loan), 129–131,

The Victoria and Albert Museum, figs. 42, 44

Tyne & Wear Museums would also like to thank those lenders who wished to remain anonymous, and whose works are therefore not credited in the above list.

In addition, we are grateful to those who generously supported the 1999–2000 exhibition with loans, but whose works, either because they are documents, or for reasons of space, could not be reproduced here: the National Library of Scotland; anonymous lenders and lenders from private collections; and many of those lenders already credited above, who lent works additional to the ones illustrated here.

Photographic Acknowledgements

Aberdeen Art Gallery & Museums, fig. 40

Birmingham Museum & Art Gallery, fig. 19

The Bowes Museum, Barnard Castle, figs. 6, 116, 137–8, 181–5

The Bridgeman Art Library, London, fig. 28

The British Library Board, figs. 50, 52

City of Bristol Museum & Art Gallery, fig. 84

British Architectural Library, RIBA, London/A.C. Cooper fig. 91

The Trustees of the British Museum, figs. 2, 5, 7, 9, 11, 22–3, 33, 37, 39, 41, 62–3, 85, 94–7, 99, 113, 119, 122, 128, 162, 167–8

Christie's Images Ltd, Frontispiece, figs. 108, 110, 125, Appendix 1, fig.7

Colin Thompson Photography, fig. 126

The Syndics of the Fitzwilliam Museum, Cambridge, fig. 38

Glasgow Museums, fig. 24

The Hatton Gallery, University of Newcastle, fig. 1

Leeds Museums and Galleries (Lotherton Hall), figs. 55–9

Leeds Museums and Galleries (Temple Newsam House)/The Witt Library, fig. 153

London Metropolitan Archives, fig. 54

National Galleries of Scotland, figs. 25, 31, 35–6, 67

The National Gallery, London, figs. 151, 179

National Maritime Museum, Greenwich fig. 10

The National Trust, figs. 103 (Peter Moody), 164, 166, 169 (Colin Dixon Photography)

NTPL/Derrick Witty, fig. 86

Collection of the Duke of Northumberland, Alnwick Castle, figs. 74, 173, 178, 180

Collection of the Duke of Northumberland, Syon House, figs. 68, 73, 77

Northumberland Record Office, figs. 140–2

Pattinsons Photography, figs. 18, 102, 143–4, 146, 149–50

Paul Mellon Centre, fig. 88

Photographic Survey of Private Collections, Courtauld Institute of Art, figs. 65–6, 69–72, 75–6, 78, 160, 175–7, Appendix 1, figs. 1–6

Picture Library, National Portrait Gallery, London, fig. 121

Private Collection, figs. 34, 163

Prudence Cuming Associates Ltd., figs. 114, 157, 159

The Pyms Gallery, London, fig. 21

The Royal Collection ©1999 and 2006, Her Majesty Queen Elizabeth II, figs. 16–7, 43, 117–8

George Skipper, figs. 104–5, 107, 170–2

Sterling and Francine Clark Art Institute, fig. 165

Tate, London, figs. 4, 8, 15, 32, 120, 132–3

Thomas Cook Archives, figs. 154, 155–6

Tyne & Wear Museums, figs. 3, 12–14, 20, 26–7, 29–30, 45–6, 48–50, 52–3, 60–61, 64, 79–83, 87, 90, 92–3, 100–101, 106, 109, 111–12, 115, 127, 129–31, 134–6, 139, 145, 147–8, 152, 161, 174, 187–9

The Victoria and Albert Museum, figs. 42, 44, 124

Rob Watkins, figs. 47, 51

The Witt Library, fig. 158

York City Art Gallery/Glen Segal, fig. 123

Index

Page numbers in *italics* refer to illustrations. For reasons of space, Grand Tour cities and sites are listed only in the case of specific references to tourism. Similarly, Northern country houses owned by Grand Tourists are indexed only in the context of the Grand Tour